Mirror of the Medieval World

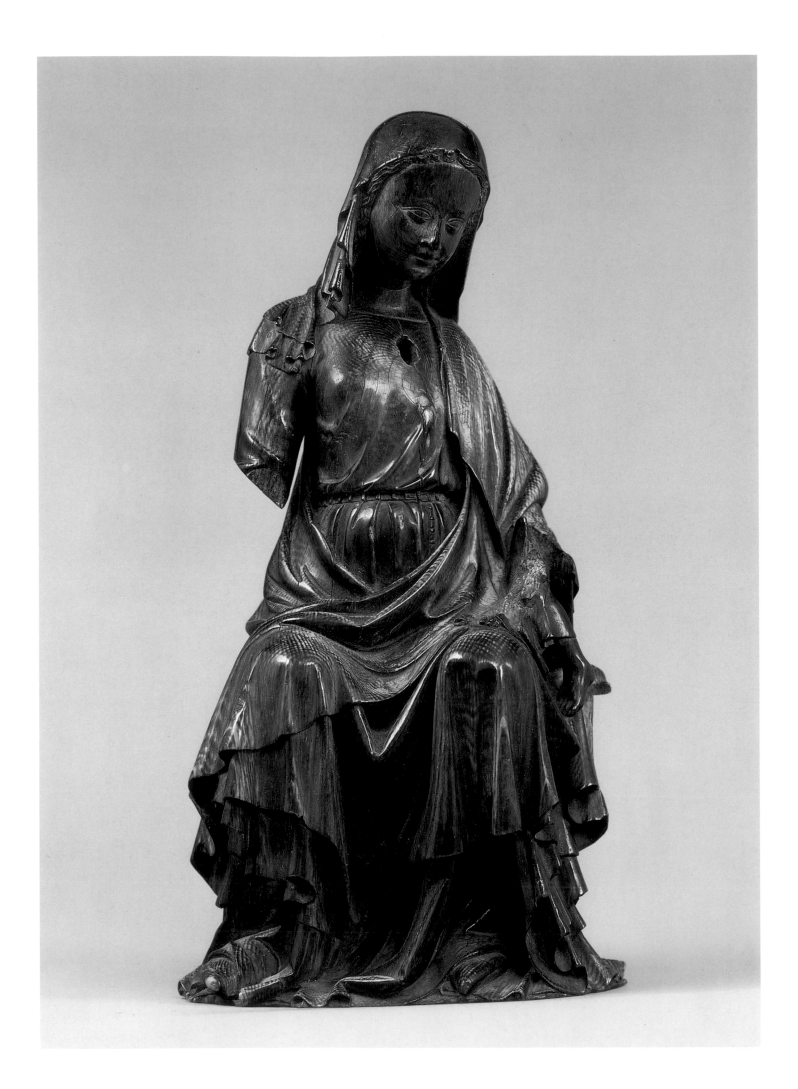

Mirror of the Medieval World

EDITED BY WILLIAM D. WIXOM

with contributions by

Barbara Drake Boehm

Katharine R. Brown

Lisbeth Castelnuovo-Tedesco

Helen C. Evans

Margaret E. Frazer

Carmen Gómez-Moreno

Timothy B. Husband

Daniel Kletke

Charles T. Little

Mary B. Shepard

William D. Wixom

THE METROPOLITAN MUSEUM OF ART, NEW YORK

Distributed by Harry N. Abrams, Inc., New York

This volume is published in conjunction with the exhibition "Mirror of the Medieval World,"
held at The Metropolitan Museum of Art, New York, March 9–July 18, 1999.

The exhibition is made possible by the William Randolph Hearst Foundation.

This publication is made possible by The Andrew W. Mellon Foundation.

Published by The Metropolitan Museum of Art, New York
John P. O'Neill, *Editor in Chief*
Ellen Shultz, *Editor*
Malcolm Grear Designers, Inc., *Designer*
Merantine Hens, *Production Manager*
Ilana Greenberg, *Desktop Publishing*

New photography of Metropolitan Museum objects by Paul Lachenauer,
The Photograph Studio, The Metropolitan Museum of Art

Front cover/jacket: Aquamanile in the Form of a Lion. See cat. no. 210
Frontispiece: Virgin and Child. See cat. no. 142

Printed in Singapore

Library of Congress Cataloging-in-Publication Data

Mirror of the medieval world / edited by William D. Wixom; with contributions by
 Barbara Drake Boehm ... [et al.].
 p. cm.
 Catalog of an exhibition held at The Metropolitan Museum of Art, March 9–July 18, 1999.
 Includes bibliographical references and index.
 ISBN 0-87099-785-8 (hc). —ISBN 0-87099-786-6 (pbk. : alk. paper). —ISBN 0-8109-6514-3
 1. Art, Medieval—Exhibitions. 2. Art—New York (State)—New York—Exhibitions.
 3. Metropolitan Museum of Art (New York, N.Y.)—Exhibitions. I. Wixom, William D.
 II. Boehm, Barbara Drake. III. Metropolitan Museum of Art (New York, N.Y.)
N5963.N4M445 1999
709'.02'0747471—dc21 98-43426
 CIP

Contents

Foreword

The publication of this remarkably comprehensive catalogue, *Mirror of the Medieval World*, marks the culmination of an extraordinarily prolific, more than twenty-year-long phase in the evolution of the Metropolitan Museum's Department of Medieval Art and The Cloisters. The distinguished career of William D. Wixom at the Metropolitan— first as the Michel David-Weill Chairman, and currently as Curator Emeritus, of the Medieval department, is celebrated most appropriately with the issuance of this volume and the installation of the exhibition of the same name, which it elucidates; both events have been timed to coincide with Bill's recent retirement from the Museum.

Without question, the book and the exhibition underscore Bill Wixom's finely tuned eye, impressive level of connoisseurship, and tireless energy as a collector, as well as the unassailable level of his scholarship. However, a glance at these printed pages in tandem with a tour of the exhibition galleries make clear that Bill is not alone in deserving of our esteem. The achievements of the Metropolitan's highly professional and accomplished curators—Bill's indisputably superb staff—is revealed to the reader and visitor alike, as the breadth and scope of this exceptional collection unfolds.

Mirror of the Medieval World aims to acquaint the public with the fascinating process by which the Museum obtains works of art. In the Introduction that follows, Bill Wixom elaborates on the complexities of building a collection, the motivations that underlie purchases, and the deliberations that result in the acquisition of one object rather than another. In addition, both the insight and foresight of the many donors who endowed the collection with major gifts as well as funds for past and future purchases are acknowledged and recorded with gratitude and admiration.

The more than three hundred works featured here are the highlights of a dazzling constellation of acquisitions that is nothing short of phenomenal. It is the rare institution that can present as outstanding and abundant an array of medieval art treasures.

It is through the generous support of the William Randolph Hearst Foundation that the exhibition was made possible. The Museum would also like to thank The Andrew W. Mellon Foundation for its support of this important publication.

PHILIPPE DE MONTEBELLO
Director
The Metropolitan Museum of Art

Preface

William D. Wixom retired in September 1998 as the Michel David-Weill Chairman of the Department of Medieval Art and The Cloisters at The Metropolitan Museum of Art. He had assumed this position in 1979, after two decades of achievement at The Cleveland Museum of Art. Bill's career in both Cleveland and New York was marked by numerous ambitious exhibitions and major projects. Surely, "Treasures of Medieval France" (1967), organized in Cleveland, and "Gothic and Renaissance Art in Nuremberg" (1986) and "The Glory of Byzantium" (1997), which were held in New York, can be counted among the most important and successful international exhibitions of medieval art in recent decades.

When he arrived at The Metropolitan Museum of Art, Bill took over the care of what were already impressive collections—much as he had done at Cleveland. Indeed, with such gifts as those of J. Pierpont Morgan, George Blumenthal, George D. Pratt, and John D. Rockefeller, Jr., the holdings of medieval art at the Metropolitan Museum became the nation's foremost, dazzling in quality and breadth. This catalogue of more than three hundred medieval works of art is in large measure a reflection of Bill Wixom's passionate and perspicacious activity as a collector, which greatly enriched the collections; for this, generations of Metropolitan Museum visitors and staff will continue to be profoundly grateful.

With the support of Philippe de Montebello—whose directorship of the Metropolitan Museum paralleled Bill's tenure here—and of the many generous donors who are cited in this volume along with the works they helped the Museum to acquire, Bill set out to strengthen and enlarge the indisputably fine collections he oversaw, both in the main building and at the Museum's uptown branch, The Cloisters. Working with curators in the Department of Medieval Art and The Cloisters, with the Museum's conservation staff, and with donors as well as dealers, Bill obtained numerous mas-

terworks, including the Early Byzantine Attarouthi Treasure (cat. no. 46), the Middle Byzantine silver cross (cat. no. 101), early medieval ivories (cat. nos. 69 and 70), the illuminated Leaves from a Spanish Romanesque Beatus Manuscript (cat. no. 92), an English Gothic ivory *Virgin and Child* (cat. no. 142), stained-glass windows from Ebreichsdorf (cat. no. 187), the lion aquamanile from Nuremberg (cat. no. 210), and the boxwood *Virgin and Child* attributed to Nicolaus Gerhaert von Leiden (cat. no. 228). However remarkable this short list appears, of necessity it omits many other outstanding works catalogued here, and, understandably, merely hints at the scope of the objects Bill added to the collection, which range from Bronze Age metalwork to silver-stained glass roundels from the Late Middle Ages.

Although major works of medieval art are becoming increasingly rare on the art market, we hope to be able to continue collecting at the high level that Bill Wixom established, for he has left the Museum in a superb position to accomplish even more. This catalogue is the first in a series of much-needed publications devoted to the Museum's medieval art, which, until now, has been only selectively published. Projects already under way include catalogues of our stained glass and medieval Italian sculpture; future volumes will be devoted to ivory carvings and to Romanesque sculpture. Exhibitions will, of course, always be a major focus, as will the reinterpretation and reinstallation of our medieval art galleries.

PETER BARNET
Michel David-Weill Curator in Charge
Department of Medieval Art and The Cloisters
The Metropolitan Museum of Art

List of Donors

The Kurt Berliner Foundation

Bastiaan Blok

Anthony and Lois Blumka

Blumka Gallery

Ruth Blumka

Victoria Blumka

Shirley Prager Branner

Ella Brummer

Miss Louise Crane

Michel David-Weill Foundation

Mr. and Mrs. Michel David-Weill

J. Richardson Dilworth

Dr. and Mrs. Paul G. Ecker

Max Falk

John L. Feldman

Helen Fioratti

Desmond Fitzgerald Charitable Fund

Frederic G. Fleming

Ilene Forsyth

The Glencairn Foundation

The Hon. Murtogh D. Guinness

Mrs. Karen Gutmann

Henry J. and Drue E. Heinz Foundation

Levy Hermanos Foundation, Inc.

Mr. and Mrs. Maxime L. Hermanos

Robert L. and Susan Hermanos

Eve Herren

Ilse C. Hesslein

Gula V. Hirschland

Mrs. Raymond Holland

Mrs. Charles C. Huber

Kawasaki Heavy Industries

Mr. and Mrs. Charles D. Kelekian

Charlotte A. Kent

Miriam H. Knapp

H. P. Kraus

Sibyl Kummer-Rothenhäusler

Ambassador and Mrs. Ronald S. Lauder

Leon Levy and Shelby White

Jack and Belle Linsky

Maan Z. Madina

The Robert Mapplethorpe Foundation, Inc.

Alastair B. Martin

Guy and Valerie Tempest Megargee

Ambassador J. William Middendorf II

Josef and Marsy Mittlemann

Mr. and Mrs. Alain Moatti

John Crosby Brown Moore

Morgan Guaranty Trust Company of New York

Mr. and Mrs. Ian Nasatir

Roy R. Neuberger

Mrs. Ernst Payer

Mrs. Hayford Peirce

Peter Pelettieri

Jeanne and Lloyd Rapport

Joseph G. Reinis

Annette de la Renta (Reed)

Mena Rokhsar

Meyer and Lillian M. Schapiro

Scher Chemicals, Inc.

Stephen K. Scher

Norbert Schimmel

Norbert Schimmel Foundation, Inc.

Georges and Edna Seligmann

Peter Jay Sharp

William Kelly Simpson

Dr. Louis R. Slattery

Nathaniel Spear, Jr.

Zita Spiss

Max and Elinor Toberoff

Miss Alice Tully

Michael and Stark Ward

Mr. and Mrs. Edwin L. Weisl, Jr.

Dr. and Mrs. Andrew J. Werner

Kurt John Winter

Mr. and Mrs. William D. Wixom

Rainer M. Zietz

Acknowledgments

Mirror of the Medieval World would not have been possible without the continuous encouragement of Philippe de Montebello, Director of The Metropolitan Museum of Art, for it was due to his unwavering interest in the Department of Medieval Art and The Cloisters that the collections were so greatly enriched over the course of the past twenty years. He deserves thanks as well for his sustained enthusiasm for this project, which presents the full panorama of acquisitions made during this period.

I am grateful also to Doralynn Pines, Associate Director for Administration, and Mahrukh Tarapor, Associate Director for Exhibitions, for their support of the publication and exhibition, respectively. I thank Kent Lydecker, Associate Director for Education, Mary B. Shepard, Museum Educator at The Cloisters, and Hilde Limondjian, General Manager of Concerts and Lectures, for organizing educational programs and lectures to accompany the exhibition.

My deep gratitude must go to the many donors both of funds and works of art cited in the preceding List of Donors. Without their timely support, the extraordinary quality and scope of the collections would have been much less substantial.

I am greatly indebted to the authors who contributed to this volume, both current and former members of the Department; their names appear on page 2. In particular, I would like to acknowledge the collegial manner in which the present staff respected and acknowledged the opinions of their predecessors, Margaret E. Frazer, Carmen Gómez-Moreno, and Jane Hayward. My thanks also to Peter Barnet, Michel David-Weill Curator in Charge of the Department of Medieval Art and The Cloisters, for without his support and collaboration both this book and the exhibition would not have been realized.

I would like to thank James H. Frantz, Richard E. Stone, Edmund P. Dandridge, Jack Soultanian, Jr., Michele D. Marincola, Lisa Pilosi, Mary Clerkin Higgins, Mark T. Wypiski, and others in the Department of Objects Conservation for their counsel as well as for their efforts in preparing objects for photography and exhibition. I would also like to thank Nobuko Kajitani and Kathrin Colburn and their colleagues in the Department of Textile Conservation for their expert work on the textiles included here.

Special thanks go to Barbara Bridgers, Joseph Coscia, Jr., and Paul Lachenauer of the Photograph Studio, and to the others who also provided the fine photographs in the catalogue.

I would like to convey my thanks to several colleagues at other institutions who furnished advice and in some cases comparative illustrations for this volume: Catherine Christiansen, Renate Eikelmann, Father John Fanning, Hermann Fillitz, Danielle Gaborit-Chopin, H. de Heinden, G. J. C. Boutmy de Katzmann, Dafydd Kidd, Thomas Kren, Daniel Hess, Sophie and Pierre Jugie, Marie-Hélène Lavallée, W. J. Meeuwissen, Florentine Mütherich, Helmut Nickel, Ursula Nilgen, Dr. Preuss, Alfred Schädler, Harvey Stahl, Alison Stones, Neil Stratford, Elisabeth Taburet-Delahaye, Father Filippo Tamburini, Gary Vikan, Paul Williamson, and P. Wodhuysen.

I am indebted to John P. O'Neill of the Editorial Department and to his staff for their extensive work and perseverance in bringing this publication to fruition. In particular, I would like to thank Ellen Shultz for her kindness and extreme patience with the authors. Thanks must go to the bibliographer Jayne Kuchna for her exacting efforts and to the many other editorial staff members who proofread galleys and assisted in the preparation of this publication. In addition, Gwen Roginsky, Merantine Hens, and Ilana Greenberg of the Production department, as well as Susan Chun and Tonia Payne, must be thanked for their essential assistance. A special thanks also to Malcolm Grear Designers, Inc., who created an elegant layout in these pages for this large and very diverse group of objects.

I would especially like to acknowledge Christine E. Brennan for her substantial work in assisting with this project during the last five years. She has been integral to the organization of material both for this publication and for the exhibition, and has served as a coordinator among the authors, editorial staff, and myself.

In the Department of Medieval Art and The Cloisters, I would like to thank Christina Alphonso, Julien Chapuis, Robert Theo Margelony, Thomas Morin, and Thomas C. Vinton for helping to make this publication and exhibition possible. Two department interns, Patricia Kiernan and Elizabeth White, assisted Christine Brennan over the past several years. Thanks also are due those scholars and graduate students who researched several works included in this catalogue: Robert Hallman, Ellen Kenney, and Dimitrios G. Katsarelias.

In the Office for Operations, Richard R. Morsches and Linda M. Sylling; in the Design Department, the designer Michael C. Batista; and in the Registrar's Office, Herbert M. Moskowitz, Aileen K. Chuk, and Blanche Perris Kahn have played vital roles in this project for which I am grateful, as have the Office for Development and the Department of Communications.

Finally, I would like to express my gratitude for the continued support and interest of my wife, Nancy, and my adult children, Llewelyn, Rachel, and Andrew.

To all the other individuals involved in this effort—too numerous to mention—I extend my deep appreciation as well.

WILLIAM D. WIXOM
Curator Emeritus
Department of Medieval Art and The Cloisters
The Metropolitan Museum of Art

Mirror of the Medieval World

Contributors to the Catalogue

BDB Barbara Drake Boehm

KRB Katharine R. Brown

LC-T Lisbeth Castelnuovo-Tedesco

HCE Helen C. Evans

MEF Margaret E. Frazer

CG-M Carmen Gómez-Moreno

TBH Timothy B. Husband

DK Daniel Kletke

CTL Charles T. Little

MBS Mary B. Shepard

WDW William D. Wixom

Twenty Years of Collecting Medieval Art

by William D. Wixom

The Metropolitan Museum's collections of medieval art are housed in two locations: at Fifth Avenue and Eighty-second Street and at The Cloisters in Fort Tryon Park at the northern tip of Manhattan. The earliest works in the galleries set aside in the main building date from the Late Bronze Age (the ninth to the seventh century B.C. in central and northern Europe), and the latest are examples produced in Italy in the International Gothic style of the early fifteenth century A.D., as well as non-Italian Late Gothic objects from the early sixteenth century. While the major focus at The Cloisters is on Romanesque and Gothic art and architecture, the earliest works there are Carolingian and Langobardic, from about A.D. 800, and the latest are mostly Late Gothic, dating from the first half of the sixteenth century. Seventy-five percent of the acquisitions made over the last twenty years and featured here have been on view at one or the other of these locations.[1] The catalogue that follows is organized within broad art-historical periods regardless of the present location of specific works at the Museum or at The Cloisters.

DUALITY OF FOCUS

A dual emphasis on excellence and on a carefully honed yet representative panorama of medieval art has long been a signal characteristic of the Museum's holdings. The works on exhibition at both sites share this duality of focus, exemplifying both high quality and the continuing expansion, with each new addition, of an already encyclopedic collection—the richest in the Western Hemisphere. This balanced approach toward acquisitions has been correlated with a careful regard for the cohesiveness of the combined medieval collections as a whole. The present survey, which, as noted, covers the last twenty years, may be evaluated, at least in part, in the light of these guiding principles.

A casual observer might assume that due to the generous purchase fund provided for The Cloisters in 1952 by John D. Rockefeller, Jr., as designated by this major donor, most if not all subsequent acquisitions of medieval art of the highest quality would have been sought by the Museum to enrich that collection. However, the Museum also

has added masterpieces, using general purchase funds given by other important donors, which have augmented the extensive series of medieval objects in the main building—magnificent donations from the collections of J. Pierpont Morgan, George Blumenthal, Michael Friedsam, George D. Pratt, Irwin Untermyer, and Jack and Belle Linsky, among others. Especially significant purchases have utilized the Cloisters Fund, together with general funds, as in the case of the Leaves from a Beatus Manuscript (1991.232.1-14; cat. no. 92), which, as a consequence, have been exhibited at both locations of the Department. The Cloisters, while clearly a museum, also is meant to evoke a western medieval architectural ambience.[2] In such a setting, many works are shown in ways that suggest their original functions. On the other hand, the medieval objects in the main building, which span the Bronze Age and the Early Christian, Byzantine, and Migration periods, and include later western art as well, are thus more widely based, and for the most part lack original architectural settings. However, both types of presentation are notable for their mix of major and minor works.

PUBLIC AUCTIONS

Certainly, chances to purchase examples of medieval art have increased over the last two decades, and it can hardly be said that the availability of fine objects in this field has been limited. A number of major works have been included in public sales. Perhaps the foremost collection to appear at auction was that of Robert von Hirsch in June 1978. While success eluded the Museum at this sale, six years later The Cloisters acquired a von Hirsch work from a private dealer: the German panel painting of the Bishop of Assisi Handing a Palm to Saint Clare (Nuremberg, about 1360; 1984.343; cat. no. 181). One of the smaller von Hirsch objects, an exquisite German amatory brooch, possibly Saxon, dating to about 1340–60 (1986.386; cat. no. 190), was acquired for The Cloisters at a subsequent auction. An additional von Hirsch work, a walrus-ivory Tableman, showing Apollonius of Tyre (Cologne, about 1170; 1996.224; cat. no. 84), purchased privately, was the partial gift of Michael and Stark Ward in 1996. Other opportunities at auction over the years resulted in both success and disappointment. We were not able to obtain the four-leaf fragment from an illustrated manuscript of the Life of Saint Thomas Becket, possibly made in London about 1230–40, which was sold to J. Paul Getty, Jr., in June 1986 and is now on deposit at the British Library. Another disappointment was our failure to acquire the gold Middleham pendant (English, about 1475–85), which was sold in December 1986 and is now in the Yorkshire Museum in York, England. The Metropolitan Museum was the underbidder in both instances. Included among our fruitful efforts were the purchases of the German ivory relief of Christ Presenting the Keys to Peter and the Law to Paul (12th century; 1979.399; cat. no. 85) from the Ernest Brummer sale in October 1979 and the ivory liturgical comb with scenes from the life of Thomas Becket (attributed to England, Canterbury[?], about 1200–1210; 1988.279; cat. no. 115) from the Béhague sale in December 1987, where it was described incorrectly as "North Italian, 12th/13th Century, Double-sided, . . . one side carved in relief with an Old Testament scene, . . . the other with the martyrdom of a saint." We also managed to acquire the imposing copper-alloy lion aquamanile (Nuremberg, about 1400; 1994.244; cat. no. 210) at auction in 1994. These are but a few of the occasions on which the Metropolitan Museum succeeded in obtaining a work at auction (the specific source for each is cited in the relevant entry below).

PRIVATE DEALERS, THEIR PRIVATE COLLECTIONS, AND OTHER SOURCES

Public auctions are not the only places where the Museum has been tempted. The rarely acknowledged role of the private dealer in the expansion of our collections has been paramount. Just as in the past, major dealers have ferreted out significant works, often masterpieces, long hidden in private collections, and the history of these objects, although often imperfectly known, holds a certain fascination for us, revealing much about changing tastes over time. The attempt, here, in each instance, is to present the history of ownership of an object as far as possible: Each entry lists the dealer source, given in brackets. When a work was in a private collection, the name of the owner is cited without brackets—even if the collector was, in fact, a dealer. Particularly important to the Museum have been the renowned private collections of the late dealers John and Putsel Hunt (see 1979.402, 1980.417, 1981.1; cat. nos. 142, 116, 93) and Leopold and Ruth Blumka (see 1980.366, 1985.133.1-2, 1989.80, 1989.293, 1989.358, 1990.283, 1991.156, 1991.411, 1992.176, 1994.270a-b, and a promised gift [*Saint Margaret*]; cat. nos. 154, 277, 251, 183, 221, 249, 226, 266, 240, 261, 237). Other sources include the heirs of the Paris collector Victor Martin Le Roy and of his son-in-law Jean-Joseph Marquet de Vasselot, a curator of medieval art at the Louvre (1991.232.1-14 and 1993.19; cat. nos. 92, 70). In addition, museums elsewhere, through their deaccessioning of works of art, have been responsible directly or indirectly for several of our noteworthy purchases (1981.1, 1986.285.1-13, 1987.15, 1990.132; cat. nos. 116, 187, 284, 126).

MAJOR PURCHASES

Major purchases are too numerous to note here in more than a highly selective way. Such acquisitions are to be found in nearly every section of the present catalogue, but my personal favorites include the exquisite gold *opus interrasile* crossbow fibula (Early Byzantine, about A.D. 480; 1995.97; cat. no. 36), certainly a technical and aesthetic high point in the evolution of the metalwork of this early period, and the resplendent array of silver-gilt chalices and other altar utensils in the Attarouthi Treasure (Early Byzantine, 6th–7th century; 1986.3.1-15; cat. no. 46), which now dominates the center of the Early Christian and Byzantine corridor in the main building. Middle Byzantine metalwork on an imposing scale is exemplified dramatically by the handsome silver and silver-gilt processional cross (first half of the 11th century; 1993.163; cat. no. 101) that graced the first gallery of the recent loan exhibition "The Glory of Byzantium."[3]

Perhaps the most striking and monumental of the several Early Medieval ivory reliefs is the plaque with the Three Maries at the Holy Sepulcher (North Italian, early 10th century; 1993.19; cat. no. 70), which forms an art-historical bridge between our Late Carolingian Metz ivories (1970.324.1 and 1974.266) and our single Ottonian example showing Christ Enthroned with Saints and Emperor Otto I (A.D. 962–68; 41.100.157). Fine Late Romanesque manuscript painting may be shown for the first time on a grand scale in the Museum's collection by the series of Leaves from a Beatus Manuscript (Spanish, about 1180; 1991.232.1-14; cat. no. 92),[4] a perfect complement to the Spanish monumental sculpture and frescoes at The Cloisters and the precious metalwork and ivories in the main building. Elegant proportions and fine workmanship characterize our exceedingly rare mid-thirteenth-century gold and crystal saltcellar,

which possibly was made for a member of the court of Louis IX (Saint Louis) (1983.434; cat. no. 125); this is the earliest example of European secular goldsmiths' work of the Gothic period to enter the collection. Prestigious and masterful, our ivory Virgin and Child (English, about 1290–1300; 1979.402; cat. no. 142) is one of the most entrancing small sculptures from the High Gothic period; its importance to the field of English art of this time parallels that of the ivory cross of about 1150–60, attributed to Bury Saint Edmunds (63.12), to the Romanesque period.[5] A silver and silver-gilt double cup (German or Bohemian, Prague [?], 1330–60; 1983.125a,b; cat. no. 178) with Jewish heraldic devices, which must have come from a Jewish context in imperial Prague, was acquired at auction in 1983. The purchase of the French ivory plaque with Scenes of Aristotle and Phyllis (Paris, about 1310–30; 1988.16; cat. no. 156) reunited the long-missing front panel with the romance casket given to the Museum by J. Pierpont Morgan (17.190.173). Restraint, proportion, and balance are especially notable in a secular silver-gilt, rock-crystal, and enameled covered beaker (Austrian, about 1350–60; 1989.293; cat. no. 183). Two outstanding Late Gothic sculptures are particularly unforgettable: the sublime boxwood statuette of the Standing Virgin and Child, of about 1470, attributed to Nicolaus Gerhaert von Leiden (1996.14; cat. no. 228), and the expressive walnut figure of a tormented Saint Anthony Abbot, of about 1500, attributed to Niclaus of Haguenau (1988.159; cat. no. 248). Since our collection of Late Gothic sculptures is extremely rich—a result of the J. Pierpont Morgan gifts of 1916 and 1917 and the purchases in the 1950s by James J. Rorimer, the late director of The Cloisters and subsequently of the Metropolitan Museum—these two recently acquired works might be described as building on the collection's preexisting strength. From this late period as well is the opulent silver-gilt and rock-crystal pax (also known as a *monile* or *Kusstafel*) from Nuremberg (about 1515–20; 1992.57; cat. no. 286), which with distinction complements our great Nuremberg silver-gilt and enameled pair of ewers with wild-men finials (about 1500; 53.20.12).[6]

CURATORIAL PURCHASES

The institution of the curatorial purchase has made possible the occasional acquisition of so-called lesser objects, which sometimes have been termed "the whispers of art history." These are works that do not require the approval of the Acquisitions Committee of the Board of Trustees. Their monetary values place such works on three separate levels: Those in the upper category need the approval of both the director and the chairperson of the Acquisitions Committee of the Museum's Board of Trustees; those in the middle range require the agreement of the director; and those of the lowest value may be acquired solely on the prerogative of the head of a department. Over the years covered by this publication, the approximately one hundred objects that have been acquired according to these guidelines tend to be works of art whose chief importance beyond their intrinsic interest is in relation to the encyclopedic nature of the collection and/or their resonance with respect to items the Museum already owns. For example, five heraldic stained-glass panels (Middle Rhenish, about 1500; 1980.214.1-5; cat. no. 290) were acquired for installation in the windows of the room at The Cloisters displaying the renowned altarpiece by Robert Campin (56.70), as these armorial panels echo the ones depicted in this famous painting. The extensive series of silver-stained roundels mostly acquired individually has allowed for a total revamping of the

window installations in the Glass Gallery on the lower level at The Cloisters. This newly enriched group was arranged thematically and by region, after mediocre and suspect examples were retired.

Several other curatorial purchases also built on the strength of an existing aspect of the collection. Two works connected with Christ Church Monastery, Canterbury, come to mind: the stained-glass panel with the Martyrdom of Saint Lawrence (Canterbury, about 1175–80; 1984.232; cat. no. 91) and the previously cited ivory liturgical comb (1988.279; cat. no. 115). Together with the English reliquaries already in the collection—the silver Becket reliquary, of about 1173–80 (17.190.520); the gold reliquary pendant of Queen Margaret of Sicily, of about 1174–83 (63.160); and the copper-gilt reliquary chest (Canterbury, about 1207–13; 1980.417; cat. no. 116)—the Metropolitan Museum can boast a highly significant representation of English monastic art of the Late Romanesque and Transitional periods.

Occasionally the attribution of a curatorial purchase takes on new interest after the publication of the object in *Notable Acquisitions* or *Recent Acquisitions*, leading to additional information. A case in point is the haunting late-fifteenth-century limestone head of Christ from a *Pietà* group, formerly believed to have come from northeast France and now identified as having been carved in the North Lowlands in the diocese of Utrecht (1983.406; cat. no. 246). This attribution signifies that the fragment is a rare survivor of the widespread destruction of stone sculptures in the Lowlands that occurred in the wake of religious upheavals. The identification of the city mark and the coat of arms on a silver-gilt chalice (1990.120; cat. no. 220) from the middle to third quarter of the fifteenth century, also a curatorial purchase, lends the work further importance, as it is a Rouen product probably made for a chapel of the deClercq family, who are recorded in northern France and in Bruges from the fourteenth to the sixteenth century. One of the recurring features of curatorial purchases is that works of art of this kind hardly ever remain at comparably low price levels. Sometimes whole categories of objects move beyond reach. For instance, examples of Bronze Age and Migration art are no longer available at their formerly modest prices and therefore are often beyond consideration as curatorial purchases.

MAJOR GIFTS

Major gifts of works of art are also an important part of the story of acquisitions. The name of each donor is always cited as part of the credit line when an object is exhibited and/or published (a list of such donors to the Department appears on page x). Several personal choices among this category of objects might be mentioned here: A bronze serpentine fibula (Hallstatt Period, 6th century B.C.; 1992.280.3; cat. no. 6) and a bronze ewer handle (Early La Tène, 5th century B.C.; 1992.280.1; cat. no. 8) were purchased with funds given for this purpose by the pioneering collector and former chairman of our Visiting Committee, Alastair B. Martin. The partially restored marble frieze sarcophagus (Late Roman, early 4th century; 1991.366; cat. no. 26) is a critical addition to our Early Christian sculpture collection. The gift of Josef and Marsy Mittlemann, it displays important New Testament episodes in the lives of Christ and Peter on the front and Old Testament representations of Adam and Eve and the Three Hebrews in the Fiery Furnace on the ends. The griffin lamp handle (Early Byzantine, 6th–7th century; 1987.441; cat. no. 47) came as the gift of Visiting Committee member Max Falk;

of imposing scale, the handle expands in a major way our series of Byzantine church and secular furnishings in bronze. A rare southern French roundel with an Elder of the Apocalypse (Conques, early 12th century; 1983.38; cat. no. 73), given by Mr. and Mrs. Ronald S. Lauder, added an important early cloisonné figurative enamel to our extensive collection of French Romanesque examples.[7] A powerful French limestone (?) head of a youth (Provençal, mid-12th century; 1997.146; cat. no. 86), the bequest of the late Meyer Schapiro, is the earliest of such eloquent fragments in the collection. A richly colorful French stained-glass panel with four censing angels (Champagne, Troyes, about 1170–80; 1977.346.1; cat. no. 82), a gift of Ella Brummer, is especially significant as a dynamic exponent in glass painting of the Transitional style that occurred between the Romanesque and the Gothic—a style partially continued in regional variants, such as the thirteenth-century stained-glass panels from Soissons and from Rouen acquired from The Glencairn Foundation (1980.263.2-4; cat. nos. 119, 121). The smiling French limestone head of an angel (Paris, about 1250; 1990.132; cat. no. 126), purchased with funds provided for this purpose by the current chairman of our Visiting Committee, Michel David-Weill, is an unusually playful and valued representative of the High Gothic Cathedral style. The refined and poignant French ivory corpus of Christ (Paris [?], about 1260–80; 1978.521.3; cat. no. 127) was the first of a series of Gothic ivories given by Mr. and Mrs. Maxime L. Hermanos and their family (the others are 1979.521.1, 1979.521.2, 1979.521.3, 1979.521.4, 1993.515, 1993.516.1, 1993.516.2a,b; cat. nos. 161, 160, 205, 158, 159, 50, 212). The arresting *bifolium* from a French manuscript of the *Decretals of Gratian* (Paris, about 1290; 1990.217; cat. no. 143), given by John L. Feldman, was illustrated by a gifted associate of Master Honoré; both artists were active a generation earlier than the renowned Jean Pucelle, who is recognized for his work on the *Hours of Jeanne d'Évreux*, in The Cloisters (54.1.2). Two small objects, an ivory and painted Passion booklet (North French, about 1300–Upper Rhenish, about 1310–20; 1982.60.399; cat. no. 152), the gift of Jack and Belle Linsky, and a silver-gilt and enameled diptych (Rhenish, 1320–40; 1980.366; cat. no. 154), the gift of Ruth Blumka, are valued additions to our collection of private devotional works intended to be held in the hands. Another enamel, the morse with Saint Francis of Assisi Receiving the Stigmata (Tuscan, 1300–1325; 1979.498.2; cat. no. 171), the memorial gift of Georges and Edna Seligmann, is remarkable not only for its experimental combination of opaque and translucent enameling on copper gilt but also is significant for recalling the monumental paintings of the same subject by or associated with Giotto in the Louvre in Paris, in the Bardi Chapel in Santa Croce in Florence, and in the saint's basilica at Assisi.

A majestic German sandstone Virgin and Child (Nuremberg, about 1425–30; 1986.340; cat. no. 214), a memorial gift of Ilse C. Hesslein, is unique not only in America but in Europe, outside of Germany, as well. The silk-and-metallic embroidery from an orphrey that illustrates the Annunciation (Netherlandish, mid-15th century; 1990.330; cat. no. 223), a memorial gift of Anthony and Lois Blumka, is amazing for its rich, well-preserved imagery, and thus superbly enhances our holdings of ecclesiastical vestments. The French alabaster statuette of Saint Margaret (Toulouse, about 1475; cat. no. 237), the promised gift of Anthony and Lois Blumka, is a masterpiece of the Late Gothic Languedoc sculptural style heretofore unrepresented in the Department's collection, and has an engaging intimacy rare for its period. Two Late Gothic tapestry panels handsomely augment our extensive tapestry collection:[8] One, with scenes from the Alsatian tale "Der Busant" (Upper Rhenish, Strasbourg, 1480–90; 1985.358; cat. no.

238), was the gift of Murtogh D. Guinness, and the other, which depicts Christ of the Mystic Winepress (South Netherlandish, about 1500; 1994.484; cat. no. 282), was the gift of Mena Rokhsar.

INTELLECTUAL GIFTS

There are gifts to the Department of Medieval Art and The Cloisters in a form other than the works cited above or the money to assist in expediting such purchases. Foremost are the gifts of experience and wisdom bestowed by colleagues and professors at museums and colleges here and abroad. Members of the Visiting Committee have been particularly supportive in this way during the years under discussion: Past chairmen J. Richardson Dilworth, recently deceased, and Alastair B. Martin, as well as the current chairman, Michel David-Weill, have offered timely advice and encouragement. Also, the late professors Harry Bober and Kurt Weitzmann were especially helpful over a long period of time, and, more recently, Professor Thomas F. Mathews provided valued suggestions with regard to Byzantine art—to name but a few of those whose assistance has been most welcome. Past members of our staff who lent their expertise include William H. Forsyth, Carmen Gómez-Moreno, and Margaret E. Frazer, each now retired, as well as the late Jane Hayward. All of this tells a story, rarely expounded, of the source of the Metropolitan Museum's greatness, significantly based, as it is, on the taste and participation of more than a few individuals who have made important unsung intellectual contributions to its success over the many years it has been in existence.

MISTAKES

Against this twenty-year record of auspicious acquisitions it is necessary, for the record, to report three purchases that have elicited questions of authenticity. The most dramatic of these is the orange-red limestone ("Verona marble") head of a king or emperor, originally described as "Northern Italian, early thirteenth century," which was shown to be a forgery because of certain carving details and following the appearance of closely related works—including an almost identical head—on the international art market; the Metropolitan Museum's sculpture subsequently was returned to the dealer and the purchase price was refunded (1982.322; see *Notable Acquisitions: 1982–1983*, 1983, pp. 18–19, color ill.). The almond-shaped seal matrix representing Saint John the Evangelist, a curatorial purchase (1981.291; see *Notable Acquisitions: 1981–1982*, 1982, pp. 17–18, ill.), has been determined to be a cast of a genuine wax impression; the original matrix, from the Hospital of Saint John, is in the Rijksarchief, Ghent. Lastly, the translucent and opaque enamels on a silver-gilt clasp decorated with birds, originally catalogued as "French or Italian" ("Court of Avignon, second quarter fourteenth century"; 1979.400; see *Notable Acquisitions: 1979–1980*, 1980, pp. 24–25, color ill.), have been shown to include "chrome green," and overall glass compositions that are indicative—at the very least—of reenameling or replacement in the nineteenth century or later. The authenticity of the rest of the piece remains under study.

Notwithstanding these few aberrations, the past twenty years have been fortunate, indeed. The surprising number of opportunities to enrich the collection could not have been predicted. The investigative work of the curatorial staff, the discipline of hard choices, the vital encouragement and taste of the director, the support of the

Trustees, and the availability of the necessary funds are the foremost factors in any successful acquisitions program, and these amply prevailed in the present context. The curatorial teamwork essential to this effort is also reflected in the scholarship and authorship of the many varied catalogue entries that follow. While the art-historical range of these acquisitions is purely accidental—dependent, as it is, on the availability of the individual objects—thought and judgment are responsible for the actual choices made. It is hoped that visitors to the exhibition and those who peruse these pages will be able to appreciate for themselves the quality and intrinsic interest of these acquisitions.

1 A number of examples of the art of the Migration Period have been held in storage awaiting the reinstallation of the collection once the second corridor along the Grand Staircase is returned to the Department of Medieval Art. Also, illustrated manuscripts and single leaves have not always been on view because of the prudent rotation policy necessary for conservation reasons. Other objects have been temporarily retired for conservation work.

2 See Landais, 1992, pp. 42–43; Wixom, 1996 a, pp. 93–119.

3 See Evans, 1997, no. 25, pp. 62–64, ill. p. 62, colorpl. p. 63.

4 The Department's acquisitions of additional illuminated manuscript pages—seven in number—have focused on examples that have particular relevance within our overall collection in other mediums. Given the strength of the holdings of our sister institution, The Pierpont Morgan Library, and the unparalleled quality of the *Hours of Jeanne d'Évreux*, illustrated by Jean Pucelle (about 1320–50; 54.1.2), and the *Belles Heures of Jean, Duc de Berry*, illuminated by the Limbourg brothers (about 1406–8; 54.1.1), we have not elected to purchase complete manuscripts for our collection. We have had the good fortune to acquire two important illuminated books from Visiting Committee member John L. Feldman: a profusely illustrated Book of Hours (about 1270; a promised gift; cat. no. 138) and a Parisian Bible (about 1250–75; 1997.320; cat. no. 137).

5 Parker and Little, 1994.

6 See Husband, 1980 a, pp. 181–83, fig. 123, colorpl. xiv; Husband, 1986 a, no. 78, p. 221, color ills. pp. 220–21.

7 See Taburet-Delahaye, 1996, no. 4, p. 74, color ill.

8 See Cavallo, 1993.

Catalogue

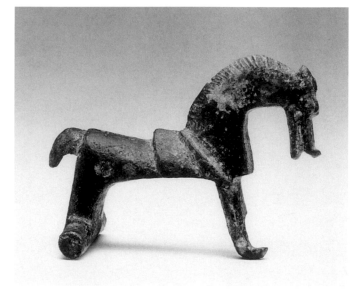

1

FIBULA IN THE FORM OF A HORSE

Hallstatt Period, 7th–6th century B.C.

Bronze: Height, 1⅛ in. (2.9 cm); length, 1⅞ in. (4.8 cm)

Gift of Ruth Blumka, in honor of Katharine R. Brown, 1992 (1992.107)

This fibula, in the form of a horse in the Geometric Style, was executed with broad flat surfaces, and its mane is indicated by incised lines. It belongs to a small group of central European animal brooches on each of which the bow is composed entirely of a three-dimensional animal; the hind legs conceal the spring gear, and the catch is attached to one of the forelegs. On this particular example, the hindquarters rest on a plinth with an indentation in the center, which once served as the attachment of the spring; the catch for the pin presumably was affixed to one of the front legs, although the right foreleg and the pin itself are now missing. A very similar horse fibula from the Upper Rhine is known,[1] but it apparently had coral terminals on the spring bar.

Because of the resemblance of the Metropolitan Museum's fibula to horse brooches from Roman Pannonia, its attribution at first presented a problem, but the expertise of Arielle Kozloff of The Cleveland Museum of Art was sought, and we now feel more comfortable with the Hallstatt Period attribution. A number of horse brooches have been found in Early La Tène (fifth-century-B.C.) graves as well. According to Vincent and Ruth Megaw, this may indicate the burial of talismans, which represented what clearly were highly prized and venerated assets.[2]

KRB

1 See Hattatt, 1989, ill.
2 See Megaw and Megaw, 1989, p. 82.

2

VOTIVE FIGURINE

Hallstatt Period, 7th century B.C.

Bronze: Height, 1⅞ in. (4.8 cm)

Bequest of Zita Spiss, 1991 (1993.3.1)

KRB

3

PIN, WITH THE HEAD AND TORSO OF A FIGURE

Hallstatt Period, 7th century B.C.

Bronze: Length, 3¾ in. (9.5 cm)

Bequest of Zita Spiss, 1991 (1993.3.5)

This pin is in the style of the well-known cult wagon, or chariot, of Strettweg, unearthed near Graz, Austria.

KRB

4

TWISTED TORQUE

Scandinavian, about 600 B.C.

Bronze: Diameter, 8¼ in. (21 cm)

Purchase, Nathaniel Spear Jr. Gift, 1987 (1987.395)

This torque belongs to a group of twisted neck rings in which the direction of the torsion changes several times. On some, including this example, the twists are marked by chiseled incisions;[1] here, the twists change direction six times. The interlocking terminals are decorated with dotted lines made with a tracer that form triangles and circles.

Although it is not known where this object was found, several twisted—as well as twisted and incised—torques have been discovered in peat bogs.[2] It is thought that they were deposited there by women as offerings to a god or goddess or as symbols of thanksgiving.

These bronze neck rings usually are dated to the end of the Scandinavian Bronze Age, when they apparently were prevalent. In this period, which lasted from the seventh to the first half of the sixth century B.C., the Bronze Age culture of central Europe was making an impact on Scandinavia.[3] It may be that the incised triangles on the present torque reflect this influence, since similar triangles are incised on the front of a bronze diadem in the Metropolitan Museum's collection (50.200).[4] However, incised geometric motifs, in general, are characteristic of Bronze Age artifacts throughout Europe.

This rare and beautiful neck ring is the Metropolitan's only example of a Scandinavian Bronze Age object, and it therefore represents a unique addition to the small but strong collection of Migration and later Viking art in the Museum. Its closest parallel is illustrated in *Antiquités Suédoises*.[5]

KRB

1 See Klindt-Jensen, 1957, fig. 37; Powell, 1966, p. 164, fig. 161.
2 See Montelius, 1912, p. 13, pl. v, no. 24.
3 See Sandars, 1968, p. 194.
4 See Foltiny, 1973, pp. 89 ff., who published the diadem as Hungarian, dating to 800 B.C.
5 See Montelius, 1873, no. 229, p. 67.

EX COLLECTIONS: [K. J. Hewett, London, 1982]; [Michael Ward, Inc., New York].

EXHIBITION: "Origins of Design: Bronze Age and Celtic Masterworks," New York, Michael Ward, Inc., October 22–December 15, 1987, no. 41.

REFERENCES: Rosasco and Ward, 1987, no. 41; Brown, 1988, p. 12, ill.

5

FIBULA

Late Hallstatt Period, 6th century B.C.

Bronze: Length, 1½ in. (3.8 cm)

Gift of Bastiaan Blok, 1992 (1992.108.1)

KRB

EX COLLECTION: [Bastiaan Blok, Noordwijk, The Netherlands].

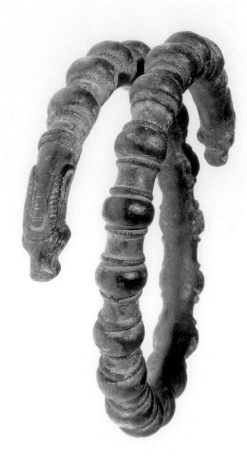

6

SERPENTINE FIBULA

Hallstatt Period, 6th century B.C.
Bronze: Height, 1½ in. (3.8 cm); length, 5 in. (12.7 cm)
Purchase, Alastair B. Martin Gift, 1992 (1992.280.3)

This is one of the most beautiful brooches in the Metropolitan Museum's collection, and may be categorized as "serpentine" because of the sinuous form of its bow. The type was particularly common in Italy, but examples have been found throughout Europe in the tombs of both men and women. Although they are usually of bronze, brooches of this kind also exist in iron, gold, and silver.[1] The present example, with antennae, is especially close to one in Rouen[2] of unknown provenance as well as to an early-sixth-century B.C. brooch from Villingen, Germany, although the latter has two pairs of antennae.[3] The British Museum owns a serpentine brooch fitted with spoked wheels, which was excavated from the Iron Age cemetery at Hallstatt, Upper Austria, and dated to the sixth century B.C.[4]

KRB

1 See Megaw and Megaw, 1989, p. 42.
2 See Verron, 1971, no. 104, p. 91, ill. p. 90.
3 See Megaw and Megaw, 1989, p. 42, fig. 32.
4 See *Jewellery through 7000 Years*, 1976, no. 31, p. 103.

EX COLLECTION: [Bastiaan Blok, Noordwijk, The Netherlands].

7

ARMLET, WITH ANIMAL-HEAD TERMINALS

Celtic (Early La Tène), about 400 B.C.
Cast bronze: Maximum diameter, 4 in. (10.2 cm)
Rogers Fund, 1980 (1980.62)

From the mid-fifth century to the first century B.C., continental Europe was dominated by the Celtic style known as La Tène, after the type site in Switzerland. One major component of the style is its Near Eastern elements, exemplified in this armlet by the horned animal heads that form the terminals. An early date can be assigned to the armlet on the basis of the fairly certain identification of these heads as those of ibex, since, in later La Tène art, animal heads became more abstract, at least in western Europe. Another argument in favor of an early dating is the penannular collars flanked by raised incised bands alternating with spaces that comprise the body of the armlet; these are characteristic of Early La Tène bronze jewelry and are derived from the plain knobs on bracelets of the Hallstatt Period. The high tin content of the bronze supports an origin in western Europe for the armlet, which represents a significant addition to the Metropolitan Museum's small but important holdings of prehistoric European art—all the more so since it is not only one of the few Early La Tène objects in our collection but also the finest.

KRB

EX COLLECTIONS: [K. J. Hewett, London, 1979]; [Michael Ward, Inc., New York].

REFERENCE: Brown, 1980, p. 20, ill.

8

HANDLE FOR A EWER

Early La Tène, 5th century B.C.
Bronze: Length, 3½ in. (8.9 cm)
Purchase, Alastair B. Martin Gift, 1992 (1992.280.1)

This ewer handle terminates in a dog's head with an open mouth; its ears are pricked and its eyes are indicated by bulges with parallel slits. The head recalls that of a dog or wolf illustrated in Jacobsthal's *Early Celtic Art*, but the latter is much cruder in execution.[1] It is dated to the fifth century B.C. and cited as a handle for a ewer. The tradition of animal-headed handles is well documented by the ewer from Basse-Yutz, Moselle, dated between the fifth and fourth century B.C. and thought to be from a German workshop.[2]

The casting of the eyes is reiterated on the "crocodile" spout of a wooden flagon of the tenth century B.C., from the Dürnberg, near Hallein in Austria,[3] as well as on the head of a bronze brooch from Steinsberg, Germany, also dating between the late fifth and early fourth century B.C.[4] Thus, the Museum's elegant handle may well be from Germany. Although there is no reason to doubt the authenticity of this handle, it is difficult to envision where it was attached on a ewer, as the dog appears to be doing a backbend. However, it surely was placed much higher than the handle of the Basse-Yutz ewer.

KRB

1 See Jacobsthal, 1944, no. 384, p. 1173.
2 See Megaw, 1970, no. 60, p. 68.
3 See Megaw and Megaw, 1989, no. 220, p. 143.
4 See Megaw, 1970, no. 94, p. 84, n. 2.

EX COLLECTION: [Bastiaan Blok, Noordwijk, The Netherlands].

9

BOW OF A FIBULA

Early La Tène (Champagne or South Germany), late 5th century B.C.
Bronze: Height, 1½ in. (3.8 cm); length, 2⅛ in. (5.4 cm)
Purchase, Alastair B. Martin Gift, 1992 (1992.280.2)

KRB

EX COLLECTION: [Bastiaan Blok, Noordwijk, The Netherlands].

10

GIRDLE CLASP

Celto-Iberian (Spain), 2nd century B.C.
Leaded bronze, with silver inlays and iron rivets: Length (plaque with concentric circles), 3⅜ in. (8.6 cm), (plaque with rectangular openings), 2⅜ in. (6 cm)
Rogers Fund, 1990 (1990.62a,b)

This is one of a large group of Celto-Iberian bronze clasps inlaid with silver that are strong in design and subtle in execution. The clasps are primarily from the central plateau region of Spain and the silver was mined in the adjoining Sierra Morena mountains. The clasps have been found in tombs in this area of Spain, together with inlaid arms that may be dated from the third to the first century B.C.

These clasps are closely related in form to engraved examples from Andalusia, the southwestern province that influenced developments in the rest of Iberia. In addition, the fact that figurines of warriors wearing belts with similar clasps have been found in Andalusia has probably contributed to the belief that inlaid clasps like this one, as well as the Andalusian examples, are military girdle clasps. Although a large number of single plaques from such girdle clasps have survived, the Metropolitan Museum's example is rare in that both plaques are preserved.

The patterns on these clasps were created by carving out the design and hammering a thin sheet of silver into the recesses. Usually,

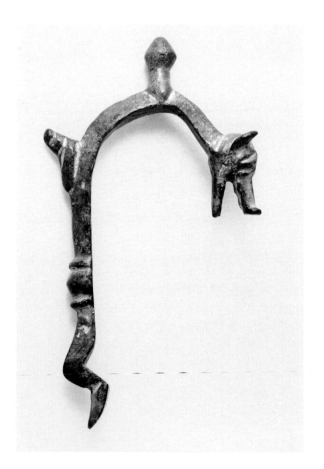

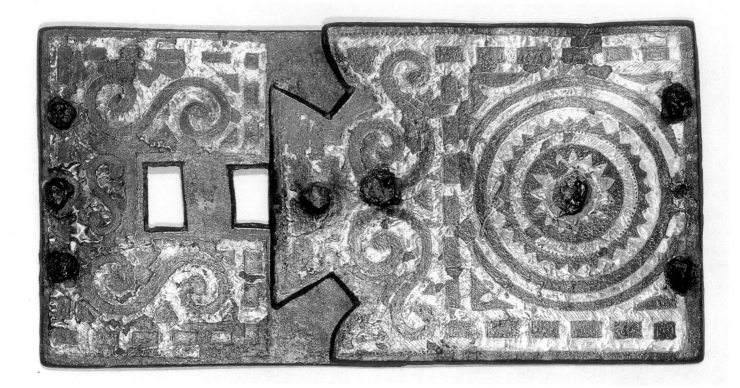

one nearly rectangular plaque is cut with a flangelike profile and with a hook on the underside, while the other plaque generally has three rectangular openings. On this particular example, the plaque originally fitted with a hook is decorated with a multipointed star surrounded by concentric circles and a pair of spirals on the flange; the other plaque has two spirals flanking a third, smaller one. Opposing spirals are a favorite motif in Celtic art and are found with concentric circular designs on many of these clasps. Both plaques have borders consisting of dashes and show the remains of the iron rivets that attached the plaques to a leather belt strap.

K R B

EX COLLECTION: [Ariadne Gallery, New York].

REFERENCES: Cabré, 1928, pp. 97–110; Cabré y Aguiló, 1937, pp. 93–125; Brown, 1990 b, pp. 16–17, ill. p. 16.

11

TERRET (REIN GUIDE)

Romano-Celtic, 1st century A.D.

Bronze, with champlevé enamel: 2¼ x 4 in. (5.7 x 10.2 cm)

Purchase, Harris Brisbane Dick Fund; Joseph Pulitzer Bequest; Pfeiffer, Rogers, Fletcher, Louis V. Bell, and Dodge Funds; and J. Richardson Dilworth, Peter Sharp, and Annette Reed Gifts, 1988 (1988.79)

Cast in series and used in pairs, rein guides are among the most characteristic artifacts to have come down to us from the Romano-Celtic period.[1] This beautiful rein guide still retains most of its red champlevé-enamel decoration, which is enhanced by the green patina of the bronze. Discovered almost twenty years ago by its last owner as he was plowing his field in Norwich, England, the terret is

one of the best-preserved examples of Romano-Celtic art—that is, art from Celtic Britain after the Roman conquest in A.D. 43. However, even before the Claudian invasion, Roman influences were seen in the traditional motifs of Celtic art.

The ring, which is elliptical in shape but round in section, is separated from the bar that attached it to the yoke by two collars. While many first-century terrets were undecorated, the lips as well as the ring of the present one display circles, peltae, and comma-shaped motifs. Circles and peltae were positioned on the pairs of lips so that they reflect each other, thus demonstrating the Roman

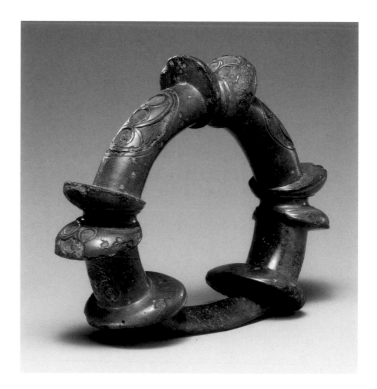

fondness for mirror images. The circles flanked by commalike motifs on the upper parts of the ring exemplify "fold-over symmetry," equally Roman in concept, while the pelta-and-circle designs of the lower parts of the ring, on opposite sides of the base, show the Roman inclination for balance. On the other hand, the comma motif is taken from the elongated scroll found in Celtic or Late Iron Age art, an example of which can be seen on the magnificent gold torque from Frasnes-lez-Buissenal (Belgium), dated about one hundred years earlier; an anonymous loan, it is on view in the Metropolitan Museum. The enameled decoration on the Metropolitan Museum's terret is closest to that on the horse trappings from Ditchley and from Polden Hill, now in the Ashmolean Museum, Oxford, and the British Museum, respectively.[2] The most common designs on these first-century horse trappings are circular motifs such as those on the lips and the uppermost portions of the present ring. In fact, one of the objects in the British Museum from the Stanwick hoard uniquely is decorated with these circular designs.[3]

The only other example of Romano-Celtic art in the Metropolitan Museum is a small bronze brooch cast in the shape of a dragon and set in the center with blue enamel in the champlevé technique (cat. no. 12). Commalike motifs similar to those that flank the circles on the terret also surround the enameled center of the brooch.[4] As has been noted already, this ornamentation is characteristic of the Late Iron Age.

Among the six types of terrets described by E. T. Leeds,[5] the Metropolitan's example is representative of the third, and is closest in form to four excavated at Stanwick and now in the British Museum. The diagram of the reconstruction of a small Celtic chariot, based on the discovery of chariot fittings from Llyn Cerrig, Anglesey (Wales), and now in the National Museum of Wales, Cardiff, demonstrates that rein guides were attached at each end of the yoke.[6]

KRB

1 See Leeds, 1933, pp. 118–26.
2 Ibid.
3 See Duval, 1977, no. 420, pp. 217, 278.
4 Acc. no. 1980.450: see Brown, 1981, p. 19, ill.
5 See note 1, above.
6 See Fox, 1958, pp. 58–59, fig. 40, plates 6, 26.

EX COLLECTIONS: S. Hall, Esq., Red House Farm, Tivetshall, St. Margaret, Norwich, England, about 1972; [sale, Sotheby's, London, December 13, 1982, lot 141]; [Rainer Zietz Limited, London]; Private collection, Germany; [Michael Ward, Inc., New York, 1987].

EXHIBITIONS: "Origins of Design: Bronze Age and Celtic Masterworks," New York, Michael Ward, Inc., October 22–December 15, 1987, no. 71; "Decorative and Applied Art from Late Antiquity to Late Gothic," Moscow, State Pushkin Museum, May 10–July 10, 1990, and Leningrad, State Hermitage Museum, August 14–October 14, 1990, no. 1.

REFERENCES: Rosasco and Ward, 1987, no. 71, color ill.; Brown, 1988, p. 13, color ill.; *idem*, 1990 a, no. 1, p. 10, colorpl. p. 11.

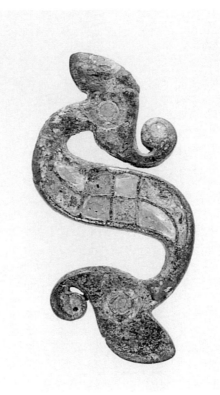

12

DRAGONESQUE BROOCH

Romano-Celtic, 1st century A.D.
Bronze, with champlevé enamel: Height, 2 in. (5.1 cm)
Rogers Fund, 1980 (1980.450)

About the time of the Claudian invasion of Britain, in A.D. 43, the "dragonesque" brooch became popular in England, primarily in the military districts of the north. It then spread to southern Scotland, and stayed in fashion in Britain and Scotland until the end of the second century A.D. Studies of the development of the type permit us to place the Metropolitan Museum's example at the end of the first century because of the lively presence of the dragon and the degree of complexity of the enamel decoration, with its four squares of green (?)—now missing—and blue champlevé enamel, flanked by four curved, tapering terminal panels. While the form derives from an Iron Age prototype, the design of the enamel decoration on this brooch classifies it as an excellent example of Celtic metalwork produced in Britain when the country was under Roman rule.

KRB

EX COLLECTIONS: [K. J. Hewett, London, 1980]; [Michael Ward, Inc., New York].

REFERENCE: Brown, 1981, p. 19, ill.

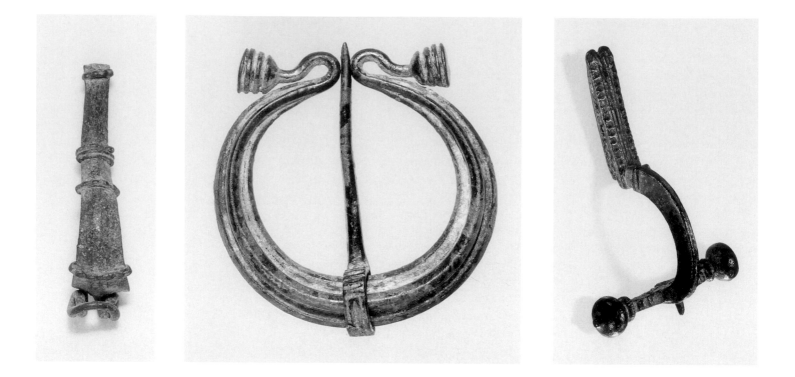

13

BOW BROOCH

Provincial Roman, mid-1st century A.D.
Bronze: Length, 2¼ in. (5.7 cm)
Gift of Bastiaan Blok, 1992 (1992.108.2)

K R B

EX COLLECTION: [Bastiaan Blok, Noordwijk, The Netherlands].

14

PENANNULAR OR OMEGA BROOCH

Provincial Roman, 1st–2nd century A.D.
Bronze: Width, 2 in. (5.1 cm); length (of pin), 2⅛ in. (5.4 cm)
Rogers Fund, 1981 (1981.205)

Provincial Roman penannular brooches in the form of a ring with a small break in the circumference for the passage of a pin served in part as the prototypes for later Irish examples, such as the ninth-century Tara Brooch. Like this Provincial Roman one, Irish brooches from the late fifth century have rounded hoops in front that are embellished at each end with terminals decorated with engraved transverse lines; the terminals of some Provincial Roman examples have slots for amber. In both Irish and Roman brooches, the pin has a plain cylindrical head and is not much longer than the diameter of the hoop; here, the pin is decorated with incised lines. The Metropolitan Museum's early-ninth-century Pictish silver brooch (1981.413; see cat. no. 63) is decorated with amber, while the ninth-century Irish ones are often of bronze, set with garnets and connected by an animal snout, as is another example in the Museum (49.125.9).

This particular Provincial Roman penannular brooch is cast, and displays four concave moldings alternating with three convex ones. A very similar contemporary brooch is in the Walters Art Gallery, Baltimore.[1] In addition, several Iron Age ribbed examples are known.

K R B

1 See *Jewelry: Ancient to Modern*, 1979, no. 358, p. 130.

EX COLLECTIONS: [K. J. Hewett, London]; [Michael Ward, Inc., New York].

15

"STRONGLY PROFILED" FIBULA

Provincial Roman (probably Pannonia), 1st–2nd century A.D.
Bronze: Length, 2½ in. (6.4 cm)
Bequest of Zita Spiss, 1991 (1993.3.4)

In profile, the bow of this fibula takes a sharp turn downward, broadening into a trumpet-shaped head while narrowing in width toward the foot, which terminates in a single knob. A molding separates the bow from the long foot. The catch plate on this example is not deep, but it is perforated. Below the trumpet head, the fibula is fitted with a "Colchester-type" spring gear. The Metropolitan Museum owns another example of a fibula with this form (55.140), which is enameled. The type originated in Pannonia and was dispersed throughout Europe by the military.[1]

K R B

1 See Hattatt, 1985, p. 65.

EX COLLECTIONS: [Spiss collection, Vienna]; Zita Spiss, Syosset, New York.

16

WING FIBULA

Provincial Roman (Pannonia), 2nd century A.D.

Silver and gold, with five carnelians: Height, 1¹⁵⁄₁₆ in. (4.9 cm); width, 1⁹⁄₁₆ in. (3.9 cm); length, 7¾ in. (19.7 cm)

Purchase, Alastair B. Martin, William Kelly Simpson, Scher Chemicals Inc., Levy Hermanos Foundation Inc., Shelby White, and Max Falk Gifts, in honor of Katharine R. Brown, 1998 (1998.76)

The richly decorated fibula, wrought in silver, is an exceptional example of a relatively rare type of brooch typical of those made in the Roman border province of Pannonia, on the Danube. These objects are called wing fibulae because of the wing like extensions that flank the knob at the bend of the bow. On this work, the knob is decorated with a zigzag pattern and the two wings are each adorned with two small knobs. A punchwork design extends from the knob for the length of the bow. As is typical of the few other surviving examples of this quality, the large, trapezoidal catch plate is covered with gold foil, except where it is pierced with elaborate patterns.[1] Twisted gold wire laid down in wavy lines and scroll-and-heart motifs decorate the foil. Five carnelians frame the two intricate openwork patterns near the tip of the catch plate—one of linked circles and one of linked hearts. Rounded and rosette-shaped silver studs also ornament the surface. Except for minor losses to the gold foil, the fibula is complete and in excellent condition.

On the basis of burial and pictorial evidence, wing fibulae like this one were worn by women in pairs, on the shoulder, with the intricately pierced catch plates protruding above their robes, creating a relatively delicate, patterned effect.[2] While the Metropolitan Museum also owns another well-wrought bronze wing fibula in the typical Pannonian style (51.115), the present work, with its brilliant surface, represents the highest quality in this tradition.

HCE

1 See Tóth, 1992, p. 56, pl. 40, for the finest examples of this type.
2 See Hattatt, 1987, p. 37, fig. 14 g.

EX COLLECTIONS: Private collection, The Netherlands; [Wolfgang Wilhelm, 1998].

17

KNEE BROOCH

Provincial Roman, 2nd century A.D.

Bronze: Length, 1¼ in. (3.2 cm)

Bequest of Zita Spiss, 1991 (1993.3.7)

A knee brooch typically is small and short, with a tapering bow, in profile, emerging from the head and turning sharply downward toward the foot, which flares outward. In this particular example, half of the spring is enclosed in the semicylindrical head. These brooches originated in the Rhineland, but the type became widespread as far eastward as Pannonia and as far westward as Britain. There are many variations.[1]

KRB

1 See Hattatt, 1985, pp. 120–23, figs. 50–51.

EX COLLECTIONS: [Spiss collection, Vienna]; Zita Spiss, Syosset, New York.

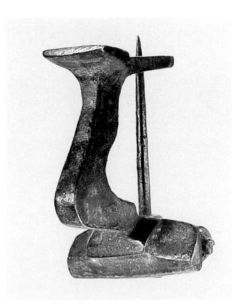

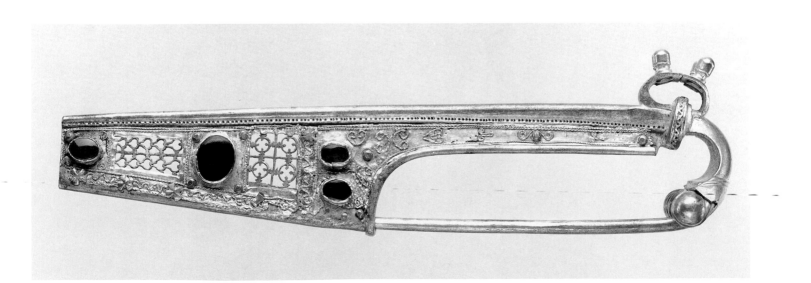

18

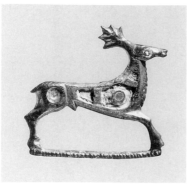

19

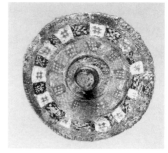

20

18

S-SHAPED FIBULA

Provincial Roman, 2nd–3rd century
Bronze: Length, ⅝ in. (1.59 cm)
Gift of Alastair B. Martin, 1991 (1991.279)

Swirling trumpets form an S-shaped design on this elegant and nearly three-dimensional Provincial Roman brooch. Since artisans in all the Roman provinces were influenced by Celtic art, the trumpet motif became part of the Provincial Roman repertory. Brooches similar to this one have been found in the Rhineland, in Switzerland, and in the area that was once Roman Pannonia, and have been dated between the second and the third century. The plasticity of the style, characteristic of the last phase of Celtic art, was echoed in such Provincial Roman objects as this brooch and the harness mount in the Metropolitan Museum's collection (cat. no. 11), as well as in several harness mounts based on trumpet motifs excavated at Dura-Europos (present-day Syria) and now in the Yale University Art Gallery.

Confronted trumpets and pairs of trumpets joined together to form peltae (heart-shaped designs) appear on the famous enameled bronze vase found at La Guierche, west of Limoges. The vase, now in the Metropolitan Museum (47.100.5), was discovered along with coins, which has enabled us to date it to the end of the third century. The small silver plaque from the Vermand Treasure—dated to the fourth century—also in the Museum (17.192.144), when placed vertically, displays the same arrangement of peltae and trumpet motifs as does the La Guierche vase. Thus, the vase and plaque represent two later examples of the Roman fondness for symmetry, in contrast to the earlier and more purely Celtic brooch and harness, with their swirling trumpet designs.[1]

KRB

1 See Brown, 1995 a, pp. 20–21.

EX COLLECTION: Alastair B. Martin, New York.

19

FIBULA IN THE FORM OF A STAG

Provincial Roman, 2nd–3rd century
Copper alloy, with champlevé enamel: Height, 1⁷⁄₁₆ in. (3.6 cm); length, 1⁷⁄₁₆ in. (3.6 cm)
Gift of Peter Pelettieri, in memory of Ruth Blumka, 1996 (1996.212)

This elegant, perky, and proud stag is portrayed advancing to the right, its head held high. Its body is decorated with blue and traces of white enamel, and it has a white enamel eye. Representations of stags are rare among Provincial Roman zoomorphic fibulae; cocks, dogs, horses, and rabbits are the most commonly encountered animal types. Therefore, this stag adds a new dimension to the Metropolitan Museum's already rich group of such zoomorphic fibulae, which includes three dogs and two birds.

To this beholder, the fibula represents several of the qualities of the person for whom it serves as a remembrance: Ruth Blumka. She was beloved by many for her perkiness, self-assurance, determination, charm, and elegance.

The brooch is fitted on the reverse with a tripartite hinge and retains its original pin and catch.

KRB

EX COLLECTION: Peter Pelettieri, Burlington, Connecticut.

20

DISK-SHAPED BROOCH

Provincial Roman, 2nd–3rd century
Bronze, with *millefiore* enamel: Diameter, 1⅜ in. (3.5 cm)
Gift of Justin E. Nasatir, 1994 (1994.483)

This brooch is decorated with two concentric circles of *millefiore* enameling on bronze. The inner circle consists of green squares alternating with squares that contain a red-and-white checkerboard pattern, and the outer circle, of white squares enclosing a "number-sign" motif in red alternating with squares on which there is a black-and-white checkerboard pattern. The brooch has a protruding central knob. *Millefiore* brooches with black and green coloring are very rare; the red, white, and blue of the Metropolitan Museum's other *millefiore* brooch (66.16) are more common.

The pin on the reverse is broken.

KRB

EX COLLECTION: [Blumka Gallery, New York].

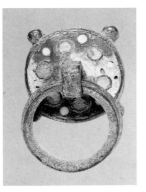

22

21

23

24

25

21

LID OF A VESSEL

Provincial Roman, 2nd–3rd century A.D.

Bronze, with champlevé enamel and floating cloisons: Diameter, ⅞ in. (2.22 cm)

Gift of Kimberly L. Nasatir, 1994 (1994.482)

This circular top for a vessel, fitted with a bronze ring, is decorated with blue champlevé enamel, four white dots, and six circular floating cloisons that once contained yellow(?) enamel. Four decorative elements project from the lid, whose underside contains two horizontal bars of the same length, each attached by a vertical projection, in order to secure the lid to the vessel. A fibula in the form of a wheel, in the Metropolitan Museum (22.50.11), represents our only other Provincial Roman example of enamel work with floating cloisons; both are rare documents in the West of champlevé enamel with floating cloisons. The Museum also possesses a Carolingian cross-shaped harness mount (51.158) in this same unusual technique.

KRB

EX COLLECTION: [Blumka Gallery, New York].

22

SEAL BOX

Provincial Roman, 3rd century A.D.

Bronze, with champlevé enamel: Length, 1¼ in. (3.2 cm); width, ¾ in. (1.9 cm)

Gift of Ruth and Victoria Blumka, 1988 (1988.408.2a,b)

This spade-shaped bronze seal box with a hinged enameled cover has three holes in the bottom. The top of the box is decorated with circles in red and turquoise enamel, parts of which are missing. While similar enameled seal boxes have been found throughout the Roman empire, spade-shaped boxes like this one seem to be typical of the Roman provinces of Gaul, Pannonia, and Britannia.[1]

KRB

1 See Brown, 1995 a, p. 20.

EX COLLECTIONS: Franz Trau, Vienna; Leopold Blumka, New York, 1954; [Blumka Gallery, New York].

23

BOW BROOCH

Provincial Roman, 3rd century A.D.

Bronze: Length, 1⅞ in. (4.8 cm)

Gift of Bastiaan Blok, 1992 (1992.108.3)

KRB

EX COLLECTION: [Bastiaan Blok, Noordwijk, The Netherlands].

24

BRACELET

Provincial Roman, mid-4th century A.D.

Bronze: Diameter, 2⅝ in. (6.7 cm)

Bequest of Zita Spiss, 1991 (1993.3.2)

The narrow band that forms this bracelet is decorated with deeply incised parallel vertical lines and with "X" motifs at the ends. A fine punched design highlights the center of the band. This consists of groups of concentric circles placed to form triangles and bands of three lines each, composed of punched dots, that fan out from these circles to form larger triangles. Additional punched designs are found on the right but not on the left end. The bracelet, similar to one excavated from a woman's grave of the mid-fourth century at Krefeld-Gellep,[1] is the only Provincial Roman example in the Metropolitan Museum's collection.

KRB

1 See Pirling, 1974, pl. 31, grave 1470, no. 20, p. 35.

EX COLLECTIONS: [Spiss collection, Vienna]; Zita Spiss, Syosset, New York.

25

CROSSBOW FIBULA

Provincial Roman, second half of the 4th century (350–80)

Bronze: Length, 3⅛ in. (7.9 cm)

Bequest of Zita Spiss, 1991 (1993.3.6)

KRB

EX COLLECTIONS: [Spiss collection, Vienna]; Zita Spiss, Syosset, New York.

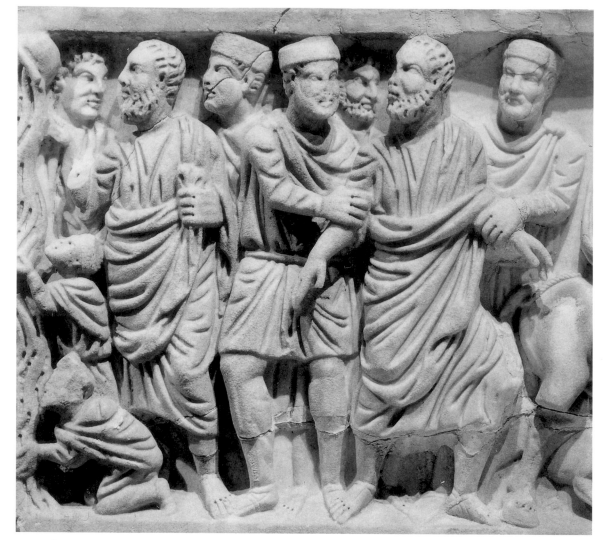

26: Detail

26

EARLY CHRISTIAN FRIEZE SARCOPHAGUS

Late Roman (Rome), early 4th century

Marble: 26 x 84 x 23 in. (66 x 213.4 x 58.4 cm)

Provenance: Villa de Felice (formerly Carpegna), Rome.

Gift of Josef and Marsy Mittlemann, 1991 (1991.366)

The boldly carved, dramatic scenes from the life of Saint Peter on the face of the sarcophagus identify it as one of the group of approximately fifty surviving Early Christian examples that combine narrative events from the apocryphal life of the saint with those from the life of Christ. The carvings date to the early fourth century, the era in which the Roman emperor Constantine established Christianity as a legal religion within the empire. Since the Petrine scenes foreshadow the future importance of Peter in the Latin West as the symbol of the primacy of Rome, the sarcophagus is a critical addition to the Museum's collection of works that document the origins of Christian art. Recently rediscovered and identified, it is the only work of its type in the Americas.[1]

Five scenes may be identified on the sarcophagus, as it exists today: Peter Drawing Water from a Rock and the Arrest of Peter (see detail, above), Christ's Entry into Jerusalem, the Miracle of the Loaves and Fishes, and the Raising of Lazarus. The boldly projecting narrative images in the Petrine scenes are original to the sarcophagus,

as are the lower third sections of the Christological scenes, which include the legs of the figures, the base, and the back. That the upper portions of the three Christological scenes to the right are restorations is underscored by the mistakes introduced, such as the depiction of Christ as a bearded man, a practice not current in the fourth century, and the presence of a frightened child before Christ in the Entry into Jerusalem. The child was included to explain a pair of small feet in the original portion of the sarcophagus that were turned away from the events portrayed in the Entry composition. When compared to other surviving sarcophagi of the type, it is clear that the feet were those of the Man Born Blind Being Cured by Christ; this last scene, originally the fourth one on the face of the sarcophagus, was situated between the Entry into Jerusalem and the Miracle of the Loaves and Fishes. On the ends of the sarcophagus are Old Testament scenes considered to be significant precursors of events recounted in the New Testament: Carved in low relief on the right end are Adam and Eve Covering Themselves by the Tree of Knowledge (Genesis 3: 6–24) and on the left end (see detail, p. 23) the Three Hebrews Standing in the Fiery Furnace (Daniel 3: 21–27).[2]

In profile, the closely packed, dense layers of original carving project boldly from the surface of the sarcophagus into the viewer's space, with the heads of the figures extending well beyond the rim. As such, the figures function like actors in a dramatic play, drawing

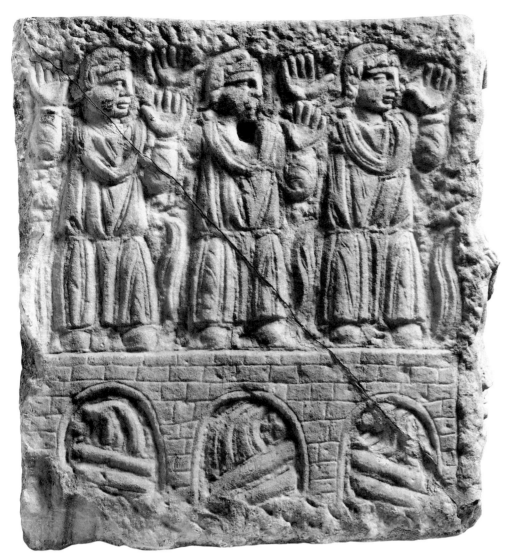

26: Detail

the viewer into the story of man's salvation. While details of the sur-
viving images are worn away as a result of the sarcophagus's use as
a garden ornament both in Rome and in America, their original
force is fully visible in the heads carved in low relief in the back-
ground of the Petrine scenes, which were protected from wear by
the overhanging rim. The expressive faces are made more dramatic
by the drill holes at the edges of the eyes—a device used to enhance
the play of light and shadow that is typical of Constantinian art.

The sarcophagus became known initially from engravings pub-
lished in 1879, which showed it in its damaged state. Later scholars
continued to publish the engravings in conjunction with icono-
graphical studies, with Becker the first to note, in 1909, that the loca-
tion of the work was no longer known. A surviving photograph and a
painting from early in this century of Burrwood, the Walter Jennings
estate in Cold Spring Harbor, New York, prove that the sarcophagus
was imported into the United States to decorate the lawn and later
a hidden garden there. By the time the sarcophagus was installed at
Burrwood, it had been restored; subsequent damage at Burrwood is
responsible for the loss of a portion of the lower right edge of the work.[3]

HCE

1 See Evans, 1993, pp. 77–84, figs. 1–8, pp. 78–83. The sarcophagus was
 brought to the attention of the Museum by Josef Mittlemann, whose
 belief in its authenticity was critical to its rediscovery.
2 Ibid.
3 Ibid., pp. 82–83.

EX COLLECTIONS: Walter Jennings, Cold Spring Harbor, New York,
1909 (?)–49; Josef and Marsy Mittlemann, 1991.

REFERENCES: Garrucci, 1879, pp. 27–29, pl. 314, figs. 2–4; Grousset, 1885,
no. 94, p. 81; de Waal, 1908, p. 52; Becker, 1909, p. 44; Stuhlfauth, 1925, no. 30,
p. 88; Wilpert, 1929, p. 311, pl. 195; *Estate of Walter Jennings*, 1949, cover ill.
(estate grounds); Sotomayor, 1962, no. 120, p. 66; Deichmann, 1967, no. 946,
pp. 394–95, pl. 151, figs. 946,1, 946,2, 946,3; Evans, 1992, p. 18, ill.; Evans, 1993,
pp. 77–84, figs. 1–8, pp. 78–83.

27

SIX TINNED PLAQUES

Late Roman (Rome ?), second half of the 4th century

Tinned copper: Maximum height, 2¼ in. (5.7 cm); maximum width, 2¼ in. (5.7 cm)

Purchase, Alastair B. Martin and William K. Simpson Gifts, Gift and Bequest of George Blumenthal, by exchange, Rogers Fund, and funds from various donors, 1989 (1989.298.1–6)

These six tinned plaques are decorated with engraved and punch-work figures. Three have portrait busts of winged genii with curly hair, in tondi, surrounded by scroll patterns; the others each have portrait busts of four youths in medallions that are arranged in pairs flanking a floral pattern. All the plaques bear the remains of one or more rivets, which indicate how they were attached originally to another, larger object—probably a casket. The three plaques with the four heads may be symbolic of the twelve months of the year, which, if true, might mean that the three surviving plaques with single heads might be three of the Four Seasons. Equally, they could be the winged genii of a city. As none of the figures holds attributes, their identification cannot be certain.

The elegant, fluid engraved lines, especially of the single heads, are most like those on a plaque from the second half of the fourth century decorated with the head of a man, possibly Dionysos, and those of four other figures probably meant to be the Four Seasons,[1] now in the Byzantine collection at the Dumbarton Oaks Research Library and Collection, Washington, D.C. Similar in style are the heads on the slightly earlier glass bowl in the Römisch-Germanisches Museum, Cologne; the engraved image on the mid-fourth-century silver spoon now in the collection of The Cleveland Museum of Art; the heads on one of the later-fourth-century flagons in the Traprain Law hoard now in Edinburgh; and those on the Ustinow bronze plaque, with an emperor and four personifications, in the University collections, Oslo.[2] Another similarly engraved plaque with the head of a man was found in the catacombs of Rome.[3]

MEF/HCE

1 See Ross, 1962, no. 59, pp. 52–53, pl. xxxvii.
2 See Wixom, 1979 b, no. 316, pp. 336–37, ill. p. 337, and Kötzsche, 1979, no. 377, pp. 420–21, ills. p. 421; Curle, 1923, p. 23, pl. ix, fig. 7; Sande, 1996, no. 11, pp. 47–49, ill. p. 48.
3 See de Rossi, 1880, p. 172, pl. vii, no. 1.

EX COLLECTION: [Michael Ward, Inc., New York, 1989].

28

BELT TAB

Late Roman (Rome ?), 4th century (?)

Gilded copper alloy: 1⅞ x 1⁹⁄₁₆ in. (4.8 x 3.99 cm)

Purchase, Rogers Fund and Alastair B. Martin Gift, 1993 (1993.166)

Both faces of this metal fragment are decorated with delicately engraved images. The beading on the rim was added separately. Originally, the gilding of the copper body on the obverse and the lower two-thirds of the reverse made the ornament appear as if it were gold. The lack of gilding on the upper portion of the reverse and the rivets and rivet holes that survive at the top suggest that this

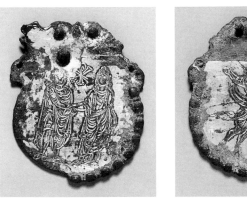

28: Front 28: Back

was once the tab for the end of a belt. A pair of openwork belt tabs in the Virginia Museum of Fine Arts, Richmond, likewise is decorated on both sides, with the upper portion of the reverse reserved for the attachment of the belt strap with rivets.[1] A belt tab in the British Museum and another excavated in Paris are also decorated on both faces.[2] Stylistically, the engravings on the Metropolitan Museum's fragment recall those on a silver spoon of the mid-fourth century, now in The Cleveland Museum of Art.[3]

On the front of the fragment is the *dextrarum iunctio*, the standard Late Antique/Early Christian Roman marriage image of a man and woman standing with hands joined. The Christian symbol of the Chi-Rho above their heads identifies the religion of the elaborately dressed couple. The man wears a short tunic, with embroidered or applied medallions, under a chlamys, or mantle, clasped at the right shoulder with a fibula. The woman's intricately draped long dress is decorated with clavi, or stripes, that indicate her high rank. Her hair is piled high on her head and covered with a veil. (The Museum owns a similar Christian marriage image on gold glass [15.168].)

On the back of the present work, Bellerophon, on his winged horse, Pegasus, triumphs over the Chimera, the composite creature, crouched at the base of the plaque. Bellerophon's victory has been interpreted as the triumph of good over evil. As the vanquishing of the Chimera by Pegasus ultimately won Bellerophon the hand of the Lycian king's daughter, the classical theme is appropriate even for a Christian celebration of marriage.[4]

HCE

1 See Gonosová, 1994, no. 50, pp. 138–39, ill.
2 See Entwistle, 1994, no. 60, p. 69, ill.; Bonnet et al., 1989, no. 178, pp. 199–200, colorplates 15–16.
3 See Wixom, 1979 b, no. 316, pp. 336–37, ill. p. 337.
4 Much of the information on the iconography of the object is drawn from the research undertaken by Ellen Kenney while in the curatorial studies program at the Institute of Fine Arts, New York University.

EX COLLECTION: [Michael Ward, Inc., New York, 1993].

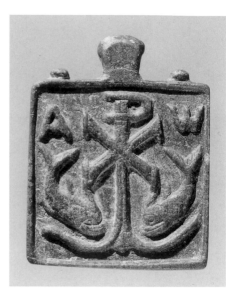

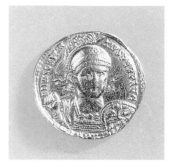

30: Obverse 30: Reverse

29

PENDANT PLAQUE

Early Byzantine, 4th–5th century

Lapis lazuli: 2½ x 1¹⁵⁄₁₆ x ¼ in. (6.4 x 4.9 x .64 cm)

Purchase, Rogers Fund, Mr. and Mrs. Maxime L. Hermanos and Anonymous Gifts, 1984 (1984.32)

This plaque is made from one piece of lapis lazuli, with the "ring" for suspension carved as part of the pendant. The pyrite in the stone makes the lapis appear "as if sprinkled with gold"—a quality described with admiration by the Greek philosopher and scientist Theophrastus (about 372–about 287 B.C.). Engraved within a narrow raised frame are a series of images that were popular in Christian art in the first centuries A.D. The base of the Chi-Rho, the monogram of Christ, extends into an anchor. At the top, on either side of the monogram, are the Greek letters alpha and omega; below them are two fish. No other example that combines these themes survives, although, individually, they are known on other gemstones.[1]

HCE

1 This information was taken from unpublished research by Rob Hallman, 1997.

EX COLLECTION: [Blumka Gallery, New York, 1984].

REFERENCE: *MMA Annual Report*, 1985, p. 43, ill.

30

SOLIDUS OF CONSTANTIUS II (SOLE EMPEROR, 353–61)

Early Byzantine, 4th century

Gold: Diameter, ²⁵⁄₃₂ in. (2 cm); depth, ³⁄₆₄ in. (.1 cm)

Obverse

Inscribed: FL[AVIVS] IVL[IVS] CONSTANTIVS PERPETVVS AVC[VSTVS] ("Flavius Iulius Constantius Eternal Augustus")

A military portrait bust depicts the emperor in three-quarter view, holding a lance and a shield on which he is shown mounted on a horse and trampling a barbarian.

Reverse

Inscribed (on the shield): VOT[A] / XXX / MVLT[IPLICATIS] / XXXX; (around the coin): GLORIA REI PVBLICAE ("Glory of the State"); (in the exergue): SMN E (probably the mint of Nicodemia)

The ceremony of the public vows is depicted.

Gift of Eve Herren, 1979 (1979.268.1)

KRB

EX COLLECTION: Eve Herren, New York.

31

STEELYARD WEIGHT AND HOOK

Early Byzantine, first half of the 5th century

Weight, bronze filled with lead; hook, brass: 9⅛ x 4¼ in. (23.2 x 10.8 cm); 5.04 lbs. (2.29 kg., or 7 Byzantine litrae)

Purchase, Rogers Fund, Bequest of Theodore M. Davis, by exchange, and Gifts of George Blumenthal, J. Pierpont Morgan, Mrs. Lucy W. Drexel, and Mrs. Robert J. Levy, by exchange, 1980 (1980.416a,b)

The weight is cast in the form of the bust of an empress, who is portrayed frontally, holding a furled scroll in her left hand and raising her right hand from beneath her mantle to gesture as she speaks. She is elaborately coiffed, with tightly curled waves framing her face and braids drawn up from the nape of the neck and turned under, above her forehead, in a style popular in the Late Antique and Early Byzantine periods. Her diadem is meant to appear richly jeweled, with hanging strands of what seem to be large pearls echoed in her four-tiered gem- and pearl-studded necklace. The bust is set on a plinth bordered with pearls and decorated with a guilloche pattern. When the weight was suspended by its hook, it could be moved along a ruled steelyard to establish the weight of the commodity hung from the opposite side.

Weights in the form of an empress were very popular in the Early Byzantine era (especially from the fifth to the seventh century),

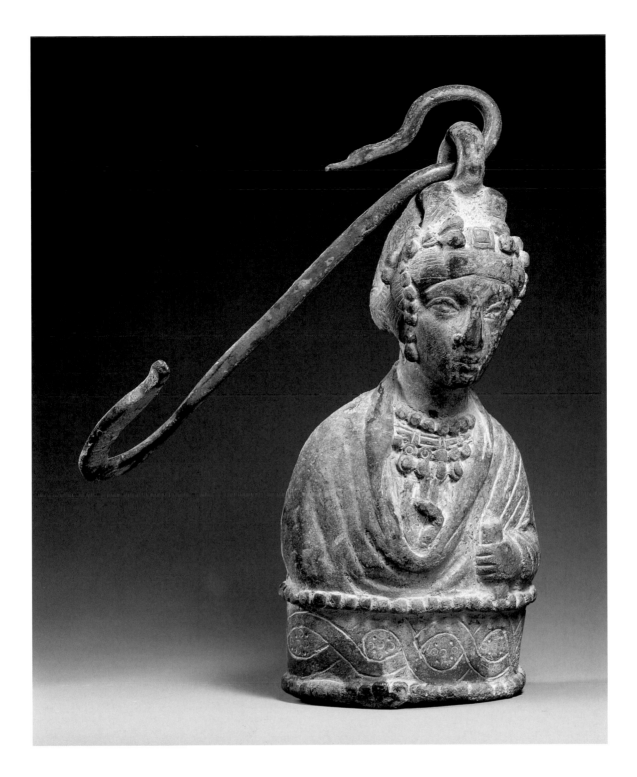

and many survive in private and public collections in America and abroad. The quality of the present work, however, is exceptional: While in keeping with the hieratic style customary for Early Byzantine weights, the face, hair, jewelry, and clothing are particularly sensitively and carefully modeled. The eyes especially are uniquely realistic in comparison with the wide-open, vacant gaze usually characteristic of such weights.

Scholarship generally is in accord in recognizing that existing empress weights often are portraits of members of the ruling Theodosian house. Pulcheria (r. 414–53), Licinia Eudoxia (r. 439–55), and Galla Placidia (about 390–455) each have been cited as the possible subject of this weight, although the most frequent references are to Licinia Eudoxia.[1] As dynastic rather than individual traits usually were emphasized in portrayals of Theodosian empresses, the Museum's weight cannot be identified convincingly on the basis of present evidence as a portrait of any particular lady, in spite of its careful modeling.

MEF/HCE

1 See Brown, 1979 b, nos. 327–328, ills. p. 345; Meriçboyu and Atasoy, 1983, nos. 5–16, pp. 23–26, ills. pp. 15–20.

EX COLLECTION: [George Zacos, Basel, 1980].

EXHIBITION: "Decorative and Applied Art from Late Antiquity to Late Gothic," Moscow, State Pushkin Museum, May 10–July 10, 1990, and Leningrad, State Hermitage Museum, August 14–October 14, 1990, no. 7.

REFERENCES: Frazer, 1981, p. 19, ill.; *idem*, 1990 a, no. 7, p. 22, colorpl. p. 23.

32

FRAGMENT OF A PLAQUE, WITH A
STANDING WOMAN

Early Byzantine (Egypt), 4th century
Bone: 2⁹⁄₁₆ x 1³⁄₁₆ in. (6.5 x 3 cm)
Gift of J. William Middendorf II, 1980 (1980.31)

The head and upper body of the curly-haired figure are all that
remain of the plaque, which originally was brightly colored, with
wax inlaid between the areas carved in relief. Although first pub-
lished as a youthful soldier holding a shield,[1] the figure was correct-
ly identified by Margaret E. Frazer as a young nimbed woman with
an elaborate coiffure tied with a ribbon, or scarf, falling to her shoul-
ders, and wearing an ornate costume; Frazer compared her to the
bride being prepared for marriage on a fourth- or fifth-century
wooden casket inlaid with bone plaques, in Cairo.[2] On two panels of
this casket the bride faces right as she turns her head back to the
left—as does the woman on the Metropolitan's plaque. The bride's
hair is also covered with a veil that falls to her shoulders, and her
large eyes, M-shaped eyebrows, small, downturned mouth, and nose
are so like those of the figure on the Museum's plaque that the lat-
ter must be contemporary with the panels on the casket. However,
the bride's less elaborately dressed attendants on the casket carry
bowls and boxes, while the woman on the Museum's plaque holds
what may be a platter on which there are two bracelets.[3] A badly
damaged mosaic from Daphne, dated to the first half of the fourth
century, depicts a richly dressed attendant figure—holding a platter
containing two bracelets and a rope of pearls—who stands beside an
elegantly dressed seated woman posed like the figure on the Metro-
politan's plaque. Above the attendant the name Chresis appears—a
personification of the abstract concept of using acquired wealth; the
seated figure is thought to be Ktisis, a personification of Acquisition
or Foundation.[4]

If the figure on the Museum's plaque originally held a platter
with bracelets, she might be associated with a personification like
that of Chresis. Noting the woman's halo, Frazer suggested that she
was a heavenly being, probably an attendant to a goddess.[5] On a
fourth-century painting in Trier, a nimbed woman with much the
same elaborate hairstyle and wearing a long scarf is depicted remov-
ing pearls from a jewel box;[6] the identity of this figure remains
uncertain.

HCE

1 See *Ernest Brummer Collection*, 1979, p. 17.
2 Accession papers prepared by Margaret E. Frazer, curator emeritus,
 Archives of the Department of Medieval Art and The Cloisters, The
 Metropolitan Museum of Art.
3 See Albertoni, 1993, figs. 50–52; Brown, 1979 b, no. 311, pp. 332–33, ill.
4 See Levi, 1947, vol. 1, p. 278, pl. LVIV a; Brenk, 1977, p. 222, pl. 223; Cimok,
 1995, pp. 40–41.
5 See note 2, above.
6 See Brenk, 1977, p. 295, pl. 347.

EX COLLECTIONS: [The Connoisseur, Inc., New York]; Ernest Brummer,
New York, n.d.; [sale, Galerie Koller AG, Zurich, in collaboration with Spink
& Son, London, October 16–19, 1979, vol. 1, lot 2, p. 17]; Museo Kircheriano,
Vatican City (according to the *Brummer* sale catalogue); J. William
Middendorf II, New York, until 1980.

EXHIBITION: "Acquisitions," New York, The Metropolitan Museum of Art,
June 30–August 23, 1981.

33

THREE PLAQUES FROM A CASKET

Early Byzantine (Egypt), 4th–5th century
Bone, with traces of red, white, and blue wax: Erotes, maximum
height, 3½ in. (8.9 cm), maximum width, 2⅜ in. (6 cm); dancing
maenad, maximum height, 4⅛ in. (10.5 cm), maximum width, 2 in.
(5.1 cm); bird and flowers, maximum height, 2⅞ in. (7.3 cm), maxi-
mum width, 2 in. (5.1 cm)
Gift of Mr. and Mrs. Charles D. Kelekian, 1978 (1978.431)
Rogers Fund, 1978 (1978.432.1,2)

These three small and thin bone plaques contain delicate intaglio
carvings of a plump, winged Erotes, a dancing maenad, and a bird
among flowers. Colored wax was inlaid between the ridges of the
designs to provide the hues on these fourth- to fifth-century works.[1]
Traces of the original color remain: most visibly, on the red-and-
blue cloak of the Erotes, the red skirt of the dancing maenad, and the
red-and-blue detailing of the bird and flowers. Few of these bone
carvings, which were used to decorate furniture, small caskets, and
funeral beds, survive in their original settings. A partially recon-
structed casket of the period, from Egypt, now in The Walters Art
Gallery, Baltimore, combines colorful bone intaglios like these with
examples carved in relief that resemble the Metropolitan Museum's
heroic male nude (1993.516.1; cat. no. 35).[2] The images reflect classi-
cal themes—often, those specifically associated with Dionysian rev-
els—that remained popular in Egypt even as it became a major
center for Christian theologians. By the fourth century, these motifs
appear to have been adopted for objects of domestic use by all reli-
gious communities in Egypt.[3] The bird and Erotes panels are very
similar to those found on a rectangular casket in the Coptic Muse-
um in Cairo.[4]

Each panel has sustained deep chips along the edges, and the
bird plaque was broken into two pieces. The missing hand of the
maenad on the upper right of the plaque originally may have held
a tambourine.[5]

HCE

1 See Friedman, 1989, no. 22, p. 114, ill.; Grimm, 1996, nos. 195, 196, pp. 197–98, color ills.
2 See Randall, 1985, no. 135, colorpl. 44.
3 See Pearson and MacCoull, 1989, pp. 32–36.
4 See Albertoni, 1993, figs. 47–48.
5 See Kondoleon, 1994, no. 64, pp. 198–99.

EX COLLECTIONS: Mr. and Mrs. Charles D. Kelekian, New York, until 1978; [C. Dikran Kelekian Ancient Arts, New York, 1978].

34

MEDALLION, WITH THE BUST OF AN APOSTLE

Early Byzantine (Rome), 5th century
Incised bone, originally inlaid with colored wax and gilded: Maximum diameter, 2⁹⁄₁₆ in. (6.5 cm)
Provenance: A Roman catacomb (?).
Rogers Fund, 1979 (1979.401)

This lively portrait of an apostle is said to have been found in a Roman catacomb in the nineteenth century. It originally may have been one of a series of medallion portraits of apostles grouped around a central image of Christ, like the one in the Museo Kircheriano at the Vatican.[1] As most surviving incised and painted bone carvings are of secular and pagan subjects and come from Egypt, it is significant that the Museum's apostle medallion is from Rome. When it was published by Garrucci in 1880, the work was identified as an image of Saint Peter.[2] The delicate low relief, set against a painted gold background, and the linear style, expressed through the finely incised lines that, originally, were filled with colored wax,

speak for the quality and sophistication of the larger work that the apostle medallion probably once decorated.

MEF/HCE

1 See Garrucci, 1880, p. 71, pl. 447, fig. 7.
2 Ibid., pl. 447, fig. 8; Volbach, 1976, p. 57.

EX COLLECTIONS: Museo Kircheriano, Vatican City; said to be in the Museo Nazionale delle Terme, Rome, 1936; L. Pollak, n.d.; [The Connoisseur, Inc., New York, 1947]; Ernest Brummer, New York; [sale, Galerie Koller AG, Zurich, in collaboration with Spink & Son, London, October 16–19, 1979, vol. 1, lot 1].

REFERENCES: Garrucci, 1880, p. 71, pl. 447, fig. 8; Stuhlfauth, 1896, p. 18; Morey, 1936, no. A 57, p. 57; Volbach, 1976, no. 210, p. 125, pl. 100.

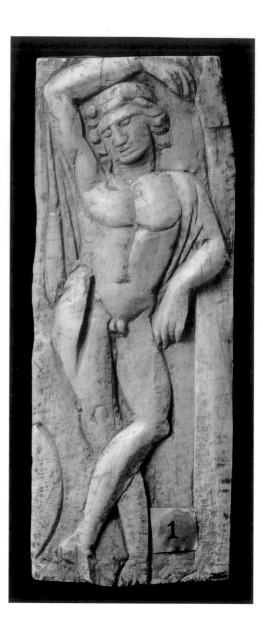

35

PLAQUE, WITH A HEROIC MALE NUDE

Early Byzantine (Egypt), 4th–6th century

Bone: 5⅜ x 2 in. (13.7 x 5.1 cm)

Gift of Robert L. Hermanos and Miriam H. Knapp, in memory of their parents, Mr. and Mrs. Maxime Levy Hermanos, 1993 (1993.516.1)

The nude male figure stands in a languid pose argued to have been adopted in the Hellenistic period for images of Dionysos, from a classical statue of Apollo Lykeios by Praxiteles.[1] His cloak is thrown over his shoulders. A hemisphere at the lower left may represent part of a shield or perhaps a not-yet-identifiable attribute. Another fifth-century bone carving of this type in the Metropolitan Museum shows a nude male in the same pose who can be identified as Dionysos by the large bunch of grapes dangling from his hand (14.4.12). Bone carvings such as these, especially when they are related to festive Dionysian rites, were used in Early Byzantine Egypt from the fourth through the sixth century to decorate secular furnishings. A casket in the Walters Art Gallery, Baltimore, combines wax-inlaid bone carvings like several in the Metropolitan's collection, which depict an Erotes, a dancing maenad, and a bird among

flowers (1978.431, 1978.432.1,2; see cat. no. 33), together with bone relief carvings of maenads similar in form to the present work.[2]

HCE

1 See Randall, 1985, no. 144, p. 92; Kondoleon, 1994, no. 63, pp. 196–97; von Bargen, 1996, no. 198, p. 198; Grimm, 1996, no. 197, p. 198.
2 See Randall, 1985, no. 135, p. 90, colorpl. 44.

EX COLLECTIONS: Mr. and Mrs. Maxime Levy Hermanos (1899–1985 and 1908–1992), Paris and New York; Robert L. Hermanos and Miriam H. Knapp, 1991–93.

36

CROSSBOW FIBULA

Late Roman or Early Byzantine, about 480

Gold: Height, 4¾ in. (11.9 cm)

Purchase, Lila Acheson Wallace Gift, 1995 (1995.97)

Birgit Arrhenius has noted that Late Roman crossbow fibulae with onion-shaped terminals—one of which secures the pin by means of a screw—and Germanic imitations of the type, such as the well-known examples from Pistoia, Italy, and Skogen, Norway, appeared simultaneously. The Roman fibulae, in vogue from 280 to the mid-sixth century, are known to have been prestigious gifts from the rulers of the empire.[1] The small, refined group of *opus interrasile*, or pierced, openwork fibulae—including the Palatine, Louvre, and Reggio Emilia examples; the fibula (now lost) from the grave of Childeric; the fibula from Apahida I; the more recent example from the Burton Berry Collection at the Indiana University Art Museum, Bloomington;[2] and the Metropolitan Museum's new acquisition—provides evidence of several instances when sumptuous gifts were given by the Romans to certain Germanic kings.

Only one other fibula in the group has a triangular foot composed of three pierced, openwork panels; this example, from the grave of Omharus, who belonged to the Gepidic leadership class, is preserved in the Muzeul National de Istoire a României in Bucharest, Romania.[3] Both this work and the Metropolitan's are distinguished by their more abstract and more overtly Christian decoration; each has a long, prominent Latin cross in the center of the top panel. These two fibulae are hollow, and have three faceted, hexagonal, onion-shaped terminals with beaded collars; the left-hand terminal screws—on a left-hand thread—into the arm of the fibula to secure the curled head of the pin. The pinhead, in turn, fits into a perforation on the back of the brooch at the center; the pin is released by unscrewing the left "onion" terminal. The base of the bow is attached to the foot by woven gold wire wound around a curved, tapering section several times. Above this is a beaded gold collar, the center of which, over the center of the foot, is marked by a bead that is larger than the others. There the exact similarities end. The top of the Apahida fibula displays a plain, large cross within a geometric field. The Museum's fibula is decorated with a large Latin cross, flanked by stylized vine scrolls; the tip, enclosed within a circle, forms the Chi-Rho, with an alpha (α) and omega (ω) suspended from its crossbars. The undersides of the triangular-shaped foot display geometric motifs, whereas the triangular tip consists of a floral Greek cross in a circle with leaves in the interstices. The two fibulae probably were made by the same goldsmith.

37

BUCKLE

Late Roman or Early Byzantine, 5th century

Gold and gold foil, with garnets and cloisonné garnets: 1⅛ x 1⅜ x ⁵⁄₁₆ in. (2.9 x 3.5 x .9 cm)

Provenance: Komárom, Hungary.

Purchase, Rogers Fund, Alastair B. Martin, Norbert Schimmel Foundation Inc., and Levy Hermanos Foundation Inc. Gifts, and funds from various donors, 1986 (1986.341)

The oval-shaped loop of this buckle is one of the earliest examples, in the Museum's collection, of stepped cloisons inlaid with garnets and backed by patterned foil. The buckle has a gold tongue and a rectangular plaque set with pyramidal and teardrop-shaped garnets in collets. The teardrop-shaped garnets recall those on the small fibula from the Pietroasa Treasure, and, like the fibula, the buckle was thought to be Hunnish.[1] However, it has now been shown to be of Late Roman or Byzantine workmanship.

Because the Metropolitan's buckle is part of a treasure (the rest is in the British Museum) consisting of silver-gilt and garnet sheath fittings from a battle dagger and sword, it may well represent a find from the grave of a prominent male, as has been proposed by Kidd.[2] In fact, the step pattern of the loop may be associated with that of the buckle from the second Apahida Treasure.[3] Arrhenius has proposed that both the Gepidic king Omharus and the Frankish king Childeric commissioned these ensembles from the same centrally located workshop in Constantinople.[4] She further proposed that such single objects of the highest quality, often with royal associations, were made in the central workshop in Constantinople, but were mounted locally.[5]

On the sheath fittings in the British Museum, the garnets, in a frame, are set into separately cast, molded mounts, which would seem to imply that the fittings were manufactured like the other ensembles mentioned above.[6] Direct contact between Constantinople and the Germanic chieftains is illustrated by the presence of Late Roman bow fibulae, like the Museum's more recent acquisition (1995.97; see cat. no. 36), in the graves of Childeric and at Apahida.[7] The Metropolitan Museum's buckle may have been part of a grave find that originally even might have included a Late Roman fibula or ring, now lost, which would indicate that this treasure was a political gift, perhaps to a Germanic official of high rank.[8]

KRB

This type of fibula was worn by senators, generals, and high-ranking officers on their military or imperial cloak, called a paludementum. Attached at the right shoulder, the fibula held the cloak so as to free the right arm for action.[4] According to Heurgon,[5] the length and weight of such fibulae were determined by the wealth of the donor or of the official for whom they were made. The length of the Metropolitan's fibula is 11.9 centimeters and its weight is 78.4 grams, whereas the Apahida fibula is 11.5 centimeters long and weighs 50.35 grams. The Apahida fibula was made for a member of the Gepidic ruling class, and our new fibula must have had a similar destination.

KRB

1 See Arrhenius, 1990, pp. 12–18, 19–21.
2 See Deppert-Lippitz, 1996, pp. 235–43.
3 See *Goldhelm, Schwert und Silberschätze*, 1994, pp. 250–51.
4 See Martin, 1994, p. 579.
5 See Heurgon, 1958, p. 25.

EX COLLECTIONS: Simon Bendel, London, 1964–75; [Michael Ward, Inc., New York, 1995].

REFERENCE: Brown, 1995 b, p. 22, colorpl.

1 See Harhoiu, 1977, fig. 6, no. 5.
2 Kidd, 1990, p. 126.
3 See Arrhenius, 1985, pp. 84, 113–18, 124.

4 Ibid., p. 120.

5 Ibid., p. 106.

6 Kidd, 1990, p. 125.

7 See Arrhenius, 1985, p. 102.

8 See *Goldhelm, Schwert und Silberschätze*, 1994, no. 98, p. 230.

EX COLLECTIONS: David Egger, Budapest, 1881–(?); Samuel Egger, Vienna, (?)–1891; [sale, Sotheby, Wilkinson & Hodge, London, June 25, 1891, lot 272 B (MMA buckle)]; Pitt-Rivers Collection, Farnham, Dorset, England, 1891–(?); [Alistair McAlpine, London, 1986]; [Michael Ward, Inc., New York, 1986].

REFERENCES: Brown, 1987, pp. 12–13, colorpl.; Kidd, 1990, p. 126.

38

PERSONIFICATION OF KTISIS (FOUNDATION)

Early Byzantine, first half of the 6th century
Mosaic, marble, and glass: 68¼ x 58¹³⁄₁₆ in. (173.4 x 149.3 cm)
Harris Brisbane Dick Fund and Fletcher Fund, 1998 (1998.69)

This monumental bust of a richly bejeweled lady who wears large pearls in her ears, a necklace of delicate stones about her throat, and two brooches—one clasping her yellow mantle and another at the

tie of her dress—is an example of the exceptional mosaics created throughout the Early Byzantine world in the first half of the sixth century. Both her elaborate diadem and the neckline of her dress are bordered with alternating black and white tesserae meant to suggest pearls. The addition of blue glass to represent sapphires, or "hyacinths," among the red and green glass gemstones on the mosaic is characteristic of sixth-century Byzantine taste.[1] The modeling of the lady's face with small olive green and beige tesserae highlighted in white and shades of pink and the slightly asymmetrical arrangement of her large, softly staring eyes are typical of Byzantine painting of the period, which survives in the form of icons.[2] Women with similar faces, hairstyles, necklaces, and pearl-bordered diadems carry martyrs' crowns in the early-sixth-century mosaics in the nave at Sant'Apollinare Nuovo in Ravenna.[3] A mosaic image of the Archangel Michael, dated to 549, in the church of Sant'Apollinare in Classe, near Ravenna, has the same hair and eyes,[4] as does the mid-sixth-century bust of the "Lady of Rank," thought to be from Constantinople, now in the Metropolitan Museum (The Cloisters Collection, 66.66.25); the rod that she holds, the measuring tool for the Roman foot, identifies her as a personification of the abstract concept of Ktisis, or Foundation, and symbolizes the donation, or foundation, of a building. Personifications of abstract ideas, as

39

Girdle (17.190.147), showing catalogue number 39 in place

developed by the Stoic philosophers, remained popular in the Early Christian era. Images of Ktisis inscribed with her name, and often showing her holding the same measure, survive on the floor mosaics of bathhouses as well as churches throughout the Byzantine Empire, from Antioch and Cyprus to such African sites as Qasr-el-Lebia and Ras-el-Hilal.[5]

HCE

1 See Brown, 1979 a, p. 57.
2 See Weitzmann, 1978, plates 1, 2, and 8, for icons of the period, from The Holy Monastery of Saint Catherine, Sinai, Egypt.
3 See Huch, 1943, pl. x.
4 See *Basilica of S. Apollinare in Classe*, n.d., fig. 20.
5 See Levi, 1947, vol. 1, pp. 255, 278, 347, 350, 357, 558, vol. 2, plates LXI c, LXIV a, LXXXII b, LXXXV a, CXXXII b; Michaelides, 1987, pp. 40, 42, pl. 47; Alföldi-Rosenbaum and Ward-Perkins, 1980, p. 34, fig. 122, plates 83, 2 and 3, and 102, 2 and 4.

EX COLLECTIONS: Private collection; Private collection, 1988; [Michael Ward, Inc., New York, 1997].

39

SOLIDUS OF EMPEROR MAURICE TIBERIUS (R. 583–602)

Early Byzantine (Constantinople?), last quarter of the 6th century
Gold: Diameter, ¾ in. (1.9 cm)

Obverse
Inscribed: D[OMINVS]N[OSTER] MAVR[I]C[IVS] TIB[ERIVS] P[ER]P[ETVVS] AVG[VSTVS] ("Our Lord Maurice Tiberius Eternal Augustus")

The emperor is shown seated, wearing consular robes and holding a *mappa* and *globus cruciger*.

Reverse
Inscribed: [VICTORI]AAVCC[VSTORVM]Θ ("Victory of the Augusti," with Θ for the *officina* mark)

A standing angel is depicted holding a tall cross ending in P in the right hand and in the left hand a *globus cruciger*.

Purchase, Morgan Guaranty Trust Company of New York, Stephen K. Scher and Mrs. Maxime L. Hermanos Gifts, Rogers Fund, and funds from various donors, 1991 (1991.136)

The acquisition of this gold solidus of the Byzantine emperor Maurice Tiberius enabled the Metropolitan Museum to restore one of the two or three missing coins on the girdle of coins and medallions from the Cyprus Treasure. The girdle was assembled by its original recipient, a high government official, at the celebration of the emperor Maurice Tiberius's first consulship on December 25, 583. The other coins on the girdle, which were given to the Museum

in 1917 by J. Pierpont Morgan (17.190.147),[1] are mounted similarly, some with beaded borders. The girdle is part of the second of two treasures discovered in Karavas, near Kyrenia, on the north coast of Cyprus.

KRB

1 See Grierson, 1955, pp. 55–70, who first proposed that coins were missing from the girdle, as evidenced by the fact that the surviving portion suggested that it would have been too short to have been worn by a man.

EX COLLECTION: [Michael Ward, Inc., New York].

REFERENCE: *MMA Annual Report*, 1991, p. 35.

40

SOLIDUS (BY THIS TIME REFERRED TO AS NOMISMA) OF PHOCAS (R. 602–10)

Early Byzantine, 7th century
Gold: Diameter, ³¹⁄₆₄ in. (2 cm); depth, ¹⁄₃₂ in. (.1 cm)

Obverse
Inscribed: δ[OMINVS]N[OSTER]FOCAS PERP[ETVVS] AVG[VSTVS] ("Our lord Phocas Eternal Augustus")

A bust-length portrait of the emperor shows him holding a globe surmounted by a cross.

Reverse
Inscribed: VICTORIA AV[GVSTI] I ("Victory of the Augusti," with I for the *officina* mark); (in the exergue): CONOB (mint of Constantinople)

A standing angel is depicted holding a staff surmounted by a Chi-Rho monogram.

Gift of Eve Herren, 1979 (1979.268.2)

KRB

EX COLLECTION: Eve Herren, New York.

40: Obverse 40: Reverse

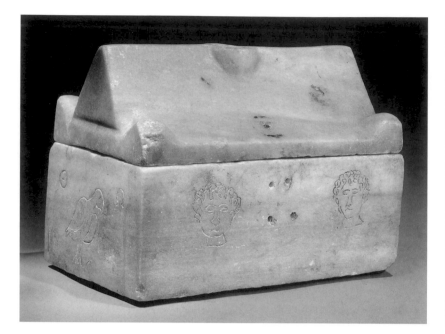

41

RELIQUARY CASKET

Early Byzantine, 6th century; incised decoration, 18th century or later

Marble: 6¼ x 8⅜ x 5⅜ in. (15.9 x 21.3 x 13.7 cm)

Gift of Blumka Gallery, in memory of Barbara C. Paley, 1978 (1978.273a,b)

This reliquary is in the form of a miniature sarcophagus decorated with acroteria at the corners of the lid. At the crest of its double sloped roof is an opening, as if for the pouring of libations. Such marble reliquaries, often containing smaller cases of precious metal to hold the relics, have been found under sixth-century altars.[1] The style of the casket is typical of that of reliquaries discovered throughout the Byzantine Empire—including areas of the Balkans, the Crimea, and the Near East. These works imitated larger sarcophagi reliquaries from the Near East, which were made to distribute oil from the tombs of holy men and women.[2] A similar reliquary recently came to light in Torcello, Italy, in an altar at the Cathedral of Santa Maria Assunta, in an eighteenth-century context, which indicates the continuing use of early works in later centuries.[3] The heads, birds, and Greek inscriptions incised on the sides of the present work date to the eighteenth century at the earliest.[4]

HCE

1 See Buschhausen, 1979, no. 569, pp. 631–32.
2 See Andreescu-Treadgold, 1992, p. 6 (with extensive bibliography).
3 Ibid., pp. 5–13.
4 Ibid., p. 13, n. 23.

EX COLLECTIONS: [Arnold Seligmann, Rey and Co., 1927]; [Julius Carlebach, Inc., 1944]; [Brummer Gallery, New York, 1947]; [Blumka Gallery, New York, 1978].

EXHIBITION: "Early Christian and Byzantine Art," The Baltimore Museum of Art (organized by The Walters Art Gallery, Baltimore), April 25–June 22, 1947, no. 35.

REFERENCES: *Early Christian and Byzantine Art*, 1947, no. 35, p. 28; *MMA Annual Report*, 1979, p. 38; Andreescu-Treadgold, 1992, p. 13, n. 23, ill. p. 12, fig. 14.

42

BOWL

Early Byzantine, 5th–6th century

Silver, partially gilded: 2⅛ x 9¹³⁄₁₆ in. (5.4 x 24.9 cm)

Gift of Mrs. Hayford Peirce, 1987 (1987.422.1)

HCE

EX COLLECTIONS: Ernest Brummer, New York, n.d.; [sale, Galerie Koller AG, Zurich, in collaboration with Spink & Son, London, October 16–19, 1979, vol. 1, lot 39, p. 61]; Hayford Peirce collection, until 1987.

43

PLATE

Early Byzantine, 659–662/63

Silver: Diameter, 11⅞ in. (30.2 cm)

Purchase, Rogers Fund, Bequest of George Blumenthal, by exchange, Alastair B. Martin, Mr. and Mrs. Maxime L. Hermanos, Ilene Forsyth, and Anonymous Gifts, Gifts in memory of Vera Ostoia, and funds from various donors, 1989 (1989.143)

The handsomely worked plate is typical of the outstanding level of artistry of Byzantine silver. The raised exterior border of the dish, about two centimeters wide, is designed like a fluted piecrust, with a repoussé line that rings its interior face, rhythmically echoing the raised, scalloped decoration. Radiating ribs connect the scallops to the medallion at the center of the plate, which is decorated with an inscribed rosette, perhaps meant to suggest a cross.[1] On the back of the plate, within the ring foot, are seven imperial control stamps from the reign of the emperor Constans II (641–68). Cruikshank-Dodd suggests that the stamps were applied in the later years of the emperor's reign because on one of the stamps he is shown with his son Constantine IV.[2] Other plates of similar type are found in Russian collections; one plate, dated 629/30–41, in the State Hermitage Museum, Saint Petersburg, is also identical in design.[3]

HCE

1 See Frazer, 1990 b, p. 18, for a description of the design as a "cosmic canopy."
2 See *Avar Treasure*, 1981, p. 31.
3 See Bank, 1985, no. 80, p. 283.

EX COLLECTIONS: Said to be in a European private collection; [private sale, Sotheby Parke Bernet, London, offered with the Avar Treasure, 1981, lot 180]; J. William Middendorf II; [Edward R. Lubin, New York, 1989].

REFERENCE: Frazer, 1990 b, p. 18, ill.

44

FLASK, WITH THE ADORATION OF THE MAGI

Early Byzantine, 6th century

Silver and silver gilt: Height, 12⅜ in. (31.4 cm); maximum diameter, 3¹⁵⁄₁₆ in. (10 cm)

Purchase, Frederick C. Hewitt Fund, by exchange; Rogers Fund and Schimmel Foundation Inc. Gift; Gifts of J. Pierpont Morgan, Mr. and Mrs. Marc B. Rojtman, Mr. and Mrs. John D. Rockefeller Jr., Lucy W. Drexel, and Anonymous, by exchange; Bequests of Mary Stillman Harkness, George Blumenthal, Gwynne M. Andrews and Michael Dreicer, by exchange; Theodore M. Davis Collection, Bequest of Theodore M. Davis, by exchange, Rogers Fund, by exchange; and The Cloisters Collection, by exchange, 1984 (1984.196)

Silver flasks dating from the fourth to the sixth century were popular with both pagan and Christian patrons, to judge from the mythological and Christian imagery on the more than a dozen flasks that survive. This example clearly was made for Christian ritual use, perhaps as a container for the holy water that was mixed with the Communion wine. The redemptive properties of the Eucharist are mirrored in the scene of the Adoration of the Magi, the flask's principal decoration, in which the kings present gifts to the Christ Child through the mediation of the angel Gabriel, the heavenly messenger. The bands of secondary decoration reinforce the Resurrection imagery. The ivy-vine and grapevine scrolls, for example, refer to the Eucharist, and the eagles rising from large acanthus plants in the lower register evoke the ascension of the soul to Heaven.

The flask still retains its original gilding, which highlights the main decorative elements of the scenic and floral motifs. The vessel appears to have been in use for a considerable period of time, since two separate ancient repairs were made to its lip—the area most often susceptible to damage. When a section of the rim broke off, it was replaced by a piece from another silver flask that was decorated with a different design but had the same contours. Sometime later, a crack developed reaching from the earlier repair about halfway around the circumference of the neck. Solder was applied where this crack extended to the rim to keep the lip of the flask intact. The only other damage is a dent in the lower register.[1]

The closest comparison in shape to the present flask is the earlier, fourth-century bottle from the Esquiline Treasure, but the friezelike organization of the decoration bears more of a resemblance to that of a sixth-century silver flask, now in The Cleveland Museum of Art, which depicts an animated Dionysian revelry, or

thiasos.[2] A similar liveliness of pose and gesture animates the scene of the Magi on the Metropolitan Museum's flask, where the central Magus stops and turns back to the third king, pointing out to his companions the Star of Bethlehem above the Christ Child's head (the star is shaped like a six-petaled rosette, of a type that frequently occurs in pilgrimage art of the sixth and seventh century).[3] The angel Gabriel, who guides the kings, also looks over his shoulder as he strides toward the outstretched arms of Christ, seated in his mother's lap; although not present in the biblical text, the angel is the messenger to the Magi in the apocryphal *Armenian Infancy Gospel.*[4] Joseph witnesses the event from behind the Virgin's wicker chair.

The vigor with which the Adoration scene is depicted characterizes the portrayal of the subject on such other sixth- and seventh-century works as a lead flask (published by J. Engemann) in the Franz Josef Dölger-Institut at the University of Bonn, and an ivory pyxis in the archaeological museum in Istanbul.[5] The acanthus-and-eagle design in the flask's lower register recalls the decorative language of the presbytery mosaics in San Vitale, Ravenna, where lush variations of acanthus plants fill the vaults, and eagles rise from cornucopias on the achivolt of the main apse. The ornamentation of the flask is more static and regimented than that of the famous mosaics, but its manner of depiction—especially, the slightly "windblown" bending of the central plant—is reminiscent of the style of decoration at the time of the emperor Justinian (r. 527–65).

MEF/HCE

1 See Drayman-Weisser, 1992, p. 191.
2 See Milliken, 1958, pp. 35–41; Shelton, 1981, pp. 82–83.
3 See Frazer, 1986 b, p. 15, color ill.
4 See Mathews, 1982, p. 205.
5 See Volbach, 1976, nos. 173 a, 171, respectively; Engemann, 1984, pp. 115 ff.

EX COLLECTIONS: Mahboubian family, by the 1960s; Houshang Mahboubian, until 1984; [Mahboubian Gallery of Ancient Art, 1984].

EXHIBITION: "Silver Treasure from Early Byzantium," Baltimore, Walters Art Gallery, April 18–August 17, 1986, no. 87.

REFERENCES: Frazer, 1986 b, p. 15, color ill.; Mango, 1986, no. 87, pp. 257–58, ill. p. 257; Drayman-Weisser, 1992, p. 191, figs. 1–2.

45

CENSER, WITH SIX FIGURES

Early Byzantine, 582–602

Silver, partially gilded: Height, 3½ in. (8.9 cm); maximum width, 5³⁄₁₆ in. (13.2 cm)

Provenance: Said to be from Mesembria, Bulgaria.

Rogers Fund, 1985 (1985.123)

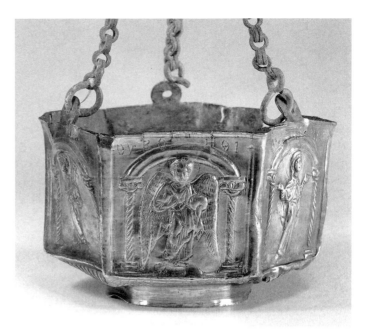

45

Censers have figured among the essential liturgical furnishings of the Byzantine Church up to the present day. Represented on this fine example, which retains its original chains of base silver, are the Virgin orans flanked by archangels, and Christ surrounded by Saints Peter and Paul, who turn toward him. The figures stand beneath segmented honorific arches supported by spirally fluted columns crowned with acanthus-leaf capitals. An inscription that calls upon the God of Saint George to pray for his servant Leontius is punched into the small area above the arches; the primitively and irregularly formed letters clearly demonstrate that they were added after the censer was made, presumably at the request of Leontius himself. Breaks in the silver and the distortion of the sides and base of the censer are consistent with damage caused by continuous use over centuries; the application of solder to the interior walls—especially to the heads of the figures—testifies to its periodic need for repair. The censer exhibits no certain evidence of having been buried.

As on much Early Byzantine silver, a set of five imperial control stamps is impressed into the base of the censer within its ring foot. These stamps have been identified as having been applied, probably in Constantinople, early in the reign of the emperor Maurice Tiberius (582–602).[1]

A number of hexagonal censers survive. The Metropolitan Museum's example is particularly close in structure and style to a smaller one in the British Museum, which comes from the so-called First Cyprus Treasure and which bears the control stamps in use during the reign of the emperor Phocas (602–10).[2] Since the walls of the latter censer are just 2⅜ inches high, they can accommodate only bust-length images of the figures framed within wreaths, not full-length figures, as on the Metropolitan's example. These two censers also are linked by a commonality of style. The caplike hair of the figures and the softly modeled folds of their draperies, for example, resemble those of the apostles on such contemporary work as a very fine silver chalice from the Hama Treasure now in the Walters Art Gallery, Baltimore. It has recently been suggested that the Hama Treasure, the Antioch Treasure in The Metropolitan Museum of Art, and other Early Byzantine silver finds formed part of a single large group of objects that served the church in Kaper Koraon in northern Syria.[3]

MEF/HCE

1 See Mango, 1986, no. 85, pp. 256–57.
2 Ibid., p. 257.
3 Ibid.

EX COLLECTIONS: Private collection, Nebraska, about 1915–about 1955; Melvin A. Whittler, West Dummerston, Vermont, about 1955–85.

EXHIBITION: "Silver Treasure from Early Byzantium," Baltimore, Walters Art Gallery, April 18–August 17, 1986, no. 85.

REFERENCES: Frazer, 1986 b, p. 16, ill.; Mango, 1986, no. 85, pp. 256–57, ill.

46

LITURGICAL OBJECTS

Early Byzantine (Attarouthi, northern Syria), 6th–7th century

Silver and silver gilt: Chalices: maximum height, 6⅞–9¹³⁄₁₆ in. (17.5–24.9 cm), maximum diameter (cup), 5²¹⁄₃₂–8⅛ in. (14.4–20.6 cm); censers: height, 2²⁵⁄₃₂–3¹⁄₁₆ in. (7.1–7.8 cm), maximum diameter, 5⅛–5¹⁹⁄₃₂ in. (13–14.2 cm); strainer: height, 7 in. (17.8 cm), width, 2³⁄₂ in. (5.8 cm), length, 3⅞ in. (9.8 cm); dove: height, 2¹¹⁄₁₆ in. (6.9 cm), length, 5²⁵⁄₃₂ in. (14.7 cm)

Purchase, Rogers Fund, and Henry J. and Drue E. Heinz Foundation, Norbert Schimmel, and Lila Acheson Wallace Gifts, 1986 (1986.3.1–15)

These silver liturgical objects are a fragmentary but nonetheless resplendent testimony to the material prosperity and religious devotion of a Christian community in the portion of the Early Byzantine Empire that fell to Islam in the seventh century. They provide rare insight into the priorities of such a community and allow us to invest the surviving ruins of the stone- and lichen-encrusted churches from which they came with some idea of the vanished brilliance that clergy and worshipers alike once experienced as they joined together to celebrate the Eucharist at Sunday services.

The ten chalices, three censers, wine strainer, and dove representing the Holy Spirit are understood to have been found many years ago in a giant storage jar in Syria, in the territory of Apamea, at or near the modern trading town of Taroutia Emporön, which is situated close to the ruins of the ancient city of Attarouthi. In the first decade of this century, the remains of ancient Attarouthi were recorded by a Princeton University expedition headed by Howard Crosby Butler, who attributed the destruction of the city to either the Persians or the Arabs in about A.D. 614. Among the ruins then visible were two limestone churches: The larger—presumably, the city's Episcopal church—bore an inscription to the protomartyr Saint Stephen, and the smaller may have been dedicated to Saint John the Baptist.[1]

The chalices and censers bear Greek dedicatory inscriptions around their rims and, on most, a village called Attarouthi (variously spelled) is mentioned.[2] The two largest chalices, which appear

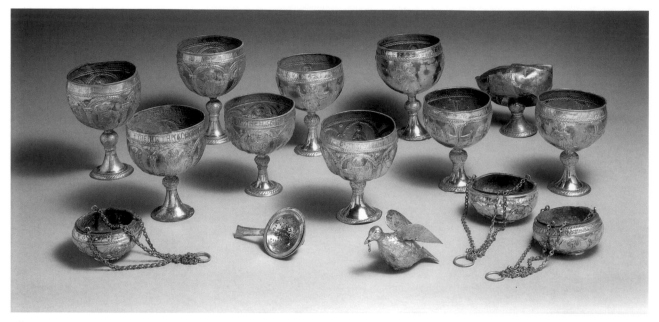

46

to form a pair, are inscribed "Of St. Stephen of the Village of Attarouthi," and decorated with a series of holy figures, none of whom is identified by name. The eight smaller chalices and the three censers also bear dedications around their rims. Among the donors mentioned are Kyriakos, the deacons Diodoros and John, and two brothers named Kerykos and Martyrios. The chalices are dedicated to Saints Stephen and George and to Saint John the Baptist.

With the exception of one of the smaller chalices, which has a cross-and-star design of a type commonly used on Early Christian objects—such as the lead ampullae now in the Cathedral Treasury, Monza—all the chalices are decorated with holy figures. With the aid of the saints mentioned in the dedicatory inscriptions— Stephen, George, and John the Baptist—tentative identification of the figures may be suggested: On the two largest chalices, for example, a youthful Christ is flanked by a deacon, probably Stephen, and a military saint, perhaps George. The Virgin orans stands between John the Baptist and another saint, possibly Theodore. Although the chalices were made in different sizes, with the figures sometimes placed under arcades and at other times standing against unarticulated fields, the designs of the borders that decorate the rims, the bottoms of the bowls of the chalices, the knops and the bands below them, and, sometimes, the bases, remain constant.

The three censers retain their original chains and copper liners. The finest example, probably made in the sixth century, is inscribed "St. John of the village of Attarouthi," within beaded and roped borders, and decorated with medallion-like bust-length images of Christ and two archangels alternating with monumental crosses of the type also found on two of the chalices. The other two censers are more difficult to place within a sixth-century chronology. Although the iconography follows the pattern of decoration of the censer just described, the style and quality of the images in relief are less elegant. The face of Christ is emaciated and the arms of the cross inscribed on his halo jut out from behind his head in a manner that most resembles the design of the coins of Justinian II during his second reign (705–11).

The liturgical objects also include a wine strainer and a small dove with removable wings. The former is made in two parts: the actual strainer, which is pierced with a cross-shaped design, and the funnel used to decant the wine. Quite a few similar examples are known from the Early Christian world, such as those, for instance, in the treasures of Traprain Law in Scotland and of Kaiseraugst in Switzerland. The dove's removable wings are patterned only on the underside, which suggests that it must have been meant to be viewed from below. It is a unique survivor of a tradition described in various Early Christian and Byzantine texts: A dove hung over the altar of Saint Gregory's church in Tours and one hovered in the apse of Hagia Sophia in Constantinople when the Russian pilgrim Anthony of Novgorod visited the church just before the Crusaders sacked the city in 1204.[3]

None of the works bears stamps or other markings to provide evidence of the date or place of manufacture. One chalice is partially crushed; the other objects are in an excellent state of preservation, allowing for intensive study of the gilding techniques of the Early Byzantine era.[4]

MEF/HCE

1 See Butler, 1920, pp. 71–75.
2 Marlia Mundell Mango of Oxford University is to be thanked for her identification of the site.
3 This text is drawn from Frazer, 1988 a, pp. 13–14, and unpublished research for an unrealized book she had planned to publish on these works.
4 See Dandridge, forthcoming.

EX COLLECTIONS: Guillaume Lestschinski, South Russia, Smyrna, and Thessalonike, 1939; Elias Bustros, Beirut, 1940–65; Sleiman Abou Taam, Beirut and Switzerland, 1965–(?); [Selim Dere, New York, 1986].

EXHIBITION: (1986.3.4,11) "Decorative and Applied Art from Late Antiquity to Late Gothic," Moscow, State Pushkin Museum, May 10–July 10, 1990, and Leningrad, State Hermitage Museum, August 14–October 14, 1990, nos. 9, 10.

REFERENCES: Frazer, 1988 a, pp. 13–14; *idem*, 1990 a, no. 9 (1986.3.4), p. 26, colorpl. p. 27, no. 10 (1986.3.11), p. 27, colorpl. p. 28; *MMA Annual Report*, 1990, p. 28, ill.; H. Maguire, 1996, p. 105, pl. 88; Dandridge, forthcoming.

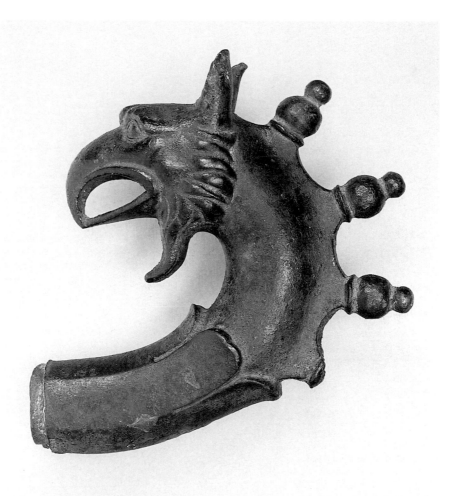

47

GRIFFIN LAMP HANDLE

Early Byzantine, 6th–7th century

Bronze: Height, 6¹⁵⁄₁₆ in. (17.6 cm); width, 1⅞ in. (4.8 cm); length, 6½ in. (16.5 cm); diameter of neck, 1¹⁄₃₂ in. (3.7 cm)

Gift of Max Falk, 1987 (1987.441)

The griffin, half lion and half eagle, was sacred to the god Apollo, for it guarded his treasure in the land of the Hyperboreans. For centuries, proud and ferocious griffins stalked the seals and reliefs of ancient civilizations. With the advent of Christianity, images of these creatures continued to be made especially for decorative and useful objects such as lamps. The size and weight of this dramatic griffin lamp handle indicate that it was attached to a standing floor lamp similar to the bronze lamps that illuminated Roman houses in prosperous cities like Pompeii and Herculaneum.[1] Interpretations of the griffin's meaning in a Christian context vary widely. The creature has been identified as a symbol of good or evil; in its composite form, as emblematic of the dual nature of Christ, or of land and air; and as the keeper of light, or as a protective guardian figure in general.[2]

The griffin's neck still contains part of the original core material and the copper pins used in its casting. When the bowl of the lamp was filled with oil and the wick lit, the griffin must have commanded the attention of all who benefited from its light. The blackened surface of the griffin probably was caused by exposure to intense heat.

MEF/HCE

1 See Frazer, 1988 b, p. 14.
2 See Kondoleon, 1994, p. 251; Pazaras, 1997, no. 2 a, pp. 36–37, color ill. p. 37.

EX COLLECTIONS: Dr. Leopold Seligmann, Cologne, until 1930; Hayford Peirce, n.d.; [Piero Tozzi Galleries Inc., New York, 1977]; Max Falk, New York, 1977–87.

REFERENCES: Clemen, von Falke, and Swarzenski, 1930, no. 27, pl. IX; Frazer, 1988 b, p. 14, ill.

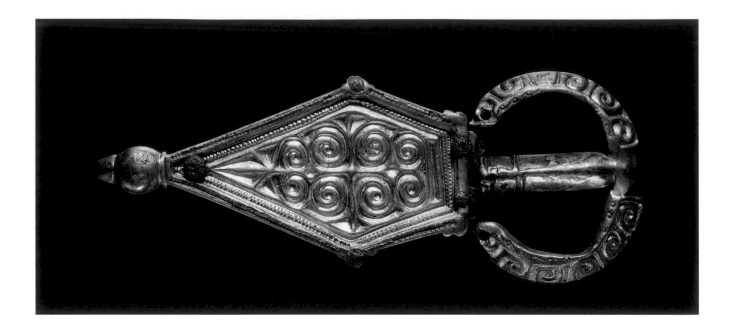

48

BUCKLE AND PLAQUE

Gepidic, 5th century
Silver gilt: Length, 5 in. (12.7 cm)
Anonymous Gift, in memory of Harry Bober, 1990 (1990.184a-c)

In the grave of an aristocrat of the mid-fifth century in Tiszalök, Hungary, a silver-gilt rhomboidal buckle, cast with symmetrical spiral designs and fitted with a heavy circular loop, was found on the skeleton of a Gepidic or Visigothic woman.[1] Both tribes lived in the vicinity of Tiszalök at that time. The present silver-gilt buckle, formerly in the collection of Harry Bober, compares favorably with the Tiszalök example and with two others in the Magyar Nemzeti Múzeum, Budapest; according to A. Kiss of the Hungarian museum, these last two buckles are related to yet another, from a Gepidic grave.[2] Whereas the Metropolitan Museum's buckle is closest in form to the one of unknown provenance purchased by the Hungarian museum, the chip-carved design is most like that on the other example in the Hungarian museum that was excavated at Macvanska Mitrovica, northwest of Belgrade. On all three, the plaque terminates in the head of a bird of prey and the loop is decorated with spirals. The cast, chip-carved design on the five-sided plate of the Metropolitan Museum's buckle, with its slightly concave sides, is based on spiral and pelta (heart-shaped) motifs. Both the chip-carving technique and the pelta motif are of Late Roman origin, while the spirals on the loop are of Celtic inspiration. The Metropolitan's buckle plate has a silver-and-niello outer border and an inner border of beading. It is exceptionally well preserved, and a fine example of Gepidic art.

KRB

1 See Menghin, 1983, p. 14, fig. 2.
2 See Kiss, 1984, pp. 57–76.

EX COLLECTIONS: Edward Ochsenschlager, New York; Harry Bober (1915–1988), New York; [sale, Sotheby's, New York, June 23, 1989, lot 170]; [Ariadne Galleries, Inc., New York].

REFERENCES: Brown, 1993, no. 25, pp. 66–67; *idem*, 1996, pp. 228–29.

49

CICADA BROOCH

Gepidic, 5th century
Bronze: Height, 1¼ in. (3.2 cm)
Purchase, William Kelly Simpson Gift, 1993 (1993.263)

This cicada brooch has very subtle demarcations and an unusually fine patina. The insect's head is in high relief, with bulging eyes and a slightly protruding proboscis. Three lines or grooves separate the head from the body and wings, each of which is triangular. The underside is flat, with a spring at the base of the body and a catch for the pin—cast with the piece—under the head.

This type of brooch was worn by women of the east Germanic tribes, although many similar examples are larger and more elaborate. Whereas the tradition of wearing cicada brooches was derived from the Sarmatians, it was perpetuated in Provincial Roman objects, as exemplified by the cicada on the tip of the shaft fitting with two rings of the large spear from the Vermand Treasure unearthed in France. By comparison with other known examples, the Metropolitan Museum's brooch is thought to be Gepidic—the product of a branch of the Goths who had established themselves in the northeastern part of the Carpathian Basin in the mid-third century and were enslaved by the Huns. Many of these brooches have been found in Hungary.[1] As has been shown by Dafydd Kidd, continuation of the tradition of representing winged insects in

Germanic art is demonstrated by a pendant made of gold, garnets, green glass, and pearls in the Museum (17.190.698). It is one of nine such pendants that, in outline, resemble stylized winged insects, and may have been suspended from two large eagle fibulae, all of which formed part of an Ostrogothic treasure of the first half of the sixth century from Domagnano in the republic of San Marino, now divided between the British Museum and the Germanisches National-museum in Nuremberg.[2] Also in the Metropolitan's collection are two Frankish silver disk fibulae (17.191.136, 17.193.109) of the seventh century, with representations of bees.

KRB

1 See Brown, 1995 a, pp. 21–22.
2 See Kidd, 1988, pp. 132–37.

EX COLLECTION: [Bastiaan Blok, Noordwijk, The Netherlands].

50

BUCKLE AND PLAQUE

Mediterranean, second half of the 5th century

Gilt bronze, with glass, garnets, and malachite: Height, 1¾ in. (4.5 cm); width, 2⅜ in. (6 cm)

Gift of Max Falk, 1991 (1991.173)

This gilt-bronze buckle with a U-shaped plate, consisting of a large central glass cabochon field (now corroded) with a decorative border of garnets and malachite, initially was thought to be Vandalic because of its similarity to several objects from Annaba (Bône), Algeria, in the British Museum. However, Dafydd Kidd, assistant keeper of that collection, who has been acquiring and studying similar buckles, brooches, and harness fittings from the Near East and Egypt,[1] concluded that these pieces, as well as the Metropolitan Museum's buckle, originated in a wider area of the southern and eastern Mediterranean regions, from the Black Sea to Spain, and in consequence they have been associated with Germanic mercenaries in Byzantine service. The examples from North Africa have been linked to the Vandals, who had set sail for Africa from Spain in 429 and conquered all of Roman Africa by 439. According to Kidd, such buckles may have been worn by Vandalic women, but the objects themselves could have their origins in Late Antique and Byzantine workshops. A similar buckle is in The Cleveland Museum of Art.

KRB

1 Kidd, in an unpublished manuscript.

EX COLLECTIONS: [Blumka Gallery, New York]; Max Falk, New York.

51

BELT BUCKLE AND TONGUE

Buckle: East Germanic, about 500; tongue: Early Byzantine, 6th century

Rock crystal and gold: Height, 1⁹⁄₁₆ in. (4 cm)

Purchase, Rogers Fund; Alastair B. Martin, William Kelly Simpson, Scher Chemicals Inc., and Max Falk Gifts; and gifts from various donors, 1995 (1995.54)

The beveled edges of this heart-shaped buckle give it a distinctive elegance; those of the oval loop in the center, specifically, serve to heighten the object's three-dimensional, tactile quality. The buckle is the natural outgrowth of a form characterized by heart-shaped designs and beveled chip carving, which was in vogue during the preceding Provincial Roman period. The intrinsic value of the masterfully carved rock crystal makes the buckle a significant emissary of the art of the Migration period, for the most characteristic aspects of that art were its portability and its role in reflecting the status of the wearer. This buckle is obviously from an important man's belt.

Such elegant rock-crystal buckles originated in the eastern Mediterranean region in the Late Antique period, probably in the wake of the revival of a glyptic tradition, and were carried westward by the east Germanic peoples. Rock crystal was used by the barbarians especially because of its richness. Like the few other extant examples, this buckle has lost its original tongue but is fitted with a fine gold Byzantine replacement with a small incised cross at the base.[1] A grooved piece of gold foil extends from the base of the tongue and is bent around a notch in the crystal to secure the tongue to the buckle.

KRB

1 See *Germanen, Hunnen und Awaren*, 1987, fig. 1, 6.

EX COLLECTIONS: Private collection, Germany; [Robert Haber & Associates, Inc., Ancient Art, New York, 1995].

REFERENCE: Brown, 1995 b, p. 23, ill.

52

HARNESS PENDANT

Visigothic, 6th century

Leaded brass: Height, 3½ in. (8.9 cm)

Purchase, Rogers Fund, Stephen K. Scher, Mrs. Maxime Hermanos, and Anonymous Gifts, Gift and Bequest of George Blumenthal, by exchange, and funds from various donors, 1990 (1990.52)

If at first the erect, taut symmetry of these two stylized, seated, and confronted panthers(?), each with its head turned backward in profile—a heraldic pose reguardant—and with its chest facing outward and the hip joints clearly demarcated, recalls Asian prototypes, closer examination indicates the artist's familiarity with Greek animal bronzes. Among harness pendants with similar iconography from Spain and southwestern France,[1] this hitherto unknown example appears to be the most finished and perhaps the most puzzling. It still retains the loop above the heads of the beasts through which the harness strap could be passed. The realistic rendering of the fur by means of fine, engraved lines on each animal's body and tail—which is elegantly curled around and resting on the haunch—as well as in the wrinkles on the neck, reveals a knowledge of Greek art, and seems to set this example apart from other related pendants.

Although the Near Eastern aspects of this object could have been derived from Greek art during its Orientalizing period, Pedro de Palol Salellas has suggested possible alternative migration routes for the theme of confronted, symmetrical animals with turned heads: The imagery might have passed from Mesopotamia to the Scytho-Sarmatian culture in southern Russia, from which it could have been taken up by the Greeks or Goths; it might have been transferred from Han dynasty China to the Huns and the Avars; or perhaps it was created independently by Greek artists in Greece or

Spain.[2] Although the immediate prototype for this pendant is suggested by an example from Lectoure, in southwestern France, on which the beasts rest on a fluted vase or capital of Roman form, it is the symbiosis of Greek and a variety of Near Eastern traditions that characterizes sixth-century Visigothic art in Iberia.[3]

KRB

1 See Palol Salellas, 1952, pp. 297–319.
2 See Palol Salellas, 1953–54, pp. 279–92.
3 See Hill, 1953, n.p.

EX COLLECTION: [Robin Symes Limited, London].

REFERENCES: Brown, 1990 b, p. 17, ill.; *idem*, 1993, no. 29, p. 69, colorpl.

53

HARNESS PENDANT, WITH MOUNTED HORSEMAN

Visigothic (Spain), 6th century

Leaded bronze: Diameter, 3¼ in. (8.3 cm)

Rogers Fund, 1990 (1990.77)

This openwork roundel, which has projections that curve around the border and the remains of a trapezoidal extension at the top for attachment, displays, in the center, an equestrian figure moving to the right with his left hand on his horse's head and his right hand raised in victory. Below the feet of the horse is a serpent motif. Along the border is an incised foliated vine-scroll pattern. The hair and the belt of the rider, and the mane of the horse as well as a triangle that appears on its neck, are also designated by incised lines.

The letters *CLD* in script on the haunch of the horse indicate its participation in the circus. Such letters on the haunch of the circus horse can be seen, too, on the Lampadii diptych in the Museo Civico, Brescia.[1] Gisela Ripoll López, who has published the present harness pendant together with two others that also show mounted riders,[2] has compared these cheekpieces with similar representations

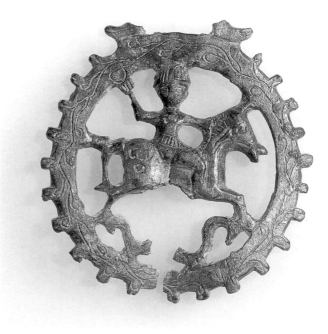

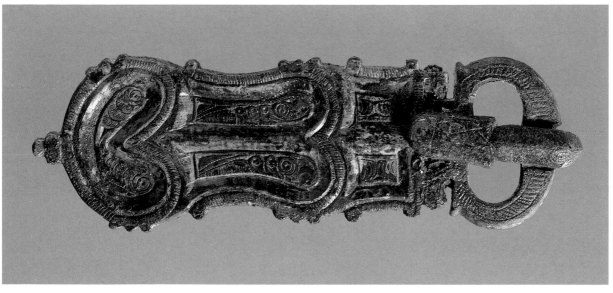

54: A

in mosaics and frescoes. There are two harness pendants with *venators* (hunters) in the Museo Lázaro Galdiano, Madrid, thus suggesting that an even wider variety of harness pendants with circus scenes once must have existed.

KRB

1 See Delbrueck, 1929, no. 56, pp. 218–21, pl. 56.
2 See Ripoll López and Darder Lissón, 1994, nos. 72, 73 (the Metropolitan's pendant), 74, pp. 326–27, fig. 21, p. 325.

EX COLLECTION: [Robin Symes Limited, London].

REFERENCE: Ripoll López and Darder Lissón, 1994, no. 73, pp. 326–27, fig. 21, p. 325.

54

A. **LYRE-SHAPED BUCKLE**

Visigothic, 7th century
Leaded bronze: Length, 5⅞ in. (14.9 cm)
Purchase, Mr. and Mrs. Ronald S. Lauder Gift, 1990 (1990.193.3a,b)

B. **PAIR OF BOW FIBULAE**

Visigothic, late 6th century
Leaded bronze: Height, 5 in. (12.7 cm)
Purchase, Mr. and Mrs. Ronald S. Lauder Gift, 1990 (1990.193.1,2)

Composed of three separately cast elements—tongue, loop, and plaque—this buckle's configuration evokes the designation "lyre shaped." Aside from the tongue, the borders of the lyre design are in the highest relief, and portions of them are chased with diagonal striations. The smooth inner edges of the borders slope down to the depressed areas, which are filled with deeply engraved lines and punched circles that represent highly abstracted foliate designs. The loop is chased with hatchings and the end of the tongue with crosshatching. The recessed reverse of the plate is fitted with five cast lugs for attachment to a now-lost belt.

Lyre-shaped buckles were produced in great quantities throughout the Mediterranean basin. In Spain, cast and chased bronze examples were modeled after Italo-Byzantine gold and silver ones.

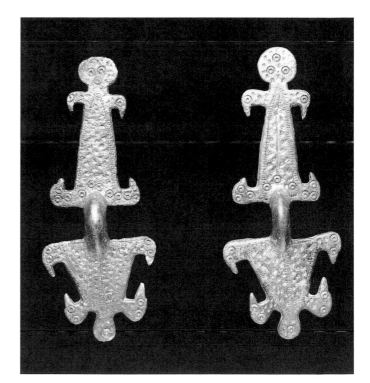

54: B

In contrast to the buckle, the pair of bow fibulae is purely Visigothic. Their basic form—a nearly triangular head connected by an arched bow to a long foot plate—was characteristic of objects produced by the Goths in the second and third centuries, when they migrated from Scandinavia to the northern shores of the Black Sea. Specifically Visigothic is the rendition of the form in bronze (rather than silver) with punched and chased designs. The increased number of appendages on each fibula—four pairs of confronted birds' heads—identifies them as later examples among the Visigothic fibulae developed in Spain.

KRB

EX COLLECTION: [Ariadne Gallery, New York].

REFERENCE: Brown, 1991, p. 14, ill.

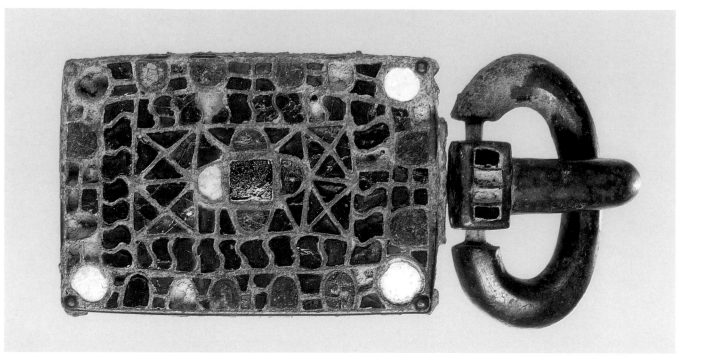

55

BUCKLE AND PLATE

Visigothic, second half of the 6th century

Copper alloy, with garnets, over gold foil, lapis lazuli, cuttlefish bone (?), and green and red glass: Length (of buckle and plate), 5½ in. (14 cm)

Rogers Fund, 1988 (1988.305a,b)

Large bronze buckles and cloisonné plates are the most characteristic items of Visigothic metalwork. This example is an excellent representation of the Ponto-Gothic style in the West. The style, marked by accents of red, blue, and green in the inlays, was developed by the Goths on the north shore of the Black Sea before the arrival of the Huns in 375, when the Goths divided into Ostrogoths and Visigoths. The style was carried westward by both the Ostrogoths and the Visigoths, who arrived in southern France and Spain by the beginning of the fifth century.

Most of the translucent red inlays of the buckle are garnets set over patterned gold foil. The deep-red glass of the central setting—the surface is now compromised by pitting and iridescence—is flanked by four lobes of green glass. This central motif is surrounded by cloisonné garnets, which, along the borders, are interspersed with green glass and lapis lazuli; although the green glass is common, the lapis lazuli is apparently unique in Visigothic metalwork. The use of lapis lazuli in jewelry, seen in Roman and Byzantine examples,[1] may be a reflection of the close relationship between the Visigothic kings and the Byzantine emperors. The round white corner inlays have the physical qualities of cuttlefish bone. The plate of the buckle, the cloisons, and the back are all made of brass. Traces of gilding remain on the tops of the cloisons and on the sides of the plate, buckle, and tongue.

The plate was joined to the buckle by a strip of metal bent around the bar of the loop and its ends soldered to the front of the plate. The strip would have been slotted to allow for the tongue. Cast into the base of the tongue are four settings for garnets that are backed by foil; only two garnets remain. Originally, the plate would have been connected to the end of a leather strap (or belt) by four small pins, and the loop and tongue attached to the other end. The tongue would have pierced the leather after the strap was passed around the loop and knotted on itself. It is thought that such belts were worn on women's tunics rather than to secure their mantles.[2]

The buckle's cell pattern relates it to a group of buckles from ancient Septimania in southwest Gaul that are now in the Musée de la Société Archéologique, Montpellier,[3] and on which none of the stones remain, as well as to others in the Museu Arqueològic, Barcelona.[4] All of these buckles are characterized by a single central rectangular cell surrounded by four small round lobes from which the rest of the cloisonné design leads toward the corners. Whereas the examples found in Septimania have three cells (two small and one large) emphasizing the corners, those in Barcelona have a single large round setting at each corner, as does the Metropolitan Museum's buckle.

Much of the garnets, lapis lazuli, glass, and cuttlefish bone on the Museum's buckle is preserved, and, when compared with our only other inlaid Visigothic buckle (47.100.22), which is damaged and heavily restored, the fine quality of the present one is particularly evident. Although the Museum's collection includes several articles of jewelry crafted by the Ostrogoths in the Ponto-Gothic polychrome style, this is the only Visigothic example worthy of exhibition.

KRB

1 See Miner and Edelstein, 1945, pp. 83–103.
2 See Bierbrauer, 1975, p. 363, fig. 43.
3 See James, 1977, vol. 1, pp. 247–49, plates 65–66.
4 See Almagro Basch, 1947, pp. 72–73, pl. XXIII.

EX COLLECTION: [Robert Haber & Associates, Inc., Ancient Art, New York].

REFERENCES: Brown, 1989, pp. 14–15, color ill. p. 14; *idem*, 1993, no. 17, pp. 61–62, color ill. p. 61.

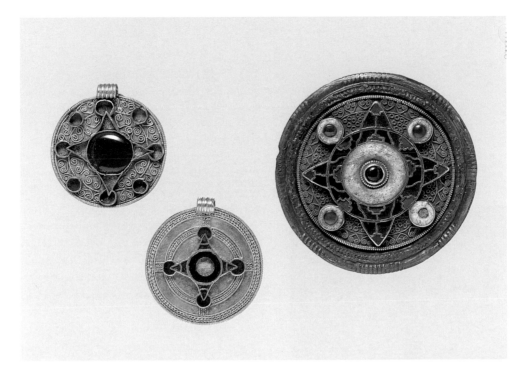

56

BROOCH AND PENDANTS

Anglo-Saxon (Kent), early 7th century

Gold, silver, and gold foil, with garnets and cloisonné garnets, blue glass, and white agglomerate: Diameter (brooch), 1⅞ in. (5 cm), (pendants), 1¼ in. (3.2 cm) and 1⅛ in. (2.9 cm)

Purchase, Joseph Pulitzer Bequest, 1987 (1987.90.1–3)

The three Kentish pieces were excavated in 1894 in Teynham, three miles from the center of production of Kentish jewelry in Faversham. The large brooch (right) is made of two parts: a silver-gilt backplate and a gold front plate consisting of cloisonné inlay, annular in shape, with four triangular settings radiating from it. Between these settings are others similar to the central setting. The interstices are decorated with bands of filigree. Whereas the filigree represents a revival of Roman techniques, the use of gold and garnets was due directly to the Franks; in fact, it is now believed by most scholars that Anglo-Saxon cloisonné was produced to order in continental workshops. The pattern of the filigree as well as the design of the gold front plate with the star-shaped cloisonné inlay typify Kentish jewelry from the late sixth to the early seventh century.

Excavated with the brooch was the gold disk pendant (center) decorated with gold wire and cloisonné garnets, which form a star-shaped pattern with a single cell encircling each tip of the star. The central cell, which has patterned foil across the bottom, is empty. A design formed of twisted wires between beaded wires fills the remaining areas of the pendant. The second pendant (left), although not from the same find, also comes from Teynham; it was in the Kennard Collection as well, and was sold by Sotheby's in 1895 with the other two items. (The central cloisonné designs of both pendants are alike.) Four bosses fill the interstices between the points of the star. The rest of the surface is ornamented with heart-shaped filigree motifs. Only one interstitial boss and the central cell retain their garnets.

Pendants such as these were rare in the sixth century, and came into vogue only at the end of that century and the beginning of the seventh. The pendant found with the brooch led Avent to conclude that the latter dates to the seventh century.

All three objects would be a tribute to the collection of any major museum because they are classic examples of their type, in a fine state of preservation, and, in addition, they are well published. They come to us from the well-known Pitt-Rivers Collection in Dorset, England.

K R B

EX COLLECTIONS: Samuel Egger, Vienna; [sale, Sotheby, Wilkinson & Hodge, London, March 12, 1895, lots 14, 16, 19, pp. 4–5]; Pitt-Rivers Collection, Farnham, Dorset, England; [K. J. Hewett, London]; [P. & D. Colnaghi & Co. Ltd., London]; [Artemis Fine Arts Ltd., London]; [Michael Ward, Inc., New York].

REFERENCES: Payne, 1895, p. 184; Smith, 1908, pp. 373, 386; Leeds, 1936, p. 117, pl. XXXIII, fig. 2; Jessup, 1950, p. 114, pl. XXIII, fig. 2 (incorrectly cited as in the British Museum); Avent, 1975, vol. 1, p. 45, vol. 2, no. 156, pl. 54; Brown, 1987, pp. 12–13, colorpl.

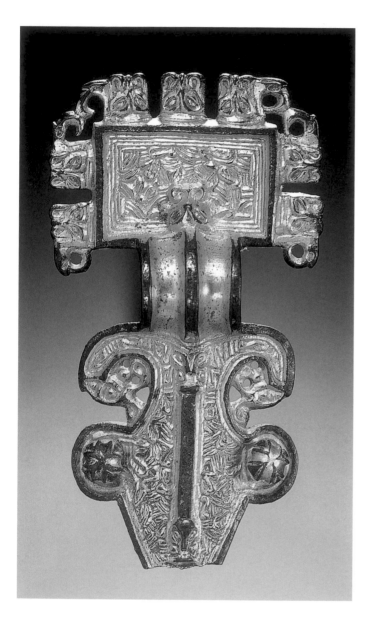

57

GREAT SQUARE-HEADED BROOCH

Anglo-Saxon, 6th century
Gilt bronze and niello: Height, 5⁵⁄₁₆ in. (13.5 cm)
Purchase, Rogers Fund and Alastair B. Martin, Levy Hermanos
Foundation, Inc., and J. William Middendorf II Gifts, 1985 (1985.209)

Two prevailing influences convened somewhere between the Baltic and the Black Seas to initiate the development of this kind of brooch. Examples of small silver bow fibulae with square or rectangular heads, which originated in the Crimea and date to the third century A.D., are thought to have provided the model for the square or rectangular head of the type. Northern elements are represented by the open-jawed heads of the monsters just below the bow, in addition to other animal motifs, and by the partitioned, lozenge-shaped foot plate, whose surface is decorated with *kerbschnitt* (chip carving) and its extremities with raised knobs (the one on the end of the foot is now missing). Dividing the foot is a strip of niello (a black substance containing silver, copper, lead, and sulfur) terminating in an animal's head, while above the foot is a pair of stylized animal heads with gaping jaws.

The gilt-bronze head of the brooch is ornamented with *kerbschnitt* and a border of freestanding masks, those at the corners having birds' beaks. The bow is plain and divided into panels by bands of niello. It is the border of freestanding masks that sets the Metropolitan Museum's example apart from the majority of great square-headed brooches, and allies it to a small group identified as the Lutton Heath type.[1] The Museum's brooch, like most of the approximately one hundred and fifty known square-headed examples that were made in England throughout the sixth century, displays the Anglo-Saxon preference for lavish surface decoration. These brooches, traditionally of gilt bronze, served to secure the garments of peasant agriculturists. Unlike some of the related Continental bow fibulae, the brooches often were worn with the head plate upward.

Aside from the six miniature fibulae in the Metropolitan, which are Kentish, the present brooch is the Museum's only Anglo-Saxon bow fibula. Such brooches provide a prime opportunity to study the Germanic Animal Style as practiced in England. Although nothing is known of the history of this fibula, it is included in a *Corpus* of such brooches.

KRB

1 See Leeds, 1949, p. 62, fig. 95.

EX COLLECTIONS: [sale, Sotheby's, London]; [Michael Ward, Inc., New York].

EXHIBITIONS: "Jewels of the Barbarians," New York, Michael Ward, Inc., Fall 1985, no. 30; "Decorative and Applied Art from Late Antiquity to Late Gothic," Moscow, State Pushkin Museum, May 10–July 10, 1990, and Leningrad, State Hermitage Museum, August 14–October 14, 1990, no. 4.

REFERENCES: Ward, 1985, no. 30, ill. (cover); Brown, 1986, p. 14, ill.; *idem*, 1990 a, no. 4, p. 16, colorpl. p. 17; Hines, 1997, group XXIV, pl. 87 b, p. 174, fig. 88.

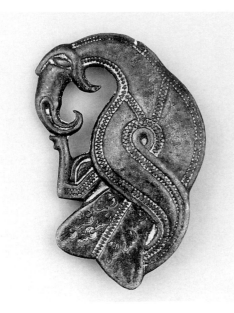

from Germany[3] and on an example of a fibula or mount from Canterbury, now in the Victoria and Albert Museum, London.[4] However, the high relief of the eye and the sharply curved caplike eyebrow and beak, which characterize the Metropolitan Museum's bird, are typical features of the Vendel style, and would seem to argue for a tentative attribution of the bird to Scandinavia and a date of about 600.

K R B

1 See the photograph in the archives of the Department of Medieval Art.
2 See Bruce-Mitford, 1979, fig. 20.
3 See Renner, 1970, no. 545, pl. 26.
4 See Heaton, 1904, pp. 30–31, fig. 72.

EX COLLECTION: [Robert Haber & Associates, Inc., Ancient Art, New York].

59

STRAP END

Late Roman (Frankish or Allemanic), 6th century
Bronze: Length, 5 in. (12.7 cm)
Gift of Max Falk, 1993 (1993.109)

Strap mounts were used to protect the extremities of a leather strap. Sometimes they were attached to a man's leggings, and were found in tombs at the position of the knees; in other instances they were part of a belt or bag. They have been discovered in the graves of both men and women. The archaeological context of this particular example—one of a pair from a German collection—is unknown. The piece is of bronze, with traces of tin near the two apertures at the top, but one can imagine the original splendor of the pair when each was entirely tinned to simulate silver. The incised decoration consists of a cross within two concentric circles from each side of which two lines extend down to a human face situated above an X-shaped motif. Most of the surface is incised with circles that enclose a point. These, together with the concentric circles and "tildes," are solar symbols, but the overall meaning of the designs is still not clear. What is known is that none of the examples in the J. Pierpont Morgan Collection at the Metropolitan Museum is as elaborately decorated, and only one other is almost as large.

K R B

EX COLLECTIONS: [Leopold Seligmann, Cologne and Berlin]; Simon Meller; [Albrecht Neuhaus, Würzburg]; Max Falk, New York.

REFERENCE: Clemen, von Falke, and Swarzenski, 1930, no. 77, p. XVI, ill. (the left strap end of the pair illustrated is the Museum's example).

58

FIBULA IN THE FORM OF A BIRD OF PREY

Scandinavian, about 600
Bronze: Height, 2⅜ in. (6 cm); width, 1⅜ in. (3.5 cm)
Purchase, Leon Levy and Shelby White Gift, Rogers Fund, and funds from various donors, 1991 (1991.308)

The head and right leg of this elegant bird brooch are in left profile, while its rounded body and flaring tail are presented frontally. The extended right wing curves behind the tail. The edges of the neck, wings, and tail, and the upper part of the leg are outlined with pseudobeading. Nine stamped (punched?) crayfish decorate the tail. The position of the head, supported by the raised leg, indicates that the bird is sleeping.

The brooch is said to have come from a Scandinavian collection before being sold in London. In fact, it is more or less comparable in form to the saddle mounts from Vallstenarum (now in the Statens Historiska Museet, Stockholm)[1] in the Vendel style (550–800)—named after the objects excavated at this royal site in Sweden—and to the shield mounts from the Sutton Hoo ship burial, now in the British Museum.[2] Whereas punched decoration consisting of crayfish is unique, in the knowledge of this author, stamped geometric decoration is found on the tails of birds of prey on openwork disks

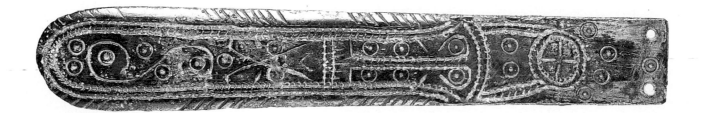

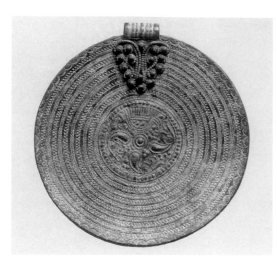

60

CIRCULAR PENDANT

Vendel Period (Gotland), 8th century
Bronze, with traces of gilding: Diameter, 2¼ in. (5.7 cm)
Rogers Fund, 1984 (1984.300)

This circular pendant is ornamented with a triangular area of granulation and filigree below the suspension loop. The disk, which is cast, is stamped with plain concentric bands alternating with bands decorated with a zigzag pattern. On the central medallion are three stylized animal heads each attacking its neighbor.

Because this gilt-bronze pendant is stamped on only one side, it is known as a bracteate.[1] Such bronze examples frequently have been found in women's burials dating to the Vendel Period (550–800). However, the manufacture of gold bracteates—Scandinavian imitations of Roman coins and medallions of the type distributed by the Romans to deserving Germans—continued throughout the Viking Period (800–1050), and many of these have been found in Scandinavia. Their decoration ranges from portraits of emperors to animal ornamentation; this example displays the latter.

A very similar pendant, now in the British Museum, although of gold sheet, is also probably from Gotland, and is believed to date to the Vendel Period, as well.[2]

KRB

1 See *Treasures of Early Sweden*, 1984, p. 54.
2 See *Jewellery through 7000 Years*, 1976, no. 203, p. 135.

EX COLLECTIONS: [K. J. Hewett, London, 1982]; [Michael Ward, Inc., New York].

61

LOOP AND TONGUE OF A BUCKLE

Early Viking, 8th century
Copper alloy: Height, 1¼ in. (3.2 cm)
Provenance: Said to be from Dorestadt (The Netherlands).
Gift of Bastiaan Blok, 1991 (1991.260.13)

KRB

EX COLLECTION: [Bastiaan Blok, Noordwijk, The Netherlands].

62

TWELVE FIBULAE

Late Merovingian or Carolingian, 8th–9th century
Bronze, with champlevé enamel: Diameter: 1991.260.1: ¾ in. (1.9 cm); 1991.260.2: ⅜ in. (1 cm); 1991.260.3: 1¼ in. (3.2 cm); 1991.260.4: ⅞ in. (2.2 cm); 1991.260.5: ¹⁵⁄₁₆ in. (2.4 cm); 1991.260.6: ⅞ in. (2.2 cm); 1991.260.7: 1¼ in. (3.2 cm); 1991.260.8: ¹⁵⁄₁₆ in. (2.4 cm); 1991.260.10: 1¼ in. (3.2 cm); 1991.260.11: ¾ in. (1.9 cm); 1991.260.12: 1 in. (2.5 cm); Height: 1991.260.9: 1 in. (2.5 cm)

Gift of Bastiaan Blok, 1991 (1991.260.1–12)

KRB

EX COLLECTION: [Bastiaan Blok, Noordwijk, The Netherlands].

62: 1991.260.2

62: 1991.260.8

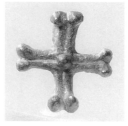

62: 1991.260.9

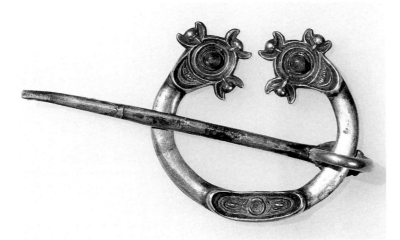

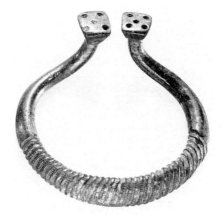

63

PENANNULAR BROOCH

Pictish (or Irish), early 9th century

Silver and amber: Diameter, 2⅜ in. (6 cm); length (of pin), 3¾ in. (9.5 cm)

Purchase, Rogers Fund, and Gift of J. Pierpont Morgan, by exchange, 1981 (1981.413)

This silver penannular brooch—a type that was widespread in the British Isles during the Early Christian period—was discovered in June 1851 in a field near Galway, Ireland. Each terminal is decorated with three stylized masks in the form of birds' or bats' heads, enframing a centrally mounted polished amber. The simple, flat-headed pin was mounted backwards when the brooch was found.

Typologically, the brooch is related to a number of Pictish examples found on St. Ninian's Isle in Scotland that, characteristically, have formalized animal or bird masks executed in relief on the terminals. Such brooches appear to have been in fashion toward the end of the eighth century. The Galway brooch is one of three attributed to the Picts—early inhabitants of Scotland—that were found in Ireland, and demonstrate the close stylistic affinities between Irish and Pictish forms. Since the brooch can be related to others of Irish origin, dated to the ninth century, this strong connection between the two cultures might be the result of the migration of the type.[1]

The present example is the first penannular brooch to have entered the Metropolitan's collection. The crisp execution of the masks that figure in its decoration makes it among the finest of all the Pictish brooches to have survived.

CTL

1 See Graham-Campbell, 1972, pp. 113–28; Smith, 1914, p. 249.

EX COLLECTIONS: Pitt-Rivers Collection, Farnham, Dorset, England; Carruthers, London; [K. J. Hewett, London, 1981]; [Michael Ward, Inc., New York].

REFERENCES: "Galway Brooch," 1854, pp. 146–47, ill.; Smith, 1914, p. 249; Small, Thomas, and Wilson, 1973, p. 90, pl. XXXVII c; Little, 1982, p. 17, ill.; Brown, 1995 a, p. 41, fig. 58.

64

RING FROM A PENANNULAR BROOCH

Anglo-Saxon, 9th century

Bronze: Diameter, 1¾ in. (4.5 cm)

Bequest of Zita Spiss, 1991 (1993.3.3)

KRB

EX COLLECTIONS: [Spiss collection, Vienna]; Zita Spiss, Syosset, New York.

65

BOX BROOCH AND PAIR OF BOAR'S-HEAD BROOCHES

Viking (Gotland), late 8th–9th century

Copper alloy: Diameter (box brooch), 1⅞ in. (4.8 cm); height (pair of brooches), each, 1¼ in. (4.5 cm)

Pfeiffer Fund, 1992 (1992.59.1–3)

These three brooches are typical of those worn by women in Gotland. Examples with boars' heads would have been paired on tunic straps, while box-shaped ones would have secured a shawl at the collarbone. The tactile appeal of these boar's-head brooches, with their smoothly modeled surfaces, contours suggested by fine cast beading, and subtly recessed eyes, is enhanced by a glossy patina. The box brooch, covered with a wide array of animals and bird-headed creatures with elongated extremities, represents the culmination of the Scandinavian Animal Style, together with elements of one of the first properly recognized Viking styles, which followed.

One of a pair of similar animal-headed brooches now in the Victoria and Albert Museum, London,[1] is of this general type, but it has larger, rounded ears, and there are no beaded borders, whereas the box-shaped brooch has a good, although less well-preserved, counterpart in the British Museum.[2] The Metropolitan Museum's box brooch is one of the finest extant examples of the style, which is characterized by the interlaced bodies, open-jawed heads, and extended feet of the animal decoration. The best stylistic parallels for this brooch are the harness mounts from Broa (Gotland), in the Statens Historiska Museet, Stockholm,[3] which date from the eighth to the ninth century and are considered Early Viking.

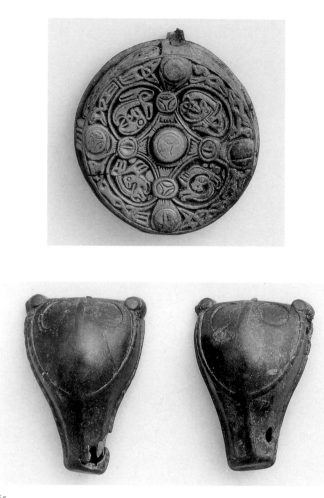

65

An impression of a textile used in the molding process is visible on the inside of the box brooch. This technique frequently was used in Viking cast-bronze pieces.[4] A group of openwork plaques among the gold treasures of Peter the Great, and generally dated from the fifth to the second century B.C., has the distinguishing feature on the reverse of a positive textile relief that duplicates in casting the original textile that must have reinforced the model. Experts are not in agreement as to whether these plaques are of Far Eastern or Central Asian origin, but cruder bronze versions occur in burials all over the eastern Eurasian steppe lands.[5] It has long puzzled interested scholars how this technique was transferred from the steppes to the Vikings, and evidence has been sought on Avaric cast objects because the Avars originated in Central Asia. Recently, Thomas Vinton, Senior Departmental Technician in the Department of Medieval Art, noted the same type of textile imprint on a cross-shaped harness mount, which may be Ostrogothic or Frankish, in the Museum's collection (51.125.5). Thus, the technique must have been transmitted to the Ostrogoths in the region of the Black Sea, and then to the Franks when the Ostrogoths moved into Italy.

KRB

1 See Hildebrand, 1883.
2 *Guide to Anglo-Saxon Antiquities*, 1923, pl. XVI, no. 1.
3 See Klindt-Jensen and Wilson, 1966, pl. XXI.
4 See Arrhenius, 1965, p. 14.
5 See Bunker, 1988, pp. 222–27.

EX COLLECTIONS: Private collection, Germany; [Robert Haber & Associates, Inc., Ancient Art, New York].

REFERENCE: Brown, 1992, p. 18, ill.

66

A. OVAL BROOCH

Viking, 10th century
Cast copper alloy, with gilding: Length, 4½ in. (11.4 cm)
Purchase, Fletcher Fund and Bequest of Gwynne M. Andrews, by exchange, 1982 (1982.323.1)

B. BOX BROOCH

Viking (Gotland), about A.D. 1000
Cast copper alloy, with traces of silver: Diameter, 2⅜ in. (6 cm)
Purchase, Fletcher Fund and Bequest of Gwynne M. Andrews, by exchange, 1982 (1982.323.2)

C. BOAR'S-HEAD BROOCH

Viking (Gotland), late 10th century
Cast copper alloy: Length, 2³⁄₁₆ in. (5.5 cm)
Purchase, Fletcher Fund and Bequest of Gwynne M. Andrews, by exchange, 1982 (1982.323.3)

The large, vaulted, and intricately ornamented oval brooch is a fine example of an important type of fastener used in pairs chiefly by Viking women to secure their shoulder straps to the fronts of their tunics. While most of the decoration derives from earlier "animal styles," the emphasis is on abstraction. The symmetrically grouped motifs are made up of recessed lines with sloping sides—a style and technique borrowed from Late Roman "chip carving." Occasionally, the eye of an animal or the beak of a bird may be deciphered. The effect is one of rich, overall light-and-dark patterning enlivened by gilding; what remains is best preserved on the lip of the separately cast collar. Comparable examples have been excavated not only in Scandinavia but also in Iceland, Ireland, Scotland, and England.[1]

The high, circular brooch, known as the "box-brooch" type, is also decorated in an abstract, "chip-carved" style. Symmetrical interlacing patterns fill the four quadrants of the convex upper surface and the collar below. Traces of silver and niello ornamentation may be seen on the separately cast dividing panels. This kind of brooch, as in the case of an earlier example acquired in 1992 (1992.59.1; cat. no. 65), was worn by the women of Gotland just below the collarbone to secure their shawls. A very close comparison for the present work illustrated here was published by Hildebrand.[2]

The brooch in the form of a stylized boar's head is notable for its simplified shape, vestigial ears, and blunted snout, and is a continuation of an earlier type represented by the two brooches acquired in 1992 (1992.59.2–3; cat. no. 65). The recessed surfaces between the smooth ridges are decorated with simple cross-hatching. Gotland women wore such brooches in pairs on their tunic straps. A similarly ornamented one is in the British Museum.[3] The various decorative motifs exhibited by the general type have been illustrated by A.W. Carlsson.[4]

Because the Metropolitan Museum's extremely rich selection of metalwork of the migrating peoples of Europe—received, for the most part, with the collection of J. Pierpont Morgan in 1917—was lacking in Viking art, the acquisition of these brooches, as well as the examples subsequently acquired in 1992 (1992.59.1–3; cat. no. 65), fills an important gap in the collection.

WDW

66: A

66: B

66: C

1 See especially Hildebrand, 1892, fig. 77; Paulsen, 1933, pl. 25; Bjørn and
 Shetelig, 1940, fig. 6; Bøe, 1940, fig. 47; Evison, 1969, pp. 330–45, fig. 2.
2 See Hildebrand, 1892, figs. 66, 67.
3 See *Guide to Anglo-Saxon Antiquities*, 1923, fig. 221 g.
4 See Carlsson, 1977, p. 137.

EX COLLECTIONS: Private collection; [sale, Christie, Manson & Woods,
London, November 26, 1980, lots 38, 37, 35, respectively, ills.]; [Rainer Zietz
Limited, London].

REFERENCES: (1982.323.1,2,3) Wixom, 1983, pp. 16–17, ill.; Brown, 1995 a,
pp. 47–48, figs. 69–71; (1982.323.1) *Christie's Review*, 1981, p. 421, colorpl.

67

COLUMBARIUM TOMB PLAQUE

Spanish, 5th–8th century

Terracotta: 12¾ x 8⅞ x 2¹⁄₁₆ in. (32.4 x 22.5 x 5.2 cm)

Gift of John Crosby Brown Moore, 1985 (1985.147)

This thick clay plaque covered a niche that contained the remains of the deceased in a simple communal tomb complex called a columbarium because of the resemblance of its numerous niches to dovecotes. This type of tomb was popular in the Roman and subsequent Early Byzantine empires. There are identical Spanish examples of the plaque, with the same Latin inscription, "BRACA RIVI/VASCUM TUIS," at the sides of the columns, in Berlin, Madrid, Cleveland, and London.[1] The Chi-Rho monogram of Christ identifies the deceased as a Christian. The first Christian Roman emperor, Constantine the Great, is said to have had the symbol placed on the shields of his soldiers before the Battle of the Milvian Bridge, which established his dominance over the empire. The monogram also was seen as representative of Christ's triumph over death, and the alpha and omega included with it—the first and last letters of the Greek alphabet—were popular as Christian symbols as well, referring to Christ as the beginning and end of all things.[2] The arcades, with floral sprays above the elaborate capitals of the columns—also a part of the decoration of the canon tables, or indexes, in Gospel books of the period, such as the Rabbula Gospels[3]—may represent a generalized architectural setting, the apse of a church, or Paradise, the abode hoped for by the deceased.

HCE

1 See Wulff, 1909, no. 1063, p. 299, ill.; Schlunk, 1947, p. 235, fig. 231; unpublished correspondence with The Cleveland Museum of Art in the files of the Metropolitan's Department of Medieval Art.

2 See Schwartz and Thomas, 1994, no. 2, ill.

3 See Weitzmann, 1977, plates 34–38.

EX COLLECTION: John Crosby Brown Moore, New York, 1926–85.

EXHIBITION: "Beyond Empire: Artistic Expressions of Byzantium," Ann Arbor, Museum of Art, University of Michigan, September 17–October 30, 1994, no. 2.

REFERENCE: Schwartz and Thomas, 1994, no. 2, ill.

68: 1986.144.1

68

FIVE ARCUATED LINTELS

Northeast Italian, or Adriatic region (Langobardic School), late 8th–early 9th century

Marble: Each, approx. 23¾ x 41 x 5 in. (60.3 x 104.1 x 12.7 cm)

The Cloisters Collection, 1986 (1986.144.1–4)

Purchase, Mrs. Helen Fioratti Gift and The Cloisters Collection, 1991 (1991.98)

These five lintels of the Langobardic School are among the earliest objects in The Cloisters Collection and provide a counterpoint to the roughly contemporary Carolingian material as well as a source of the decorative tradition renascent in numerous later works. The Lombardic decorative vocabulary—which would exert a seminal influence on successive sculpture styles up to the Late Romanesque period—as seen here, displays an uncommon density and an unusual exuberance. The lintels originally were thought to have been part of a ciborium largely because reliefs of very similar design, although of a different stone and a lesser quality, were incorporated into a ciborium at San Giorgio in Valpolicella,[1] near Verona, the capital of the Langobardic dukedom. The subsequent acquisition of a fifth lintel (1991.98) nearly identical to one in the first group (1986.144.2) casts doubt on this supposition, and the possibility that they belonged to an ambo, chancel screen, or choir enclosure now seems more probable. Recent petrographic analyses have established that the marble is Thasian, a type that was used for a number of monuments in northeastern Italy and along the Dalmatian coast. The purported provenance of the fifth lintel (1991.98)—an island off the Venetian coast—suggests an Istrian origin for the group.

TBH

1 See Arslan, 1943, pp. 1–22, figs. 2–8.

EX COLLECTIONS: (1986.144.1–4) [Margaret Széchényi, Fortuna Galerie für Alte Kunst, Zurich]; (1991.98) Helen Fioratti, New York.

REFERENCES: (1986.144.1–4) Husband, 1987 b, p. 14, ills.; Brenk, 1992, pp. 63–85, figs. 1–22.

68: 1986.144.2

68: 1986.144.3

68: 1986.144.4

68: 1991.98

69

PLAQUE, WITH SAINT JOHN THE EVANGELIST

Carolingian (Aachen, Court School of Charlemagne), early 9th century
Elephant ivory: 7½ x 3⅝ in. (19.1 x 9.2 cm)
The Cloisters Collection, 1977 (1977.421)

Until 1977, when this ivory from the Carolingian "Renaissance" appeared at a London auction, it was unknown. Carved in high relief, the frontally enthroned Evangelist displays his Gospel with the opening phrase IN PRINCI/PIO ERAT/VERBVM ("In the beginning was the Word." John 1: 1). The arch, with its rich acanthus decoration, is supported by elaborate columns, and encloses John's symbol, the eagle, which is directly above him. The entire composition is framed by a simple border that includes, on the top, a partially damaged placard inscribed: MORE V̊LANS AQVILE VERBVM PETIT ASTRA [IOHAN]NI[S] ("Flying like an eagle the word of John aspires to Heaven"). The text is based on a line from the fifth-century poem "Carmen Paschale" by Sedulius.

Among the remarkable features of this ivory is John's loose, classical pallium and mantle, whose calligraphic treatment and plasticity verge on pure fantasy. This tendency toward a sumptuous, ornamental effect, in which the abundance of drapery patterns and textures takes on a life of its own, becomes a characteristic of several ivories of the Court School of Charlemagne (r. 768–814). These include the celebrated panel of *Saint Michael* (Museum des Kunsthandwerks, Leipzig), the covers of the *Lorsch Gospels* (Victoria and Albert Museum, London, and Biblioteca Apostolica Vaticana), and the panel with *The Ascension* (Hessisches Landesmuseum, Darmstadt). The present ivory is especially close to the Darmstadt *Ascension*, with respect to the physiognomic types of the figures and the similarity in the handling of the drapery.

Artistically, these ivories are very close to the manuscripts produced in Aachen for the court of Charlemagne, which suggests that they probably were carved there. However, Harbison and Pawelec have maintained that some of these ivories may date into the reign of Louis the Pious (813–40).

On a book cover in Paris (Bibliothèque Nationale de France, Cabinet des Médailles), all four of the Evangelists are shown seated and almost identical in facial type to the *Saint John* in New York. The Paris book-cover panel, which is more complete, suggests that the Cloisters' *Saint John* ivory once formed part of a group of the Four Evangelists that perhaps decorated an important manuscript. However, because of the evidence of hinges—which appear to be original—on our *Saint John* plaque, it is quite possible also that it once belonged to a triptych, with the Evangelists occupying the wings and a figure of Christ in Majesty the center. Functioning like an icon, such an ensemble would visually relate the Evangelists with Christ. This theme of unity in Christ is central to the hexameter from Sedulius's "Carmen Paschale"—the inscription that appears above the figure of John. In any case, whatever its original function, the ivory still conveys the impression of great splendor appropriate to works produced by the Court School of Charlemagne, and it remains a precious vestige of the Carolingian *renovatio*.

CTL

EX COLLECTIONS: C. Cain, London; [sale, Sotheby Parke Bernet, London, 1977, lot 23, color ill.].

EXHIBITION: "Decorative and Applied Art from Late Antiquity to Late Gothic," Moscow, State Pushkin Museum, May 10–July 10, 1990, and Leningrad, State Hermitage Museum, August 14–October 14, 1990, no. 5.

REFERENCES: Schrader, 1979, p. 22, color ill.; Harbison, 1984, pp. 455–71; Little, 1985 a, pp. 11–28, with earlier literature; Little and Husband, 1987, p. 42, colorpl. 33; Little, 1990, no. 5, p. 18, colorpl. p. 19; Pawelec, 1990, pp. 150–51, 168.

70

THE THREE MARIES AT THE HOLY SEPULCHER

North Italian (Milan ?), early 10th century
Elephant ivory: 7½ x 4¼ in. (19.1 x 10.8 cm)
Purchase, The Cloisters Collection and Lila Acheson Wallace Gift, 1993 (1993.19)

This noble ivory almost certainly once decorated the cover of a Late Carolingian liturgical manuscript, such as a Sacramentary or a Gospel book. The subject of the Three Maries at the Holy Sepulcher, one of the most compelling in Christian art, is an attempt to portray the divinity of Christ by showing that he has risen from his tomb. While the scene follows the Gospel according to Matthew (28: 1–6) and Mark (16:1–6), the story is told in highly dramatic visual terms. The guards, who, frightened by the angel, "were struck with terror, and became as dead men," are positioned above and behind the tomb, as the Three Maries, approaching with their ointment jars, recoil in surprise at the sight of the angel sitting atop the lid of a sarcophagus. In the center is the Holy Sepulcher, depicted here as a cylindrical structure with an arcaded and domed tower; an empty shroud is visible within. The focus on the episode of the angel's appearance to the Three Maries coincides with the rise in popularity, in the ninth century, of the *Visitatio Sepulchri*, which emphasized the events that took place at the tomb and, particularly, the testimony of the angel.

Pictorially, the story unfolds with a boldness that makes clear the symbolic significance of the scene. The figures, framed by an acanthus border, are rendered in high relief. The carving of the soldiers in the upper part of the panel is especially deeply undercut. The highly controlled presentation of the characters is heightened by the treatment of their tunics and mantles, which are wrapped tautly around their bodies, producing an effect of linear energy. By increasing the size of the trees toward the top, the normal spatial relationships of the landscape setting are reversed. This abstraction of certain details dominates the imagery and is the primary means of conveying the power of the subject: Throughout, ornamentation, spatial destabilization, and the rhythmic correlation of forms prevail over naturalism. Perspective is almost arbitrarily disposed in order to enhance the impact of the staging of the scene.

Few carvings from the Early Middle Ages present the Easter miracle with a comparable sculptural and visual immediacy. Breaking away from a traditional (Carolingian) formulation, which was based primarily on Early Christian models, the artist here interprets the subject in a new way: The vignettelike effect of the main

characters; the linear rhythms of the trees, which echo the silhou-ettes of the soldiers; and the vitality of the composition, which, lit-erally, seems to burst out of the traditionally confining frame, foreshadow future developments in medieval art, rather than rely-ing on the art of the past.

The Metropolitan Museum's panel may be attributed to Milan on the basis of an early-ninth-century ivory, almost certainly carved in that city and still in the Milan Cathedral Treasury, which includes a similar scene among other narrative episodes. That the ivory was made no later than the mid-tenth century is evidenced by a reduced copy of this same image on a casket of about that date in the Treasury of Quedlinburg Cathedral in Lower Saxony.

CTL

EX COLLECTIONS: Victor Martin Le Roy, Neuilly-sur-Seine; Jean-Joseph Marquet de Vasselot, Paris; [Alain Moatti, Paris].

REFERENCES: Koechlin, 1906, pp. 25–27, pl. VI, no. 9; Goldschmidt, 1914, no. 148; Little, 1993 b, pp. 24–25, colorpl. p. 24.

71

STAR-SHAPED BROOCH

Ottonian (Rhineland ?), second half of the 10th century (setting); Constantinian, 337–50 (sapphire intaglio)
Gold, with pearls and a star sapphire: Diameter, 1⅞ in. (4.8 cm)
The Cloisters Collection, 1988 (1988.15)

Jewels conceived as microarchitecture are one of the distinctive hall-marks of Ottonian goldsmiths' work. This brooch is composed of a series of arcaded gold cells, linked together to form a star, but its definite horizontal and vertical axes, in fact, make it cross shaped. Because the brooch was buried some gems are missing. Although most of the spaces between the arms of the cross still contain pearls, the arms themselves probably would have been set with amethysts. Raised above the arcaded cluster is an arcaded rotunda that sup-ports a large star-sapphire intaglio.

This sumptuous object was created specifically to preserve an exceptionally rare, Late Antique gem carved with a profile portrait. Despite a small fracture to part of the face, the portrait is still rec-ognizably close to likenesses of the sons of the emperor Constantine, Constans I (r. 337–50) and Constantius II (r. 337–61). That a slightly damaged intaglio sapphire from the Late Antique period was so highly prized by the Ottonians can be explained by the fact that they regarded themselves as the inheritors of the Christian Roman Empire established by Constantine. Therefore, such a portrait in a bejeweled cruciform setting not only evoked the concept of the renewal of the Christian Empire but also, in its position at the inter-section of the arms of a cross, placed the ruler, symbolically, under its protection. The contemporary Lothair Cross of about 1000 (in the Treasury of Aachen Cathedral), with its classical cameo portrait of the Roman emperor Augustus in the center, makes explicit the political significance of this iconography. Furthermore, the gem por-trait compares to portraits on coins of Otto III (r. 983–1002), which suggests that the predecessors of the Ottonian rulers used such gem portraits as models for their official likenesses. The original owner of this brooch might well have been a member of the imperial Ottonian family or of the court.

Other technical and stylistic characteristics of the brooch relate it to Ottonian imperial goldsmiths' work. The construction of the diaphanous swaged-wire arcades and the focus of the setting on an antique gem are features shared with the aforementioned Lothair Cross. Two star-shaped brooches found near Mainz Cathedral in 1896 (and now in the Hessisches Landesmuseum, Darmstadt) dis-play a similar type of setting, arcading, and fastening device. The date of these and other Ottonian brooches, as well as their artistic context in Germany during the Ottonian dynasty (962–1002), can be established only on the basis of technical, stylistic, and iconograph-ic relationships that connect them to more securely dated luxury objects, such as book covers.

CTL

EX COLLECTIONS: [sale, Hôtel Drouot, Paris, spring 1957]; [Édouard Stisken, Paris, spring 1957]; [Albert Salmona, Paris]; Dr. Dietrich von Kobyletzki, Gelsenkirchen, Germany; [Michael Ward, Inc., New York].

REFERENCES: Westermann-Angerhausen, 1974, pp. 1230–31, ill.; *idem*, 1975, pp. 67–71, ill.; *idem*, 1983–84, pp. 20–36, ill.; Little, 1988, pp. 14–15, color ills. p. 14; Schulze-Dörrlamm, 1991, p. 90, fig. 64; Westermann-Angerhausen, 1991 a, p. 207, fig. 14; *Reich der Salier*, 1992, no. 1, pp. 272–73, pl. 274.

72

Master Engelram and His Son Redolfo
PLAQUE, WITH SCENES FROM THE LIFE OF SAINT AEMILIAN

Spanish, 1060–80
Elephant ivory, with glass inlay: 6⅝ x 3 in. (16.8 x 7.6 cm)
Provenance: Shrine of Saint Aemilian, Monastery of San Millán de la Cogolla (Logroño), Spain.
The Cloisters Collection, 1987 (1987.89)

This panel, from the gold, ivory, and gem-encrusted reliquary shrine of Saint Aemilian, represents one of the exceptionally rare instances in which precise documentation exists for the creation of a work of art from the Middle Ages. The lavish house-shaped shrine was made to contain the remains of the celebrated hermit-shepherd Saint Aemilian, to whom a number of miracles are attributed, and who died a centenarian in 574 in Rioja. The construction of a new reli-quary was occasioned by the translation of the saint's relics from

Suso to the monastery church of San Millán de la Cogolla, newly completed and dedicated in 1067. The elaborate shrine incorporated a number of donor portraits, including those of monarchs and abbots, which suggests that the execution of such an ambitious project took considerable time to complete. Depicted on the shrine were King Ramiro I of Aragon (d. 1063) and his abbot, Petrus, who ruled from 1061 to 1070, and King Sancho IV of Navarre (r. 1054–76), his wife, Queen Placentia, and his abbot, Blasius, who ruled from 1070 to 1080.

The shrine was severely damaged in the course of the Napoleonic invasion of Spain in 1809, when it was stripped of its precious materials and many of its ivory plaques were dispersed. Some of the ivories have since surfaced in public collections in Washington, Boston, Berlin, Florence, and Saint Petersburg; those remaining in San Millán were remounted on a new casket made in 1944. However, the original appearance of the shrine is known from a detailed description made in 1601 by Prudencio de Sandoval. The artistic accomplishment of the work was commemorated by two panels, one of which (in Berlin) depicts a procession of four figures carrying the elephant tusk used for the carvings, and the other (in the State Hermitage Museum, Saint Petersburg) the ivory carver in his workshop sculpting the panels, aided by an assistant; the latter is inscribed ENGELRA[M] MAGIS/TRO ET RE/DOLFO FILIO ("Master Engelram and his son Redolfo"). It is this celebration of an artist's creation that makes the shrine a unique document in the history of medieval ivory carving.

The present panel, which illustrates two events in the early life of the saint, was—according to the seventeenth-century description—mounted at the beginning of the pictorial cycle, on the roof of the shrine. In the lower register, the shepherd Aemilian sits on a rock tending his sheep, which nibble on a nearby tree. Wearing a knee-length tunic and a mantle, and with a kithara suspended over his shoulder, he grips a staff with his left hand and blows on a horn that he holds with his right hand. Above him, on the arch, which is supported by twisted columns, is an engraved inscription: FUTU RUS PASTOR HOMIN[U]M ERAT P[A]ST[O]R OUI UM ("The future shepherd of men was the keeper of sheep"). In the top register, Aemilian energetically climbs a mountain to receive a benediction from the hand of God. Again, the identity of the scene is made clear by an inscription on the arch above: UBI[A]EREMUM EXPETIT MONTIS DIRCEC II [DISTERTII] ("Where he sought [or attained] the wilderness of Mount Dircetius").

These scenes and the others on the shrine, which, essentially, are pictorializations of the saint's life, are based on the seventh-century *Vita S. Aemiliani Confessori* by Saint Braulio, Bishop of Saragossa; this is confirmed by the inscriptions on the plaque, which paraphrase the biography. The Saint Aemilian cycle, therefore, is extremely unusual, as it represents the direct translation of a medieval literary account into a visual narration without relying on existing illustrations of episodes in the saint's life.

The pastoral scenes on the Cloisters' ivory are conveyed with immediacy and charm. The entire surface seems to teem with life because of the combined density of design and the engraved details achieved by means of the extensive use of the drill. This decorative effect probably reflects the influence of Andalusian art, in which dramatic movement and expression take precedence over anatomical accuracy or naturalism. The San Millán carvings are typical of the work produced in the second most important center of ivory

carving in Romanesque Spain after León. Indeed, the surface lyricism of the present plaque anticipates the León ivories of the early twelfth century, as represented by the Metropolitan Museum's celebrated ivory of Christ Appearing to Mary and The Way to Emmaus (17.190.47).

CTL

EX COLLECTIONS: Jules Lowengard Collection, Paris; Duvale Collection, Paris; Heugel Collection, Paris; [Cyril Humphris, Geneva].

REFERENCES: Sandoval, 1601, pp. 24 ff.; Little, 1987 b, p. 15, color ill.; Harris, 1989, pp. 40–46; *idem*, 1991, pp. 69–81; *idem*, 1993, no. 125 c, pp. 262–63, color ill. p. 262.

73

ROUNDEL, WITH AN ELDER OF THE APOCALYPSE

South French (Conques), beginning of the 12th century
Copper gilt, with champlevé and cloisonné enamel: Diameter, 3¹⁄₁₆ in. (7.8 cm)
Gift of Mr. and Mrs. Ronald S. Lauder, 1983 (1983.38)

The seated Elder, with his remarkable white hair and beard, is shown within a mandorla, holding a scepter and a stringed instrument. In his pose and in the stylistic rendering of the details, the figure is comparable to several of the Elders of the Apocalypse in the circular representation of the *Adoration of the Lamb* (Apocalypse 7:9–11) in the Beatus manuscript of Saint-Sever, executed in Spain or in western France about 1130, as well as to the monumental figures on the tympanum at Moissac. In appearance and technique, the roundel is very similar to a plaque representing a female saint, which also once belonged to the Parisian collector Victor Gay, and to a series of enamels that have been attributed to Conques, where several such enamels survive on a portable altar. At this monastery in south central France, the abbot Bégon III (r. 1087–1107) "encased

numerous relics in gold."[1] Our roundel similarly may have been conceived as a decorative element on a portable altar.

BDB

1 See Desjardins, 1879, p. xliv.

EX COLLECTIONS: Victor Gay, Paris, by 1908; [sale, Hôtel Drouot, Paris, March 23–26, 1909, lot 48]; Alphonse Kann (?), Paris, after 1909; Mr. and Mrs. John Hunt, Drumlech Bailey, County Dublin, Ireland, 1959; Mr. and Mrs. Ronald S. Lauder, New York.

EXHIBITIONS: "Romanesque Art, c. 1050–1200, from Collections in Great Britain and Eire," Manchester, England, City of Manchester Art Gallery, September 22–November 1, 1959, no. 93; "Enamels of Limoges, 1100–1350," Paris, Musée du Louvre, October 23, 1995–January 22, 1996, and New York, The Metropolitan Museum of Art, March 5–June 16, 1996, no. 4.

REFERENCES: *Romanesque Art*, 1959, no. 93; Brown, 1983, p. 17, ill.; Gauthier, 1987, no. 24, p. 54, ill. 71, pl. x; Taburet-Delahaye, 1996, no. 4, p. 74, color ill.

74

CHRIST ON THE CROSS

Austrian (Tirol or Salzburg ?), second quarter of the 12th century
Linden wood (corpus) and fir (cross), with traces of polychromy: corpus, 20⅞ x 17½ in. (53 x 114.5 cm); cross (height before restoration), 29¼ in. (74.3 cm)
Provenance: Found at Olang, near Bruneck, Austria.
The Cloisters Collection, 1984 (1984.129)

The symmetrically positioned corpus, which represents the triumphant rather than the dead or suffering Redeemer on the cross, seems almost to be standing before the cross, on a suppedaneum. The figure is fastened to the cross by means of four nails. His arms are extended horizontally, his head is slightly turned, and his eyes are open. Christ's beard and moustache are simply defined, and his hair, which falls behind his ears onto the shoulders, is tooled only near the forehead, which suggests that the figure originally was crowned. He wears a symmetrical, centrally knotted *perizonium*, with lappets on each side. The figure's sturdy proportions convey a physical strength and a restraint that are exceptional for Romanesque corpora. The firmly modeled torso and the overall alertness of the face especially emphasize Christ's victory over death on the cross.

The corpus is constructed of two pieces of linden wood, with the arms actually one continuous section channeled into the torso. The hands have been replaced, perhaps because they, like the suppedaneum and one of the arms of the cross, were scorched by candles. Careful examination of the polychromy of the figure and the cross has revealed evidence of up to six layers of later paint and gesso on the corpus, which have since been removed. Now, all that remain are small traces of the original red polychromy on the loincloth and on the back of the figure.

The cross, which was painted with alternating bands of azurite blue and vermilion on the arms and the shaft, retains more of its color than does the corpus. This alternating color system is characteristic of several early German crosses, such as the late-eleventh-century crucifix in Worms Cathedral.[1] The back of the cross bears the same design, only painted in gray and black. The size of the cross was altered when the top and the right arm were cut down and the

bottom stepped, at a later date, to fit into a base, but, recently, these areas were restored to approximate the original proportions.

The crucifix allegedly comes from the village of Olang near Bruneck, Austria, in the South Tirol. Another closely related corpus, similar in size, physiognomy, and in the stylization of the anatomy and the *perizonium*, is in Sand, in the South Tirol, near Taufers, in the vicinity of Sterzing (Vipiteno). However, a study of the forms of these figures indicates that they have limited connections with the sculpture of this region, which normally demonstrates stronger affinities with wood carving in northern Italy—as, for example, with a torso in the Museo Diocesano in Bressanone.[2] It is more likely that these crucifixes, given their small size and portability, were made elsewhere, and only subsequently were brought to the South Tirol. In many respects, the cubically reduced forms and the economic organization of the linear and planar elements of the anatomical and facial structure of these corpora are characteristic of Ottonian crucifixes. In the twelfth century, these Ottonian types persisted in a number of variants, and the present corpus seems to reflect a conscious effort to imitate the form and meaning of these earlier images.

One of the closest parallels to the Cloisters' corpus—which also is the first Romanesque sculpture of Germanic origin to have entered the Metropolitan Museum's collection—is a larger and perhaps slightly later example in the Abbey Church of Nonnberg, in Salzburg.[3] Although that work is more elongated, the torso and the planar construction of the *perizonium* bear striking similarities to those of our corpus, which suggests that both are products of the Salzburg region. The abstraction of the forms evident in each figure intentionally preserves features of older models, thereby incorporating a large sphere of influences within this classic type of Romanesque image of the Crucifixion.

CTL

1 See Hürkey, 1983, p. 240, fig. 309 a.
2 See Semff, 1980, pp. 339–46, figs. 1–3.
3 Ibid., p. 339, fig. 4.

EX COLLECTIONS: Innsbrucker Kunstgewerbemuseum, 1884; Tiroler Landesmuseum Ferdinandeum, Innsbruck; Dr. Peter Hierzenberger, Vienna; [sale, Sotheby Parke Bernet, London, April 3, 1984, lot 30, color ill.].

REFERENCES: Little, 1985 c, pp. 10–11, ill. p. 10; *idem*, 1987 a, pp. 167–68; Little and Husband, 1987, p. 66, colorpl. 58.

75

ARCHITECTURAL FRIEZE

French (Burgundy, Cluny), second quarter of the 12th century
Limestone: 11½ x 22 x 8¾ in. (29.2 x 55.9 x 22.2 cm)
The Cloisters Collection, 1980 (1980.263.1)

On the principal face of this double-sided horizontal frieze is a series of four raised, beaded arches, surmounted by a dense cityscape. The arches frame large rosettes surrounded by drilled, beaded borders, and the spandrels of each arch terminate in suspended foliate and beaded tongues. The miniature buildings above the arcade include apsidal chapels, towers, and arcaded structures, all with tile roofs and walls of coursed masonry clearly indicated. On the reverse side is a simplified frieze of coupled rosettes over a horizontal molding.

The architectural function of this frieze cannot be established decisively. The existence of other double-sided carvings of arcades of similar dimension, design, and technique, dispersed in various collections, suggests that, together, they comprised a long, continuous frieze, intended to be seen from both sides. A small fragment in the Busch-Reisinger Museum in Cambridge, Massachusetts,[1] and two complete and impressive sections in the Glencairn Museum in Bryn Athyn, Pennsylvania,[2] all originally formed part of the same decorative system. It has been proposed that the present example belonged to the gallery of a house in Cluny.[3] Another frieze in the Musée Ochier in Cluny, which presents a series of figures, rosettes, or animals inscribed within small arcades, is, indeed, known to have come from one of the Romanesque houses in Cluny.[4] However, the arcades that exist on the houses are of a much larger scale and simplified design, and none displays miniature architectural panoramas. The Musée Ochier frieze may have been recycled from another context, perhaps from the Abbey of Cluny (Cluny III) itself, which was the largest and most ambitious building enterprise in medieval Europe. Recent analysis of the limestone by means of neutron activation has demonstrated a close correspondence of trace elements among samples taken from these friezes, the spandrel segment, other sculptural elements from Cluny III, and the window frame from a Gothic house in Cluny.[5] Therefore, it is equally possible that the Cloisters' frieze is from one of the monastic buildings of Cluny III, the schematic representation of architectural vignettes having been intended to approximate a panorama of Cluny III. A date in the second quarter of the twelfth century is likely on the basis of the similar conception of the visionary cityscape of the Gates of Heaven on the Last Judgment portal at Autun Cathedral, where the same technique of carving details may be observed.

CTL

1 See Cahn and Seidel, 1979, no. 3, pp. 143–44, fig. 135.
2 Marburg Photo Archive, LA 107/13; for a detail illustration see Williamson, 1982, p. 472, fig. 92.
3 See Gómez-Moreno, 1968, no. 29, ill.
4 For example, the house at 15, rue d'Avril, illustrated in Halbach, 1984, pl. 6.
5 See Holmes, Little, and Sayre, 1986, pp. 434–37.

EX COLLECTION: The Raymond Pitcairn Collection, Bryn Athyn, Pennsylvania.

EXHIBITIONS: "Medieval Art from Private Collections," New York, The Cloisters/The Metropolitan Museum of Art, October 30, 1968–January 5, 1969, no. 29; "Radiance and Reflection: Medieval Art from the Raymond Pitcairn Collection," New York, The Cloisters/The Metropolitan Museum of Art, February 25–September 15, 1982, no. 20.

REFERENCES: Gómez-Moreno, 1968, no. 29, ill.; Cahn and Seidel, 1979, p. 143; Wixom, 1981, pp. 20–21, ill.; Hayward et al., 1982, no. 20, pp. 78–79, ill.; Holmes, Little, and Sayre, 1986, pp. 419–38; Little, 1987 a, pp. 162–63.

76

CENSER COVER

Mosan, mid-12th century

Cast, engraved, chased, punched, and gilded copper alloy:
Height, 4⅛ in. (10.5 cm); diameter (at base), 4⅛ in. (10.5 cm)

Signed: GODEFRIDVS FECIT TVRIBVLVM

The Cloisters Collection, 1979 (1979.285)

This cover served as the top—and more important half—of a censer, the container for smoking incense used during church services. The many apertures allowed the incense to escape as the censer was swung to and fro. Four loops riveted to the lower rim, two of them old replacements, guided the chains that were fastened to the lower half of the vessel. The small loop at the top, cast as one piece with the rest of the lid, was once connected to a chain, which, when pulled, lifted the cover off the bottom part. Despite wear from use and the corrosion of a portion of the surface probably due to a long burial, the original gilding is fairly well preserved.

The architectural form, subjects represented, inscriptions, and signature set this censer cover apart from the numerous preserved but less complex examples. Four unidentified human heads, possibly symbolizing the four winds or cardinal directions, top the conical roof of a central octagonal windowed tower. The tower is supported by a small centralized building, cross shaped in plan, whose pedimented end walls are pierced by sets of three windows and whose imbricated roofs are guarded by apotropaic basilisks. Four round towers with scalloped roofs punctuate the exterior corners of the structure. This ensemble is supported by four relatively large arcs, which spring from the lower rim. One of these arcs contains the rare signature of the donor or maker of the censer, who may have been the very same person.

The figural subjects rendered in openwork within the arcs are from the Old Testament, as identified by the series of inscriptions that appear beneath them:

Scene 1. ABEL OFFERT AGNV[M]
("Abel offers a lamb." Genesis 4:4).

Above, on the arch:

GODEFRIDVS FECIT TVRIBVLVM
("Godefridus has made the turibulum [censer]").

Scene 2. IOSVE [ET] CALEP FER[VN]T BOTR[VM]
("Joshua and Caleb carry the grapes." Numbers 13:24).

Scene 3. [MO]YSES EXALTAT SERPENTE[M]
("Moses exalts the serpent." Numbers 21:9).

Scene 4. MELCHISEDEC PANEM/

Above, on the arch:

ET VINVM
("Melchizedek [brings forth] the bread and wine."
Genesis 14:18; Epistles to Hebrews 7:1–4).

These four subjects, whose selection and combination are especially characteristic of mid-twelfth-century Mosan art (the Meuse Valley in present-day Belgium), represent typological prefigurations of the sacrifice of Christ on the cross. These references, rarely found in medieval works preserved in American collections, are focused and intensified by the churchlike cruciform structure of the censer. When used during the Mass, it proclaimed the celebration of the Eucharist as a sacrament of the Church.

The censer's detailed architectural elements closely correspond to the intricate description by the twelfth-century author-craftsman Theophilus,[1] which suggests some of the subtle meanings associated with such works. A related but more decorative architectural censer, signed by a certain Gozbert, is in the Cathedral Treasury at Trier.[2] This object, which symbolizes the Temple of Solomon and includes a series of Old Testament figures and inscribed sacrifice scenes, has been dated to the early twelfth century. Another twelfth-century example of this elaborate architectural type, in the British Museum, is embellished with the symbols of the Four Evangelists as well as angels and lions.[3] However, the style of the figures on the Cloisters' censer cover is closest to that of the angel with the three worthies in the fiery furnace (Daniel 3:92) perched on top of a possibly contemporary censer preserved in Lille—a Mosan work of about 1160–65 signed Reinerus.[4] The name Godefridus, which appears in the signature on the lid of the present censer, was not unique in the Romanesque period. It is presumably this name, but not necessarily the same person, that is indicated by *G* in a frequently cited letter of 1148 from Wibald, Abbot of Stavelot (r. 1130–58), requesting delivery of unspecified yet overdue goldsmiths' works.[5] The association of our censer with those commissioned by Wibald remains a tantalizing conjecture.

In its totality, the Cloisters' censer cover is particularly remarkable for its subtle internal balance of content and structure, while, at the same time, it represents a microcosm of medieval thought and exegesis. Also, the centralized-cross-plan church may symbolize the Holy Sepulcher or Sion, the City of God or the Heavenly Jerusalem, as in the case of the Byzantine cross base (1993.165; cat. no. 100).

WDW

1 See Theophilus, 1963, pp. 135–36.
2 See Braun, 1932, p. 613, pl. 131, fig. 523; von Euw, 1972–73, vol. 1, no. H 1, p. 264, ill. (with bibliography); Gousset, 1982, pp. 81–83, ill. p. 82; Westermann-Angerhausen, 1991 b, pp. 201–8, figs. 8–14.
3 See Tonnochy, 1933, pp. 1–16, pl. 1.

4 See Braun, 1932, p. 616, pl. 127, fig. 505.

5 For a recent discussion of the implications of Wibald's letter see Lasko, 1994, p. 194.

REFERENCES: *Aliénor d'Aquitaine*, 1976, pp. 43–45, pl. 22; Wixom, 1980, p. 21, ill.; Gousset, 1982, pp. 86–88, ill. p. 87.

77

FRAGMENT OF A STAINED-GLASS BORDER

French (Saint-Denis), about 1144

Pot-metal glass and vitreous paint: 12¼ x 5¼ in. (31.1 x 13.3 cm)

Provenance: Saint Benedict window, former Abbey Church of Saint-Denis.

The Cloisters Collection, 1980 (1980.10)

Incorporated at an unknown date into a composite panel of varying fifteenth- and seventeenth-century elements, this fragment of a window border is one of several such survivors from the successive campaigns of destruction and restoration endured by the former Abbey Church of Saint-Denis after the French Revolution. A drawing by Charles Percier made in 1794/95 (Bibliothèque Municipale, Compiègne) and tracings by Just Lisch from about 1850 (Monuments Historiques, Paris) associate this border pattern with the former abbey church and, specifically, with the Saint Benedict window. (A chapel dedicated to the saint was located in the crypt.)

Two of the border's interlocking foliate patterns are partially visible in this fragment. Flanked by green glass, this repeated pattern is composed of white, heart-shaped vines sprouting leaves that enclose a blue ground and a "bouquet" of alternating murrey and yellow palmette fronds, which curl to reveal veined and pearled undersides. Other border elements from this series are now in The Glencairn Museum in Bryn Athyn, Pennsylvania, and in Paris in the Musée National du Moyen Âge, Thermes de Cluny, and in a private collection.

MBS

EXHIBITIONS: "Stained Glass from The Cloisters," supplement to "Viollet-le-Duc: Architect, Artist, Master of Historic Preservation," New York, The Grey Art Gallery and Study Center, January 19–February 27, 1988; "Recent Acquisitions of the Department of Medieval Art and The Cloisters," New York, The Metropolitan Museum of Art, June–December 1981.

REFERENCES: Martin and Cahier, 1841–44, vol. 2, pl. L 13 (reproduces border design); *MMA Annual Report*, 1980, p. 41; Hayward, 1981 a, p. 90; *idem*, 1985, p. 93, ill.

78

ENGAGED CAPITAL, WITH ACANTHUS-LEAF DECORATION

French (Île-de-France), Royal Abbey of Saint-Denis(?), mid-12th century

Limestone, with traces of polychromy: Height, 18¾ in. (47.6 cm); length, 32 in. (81.3 cm); depth, 15½ in. (39.4 cm)

The Cloisters Collection, 1983 (1983.226)

Three faces of this massive rectangular capital from a pillar are decorated with a repeating organic frieze of acanthus leaves. Each of the deeply undercut plants, which spring from a simple base molding, symmetrically frames a central flower bed. This type of embellishment for capitals emerged in the Île-de-France in the first generation of Gothic architecture. The same naturalistic development of the acanthus-leaf motif is especially evident on the capitals in the choir, crypt, and west end of the Royal Abbey of Saint-Denis, consecrated in 1144. Although a Saint-Denis provenance for this engaged capital cannot be documented, a similar capital in the Metropolitan Museum's collection (13.152.1) is said to have come from the abbey. Both of these capitals are part of a larger group of related objects that includes two more capitals, now in the Glencairn Museum in Bryn Athyn, Pennsylvania. It was suggested by the late Sumner McKnight Crosby that the capitals might have been intended to be used in Abbot Suger's reconstruction of the old Carolingian nave and transept of the abbey, which was not actually replaced

until the thirteenth century. Blocks of similar size and decoration now *in situ* in the ambulatory of the crypt demonstrate how the capitals originally might have functioned.

The translation of natural forms into art, with a crispness, plasticity, and vitality, as seen here, admirably pinpoints the essential qualities of the initial phase of Gothic architectural ornamentation. Indeed, this type of richly textured naturalistic decoration had an enduring influence on the vocabulary of sculptural embellishment well into the thirteenth century.

CTL

EX COLLECTIONS: Lucien Demotte, New York and Paris; The Raymond Pitcairn Collection, Bryn Athyn, Pennsylvania; The Academy of the New Church, Bryn Athyn, Pennsylvania; [sale, Sotheby Parke Bernet, New York, June 10–11, 1983, lot 11, ill.].

EXHIBITION: "The Royal Abbey of Saint-Denis in the Time of Abbot Suger (1122–1151)," New York, The Cloisters/The Metropolitan Museum of Art, March 31–May 31, 1981, no. 8 A.

REFERENCES: Cahn, 1977, no. 12, p. 74, fig. 12 a; Little, 1981 c, no. 8 A, p. 55, ill. p. 56; *idem*, 1984 b, p. 9, ill.

79

TABLEMAN

German (Cologne), about 1150

Walrus ivory: Diameter, 2⅞ in. (7.3 cm)

The Cloisters Collection, 1988 (1988.158)

Tablemen for board games are rare surviving examples of the non-ecclesiastical art of Romanesque Europe. The principal ivory-carving center, where the most game pieces were produced, was the city of Cologne. Scenes of the legendary feats of Samson and Hercules were favorite subjects.

Here, the figures are set within a deep space. The composition illustrates an episode from the Book of Judges (16: 26): A boy guides

Samson, who has been blinded by the Philistines, to the pillars of the Philistine temple. The fact that Samson is clutching a branch may have been intended as a reference to an event, not recorded in Judges, in which Samson uprooted a tree to prove that his strength had been regenerated. The same scene is also depicted on a relief, of about 1130, in the cathedral of Pécs in Hungary.

This game piece was part of a set for the board game known as "tables," a medieval form of backgammon that required thirty tablemen. Thus, the blind Samson led by a boy would have been one of fifteen tablemen, with scenes from Samson's life played against an equal number representing the physical exploits of Hercules.

CTL

EX COLLECTIONS: [sale, Phillips, London, November 17, 1987, lot 170]; [Michael Ward, Inc., New York].

REFERENCE: Little, 1989 b, p. 15, ill.

80

MONK-SCRIBE ASTRIDE A WYVERN

North German (Magdeburg), mid-12th century
Cast and chiseled leaded brass: 9⅜ x 7½ x 3⅝ in. (23.8 x 19.1 x 9.2 cm)
The Jack and Belle Linsky Collection, 1982 (1982.60.396)

A young, beardless monk, tonsured and wearing a hooded habit, is seated backward on a wyvern. With head slightly bowed, the monk is intent on what he is inscribing with the pen in his right hand. A correcting knife, or scraper, is poised in his left hand. His habit, decorated with widely spaced punch marks and engraved crosshatched borders, is shortened because the figure sits astride rather than sidesaddle. The monk's face is long and oval. Wide-open eyes protrude beneath broad, curved brows and above high cheekbones. The prominent nose continues in a straight line the profile of the sloping brow. His full-lipped yet small, somewhat puckered mouth projects from the shallow hollow between the nose and chin. The jaw and neck are firmly curved. A fringe of hair forms a band around his head. In contrast to the textured imbrications of the wyvern's wings, the monk's lower legs and feet are bare and smooth; his left leg is bent sharply, accentuating the point of the knee, whereas the right leg is less flexed, so the foot is parallel to the wyvern's body.

The wyvern is truly Romanesque, with richly feathered wings, crosshatched shoulders, furry legs, and vegetal extensions. Its tail, resting on a footlike support, is, in fact, a nubby stem beneath the lectern on which the monk writes. The head and neck of the wyvern curl upward in an S curve and, with the crest, form a back support for the monk. The wyvern's head, almost serpentlike, is alert, the pointed ears raised, and the long, nearly smiling mouth firmly closed. Contrasting textures and patterns of points and engraved lines are effectively used throughout the work.

Examination of the wyvern's feet reveals their method of attachment to a larger ensemble, now missing. Placed at an angle, the front left foot is drilled horizontally, whereas the third foot is drilled vertically. Hints of the original lugs beneath the front feet, as well as underneath the lower edge of the chest, suggest, as does the pose of the monk, that the Linsky group was designed to be mounted on a diagonal, the wyvern's chest facing downward and the monk's back erect, his knees hugging the wyvern as those of a jockey would a rearing horse. The support could have consisted of a much larger work, assembled from multiple castings that were bolted together. Carmen Gómez-Moreno, without correcting the angle, plausibly suggested that the group could have come from a large Romanesque candlestick or lectern. Ursula Mende has proposed an alternative function: With all three feet of the wyvern on a common horizontal plane, the beast's head would face upward vertically and could have helped to support a stem and pan for a smaller candlestick comparable to those wyvern or dragon candlesticks on which human figures, when they appear, are proportionately smaller.[1] However, no broken vine stems necessary for such a scheme remain. Furthermore, the snout, holes for nostrils, and closed jaws of the wyvern show no evidence of tampering. These facts, together with the holes in the feet and the remnants of lugs on the underside of the wyvern, appear to confirm that this work is a fragment of a much larger one.

Many elements of this engaging object, which at first appears unusual, occur in other related works. The pose and activity of the monk seem to be heir to those smaller Evangelist-scribes riding fantastic creatures—and in one instance a wyvern—on several Lower Saxon cross bases of the eleventh and twelfth centuries.[2] Certain details have parallels in Mosan and Rhenish copper-alloy castings from the middle of the twelfth century. The writing implements held by the monk are grasped from above with the first two fingers, a detail seen on the Stavelot portable altar as well as on the foot of the cross from the Abbey of Saint-Bertin in Saint-Omer.[3] The Metropolitan's monk writes directly on the lectern without any indication of a book or scroll, as is also the case with the Stavelot portable altar. The only other such hooded and tonsured monk known is paired with a bishop on either end of the large cross base in the Victoria and Albert Museum, London.[4] Because the two churchmen do not straddle the support beneath them as does our monk, their garments fall easily to their ankles. The third foot of the present wyvern has parallels on candlesticks in Maihingen and Stuttgart,[5] and the angular profile of its chest is echoed by other examples in Florence, Frankfurt, Innsbruck, and Boston.[6]

At the time of acquisition, the figure style of our monk had not been convincingly localized, even though Gómez-Moreno stated that Erich Meyer, who had intended to publish this work, "believed it to have come from Lorraine." Because she regarded the extant works from that region as more elaborate and refined, Gómez-Moreno proposed a north German/Lower Saxon locale as the source of the object's style. Mende has gone beyond confirming this attribution by closely relating this work to the large doors of Novgorod Cathedral, which were made in a Magdeburg workshop in the mid-twelfth century (1152–56).[7] In further support of this attribution are the additional similarities in the physiognomies;[8] in the hatching, and in the points and dots in the decoration on the draperies;[9] in

the linear patterns of the wings;[10] and in the expression and shape of certain animals' heads.[11]

The Linsky group underwent extensive laboratory examination at the time of its acquisition. Several interesting observations appear in the report of July 29, 1983, by Richard E. Stone of the Metropolitan Museum's Department of Objects Conservation. The thick casting is hollowed out from below, obviating the need for the core holders usually found in medieval aquamaniles. The first thermoluminescence dating revealed that the core was "last fired between 180 and 300 years ago, 250 most probably." However, an accidental or intentional reheating may have occurred between 1683 and 1803, with the most likely date about 1733, well before the medieval revivals of the nineteenth century. A second thermoluminescence reading indicated that the core was last fired between 1450 and 1650. Microbeam probe confirmed that the metal was "leaded brass, approximately 15 percent zinc, 5 percent lead, the balance being copper." There are no repaired breaks. The work was cleaned with sulfuric acid at some undetermined date. The subsequent surface has a natural brown patina from copper oxides.

The Metropolitan Museum of Art has an extremely rich collection of medieval objects of cast copper alloys—especially aquamaniles—but the acquisition of the Linsky monk-scribe adds a previously unrepresented type and style of work to the Museum's holdings. Since this object probably belonged to a larger work—possibly a base for a monumental candlestick—it may provide an important insight into the nature of monumental church furnishings of the Romanesque period.

w d w

1 See Mende, 1992, pp. 99–100, figs. 1, 4–5; von Falke and Meyer, 1935, nos. 199–220, figs. 165–186.
2 See Springer, 1981, no. 3, figs. K22–23, K30–33, no. 17, figs. K143–144, K149–155, no. 36, figs. K277–279.
3 See Kötzsche, 1972–73, vol. 1, no. G 13, p. 252, colorpl. facing p. 261, no. G 17, p. 254, ill. p. 255, respectively; Springer, 1981, no. 47, figs. K348–351, K356–359.
4 See Springer, 1981, no. 25, figs. K197–200, K202.
5 See von Falke and Meyer, 1935, no. 204, fig. 170, no. 215, fig. 181.
6 Ibid., no. 200, fig. 166, no. 201, fig. 167, no. 221, fig. 187, no. 222, fig. 188.
7 See Mende, 1992, p. 103, figs. 3, 7.
8 See Mende, 1983, plates 103, 115, 118.
9 Ibid., pl. 119.
10 Ibid., pl. 115.
11 Ibid., pl. 117.

EX COLLECTIONS: Mr. and Mrs. John Hunt, Drumlech Bailey, County Dublin, Ireland; Jack and Belle Linsky, New York.

EXHIBITION: "Medieval Art from Private Collections," New York, The Cloisters/The Metropolitan Museum of Art, October 30, 1968–January 5, 1969, no. 93.

REFERENCES: Gómez-Moreno, 1968, no. 93, ill.; Wixom, 1984 a, no. 49, pp. 130–31, ills.; *idem*, 1984 b, pp. 10–11, ill.; Mende, 1992, pp. 98–104, 111–12, figs. 1–4.

81

CORPUS FROM A CROSS

Mosan-Rhenish, third quarter of the 12th century
Cast, engraved, and stippled copper alloy, with traces of gilding, 6½ x 6³⁄₁₆ x 1½ in. (16.5 x 15.7 x 3.8 cm)
The Jack and Belle Linsky Collection, 1982 (1982.60.395)

In this representation of the dead Christ, the outstretched hands, arms spread in a wide curve, incisions and planes indicating the ribs and chest muscles, convex curves of the abdomen, smoothly tapered legs, and splayed position of the feet resting on a wedge-shaped support (the suppedaneum) are all formulated so as to accentuate the frontality and symmetry of the figure. Tension is created by two asymmetrical elements, both on the figure's right side: the bowed head and the loincloth (or *perizonium*) pulled in tight folds across the body to a projecting knot. The angular cone of excess cloth suspended from the knot intensifies the sense of countertension. Subtle textural contrasts enrich the work, as, for example, between the smooth flesh areas and the fine-punched pattern of the loincloth.

Rounded and blocky at the same time, the head is further characterized by a broad nose; closed, swollen eyes; a short, incised beard; and long hair, the twisted and curvilinear strands of which form a ridge over the forehead and fall in three pointed locks over the shoulders. The figure, hollowed out at the back, was once attached to a wooden or metal cross by means of small spikes through the holes in the palms and through the loop below the suppedaneum.

The late Peter Bloch pointed out that this corpus is one of at least twenty-eight examples ultimately derived stylistically from a type created by Reiner of Huy in the early twelfth century in the Meuse Valley (present-day Belgium). A corpus by Reiner of Huy, from about 1110–20, is in the Schnütgen-Museum, Cologne.[1] Reiner is best known for the impressive bronze baptismal font of 1107–8

preserved in Liège.[2] The figures in both works are remarkable for their subtle yet firm modeling and for their underlying classicism. The rounded folds of drapery tend to emphasize the figural masses that they cover. Undulating rolls of hair frame the faces.

This fluid, organic style is modified, even codified, in such crucifix figures created after the middle of the twelfth century as the Linsky corpus, or such smaller, related examples as those in the Kestner-Museum, Hannover, and The Cleveland Museum of Art.[3] Changes include the taut displacement of the folds of the loincloths and the more planar and linear simplifications of the torsos, hair, and facial features. The character of the heads reflects more monumental works. For example, the proportions of the head of the Linsky corpus and its schematic features—the broad, aquiline nose, bulging eye sockets, and wide mouth—are also characteristic of the larger Mosan *Head Reliquary of Pope Alexander* of 1145 (now in the Musées Royaux d'Art et d'Histoire, Brussels), originally from Abbot Wibald's Abbey of Stavelot.[4]

A precise localization of crucifix figures such as the Linsky example remains elusive. While the source of the style and figure type is demonstrably Mosan, and ultimately that of Reiner of Huy, the emanation of the type into the Rhineland and northern Germany precludes a more exact geographic attribution for this fine Romanesque corpus.

W D W

1 Bloch, 1972–73, vol. 2, no. 1, p. 256, ill. p. 252.
2 Kötzsche, 1972–73, vol. 1, no. G 1, pp. 238–39, ill.
3 See Wixom, 1972, pp. 86–89, figs. 5–6, 1–4, respectively.
4 See Kötzsche, 1972–73, vol. 1, no. G 11, p. 250, ill.

EX COLLECTIONS: [Leopold Seligmann, Cologne]; Jack and Belle Linsky, New York.

EXHIBITION: "Medieval Art from Private Collections," New York, The Cloisters/The Metropolitan Museum of Art, October 30, 1968–January 5, 1969, no. 92.

REFERENCES: Lüthgen, 1920, pp. 27, 110, pl. 2, called "Rhenish or Saxon"; *idem*, 1921, p. 75, pl. 17, identified as "Rhenish"; Clemen, von Falke, and Swarzenski, 1930, no. 115, pl. 30, called "Mosan"; Gómez-Moreno, 1968, no. 92, ill., described and discussed as "Northwest German or Mosan, second half of the XII century"; Bloch, 1972–73, vol. 2, no. 14, pp. 254, 255, 260, identified as "Rhein-Maas-Gebiet, 2. H. 12. Jh."; Wixom, 1984 a, no. 48, pp. 128–29, ill. p. 129; *idem*, 1984 b, pp. 11–12, ill.

82

FOUR CENSING ANGELS

French (Champagne), about 1170–80
Pot-metal glass and vitreous paint: 18½ x 17⅜ in. (47 x 44.1 cm)
Provenance: Collegiate Church of Saint-Étienne, Troyes.
Gift of Ella Brummer, in memory of her husband, Ernest Brummer, 1977 (1977.346.1)

The stained glass produced for the Collegiate Church of Saint-Étienne in Troyes during the late twelfth century represents a major transition from the Romanesque to the Gothic style. None of the panels from what was once an ambitious cycle of scenes that ranged in theme from the public life and Passion of Christ and the Dormition of the Virgin to the life of Saint Nicholas of Myra remains in its original setting, since the church was destroyed in the wake of the French Revolution. The glass is now scattered in public and private collections in Europe and America.

Our panel of censing angels conforms to a window design of connected semicircles, whose overall subject was the Dormition of the Virgin. Although it is difficult to envision a complete reconstruction of the window, several other fragments from it still exist: a semicircle with a single censing angel (Wellesley College Museum, Massachusetts; 1949–19a), a panel with two apostles in connected arcs surmounted by a censing angel (Treasury, Troyes Cathedral), and a group of apostles gathered at the Virgin's bier (Glencairn Museum, Bryn Athyn, Pennsylvania). What certainly is the head of the Virgin from the Dormition scene (1977.346.17) also was given to the Metropolitan Museum by Ella Brummer, along with a group of fragments from Troyes. As demonstrated by Pastan, the dispersed panels all originated in Saint-Étienne, which was founded in 1157 and served as the "palace chapel" of the counts of Champagne.

Here, the pairs of angels, seen moving away from the connected arcs, are painted with an exceptional precision, against a ground decorated with a fine pattern of *rinceaux*. The organic articulation of the figures and the strikingly balanced colors are analogous to similar effects found in both manuscript illumination and enamel work. However, it is the chevron-shaped folds of the drapery, which radiate with a metallic precision, that especially invite comparison to a group of contemporary manuscripts produced in Champagne by illuminators originally trained in northern France. Stylistic links with Mosan enamel work also demonstrate that the Troyes artist had assimilated techniques, color relationships, and figure types uncharacteristic of twelfth-century stained-glass painting.

C T L

EX COLLECTION: Ernest and Ella Brummer, New York.

EXHIBITION: "Medieval Art from Private Collections," New York, The Cloisters/The Metropolitan Museum of Art, October 30, 1968–January 5, 1969, no. 182.

REFERENCES: Gómez-Moreno, 1968, no. 182, ill.; Caviness, 1973, pp. 205 ff.; Grodecki, 1973, pp. 191 ff.; *idem*, 1977, pp. 140 ff.; Newman, 1978, no. 1, p. 7; Little, 1979 b, p. 23, ill.; *idem*, 1981 a, pp. 119–27; Little and Husband, 1987, p. 73; Pastan, 1989, pp. 338–72; Hayward, forthcoming.

83

TWO SEGMENTS FROM A STAINED-GLASS BORDER

French (Braine or Reims ?), about 1185–1200

Pot-metal glass and vitreous paint: (1978.408.1) 24⅜ x 8⅝ in. (61.9 x 21.9 cm); (1978.408.2) 23⅝ x 8½ in. (60 x 21.6 cm)

The Cloisters Collection, 1978 (1978.408.1,2)

Set against vibrant blue and red grounds, these two fragments from a foliate pattern were once part of a stained-glass border that framed a figural image in a large church window. The repetitive motif consists of a white undulating vine that emanates from both sides of the calyx of each palmette and encircles a rosette. A similar use of specific ornamental details associates these border fragments with the stained glass of northeast France, particularly that of the Abbey Church of Saint-Yved in Braine or of the Abbey Church of Saint-Remi in Reims.

Although these border segments cannot be placed definitively at either Saint-Yved or Saint-Remi, the composition of an inscribed

floral motif alternating with a palmette growing laterally is very much within the documented vocabulary of the glaziers who worked at both sites. Even the meandering vine that connects each ornamental motif is present—albeit in more angular forms—at Braine and at Reims. Yet, the four fronds curling out at oblique angles, as opposed to the more typically encountered paired symmetrical leaves, distinguish the palmettes in the Metropolitan Museum's fragments. Subtle changes in shades of color, particularly among the blues and greens, contribute to the lushness of the design.

MBS

EX COLLECTION: [Brimo de Laroussilhe, Paris].

REFERENCES: (1978.408.1,2) *MMA Annual Report*, 1979, p. 39; Hayward, 1985, p. 96, ills.; (1978.408.1) Hayward et al., 1982, p. 119, fig. 19, p. 118; (1978.408.2) Caviness, 1990, p. 388, ill.

84

TABLEMAN, WITH AN EPISODE FROM THE LIFE OF APOLLONIUS OF TYRE

German (Cologne), about 1170

Walrus ivory: Diameter, 2¼ in. (5.7 cm)

Purchase, Stark and Michael Ward Gift, Joseph Pulitzer Bequest, and Pfeiffer and Dodge Funds, 1996 (1996.224)

1 Brussels, Musées Royaux d'Art et d'Histoire; Staatliche Museen zu Berlin, Kunstgewerbemuseum; see Goldschmidt, 1923, nos. 53, 54.
2 See Mann, 1977, no. 207.

EX COLLECTIONS: Anton Prinz von Hohenzollern-Sigmaringen, 1811–1885; Baron Robert von Hirsch, Frankfurt am Main and Basel; [sale, Sotheby Parke Bernet, London, 1978, lot 267, color ill.]; Stark and Michael Ward, New York.

REFERENCES: von Hefner-Alteneck, 1866, pl. 36; Lehner, 1871, no. 294; Westwood, 1876, no. 837; Volbach, 1922, no. 45 a; Goldschmidt, 1923, no. 231; Sprinz, 1925, no. 5, pl. 2; Giesen, 1956–57, pp. 74–77, pl. IX, fig. 1; Mann, 1977, no. 206; Kortekaas, 1984, frontispiece; Kluge-Pinsker, 1991, p. 213; Little, 1997 c, p. 20, ill.

The scene on this game piece, presented with great sensitivity and imbued with emotion, represents an episode from the well-known but rarely illustrated Late Antique legend of Apollonius of Tyre. When Apollonius's wife dies, he has her buried at sea. Two men are shown here lowering her elaborately decorated coffin from a boat into the waves, while two other men watch, one touching his hair and the other holding onto the mast, whose billowing sail rises between them.

The composition is conceived in multiple spatial layers: the decorated coffin, the first two figures lowering it into the water, the second pair looking on, and finally the billowing sail. This illusion of deep space is further enhanced by the nearly three-dimensional figures, some parts of which are carved in the round—a rare feature in reliefs made of walrus ivory. While the subject is unique in Romanesque art, the plastic style of the carving of the figures and the attention to detail have parallels in Cologne ivories from the second half of the twelfth century. In addition, the figures and the acanthus border can be related in style to an ivory reliquary in Brussels, and to a cupola reliquary in Berlin made in Cologne between 1170 and 1190.¹ The Brussels ivory reliquary contains borders that are almost identical to those of the present tableman, which would indicate that a single workshop produced both ecclesiastical and secular objects. The game piece represents the apogee of carving in Cologne, which was one of the principal Romanesque art centers, particularly known for its ivories.

Another tableman (Burrell Collection, Glasgow), which depicts the Entombment of Christ but is exactly the same size and style, is similar in composition to the Metropolitan's example; these analogies suggest that the two may have belonged to the same set.² Thus, the themes of the complete set of game pieces would have been divided equally between the Life of Christ and typological parallels based on classical literature.

Tables—a medieval precursor of backgammon—was a game of skill and chance actually played on a table like the modern backgammon board. The fifteen disks on each side were moved after throwing dice, with the objective of removing all the opponent's tablemen from the board. Normally, the images on the game pieces would depict the feats of strength of Hercules versus those of Samson on opposing sides, thus pitting the mythological hero against the Old Testament strong man. Table games were enjoyed by the nobility and romanticized in literature—as, for example, in Chrétien de Troyes's *Perceval*.

Here, the game appears to have been more allegorical, utilizing the classical legend of Apollonius of Tyre as an antetype for episodes from the New Testament. The critical event shown on our game piece is followed by the miraculous resurrection of Apollonius's wife. The lasting appeal of this tragic love story led Shakespeare to adapt it as the basis for the play *Pericles, Prince of Tyre*.

CTL

85

CHRIST PRESENTING THE KEYS TO PETER AND THE LAW TO PAUL

German (Westphalia), second half of the 12th century

Elephant ivory: 5¹⁵⁄₁₆ x 3¹¹⁄₁₆ in. (15.1 x 9.4 cm)

The Cloisters Collection, 1979 (1979.399)

Christ Giving the Keys to Peter and the Law to Paul (*Traditio Clavis et Legis*) became an established theme in art in fourth-century Rome in order to visually emphasize the primacy of Peter and the importance of Paul. Early depictions of the subject are usually monumental in scale, as, for example, when they served as apse decorations, but occasionally, in the later medieval period, the event is represented in ivory. The present ivory panel, enframed by a border composed of repeating stylized palmettes, is a powerful image of the two major apostles receiving their sacred mission with veiled arms. A striking departure from traditional depictions of this scene is the absence of the rock upon which Christ usually stands, which, here, has been replaced by a domed and arcaded rotunda—a specific reference to the establishment of the Universal Church, as recorded in Matthew 16:18: "And I say to thee: that thou art Peter; and upon this rock I will build my church."

The axial symmetry of the composition and its pyramidal grouping of the figures contribute to its impression of monumentality. The perforated a-jour ground isolates and thus heightens the sculptural quality of the figures. In addition, the carver intersected

the symmetrical group with two diagonals created by the angled scroll and the keys, which are echoed further in the patterns of drapery around Christ's legs. Finally, the wide-open eyes of all three figures are the result of deep drilling, which produces a staring expression and a haunting effect that are appropriate to the mystical and symbolic nature of the subject.

The scroll offered to Paul contains a post-medieval inscription—s[ʌɴᴄ]ᴛᴀ ᴛʀᴇ.ᴠ:[ᴇʀᴏʀᴜᴍ], a reference to the saints of the city of Trier where the ivory was, in the nineteenth century—unrelated to the *Traditio Clavis et Legis* iconography. The "1200" inscribed on the base of the rotunda is similarly of a later date. Saint Peter is the patron saint of Trier Cathedral and appears on the city's earliest seal, which dates to before 1149. However, the fact that the ivory belonged to Count Christoph von Kesselstatt (1757–1814), dean of Paderborn Cathedral and a collector of important illuminated manuscripts from both Paderborn and Helmarshausen, strongly indicates that the panel also may have originated in Westphalia. Indeed, the naturalistic figures, with their fluid drapery, are similar to various images on several Helmarshausen silver-repoussé book covers.

Stylistically, the ivory displays characteristics of German Romanesque art of the second half of the twelfth century: dramatically expressive yet naturally conceived figures, whose bodies are revealed by a system of fluid, clinging drapery, as well as a predilection for openwork carving.

A nineteenth-century copy of this ivory, once thought to be the original, is in the John Rylands Library in Manchester, England.

ᴄᴛʟ

ᴇx ᴄᴏʟʟᴇᴄᴛɪᴏɴs: Count Christoph von Kesselstatt (1757–1814), Trier; Private collection, Rhineland; Arthur Sachs, Cambridge, Massachusetts; Ernest Brummer, New York; [sale, Galerie Koller AG, Zurich, in collaboration with Spink & Son, London, October 16–19, 1979, vol. 1, lot 77].

ʀᴇꜰᴇʀᴇɴᴄᴇs: Weerth, 1868, pp. 90–91, pl. ʟᴠɪɪɪ, fig. 6; Schnitzler, 1932, pp. 13–18, fig. 1; Jansen, 1936, p. 358; Little, 1980, p. 22, ill.; Deshman, 1986, p. 268, pl. 8.

86

HEAD OF A YOUTH

French (Provence), probably from Saint-Gilles-du-Gard, mid-12th century
Limestone: Height, 7⅛ in. (18.1 cm)
Bequest of Meyer Schapiro, 1996 (1997.146)

The pilgrimage church of Saint-Gilles-du-Gard marks the apogee of antique influence on Romanesque art, and this remarkable head of a youth, probably from there, is one of the finest expressions of this tendency in twelfth-century sculpture. The articulation of the face, with its slightly pouting lips, swelling cheeks and squarish jaw, and spherical eyes that slope downward, and the wavy hair, all indicate that this is the work of a master carver, who understood the lessons of antiquity, but thoroughly transformed them to suit his own artistic orientation. The right side of the head is only partially finished, which suggests that the figure to which it belonged was intended to be seen primarily in left profile, set in high relief. The technique of articulating the eyes with lightly drilled pupils and the gently swelling surfaces that produce the serene expression of the face

closely resemble the style of the principal sculptor at the abbey church, who carved the imposing relief of Saint Michael on the façade.[1] This master also directly influenced works in the immediate area, such as the figural reliefs from the church of Saint-Martin at Saint-Gilles-du Gard,[2] and those somewhat farther afield at Saint-Guilhem le Désert (Hérault).[3] Although the stone itself appears to differ, the present head is comparable in size and style to the heads in the Saint-Martin relief.

This sculpture joins another distinguished Romanesque head of a youth in the Museum's collection that comes from Saint-Sernin, Toulouse (1976.60). Together, the two heads reveal the tendency of Romanesque sculptors to abstract natural forms, using their direct understanding of antique models as the point of departure and as a means of independent expression.

CTL

1 See Hamann, 1955, pp. 134–43, plates 6–9; Stoddard, 1973, pp. 36–41.
2 See Wixom, 1967, pp. 120–21, 359, no. III–38, ill. p. 121; Gouron, 1950, pp. 115–20; see also Stoddard, 1973, fig. 142.
3 See Stoddard, 1973, figs. 437–438.

EXHIBITION: "Medieval Art from Private Collections," New York, The Cloisters/The Metropolitan Museum of Art, October 30, 1968–January 5, 1969, no. 25.

REFERENCE: Gómez-Moreno, 1968, no. 25, ill.

87

CORBEL

Central or west French, third quarter of the 12th century
Calcareous sandstone: 11½ x 7⅞ x 13¼ in. (29.2 x 20 x 33.7 cm)
Gift of Roy R. Neuberger, 1980 (1980.475)

This crouching, bearded figure wearing a cap is part of a corbel that probably served as a support for a cornice or a stringcourse on the exterior of a church. The figure's original function is suggested by its size, its weight-bearing pose, the abbreviated manner of the articulation, and the considerable weathering of the stone. In spite of the sculpture's somewhat eroded surface, it nevertheless retains a strong visual presence, conveyed in such details as the deep-set, staring eyes, the arched brows, and the grooved ribs of the torso (visible at the left in this illustration). Although simply modeled, the solid planes of the face lend it a highly plastic appearance.

Corbels were an integral part of the structural decoration of nearly all Romanesque churches and often were endowed with human or animal attributes, the former perhaps intended as the medieval equivalents of the classical atlantes. The geographic origins of the present carving are unknown. Although in style and type the corbel is loosely related to the recently discovered atlas figure on an engaged console at the Church of Saint-Lazare in Avallon, the fact that the material is calcareous sandstone, which is more typical of western France, thus makes a Burgundian origin unlikely.[1] However, Burgundian sources are fundamental to the plastic development of the forms, which also may be compared with those of a Burgundian corbel fragment in the Museum of Art at Duke University in Durham, North Carolina.[2] Likewise, there seems to be a general Chartrain influence in the overall conception of the head,

with its carefully delineated receding planes, especially when compared with the figures on the doorpost and on the frieze of a capital on the west façade of Chartres Cathedral.[3]

CTL

1 See Recht, 1983, pp. 149–63, fig. 6.
2 See Bruzelius, 1991, no. 7, ill.
3 See Hamann, 1955, fig. 374.

EX COLLECTION: Roy R. Neuberger, New York.

REFERENCES: Little, 1981 b, p. 21, ill.; *idem*, 1987 a, pp. 163–64, fig. 12.

88

TWO CAPITALS

A. **CAPITAL, WITH THE ADORATION OF THE MAGI**

French (Provence), second half of the 12th century
Limestone: 11½ x 11 x 9¼ in. (29.2 x 27.9 x 23.5 cm)

B. **CAPITAL, WITH CHRIST GIVING THE KEYS TO SAINT PETER**

Southwest French, second half of the 12th century
Sandstone: 9⅛ x 10 x 9½ in. (23.2 x 25.4 x 24.1 cm)
Gift of Meyer and Lillian M. Schapiro, 1991 (1991.417.1,2)

The massive proportions of the strongly projecting figures of the seated Virgin and Child, and the boldly carved, ribbed folds of their drapery, are virtually all that survive of this once-impressive narrative capital. Clearly part of a larger sculptural cycle, it is closely related in style and composition to the late-twelfth-century capitals depicting the Infancy of Christ in the Cloister of Saint-Trophime in Arles.

The subject of the other capital may be identified as Christ Giving the Keys to Saint Peter (Matthew 16:19). The strongest parallels to this work may be seen in the sculpture of the Cloister of Saint-Étienne in Toulouse, as well as in other examples from the region of Narbonne in southwestern France.

CTL

EX COLLECTION: Meyer and Lillian M. Schapiro, New York.

EXHIBITION: (A) "Medieval Art from Private Collections," New York, The Cloisters/The Metropolitan Museum of Art, October 30, 1968–January 5, 1969, no. 27.

REFERENCES: (A) Gómez-Moreno, 1968, no. 27, ill.; (A, B) Little, 1992, p. 19, ills.

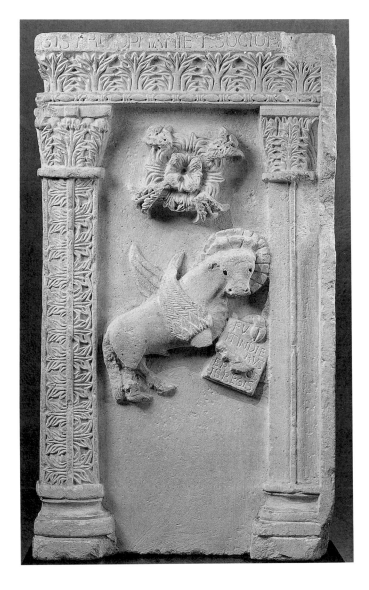

89

CAPITAL WITH AN ENGAGED ABACUS, DEPICTING FOUR BASILISKS AND FOUR FELINE HEADS

South French, second half of the 12th century

Limestone: 14½ x 11¼ x 15½ in. (36.8 x 29.8 x 39.4 cm); diameter (base), 7⅛ in. (18 cm)

Gift of Charlotte A. Kent, in memory of Frances Kent Lamont, 1991 (1991.193)

CTL

EX COLLECTION: Charlotte A. Kent, Orleans, Massachusetts.

90

PANEL, WITH THE SYMBOL OF SAINT LUKE

Central Italian (Abruzzo), about 1180

Perla d'Abruzzo and lead: 40 x 22 x 8¼ in. (101.6 x 55.9 x 21 cm)

Provenance: San Michele Arcangelo, San Vittorino (Abruzzo).

The Cloisters Collection, 1984 (1984.197)

The symbol of Saint Luke, a winged and nimbed ox holding a book, appears below an intricate foliate boss on this relief panel from a pulpit. The motifs are framed at the sides by pilasters topped by engaged capitals, and above by an elaborate architrave decorated with a row of sharp acanthus leaves. The uppermost horizontal border contains part of a dedicatory inscription, now much damaged.[1] The decoration on the left side of the slab is the same as that on the front of the pilaster, the capitals, and the architrave. The back has a deep step that terminates just below the architrave; otherwise, it is unfinished. A significant portion of the right pilaster has been trimmed away, but it was probably identical in design to the left one.

The broad lip of the right edge and the stepped finish of the left side of the fragment support the likelihood that it would have been positioned on the front of a rectangular pulpit at the left. The right side of the slab would have abutted a projecting lectern, while the left side would have fitted at right angles to the slab that formed the left side of the structure. This construction is characteristic of a number of central and south Italian pulpits of the Romanesque period.

Another fragment of the same pulpit, a double panel with the winged angel-man symbol of Saint Matthew and the eagle of Saint John flanking architectural elements of the same design as those on the Cloisters' relief, is now in the Museo Nazionale d'Abruzzo, L'Aquila.[2] The latter relief is from the town of San Vittorino (L'Aquila), where it once ornamented the façade of the sixteenth-century church of Santa Maria della Consolazione.[3] Charles Little suggests that both reliefs are from an ambo made for San Michele Arcangelo, the principal medieval church in San Vittorino, founded in the eighth or ninth century.[4] Other fragments of relief sculpture remain at San Michele Arcangelo, including a frieze with a border of *rinceaux* and spiky palmettes—now mounted into the exterior wall of the church—which may have been part of the pulpit architrave.[5]

A complete reconstruction of the ambo probably is impossible, but a general impression of it can be gained from other examples in the Abruzzo, an area exceptionally rich in pulpits of the twelfth and the thirteenth century. At Sant'Angelo (formerly, Santa Maria Maggiore) in Pianella, the pulpit of about 1180, signed by Master Acutus, shows each of the Evangelist symbols floating on a single panel framed by a leafy border.[6] The ornamentation of the reliefs at The Cloisters and in L'Aquila is closely paralleled in the extremely well-preserved pulpit at Santa Maria Assunta, Bominaco (L'Aquila). Dated 1180 in the inscription, and made of a similar crystalline limestone, the pulpit offers a clear source for the patterns and carving technique of the Cloisters' relief.[7] The close correspondences among the sculpture at Bominaco, the Cloisters' and L'Aquila reliefs, and the fragments in San Vittorino hint at their production by the same workshop.

Louis Waldman attributes the Cloisters' relief to the Magister Stephanus, whose signature he sees in the inscription; this suggests to him that the master may have been responsible as well for the Bominaco sculpture.[8] Charles Little, instead, associates an inscription from San Michele Arcangelo that records an artist's name, Petrus Amabilis, and the date 1197, with the pulpit's construction.[9] Neither of these ingenious interpretations offers enough evidence to be definitive. Although its maker remains unknown, the Cloisters' relief, with its contrasting crisp and rich decorative forms and plain surfaces, is characteristic of the finest late-twelfth-century sculpture of the Abruzzo.

Prior to its purchase by The Cloisters, the relief was vigorously cleaned; although the skin of the stone was dislodged, the quality of the carving has not been altered significantly.

LC-T

1 The inscription reads: GISTRI[] OPHANIE T SOCIOʀ: Little, 1985 b, p. 157, transcribes the inscription without further interpretation, while Waldman, 1994, p. 60, interprets it as: [MA]GISTRI [STE]PHANI ET SOCIOR[VM] [ʔSVORVM] ("Of Magister Stephanus and [his] associates"). In addition, the book held by the ox of Saint Luke is inscribed: FV/IT INDIE/BVS/[H]ER/OD/ISREGIS (Luke 1: 5) ("There was in the days of Herod the King").

2 Inv. no. 434; illustrated in Waldman, 1994, fig. 2. The L'Aquila relief also carries an inscription on its upper edge: [NI]COLAI HVIVS ECCLE AR[CH]IPBR[I] ("of Nicholas, the archpriest of this church"). Waldman, 1994, p. 60, suggests that the complete inscription would have read: "Anno Domini x, tempore Nicolai huius ecclesie archipresbyteri, y hoc opus fieri fecit per manus magistri Stephani et sociorum suorum" ("In the year x, y had this made by the hands of Maestro Stefano and his associates in the time of Niccola, the archpriest of this church"). Charles Little's reading of the L'Aquila inscription is basically the same.

3 Moretti, 1972, p. 148, illustrates the relief in situ. Damaged by an earthquake in 1915 and a fire in 1944, the church was demolished in the 1960s, and the relief removed to the museum in L'Aquila.

4 Little, 1985 b, p. 158; see also Little, 1985 c, pp. 11–12.

5 Illustrated in Lehmann-Brockhaus, 1942–44, fig. 355.

6 Moretti, 1971, pp. 162–63, ill. p. 163, figs. 11–12. For an earlier example of the isolated flower decoration in high relief see the pulpit dated about 1168–78 from the Cathedral of San Pelino (Cattedrale Valvense), Corfinio (L'Aquila), illustrated in Moretti, 1971, p. 76, figs. 16–17.

7 Illustrated in Moretti, 1971, p. 48, fig. 8; Lehmann-Brockhaus, 1942–44, figs. 352–353. The barbed leaves also occur on the heavily restored cathedra of Abbot Giovanni, most probably by the same artist, in the church at Bominaco, illustrated in Moretti, 1971, p. 51, fig. 13.

8 Waldman, 1994, p. 63, figs. 5–6, tentatively identifies the Magister

Stephanus with an artist of the same name, who signed the pulpit in San Nicola, Corcumello, in 1267. The style and date of this monument are unrelated to the Cloisters' and the L'Aquila reliefs, as well as to the pulpit at Bominaco.

9 Little, 1985 b, p. 158, cites the inscription: ANNO D[OMI]NI MC/ NON[A]G[ESIMO] VII/MAGIST[ER] PETRUS AMABIL[IS] H[OC] OPUS/FECIT T[EMPORE] RAY[MU]NDI NICOL[AI] HUI[US]/ECCL[ESIE] ARCH[I]PR[ESBITER]I ("In the year of our Lord 1197 Master Petrus Amabilis made this work in the time of Raymond Nicholas who was archpresbyter of the church"). Conceivably, the "Raymond Nicholas who was archpresbyter of the church," of the above inscription, may be the same "Nicholas the archpriest" whose name is inscribed on the L'Aquila relief. Bertaux, 1904, p. 572, n. 3, records the lost inscription, but does not link it directly with the pulpit.

EX COLLECTION: [Robin Symes Limited, London].

REFERENCES: Bertaux, 1904, p. 572, n. 3; Little, 1985 b, pp. 157–58, figs. 1, 2; idem, 1985 c, pp. 11–12, ill. p. 11; Wixom, 1989 a, p. 46, ill.; Waldman, 1994, pp. 60–64, figs. 1, 3–4.

91

THE MARTYRDOM OF SAINT LAWRENCE

English (Canterbury), about 1175–80
Pot-metal glass and vitreous paint: 25⅝ x 12⅝ in. (65.1 x 32.1 cm)
Inscribed: S: LORV̄S ORAP·NOBIS ("Saint Lawrence pray for us")
Provenance: Cathedral of Christ Church, Canterbury.
The Cloisters Collection, 1984 (1984.232)

Saint Lawrence, contrary to iconographic convention, is shown in supplication, amid bands of fire, rather than stretched out on the grill. This representation reflects the writings of both Saints Augustine and Ambrose, which relate that Saint Lawrence conquered the fire without—shown here licking at his feet—with the three fires within: inflamed by the ardor of faith, the love of Christ, and the true knowledge of God, which are represented by the bands of fire at waist and shoulder level and by the column of fire above his head.

The attribution of the panel to Canterbury is based largely on style; its precise location in the cathedral choir has not been determined. The bearded head is not that of Saint Lawrence but came from elsewhere in the same glazing program and was later inserted, probably in the nineteenth century; most of the inscription and much of the architectural framings are recent restorations to fill out the panel.

TBH

EX COLLECTIONS: Dr. J. Francis Grayling, Sittingbourne, Kent, until 1923; Bertram Christian, London, until 1952; Gerard Kirsopp Lake, Boston, until 1972; Lydia Kirsopp Lake, Lexington, Massachusetts.

EXHIBITIONS: "Medieval and Renaissance Stained Glass from New England Collections," Cambridge, Massachusetts, Busch-Reisinger Museum, April 25–June 10, 1978, no. 2; "Decorative and Applied Art from Late Antiquity to Late Gothic," Moscow, State Pushkin Museum, May 10–July 10, 1990, and Leningrad, State Hermitage Museum, August 14–October 14, 1990, no. 15.

REFERENCES: "Fogg Art Museum," 1940–41, p. 18; Caviness, 1978, no. 2, p. 11, ill. p. 10; idem, 1981, pp. 312–13, figs. 591, 591 a; idem, 1985, p. 67, ill.; Hayward, 1988, p. 15, ill.; Husband, 1990 c, no. 15, p. 38, colorpl. p. 39.

91

92

LEAVES FROM A BEATUS MANUSCRIPT

Spanish (Burgos), about 1180

Tempera, gold, and ink, on parchment: Each folio (approx.), 17⅝ x 11⅞ in. (44.8 x 30.2 cm); *bifolium* (1991.232.2), 17⅜ x 23¼ in. (44.1 x 59.1 cm)

Provenance: Benedictine Monastery of San Pedro de Cardeña, Burgos.

Purchase, The Cloisters Collection, Rogers and Harris Brisbane Dick Funds, and Joseph Pulitzer Bequest, 1991 (1991.232.1–14)

Beatus manuscripts are illustrated commentaries on the Apocalypse, the biblical revelation to Saint John. The compilation of visionary texts, made about 776 by an Asturian monk called Beatus of Liébana, consists of passages from the Book of Revelation accompanied by interpretations cast as Christian allegories.[1] The pages shown here came from a manuscript attributed to the Monastery of San Pedro de Cardeña, a tenth-century foundation a short distance from Burgos.[2] The major part of this work, which was dispersed in the 1870s, is now in Madrid.[3]

The overall style of the illustrations in the Cardeña Beatus is notable for the vibrant and dramatic color contrasts, the powerfully controlled linear treatment of the figures and their draperies, and the refined yet intricate patterns in the pen work. The illustrations—occasionally, quite literal interpretations of the texts—partially reflect an earlier, Mozarabic tradition in such manuscript illuminations, as demonstrated by the banded backgrounds and certain architectural details. On the other hand, the linear configurations and proportions of the monumentally conceived figures are characteristic of the European transitional style of the late twelfth century, which was powerfully informed by Byzantine conventions conveyed to western Europe through those figured silks and ivory icons that had been transferred to the Latin West during the previous two centuries.[4]

The leaves illustrated here demonstrate the dual modes of depicting drapery seen in the manuscript. The first two examples show a detail of a *bifolium* with the Adoration of the Magi (1991.232.2) and a page with the fourth angel sounding the trumpet, the sun, moon, and stars darkened, and an eagle crying "woe to the inhabitants of the earth" (Apocalypse 8:12–13; 1991.232.9). These miniatures are representative of the more descriptive, less abstract, style in the manuscript. The draperies are almost always layered in pleats with zigzagged or stepped edges, the whole suggesting the low-relief configurations of Middle Byzantine ivory icons, a few of which reached the Iberian Peninsula as early as the late eleventh century.[5] Certain other Byzantine conventions are apparent, such as the Virgin's veil (or *maphorion*), as well as her high seat, with its cushion and footstool. The second style is exemplified by the miniature that shows Christ in Majesty with angels, above the scene of God's angel commissioning Saint John the Evangelist (who is shown twice) to write the Book of Revelation (Apocalypse 1:1–6; 1991.232.3), where a "damp-fold" style of clinging drapery—which was pervasive throughout western Europe from about 1100—is vividly rendered.[6] Byzantine tradition is so dramatically reinterpreted here that this ancestry seems removed, as if seen through the prism of English manuscript painting, as practiced in the second quarter of the twelfth century at the English Abbey of Bury Saint Edmunds, as well as at Canterbury and Winchester.[7] The Majesty illustration provides

92: 1991.232.2

92: 1991.232.9

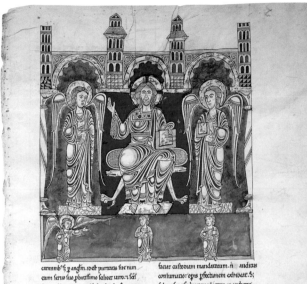

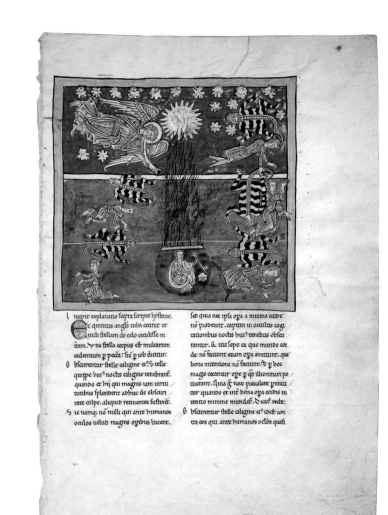

carumb's p angim ioch purmas sue nun
cum sero suo pheuhmo salicer uiro. scal
simo aplox omnum iohi durech ex. a ur ee
smonium pibur ubo de vidchar qui p
dearur filum di assaruc uiraem er ee
smonium rodidir de dno ihu xpo que
cumqe uidear in illo ur audiar ex illo.

oo unde in epla sua loquur dicens. Quod uidi
mus ee audiuim'r man'nre mactauerunt
de uerbo uie. r uia abhur. manifesta
uimus uobis, S cuus qui legir er qui
audir uerba, phe'r seruar que in es ser
pta sunt. S ntelligi uult quod lecho non

facur custodiam mandatoreum. n audius
consumato opis pfectionem exhibear. S;
solum sir pfecho que legens er audiens
er ope facere concis, C orpus enim ipe
est. r facumb'ea no longum temp'renu
neranonis facir. S uicinum die ee diuini
mulhs donum. D einde ordirur dictox
suox imeum er dicar, I ohs septe ecclis
que sunt in asia. R unqo no tam'er ralis
ur uni anum puinae r no omib'gen
ribus diuini misterium pandere reuelano
mis incaluir. ut tam pariam numerum
ecchiarum unus puinae sua deshinaret

napir explanano supra scripre hystorie.
Er quintus angls tuba cecanir er
uidi stellam de cedo cecidisse in
ram. S na stella corpus est mulcarum
cadenum p pecca. hic p iob dicitur.
b scurentur stelle caligine er S celle
quipe hui'nochs caligine tenebranr.
quando er bn qui magnis iam uirtu
tunbus isplendere adhuc de obscuri
tare culpe. aliquid retinentes sustiner.
S ie namqe. no nulli qui ante humanos
oculos ueluch magnis opibus lucere.

sed quia nec ipsa opa a mundo corde
no prodeunt. captiui in occultis cogi
tanonibus nochs hui' tenebris obscu
ranrur. a ua sepe ea que mundo cor
de no faciunt enam opa amittunt. que
bona intencione no facetur. At p hoc
magis cecantur ope p qd illuminari po
tuerunt. Quia gr nox pseuuere pmit
tur quando er ipe bona opa cordis in
uento minime mundar. S icat recte.
b scurentur stelle caligine eo idest con
tra eos qui ante humanos oclos quasi

an especially striking echo of the clinging curvilinear drapery style advanced in the Bible produced about 1135 at Bury Saint Edmunds.[8] Also decidedly Western is the zoomorphic faldstool supporting the figure of Christ.

W D W

1 See Williams, 1977, pp. 24–28; *idem*, 1992, pp. 217–33.
2 See Rada y Delgado and Malibrán, 1871, p. 26; Lemoisne, 1909, pp. 131–40; Williams, 1991, pp. 371–82; Wixom, 1992 b, p. 20; Wixom, 1997 a, no. 315, pp. 478–79, color ill.; Williams, forthcoming, no. 21.
3 Museo Arqueológico Nacional. Other leaves reside in the collection of Francisco de Zabálbluru y Basabe, Madrid, and in the Museu d'Art, Gerona; see Williams, 1993, no. 153, p. 300.
4 See Wixom, 1997 a, pp. 438, 441, 446.
5 See Little, 1997 a, no. 304, p. 466, color ill.
6 See Wixom, 1997 a, no. 311, pp. 473–74, color ill.
7 For the "Bury Bible" see Kauffmann, 1975, no. 56, pp. 88–90; for the Canterbury "Lambeth Bible," of about 1140–50, see Kauffmann, 1975, pp. 99–100, ills. 194, 195, figs. 30, 32, 36; for the "Winchester Psalter" see Carr, 1997, no. 312, pp. 474–75, color ill. p. 474. The artist of the "Lambeth Bible" was responsible also for two monumental Evangelist portraits datable to 1146 that are preserved in Avesnes-sur-Helpe, France; see Kauffmann, 1984, no. 54, p. 116 (*Saint Mark* illustration). For a discussion of the damp-fold style in England see Kauffmann, 1975, p. 25.
8 See Kauffmann, 1975, no. 56, especially fig. 152: *Ezekiel's Vision of God* (Cambridge, Corpus Christi College 2, fol. 281 v).

EX COLLECTIONS: Victor Martin Le Roy, Neuilly-sur-Seine; Jean-Joseph Marquet de Vasselot, Paris; [Alain Moatti, Paris].

EXHIBITION: "The Glory of Byzantium: Art and Culture of the Middle Byzantine Era, A.D. 843–1261," New York, The Metropolitan Museum of Art, March 11–July 6, 1997, no. 315.

REFERENCES: Lemoisne, 1909, pp. 131–40; Domínguez Bordona, 1933, vol. 1, p. 487; Klein, 1976, p. 414; *Los beatos*, 1986, p. 115; Williams, 1991, pp. 374–76 (the Metropolitan's Cardeña leaves); Wixom, 1992 b, p. 21, colorplates p. 20 and cover; Cardona, 1993, pp. 64–66, n. 8, pp. 70, 71, n. 21, pp. 76–77 (the Metropolitan's Cardeña leaves); Williams, 1993, no. 153, pp. 300–301, colorplates; Cardona, 1995, p. 86, n. 5, pp. 88, 94–98, 102, n. 30 (the Metropolitan's Cardeña leaves); Wixom, 1997 a, no. 315, pp. 478–79, color ill.; Williams, forthcoming, no. 21.

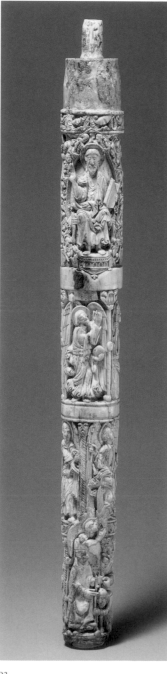

93

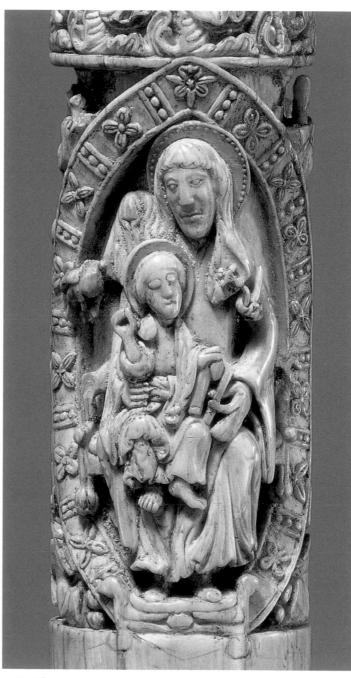

93: Detail

93

SEGMENT OF A CROSIER SHAFT

North Spanish, late 12th century

Elephant ivory: Height, 11¼ in. (28.6 cm); diameter, 1⅜ in. (3.5 cm)

The Cloisters Collection, 1981 (1981.1)

Because they were key symbols of ecclesiastical authority, crosiers often were lavishly decorated. The present segment of a crosier shaft is among the most elaborate examples, its surface decoration divided into four bands that depict two principal realms—the celestial and the terrestrial—each heralded by angels. In the top register, on one side, Christ is shown enthroned within a mandorla composed of ten bust-length figures of the Elders of the Apocalypse supported by seraphim. This type of inhabited mandorla is exceptionally rare, and is known only in Spain. As described in the Pilgrim's Guide, written about 1120–30, such an image was found on the silver-gilt altar frontal at the shrine of Saint James at Santiago de Compostela,[1] which, although it no longer exists, might have been copied in the apsidal wall paintings in the Church of San Justo in Segovia.[2] This heavenly vision is amplified, on the opposite side of the Cloisters' crosier shaft, by the enthroned Virgin and Child, who appear in a "mandorla of light" decorated with stars; next to the throne is a dove—a direct allusion to the Incarnation.

The central registers of the shaft are filled with depictions of angels dressed as deacons, who stand within arcades. Each figure holds an orb and a long staff surmounted by a lantern—possibly a reference to Christ as the Light of the World. In the bottom register, a bishop, who sits upon a high-backed episcopal chair, is receiving his miter from an angel descending from the register above while he simultaneously accepts a crosier from a secular donor, who kneels before him as other deacons and saints look on. Since he has no nimbus, the scene probably commemorates the bishop's actual installation, in the presence of the donor of what, most likely, is the present crosier.

Characteristic of the technical virtuosity of the carving are the figure style and the animated folds of the heavy drapery. This energized drapery style seems to embody the Byzantine influence that prevailed toward the end of the twelfth century. The figures themselves are thickset, with fleshy faces and large hands. In painting, the closest parallel to this style is found in the Beatus from San Pedro de Cardeña,[3] or in the image of Saint James in the Codex Calixtinus. In sculpture, the treatment of the apostles who support the vaults in the Cámara Santa at Oviedo, and of the heavily draped figures on the monumental frieze in the Church of Santiago in Carrión de los Condes displays the same "baroque" Romanesque quality.[4]

Two other cylindrical shafts are related stylistically to the Cloisters' example: a crosier shaft in the British Museum, with registers of apostles in arcades (similar in design to the marble column shafts of the Puerta de las Platerías at Santiago de Compostela),[5] and a second crosier, in the Museo Nazionale del Bargello, Florence, on which are depicted the Labors of the Months, including an unusual representation of March as the "Spinario"—an image that was unknown in Spain at the time.[6] These crosiers traditionally have been thought to have originated in northern France or in England, although Spain now seems the most certain place of manufacture. While these ivory carvings do reflect the often wide-ranging international influences that occurred in northern Spain during the age of pilgrimage, the quality of their workmanship, their design, and various iconographic idiosyncrasies point toward a Spanish provenance for the group.

CTL

1 See Shaver-Crandell and Gerson, 1995, p. 92.
2 See Grau Lobo, 1996, plates 61, 62.
3 See Williams, 1993, no. 153, pp. 300–301, colorplates, and catalogue number 92, above, with color ill.
4 See Simon, 1993, pp. 199–201, ills.
5 See Shaver-Crandell and Gerson, 1995, figs. 10, 17–20.
6 See Goldschmidt, 1926, no. 62.

EX COLLECTIONS: Karl Ferdinand von Nagler (1770–1846), Berlin; Kaiser-Friedrich-Museum, Berlin, 1835–1936; Joseph Homberg Collection, Paris; [sale, Sotheby & Co., London, July 19, 1949, lot 159, frontispiece]; Mr. and Mrs. John Hunt, Drumlech Bailey, County Dublin, Ireland; [Howard Ricketts, London].

REFERENCES: Vöge, 1900, no. 75; Volbach, 1923, p. 30, J. 614, pl. 34; Goldschmidt, 1926, no. 64, p. 21, pl. XVI; Little, 1981 b, pp. 21–22, colorplates and ill. p. 22; Little and Husband, 1987, p. 54, colorpl. 47; Little, 1993 a, no. 142, pp. 288–89, color ills.

94

SPOUTED POT

German (Middle or Lower Rhineland), 12th–13th century

Unglazed earthenware: Height, 5½ in. (14 cm)

Gift of Anthony and Lois Blumka, 1991 (1991.471.1)

Said to have been excavated at Trier, this footless cooking vessel was designed to be nestled in the ashes of a fire.

TBH

EX COLLECTION: [Bastiaan Blok, Noordwijk, The Netherlands].

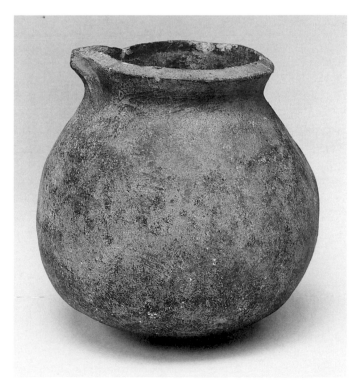

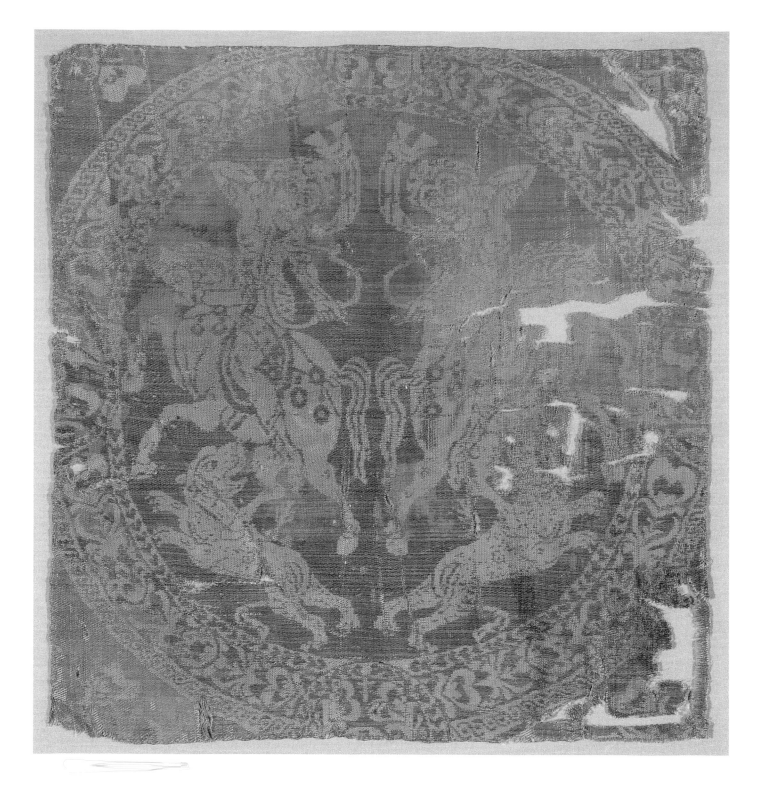

95

ROUNDEL, WITH TWO MOUNTED AMAZONS HUNTING LIONS

Early/Middle Byzantine, 8th–9th century

Silk: 8¼ x 7¹³⁄₁₆ in. (21 x 19.9 cm)

Gift of Mrs. Hayford Peirce, 1987 (1987.442.5)

This portion of a larger length of silk retains one roundel of a pattern, in white on a faded green ground, that was long popular in the Byzantine world. Two confronted, mirror images of mounted Amazon warriors shoot at two running lions at the base of the roundel. The horses dramatically rear on their hind legs as the Amazons twist to shoot at the lions. The broad chests of the powerful horses are emphasized by their contrastingly disproportionately small heads. The roundel is framed by three concentric circles: A narrow guilloche pattern decorates the outer one, a broad band of hearts and foliate designs is in the center, and linked hearts form the inside row. At each cardinal point on the roundel the heart motif is repeated in a hemisphere that originally linked the roundel to repeats of the pattern. At the apex of each hemisphere is a small cross, which suggests that this silk was made for a Christian patron.

Silk fragments with this design entered church treasuries as early as the ninth century in cities like Maastricht, Säckingen, and Saint-Maurice d'Agaune, and, at a much later date, museum collections in London, Lyons, Paris, Berlin, and Washington, D.C.[1] The

Metropolitan Museum's Department of Islamic Art possesses two fragments of the same pattern without the cross motif (27.58.1 and 51.57) attributed to Syria or Egypt. The origin of the design has long been debated, with connections also made to Sasanian art as well as to Byzantium, Syria, and Egypt.[2] A roundel with a very similar pattern, even with regard to the frame, is found on a ninth-century silk on which the confronted warriors are identified as the hero Bahrām Gūr. Although the event in the life of the fifth-century hero was first recorded by the Arab historian Ṭabarī (838–923), the silk is attributed to Constantinople. The large crosses on cardinal points of the medallion's frame support this attribution.[3] The pattern of mounted Amazons also probably originated in the Byzantine capital, and was copied by silk weavers elsewhere. Its popularity in the Islamic world is attested by the Arabic inscription, in Kufic, "God is my stay," on one of the above-mentioned silks in the Museum's Islamic collection (51.57). According to the most recent scholarship, the nearly identical fragments in Lyons are dated to the eighth or the ninth century.[4]

HCE

1 See Martiniani-Reber, 1986, nos. 99, 100, pp. 115–17, ills.
2 Ibid. See also Morris, 1927, pp. 118–20, ill. p. 119.
3 See Martiniani-Reber, 1992, no. 130, p. 195, color ill.
4 See Martiniani-Reber, 1986, pp. 115, 117.

EX COLLECTION: Hayford Peirce collection, until 1987.

96

SIGNET RING

Middle Byzantine, 10th century

Gold and niello: Diameter, 1 in. (2.5 cm)

Inscribed: +K[ΥΡΙ]Ε ΒΟ[Η]/Θ[ΕΙ] ΤΟ Δ[ΟΥ]Λ[Ω]'
ΙΩ[ΑΝΝΗ]/Β[ΑΣΙΛΙΚΩ] ΣΠ[Α]Θ[ΑΡ]Ι[Ω] …?

Gift of Guy and Valerie Tempest Megargee, 1992 (1992.239)

The expansion of the hoop of this massive Middle Byzantine gold ring, from its narrow base to the broad flat surface of the bezel, is enhanced by a stylized vine pattern worked in niello. The face of the ring is inscribed in Greek, in reverse, in niello, "… Lord, help [your] servant John, imperial *spatharios* … (?)." At present, nothing more of the text can be read.

Such rings may have been meant for actual use as signets, or they merely may have been costly imitations of more practical objects. A tenth-century date reasonably can be assigned to the ring on the basis of the manner in which the engraver has set the abbreviation marks in the text.[1]

HCE

1 See Nesbitt, 1997, no. 172, pp. 247–48, color ills. p. 248.

EX COLLECTIONS: Pauline Villette Pickering, La Jolla, California; Guy and Valerie Tempest Megargee, Sciota, Pennsylvania, by 1947–92.

EXHIBITION: "The Glory of Byzantium: Art and Culture of the Middle Byzantine Era, A.D. 843–1261," New York, The Metropolitan Museum of Art, March 11–July 6, 1997, no. 172.

REFERENCES: *MMA Annual Report*, 1992, p. 41; Nesbitt, 1997, no. 172, pp. 247–48, color ills. p. 248.

96

97

97

RING OF LEONTIUS

Middle Byzantine, early 11th–13th century

Gold and niello: Diameter, ⅞ in. (2.22 cm); weight, 1.1 oz. (30 g)

Inscribed: ΚΕΒΘ/ΛΕΟΝΤΙΩ/ΠΑΤΡΙΚΙΩΣ/ΚΟΜΜΙΤΗ/ΤΟΥ ΘΕΟΦΥΛΑ/ΚΤΟΥ ΒΑΣΙ/ΛΙΚΟΥ ΟΨΙΚΙΟΥ ("Lord, help Leontios, *patrikios* and count of the God-guarded Opsikion [i.e., northwestern Turkey]")

Rogers Fund, 1982 (1982.282)

From the ninth through the fourteenth century, massive gold rings—usually with nielloed decoration—bearing Greek invocational prayers on their bezels were commonly worn by high officials of the Byzantine court. They were probably made in imperial workshops, and may have been rings of investiture. We know from the engraved and niello-filled Greek inscription on the bezel of this example, invoking the help of the Lord, that it belonged to one Leontius, a count of Opsikion (Bithynia, Asia Minor), but no other information is known concerning this official.

This ring was included in the Metropolitan Museum exhibition "The Glory of Byzantium" in March 1997, at which time it was studied by the internationally renowned expert on Byzantine seals and rings John Nesbitt. Because the last syllable of the final word in the inscription is set on its own line, between two bars, Nesbitt dates the ring between 990 and 1030. He notes that the practice of ending an inscription in this manner first appeared among Byzantine lead seals only in about the year 1000, and for this reason he has proposed a similar date for this ring. The floral acanthus-scroll motifs on the hoop, also in niello, are, however, similar to *rinceaux* represented in thirteenth-century Byzantine illuminated manuscripts. Furthermore, the polylobed circumference of the ring's bezel is comparable to that on the example in the British Museum ascribed to Manuel Palaeologus (1348–1425). These comparisons lead us to believe that the ring may be as late in date as the thirteenth century, but perhaps additional study is needed before the ring can be dated more specifically.

KRB

EX COLLECTIONS: [Feuardent, Paris, 1924]; Private collection; [sale, Sotheby Parke Bernet, New York, May 21–22, 1982, lot 30]; [Michael Ward, Inc., New York].

EXHIBITION: "The Glory of Byzantium: Art and Culture of the Middle Byzantine Era, A.D. 843–1261," New York, The Metropolitan Museum of Art, March 11–July 6, 1997, no. 173.

REFERENCES: Blanchet, 1924, pp. 173–76; Ross, 1954, p. 169; Brown, 1983, p. 18, ill.; Nesbitt, 1997, no. 173, p. 248, color ill.

98: Exterior 98: Interior

98

LEFT WING OF A TRIPTYCH

Middle Byzantine (Constantinople ?), late 10th–early 11th century

Elephant ivory: Height, 7⁹⁄₁₆ in. (19.3 cm); maximum width, 1¹³⁄₁₆ in. (4.6 cm)

Provenance: Said to have come from Dume, near Braga, Portugal.

Rogers Fund, 1980 (1980.294)

The Annunciation, the Crucifixion, and the Women at the Tomb of the Risen Christ are depicted on the inner face of this now-fragmentary ivory panel. Two standing figures in low relief—one of whom holds a book, which is still intact—are carved on the exterior. The ivory's right, rounded edge, which is cut with dowel holes for hinges, shows that it formed the left wing of a triptych. Three more Christological scenes probably were carved on the missing right wing, and a single subject, or several, filled the larger central panel, as on Byzantine triptychs now in Paris, Munich, and Saint Petersburg. The Museum's panel belongs to a relatively small group of Byzantine ivories decorated with feast scenes.[1] The detailing of the face of the standing figure, which survives on the exterior of the triptych, remains in relatively pristine condition, while the faces of the figures in the narrative scenes from the Life of Christ, which were on

the interior, have been worn almost smooth, probably through veneration by touching and kissing.

Schnitzler, Volbach, and Bloch dated the triptych wing to the tenth century and attributed it to the so-called Romanos Group.[2] Frazer identified its style as a later development of that of the ivory Ascension panel in the Museo Nazionale del Bargello in Florence. She found the closest counterparts to the slender, somewhat elongated, and lively figures in eleventh-century Constantinopolitan manuscript illustrations, such as those found in a Gospel book in the Bibliothèque Nationale de France in Paris (gr. 64) and in a Psalter in the British Library (Add. gr. 19532).[3] While details of the triptych are also found on ivories attributed to the Romanos Group, it lacks the elegant refinement in proportions and composition that defines the objects in that group.[4] Most telling is the Crucifixion scene, in which a small John the Evangelist stands beneath an oversized crucified Christ with very thin limbs. John holds his right hand before his chest, his left hand grasping his Gospel; his face, which now is very worn, looks either up at the head of Christ or out toward the viewer. The closest parallel to this composition is found not in its rare occurrence among the Romanos ivories but in works of the less sophisticated Triptych Group, originally dated to the late tenth century. Most similar is the ivory Crucifixion scene on the cover of an eleventh-century French manuscript,[5] which Durand recently has dated between the late tenth and early eleventh century, possibly about 1000.[6] The Metropolitan's triptych fragment should be dated to the same period; it joins two other ivories now in the Museum's collection traditionally attributed to the Triptych Group: a Deesis plaque (17.190.133) and another triptych panel (41.190.99).[7]

MEF/HCE

1 See Frazer, 1981, p. 20.
2 See Schnitzler, Volbach, and Bloch, 1964, no. S 10, p. 13, ill.
3 See Frazer, 1981, p. 20.
4 The face of the standing figure on the exterior, with his hooded lids and deep folds under the eyes, as well as his finely detailed, stringy beard and large ears, is analogous to those of the prophets and apostles attributed to the Romanos Group, as seen on the great triptych in the Louvre. Similarities to details in the narrative scenes are also found on ivories attributed to the Romanos Group. The pose of the archangel at the tomb, the arresting spread of his wings, and the strong vertical of his staff recall the angel in a narrative panel in Milan, as does the composition of the Crucifixion scene; the pose of the Virgin standing before her throne at the Annunciation is reminiscent of the scene on a narrative ivory in Saint Petersburg; see Goldschmidt and Weitzmann, 1934, pp. 14–17, plates x–xxix, especially nos. 33, 42, and 59.
5 Ibid., p. 18, plates xlvii–lxiv, especially no. 166.
6 See Durand, 1992, no. 165, pp. 254–56. Randall, 1985, no. 194, p. 124, dated another ivory Crucifixion scene in the group, with the same composition, between the late tenth and the early eleventh century.
7 See Goldschmidt and Weitzmann, 1934, nos. 137, 153, pp. 63, 67.

EX COLLECTIONS: Ernst and Marthe Kofler-Truniger, Lucerne, until 1979; [sale, Sotheby Parke Bernet, London, December 13, 1979, lot 16]; [Blumka Gallery, New York, 1980].

EXHIBITIONS: "Avori dell'alto Medio Evo," Ravenna, Chiostri Francescani, September 9–October 21, 1956, no. 101; "Sammlung E. und M. Kofler-Truniger, Luzern," Zurich, Kunsthaus, June 7–August 2, 1964, no. 673; "Mittelalterliche Kunst der Sammlung Kofler-Truniger, Luzern," Aachen, Suermondt-Museum der Stadt, 1965, no. S 10.

REFERENCES: *Avori dell'alto Medio Evo*, 1956, no. 101; *Sammlung E. und M. Kofler-Truniger*, 1964, no. 673, p. 71; Schnitzler, Volbach, and Bloch, 1964, no. S 10, p. 13, ill.; Schnitzler et al., 1965, no. S 10, p. 13; Frazer, 1981, p. 20, ills.

Figure 1. Folio 114 *r* of the *Homilies of Gregory Nazianzos*, showing lamp brackets similar to catalogue number 99. Jerusalem (Patr. Lib. Cod. Taphou 14)

99

LAMP BRACKET

Middle Byzantine(?), 11th century(?)

Brass: Maximum length, 16¼ in. (41.3 cm); maximum width, 3 in. (7.6 cm)

Rogers Fund, 1979 (1979.349)

Light was an important mystical as well as practical element in the decoration of Byzantine churches, since, according to Saint John, Christ was the Light of the World. Paul the Silentiarios, in his poem in praise of the emperor Justinian's sixth-century Church of Holy Wisdom (Hagia Sophia) in Constantinople, evokes the startling and overwhelmingly beautiful effect of the polycandela suspended from the dome of the great building in a "circling choir of bright lights." He also extols the luminosity of the single lamps that hung over the aisles, presumably from brackets—a time-honored custom inherited from Rome.[1]

The Metropolitan's bracket originally carried a lamp suspended by chains from its finger-shaped terminal hook, and possibly a small lamp on the boss attached to the topmost volute. Very similar brackets appear in an eleventh-century Byzantine manuscript illustration, where they are shown projecting from columns at the bases of elaborately carved capitals (fig. 1).[2] It is probable that the Museum's bracket was made in the Middle Byzantine period, although an Early Byzantine date cannot be excluded. Few such elegantly worked examples survive.

MEF/HCE

1 See Frazer, 1980, pp. 20–21, ill. p. 20; Mango, 1972, p. 90.
2 The connection originally was suggested to Dr. Margaret E. Frazer by Dr. Gary Vikan, director of the Walters Art Gallery, Baltimore. Images of similar brackets are found on folio 114 *r* of the *Homilies of Gregory of Nazianzos* now in Jerusalem (Patr. Lib. cod. Taphou, 14).

EX COLLECTIONS: Ian T. Roper, n.d.; [René Gott, Geneva, 1979].

REFERENCE: Frazer, 1980, pp. 20–21, ill. p. 20.

100

ARCHITECTURAL BASE FOR A PROCESSIONAL CROSS

Middle Byzantine (Constantinople ? or Asia Minor), 11th–12th century

Copper alloy of leaded medium-tin bronze, with traces of zinc: 10½ x 2 x 2 in. (26.7 x 5.1 x 5.1 cm); diameter (staff end interior), 1⅜ in. (3.5 cm), (exterior), 1⅝ in. (4.1 cm)

Purchase, Max Falk, Alastair B. Martin, Stephen Scher, and William Kelly Simpson Gifts, in honor of William D. Wixom, 1993 (1993.165)

This base for a cross is in the form of a three-dimensional, Middle Byzantine church of the Greek-cross plan, set within a square.[1] A central high drum, punctuated by four keyhole windows, provided support for a missing cross. The tapered cylinder below, into which the missing staff, possibly of wood, would have fitted, is flanged at the top and bottom and abuts the circular opening in the floor of the putative church. The corrosion, patinas, and encrustation of this base probably are the result of its long burial. In addition, the pendulums are missing from the suspension loops below the four corners of the rectangular structure.

Its elongated proportions, height, and impression of openness set this base apart from other examples,[2] although the cagelike effect is loosely analogous to that of bases found in Berlin,[3] Hamburg,[4] and Saint Petersburg.[5] The arched openings, horseshoe shaped in profile, flank taller central arches that, as they are contiguous with the arches of the transept roofs, imply barrel vaults.

The high level of artistry in bronze work in Constantinople, documented by the series of monumental doors commissioned—from the 1060s on into the first half of the twelfth century—for churches on the Italian peninsula, suggests that that city was the possible origin of some of the extant cross bases. Examples in Berlin are reported to have been acquired in 1898 in Constantinople,[6] and in 1909 from Smyrna (present-day İzmir) in Asia Minor.[7] However, parallels in actual buildings located across the widespread Middle Byzantine Empire preclude any attempt at precise localization for many of these cross bases.

Like the Aachen artophorion,[8] with its central-plan structure and single dome surmounted by a cross, processional crosses set atop centralized-plan architectural bases also may refer simultaneously to the Holy Sepulcher and to "Sion," the City of God or the Heavenly Jerusalem.[9] It is possible that these processional crosses with related structures as part of their bases may represent more than simply Middle Byzantine parallels to some of the architectural bases of altar crosses of the twelfth century made in the Latin West.[10]

WDW

1 Compare this with the interior of Hosios Loukas; see *Glory of Byzantium*, 1997, p. 20, colorpl.
2 See Wixom, 1997 a, no. 21 A–D, pp. 55–56, color ills. pp. 56–57.
3 Staatliche Museen zu Berlin, Preussischer Kulturbesitz, 2487; see Wulff, 1911, no. 1981, p. 92, pl. xv; Volbach, 1930, pp. 165–66, ill.
4 Museum für Kunst und Gewerbe, 1963.94; see *Ausgewählte Werke aus den Erwerbungen*, 1972, no. 74, p. 143, ill., called Constantinople, Early Byzantine, sixth to seventh century.
5 *Byzantine Art in the Soviet Union*, 1977, vol. 3, no. 912, pp. 34–35.
6 See Wulff, 1911, no. 1981, p. 92, pl. xv; Volbach, 1930, pp. 165–66, ill.
7 See Wixom, 1997 a, no. 21 B, pp. 55–56, color ill. p. 57.
8 See Grabar, 1957, pp. 283–84, 293–94; Saunders, 1983, p. 216; Ousterhout, 1997, no. 300, pp. 460–61, color ill. p. 461.
9 This may be a kind of parallel to the mosaic and painted Pantokrator images on the interiors of the domes of Byzantine monastic churches at Daphni, Hosios Loukas, and Chios in Greece, and at Lysi, Lagoudera, and Trikomo on Cyprus; as well as at Santa Maria dell'Ammiraglio (the Martorana) and the Cappella Palatina in Palermo, and on the central dome of San Marco in Venice.
10 See Springer, 1981, nos. 19, 27, 28, figs. K161–163, K222–236, K244–251; *Ornamenta Ecclesiae*, 1985, vol. 1, nos. B–111, B–112.

EX COLLECTION: [Ariadne Gallery, New York].

EXHIBITION: "The Glory of Byzantium: Art and Culture of the Middle Byzantine Era, A.D. 843–1261," New York, The Metropolitan Museum of Art, March 11–July 6, 1997, no. 21 E.

REFERENCES: *MMA Annual Report*, 1993, p. 32, ill.; Wixom, 1997 a, no. 21 E, pp. 55–56, color ill. p. 57.

101

PROCESSIONAL CROSS

Middle Byzantine, first half of the 11th century

Silver and silver gilt: 23⅝ x 17¾ in. (60 x 45.1 cm)

Inscribed (on the front medallions): IC XC ("Jesus Christ"), MP ΘΥ ("Mother of God"), O A IⲰ O ΠΡ ("John the Precursor"), MIXAIΛ ("Michael"), ΓΑΒΡΙΛ ("Gabriel"); (on the back medallions): O A ΘΑΛΕΛΕΟC ("Saint Thalelaios"), O A NIKOΛAOC ("Saint Nicholas"), O A IⲰ O XPOC ("Saint John Chrysostom"), OPIΛ ("Uriel"), ΡΑΦΙΛ ("Raphael"); (on the foot): ΔΕΗCIC ΛΕⲰΝΤⲰC ΕΠΗCΚΟΠΟΝ ("supplication of Leo, bishop")

Rogers Fund, 1993 (1993.163)

The silver-gilt medallions on both sides of this exceptionally handsome processional cross, which is finely wrought in silver and silver gilt, make it unique among surviving Byzantine examples. On the face of the cross, at the center, is a medallion with a bust of the blessing Christ, surrounded by an incised pattern of freely worked repoussé *rinceau* vine scrolls on each of the four arms, which together form a smaller cross. At the ends of the crossbar are medallions with images of the Virgin and of John the Precursor (the Baptist) raising their hands in prayer toward the image of Christ—the standard Deesis composition in the Byzantine world. At the terminals of the vertical arm of the cross are the archangels Michael and Gabriel, respectively, each dressed in a different Byzantine court costume. An elegant acanthus leaf decorates the gilded foot of the cross, at the point where the staff by which the cross was carried was inserted. A ruched ribbonlike band outlines the cross.

The reverse is severely plain except for five silver-gilt medallions: At the center is Saint Thalelaios, a medical saint martyred in

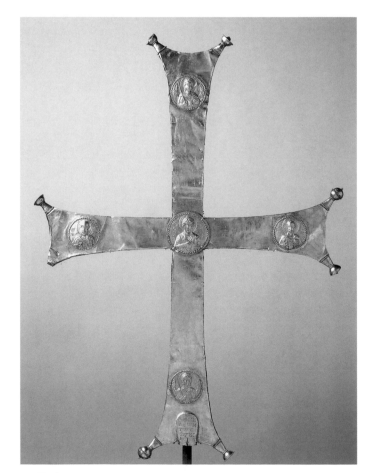

101: Back

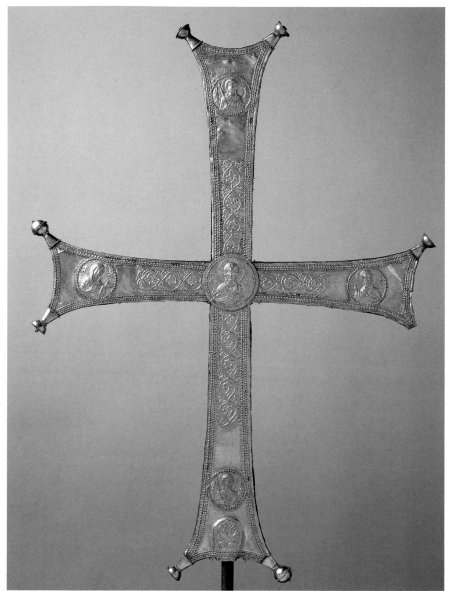

101: Front

the late third century, who carries the medical case and lancet of his profession; he is flanked by the popular Byzantine saints Nicholas and John Chrysostom. At the ends of the vertical arm of the cross are the archangels Uriel (above) and Raphael (below), again in Byzantine court dress. The silver-gilt base is inscribed in Greek, "supplication [gift] of Leo, bishop," and an inscription identifies each of the figures on the cross, as well.

The donor of the cross cannot yet be connected with a historical figure. In style, however, the work is similar to a group of processional crosses made between the eleventh and thirteenth centuries, which have medallions on the front and niello decoration on their reverse sides. The freely wrought *rinceau* pattern and the elegant articulation of the figures on this example identify it as among the earliest in the series; it probably dates to sometime between the early and mid-eleventh century. It is argued that these crosses were meant as votive offerings to the central image on the reverse side. As Saint Thalelaios, while now little known, was widely popular in the Byzantine world, the site of the consecration of this cross and even that of its manufacture remain uncertain.[1] It may have been dedicated to a site named for the saint or it may have been meant as a general gift of thanksgiving for a cure and not associated with a place that bore a specific connection to him.[2] It has been

suggested that as the saint is named in the liturgy for the blessing of the waters at Epiphany (January 6), the cross may have been meant for use in that rite.[3]

The Museum's cross was constructed of eight hammered silver sheaths, which were held together at the ends of the crossarm by eight ball-shaped finials. The medallions decorating the cross were first filled with gypsum and backed with iron disks, which were soldered on for additional support before the sheaths were attached to the core with the same solder. The separately modeled central medallions covered the ends of the sheaths. The burnished silver and partially gilded surfaces of the cross are well preserved,[4] and portions of the iron core survive, but only two of the finials are complete.

HCE

1 See Evans, 1997, no. 25, pp. 62–64, ill. p. 62, colorpl. p. 63, and nos. 24, 26, and 27, pp. 60–62, 64–67, ill. p. 65, colorplates pp. 61, 65, 66, 67, for other processional crosses and a full discussion of the attributions of these works.
2 Ibid., p. 64.
3 Ibid. See also Katsarelias, 1997, no. 23, pp. 59–60, colorpl. and ill. p. 59.
4 Evans, 1997, p. 62. See Dandridge, forthcoming.

EXHIBITION: "The Glory of Byzantium: Art and Culture of the Middle Byzantine Era, A.D. 843–1261," New York, The Metropolitan Museum of Art, March 11–July 6, 1997, no. 25.

REFERENCES: *MMA Annual Report*, 1993, p. 33; Cotsonis, 1994, p. 58; Evans, 1997, no. 25, pp. 62–64, ill. p. 62, colorpl. p. 63; Dandridge, forthcoming.

102

DOUBLE-FACED ICON PENDANT

Middle Byzantine, late 11th–early 12th century
Gold and cloisonné enamel: Height, 1¼ in. (3.2 cm)
Inscribed (on the front): MP/ΘY ("Mother of God"); (on the back, in the lobes): IC/XC ("Jesus Christ"), OB/TΔ ("King of Glory")
Purchase, Lila Acheson Wallace Gift, 1994 (1994.403)

This exquisite double-faced icon pendant is a triumph of the greatest era of Byzantine cloisonné-enamel production. It is a rare, if not unique, example of enameling on both surfaces of a single sheet of gold that, together, represent the Virgin interceding with her son on behalf of mankind. On one side is an austere, majestic bust of Christ encased in a golden frame, symbolic of Heaven. His right hand is raised in a gesture of benediction, while in his other hand he presents the Gospels—their clasp open—to the viewer, inviting us to open the book and read. As indicated by the Greek inscriptions in the half-lobes of the frame, abbreviations for "Jesus Christ, King of Glory," the image is a miniature replica of Christ as Pantokrator—a popular theme for the decoration of the central dome of Middle Byzantine churches. Christ looks to the left as if he recognizes his mother, seen on the other side. The Virgin, identified in abbreviated Greek notations as the "Mother of God," turns toward the (now-damaged) hand of God in the upper right corner, her hands raised in prayer. The (partially lost) sky-blue ground surrounding her and the vivid green of the half-lobes place her in the earthly realm of the icon's owner, whose prayers would have sought her assistance. Her pose, that of the Virgin Hagiosoritissa, was widely popular during the Middle Byzantine era.[1]

HCE

1 See Evans, 1997, no. 112, p. 165.

EX COLLECTION: [Artemis Fine Arts Limited, London, 1994].

EXHIBITION: "The Glory of Byzantium: Art and Culture of the Middle Byzantine Era, A.D. 843–1261," New York, The Metropolitan Museum of Art, March 11–July 6, 1997, no. 112.

REFERENCES: Evans, 1995, p. 23, color ills.; Evans, 1997, no. 112, p. 165, color ills.

102: Front

102: Back

103

TEMPLE PENDANT AND STICK

Middle Byzantine (Constantinople), late 11th–first half of the 12th century
Gold and cloisonné enamel: Height (pendant, including loop), 1¹⁵⁄₁₆ in. (4.9 cm); length (stick), 2 in. (5.1 cm)
Rogers Fund, 1990 (1990.235a,b)

These objects are among the few surviving examples of secular Byzantine cloisonné enamel work. The pendant, a hollow, crescent-shaped gold receptacle, has an opening and a suspension loop at the top. The convex sides are covered with exquisitely worked cloisonné enameling in colorful patterns of florets, interlocked palmettes, variegated borders, and a medallion with a beardless male head that may represent an angel or possibly Saint John the Evangelist. The accompanying thin, tapering stick is embellished with a pattern of cloisonné-enameled crosses.

The meticulous craftsmanship and minute scale of the enameling on both objects, as well as their individual motifs, ally them with a small group of enameled works that may be the luxury products of a highly specialized workshop active in Constantinople during the late eleventh and the first half of the twelfth century. These objects include, among others, a pear-shaped pendant from a *loros*, in the Dumbarton Oaks Research Library and Collection, Washington, D.C.;[1] a hexagonal tip of a pointer, now in the Metropolitan Museum (1997.235; cat. no. 104);[2] a similar pointer tip, in Princeton;[3] and four convex lunate plaques mounted on a later reliquary cross, recently returned to the Monastery of Vyšší Brod (Hohenfurth), in the Czech Republic.[4]

The purpose of the pendant is clarified by the presence of its vessel-like cavity, which relates it to the Kievan Rus' gold and cloisonné-enameled pendants of the eleventh and twelfth centuries given to the Metropolitan Museum by J. Pierpont Morgan in 1917. Several of these pieces, referred to since the nineteenth century by the Ukrainian ethnographic misnomer *kolty* (temple pendants), are thought to have been worn in pairs by both men and women near the temples or cheeks, suspended from the hair, or from caps, headbands, or the flaps of a headdress. They probably contained bits of cloth soaked in aromatic oil.

This type of ornament, as well as the cloisonné-enameling technique, may well have originated with Byzantine craftsmen in or from Constantinople. Our pendant is the first physical evidence to support this theory. Because of its extreme refinement and style, the pendant is a prestigious object. As such, it was undoubtedly a fragment of court costume, and even may have been part of imperial regalia. By its very form and opulence it may represent a source of influence of Byzantine luxury articles abroad. The enameled gold stick most likely served as an aid for inserting the cloth into the narrow cavity of the pendant.

WDW

1 See Boyd, 1997, no. 146, pp. 212–13, color ill. p. 212.
2 See Wixom, 1997 a, no. 175, p. 249, color ill.
3 See Wixom, 1995 a, p. 661, n. 21.
4 See Wessel, 1968, no. 50, pp. 163–64, ills. pp. 162, 165; Wixom, 1995 a, p. 661; *idem*, 1997 a, pp. 246, 442, color ill. (detail), p. 441.

EX COLLECTION: [Robert Haber & Associates, Inc., Ancient Art, New York].

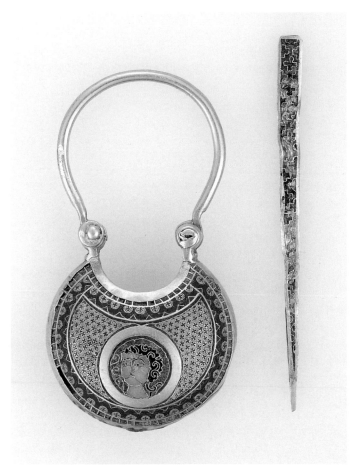

103

103: Back of temple pendant

104

104

TIP OF A POINTER

Middle Byzantine (Constantinople), late 11th–first half of the 12th century
Gold and cloisonné enamel: Height, 1 in. (2.5 cm)
Purchase, Louis V. Bell Fund and Henry G. Keasby Bequest, 1997 (1997.235)

This delicately wrought and finely detailed tip of a pointer—or, less likely, scepter—represents the highest form of the enameler's art. Hexagonal in shape, with a flat-domed tip, it is decorated on the sides with alternating bands of geometric stepped lozenge patterns and quatrelobe pseudofoliate ornamentation. The base of the pointer is defined by alternating lobes and semicircles filled with leaf patterns; the tip is decorated with alternating pseudogeometric patterns and vine stems. Ladderlike strips of cloisons in translucent green enamel separate the decorative zones and hide the angles of the hexagonal form. The intricate designs are worked predominantly in white, red, and translucent blue enamels.

The elaborately detailed patterns are typical of the small-scale decoration favored in Middle Byzantine art in many mediums,

including manuscript illumination—as seen in catalogue number 105 (1991.232.15). One of the few enameled works of similar quality that survive is the Museum's temple pendant and stick (1990.235 a,b; cat. no. 103). A pendant from a *loros*, or imperial sash of office, in the Byzantine collection at the Dumbarton Oaks Research Library and Collection, Washington, D.C.; a ring thought to be from the "Gisela" Treasure, in the Kunstgewerbemuseum, Staatliche Museen Preussischer Kulturbesitz, Berlin; a four-sided "scepter" tip in the Art Museum, Princeton University; and the Byzantine lunate enameled plaques on the cross from Vyšší Brod (Hohenfurth) in the Czech Republic also may be included in the group.[1] The refinement of their designs and workmanship suggests that the workshop that produced them was located in the capital of the Byzantine empire in Constantinople.

While its function is not certain, William D. Wixom has suggested that the Museum's work is the tip of a pointer that was used to mark the place while reading a manuscript.[2] The *Homilies of John Chrysostom* (ms. Coislin 79A), in the Bibliothèque Nationale de France, Paris, shows the monk Sabas using a long, thin pointer as he reads to the emperor Nikephoros III Botaneiates.[3] The elegance of this tip would have made it a fitting embellishment for a tool used to assist in reading texts to the imperial family. No complete pointer survives, and no scepter, or depiction of a scepter, is known with a similar design.

HCE

1 For the most recent discussion of the issue, with related bibliography, see Boyd, 1997, no. 146, pp. 212–13, color ill.; Little, 1997 a, no. 341 C, pp. 503–4, color ill.; Wixom, 1997 a, no. 170, pp. 246–47, color ill., no. 175, p. 249, color ill.
2 See Wixom, 1997 a, no. 175, p. 249.
3 See H. Maguire, 1997, no. 143, pp. 207–9, colorpl. p. 82 (with related bibliography).

105: Recto

105: Verso

105

Joannes Koulix, scribe

LEAF FROM THE EPISTLE TO THE HEBREWS

Middle Byzantine, 12th century (1101)

Tempera, gold, and ink on parchment: 7³¹⁄₃₂ x 6¼ in. (20.3 x 16 cm)

Provenance: Meteora, Greece, before 1898.

Purchase, The Cloisters Collection, Rogers and Harris Brisbane Dick Funds, and Joseph Pulitzer Bequest, 1991 (1991.232.15)

This leaf, the first page of Saint Paul's Epistle to the Hebrews, is decorated with a handsome rectangular headpiece and an incipit letter topped with a portrait bust of the author. Dimitrios G. Katsarelias, while a Kevorkian Fellow at The Metropolitan Museum of Art—and with the advice of Professor Robert Nelson of the University of Chicago—identified the leaf as originally part of a *Praxapostolos*, a text used only for the celebration of the Eucharist, which was copied by the scribe Joannes Koulix in A.D. 1101.[1] Most of the remainder of the manuscript is now in the Bibliothèque Nationale de France, Paris (ms. suppl. gr. 1262).[2] The finely detailed portrait bust of Saint Paul and the richly colored geometric and foliated patterns of the headpiece, both set against a gilded ground, are typical of Byzantine art of the period, as is the presence of an extensive catena, or commentary, around the primary text; here, the commentary is on the epistles written by Oecimenius, Bishop of Thriccae.[3] The undecorated verso of the leaf contains the last eight chapter headings of the epistle.

HCE

1 From the forthcoming article on the leaf by Dimitrios G. Katsarelias, deputy director, The Foundation for Hellenic Culture, New York.
2 Ibid.; the present locations of other individual leaves are also identified.
3 Ibid.

EX COLLECTIONS: Victor Martin Le Roy, Neuilly-sur-Seine; Jean-Joseph Marquet de Vasselot, Paris; [Alain Moatti, Paris].

REFERENCE: *MMA Annual Report*, 1992, p. 41.

106

THREE BYZANTINE CERAMIC BOWLS

A. BOWL, WITH A GEOMETRIC ROSETTE

Middle Byzantine, first half of the 12th century

Engraved slipware (orange clay, cream slip, and transparent yellowish glaze): Height, 2¼ in. (5.7 cm); maximum diameter, 7⅞ in. (20 cm)

Rogers Fund, 1994 (1994.306)

B. BOWL, WITH A SCROLLING ROSETTE

Middle Byzantine (Corinth?), first half of the 12th century

Engraved slipware (red clay, cream slip [now greenish gray], and transparent glaze): Height, 3¾ in. (9.5 cm); maximum diameter, 9¼ in. (23.5 cm)

Gift of Professor Maan Z. Madina, in honor of Margaret English Frazer, Curator Emeritus of Medieval Art, 1994 (1994.517)

106: A

106: B

C. BOWL, WITH A RAPTOR

Middle Byzantine, 12th century

Engraved slipware (orange clay, cream slip, and transparent yellowish glaze): Height, 2½ in. (6.4 cm); maximum diameter, 9⅝ in. (24.4 cm)

Anonymous Gift, 1984 (1984.302)

Byzantine art encompasses not only the formal works of great elegance associated with the wealthiest of churches and the court but also objects of charming simplicity. Foremost among these are ceramics, which survive in some number. Turned on the potter's wheel, coated with cream-colored slip, decorated with quickly incised lines, and then usually dipped in a transparent glaze before firing, they suggest drawings in the immediacy of their designs. Most that survive, like these, are tableware from shipwrecks.[1]

Examples with geometric patterns are often reminiscent of metalwork. The Museum possesses two such works. As is typical of decoration in this period, it is restricted to the interiors of the bowls. In the conical interior of the smaller of the two examples (A), a compass was used to mark off a series of bands, filled with scroll patterns, around a central rosette carefully divided into eight lobes.[2] The pattern of the rosette is like that found in a more elaborate form on the Museum's silver plate (1989.143; see cat. no. 43). The larger of these bowls (B) has gently swelling sides covered with a clear glaze that turned a soft gray green during its immersion in the sea. A compass, whose point mark is still visible at the center of the bowl, was used to define a narrow band and a large rosette filled with richly ornamented patterns like those seen on contemporary metalwork and on enamel work.[3]

Bowls of similar construction also were decorated with motifs of the hunt, which were thought to be symbolic of power and social status. The Museum's example (C) of a bowl with this theme has a handsome bird of prey inscribed in its interior. As with other bowls of the type, scrolling branches extend from the bird's beak and provide a perch for his feet.[4]

HCE

106: C

1 See Armstrong, 1997, pp. 5–6.
2 See E. D. Maguire, 1997, no. 181, p. 259, ill. and colorpl.
3 Ibid., no. 182, p. 260, ill. and colorpl.
4 Ibid., no. 187, p. 265, ill. and colorpl.

EX COLLECTIONS: (A) [John P. Demoleas, New Brunswick, New Jersey, 1994]; (B) Maan Z. Madina, until 1994; (C) [Blumka Gallery, New York, 1984].

EXHIBITION: "The Glory of Byzantium: Art and Culture of the Middle Byzantine Era, A.D. 843–1261," New York, The Metropolitan Museum of Art, March 11–July 6, 1997, nos. 181, 182, 187.

REFERENCES: (A, B, C) E. D. Maguire, 1997, nos. 181, 182, 187, pp. 259, 260, 265, ills. pp. 259, 260, 265, colorplates pp. 259, 260, 265; (A, B) Evans, 1995, p. 24, ill.; (C) *MMA Annual Report*, 1985, p. 43.

107

BOWL FRAGMENT, WITH HORSE AND RIDER

Crusader (Antioch?), early 13th century

Engraved slipware: Maximum diameter, 10½ in. (26.7 cm)

Anonymous Gift, 1984 (1984.181)

This fragment of a large bowl retains a portion of an engraved image of a rider on horseback. The rim is decorated with a quickly drawn, double-lined, running zigzag motif, probably an abstraction of a leaf pattern. After they were thrown and had dried, bowls such as this one were covered with a slip—usually white, as here. The engraving of the decoration revealed the darker clay body beneath. During firing, the lead glaze then applied to the decorated bowl often produced a green glaze like that on the Museum's fragment.[1] No parallel example is known on which to base a complete reconstruction of the decoration. The traditional association of such apparently secular figures with the popular Middle Byzantine epic hero Digenes Akritas can no longer be sustained.[2] Most recently, the rider has been identified as a falconer who holds the lure with which he will attract the bird in his left hand.[3]

HCE

1 See Biers, 1977, p. 334.
2 Ibid., pp. 335–36.
3 See E. D. Maguire, 1997, no. 268, p. 401, color ill.

EX COLLECTIONS: Mr. and Mrs. Charles D. Kelekian, New York, until 1978; [Kelekian Associates Ancient Art, New York, until 1984].

EXHIBITION: "The Glory of Byzantium: Art and Culture of the Middle Byzantine Era, A.D. 843–1261," New York, The Metropolitan Museum of Art, March 11–July 6, 1997, no. 268.

REFERENCE: E. D. Maguire, 1997, no. 268, p. 401, color ill.

108

SAINT MICHAEL THE ARCHANGEL

Late Byzantine, late 13th century

Marble: 10 x 6¾ x 4³⁄₁₆ in. (25.4 x 17.1 x 10.7 cm)

Provenance: Possibly from the Monastery of the Virgin Peribleptos, Constantinople (now Istanbul), presently occupied by the Sulumanastir.

Purchase, Gifts of J. Pierpont Morgan, George Blumenthal, and Messrs. Duveen Brothers, by exchange; Bequests of George Blumenthal and Anne D. Thomson, The Collection of Michael Dreicer, Bequest of Michael Dreicer, and Theodore M. Davis Collection, Bequest of Theodore M. Davis, by exchange; Rogers Fund and Mr. and Mrs. Maxime L. Hermanos Gift, 1983 (1983.167)

This capital, in the form of a bust-length image of the winged archangel Michael, whose name is inscribed in Greek on its abacus, shows him turning to the right and holding a trilobed scepter, and an orb covered with parallel lines, on which is set a quatrelobed cross. The archangel is dressed in imperial robes, consisting of a *divetesion*, or tunic, the bodice of which is divided into bands whose raised decoration is meant to represent embroidery, jewels, and pearls, under a himation, or cloak. A wide diadem with a central jewel separates the curls that frame his face and the hair that is pulled straight back toward the halo encircling his head. His blank eyes are deeply set in his round, full face; its surface areas are articulated in a sophisticated manner. It has been suggested that the blank eyes were once painted, as are those of a male head now in the

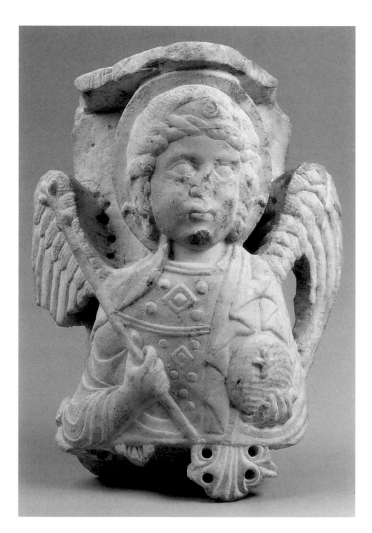

Saint Sophia Museum in Istanbul.[1] A row of acanthus leaves—only one survives intact—provided a base for the bust of the archangel.

In the details of the shape of the archangel's face; the design of the hair, diadem, scepter tip, and unusually patterned orb; as well as in the position of the soft, full hands, this image is most like a full-length sculpture of the archangel Michael, now in Berlin and said to be from the destroyed Monastery of the Virgin Peribleptos in Constantinople, founded in the early eleventh century.[2] This work has been dated variously between the twelfth and the last quarter of the thirteenth century.[3] The designs on the orb held by the present figure, which are without parallel, to my knowledge, except on the example in Germany, support the association of the two carvings with the same workshop, if not the same monument. The Museum's bust of the archangel Michael also has been compared to the figures on some late-thirteenth-century and early-fourteenth-century architectural sculpture of similar scale found in Constantinople, especially in the churches of Christ of the Chōra (now the Kariye Camii), the Theotokos hē Pammakaristos (now part of the Fethiye Camii), and Saint John the Baptist at the Lips Monastery (now part of the Fenari Isa Camii), where they decorated ciborium arches, altar screens, tomb canopies, and freestanding column capitals.[4] The similarities in the scale of the angel and in the use of acanthus leaves on the bases of these monuments argue for a probable dating of the Metropolitan's archangel to the late thirteenth century.

The sides of the capital are sharply beveled, which indicates that the carving was never freestanding but probably crowned an engaged pilaster or colonnette in a corner inside a church. Related although undecorated capitals are found on engaged colonnettes in two corners in the mid-eleventh-century Church of Nea Mone on the island of Chios. Images of Michael, perhaps accompanied by other archangels, may have been placed similarly in a church in Constantinople (now Istanbul).[5]

MEF/HCE

1 See Frazer, 1984, p. 14.
2 See Effenberger, 1992, nos. 146, 147, pp. 245–47, color ill.
3 See Volbach, 1968, no. 107 b, p. 206, pl. 107 b (12th century); Mathews, 1997, no. 12, pp. 45–47, colorpl. p. 46 (late 12th century); Effenberger, 1992, nos. 146–147, pp. 245–47 (last quarter 13th century).
4 See Frazer, 1984, pp. 13–14, ill. p. 14.
5 Ibid., p. 14.

EX COLLECTION: [Robin Symes Limited, London, 1983].

REFERENCE: Frazer, 1984, pp. 13–14, ill. p. 14.

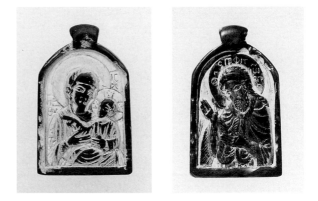

109

ICON PENDANT, WITH THE VIRGIN HODEGETRIA AND SAINT JOHN THE BAPTIST

Middle Byzantine, 12th–13th century

Serpentine: 1 ⁹⁄₁₆ x ³¹⁄₃₂ in. (4 x 2.45 cm)

Purchase, Gift of J. Pierpont Morgan and Bequest of Thomas W. Lamont, by exchange, 1981 (1981.414)

Byzantine icons, objects for religious veneration, range in size from monumental wall paintings to small and intimate images for personal devotion often worn by their owners, such as this double faced amulet. On one side is a bust of the Virgin holding the Christ Child in her left arm—an image known as the Virgin Hodegetria, the most widely copied among the icons of the Virgin.[1] Looking tenderly at her son, she gestures toward him with her right hand. The abbreviated inscription in Greek above her shoulder identifies her as the Mother of God, while the one alongside her halo identifies her son as Jesus Christ. The Christ Child looks beyond his mother, in recognition and blessing, in the direction in which he is pointing with the deliberately oversized fingers of his right hand; in his left hand is a scroll. The slight exaggeration of the blessing hand of the Child is meant to direct attention to John the Precursor (the Baptist), the figure on the reverse side of the amulet, who is identified by the abbreviated inscription in Greek on his halo. John wears the fur cloak and is shown with the ungroomed hair of a desert ascetic that became popular in depictions of him beginning in the eleventh century. He bows his head before the Christ Child[2] and raises his hands in the Byzantine gesture of prayer, thus returning the viewer's gaze to the other side of the amulet, which bears the object of his veneration.

This image of the Virgin and Child can be dated by its affinity to a less finely carved twelfth-century jasper cameo in Paris and a steatite carving from the twelfth or thirteenth century, with the same subject, in London.[3] The serpentine has changed from brown to white through some unknown natural cause.

The extensive wear on the surface is probably the result of the frequent handling of the icon when its owners were engaged in prayer.

HCE

1 See Ševčenko, 1991, vol. 3, pp. 2172–73.
2 See Irmscher et al., 1991, vol. 2, pp. 1068–69.
3 See Avisseau, 1992, no. 199, p. 286, ill.; Kalavrezou-Maxeiner, 1985, no. 80, pp. 169–70, pl. 45.

EX COLLECTION: [Robin Symes Limited, London, 1981].

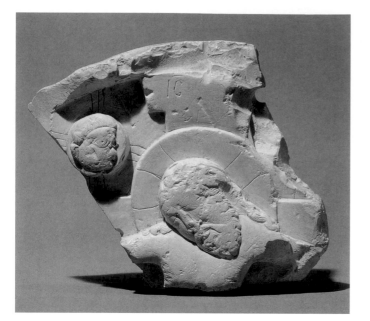

110

HEAD OF CHRIST, FROM AN ICON OF THE CRUCIFIXION

Middle Byzantine, 12th–13th century

Light green steatite: Height, 2⁹⁄₁₆ in. (6.5 cm); maximum width, 3 in. (7.6 cm); maximum depth, ¾ in. (1.9 cm)

Gift of Dr. and Mrs. Andrew J. Werner, 1981 (1981.215)

HCE

EX COLLECTIONS: [Blumka Gallery, New York]; Dr. and Mrs. Andrew J. Werner, 1981.

111

DOUBLE-SIDED ICON PENDANT, WITH THE ARCHANGEL MICHAEL AND THE PROPHET DANIEL IN THE LION'S DEN

Late Byzantine, 13th century(?)

Serpentine (lizardite?): 2¼ x 1⅜ x ½ in. (5.7 x 3.5 x 1.27 cm)

Gift of Mrs. Hayford Peirce, 1987 (1987.442.4)

HCE

EX COLLECTION: Hayford Peirce collection, until 1987.

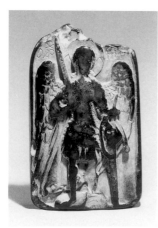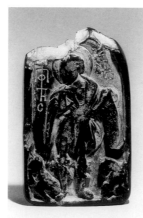

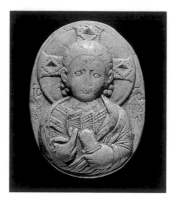

112

OVAL ICON PENDANT, WITH CHRIST EMMANUEL

Late Byzantine, 13th–14th century

Beige steatite: 1⅛ x ¹³⁄₁₆ in. (2.9 x 2.08 cm)

Purchase, William Kelly Simpson Gift, 1987 (1987.23)

This delicately carved steatite icon displays a frontal bust of the youthful Christ Emmanuel, the incarnate Word, identified by the damaged inscription in Greek flanking his shoulders. Christ's head is silhouetted against a large cruciform nimbus, and he holds a scroll in his left hand while his right hand makes a preaching gesture. The pendant retains its finely carved surface and highly polished back and sides, although details of the features of Christ's face are worn away, probably from the constant touching and kissing of the icon in veneration.

The steatite can be dated by the exquisite detailing of the carving and by the three stylized locks of hair behind each ear. Such highly detailed carving is typical of Byzantine works of the thirteenth to the fourteenth century, as seen in the depiction of Christ Emmanuel in the sculptural decoration of the early-fourteenth-century Palaiologan religious complex, now the Fethiye Camii in Istanbul.[1] A similar stylized treatment of the hair also occurs on a less finely detailed pendant of Christ Emmanuel in Cleveland, dated between the thirteenth and the fourteenth century.[2]

There is a small loss on the right edge of the face and several chips on the undecorated back of the pendant.

HCE

1 See Firatli, 1990, no. 300, p. 150, pl. 92.
2 See Kalavrezou-Maxeiner, 1985, no. 114, p. 190, pl. 55.

EX COLLECTIONS: Derek Content, Israel, n.d.; [Benedicte Oehry, Zurich, until 1987].

REFERENCE: *MMA Annual Report*, 1987, p. 34, ill.

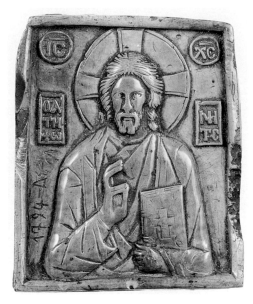

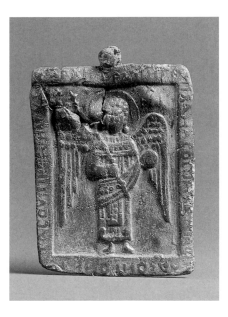

113

ICON OF CHRIST ANTIPHONETES

Late Byzantine (Greece?), 14th–15th century(?)

Green steatite, with traces of gilding: 2⅝ x 2⅝ x ¾ in. (6.7 x 6.7 x 1.9 cm)

Rogers Fund, 1979 (1979.217)

This bust-length image of Christ shows him raising his right hand in a gesture of blessing as he holds his Gospel book in his left hand. The use of this small icon for personal devotion over many centuries is evidenced by the nose, in particular, which has worn smooth and become flattened probably by generations of its owners touching and kissing the face in veneration. The chips on the raised frame of the icon, as well as the incised inscription in Greek alongside the right arm of Christ, added on December 11, 1794, also attest to its continued use. While the figure's pose is typical of representations of Christ Pantokrator, the surrounding inscriptions carved in Greek in relief identify the subject as Christ Antiphonetes—literally, "the one who responds," or "the guarantor." A famous miracle-working image with this theme was known in Constantinople as early as the seventh century.[1] The style of the Metropolitan's icon demonstrates the lasting popularity of the subject, for such depictions of Christ, with a small head in proportion to his body, are typical of the Palaiologan period (1261–1453)—the last centuries of Byzantine rule. The present work has been attributed to Greece.[2]

Traces of gilding remain on the halo and in the inscription.

HCE

1 See Ševčenko, 1991, vol. 1, p. 439.
2 Accession papers prepared by Margaret E. Frazer, curator emeritus, Archives of the Department of Medieval Art and The Cloisters, The Metropolitan Museum of Art; see also Kalavrezou-Maxeiner, 1985, who specifically attributes the work to southern Greece.

EX COLLECTION: [Galerie Kourd, J. Kourdoglanian, Brussels, until 1979].

REFERENCE: Kalavrezou-Maxeiner, 1985, no. 147, p. 216, pl. 68.

114

ICON PENDANT, WITH THE ARCHANGEL MICHAEL

Late Byzantine, 14th century

Lead: 2⅛ x 1⅝ x 1/16 in. (5.4 x 4.1 x .16 cm)

Gift of Ruth and Victoria Blumka, 1988 (1988.408.1)

HCE

EX COLLECTION: [Blumka Gallery, New York, 1988].

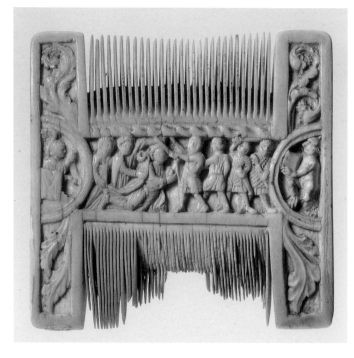
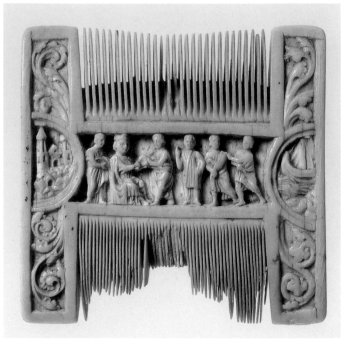

115

LITURGICAL COMB

English (Canterbury?), about 1200–1210

Ivory: Width, 3⅛ in. (7.9 cm)

Purchase, Rogers Fund, and Schimmel Foundation Inc., Mrs. Maxime L. Hermanos, Lila Acheson Wallace, Nathaniel Spear Jr., Mrs. Katherine S. Rorimer, William Kelly Simpson, Alastair B. Martin, and Anonymous Gifts, 1988 (1988.279)

Liturgical combs were used in preparing the priest for the Mass. Although they existed throughout the Middle Ages, this splendid example is one of the richest to survive, and the only comb known that is decorated with scenes from the life and martyrdom of Thomas Becket. On one side is the rarely depicted episode of Henry II informing Becket that he will become the archbishop of Canterbury—an event that took place at Henry's castle at Falaise, in Normandy, in May 1162. The subject can be verified from its only other representation, which appears in the early-fourteenth-century *Psalter of Queen Mary* (London, British Library, Royal MS 2.B.vii, fol. 290 v).[1] In the adjacent scenes are the boat that will take Thomas on his final mission to England (right) and a Romanesque façade (left), which bears a close resemblance to a depiction of Canterbury Cathedral on an 1161 seal of the Priory of Christ Church, Canterbury. The four corners of the comb are ornamented with scrolling acanthus leaves.

The opposite side shows the martyrdom of Thomas Becket in Canterbury Cathedral on December 29, 1170. The half-circles flanking the event contain an angel at the altar of martyrdom (left) and a devil holding a book (right). Thus, good is correlated with the Church and with Becket, and evil with the king and his knights. Again, four acanthuses, each slightly different, occupy the corners.

The naturalism of the figures is remarkable: Dressed in pallia with precisely drawn, clinging drapery, the courtiers in the nomination scene twist and turn in a stagelike space, their gestures and contrapposto poses adding clarity to the composition. The adoption of a style that ultimately depends on the art of classical antiquity is one of the hallmarks of English art about 1200.

The fact that virtually the entire surface is filled with narrative and decorative elements, together with its other stylistic characteristics, points to an English origin for the comb. Furthermore, details of the figures and of the drapery style, decoration, and narrative presentation correspond closely to the repoussé scenes on the English silver ciborium at Saint-Maurice d'Agaune, in Switzerland, of about 1200–1210.[2] In addition, the increasing interest in naturalistic floral ornamentation is also seen on English sculpture from this time, with analogies provided, for example, by the capitals at Canterbury Cathedral. A possible origin at Canterbury for the present comb is suggested by stylistic parallels in manuscripts illuminated there from about 1180 to 1220, such as the *Great Canterbury Psalter* or the *Little Canterbury Psalter* (Paris, Bibliothèque Nationale de France, MSS lat. 8846 and 770).[3] Finally, the iconographic authority and historical accuracy of the scenes make Canterbury an even stronger candidate as the source of the Metropolitan Museum's comb.

CTL

1 See Warner, 1912, pl. 284.
2 See Stratford, 1984, no. 309, p. 288, ill. p. 26.
3 See Caviness, 1979, pp. 38–58.

EX COLLECTIONS: Marquis de Ganay; Martine, Comtesse de Béhague, Paris; [sale, Sotheby's, Monaco, December 5, 1987, lot 166, color ill.]; [Edward R. Lubin, New York].

REFERENCES: Little, 1989 b, p. 16, ill.; *idem*, forthcoming.

116

RELIQUARY CHEST

English (Canterbury), about 1207–13
Copper gilt: 7 x 10 x 4½ in. (17.8 x 25.4 x 11.4 cm)
The Cloisters Collection, 1980 (1980.417)

Traditional in shape and self-contained, this oblong reliquary chest, with a hipped roof, lion's feet, and openwork crest, is remarkable not only for its simplicity of form, sturdy construction, and fine technique, but also for its animated decoration and important iconography. The embellishment of the plaques that form the body and roof of this chasse was achieved through the processes of casting, engraving, chiseling, burnishing, and fire-gilding. The decoration is offset visually by separately cast and riveted border moldings that serve to hold the chest together.

The reliquary is fastened at the front by means of a hasp, suspended in a pinned tongue-and-groove fashion from a stylized floral shape that partially echoes, in reverse, the palmettes of the crest. The tongue-and-groove mechanism, which recurs at the lower edge of the rear panel, may have been the connecting point for an iron chain that once must have secured the chest in place. These closing and attachment devices, as well as the sturdiness of the construction itself, testify to a concern for the security of the now-lost relics that were kept inside.

Intended primarily as a reliquary to be placed on or above an altar, this work must have been designed with the dim light of a church interior and the flickering illumination of candles in mind. In the Middle Ages, when the original overall gilding of the object was intact, the decoration was discernible by means of the varying refraction of light on the beveled surfaces of the incised lines and crosshatched backgrounds—as is still the case in the less worn areas of the back panel. Today, with much of the gilding lost from the more exposed surfaces, the designs are mostly read as gilded lines and textured grounds, against the warm, light-chocolate-colored natural patina of the copper—a condition shared by other copper-gilt church utensils from the same period.[1]

The extensive series of holy personages represented in the medallions, each identified by an inscription, is of special importance. Christ, flanked by Saints Peter and Paul, appears at the center of the panel on the front of the lid, while Mary, with Ursula and Cordula, is depicted in the center of the panel on the opposite side. The horizontal panel in front, on the lower level, contains images of four canonized archbishops of Canterbury: Saint Elphege (martyr and twenty-eighth archbishop, 1005–12), Saint Thomas Becket (martyr and thirty-ninth archbishop, 1162–70), Saint Dunstan (twenty-fourth archbishop, 960–88), and Saint Anselm (thirty-fifth archbishop, 1093–1109). The back panel shows Saint Blaise, the bishop of Sebaste in Armenia, martyred in 316. Saint Blaise is known to have been represented by a relic in the Canterbury monastery that originally was dedicated to Peter and Paul but was later consecrated to Saint Augustine (the first archbishop of Canterbury, 597–605), who is seen next to Blaise. Images of the canonized kings Edward the Confessor (King of the English, 1042–66) and Edmund (King of East Anglia, 855–70) occupy the end panels. The representation of five archbishops of Canterbury, two saintly British monarchs, and two female martyr saints thought to have come from Britain (Ursula and Cordula) gives this reliquary chest a unique and special connection with Canterbury, the preeminent diocese in England.

The stylistic and paleographic details not only emphasize the English character of the chest but also firmly establish its origin in Canterbury in the early thirteenth century.[2] The inscriptions, while occasionally eccentric and not the work of a scribe—they are the efforts of an engraver or metalworker, who copied models supplied to him—tend to confirm this dating.[3] The attribution is further supported by the iconography, which is entirely compatible with

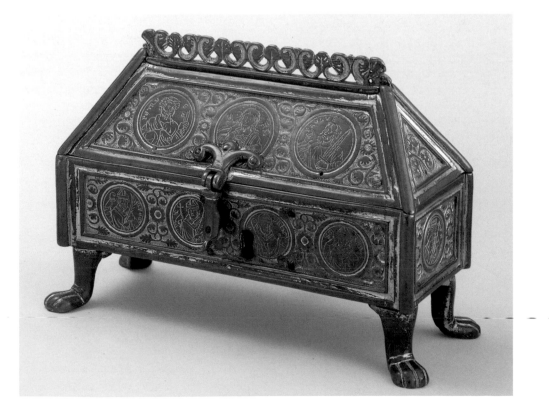

information gleaned from early Canterbury chronicles, inventories, and calendars.[4] Probably commissioned by the monks of Christ Church sometime from 1207 to 1213,[5] the reliquary chest represents a transitional crossroad between a Late Romanesque and a fully developed Gothic style at Canterbury.[6]

As the *only* surviving reliquary that may be attributed to Canterbury, neither the historical, stylistic, iconographic, and functional importance of the Cloisters' chest—within the larger issue of the artistic patronage of the monks—nor its purely artistic merits should be underestimated. The reliquary's fine proportions and rich decoration, however worn, are immediately appealing, while close study reveals the marvelously free, nervous lines of the drawings of the various holy personages. These drawings, confined within the firm borders of the medallions—combined with the interspaced foliated stems and rosettes and the careful, logical, and sturdy construction—yield the extraordinary balance of freedom and control for which the reliquary chest may be admired. This chest, a very significant addition to the Metropolitan Museum's small collection of fine and rare English medieval works of art, is a major document of the iconographic and stylistic trends in monastic art in England about 1200.

WDW

1 See Wixom, 1992 a, p. 197, figs. 9, 10.
2 Ibid., pp. 199–203.
3 Ibid., pp. 202–3.
4 Ibid., pp. 203–7.
5 Ibid., pp. 207, 209–13.
6 Ibid., pp. 213–17.

EX COLLECTIONS: Samuel James Whawell (b. 1857–d. 1926), Hampstead, England; Robert Haynes, England; [D. Black, London, 1966]; Mr. and Mrs. John Hunt, Drumlech Bailey, County Dublin, Ireland.

EXHIBITIONS: "The Year 1200," New York, The Metropolitan Museum of Art, February 12–May 10, 1970, no. 88; "Memory and the Middle Ages," Chestnut Hill, Massachusetts, Boston College Museum of Art, February 17–May 21, 1995, no. 16; "Heinrich der Löwe und seine Zeit," Braunschweig, 1995, no. D 120; "The Glory of Byzantium: Art and Culture of the Middle Byzantine Era, A.D. 843–1261," New York, The Metropolitan Museum of Art, March 11–July 6, 1997, no. 302.

REFERENCES: Hoffmann, 1970, no. 88, pp. 80–81; Newton, 1975, p. 263; Wixom, 1981, pp. 23–24, colorpl. p. 23; Wixom, 1992 a, pp. 195–227 (with bibliography), figs. 1 a–e, 7 a–b, 8, 11 a–c, 12 a–d, 13 a–b, 14 a–b, colorpl. 4; Dandridge, 1992, pp. 229–33; *Heinrich der Löwe*, 1995, vol. 1, no. D 120, pp. 328–29, colorpl. p. 328; Reinburg, 1995, no. 16, p. 23, ill.; Wixom, 1997 a, no. 302, pp. 463–64, ills. p. 464, colorpl.

117

CANDLESTICK

North European or English, 13th century
Copper gilt: Height, 3⅝ in. (9.2 cm)
Gift of Dr. Louis R. Slattery, 1982 (1982.481)

This miniature pricket may have formed part of a traveling altar set employed by the clergy to celebrate Mass or the sacraments for those unable to attend church. The scalloped and petaled designs engraved on the foot and on the underside of the drip pan give this work an understated elegance.

TBH

EX COLLECTION: [Blumka Gallery, New York].

REFERENCE: Wixom, 1992 a, pp. 197, 204, fig. 10.

118

MINIATURE STATUETTE, OR GAME PIECE (?)

North German(?), about 1200–1250
Fine pumice stone: 1⅞ x 1 x ¾ in. (4.8 x 2.5 x 1.9 cm)
Rogers Fund, 1978 (1978.494)

CTL

EX COLLECTION: [Mythological Art, New York].

118

119

THEODOSIUS ARRIVES AT EPHESUS (SCENE FROM THE LEGEND OF THE SEVEN SLEEPERS OF EPHESUS)

French (Rouen), about 1200–1205

Pot-metal glass and vitreous paint: 25 x 28⅛ in. (63.5 x 71.4 cm)

Provenance: Nave, Cathedral of Notre-Dame, Rouen.

The Cloisters Collection, 1980 (1980.263.4)

Seven noble retainers of the Roman emperor Decius were converted to Christianity and refused to perform pagan rites. To avoid persecution, the seven hid in a cave and prayed for deliverance. God answered their prayers by putting them into a deep sleep just as the soldiers of Decius found the hiding place and sealed the cave with a huge stone. Two centuries later, during the reign of Theodosius II, a shepherd removed the stone to use as building material, and one of the sleepers, Malchus, ventured forth to buy bread. After he tried to pay the baker with an ancient coin, he was brought before the prefect and the bishop, who, although skeptical at first, soon realized, when they arrived at the cave, that they were witnessing a miraculous resurrection. Hearing the news, Theodosius traveled to the cave to venerate the seven, but after talking to the emperor, they once again fell into a deep sleep. Despite the popularity of the legend of the Seven Sleepers of Ephesus in the Middle Ages, its appearance as a theme in French stained glass is highly unusual; no other extensive cycles predate the glass from the nave of the cathedral of Rouen.

In the 1270s, the nave windows at Rouen were removed to make way for the addition of side chapels, which featured taller and narrower lancet windows in the Rayonnant Style. At the time, the format of the earlier glass was altered to fit the more elongated windows. Thus, none of the Seven Sleepers panels, which originally

were composed of cluster medallions surrounded by a mosaic ground—like the contemporary windows at Chartres—survives in its early-thirteenth-century state.

The presence of this panel and others from the Seven Sleepers cycle in the south aisle of the cathedral of Rouen was noted in published accounts by the historian Eustache Langlois issued between 1823 and 1832; however, by the middle of the nineteenth century, the Seven Sleepers panels had been placed in a tower storeroom. Although the Cloisters' panel was there when Jean Lafond inventoried the glass in 1911, between that date and 1932, a significant number of panels, including ours, disappeared, only to reappear on the art market.[1]

The attribution of the Seven Sleepers series to the cathedral of Rouen is based on its similarity to a window devoted to Saint John the Evangelist that is still in the nave of the cathedral. Both are distinguished by a light, bright palette of unusual colors. The expressive characterizations of the boldly silhouetted figures and the dramatic sense of narrative imparted by their articulation make these windows among the finest of the period, rivaling the stained glass at the cathedrals of Chartres and Bourges.

T B H / M B S

1 See Lafond, 1975, pp. 400–408, n. 8; Hayward et al., 1982, pp. 150–51; Cothren, 1986, pp. 205–13.

EX COLLECTIONS: [Augustin Lambert, Paris, 1923]; Raymond Pitcairn, Bryn Athyn, Pennsylvania.

EXHIBITION: "Radiance and Reflection: Medieval Art from the Raymond Pitcairn Collection," New York, The Cloisters/The Metropolitan Museum of Art, February 25–September 15, 1982, no. 56(D).

REFERENCES: Lafond, 1913, pp. 112–13; Ritter, 1926, pp. 7–8, 37–38; Grodecki, 1956, pp. 102–4; Hayward, 1970, pp. 2–3; Perrot, 1970, pp. 262–64; Lafond, 1975, pp. 399–416; Hayward, 1981 b, pp. 24–25, colorpl. p. 24; Hayward et al., 1982, no. 56, pp. 149–52, ill. p. 151(D); Hayward, 1985, p. 96, ill.; Cothren, 1986, pp. 203–26.

120

HEAD OF A BEARDED MAN

French (Rouen), about 1235

Pot-metal glass and vitreous paint: Height, 2½ in. (6.4 cm)

Provenance: Clement of Chartres window, Ambulatory, Rouen Cathedral.

Gift of Shirley Prager Branner, 1991 (1991.472)

On the basis of style, this striking head is thought either to have come from one of two ambulatory windows devoted to the Legend of Joseph or to be closely related to them. The name of the glass painter responsible for these glazings, Clement of Chartres, appears at the bottom of one of the scenes—an extremely rare instance of a signed thirteenth-century French window.[1]

T B H

1 See Grodecki and Brisac, 1984, p. 31, pl. 18, no. 68, p. 257.

EX COLLECTIONS: Jean Lafond, Paris; Robert and Shirley Prager Branner, New York.

120

121

TWO SCENES FROM THE LIFE OF SAINT NICHOLAS

A. **THREE KNIGHTS ARE CONDEMNED TO DEATH BY A CONSUL**

B. **SAINT NICHOLAS PLEADS ON BEHALF OF THE THREE KNIGHTS**

French (Soissons), about 1200–1210

Pot-metal glass and vitreous paint: (A) 21⅜ x 16 in. (54.3 x 40.6 cm); (B) 21½ x 16¼ in. (54.6 x 41.3 cm)

Inscribed (A): [S N]ICO/LAVS• PR[A]ESĒS/MILĪTES ("Saint Nicholas protects the soldiers")

Provenance: Cathedral of Saint-Gervais-et-Saint-Protais, Soissons.

The Cloisters Collection, 1980 (1980.263.2,3)

The brilliant palette; small, tubular, molded drapery patterns (*Muldenfalten*); and slender, elongated figure types evident in these stained-glass panels are characteristic of a style that emerged about 1200. The stained glass at Soissons reflects the earlier version of this style, probably influenced by antique models, which first appeared during the late twelfth century in the Meuse Valley. It is on the basis of this distinctive style that the panels are attributed with assurance to Soissons, even though no glass dedicated to Saint Nicholas is explicitly documented as having been there. A new principle of composition seems to have developed at Soissons—apparent in these panels, although both have been reduced—in which scenes were no longer organized in cluster medallions comprising lobes or circles, but in rectangular panels, set within arcades. This compositional innovation at Soissons would become the standard format by the middle of the thirteenth century. The choir of Soissons Cathedral may have been begun as early as about 1192 and was in use in 1212; it is thought, however, that the radiating chapels were glazed, at least in part, by 1208–9, or even earlier.[1] The glazing at Soissons was extensively damaged by the Huguenots, as well as by a munitions explosion in the early nineteenth century; little glass remains *in situ*, and many of the panels that have survived were removed during restoration in the nineteenth century and are now preserved in museum collections.

121: A

121: B

The two scenes depicted in these panels are of early events in Nicholas's life, and are rarely included in windows devoted to the saint. They concern a corrupt Roman consul, who condemned three innocent knights to death. Saint Nicholas, in response to the prayers of the knights, pleads their cause to both the emperor and the consul, ultimately miraculously winning the knights' freedom.

TBH/MBS

1 See Barnes, 1967, p. 265; Hayward et al., 1982, p. 138.

EX COLLECTION: Raymond Pitcairn, Bryn Athyn, Pennsylvania.

EXHIBITION: "Radiance and Reflection: Medieval Art from the Raymond Pitcairn Collection," New York, The Cloisters/The Metropolitan Museum of Art, February 25–September 15, 1982, no. 51.

REFERENCES: Grodecki, 1953, pp. 169–76; Verdier, 1958, pp. 4–22; Grodecki, 1960, pp. 163–78; *idem*, 1965, pp. 188–89; *idem*, 1977, pp. 218–19; Hayward, 1981 b, pp. 25–26, color ills.; Hayward et al., 1982, no. 51, pp. 137–39, ills. p. 138, colorplates VI, VII; Caviness, Pastan, and Beaven, 1984, p. 10, n. 17; Childs, 1985, pp. 25–33, figs. 1, 2, 10; Hayward, 1985, p. 97, ills.

122

VALVE OF A MORSE

French (Limoges), mid-13th century

Copper gilt: 6¹¹/₁₆ x 2 in. (17.1 x 5.1 cm)

The Erich Lederer Collection, Gift of Mrs. Erich Lederer, 1986 (1986.319.72)

BDB

EX COLLECTION: The Erich Lederer Collection, Geneva.

REFERENCE: Avery, 1895, no. 2, ill.

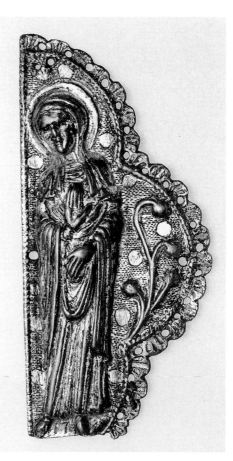

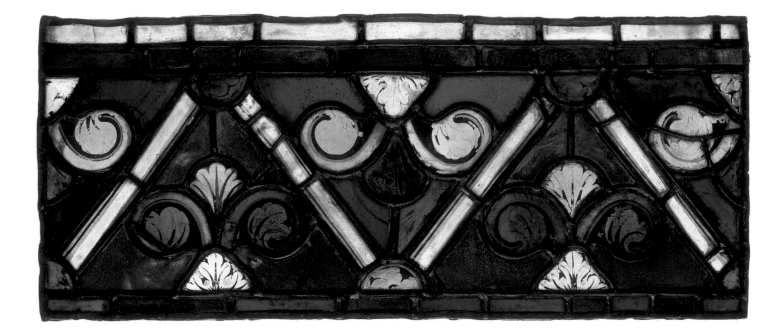

123

SECTION OF A BORDER

French (Île-de-France: Aisne), 1200–1205/30
Pot-metal glass and vitreous paint: 10 x 23¼ in. (25.4 x 59.1 cm)
The Cloisters Collection, 1992 (1992.284)

The provenance of this border fragment is uncertain: Borders with this pattern are recorded in the Cathedral of Saint-Gervais-et-Saint-Protais, Soissons, but they may have originated in the nearby Premonstratensian Abbey Church of Saint-Yved in Braine.[1]

TBH

1 See Caviness, 1990, pp. 359, 390, B/S.b.2.

EX COLLECTION: [Galerie für Glasmalerei, Zurich].

124

SECTION OF A BORDER

French (Picardy), about 1230
Pot-metal glass and vitreous paint: 13¾ x 5½ in. (34.9 x 14 cm)
The Cloisters Collection, 1982 (1982.356)

While the design of this border, in general, can be linked stylistically with Picardy glass, the reason for the attribution is largely circumstantial: A nearly identical pattern was used in a mid-nineteenth-century glazing of one of the radiating chapels in Amiens Cathedral, which suggests that fragments of a border from the original glazing may have served as the model.

TBH

EX COLLECTION: [Galerie für Glasmalerei, Zurich].

EXHIBITION: "Stained Glass from The Cloisters," supplement to "Viollet-le-Duc: Architect, Artist, Master of Historic Preservation," New York, The Grey Art Gallery and Study Center, New York University, January 19–February 27, 1988.

REFERENCE: Hayward, 1985, p. 97, ill.

125

SALTCELLAR

French (Paris), mid-13th century
Gold, with rock crystal, emeralds, pearls, and spinel or balas rubies:
Height, 5½ in. (14 cm); diameter (of foot), 3⅛ in. (8 cm)
The Cloisters Collection, 1983 (1983.434)

A marvel of exquisite craftsmanship, this small, gold-mounted rock-crystal boat, which rests on a high, knopped stem, above a tapered, conical base, is a rare example of Early Gothic goldsmiths' work. The crystal boat is meticulously carved with a pointed prow, a flat yet sloping stern, a keel that is rectangular in profile, and simple notching for the double oarlocks. Three interconnected hollows in the interior are arranged symmetrically along the boat's axis. The dovetailed sections of the stem, knop, and foot are executed entirely in gold, each joined to the next with small gold rivets. The upper surface of the rim of the vessel is decorated with seed pearls, emeralds, and spinel or balas rubies, set in minute, yet proportionally high, cylindrical gold collars, and below is an encircling border of tiny trefoils or a series of ivy leaves. This composite rim is fastened to the gold-sheathed keel by means of tongue-and-groove hinges. One-fourth of the cover is stationary, while the rest is hinged to the first part and may be lifted by means of a thin, engraved handle in the form of a serpent. The gems and pearls in combination with the serpent probably had an apotropaic meaning, as serpents' tongues were thought to warn against poison by breaking out into a sweat.[1]

The remarkable simplicity and elegant proportions of the Cloisters' object recall those of two French silver-gilt monstrance reliquaries of the Holy Thorn, preserved, respectively, in the Treasury of Saint-Maurice d'Agaune in Switzerland and in the Basilica of San Francesco in Assisi. Both are believed to have been made in Paris—the first, about 1262, and the second, before 1270[2]—and have similar tapered, conical stems and circular bases. The knops of the Cloisters' work and of the Saint-Maurice d'Agaune monstrance resemble peeled and opened tangerines, and, in addition, these two objects have pearls, emeralds, rubies, and tongue-and-groove hinges in common. The finial of a silver-gilt covered cup, also French, from the thirteenth century, and in the Treasury of Saint-Maurice d'Agaune as well, incorporates a serpent with comparable cross-hatched engraving and a similar form.[3] Additional parallels for the cylindrical collars of the gems and for the tongue-and-groove hinges may be seen in yet another, but more elaborate, thirteenth-century silver-gilt reliquary of the Holy Thorn from northeastern France, preserved in Arras.[4] In light of these comparisons, a date in the mid-thirteenth century is certain for the Cloisters' work, and a Paris localization for its manufacture is indicated on the basis of its especially close resemblance to the monstrance at Saint-Maurice d'Agaune, in Switzerland. Paris is also plausible, given the capital's preeminence in lapidary carving and goldsmiths' work, the latter activity centered on the Pont-Neuf.[5] The Parisian guild regulations for crystal carvers, cited in Étienne Boileau's *Le Livre des métiers*, of about 1268,[6] also lend further credence to the attribution of this splendid work to Paris.

Given that workshops must have produced both secular as well as liturgical vessels of stone and of gold, and that the closest parallel to the saltcellar, stylistically and technically, is a reliquary monstrance, the question arises as to the true function of the Cloisters'

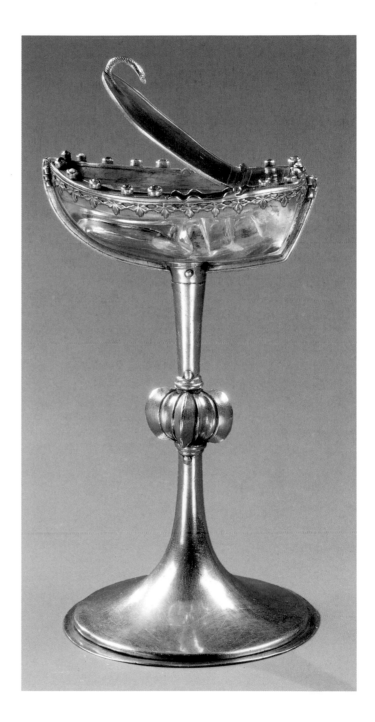

object. It was exhibited in New York in 1968 as an incense holder, or *navette*—a container to hold the incense before it was spooned out into a censer.[7] While the general shape of a *navette* is derived from that of a boat, the interior hollows of our delicate crystal are too small and intricate to contain sufficient incense to satisfy this function. Rather, its diminutive scale and costly materials suggest that this luxury object served, instead, as a receptacle for a precious commodity for the table, such as salt or a spice. Published inventories dating a century or more later than the present work—especially that of the possessions of the Valois king Charles V—include a number of tantalizing accounts of royal saltcellars (*salières*), some of them undoubtedly inherited from earlier generations, as in the case of Charles's manuscripts. Described as small, footed boats, *navettes*, or *nefs*, they often seem to have been made of similar materials and garnished in a comparable way to our object.[8] A preserved saltcellar, formerly in the collection of Louis Fould and dating from the fourteenth century, is composed of a shallow, agate vessel like the crystal boat of the Museum's example, and the hinge of the lid also is placed off-center[9] and the lid lifted by means of a serpent's head. The Fould saltcellar differs in that it is mounted on four wheels, not on a central support. The use of a proportionately high, stationary stem or foot like that inferred from the inventory descriptions of the royal saltcellars continued to prevail into the fifteenth century, as evidenced by a gold-mounted agate saltcellar, only ten centimeters high, in the Musée du Louvre, Paris.[10] What sets the Paris example apart is its elaborate architectural vocabulary of arcades, crenellations, buttresses, and turrets.

Ecclesiastical saltcellars, used in the sacrament of baptism and for the hallowing of water, appear only rarely in medieval inventories,[11] but this usage for our object cannot be excluded. Indeed, it is possible that these works may have been made first for an aristocratic or royal table, only later to be transferred to a church, as a gift or a bequest, for ecclesiastical use. However, information gleaned from early inventories does suggest that such prestigious objects in gold and crystal, enhanced with gems, undoubtedly signified royal patronage, ownership, or presentation, as a gift.[12]

In any case, these are only two examples of the historical fate that awaited Early Gothic secular table furnishings; works were also buried or destroyed during the long periods of looting, war, and revolution. Furthermore, some precious-metal objects were converted into coins in the Middle Ages by royal command, as in the ordinance of 1294 issued by Philippe le Bel;[13] others—in view of changing tastes—were melted down, and the gold and jeweled embellishments reused.

Thus, the Cloisters' saltcellar is precious on several accounts: for its costly materials—crystal, gold, pearls, and gems—fine workmanship, and elegant form, as well as for its status as an exceedingly rare medieval object of a type that has almost entirely disappeared. This thirteenth-century saltcellar remains the earliest and foremost example of goldsmiths' work among the Museum's distinguished collection of Gothic secular objects.

Lacking is any indication of a town mark—a feature that did not come into use in France until the last quarter of the thirteenth century, following the general ordinance of Philippe le Hardi of December 1275.[14] Significantly, indications of town marks are also lacking in Boileau's *Le Livre des métiers*.[15]

WDW

1 See Lightbown, 1978, pp. 29–30.
2 See Bouffard and Theurillat, 1974, pp. 24–26, 153–55, 194, colorplates pp. 155, 184; Gauthier, 1983, pp. 108–9; Wixom, 1987 b, pp. 32–33, figs. 4, 5.
3 See Bouffard and Theurillat, 1974, pp. 151–52, colorpl. p. 152.
4 See *Trésors des églises*, 1965, no. 40, pl. 114.
5 See Garlande, "Dictionarius," about 1220–29, in Scheler, 1867, p. 27, paragraphs 38–40; Egbert, 1974, pp. 33, 53, 57, 73, 79.
6 See Boileau, 1879, pp. 61–63.
7 See Viollet-le-Duc, 1871, pp. 133–34.
8 See Labarte, 1879, nos. 326, 327, 2097, 2165.
9 See Viollet-le-Duc, 1871, p. 151, fig. 2; Wixom, 1987 b, p. 32, fig. 3.
10 See Lightbown, 1978, p. 106, pl. 77.
11 See Oman, 1957, p. 101.
12 See Wixom, 1987 b, *passim*.
13 See Lightbown, 1978, p. 37.
14 Ibid., pp. 6–7.
15 See Boileau, 1879.

EX COLLECTIONS: Maurice Tempelsman, New York; [À La Vieille Russie, New York, until 1960]; Hembleton (The Cygnus Collection), New York; [Robin Symes Limited, London and New York].

EXHIBITION: "The Art of the Goldsmith and the Jeweler," New York, À La Vieille Russie, November 6–23, 1968, no. 1.

REFERENCES: *Art of the Goldsmith*, 1968, no. 1, pp. 9, 17, color frontispiece; Wixom, 1984 b, pp. 12–13, colorpl. p. 12; *idem*, 1987 b, pp. 30–35, color ill. p. 31.

126

HEAD OF AN ANGEL(?)

French (Paris), about 1250
Limestone, with traces of polychromy: Height, 9⅝ in. (24.4 cm)
Purchase, Michel David-Weill Gift, 1990 (1990.132)

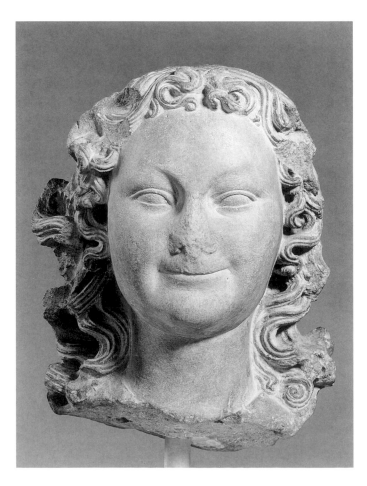

Beauty and tenderness mark the irresistible appeal of this angelic head, which possesses both a precociousness and a playfulness rarely seen in High Gothic sculpture. The deeply undercut elastic and cascading locks of hair; the suggestive, tight-lipped smile; and the refinement of the surface help place the work at the forefront of Parisian Gothic sculpture, about the middle of the thirteenth century. Carved from fine-grained limestone that was used for much of the decorative sculpture at Notre-Dame in Paris, the head can be linked by its stone and its style to the *Theological Virtues* formerly on the portal of the cathedral's north transept, which was completed about 1245;[1] however, the crispness of the lines and of the forms, together with the absence of weathering, suggests that it was part of an interior setting.

The jube that was destroyed by the architect Jules Hardouin-Mansart (1646–1708) at the end of the seventeenth century offers a plausible source for the head and for several fragmentary figures, as well as for portions of the *Raising of Adam and Eve*, now in the Musée du Louvre, Paris.[2] These sculptures, all nearly freestanding, survive as testimony to the scale and grandeur of the jube. The interiors of the terminals of the transepts, which contained the monumental figures of Adam and Eve and trumpeting angels, represent alternative contexts for the Metropolitan Museum's angel's head. Recent analysis of the limestone demonstrates that the geologic source of our sculpture and of a number of other fragments from Notre-Dame was situated in Paris. Although there is a strong probability that the carving came from the cathedral, the possibility that another thirteenth-century Parisian church utilized the same quarry for its sculptural decoration cannot be ruled out.

CTL

1 See Erlande-Brandenburg, 1982, no. 242. See also Kimpel, 1991, pp. 124–39.
2 Inv. no. RF 991. See Baron, 1996, p. 91.

EX COLLECTIONS: [Joseph Altounian, Mâcon]; [Joseph Brummer, New York]; Alexander M. Bing, New York; [Joseph Brummer, New York]; Des Moines Art Center; [sale, Sotheby's, New York, May 31, 1990, lot 20, ill.].

REFERENCES: Little, 1991, p. 16, ill.; *idem*, 1994 a, pp. 31–32.

127

CORPUS OF CHRIST

French (Paris?), about 1260–80
Elephant ivory, with traces of polychromy: Height, 6½ in. (16.5 cm)
Gift of Mr. and Mrs. Maxime L. Hermanos, 1978 (1978.521.3)

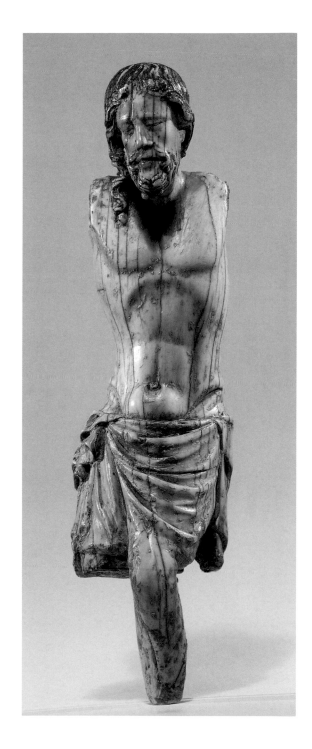

The suffering Christ on the Cross is a central theme in Gothic art. So significant was the subject that a mid-thirteenth-century Parisian statute authorized a guild specifically to carve such images, including examples in ivory. Unfortunately, few of these crucifixes have survived.

The present figure of Christ, whose pathos and agony are beautifully conveyed, was executed in the round, and most certainly was intended for an altar cross. In spite of the loss of both arms and parts of the legs (which, originally, were attached to the body by means of pegs), the modeling of the figure reveals a profound sensitivity to form and expression. The powerful anatomical structure—portraying, naturally, the corporeality of the dying Christ—is

remarkable for a crucifix from this period. The short loincloth is not fastened by a knot, but is tucked in at both sides, closely following the shape of the body; the thin, rhythmic folds of the drapery cling to the figure in the front, while the cloth at the sides is more fully draped. The face of Christ is carved with as much sensitivity as is the torso. The closed eyes and the long hair, which falls down the back and the right side of the head, reveal the emotional impact of death. A subtle twist in the torso was produced, in part, by the positioning of the legs, which were crossed and mounted on the cross with a single nail.

The important place occupied by this magnificent corpus within the development of Gothic sculpture can be determined by comparing it to works in stone, wood, and ivory produced in the Île-de-France at about the middle of the thirteenth century. Something of the spirit of this ivory and its sculptural presence is found in the wooden crucifix from Cerisiers, dated about 1260, now in the nearby cathedral of Sens.[1] The short loincloth of the Metropolitan's corpus has a close parallel in the same image as seen in the *Crucifixion* and *Deposition* scenes on the choir screen in the cathedral of Bourges, or in the Saint Honoratus portal at Amiens Cathedral.[2] However, the strong articulation of the torso and the rendering of the *perizonium* bear a striking resemblance to the Christ of the silver crucifix in the shrine in the Church of Sainte-Gertrude, in Nivelles, Belgium, created after 1272.[3]

Some aspects of Christ's physiognomy here—especially the closely trimmed beard and the short moustache, which leaves the middle of the upper lip bare and curves down at the corners of the mouth—can be compared with the face of Christ in a celebrated ivory *Deposition* in the Musée du Louvre, Paris.[4] The retrospective tendencies of the New York corpus, such as the clinging folds of the loincloth, which reflect the classicizing trends in the art of the early thirteenth century, add to its refined style and to the pathos it conveys—features that also would become revitalizing components of the mature Gothic style in the second half of the thirteenth century.

CTL

1 See Sauerländer, 1972, pl. 63.
2 Ibid., plates 294, 279, respectively.
3 See *Schatz aus den Trümmern*, 1995, p. 25, fig. 5.
4 See Gaborit-Chopin, 1978, figs. 206, 207.

EX COLLECTION: Mr. and Mrs. Maxime Levy Hermanos (1899–1985 and 1908–1992), Paris and New York.

EXHIBITION: "Images in Ivory: Precious Objects of the Gothic Age," The Detroit Institute of Arts, March 9–May 11, 1997, and Baltimore, Walters Art Gallery, June 22–August 31, 1997, no. 8.

REFERENCES: Little, 1979 a, pp. 58–67, especially pp. 59–60; *idem*, 1979 b, p. 24, ill.; Little and Husband, 1987, p. 95, colorpl. 86; Little, 1997 b, no. 8, pp. 128–29, ill.

128

THE CRUCIFIXION, FROM A MISSAL

French (Paris), about 1270–90
Tempera and gold leaf on parchment: 8¾ x 5⅞ in. (22.2 x 14.9 cm)
Purchase, Bequest of Thomas W. Lamont, by exchange, 1981
(1981.322)

An exquisite example "of that art which, at Paris, they call illumination,"[1] this painting on parchment was once set into a Missal, containing the liturgical texts for the celebration of the Eucharist. Jesus hangs on the cross, flanked by his mother, the Virgin Mary, and Saint John in mourning. The diminutive figure of Adam is seen rising from a sarcophagus at the foot of the cross and holding up a chalice to catch the sacrificial blood that spills from the wound in Christ's foot. Two angels bearing symbols of the sun and the moon emerge from clouds at each of the upper corners. The figures are dramatically isolated against alternating panels of diapered and tessellated backgrounds. The pigment used for flesh tones has flaked away in several areas, exposing the refined pen work underdrawing; the head of Saint John is the best preserved.

The miniature belongs to an important series of illuminations named for the Sainte-Chapelle Evangelistary (Bibliothèque Nationale de France, Paris, lat. 17326) and its immediate subcategory, called the Cholet Group after a Missal and Epistolary for Franciscan use made for Cardinal Jean Cholet of Nointel (Biblioteca Capitolare, Padua, D. 34, 37) and a Missal made between 1254 and 1286 for Saint-Denis use (Bibliothèque Nationale de France, Paris, lat. 1107).[2]

These deluxe Parisian Missals were ornamented with a series of historiated initials that incorporated illustrations of the principal feasts of the Church year. Preceding the Canon of the Mass (that part of the service when bread and wine are consecrated as the body and blood of Christ) were full-page illuminations representing the Crucifixion and Christ in Majesty.

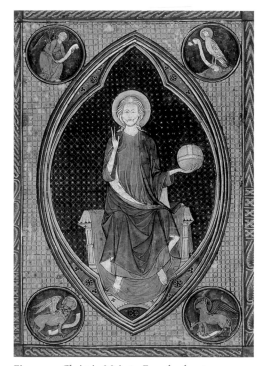

Figure 2. *Christ in Majesty*. French, about 1270–90. Tempera and gold leaf on parchment. Fitzwilliam Museum, Cambridge (Ms. Marlay Cutting Fr. 1.)

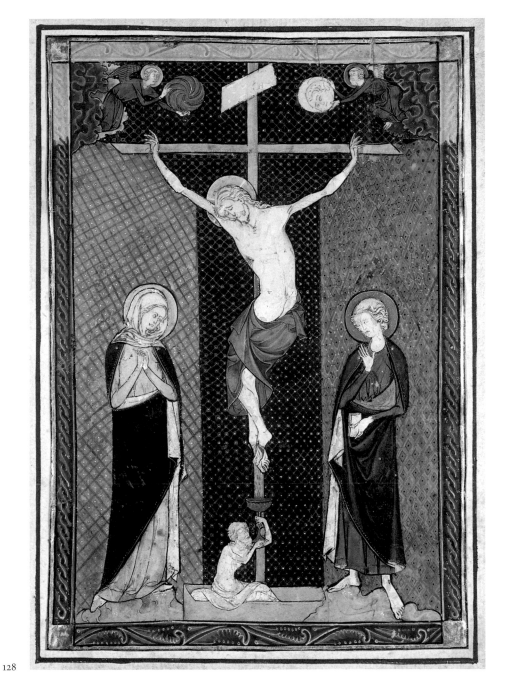

128

A leaf with Christ in Majesty now preserved in the Fitzwilliam Museum, Cambridge (fig. 2), seems to be the one that was once paired with the present image since it is almost identical in size and betrays the signature style of the same painter in such details as the elongated hands and feet and the looping line defining the toes of the figures, the rope border, and the dotted and diapered ground.[3] The generous size of these miniatures, even after having been cut from the full page, suggests that they were commissioned by an important patron.

It is significant that the Padua Missal made for Cardinal Cholet is missing both its Crucifixion and Majesty paintings. Its text block nearly corresponds in size (21 cm) to that of the New York and Cambridge miniatures, and the decorative patterns in the initials in the Padua manuscript are identical to those framing the Metropolitan's and the Fitzwilliam's illuminations. Could these splendid miniatures, in the finest Parisian tradition, be the missing full-page scenes from the Missal of Jean Cholet, originally set into the manuscript as a *bifolium*?[4] At the very least, the New York and Cambridge

leaves may be considered contemporary with the Missal that was made for Cholet when he was a cardinal, from 1290 to 1291.[5]

BDB/CTL

1 Dante, *Purgatorio*, canto XI, lines 79–81.
2 For related works see Branner, 1977, pp. 130–32, 237–38.
3 We are grateful to P. Wodhuysen, keeper of manuscripts and printed books at the Fitzwilliam Museum, Cambridge, for bringing this leaf to our attention.
4 We wish to thank Alison Stones of the University of Pittsburgh and Harvey Stahl of the University of California at Berkeley for this information and for photographs of the Cholet Missal.
5 This information also was provided by Alison Stones.

EX COLLECTIONS: Private collection; [sale, Sotheby Parke Bernet, London, July 11, 1978, lot 7]; Mr. Schumann; [H. P. Kraus, Inc., New York, 1981].

REFERENCES: Kraus, 1981, no. 27, colorpl. XXVI; Little, 1982, pp. 18–19, color ill. p. 18; Frazer, 1986 a, pp. 38, 39, no. 44, colorpl. p. 39; Little and Husband, 1987, p. 95, colorpl. 85.

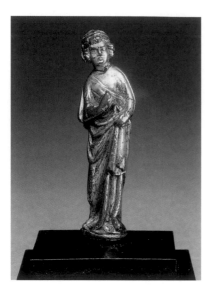

129

STANDING ANGEL

Northeast French, about 1275

Copper alloy, with mercury gilding: Height, 2⅜ in. (6 cm)

Purchase, Michel David-Weill Gift, 1991 (1991.309)

Modeled with a conviction and a clarity uncommon in the surviving examples of thirteenth-century metalwork on this scale, this diminutive, subtly pivoting figure conveys an intriguing sense of arrested movement. This organic tension, or contrapposto, together with the figure's proportions, rounded head, and cap of hair, and the configuration of the folds, recalls the large stone Angel of the Annunciation, of about 1245–55, on the left jamb of the right doorway on the façade of Reims Cathedral.[1] The widespread dissemination of this style during the High Gothic period in Northern Europe may have been facilitated by the export of such small statuettes as well as by stylistically related, larger statuettes in polychromed wood or ivory, which depicted not only figures of angels but also the Virgin Mary and various saints.

While the original function and context of this angel statuette are unknown, it seems certain that the figure was once part of a small private devotional shrine or reliquary, along with similar figures, all rendered in a gilded copper alloy. This suggestion is upheld by the remnants of two attachment pins on the reverse. The identification of the figure as an angel is immediately apparent from the physiognomic type and the coiffure, which are characteristic of representations of angels in this period, and is further confirmed by the flat rectangular bridge between the shoulders, which supported the separately worked wings that were soldered there. The configuration of the lost wings is evoked by the upswept wings of the angels on a Mosan silver-gilt reliquary crown, of about 1260, in the Musée du Louvre, Paris.[2] The Metropolitan Museum's figure is probably the Archangel Gabriel from an Annunciation group because of the gesture of the raised right hand.

WDW

1 See Sauerländer, 1972, pl. 198; Wixom, 1974 b, pp. 92–93, fig. 30.
2 Wixom, 1974 b, pp. 87–88, fig. 15.

EX COLLECTIONS: Peter Wilson, London; [sale, Sotheby's, London, July 4, 1991, lot 27, color ill.].

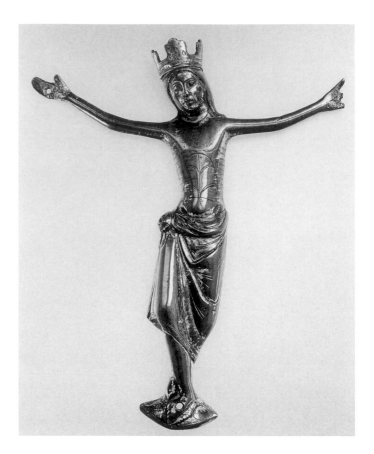

130

CORPUS OF CHRIST

French (Limoges), mid-13th century

Copper gilt: Maximum height, 8½ in. (21.6 cm); maximum width, 6⅞ in. (17.5 cm)

The Erich Lederer Collection, Gift of Mrs. Erich Lederer, 1986 (1986.319.73)

BDB

EX COLLECTION: The Erich Lederer Collection, Geneva.

REFERENCE: Avery, 1985, no. 1, ill.

131

GRISAILLE PANEL

French (Auxerre), 1240–45

White glass and vitreous paint: 23 x 22⅛ in. (58.4 x 56.2 cm)

Provenance: Axial chapel dedicated to the Virgin, Cathedral of Saint-Étienne, Auxerre.

The Cloisters Collection, 1982 (1982.204.2)

This grisaille panel from Auxerre Cathedral exhibits an integral, centripetal pattern typical of mid-thirteenth-century stained glass. Marred by extensive surface corrosion and paint loss, the panel's ornament consists of a canted, lobed quatrefoil interlaced with a canted square. The bold outlines of the lead cames that join the different pieces of glass together also emphasize the compositional structure of these interlocking forms. Stylized foliate vines grow from the center of the panel, contrasting with the underlying net of cross-hatching over which they are superimposed. Panels with

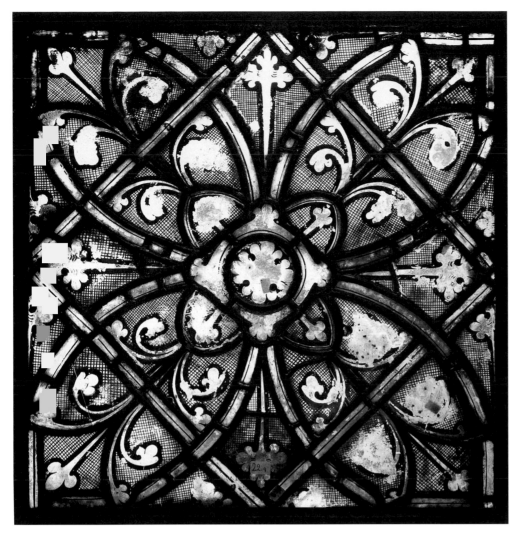

131

132

identical grisaille patterns remain *in situ* at Auxerre in the axial Chapel of the Virgin, whose proportionately large number of grisaille windows anticipated the glazings embraced in the second half of the thirteenth century that combined colored and grisaille glass. The Cloisters' panel likely was removed during the restorations carried out by Louis Steinheil and Charles Leprévost in the late nineteenth century.

M B S

EX COLLECTIONS: Charles Leprévost (?), Paris; [Michel Acézat, Paris]; [sale, Hôtel Drouot, Paris, November 24–25, 1969, lot 22, n.p. (one of thirteen panels)]; [Michael Meyer, Paris]; [Sibyll Kummer-Rothenhäusler, Galerie für Glasmalerei, Zurich].

REFERENCES: Viollet-le-Duc, 1875, vol. 9, pp. 448–49, 450, fig. 40 (identifies this grisaille pattern as having originated in the Chapel of the Virgin, Auxerre Cathedral, and reproduces the design); Ottin, 1896, p. 25, fig. 20 (reproduces the design); *MMA Annual Report*, 1983, p. 41; Hayward, 1985, p. 98, ill.

132

SECTION OF A BORDER, WITH A BAND OF GRISAILLE

French (Troyes), about 1260–80

Pot-metal and colorless glass, and vitreous paint: 22½ x 8¾ in. (57.2 x 22.2 cm)

Provenance: Probably from the Collegiate Church of Saint-Urbain, Troyes.

Gift of John L. Feldman, 1994 (1994.108.2)

The combination of a narrow colored-glass border and a band of grisaille, which originally flanked a narrative scene, appears to have been employed in the choir windows of the Church of Saint-Urbain, Troyes. The present example is one of two given to the Metropolitan Museum (the other panel is 1994.108.1).

T B H

EX COLLECTIONS: Augustin Lambert, Paris, until 1928; [Joseph Brummer, New York, until 1949; [sale, Parke-Bernet Galleries, New York, May 13, 1949, lot 603, p. 152]; [Christie's, New York, January 11, 1994, lot 1, p. 11, ill.]; John L. Feldman, Lakewood, Colorado.

REFERENCE: Shepard, 1990, pp. 181–82.

133

SIX GRISAILLE PANELS

French (Bourges), 1260–70
White and pot-metal glass, with vitreous paint

A. 23½ x 18½ in. (59.7 x 47 cm)
 Provenance: Southeast nave clerestory, Cathedral of Saint-Étienne, Bourges.
 The Cloisters Collection, 1982 (1982.433.1)

B. 22⅞ x 17⅜ in. (58.1 x 44.1 cm)
 Provenance: Nave clerestory, Cathedral of Saint-Étienne, Bourges.
 The Cloisters Collection, 1982 (1982.204.4)

C. 27½ x 18¼ in. (69.9 x 47 cm)
 Provenance: Upper ambulatory, Cathedral of Saint-Étienne, Bourges.
 The Cloisters Collection, 1982 (1982.204.5)

D–F. (1982.204.7) 17¾ x 11⅜ in. (45.1 x 28.9 cm); (1982.204.8) 18⅛ x 11⅜ in. (46 x 28.9 cm); (1982.204.9) 18⅛ x 11⁵⁄₁₆ in. (46 x 28.7 cm)
 Provenance: Upper ambulatory, Cathedral of Saint-Étienne, Bourges.
 The Cloisters Collection, 1982 (1982.204.7-9)

133: A

These six grisaille panels come from Bourges Cathedral, whose extensive medieval glazing included grisaille windows in the nave and ambulatory clerestories. The attribution to Bourges rests on the similarity between the Cloisters' panels and grisaille windows from the cathedral published by Arthur Martin and Charles Cahier from 1841 to 1844. Each of the four patterns seen in these panels is strongly centripetal in design: Stylized foliage, undulating strapwork, and interlocking geometric shapes all extend outward from centralized motifs. The boldly painted cross-hatching indicates the panels' original location in the upper reaches of the cathedral's windows.

The panels most likely were removed from the cathedral during the extensive restoration campaign undertaken by Louis Steinheil and Charles Leprévost in 1885, when a large number of the grisaille windows were heavily restored or replaced with modern copies. It was not at all unusual in the nineteenth century for glass painters to substitute copies for panels with broken or especially weathered glass, frequently keeping the original medieval panels or fragments. These, in turn, inevitably would find their way onto the art market through the estate sales of glass painters or their heirs.

MBS

EX COLLECTIONS: Charles Leprévost(?), Paris; [Michel Acézat, Paris]; [sale, Hôtel Drouot, Paris, November 24–25, 1969, lots 22 (one of thirteen panels), 23 (one of fourteen panels), n.p.]; [Michael Meyer, Paris]; [Sibyll Kummer-Rothenhäusler, Galerie für Glasmalerei, Zurich].

REFERENCES: Martin and Cahier, 1841–44, vol. 2, pp. 301–2, plates XXXI–XXXIII, and "Grisailles A, B, C" (reproduce grisaille designs); *MMA Annual Report*, 1983, p. 41; Hayward, 1985, pp. 101–2, ills.

133: D

133: B

133: C

133: E

133: F

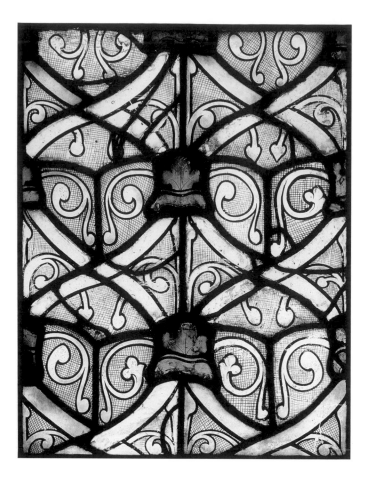

134

GRISAILLE PANEL

French, 1260–70

White and pot-metal glass, with vitreous paint: 23⅜ x 18 in. (60 x 45.7 cm)

The Cloisters Collection, 1982 (1982.433.2)

With its complex, interwoven design, including tendrils shown—atypically—growing downward, and vibrant cobalt bosses, this grisaille panel attests to the subtle inventiveness of French glass painting in the second half of the thirteenth century. Although comparable to grisaille designs from nave clerestory windows at Bourges Cathedral dating to the 1260s, the intricate interlace pattern of this panel cannot be linked definitively with any one site.

MBS

EX COLLECTIONS: Charles Leprévost(?), Paris; [Michel Acézat, Paris]; [sale, Hôtel Drouot, Paris, November 24–25, 1969, lot 22, n.p. (one of thirteen panels)]; [Michael Meyer, Paris]; [Sibyll Kummer-Rothenhäusler, Galerie für Glasmalerei, Zurich].

REFERENCES: *MMA Annual Report*, 1983, p. 41; Hayward, 1985, p. 102, ill.

135

WOVEN SILK, WITH ADDORSED AND REGARDANT GRIFFINS IN ROUNDELS

Western Mediterranean (Spanish?) or East Iranian(?), late 13th–early 14th century

Lampas weave, silk, and gilt parchment, over cotton yarn:[1] 69¼ x 38¼ in. (175.9 x 97.2 cm)

The Cloisters Collection, 1984 (1984.344)

Golden paired griffins set in interlocking roundels enliven this exceptionally rare medieval silk, among the finest of the extant examples known. The beasts are outlined in pink and set against a greenish blue plain-weave ground. Filling the interstices between the roundels are stylized palmette motifs in gold, outlined with blue against a pink ground. A band along the top edge loosely imitates an Arabic inscription. The woven fabric, a complete loom width, interconnects two structures: warp-faced plain weave (in greenish blue) for the foundation and weft-faced ½ twill (in gold and pink) for the pattern.

Until recently, such large and rich silks have been preserved almost exclusively in the great church treasuries of Europe, and are

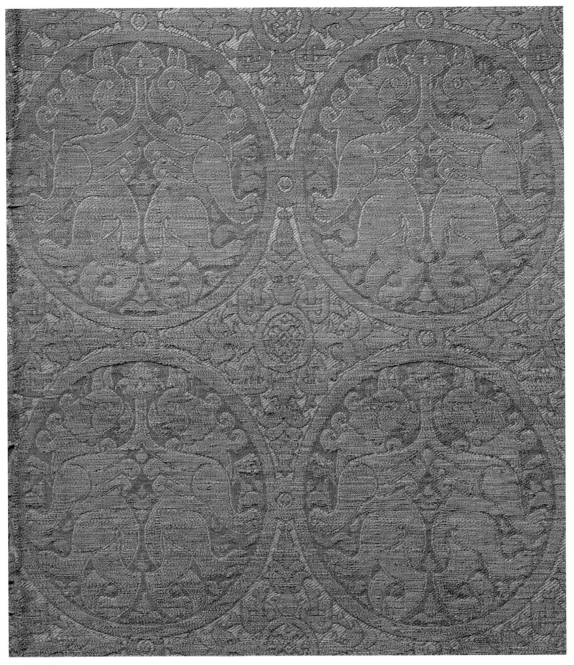

135: Detail

associated with popes, emperors, and sainted bishops. Related panels of this size were used chiefly as funeral palls. A woven silk with a very similar pattern, and incorporating an Arab weaver's name, but without gold, was excavated from a tomb in Bremen Cathedral.[2]

While there has been universal recognition among textile scholars concerning the importance and rarity of the Cloisters' silk, there has been little if any consensus concerning its attribution. According to the dealer from whom it was purchased, this silk was removed from the back of a *thangka* preserved in a Tibetan monastery—a testament to its status. This history, combined with technical aspects of the weaving (notably, the type of selvage and the use of a cotton-core yarn for gold thread), led Anne Wardwell to conclude initially that the Cloisters' silk was made in Central Asia before the Mongol conquest and, subsequently, to attribute it to the eastern Iranian world in the mid-thirteenth century.[3] Leonie von Wilckens, who first considered the silk to be Spanish or North African, later attributed it to Baghdad.[4]

Clearly, while the attributions of such eminently portable objects must be approached with caution, none of these putative provenances is inconsistent in the context of medieval collections. Exchange among centers of textile production and the sites of their subsequent use—exemplified in an inventory of the Cathedral of Lugo in northern Spain, which includes a cope made of cloth produced in Baghdad—was the rule, not the exception, in the Middle Ages.[5]

Nobuko Kajitani, conservator in charge, Department of Textiles, at The Metropolitan Museum of Art, finds the individual technical aspects of the silk—the use of cotton and the selvage—consistent with a Spanish context, and cites, additionally, similarities to Spanish silks in the palette of pink and blue, the use of gilt parchment, and the disposition of the inhabited roundels. Whereas the weavers of Eastern silks arranged complete roundels across the width of the selvage, the creators of the Cloisters' silk, working from the left side, placed six roundels across, with apparent disregard for the precise measurement of the design against the loom width, with the result that the final roundel is incomplete. Kajitani associates this uniquely with silks of western provenance, including examples unearthed from Spanish tombs.[6]

Nor is it cavalier to posit the transference of a western silk to the East. Indeed, the thirteenth century was a period of numerous western political and spiritual initiatives to Asia, especially through the efforts of the Dominican and Franciscan orders.[7] On such missions, textiles frequently were offered and received as gifts. When Andrew of Longjumeau served as emissary to the Mongols on behalf of Louis IX, he carried a tent chapel embroidered in scarlet as an offering; he returned with rich cloth, a gift from the Mongol queen.[8]

BDB

1 According to Robert Koestler and Norman Indictor, in a report dated September 11, 1984, in the Department of Medieval Art archives.
2 The comparison was first noted by the late Leonie von Wilckens, curator of textiles at the Germanisches Nationalmuseum, Nuremberg. See Nockert and Lundvall, 1986, no. 12, p. 56.
3 See Wardwell, 1989, pp. 175–84 (for the attribution to Central Asia); Watt and Wardwell, 1997, no. 44, pp. 156–57.
4 See letters of April 19 and July 11, 1987, from von Wilckens to William D. Wixom, in the Department of Medieval Art files (for Spain or North Africa) and von Wilckens, 1991, pp. 35–38 (for Baghdad).
5 See May, 1957, p. 51.
6 Oral communication, Spring 1998.
7 See Jackson, 1990, pp. 2–3, 27–30.
8 Ibid., pp. 35–36.

EX COLLECTIONS: Stephen McGuinness; Henry Ginsburg, London.

EXHIBITION: "When Silk Was Gold: Central Asian and Chinese Textiles," The Cleveland Museum of Art, October 26, 1997–January 4, 1998, and New York, The Metropolitan Museum of Art, March 3–May 17, 1998, no. 44.

REFERENCES: Boehm, 1985, p. 12, color ill.; Wardwell, 1989, pp. 175–84; von Wilckens, 1991, pp. 35–38, fig. 15; Boehm, 1995 b, p. 36, color ill.; Watt and Wardwell, 1997, no. 44, pp. 135–37, 156–57, colorplates pp. 156–57.

136

AQUAMANILE IN THE FORM OF A COCK

German (Lower Saxony), second half of the 13th century

Latten alloy: Height, 9 15/16 in. (25.2 cm)

The Cloisters Collection, 1989 (1989.292)

Aquamaniles are vessels to hold water, used when washing the hands. They were probably first employed by priests during the celebration of the Mass and subsequently came into favor at the dining tables of princes, aristocrats, and wealthy merchants. Over 250 are preserved from the Middle Ages.[1] As recorded in the 1252 inventory of the Treasury of the Cathedral of Saint Martin and Saint Stephan in Mainz, the early examples were made in the form of lions, dragons, birds, and griffins;[2] later ones, created for domestic use, included horses, equestrian knights and falconers, dogs, centaurs, and unicorns as subjects. While it is generally difficult to prove that a particular aquamanile was either purely decorative or had symbolic significance, literary references or allusions to the Bible, patristic literature, bestiaries, and romances cannot be ruled out in the interpretations of their subject matter.

This aquamanile, a noteworthy addition to the Metropolitan Museum's distinguished collection, is a superb example of a previously unrepresented and very rare iconographic and stylistic type. Cast in the lost-wax process, with the lidded aperture located between the rows of upright tail feathers, and supported on two feet, the vessel—in its modeling, proportions, and engraving, and,

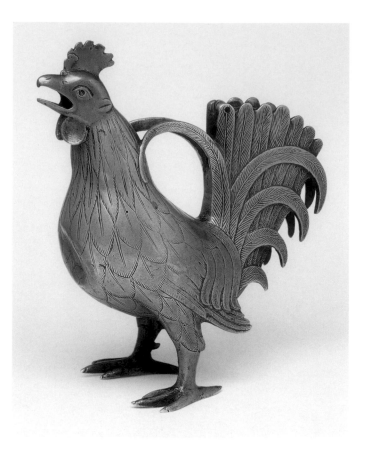

specifically, in the treatment of the eyes, beak, comb, wattles, and feathers of the cock—is a finished, three-dimensional sculpture, finely observed with regard to natural detail. Yet, there was also a concern for reducing natural features to essentials—a characteristic of many works of the Late Middle Ages. The swelling form and feathered textures, which resemble those of an actual bird, are not an indication of realism in the modern sense but, rather, of verisimilitude—the result of both observation and purposeful selection.

This artistic focus, as well as the technical details (and flaws) of the casting, allies this aquamanile with others that date from the mid-thirteenth century and later. The location of its place of manufacture depends upon the character of the linear pattern of the feathers and on the rounded mass of the body. Two thirteenth-century dragon aquamaniles—one at The Cloisters (47.101.51)—that exhibit similar qualities have been attributed to Lower Saxony on the basis of comparison with the reliefs on the baptismal font dating to before 1220 in Hildesheim Cathedral. The early-thirteenth-century eagle lectern in the same cathedral underscores the desire for simplification in the portrayal of feathered creatures, both real and imaginary.[3] It is reasonable to assume that the Cloisters' aquamanile, along with the two others in the form of a cock preserved in Frankfurt and in Nuremberg, is part of this tradition of modeling and brass casting in Lower Saxony.[4]

Because it is impossible to establish that such vessels were exclusively liturgical or secular, a definitive interpretation of the iconography is elusive. According to Fernand Cabrol and Henri Leclercq, the cock, in announcing the dawn and as part of the biblical story of Peter's denial and repentance, symbolized Christ's Passion and Resurrection.[5] In the Early Christian period, the cock was represented on terracotta lamps, gems, textiles, ivory reliefs, and sarcophagi, as well as in frescoes and mosaics. The theme of cockfighting occurs on several Burgundian Romanesque capitals.[6] The further

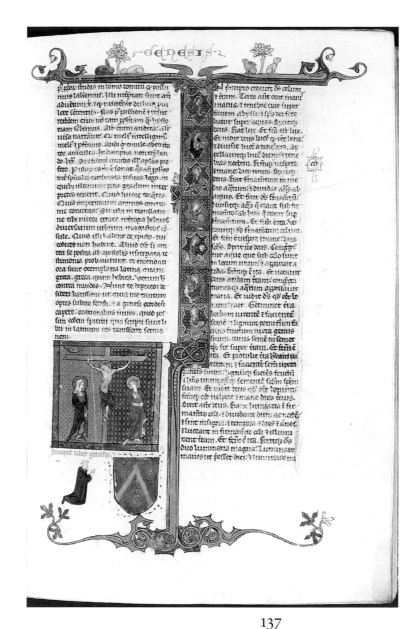

137

importance of the cock during the Middle Ages is emphasized by accounts in twelfth- and thirteenth-century Latin bestiaries, which were moralizing compilations of fact and lore, some highly imaginary, relating to the animal world. Depictions of cocks appear not only in bestiaries but also at the line endings and in the margins of other manuscripts, especially in thirteenth- and fourteenth-century Books of Hours, such as the *Hours of Jeanne d'Évreux* (The Cloisters Collection; 54.1.2). The popularity of the cock as a subject during the Late Medieval period is evident in the engaging story of Chauntecleer in *The Canterbury Tales*.

WDW

1 See von Falke and Meyer, 1935; Wixom, 1972, pp. 101–2, fig. 33; *idem*, 1974 a, pp. 260–70; *idem*, 1986, nos. 18–22, pp. 75–80, 138–41, ill.; *idem*, 1995 b, p. 26, colorpl.
2 See Gay, 1887, p. 40.
3 See Born, 1989, no. 11, pp. 191–204, figs. 11–25; Niehr, 1989, no. 11, pp. 183–90, figs. 1, 2, 8.
4 See von Falke and Meyer, 1935, pp. 41, 107, figs. 243, 244.
5 Cabrol and Leclercq, 1914, pl. 2, cols. 2886–2905.
6 See Forsyth, 1978, pp. 252–82.

EX COLLECTION: [Walter Randall, Paris and New York].

REFERENCE: Wixom, 1990, pp. 20–21, colorpl. p. 21.

BIBLE

French (Paris), about 1250–75

Tempera and gold leaf on parchment; leather binding: 560 leaves, 10 x 6½ in. (25.3 x 16.5 cm)

Partial and Promised Gift of John L. Feldman, in memory of his father, Alvin Lindberg Feldman, 1997 (1997.320)

In the thirteenth century, Paris, with its renowned university, became Europe's premier center for the creation of illuminated manuscripts. Typical of the work of the city's busy ateliers are the "University Bibles," which were created for a wide range of clients, including clerics, laity, and students, and are characterized by painstaking scribal work and tiny but detailed illustrations.[1] The Feldman Bible is one of the finest examples of this type of manuscript, which survive in relatively large numbers. More richly illustrated (with eighty-one historiated initials) and significantly larger than most such bibles, it is particularly interesting for its opening of the Book of Genesis, which presents the seven days of Creation in superimposed octofoils and the silhouette of a Dominican kneeling beneath an image of the Crucifixion.

Sometime after 1325, the manuscript, which was for Dominican use, entered the library of the Carthusian Abbey of Fontaine-

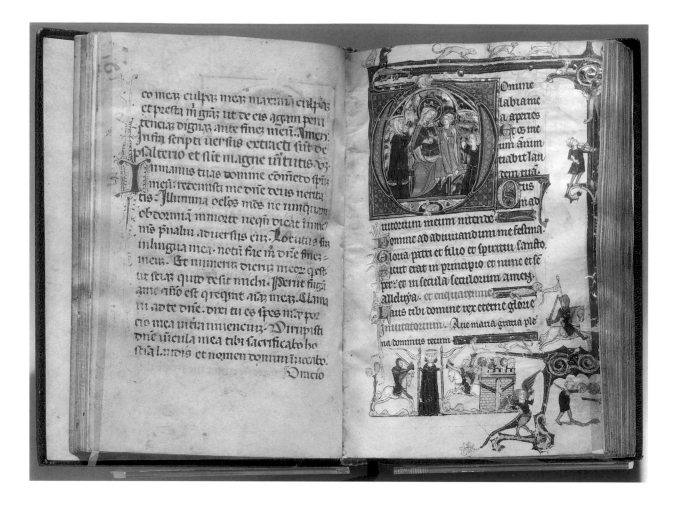

Notre-Dame, in the diocese of Soissons. The exceptional quality of this bible has caused it to be treasured by celebrated bibliophiles since the fifteenth century, including Jean Budé, notary and secretary to Louis XI (who added his coat of arms under the Crucifixion), and the English collectors Sir Sydney Cockerell and Sir Alfred Chester Beatty.

BDB

1 On the location of the makers of these books and their specialties see Rouse and Rouse, 1990, pp. 103–15.

EX COLLECTIONS: Carthusian Abbey of Fontaine-Notre-Dame, after 1325; Jean Budé, Paris (d. 1501); Guillaume Budé, Paris (d. 1540); Président de Saint-André; Jesuit Collège de Clermont, Paris (dispersed 1589–1610); Byron Holland; [Sir Sydney Cockerell, Cambridge (b. 1910–d. 1957)]; Sir Alfred Chester Beatty, London, sold 1933; [Permain]; William Randolph Hearst; [Ernest Brummer, New York]; Joel and Maxine Spitz, Glencoe, Illinois, acquired 1948; [sale, Sotheby's, London, November 29, 1990, lot 98]; John L. Feldman, Lakewood, Colorado.

REFERENCES: Millar, 1930, no. 51, pp. 32–37, pl. CXIX; de Ricci, 1937, no. 1, p. 1687; Faye and Bond, 1962, no. 5, p. 166; Branner, 1977, pp. 130–231 (incorrectly cited as being in Dublin).

138

BOOK OF HOURS

Northeast French, about 1270
Tempera and gold on vellum: Page size, 6 15/16 x 5 15/16 in. (17.7 x 15.1 cm)
Promised Gift of John L. Feldman, in memory of Rosemily Petrison Feldman

This Book of Hours, in Latin and French, is richly decorated with historiated initials, marginal imagery of great variety and whimsy, and line endings inhabited by real and fantastic beasts. Among the many historiated—or narrative—initials, which range in height from three to nine text lines, ten, of exceptional size, illustrate the Hours of the Virgin and the Penitential Psalms. While the illuminations include some conventional motifs, like the enthroned Virgin and Child at the opening of Matins, what is absolutely extraordinary is the degree to which figures of unidentified devout and saintly women are presented. The woman for whom the book was made, a certain Marie, is named in a prayer on the verso of folio 198.

In many ways, the manuscript is a textbook example of the lively and inventive themes of Gothic illumination. Its marginal vignettes of battling knights, hunting dogs, and energetic musicians have great popular appeal, and its numerous depictions of medieval women have considerable contemporary interest.

The Feldman Hours significantly broadens the Metropolitan Museum's collection of Gothic illuminated manuscripts, and represents the earliest Book of Hours among the holdings of the Department of Medieval Art and The Cloisters. Antedating the *Hours of Jeanne d'Évreux* (54.1.2) by more than two generations, it

was produced in the second half of the thirteenth century, when such volumes of prayers replaced Psalters as the preferred books of devotions among wealthy, educated, and—especially—female patrons.

BDB

REFERENCES: Bennett, 1996, pp. 21–50; Boehm, 1997, p. 21, colorpl.

139

GRISAILLE PANEL

French (Sées), 1270–80

White and pot-metal glass, with vitreous paint: 22 x 20¼ in. (55.9 x 51.4 cm)

Provenance: Choir Chapel of Saint Mary Magdalene, Cathedral of Saint-Gervais and Saint-Protais, Sées.

The Cloisters Collection, 1982 (1982.204.3)

This grisaille panel, composed of stylized geranium foliage, was once part of the glazing of the ambulatory of the Cathedral of Sées in Normandy. The panel's design is centralized around a red, green, and golden yellow *fermaillet*, which, in turn, is framed by a quatre-foil medallion with interlocking diagonal straps of colorless glass. Visible beneath these elements is a central stalk from which four vines symmetrically branch out into spirals within each of the panel's quadrants. This vigorous foliage—its unfolding leaves are painted to reveal their ventral surfaces—stands out against the finely cross-hatched ground. Similarly designed grisaille panels from Sées also are found in the Corning Museum of Glass in Corning, New York.

The left border is modern.

MBS

REFERENCES: *MMA Annual Report*, 1983, p. 41; Hayward, 1985, p. 103, ill.; Zakin, 1985, p. 86, fig. 5; Lillich, 1990, p. 153.

140

A SEATED FRIAR, OR VERGER

French (Reims?), about 1280

Leaded bronze, cast in the lost-wax technique, with mercury gilding:
2⅝ x 1⅜ x 1¹¹⁄₁₆ in. (6.7 x 3.5 x 4.3 cm)

The Cloisters Collection, 1991 (1991.252)

This statuette depicts a young cleric wearing a full-skirted cassock
and a tight cap. The pose and torsion suggest that the friar once sup-
ported the corner of a larger object of great weight, possibly an
architectural shrine, as is indicated by the deep right-angled inden-
tation cast into the back.[1] As there are two comparable figures in
other collections, it appears that this cleric was one of several such
Gothic telamones.[2] Bending under their former burdens, these
figures steady themselves in varying ways by placing their hands
upon their thighs and knees. Their subtle plasticity, clarity of form,
and dramatic poses are important extensions of the style of the con-
sole figures of about 1274–75 on the west façade of Reims Cathedral,
as well as of one of the telamones on the exterior of the nave
clerestory.[3] Such support figures appear later, in the illustrations in
the *Hours of Jeanne d'Évreux*, made in Paris from 1325 to 1328 (in The
Cloisters Collection),[4] and in the gilt-bronze statuettes beneath the
Reliquary of Saint Germain, of 1409 (formerly in the Church of
Saint-Germain-des-Prés, Paris).[5]

W D W

1 See Wixom, 1994, p. 797, fig. 5.
2 Ibid., pp. 801–2, figs. 12–14.
3 Ibid., p. 800, figs. 2, 9.
4 Acc. no. 54.1.2; ibid., p. 801, figs. 8, 10.
5 Ibid., p. 798, n. 7, fig. 7. These later statuettes are in the collections of
 the Musée du Louvre, Paris, and The Cleveland Museum of Art.

EX COLLECTIONS: Private collection; [sale, Christie, Manson & Woods,
London, December 15, 1982, lot 22, color ill.]; Peter Wilson, London; [sale,
Sotheby's, London, July 4, 1991, lot 15, color ill.].

REFERENCES: Wixom, 1992 b, p. 21, colorpl.; *idem*, 1994, pp. 797–802, figs. 1,
3, 5, 6.

141

THREE LEAVES FROM A BIBLE

French (Paris), 1280–1300

Tempera and gold leaf on parchment: Each, 15⅞ x 10⅝ in. (40.3 x 27 cm)

Gift of Mr. and Mrs. William D. Wixom, 1994 (1994.539)
Promised Gift of Mr. and Mrs. William D. Wixom

Typical of the style of bible decoration in Paris, primarily in the thir-
teenth and fourteenth centuries, these leaves, with their regularly
cadenced Gothic script and their red and blue painted ornamenta-
tion accented with gold, combine delicate leafwork with charming
imaginary creatures. Such so-called University Bibles represent the
fruit of the labors of the city's active bookmakers at a time when
students from all over Europe were drawn to the University of Paris.

The two leaves recently acquired as promised gifts contain the
opening texts of the Book of Nehemias and of Saint Paul's Epistle to
the Ephesians, and are thus embellished with historiated initials,
eleven text lines high, appropriate to the accompanying passages.
Nehemias, the cupbearer to the Persian king Artaxerxes I, traveled to
Jerusalem and oversaw the rebuilding of the city walls. Here, in the
illustration to the book that bears his name, he kneels before the
king to receive permission to make the journey. The lively drawing
emphasizes the dialogue between the monarch and his servant, who
has just entered the royal chamber (the initial), his back leg still trail-
ing outside the curve of the letter *V*. The second leaf contains the
opening text of the Epistle of Saint Paul to the Christians of Ephesus,

141: 1994.539

illustrated by an eleven-line initial. Following a convention used to illustrate the letters of Saint Paul in other Paris bibles, the apostle stands within a towerlike structure and holds up his text, aided by a kneeling assistant. As in the illumination for the Book of Nehemias, one leg of the kneeling figure extends outside the frame of the opening letter—in this case a *P*. The third leaf contains text, but not the openings, from the eighth, ninth, and tenth chapters of the Book of Joshua—and thus has no large initial. Nonetheless its decoration reveals the care and attention given to the preparation of each page of the book.

Complete codices as well as individual leaves from these bibles survive today in relatively large numbers, the leaves having been unbound in the nineteenth and twentieth centuries by bibliophiles, dealers, collectors, and educators. Indeed, in the nineteenth century, it was considered that "a few leaves [from a medieval manuscript], dispersed among parish schools, would do more to educate the children of the poor than all the catechisms that ever tortured them."[1] It was the intention of Otto F. Ege, a self-proclaimed "Biblioclast" and a previous owner of these leaves, to increase awareness of the history of book production by the dissemination of individual leaves from medieval manuscripts to schools, libraries, calligraphers, and printers.[2] Other folios from this same bible have appeared on the art market,[3] and one is in the collection of the Mead Art Museum at Amherst College in Massachusetts.

B D B

1 See Munby, 1972, p. 160.
2 See Voelkle and Wieck, 1992, p. 15; Wieck, 1996, pp. 248–49; de Hamel, 1996, pp. 16–18.
3 See Sotheby's, London, December 11, 1984, lot 39, color ill.; Hindman, 1987, nos. 25–27, p. 44, ill.

142

VIRGIN AND CHILD

English (attributed to Westminster or London), about 1290–1300
Ivory: 10¾ x 5⁵⁄₁₆ x 3¾ in. (27.3 x 13.5 x 9.5 cm)
The Cloisters Collection, 1979 (1979.402)

Long hidden in private collections, this ivory sculpture, one of the great masterpieces on view at The Cloisters, belongs to a larger series of European thirteenth- and fourteenth-century generally small-scale ivory statuettes of the Virgin and Child in seated and standing postures. Most of the series is French, and certainly from the Île-de-France, if not from Paris itself. All of these statuettes—the few English examples and the flood of French works—are devotional

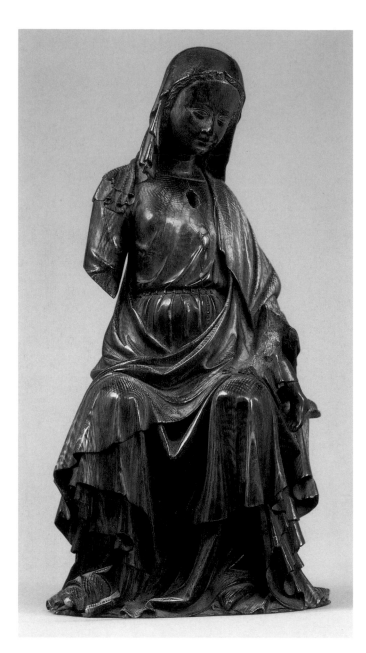
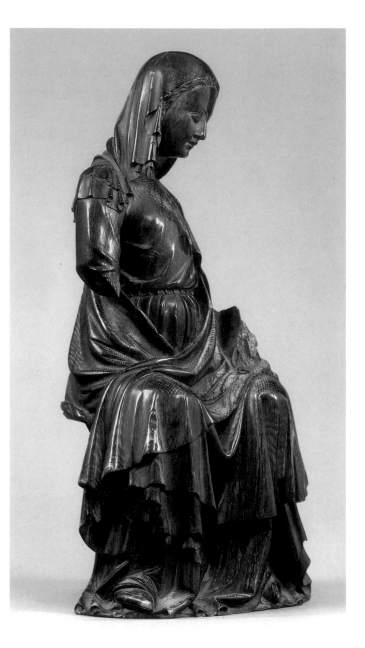

in nature, and date from the height of the popularity of the cult of the Virgin. They must have been intended for countless chapels and oratories, and some undoubtedly were commissioned for use by royal and noble families in France and England. The most famous French example is the large standing *Virgin and Child*, of about 1265, from the Sainte-Chapelle in Paris, one of the finest treasures of the Musée du Louvre.[1] The original context of such statuettes, as objects of veneration on small altars, may be seen repeatedly in the miniatures of contemporary illuminated manuscripts; occasionally, works with this function were made in stone. These devotional statuettes, which tend to emphasize an intimate and reciprocal tenderness between the Virgin and the Child, represent a complete change from the rigid frontality of the Romanesque sculptures of the eleventh and twelfth centuries that portray the Virgin as the Seat of Holy Wisdom, or *Sedes Sapientiae*.

What today appear as independent ivory statuettes of the Virgin and Child most likely are accidents of history. Many originally were part of a larger context that possibly included an architectural canopy with columns, gables, and, in some cases, folding shutters.[2] Ivory images of the Virgin are described in the wardrobe account

(1299–1300) of King Edward I (r. 1272–1307),[3] and in an inventory (1307) of the contents of the Bishop's Palace in Exeter, as being part of ivory tabernacles. Similar references are found in European inventories, as well.[4] Although most of the existing tabernacles are of ivory, such statuettes were also enclosed by structures of silver and silver gilt, as attested by a small example in the Kunstgewerbemuseum, Berlin.[5] Considering the large size of the Cloisters' *Virgin*, an original setting of silver or silver gilt would seem to be a distinct possibility.

The Cloisters' *Virgin* turns slightly to her left to face the blessing Christ Child, who at one time climbed up over her left knee. Only a portion of the toes of the infant Christ's right foot and of his lowered left leg and foot remains.[6] The Virgin's head is partly covered by a short veil, which hangs in thin parallel folds, enframing both the curvilinear strands of her hair and her smoothly modeled face. Her long gown, tied at the waist by a beltlike girdle, is partially hidden by an enveloping mantle, which falls in long folds over the Virgin's left shoulder and over her lap, like an apron. A series of deeply cut folds extends from her knees and from over the throne, and, together with the folds of the gown beneath, are spread out on the ground beside and below the Virgin. Her slippered feet emerge from within

these folds and press down on some of them. The Virgin's back is carved with low-relief folds, which suggests that this sculpture, while executed in the round, was not meant to be seen in the round. The principal viewpoints are limited to three: directly in front, or slightly to one side or the other, relative to the position of the worshiper.

Losses in addition to the Child include the separately worked seat, or throne (which may have been made of another material), and the Virgin's lower right arm and hand, left hand, and an inset jewel or crystal-covered relic below her collar. The Virgin's highly polished surfaces are notable for their appealing, dark reddish brown patina, which one occasionally sees on Byzantine as well as on other, Gothic ivories.[7] This color may have been produced as a result of staining with something like rubric (or madder) and walnut oil, a treatment described by Theophilus,[8] while the very dark brown—almost black—surfaces on the back of the statuette may have been caused by exposure to excessive heat.[9]

Despite the changes wrought by time, this miniature sculpture is a marvel for the great skill and economy of means evident in all aspects of its carving. It is a masterpiece for its unified clarity of vision, its intense refinement—which is both pervasive and detailed—and its impression of monumentality. The face of the Virgin, with the high forehead and small features, is exquisitely modeled and courtly. The slightly twisting mass of the figure is realized in a subtle and eloquent manner; the organization of the deeply undercut cascading folds, some of them paper thin, is controlled and elegant.

This figure is the second or third earliest, and the finest and largest, of only seven or eight ivory statuettes of the Virgin attributed to England during the thirteenth and fourteenth centuries. Yet, the slighter examples are of little help in pinpointing the date and localization of the Cloisters' *Virgin* because they lack its controlled elegance and scale.[10] The same conclusion is true concerning the only securely dated English ivory reliefs, which are grouped around triptychs with the arms of John de Grandisson, Bishop of Exeter, and are from about 1330–40.[11] These reliefs are notable for their loosely conceived, even flaccid, depictions of draperies, and for their renditions of the face of the Virgin, with their domelike foreheads and beaklike noses.

The best stylistic parallels for the Cloisters' *Virgin* are found in the monumental sculptures produced for Edward I and his court during the last decade of the thirteenth century. These include some of the figures on the Queen Eleanor crosses,[12] and, in Westminster Abbey, London, the gilt-bronze effigy of Queen Eleanor by William Torel[13] and the weepers and angels on the tomb of Edmund Crouchback.[14] The shared precision and refinement in the treatment of figural mass, the deep cascading drapery folds, and the smooth modeling of the faces suggest that the Cloisters' ivory *Virgin*, clearly a prestigious work, could very well have been a royal or court commission from the same period as these other sculptures.[15]

When the Cloisters' statuette was listed in the catalogue to the *Seventh Loan Exhibition: French Gothic Art* (Detroit, 1928), it was not only described as "French, about 1350," but it also was "believed to be the Virgin offered to Jean de Dormans at the time he was made Bishop of Lisieux [*sic*, Beauvais] in 1359."[16] If the statuette is English, as has been universally accepted, and it is stylistically related to the monuments of Edward I, then there is approximately a sixty-year gap between its creation and the election of Jean de Dormans as bishop. It seems unlikely that an already old ivory from England would be presented in honor of this occasion in Beauvais two generations later.

Such a reputed connection may have made sense to G. J. Demotte, the lender of the work to the 1928 exhibition and an often highly unreliable dealer because he believed that the work was French and dated to about 1350. With its Lisieux or Beauvais provenance discredited, the attribution on stylistic grounds to Westminster or London in the last decade of the thirteenth century, the possibility that it was a court commission, and the evocative citations in the accounts of Edward's possessions mentioned above remain the most reasonable arguments in establishing the origin of this rare and masterful work.

WDW

1 See Gaborit-Chopin, 1978, pp. 136–37, 204, color ill. p. 198, ill. p. 199.

2 Compare with existing tabernacles in ivory, wood, and silver gilt cited in Wixom, 1987 a, pp. 346–47, fig. 5.

3 Examples quoted by Porter, 1974, pp. 196–97, from the *Liber quotidianus contrarotulatoris garderobae*, 1787, pp. 351, 352, include the following: "Imago beate Marie de *eburn'* cum tabernaculo *eburn'* in uno coffino" and "Quatuor mariole beate Marie cum tabernaculis de *eburn'* et diversis imaginibus."

4 See Porter, 1974, p. 197; Wixom, 1987 a, pp. 344, 345.

5 See Wixom, 1987 a, p. 344, fig. 6, p. 347.

6 The original position of the infant Christ may have resembled that of the Child in certain French ivories, as, for example, a work of about 1260–80 in The Metropolitan Museum of Art (Gift of J. Pierpont Morgan, 17.190.175); see Wixom, 1987 a, pp. 341–42, fig. 4.

7 Ibid., pp. 342, 347, fig. 9.

8 Ibid., p. 343, n. 11.

9 Ibid., p. 344, n. 12.

10 The fact that two ivories cited in *Images in Ivory* (see Little, 1997 b, p. 183, fig. 33 a), a seated *Virgin* that was in the Baudry collection in Rouen and a polyptych in the Carnegie Museum of Art in Pittsburgh, are characterized by looser and softer draperies tends to place these works a generation or two later than the Cloisters' *Virgin*. Also, the proposed connection with the Baudry *Virgin* due to its location in Rouen is weakened by the restriction of similarities to the superficial features of the stain and to the Child having broken off. More importantly, the mantle of the Baudry *Virgin* differs in that it covers almost the entire torso and is draped in the opposite direction.

11 See Stratford, 1987, nos. 593–596, pp. 465–67, ill.

12 See Wixom, 1987 a, p. 348, fig. 10, pp. 355, 358; Lindley, 1987, no. 374, p. 363, ill.

13 See Wixom, 1987 a, p. 350, fig. 12 a–b, pp. 355–58; Binski, 1995, pp. 107–9, colorpl. fig. 148.

14 See Wixom, 1987 a, pp. 351–52, fig. 13 a–b, p. 357; Binski, 1995, p. 115, fig. 157, p. 116.

15 See Wixom, 1987 a, p. 358.

16 *French Gothic Art*, 1928, no. 69; Wixom, 1987 a, p. 352; Little, 1997 b, no. 35.

EX COLLECTIONS: [G. J. Demotte, New York, 1928]; Mr. and Mrs. John Hunt, Drumlech Bailey, County Dublin, Ireland, before 1936–1979.

EXHIBITIONS: "Seventh Loan Exhibition: French Gothic Art," The Detroit Institute of Arts, November 16–December 6, 1928, no. 69; "Gothic Art in Europe," London, The Burlington Fine Arts Club, 1936, no. 24; "Age of Chivalry: Art in Plantagenet England, 1200–1400," London, Royal Academy of Arts, November 6, 1987–March 6, 1988, no. 518; "Images in Ivory: Precious Objects of the Gothic Age," The Detroit Institute of Arts, March 9–May 11, 1997, and Baltimore, Walters Art Gallery, June 22–August 31, 1997, no. 35.

REFERENCES: *French Gothic Art*, 1928, no. 69, ill.; *Gothic Art in Europe*, 1936, no. 24, pl. XXVII; Porter, 1974, no. 33, pp. 96, 98, 101–2, ill.; Wixom, 1980, pp. 22–23, colorpl.; Stratford, 1983, pp. 208–16; *idem*, 1987, no. 518, p. 424, ill.; Wixom, 1987 a, pp. 337–58, fig. 1 a–d; *idem*, 1989 a, p. 61, colorpl.; Little, 1997 b, no. 35, pp. 182–83, color ill.

143: Detail

143

BIFOLIUM, FROM A MANUSCRIPT OF THE
DECRETALS OF GRATIAN

French (Paris), about 1290

Tempera and gold leaf, with brown ink, on parchment: Page, 18⁹⁄₁₆ x
11⁷⁄₁₆ in. (47.1 x 29 cm); text (56 lines), 12¼ x 6⁷⁄₈ in. (31.1 x 17.5 cm);
gloss (99–104 lines), 17¼ x 10¼ in. (43.8 x 26 cm)

Gift of John L. Feldman, 1990 (1990.217)

Like the *Crucifixion* from a Missal, this illuminated *bifolium*, or double
page, ranks with the finest painting produced in thirteenth-century
Paris. The *bifolium*, which formed part of a manual of medieval
canon law, the *Decretals of Gratian*,[1] was compiled by a monk who
taught at Bologna in the mid-twelfth century. On the sheet shown
here, a gloss, or commentary, written by Bartolomeo of Brescia,
frames the central, two-column text block representing the work of
Gratian, which is preceded by an illustration of the chapter, or *causa*.

The *bifolium* incorporates parts of *causae* 16–19.[2] The minia-
ture signals the beginning of *causa* 19: "Two clerics wished to trans-
fer to a monastery; both sought permission from their bishop. One
left his church against the will of his bishop, the other after having

renounced his regular canonicate." The bishop's prerogative is man-
ifest in the miniature: Mitered and enthroned, he holds a crosier and
a document with a seal, as he gestures toward two kneeling clerics,
who appear to petition him with raised hands. Their facial features
and their hair are rendered with a few fine pen strokes. The elegance
of line, combined with an almost cartoonlike presentation of the
composition, creates an easily legible narrative that is typical of
Parisian Gothic manuscript illumination.

The leaf is one of two known to have been extracted before 1910
from a manuscript now in the state archives of the Czech Republic
at Olomouc (ms. no. C.D. 39). Both sheets have been associated with
Maître Honoré, a native of Amiens,[3] whose name has become syn-
onymous with the best illuminations produced in thirteenth-
century Paris. There is, however, only one documented manuscript
by Honoré and his workshop—a copy of Gratian's *Decretals* at Tours
(Bibl. Mun. ms. 558), dated 1288.[4] It is conceivable that the Metro-
politan's *bifolium* and the Olomouc manuscript also are the work
of an illuminator in Honoré's atelier; the illumination for *causa* 19
of the Tours *Decretals* has compositional and iconographic elements
in common with the Metropolitan's *bifolium*. Since Honoré himself

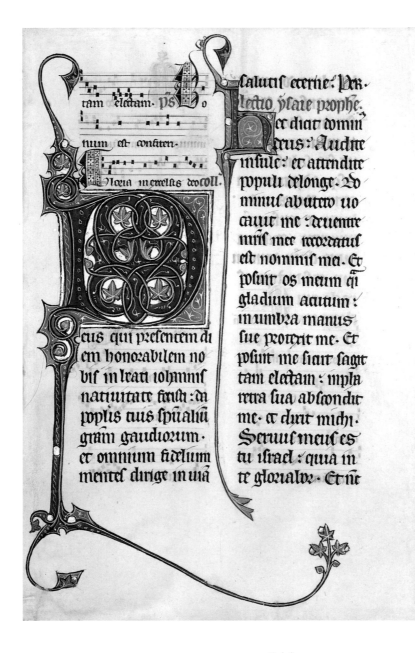

was only one of a number of prominent Parisian illuminators active at that time, working in close proximity to and in collaboration with one another,[5] the generic similarities to the Tours *Decretals* help to confirm a date for the Museum's illumination of about 1290 but not its authorship.

BDB

1 See Melnikas, 1975, pp. 605–6, 618–20.
2 See Schmidt, 1975, pp. 159–70.
3 See Baron, 1969, especially pp. 41–43.
4 See Kosmer, 1975, pp. 63–68.
5 See Rouse and Rouse, 1990, pp. 103–15.

EX COLLECTIONS: Franz Trau [sale, Gilhofer and Ranschburg, Vienna, October 27, 1905, lot 92, ill.]; Dr. Arthur Simony, London(?); [Bernard Quaritch, London]; Sir Sydney Cockerell, Cambridge (b. 1910–d. 1957); Brian S. Cron, Kew, England, 1957– (?); [Bernard Quaritch]; [Bruce Ferrini, Akron, 1987]; John L. Feldman, Eagan, Minnesota.

REFERENCES: Millar, 1953, p. 12; *idem*, 1959, p. 14; de Hamel, 1987, p. 202, no. 61; Hindman, 1987, no. 5, pp. 14–16; Boehm, 1991, p. 17, colorpl.

144

LEAF, FROM A MISSAL

Northeast French (Beauvais?), about 1290
Tempera and gold leaf, on parchment: 11⅜ x 7¼ in. (28.9 x 18.4 cm)
Gift of Mrs. Karen Gutmann, in memory of Harry Bober, 1992 (1992.238)

With its marriage of elegant foliate decoration and refined lettering, this leaf from a Missal is characteristic of Gothic manuscript illumination in northern France. The taut vines and letters are close to those on a number of manuscript leaves that were attributed to Beauvais by Otto F. Ege, a teacher at the Cleveland Institute of Art and a *marchand-amateur*. The text comprises the special prayers for the Feast of Saint John the Baptist (June 24): readings from Psalm 91 and the Books of Isaiah and Jeremiah, the Gradual, the Gloria, and the Alleluia.

BDB

EX COLLECTIONS: [H. P. Kraus, Inc., New York]; Harry Bober, New York; Mrs. Karen Gutmann, New York.

REFERENCE: Boehm, 1993, p. 26, colorpl.

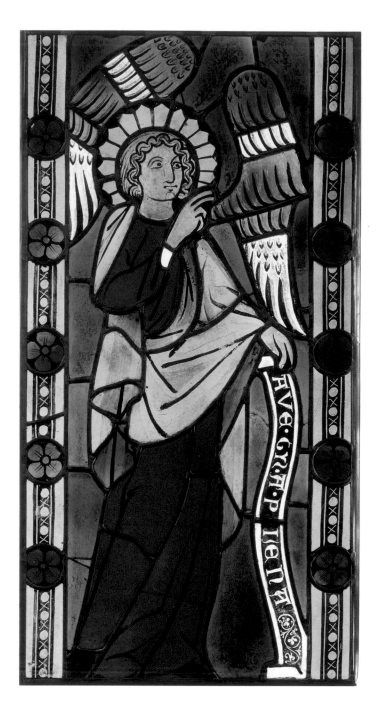

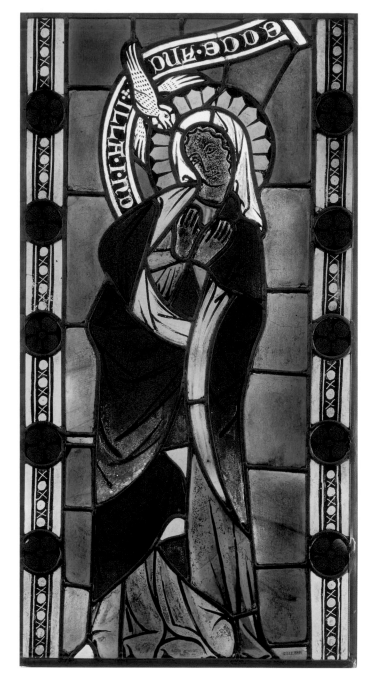

145

THE ANGEL ANNUNCIATE AND THE STANDING VIRGIN

German (Hesse: Altenberg-an-der-Lahn), 1290–1300

Pot-metal glass and vitreous paint: Each, 29½ x 16 in. (74.9 x 40.6 cm)

Inscribed (on the angel's banderole): AVE•[MARIA]GR•A[TIA]• P LENA; (on the Virgin's banderole): ECCE•ANC •ILLA•I[ESU]• N[OSTRI]•D[OMINUS]

Provenance: Premonstratensian convent church, Altenberg-an-der-Lahn.

The Cloisters Collection, 1993 (1993.251.1,2)

The convent church in Altenberg-an-der-Lahn, near Wetzlar, in its present form, was begun between 1250 and 1267, under the abbacy of Gertrud von Nassau (d. 1297), and construction continued until about 1280. The original glazing of the apsidal windows was removed when the church was redecorated in the Baroque style, except for the axial window, which had been blocked since 1734 by a Baroque altarpiece. The panels from this double-lancet window—with "biblical representations," according to the earliest descriptions—apparently were removed during the period of secularizations and given to Graf Franz von Erbach in 1804, at which time he installed them in Schloss Erbach. They are described in the 1805 catalogue of the collection, and are said to have been donated by King Adolf of Nassau, who had died in the battle of Göllheim in 1298. Two watercolors record the now-lost panels that represent Adolf and his wife, Imagina von Limburg. The earliest descriptions also mention a panel with imperial arms. According to Franz von Erbach, donor panels were placed under the scenes of the Infancy and Passion of Christ in the axial window. A probable reconstruction thus would situate the imperial arms and those of Nassau in the first register, with the donor figures above, followed by seven scenes from the *Vita Christi* in each lancet, *Manna from Heaven* and *The Pentecost* in the lancet heads, and *The Last Judgment* in the

oculus above.[1] An 1832 engraving shows the present panels installed over *The Adoration of the Magi* in a single lancet window in the funerary chapel at Erbach, which suggests that it was for this installation that they were joined together by a border to make one (fig. 3); an inventory of 1865–66 records that they were still in this location, where they seem to have remained until about 1940, when they entered a Frankfurt-am-Main private collection (perhaps that of G. Hartmann). The *Annunciation* panel alone was consigned to Sotheby's in 1992. Once acquired by the Metropolitan Museum, this panel was separated, its components were returned to their original format, and the lost border was replaced by a modern one; nineteenth-century watercolors of the two panels before they were conjoined (fig. 4) guided the restoration of the missing border.

The monumentality and the bold outlines of the animated figures, along with the somewhat archaized treatment of the drapery and the lack of architectural framings, argue for a date no later than the end of the thirteenth century for the panels.

TBH

1 For the history of the glazing program see Hess, forthcoming, pp. 5–8 (I am grateful to Daniel Hess for providing page proofs of this as-yet-unpublished text).

EX COLLECTIONS: Grafen von Erbach, Schloss Erbach, Germany; G. Hartmann, Frankfurt-am-Main; [sale, Sotheby's, London, December 10, 1992, lot 25, pp. 18–19].

EXHIBITION: "Glasgemälde aus Frankfurter Privatsammlungen," Frankfurt am Main, Historisches Museum, 1965, no. 6.

REFERENCES: Dieffenbach, 1879, p. 131; Schäfer, 1891, pp. 62, 66, 75, fig. 34; Galliner, 1932, p. 69, n. 1; Wille, 1952, vol. 1, pp. 52–69, vol. 2, pp. 37–52; Wentzel, 1954, p. 40; Beeh-Lustenberger, 1965, no. 6, pp. 31–34, ill. p. 33; Hayward, 1994, p. 19, colorpl. p. 18; Hess, forthcoming, pp. 5–8, 17, pl. 1, fig. 1.

Figure 3. The Begräbniss-Kapelle, Alteberg an der Lahn, Schloss Erbach, Germany. 1832. Engraving. From *Rittersaal im Schlosse zu Erbach im Odenwalde gezeichnet und in aqua tinta geätzt von G. L. v. Kress* (Offenbach a.M., 1832)

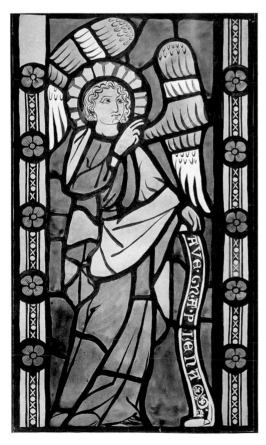

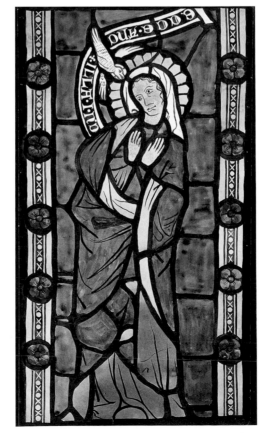

Figure 4. Johann Wilhelm Wendt. *The Annunciate Angel* and *The Standing Virgin*. 1805. Watercolor. Schloss Erbach, Germany

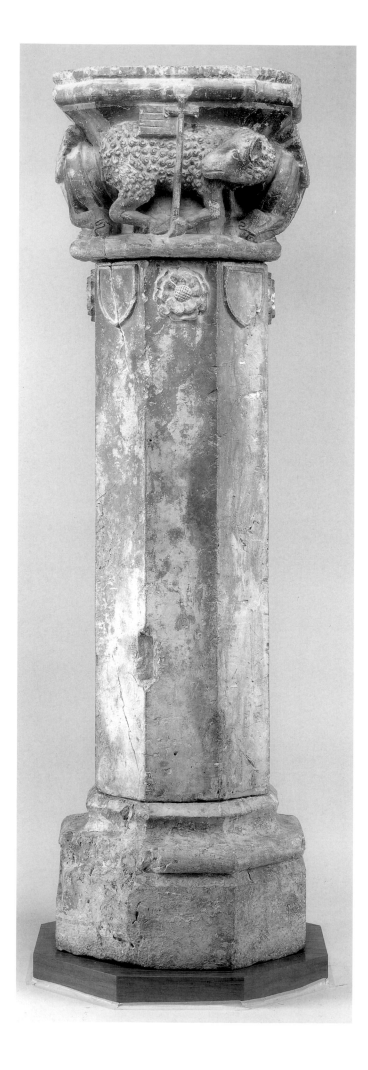

146

CAPITAL, SHAFT, AND BASE

French (Charente-Maritime), about 1300

Limestone, with traces of polychromy: Height (overall), 73⅞ in. (187.6 cm); capital, 15⅜ x 20¼ in. (39.1 x 51.4 cm); shaft, 43½ x 15 in. (110.5 x 38.1 cm); base, 15 x 20¹/₁₆ in. (38.1 x 51 cm)

Rogers Fund, 1981 (1981.9a–c)

This historiated capital, octagonal shaft, and base are carved from a white limestone. The capital has a low abacus, octagonal in shape, decorated with a rounded molding. In high relief and with a sharpness that the hardness of the stone allowed, the front of the capital represents Veronica's Veil—the visage of Christ imprinted on the cloth used by Veronica to wipe his face on the way to Calvary. It follows an iconographic tradition that goes back to now-lost Eastern representations, especially the Mandylion of King Abgar, or the Holy Image of Edessa, which was in Constantinople from 944 to 1204 and was copied many times. The origin of that lost painting is unknown, but according to legend it was a true portrait from the time of Christ.

In our sculpture Christ's hair is parted in the middle and falls in soft waves on either side. The forehead is flat, and the oval-shaped eyes with concave pupils—once painted—are set rather close together under curved eyebrows. The long, straight nose is clearly defined in spite of being partly broken. The cheeks are high and rounded, and the pursed lips are surmounted by a moustache also parted in the middle and curving down at the corners of the mouth. The beard is parted as well and forms two curls at its tip and two on each side. The top and arms of the cross appear behind Christ's head but are not enclosed in a nimbus, as is usually the case.

Two remarkably beautiful angels kneel on either side of the capital, each stretching forward to grasp an upper corner of the veil with one hand while gently holding a folded vertical border with the other. Their exquisite heads are crowned with wavy hair held by a diadem decorated with rosettes, and their faces have rounded cheeks and delicately pointed chins. The pupils of the eyes once contained paint, traces of which can still be detected. The wings parallel the abacus and are horizontally divided into bands in which the feathers are described in short, oblique incised lines that form a herringbone pattern. The capital is meant to be seen from below; the legs of the angels closest to the viewer and the undersides of their bodies are carved almost in the round, while their other legs are hidden by the drapery that falls in the background in simplified folds. The angel on the left has a decorated girdle and the one on the right a cord ending in tassels.

The side opposite the Holy Face represents the Lamb of God, the two images comprising a perfectly usual iconographic combination. The lamb, also carved in very high relief, holds a cross with a flag between the hooves of its bent legs and turns its head backward. Its wool is described in sharply defined curls. Its one visible eye has a concave pupil that, like the eyes of Christ, originally was painted.

The top of the shaft, just under the *collarino* (collar) of the capital, is decorated with alternating carved roses and shields that once must have been painted with coats of arms. The roses have a double series of five heart-shaped petals around a central boss sculpted to

146: Detail of capital

simulate the anthers of the stamens. The octagonal base has a torus under a narrow border and a simple plinth.

Apart from the break in Christ's nose, the condition of the ensemble is unusually good. The wear from exposure to atmospheric elements, which is characteristic of many sculptures once part of architectonic monuments, is lacking here, which would suggest that the limestone was never exposed to adverse weather conditions. Because its overall height would be too low for the nave of a church, it has been alleged that the pillar came from a crypt, where it would have supported the intersection of four groin vaults. Further evidence is nonexistent because the top of the capital at some point was filled in and smoothed down with cement.

Although some characteristics of the capital are thirteenth century in style, such as the heads of the angels and the depiction of Veronica's Veil suspended from the two upper corners (an iconographic device introduced about the middle of the same century), the elements of the base seem to indicate a date closer to the fourteenth century. Until further research is concluded, the most plausible date remains about 1300. As for the provenance, we have only an undocumented account that the column came from the crypt of a church in Aubeterre, Charente-Maritime, demolished long ago. There are, however, additional supporting facts that make the Charente-Médoc region the most probable source for this work. Historically, this area of western France was part of old Aquitaine. Veronica (also known as Véronique, Fronica, Bérénice, and Venisse, among other names) is a legendary figure, who is mentioned only in the Apocrypha but who was very popular during the Middle Ages in France, where it was believed that, after the Crucifixion, she built a hermitage in Soulac in the Médoc. She supposedly was buried in that town, and became known as "the apostle of Aquitaine." (Actually, the name Veronica must be a derivation of *vera icon*, or "true image," a reference to the portrait of Christ.) For centuries, Aquitaine was under English domination, which, perhaps, explains why the roses in the shaft under the capital are identical to the Lancaster roses on English Gothic monuments. The Lancasters were connected with the Plantagenets of Aquitaine in the early thirteenth century, and it seems quite possible that the crypt where this architectural element stood originally belonged to the latter family. This would also account for some similarities of style and iconography

between our acquisition and certain architectonic decorations and sculpture produced in England about the same time. No other area in Europe would be as likely a place of origin for this work as Aquitaine, especially given the popularity of representations of Veronica's Veil in that region. To my knowledge, there is no other representation of this subject in sculpture before the fourteenth century, although it was very common much earlier in painting, from the East to the Atlantic.

CG-M

EX COLLECTION: [Charles van der Heyden, Rotterdam, The Netherlands].

REFERENCE: Gómez-Moreno, 1981, pp. 27–28, ill. p. 27.

147

FOOTED POT

South Lowlands (Meuse Valley), 13th century
Partially glazed earthenware: Height, 5 in. (12.7 cm)
Gift of Anthony and Lois Blumka, 1991 (1991.471.2)

The feet of this pot, which is said to have been excavated at Huy, whimsically were pressed into the clay with a thumb. The extended, glazed lip suggests that the vessel was intended to be stoppered.

TBH

EX COLLECTION: [Bastiaan Blok, Noordwijk, The Netherlands].

148

JUG

South Lowlands (Andenne), 13th or 14th century
Partially glazed earthenware: Height, 8 in. (20.3 cm)
The Cloisters Collection, 1995 (1995.325)

The body of this wheel-thrown, well-preserved jug was patterned with horizontal striations and randomly applied patches of ferruginous glaze. It is typical of utilitarian earthenware vessels produced at Andenne, situated between Namur and Huy, where it is said to have been excavated.

TBH

EX COLLECTION: [Bastiaan Blok, Noordwijk, The Netherlands].

149

TILE

Austrian (Niederösterreich), late 13th–early 14th century
Lead-glazed earthenware: 7¾ x 8 in. (19.7 x 20.3 cm)
Provenance: Burg Kreuzenstein.
The Cloisters Collection, 1991 (1991.112.1)

Both the thickness and the worn surface of this molded and green-glazed tile indicate that it once formed part of a paving.

TBH

EX COLLECTIONS: Hans Wilzcek, Burg Kreuzenstein, Austria; [Blumka Gallery, New York].

EXHIBITION: "Medieval Monsters: Dragons and Fantastic Creatures," Katonah, New York, Katonah Museum of Art, January 15–April 16, 1995.

REFERENCE: Benton, 1994, pp. 12, 33, fig. 16, p. 11.

150

GLASS FRAGMENT

French, 1280–1325
Pot-metal glass and vitreous paint: 2⅜ x 4 in. (6 x 10.2 cm)
Gift of Shirley Prager Branner, 1985 (1985.91.8)

The painted maker's mark on this quarry from a grisaille window makes it highly unusual.

TBH

EX COLLECTIONS: Jean Lafond, Paris; Robert and Shirley Branner, New York.

151

TWO ARMORIAL ROUNDELS

French (Limoges), 13th century or later
Copper gilt, with opaque enamels: Diameter (each), 1⅝ in. (4.1 cm)
Gift of Max Falk, 1986 (1986.464.1,2)

TBH

EX COLLECTIONS: Dr. Johannes Jantzen, Bremen; Thomas F. Flannery Jr., Chicago; [sale, Sotheby Parke Bernet, London, December 1, 1983, lot 35, p. 46, ill. p. 47]; [Edward R. Lubin, New York]; Max Falk, New York.

REFERENCE: *MMA Annual Report*, 1987, p. 35, ill.

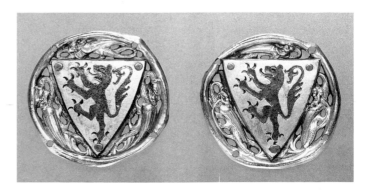

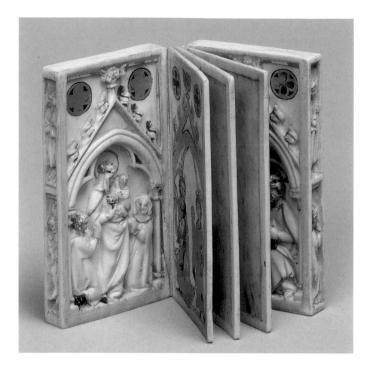

152

BOOKLET, WITH SCENES OF THE PASSION

North French, about 1300 (carving); Upper Rhenish, about 1310–20 (painting)

Elephant ivory, with polychromy and gold: Height, 2⅞ in. (7.3 cm); width (closed), 1⁹⁄₁₆ in. (4 cm); depth, ⅞ in. (2.22 cm)

The Jack and Belle Linsky Collection, 1982 (1982.60.399)

Gothic ivory carvings of the thirteenth and fourteenth centuries took the form of a profusion of rich and varied works, such as diptychs, triptychs, caskets, and mirror backs. One of the most exceptional objects, however, is the ivory booklet. Secular examples were common, but tablets with religious subjects were extremely rare, and are known primarily from surviving inventories.

This diminutive booklet is unusual in that the exterior covers are not the only carved components: The interior of each cover and its outer vertical edge are carved as well. The subjects of the upper and lower exterior covers are (from right to left, bottom to top): the Betrayal of Christ, Judas's acceptance of the thirty pieces of silver, the Flagellation, Pilate washing his hands, the Way to Calvary, and the Crucifixion, in which Christ is surrounded by the two thieves and the event is witnessed by the Virgin and John the Evangelist. Scenes and figures secondary to the principal narratives are continued on the outer vertical edges, so that Judas committing suicide is adjacent to the Betrayal (at the lower left), a man with a hammer(?) is part of the Way to Calvary (at the upper left), Longinus with his spear and sword is alongside the Crucifixion (at the upper right), and a counselor(?) appears next to the scene with Pilate (at the lower right). On the interior of the front cover is a carving of the standing Virgin and Child beneath a trefoil arch and between kneeling donors, and on the interior of the back cover is a depiction of the Coronation of the Virgin also set beneath a trefoil arch. Two images painted on the leaves facing the interior covers clearly are later additions, which transform the standard iconic subjects of the carvings. Along with the kneeling donors, the three Magi under a trefoil arch

create an unusual Adoration group, while the corresponding scene added to the Coronation includes a fair-haired female figure dressed in a golden gown and with attendant angels—one has a viol—who unquestionably are presenting her to the royal heavenly couple. As there is no nimbus or attribute for this young maiden, she would seem to be a purely secular conception, yet such an interpretation makes the reason for her presence in the depiction of this event all the more mystifying. The fact that donors inhabit the scene with the Virgin and Child might suggest an association between the female donor who wears a wimple and the figure with angels, but, since the painting was a later inclusion, perhaps the female figure is a new donor. More likely, however, is that she symbolizes the elect in the celestial court, as seen in a much expanded form in the *Hours of Mahaut de Brabant*, which dates from before 1288.[1] Conversely, the praying figure might correspond to the kneeling nuns that so frequently occur in the margins of fourteenth-century Rhenish manuscript illustrations of the Coronation.[2] The donors actually seem to represent idealized symbols of the faithful rather than the patrons who commissioned this work.

In spite of the fact that the addition of painted panels to the carved scenes creates a certain iconographic ambiguity, from the beginning these spaces must have been intended for some purpose. Except for the two painted leaves, all the others have raised edges on the surfaces of which wax could have been applied to allow them to be written on with a stylus. The religious nature of this booklet suggests that it served as an accessory for private devotion. The wax tablets within could have contained prayers of intercession or the litanies of saints.

The Metropolitan Museum's booklet is related to a series of ivories that derive from a late-thirteenth-century diptych (now in the Victoria and Albert Museum, London) said to have come from the Abbey of Saint-Jean-des-Vignes in Soissons.[3] An a-jour panel of the Passion, in the British Museum, retains many of the distinguishing features of this Soissons diptych type, especially the architectural system that isolates each episode, but the proportions of the figures are more compact, while the heads are larger. An almost identical figure type and composition characterizes the New York ivory booklet, but the visual effect is different because the architecture has been eliminated and the narrative is more compressed. Also similar to the Linsky example are a small triptych of the Last Judgment and the Crucifixion, in the Schnütgen-Museum, Cologne, and a miniature polyptych with scenes from the Infancy of Christ, in the Victoria and Albert Museum.[4] The predilection for selective polychromy and gilding on exceptionally small works is a feature of this group.

The chronological position of our ivory can be established better by examining the painted portions of the booklet. The artist either worked or trained in the vicinity of Lake Constance. His style is close to that of the illuminations in the *Manesse Codex* and in the *Weingarten Liederhandschrift*.[5] Several of the twenty-five miniatures in the *Liederhandschrift*, in particular, present comparable figure types—as, for example, the couple in the "Herr Rubin" illumination (folio 131), who recall the angelic group: Each of the similar long-waisted figures has a doll-like face, wavy golden hair, and draperies marked by simple breaking folds.[6] The *Liederhandschrift*, which dates just after the *Manesse Codex*, was painted about 1310–20. Even if the paintings in the ivory booklet are an addition, placed there shortly after the ivory was carved, they establish a terminus

ante quem for the work in the second decade of the fourteenth century. Therefore, no more than a decade or two seem to have elapsed between the creation of the booklet—at the end of the thirteenth or the beginning of the fourteenth century—and the inclusion of the paintings.

If it can be demonstrated that the paintings probably were made in the Bodensee area, that might suggest that the booklet, as a whole, originated there, but with no evidence of the influence of the carving style upon that of the paintings it is unlikely that both were executed in the same place. The dichotomy between the carved and painted portions speaks strongly in favor of the London and New York ivories having been carved in one locale and painted in another. Works of art frequently were produced especially for trade and export. In addition, the employment by workshops (especially those in Paris) of journeymen with foreign backgrounds, which yielded a complex set of stylistic characteristics, compounds our problem today in determining the artistic origins of these works. Also, the possibility that carvers from a single atelier collaborated on a particular object must not be excluded. Whether these important works were produced in Paris, at another center in France, or even in the Rhine-Meuse Valley under Parisian influence is highly debatable. Clearly, the figure style and compositions of the carvings in the booklet are linked to the orbit of the Soissons diptych type, in spite of the absence of the characteristic architectural framework. This alliance is further reinforced by the formal pose and rapport between the Virgin and Child, which are related to those of a Parisian, northern French type. The accepted view that the Soissons diptych group evolved from the same artistic milieu as the *Psalter of Saint Louis*[7] or the transept sculptures in Notre-Dame underscores the notion that the work is of Parisian origin but was made for export. Although at present it may not be possible to isolate another specific geographic center for the New York booklet carvings, they nevertheless imitate Parisian models, while Cologne works of this period manifest a distinguishably different set of characteristics. It is unlikely that these "relatives" of the Soissons diptych type reflect either the permeation of Rhenish stylistic features in a northern French atelier or the transplanting of that style to the Rhine Valley. On the contrary, the ivory booklet from the Linsky Collection becomes a significant point of reference in recognizing the complex formative influences within the context of the Soissons diptych tradition.

CTL

1 Cambrai, Bib. Mun., ms. 87, fol. 17 *v*. See Verdier, 1980, pl. 71.
2 See, for example, a leaf from a Gradual in *Medieval and Renaissance Miniatures*, 1975, no. 36; and Weigelt, 1924, figs. 4–5.
3 See Koechlin, 1924, vol. 2, no. 38; Longhurst, 1929, pp. 10–11, frontispiece; Grodecki, 1947, pp. 88 ff.
4 See *Schnütgen-Museum*, 1968, no. 81, ill.; Longhurst, 1929, p. 23, fig. 2.
5 Heidelberg, Universitätsbibliothek, Bibl. ms. pal. germ. 848; Stuttgart, Württembergisches Landesbibliothek, ms. HB XIII I.
6 See Irtenkauf, Halbach, and Kroos, 1969, pp. 133 ff. See also Spahr, 1968.
7 Paris, Bibliothèque Nationale de France, ms. lat. 10525.

EX COLLECTIONS: Albert Freund, Vienna; [Blumka Gallery, New York]; Jack and Belle Linsky, New York.

REFERENCES: Little, 1984 a, no. 50, pp. 132–34, ill. p. 132, color ill. p. 134; *idem*, 1984 b, pp. 14–15, color ill.; *idem*, 1997 b, pp. 89–90, figs. VI–14.

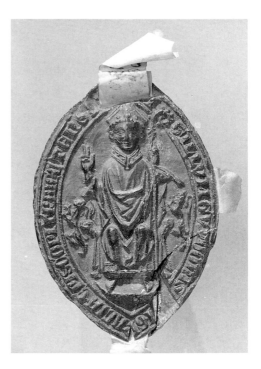

153

EPISCOPAL SEAL OF GUI D'AVESNES, BISHOP OF UTRECHT (ONE OF A GROUP OF 545 SEALS AND SEAL IMPRESSIONS)

Netherlandish, about 1300–1314
Green wax: 3 x 1⅛ in. (7.6 x 2.86 cm)
Gift of H. P. Kraus, 1981 (1981.534.5)

BDB

EX COLLECTIONS: Pieter Bondam (d. 1800), Utrecht; Petrus van Musschenbroek (1764–1823), Leyden; Sir Thomas Phillipps, London, 1826; [sale, Sotheby Parke Bernet & Co., London, December 10, 1980, lot 21]; [H. P. Kraus, Inc., New York].

154

DIPTYCH, WITH THE ANNUNCIATION, THE NATIVITY, THE CRUCIFIXION, AND THE RESURRECTION

German (Rhineland), 1320–40
Silver gilt, with translucent and opaque enamel: (open) 2⁷⁄₁₆ x 3⅜ in. (6.1 x 8.6 cm)
Gift of Ruth Blumka, 1980 (1980.366)

An outstanding example of Gothic goldsmiths' work and enameling, this small devotional diptych achieves a gemlike quality through its accomplished technique and graceful style. The outer scenes of the Crucifixion and the Resurrection are executed in *basse-taille* enamel, with details in opaque enamel, while the inner scenes of the Annunciation and the Nativity are in the form of cast reliefs. The diptych generally has been attributed either to a Parisian or a Cologne workshop, but a more precise localization is made difficult not only by the mobility of artists and the resultant transmission of styles, but also by the palpable stylistic differences between the outer

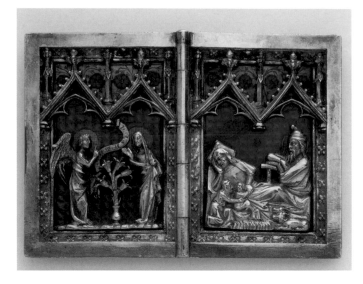

and inner wings. The deep-cut silver plaques of *basse-taille* enamel and the combination of both translucent and opaque enamels are often associated with Constance. On the other hand, the broad planes of the drapery, with its deep tubular but softened folds; the strict triadic arrangement of the figures; and the angled hand gestures, counterpoised by a slight *déhanchement*, point to the refinements of the Cologne style between 1320 and 1340. Likewise, the finely detailed and elegantly composed cast figures in the Annunciation on the left inner wing, separated by a banderole and a vase of Madonna lilies, fit directly into a Cologne tradition of figures cast in high relief and set under elaborate arcades with trefoil arched and crocketed gables, which continued well into the second half of the fourteenth century. The figures in the Nativity scene, however, although no less detailed, are not as finely styled as those of the Annunciation, and, curiously, are larger in scale. The unusual inclusion of a midwife in the Nativity scene is an iconographic peculiarity that appears for the most part to be of Austrian origin.[1] These disparate technical, stylistic, and iconographic elements could be accounted for if the workshop in question was large and was situated at a major international crossroads. Cologne was just such an artistic center in the fourteenth century, primarily because of the

Parler family, in whose cosmopolitan workshops, extending from Prague to Cologne, the stylistic traditions of individual artists were fused and eventually transmuted, toward the end of the century, into the International Style. While the place in which this diptych originated remains somewhat uncertain, the essential stylistic qualities of the work do, in fact, link it with Cologne.

TBH

1 See Gómez-Moreno, 1968, no. 166, ill.

EX COLLECTIONS: John Edward Taylor, London, until 1912; [sale, Christie, Manson & Woods, London, July 1–4 and 9, 1912, lot 235, p. 67, ill.]; Ruth and Leopold Blumka, New York.

EXHIBITIONS: "A Collection of European Enamels from the Earliest Date to the End of the XVII. Century," London, The Burlington Fine Arts Club, 1897, no. 231; "Treasures from Medieval France," The Cleveland Museum of Art, 1967, no. V-12; "Medieval Art from Private Collections," New York, The Cloisters/The Metropolitan Museum of Art, October 30, 1968–January 5, 1969, no. 166; "Decorative and Applied Art from Late Antiquity to Late Gothic," Moscow, State Pushkin Museum, May 10–July 10, 1990, and Leningrad, State Hermitage Museum, August 14–October 14, 1990, no. 51.

REFERENCES: *European Enamels*, 1897, p. xx, no. 231, pl. 13; Wixom, 1967, no. V-12, pp. 192–93, 367–68, ill.; Gómez-Moreno, 1968, no. 166, ill.; Husband, 1981, pp. 26–27, ills.; *idem*, 1990 c, no. 51, p. 108, colorpl. p. 109.

155

THE INITIAL *R*, WITH THE ANNUNCIATION, FROM A GRADUAL

Lake Constance, about 1300
Tempera and gold leaf on parchment: 4 x 3 1/16 in. (10.2 x 7.8 cm)
Purchase, Gift of J. Pierpont Morgan, by exchange, 1982 (1982.175)

Protected by the arching curve of the blue-and-white letter *R*, the standing figures of the Archangel Gabriel and the Virgin Mary are set against a burnished gold background. The barefoot angel wears a simple salmon-colored tunic, belted at the waist, and holds a staff. His right hand raised and his wings outstretched, he addresses the Virgin Mary, who stands before him and lifts both hands as the dove of the Holy Ghost whispers in her ear.

The letter *R* is the opening of the Introit, or entrance hymn, "Rorate caeli de super" ("Drop down dew, you heavens, from above"), sung on March 25, the Feast of the Annunciation, to celebrate the Archangel Gabriel's announcement to the Virgin Mary that she would be the mother of Jesus. The cutting once was part of a Gradual that has been preserved since 1866 in the Germanisches Nationalmuseum, Nuremberg (Hdschr. 21.897).[1] Dating to about 1300, it was probably painted by the Dominican nuns at the convent of Sankt Katharinenthal on Lake Constance. Common to the Metropolitan Museum's leaf and the Gradual are the foliate terminals of each letter and the concentric circles in its stem, as well as the elongated figures, with their detailed features and hair. Another cutting from the same manuscript is now in The J. Paul Getty Museum, Los Angeles (fig. 5).[2]

Our illumination was an especially welcome addition to the Metropolitan's collection because of two well-known and stylistically related Middle and Upper Rhenish polychromed wood sculptures, both also the gifts of J. Pierpont Morgan: the *Visitation* group (17.190.724), of about 1310, attributed to Master Heinrich of

Figure 5. *The Initial* G, *with the Virgin Mary, Saint Elizabeth, the Infant John the Baptist, and the Infant Christ.* Lake Constance, about 1300. Tempera and gold leaf on parchment. The J. Paul Getty Museum, Los Angeles (85.MS.77)

Constance, and the *Vierge Ouvrante* (17.190.185), of about 1300, with paintings on the insides of the hinged panels illustrating scenes from the Infancy of Christ. The exquisite refinement of the faces in the illumination is echoed in those of Anna and Mary in the *Visitation* group, with their delicate features and smoothly rounded, subtly painted cheeks.

BDB

1 Our leaf was folio 154 *v.*
2 Other missing leaves are those with the letter *P* and the Nativity and the initial *I* and Saint Peter.

EX COLLECTIONS: L. Salavin, Paris; [sale, Hôtel Drouot, Paris, April 22, 1982, lot 267, ill.]; Anne Otto Wertheimer, Paris.

REFERENCES: Wixom, 1982, p. 19, ill.; Knoepfli, 1989, pp. 166–70.

156

PLAQUE, WITH SCENES OF ARISTOTLE AND PHYLLIS AND PYRAMUS AND THISBE

French (Paris), about 1310–30
Elephant ivory: 3¹⁵⁄₁₆ x 9¹³⁄₁₆ in. (10 x 24.9 cm)
The Cloisters Collection, 1988 (1988.16) [now incorporated with the casket, Gift of J. Pierpont Morgan, 1917, 17.190.173]

This ivory plaque from a secular casket depicts two literary themes popular in the Late Middle Ages that deal with the folly and tragedy of love. The left compartment shows Aristotle instructing the youthful Alexander. The next scene shows Phyllis, Alexander's lover, riding on the back of Aristotle—whom she has resolved to humiliate for interfering with love's progress—while Alexander looks on.

The two episodes on the right are devoted to the tragedy of Pyramus and Thisbe: Pyramus had arrived at a fountain, and, believing Thisbe was dead, fell upon his sword, whereupon Thisbe returned to find her lover dying, and she joined him in death.[1] In the first scene, a lion is eating Thisbe's mantle, as she clings to a tree, and, in the other, the suicides of Pyramus and Thisbe are depicted with a simple and unforgettable immediacy. The compactness of the narration within a limited space does not seem crowded but, rather, imparts a sense of grandeur to the scenes, while the carefully calculated gestures of the elegant, naturalistic figures enrich their meanings.

Its subject matter, style, dimensions, and technique of mounting are all proof that this plaque is the original front panel of the Metropolitan Museum's romance casket (17.190.173), which was already missing when the casket entered the collection of Sir Francis Douce (1757–1824).[2] With the plaque now reintegrated, the casket is again complete, and despite the missing silver-gilt mounts that would have adorned such a deluxe object—the blank square in the center would have held the lock plate—it remains the largest and most masterfully accomplished romance casket to survive.

The same combination of subjects dealing with love occurs on at least three other romance caskets, although these are of lesser quality (the three are in the Museo Nazionale del Bargello, Florence; the Treasury of Kraków Cathedral; and the Barber Institute of Fine Arts, Birmingham, England).[3] These romance caskets probably were made as presents to be given to aristocratic ladies by their suitors, or as marriage gifts, and possibly were used as containers for jewelry. Beginning in the thirteenth century and continuing into the

Romance casket (17.190.173), with catalogue number 156 in place

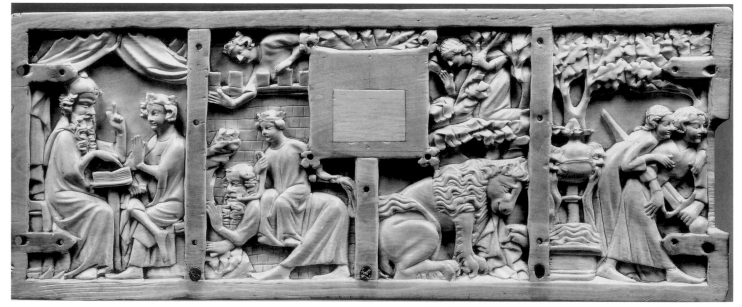

156

fourteenth, a new interest in playful themes of female superiority juxtaposed with scenes that depict the more tragic consequences of love had been characteristic of secular ivories, and, primarily, of those produced in Paris.

CTL

1 Ovid, *Metamorphoses*, 4: 55–166.
2 See Meyrick, 1836, p. 383.
3 See Koechlin, 1924, vol. 2, nos. 1281, 1285, plates CCXVIII, CCXIX.

EX COLLECTIONS: Private collection, Sevenoaks, Kent, England; [sale, Parson, Welch and Cowell, Sevenoaks, Kent, April 1, 1987, lot 26, ill.]; [Alain Moatti, Paris].

EXHIBITION: "L'Art au temps des rois maudits, Philippe le Bel et ses fils: 1285–1328," Paris, Galeries Nationales du Grand Palais, March 17–June 29, 1998, no. 101.

REFERENCES: Little, 1988, p. 16, ills.; Bruckner, 1995, p. 66, fig. 25; Gaborit-Chopin, 1998, no. 101, pp. 165–66, ills. p. 165.

157

RIGHT WING OF A DIPTYCH, WITH THE CRUCIFIXION, AND THE VIRGIN, SAINT JOHN, PROPHETS, AND MOURNING WOMEN

French(?), first half of the 14th century
Elephant ivory: 3⅝ x 2⅝ in. (9.2 x 6.7 cm)
Gift of Mr. and Mrs. Maxime L. Hermanos, 1981 (1981.476)

CTL

EX COLLECTION: Mr. and Mrs. Maxime Levy Hermanos (1899–1985 and 1908–1992), Paris and New York.

158

WING OF A TABERNACLE, WITH THE ANNUNCIATION AND TWO MAGI

North French, mid-14th century
Elephant ivory, with traces of polychromy. 8⅛ x 1½ in. (20.6 x 3.8 cm)
Gift of Mr. and Mrs. Maxime L. Hermanos, 1979 (1979.521.4)

CTL

EX COLLECTION: Mr. and Mrs. Maxime Levy Hermanos (1899–1985 and 1908–1992), Paris and New York.

159

LEAF OF A DIPTYCH, WITH THE VIRGIN AND CHILD AND ANGELS

North French, about 1340–60
Elephant ivory: Height, 3½ in. (8.9 cm)
Gift of Robert L. Hermanos and Miriam H. Knapp, in memory of their parents, Mr. and Mrs. Maxime Levy Hermanos, 1993 (1993.515)

Originally adjoined to a leaf depicting the Crucifixion (now lost), the panel with the Virgin and Child shows them seated on a long bench under a trefoil arch between two wingless yet hovering angels, who place a crown on the Virgin's head. The image emphasizes both the glorification of the Virgin and her coronation, common themes in Gothic devotional works. The architectural setting, and the deep folds of the figures' drapery, along with their emphatic gestures, relate this ivory to others made in northern France during the fourteenth century. Such devotional diptychs, used as aids in prayer, were widely produced, and comprise the largest category of the ivory objects created in the Gothic period.

CTL

EX COLLECTIONS: Mr. and Mrs. Maxime Levy Hermanos (1899–1985 and 1908–1992), Paris and New York; Robert L. Hermanos and Miriam H. Knapp, 1991–93.

REFERENCE: Little, 1994 b, p. 19, ill.

160

TABLET, WITH THE CRUCIFIXION AND THE ADORATION OF THE MAGI

French (Eastern France or the Rhineland), mid-14th century
Elephant ivory: 4 x 2⁷⁄₁₆ in. (10.2 x 6.2 cm)
Gift of Mr. and Mrs. Maxime L. Hermanos, 1979 (1979.521.2)

This tablet is unusual in that its reverse side, which is divided into four shallow compartments set around a slightly deeper circular one, is presumed to have functioned as a palette for mixing pigments. A panel of this type might have preceded a series of ivory tablets that contained compartments filled with thin layers of wax on which messages or texts were written. A wax tablet in Paris (Musée du Louvre, OA 25517), which depicts the Betrayal of Christ in the Garden of Gethsemane and the Flagellation of Christ, is carved in the same style.

CTL

EX COLLECTION: Mr. and Mrs. Maxime Levy Hermanos (1899–1985 and 1908–1992), Paris and New York.

161

MIRROR CASE (ONE VALVE)

French, 14th century

Elephant ivory: Diameter, 3⅛ in. (7.9 cm)

Gift of Mr. and Mrs. Maxime L. Hermanos, 1979 (1979.521.1)

Divided by a stylized, leafy tree, each of the four quadrants of this mirror case contains a pair of lovers: At the top left, a lady carrying a lapdog is being approached by a man holding a falcon, who is about to crown her with a wreath; at the top right, a kneeling man is being crowned by a lady; at the lower left are a seated man with a falcon and a seated woman with a lapdog; and at the lower right, a man caresses a lady's chin. Four fabulous beasts decorate the rim that forms the four corners of the ivory.

The subject of pairs of lovers divided by trees may be found on other French mirror cases—as, for example, those in the Musée du Louvre, Paris; in a French private collection; and in the Walters Art Gallery, Baltimore.[1] The present example is a somewhat corrupted version of the others, which suggests that it was made in a provincial center of ivory carving.

Ivory mirrors were composed of two interlocking valves, with one side containing a polished piece of metal. Forerunners of the modern compact, they were designed primarily for a courtly or mercantile clientele. Curiously, none survives with its metal mirror intact.

CTL

1 See Koechlin, 1924, vol. 2, nos. 1007, 1014; Randall, 1985, no. 327.

EX COLLECTIONS: Frédéric Spitzer, Paris; [sale, Paris, April 17–June 16, 1893, lot 97, pl. III]; Mr. and Mrs. Maxime Levy Hermanos (1899–1985 and 1908–1992), Paris and New York.

EXHIBITION: "Treasures from The Metropolitan Museum of Art: French Art from the Middle Ages to the Twentieth Century," Yokohama, Museum of Art, March 25–June 4, 1989, no. 18.

REFERENCES: *Collection Spitzer*, 1890, no. 65, p. 48; Little, 1989 a, no. 18, p. 73, color ill. p. 72.

162

TWO GRISAILLE PANELS

French (Paris), 1320–24

Pot-metal and white glass, and silver stain: Each, 23½ x 15¼ in. (59.7 x 38.7 cm)

Provenance: Chapel of Saint-Louis, north aisle, Royal Abbey of Saint-Denis.

The Cloisters Collection, 1982 (1982.433.3,4)

Traditionally thought to have come from the Cathedral of Notre-Dame in Paris, this pair of grisaille panels is now attributed to the Chapel of Saint-Louis at the Royal Abbey of Saint-Denis.[1] Their distinctive feature, the inclusion of the small fleurs-de-lis, which sprout, budlike, from the stems of the foliage, is unique to these panels and to four other related examples—a detail that may well indicate that the glass was created for a royal foundation. The most likely candidate is Saint-Denis, the royal necropolis, where a nave chapel dedicated to Louis IX—who was canonized as Saint Louis in 1297—most probably was completed before 1324. The rebuilding of the abbey church began shortly after Louis ascended to the throne and continued throughout most of his reign (1226–70). Fleurs-de-lis appear elsewhere in the thirteenth-century decoration, and, as a royal emblem of both a popular saint and of his royal Capetian line, the motif thus may have been continued in the fourteenth-century glass. Indeed, the measurements of the Cloisters' panels correspond convincingly to the aperture of the lancet windows in the Chapel of Saint Louis. Furthermore, a nineteenth-century tracing of one of the related panels (fig. 6) undoubtedly was made along with tracings of other Saint-Denis stained glass before the glass was removed from the abbey church.

A composite panel with three quarries from this glazing program was acquired subsequently by the Museum (fig. 7) and the quarries were removed and used to replace nineteenth-century restorations in the present panels.

TBH

1 See Hayward, 1992, pp. 305, 315–20.

EX COLLECTIONS: [Bacri Frères, Paris]; [Michel Acézat, Paris]; [sale, Hôtel Drouot, Paris, November 24–25, 1969, lot 39, pl. 4].

REFERENCES: de Guilhermy, 1840–72, MS 6121: folios 9 *v*, 14 *v*, 17, 17 *v*, 18, 19, 40, 139, 235, MS 6122: fol. 239 *v*; Lafond, 1959, pp. 13–18, Appendixes II, III, pp. 335–36; Kraus, 1966, pp. 131–48; *idem*, 1967, pp. 65–78; Grodecki, 1976, pp. 140–41; Hayward, 1985, p. 106, ill.; *idem*, 1992, pp. 303–25, figs. 1, 2 a,b.

(illustrations on following page)

162: 1982.433.3

162: 1982.433.4

Figure 6. Just Lisch. Tracing of a grisaille panel now in the Musée National du Moyen Âge, Thermes de Cluny, Paris. About 1850. Ink and pencil on tracing paper. Archives de la Direction de l'Architecture, Secrétariat d'État à la Culture, Paris

Figure 7. Composite grisaille panel of French quarries from Saint-Denis, of about 1325, and 19th-century glass, as purchased by The Metropolitan Museum of Art (The Cloisters Collection, 1990.212). Pot-metal and color-less glass, with vitreous paint. The 14th-century glass was incorporated into catalogue number 162; shading indicates the later, unused sections

163

STAINED-GLASS WINDOW, WITH GRISAILLE DECORATION

French (Rouen), about 1325
Pot-metal and colorless glass, with silver stain and vitreous paint:
10 ft. 7½ in. x 35½ in. (323.9 x 90.2 cm)
Provenance: Abbey Church of Saint-Ouen, Rouen.
The Cloisters Collection, 1984 (1984.199.1-11, and 48.183.2)

The vibrant color and robust lines of thirteenth-century stained glass were dispensed with, in these fourteenth-century panels, in favor of colorless glass painted with leafy vines growing on a trellis. The three foliate designs, each of which is remarkable for its delicacy and refinement, are identifiable not only by their botanical species but also as patterns known to have originated at Saint-Ouen. The two lower panels display the *pervenche*, or periwinkle flower; the third panel represents the leaf of the strawberry plant; and the top two depict geranium foliage. The colored borders incorporate buttercup, or Ranunculus, leaves with red and green quarries, and the center bosses are composed of whorls of artemisia leaves entwined with knotted ribbons of color.

Originally, the midpoint of each grisaille window at Saint-Ouen incorporated an architectural canopy with a scene from the life of the saint to whom the chapel was dedicated. The glazing of the light, both above and below this scene, was completed by nine panels of grisaille. The resulting windows, approximately three times the height of the five panels now installed in the Early Gothic Room at The Cloisters, are among the largest to survive from the medieval period.

TBH

EX COLLECTIONS: (1984.199.1-11) [Brimo de Laroussilhe, Paris]; [Ellin Mitchell, New York]; (48.183.2) [A. Lion, Paris].

REFERENCES: Ritter, 1926, pp. 10–12; Lafond, 1927; *idem*, 1954, pp. 185–238; Aubert et al., 1958, pp. 166–67; Lafond, 1970, pp. 13–174; Perrot, 1972, pp. 20–24; Lafond, 1978, pp. 136–55; Hayward, 1985, p. 107, ill. (48.183.2); *idem*, 1986, pp. 16–17, colorpl. p. 17.

164

165

164

GRISAILLE PANEL

French (Normandy?), about 1325
White glass and silver stain: 24¾ x 16¼ in. (62.9 x 41.3 cm)
The Cloisters Collection, 1982 (1982.204.1).

MBS

EX COLLECTIONS: [Michel Acézat, Paris]; [sale, Hôtel Drouot, Paris, November 24–25, 1969, lot 40, n.p.]; [Michael Meyer, Paris]; [Sibyll Kummer-Rothenhäusler, Galerie für Glasmalerei, Zurich].

REFERENCES: *MMA Annual Report*, 1983, p. 41; Hayward, 1985, p. 106, ill.

165

GRISAILLE PANEL

French (Normandy?), about 1325–30
White glass and silver stain: 16⅛ x 15¾ in. (41 x 40 cm)
The Cloisters Collection, 1982 (1982.204.6)

MBS

EX COLLECTIONS: [Michel Acézat, Paris]; [sale, Hôtel Drouot, Paris, November 24–25, 1969, lot 40, n.p.]; [Michael Meyer, Paris]; [Sibyll Kummer-Rothenhäusler, Galerie für Glasmalerei, Zurich].

REFERENCES: *MMA Annual Report*, 1983, p. 41; Hayward, 1985, p. 107, ill.

166

FRAGMENT: HEAD OF A MAN

North French, late 13th–early 14th century
Colorless glass and vitreous paint: Height, 3¾ in. (9.5 cm)
Gift of John L. Feldman, 1994 (1994.518.2)

The profile of this head is indicated not by trace lines but by silhouetting against the background; the headdress is that of an ordinary laborer.

TBH

EX COLLECTION: John L. Feldman, Lakewood, Colorado.

166 167

167

FRAGMENT: HEAD OF A WOMAN

North French, early 14th century
Colorless glass and vitreous paint: Height, 5¼ in. (13.3 cm)
Gift of John L. Feldman, 1994 (1994.518.1)

Sure and economic strokes of trace paint distinguish this head, the product of an accomplished glass painter.

TBH

EX COLLECTION: John L. Feldman, Lakewood, Colorado.

168

QUATREFOIL, WITH THE HEAD OF A WOMAN

French (Rouen), about 1325
Pot-metal glass and vitreous paint: Maximum height, 7¾ in. (19 cm); diameter of central medallion, 4 in. (10.1 cm)
Provenance: Church of Saint-Ouen, Rouen.
Gift of Mr. and Mrs. Iain Nasatir, 1980 (1980.543)

This finely painted fragment formed part of the central boss set in a grisaille panel.

TBH

EX COLLECTION: [Blumka Gallery, New York].

REFERENCE: *MMA Annual Report*, 1981, p. 40, ill.

169

PANEL, WITH NINE TILES

French, 14th century
Tin-glazed earthenware: 13¾ x 13¾ in. (34.9 x 34.9 cm)
Provenance: Church of Saint-Julien, Brioude (Haute-Loire).
Gift of Anthony and Lois Blumka, 1994 (1994.404 a–i)

The pattern in this section of floor paving comprises nine tiles, and is centered on a shield with an unidentified coat of arms, presumably that of a patron of the Church of Saint-Julien.

TBH

EX COLLECTIONS: Gaston le Breton; Émile Molinier, Paris; J. Pierpont Morgan (d. 1913), New York; The Metropolitan Museum of Art, New York, 1917 (17.190.1815); deaccessioned, March 8, 1971; [Blumka Gallery, New York, by exchange, June 1971].

170

TWO HANAPS

French (Toulouse?), 1320–60

Silver and silver gilt, with *basse-taille* and opaque enamels:
Diameter (each), 6 in. (15.2 cm)

The Cloisters Collection, 1982 (1982.8.1,2)

Hanaps are a form of drinking vessel frequently encountered in the inventories of wealthy households from the twelfth through the fourteenth century. Riveted to the bottom of each of the Metropolitan Museum's examples is a circular, silver-gilt openwork boss, surmounted by a *basse-taille* enamel representing a human-headed grotesque within a trefoil. As was customary throughout the Middle Ages, wine was poured to the top of the boss and then water was added until the wine was diluted by one part to three.

Inventories indicate that all but the most lavish hanaps were made in sets, which suggests that the present pair no doubt belonged to a larger service. While neither hanap is marked, they are identical in size and shape to several others excavated in the Ariège, in southern France, all of which bear the town mark of Toulouse. As silver plate made from melted-down vessels of standard often was exempted from control marks, the Museum's hanaps likewise could have come from a Toulouse workshop.

TBH

EX COLLECTIONS: Victor Gay, Paris, until 1909; [sale, Hôtel Drouot, Paris, March 26, 1909, lot 241]; R. M. W. Walker, London, until 1945; Private collection; [sale, Christie, Manson & Woods, London, December 9, 1980, lot 19, ill.]; [S. J. Phillips Ltd., London]; [Blumka Gallery, New York].

REFERENCES: Gay, 1887, pp. 604–6, fig. B; Husband, 1982, pp. 19–20, ill. p. 20.

171

MORSE, WITH SAINT FRANCIS OF ASSISI RECEIVING THE STIGMATA

Tuscan, first quarter of the 14th century

Copper gilt, with champlevé enamel: Diameter, 4¼ in. (10.8 cm)

Gift of Georges and Edna Seligmann, in memory of his father, Simon Seligmann, the collector of Medieval art, and of his brother, René, 1979 (1979.498.2)

"Among all the gifts which God bestowed on . . . Francis, there was one special and . . . unique privilege: that he bore on his body the stigmata of our Lord Jesus Christ. . . ." In this way, Saint Bonaventure, the thirteenth-century biographer of Francis of Assisi, articulated the distinctive, defining miracle of Francis's life, which became the emblem of his sanctity in hagiographic literature as well as in works of art. On this enameled morse, worn at the chest to clasp a priestly garment, Francis is shown receiving the marks on his hands, feet, and side. Dressed in the brown robe with knotted cord that distinguishes his order, Francis crouches, with his weight on one knee, in the rocky landscape at La Verna, across a footbridge from a small chapel. The dramatic appearance of the outcroppings seems to correspond to the legend that God had revealed to Francis "that those striking chasms had been made in a miraculous way at the hour of Christ's Passion when, as the Gospel says, 'the rocks split.'"[1] At La Verna, according to his earliest biographer, Francis "saw. . . a man standing above him, like a seraph with six wings, hands extended and his feet joined together and fixed to a cross. Two of the wings were extended above his head, two were extended as if for flight, and two were wrapped around the whole body. . . and so he arose [and] the marks of the nails began to appear in his hands and feet, just as

he had seen them a little before in the crucified man above him."[2] To convey the intensity of this spiritual branding, the goldsmith depicted the gilded rays that descend from the limbs of the Christlike seraph searing the flesh of Saint Francis, whose body, like that of the heavenly apparition, is surrounded by an aureole of light. In this, the enamel follows the example of Giotto and of other painters' representations of the miracle.[3] To heighten the drama of the scene, the goldsmith invented a nocturnal landscape with a deep blue sky, pierced by stars and a crescent moon, which sets off the gold-and-crimson glow of the saint's mountain retreat.

The effective contrast of areas of gilded metal in reserve and those decorated with champlevé is seen especially in Florentine and Sienese enamels on copper from the beginning of the fourteenth century.[4] As on the plaque with the Man of Sorrows (cat. no. 177), where dark enamel is used primarily to define the drapery, features, and musculature of figures in reserve, Saint Francis's head and extremities, here, are similarly emphasized, while the gilt areas in reserve make the landscape appear electrically charged. The extent to which this effect may have been imposed, or at least enhanced, by the hand of a later restorer is not clear,[5] but, in any event, it is consistent with the dramatic aesthetic of this scene as realized in other mediums—especially that of panel painting. Remarkable, too, as Gómez-Moreno, in particular, has noted, is the translucent quality of some of the enamel work—as, for example, the robe of Saint Francis.

BDB

1 Cited in Goffen, 1988, p. 61.
2 Ibid., p. 41.
3 See Kaftal, 1950.
4 See Leone de Castris, 1988, pp. 41–56.
5 See the similar discussion regarding the plaque with the Man of Sorrows (cat. no. 177). Pete Dandridge, conservator, Sherman Fairchild Center for Objects Conservation at The Metropolitan Museum of Art, suggests that a restorer working before the time that the morse first was published, by Victor Gay, may have removed damaged enameling from the areas of the rocks, smoothed the ground, and selectively regilded some parts of the plaque.

EX COLLECTIONS: Victor Gay, Paris, by 1887–1909; [sale, Hôtel Drouot, Paris, March 23, 1909, lot 72]; [Simon Seligmann, Paris]; Georges and Edna Seligmann, New York.

EXHIBITION: "Medieval Art from Private Collections," New York, The Cloisters/The Metropolitan Museum of Art, October 30, 1968–January 5, 1969, no. 167.

REFERENCES: Gay, 1887, p. 8; Gómez-Moreno, 1968, no. 167, ill.; *idem*, 1980, pp. 23–24, color ill.; Leone de Castris, 1988, pp. 50–52; *Metropolitan Museum of Art Guide*, 1994, p. 387, no. 39, color ill.

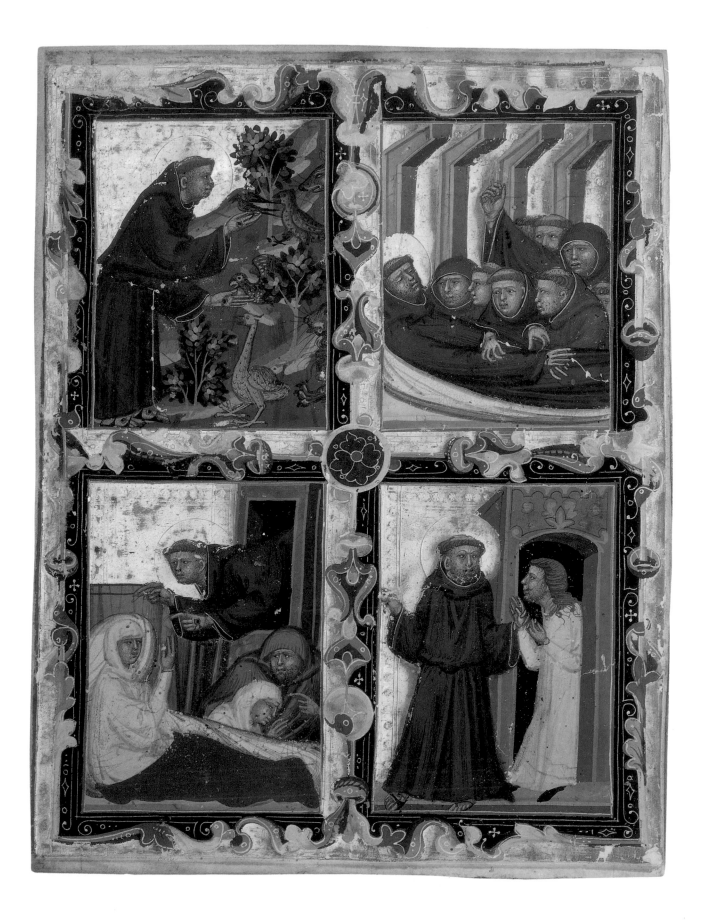

172

LEAF FROM A ROYAL MANUSCRIPT, WITH SCENES FROM THE LIFE OF SAINT FRANCIS

Bolognese school, for Hungarian use, about 1320–42
Tempera and gold leaf on parchment: 8⅝ x 6⅝ in. (21.9 x 16.8 cm)
Gift of Mr. and Mrs. Edwin L. Weisl Jr., 1994 (1994.516)

Scenes from the story of Saint Francis of Assisi, as articulated in *The Golden Legend*—a compilation of the lives of the saints that was widely diffused in the Middle Ages[1]—appear in the quadrants of this manuscript leaf. At the upper left the nimbed and tonsured saint is shown wearing the characteristic garb of the Franciscan order: a hooded brown robe, secured at the waist by a knotted cord, and sandals. The stigmata are visible on his feet and outstretched hands. He addresses a group of birds and two timid animals, whose whiskered muzzles and paws alone can be discerned. Depicted at the upper right is the death of Saint Francis, who is surrounded by his followers. At the lower left the saint appears through a window to revive a dead woman so that she may make her last confession. At the lower right he leads a debtor out of prison.

This leaf is part of a celebrated manuscript, already dispersed by the seventeenth century, now divided among the Biblioteca Apostolica Vaticana (Lat. 8541), the Pierpont Morgan Library in New York (M 360), the State Hermitage Museum in Saint Petersburg, and the Bancroft Library at the University of California, Berkeley.[2] The legend of Saint Francis originally comprised five leaves, but the whereabouts of two of them presently are unknown. The rich gilding and lavish decoration of the profusely illustrated ensemble indicate that the manuscript was a royal commission, and the combination of scenes from the lives of the Angevin prince and Franciscan Saint Louis of Toulouse with those of the Hungarian king László, and Stanislaw, the sainted bishop of Kraków in Poland, suggests that its patrons were the Angevin king Charles II of Hungary and his wife, Elizabeth, a Polish princess.

BDB

1 See *The Golden Legend*, 1969, pp. 605–7.
2 For the Morgan leaves see Harrsen, 1958, no. 35, pp. 49–50, pl. 53; for the Vatican sheets see Stickler, Boyle, and De Nicolò, 1985, p. 144, plates LXIX, LXIX A, LXIX B.

EX COLLECTIONS: Giovanni Battisti Saluzzi (1579–1642); Gabriele Laureani, The Vatican; Prince Giulio Sterbini, Rome, sold 1845; Léonce Rosenberg, Paris, sold 1913; [Edward R. Lubin, New York]; Mr. and Mrs. Edwin L. Weisl, Jr., New York.

REFERENCES: de Ricci, 1913, no. 73, p. 26, pl. x; Karl, 1925, p. 296; Harrsen, 1949, pp. 4, 39, 66–67; *Illuminated Books*, 1949, p. 59; Levárdy, 1963, pp. 75–138; Vayer and Levárdy, 1972, pp. 71–83; Levárdy, 1973, p. 17; Török, 1992, pp. 570–72, fig. 4; Boehm, 1995 a, p. 24, colorpl. p. 25.

173

CHALICE OF PETER OF SASSOFERRATO

Italian (Siena), about 1341–42
Silver gilt and translucent enamel: Height, 8⁷⁄₁₆ in. (21.7 cm); diameter of base, 5⅞ in. (14.9 cm)
Provenance: Franciscan church of Sassoferrato.

Inscribed (on the stem above the knop): + FRA/T(R)IS P/ETRI PENIT/ENTI/ARII +/DOMI/NI PA/PE ("of Brother Peter Penitentiary of the Lord Pope"); (on the stem below the knop): +LOCI SAS/SIFERATI/NON VEN/DATVR/NEC DI/STRATVR ("of the place of Sassoferrato neither sell nor destroy")
The Cloisters Collection, 1988 (1988.67)

Rivaling the renowned paintings created in the city of Siena in the fourteenth century are its masterpieces of goldsmiths' work, which glow with the reflective warmth of gold and shimmer with the translucent glazes of their brilliant enamels. The Cloisters' chalice is one of the finest testaments to the accomplishment of Siena's enamelers. Its base, knop, and stem are richly decorated with raised leafwork in gilded silver, enclosing gemlike figurative hexafoils of enameling. On the base is an image of Jesus on the cross set against a blue field with stars, flanked by half-length figures of the Virgin Mary and Saint John the Evangelist. Three additional enamels represent Saint Louis of Toulouse—identifiable by the fleur-de-lis at his shoulder—wearing the brown habit of a Franciscan, and bearing a crozier; John the Baptist, clothed in a robe of camel's hair; and Anthony of Padua, with a deep blue beard, holding a book and a cross. The enamels on the knop represent Saint Michael; Saint Francis, holding a book and a staff; an unidentified female saint; a female saint, probably Mary Magdalene, carrying an unguent jar; Saint Catherine of Alexandria, holding a palm and a wheel; and Saint Elizabeth of Hungary, wearing the brown habit of a Poor Clare, holding a flaming dish. The two bands of inscriptions and a single band of fantastic birds encircle the stem above and below the knop. Images of seraphim, once enameled, cradle the bowl of the chalice and, retaining their enameling, fill the spandrels where the base meets the stem.

The form of the Cloisters' chalice (with the exception of the cup, which is an early replacement) is typical of those made in Siena from the late thirteenth century—initiated by the example executed by Guccio di Manaia in 1290 for Pope Nicholas IV as a gift to the Basilica of Saint Francis at Assisi—and continuing into the fifteenth century.[1] What distinguishes the present chalice is the exceptionally accomplished—and well-preserved—enamel work. The engraving of the silver to create the delicate facial features, gently flowing hair, elongated fingers and hands, and variable thicknesses of drapery is arguably the clearest indication of the artist's achievement, but this is matched by the richness of his palette, with such surprising juxtapositions as the pistachio green and deep purple on the figure of John the Baptist.

In quality, the enamels of the chalice rival the finest surviving Sienese enamels anywhere. A particularly noteworthy comparison, with regard to both engraving and palette, is a chalice signed by Tondino di Guerrino and Andrea Riguardi, dated about 1320, in the British Museum (fig. 8).[2] In fact, Tondino di Guerrino was one member of a family of goldsmiths active during the better part of the fourteenth century, and it is surely to this workshop that the Cloisters' chalice should be assigned.[3] The name of Tondino himself first appears in a document of 1322 that records his payment for a silver basin;[4] he is last mentioned in 1340, when he makes a loan to another party.[5] His brother Giacomo, whose signature occurs on a chalice preserved in The Martin D'Arcy Gallery of Art, Loyola University, Chicago (figs. 9, 10), is first documented in 1348, prior to Giacomo's marriage.[6] This last chalice, less accomplished in its

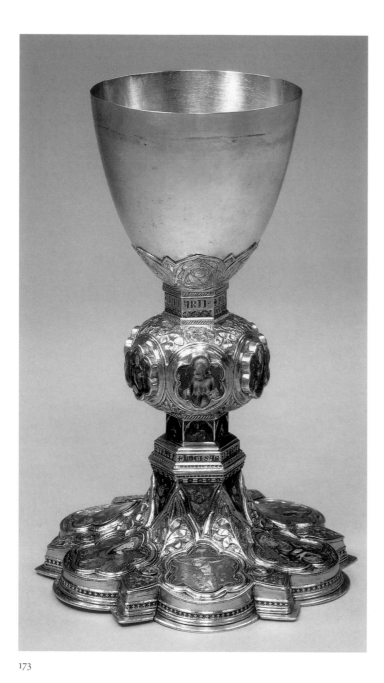

173

figurative decoration than the Cloisters' example, nonetheless displays similar floral enameled medallions resembling *émail de plique* set between the figurative medallions of the base, a feature that seems to have originated about the middle of the fourteenth century.[7] The clues provided by the inscriptions encircling the knop of the Cloisters' chalice allow it to be dated to 1341, at the end of the documented career of Tondino di Guerrino, whose work the chalice most closely resembles. Although his son Giacomo di Tondino was also a goldsmith, he is first listed only in 1362.[8]

The inscriptions mention Brother Peter, a member of the Papal Penitentiary (an exclusive tribunal under the direct authority of the pope that dealt with absolutions from particular sins, and dispensations from vows and oaths),[9] and the town of Sassoferrato in Umbria (Marches). The name of Peter of Sassoferrato appears in the lists of Papal Penitentiaries in December 1341, when he was appointed to Rome by Pope Benedict XII.[10] Peter was an important figure in the Franciscan community during a period fraught with great spiritual debate, heretical intrigue, and political posturing. He served as provincial minister for the order for Umbria in 1332, and

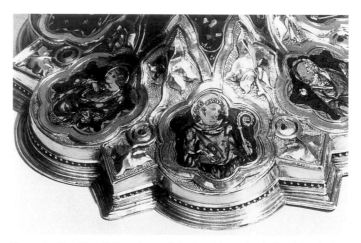

Figure 8. Tondino di Guerrino and Andrea Riguardi. Chalice (detail of base). Siena, about 1320. Silver gilt and translucent enamel. British Museum, London (1960.12.1)

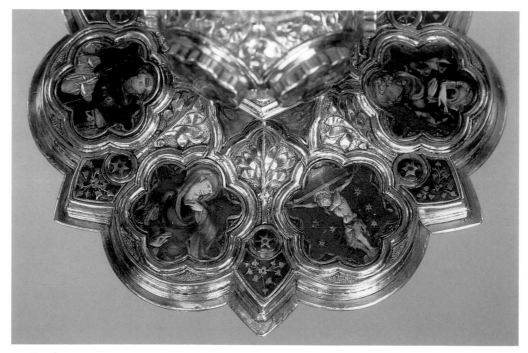

173: Detail

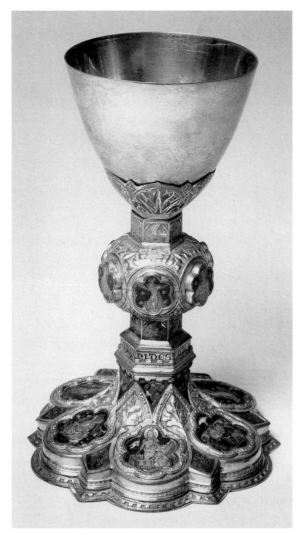

Figure 9. Giacomo di Guerrino. Chalice. Siena, 3rd quarter of the 14th century. Copper gilt and silver gilt, with *basse-taille* enamel. The Martin D'Arcy Gallery of Art, Loyola University, Chicago (18.69)

Figure 10. Detail of the base of the chalice in figure 9

later for the Marche d'Ancona, overseeing the visitation of Franciscan communities in those regions on a regular basis. Peter of Sassoferrato is known to have collaborated on Benedict XII's reform of the order in 1334,[11] and was appointed Inquisitor at Assisi in July 1340,[12] but he is not listed among the penitentiaries named when Clement VI became pope in 1342.

The chalice, with its prominently placed Franciscan saints and its inscription naming Peter of Sassoferrato, seems to have been Peter's gift to the Franciscan community in his hometown, or else to have passed to that community upon his death, for its presence there was described by Orazio Civalli, provincial minister of the region from 1594 to 1597. Civalli referred to the chalice as being "entirely of silver," and to the mention in the inscription of Peter of Sassoferrato as a penitentiary, also noting the cautionary admonition that the chalice not be sold or destroyed: "Non vendatur nec distratur."[13] However, by 1650 the Church had fallen into ruin, and its community was suppressed in 1652. All practice of religion there was abandoned by the 1870s, about the time that the chalice was first published as belonging to a private collection in Germany.[14]

BDB

1 See, for example, Martini, 1985, nos. 6–8, pp. 36–38, ills.
2 See Taburet, 1983, no. 46, pp. 151–52, ill.; Cioni, 1996, p. 68.
3 The chalice was associated with this atelier by Boehm and Wixom, 1988, pp. 17–18. For documentation on the workshop see Leone de Castris, 1980, and, most recently, Cioni, 1996.
4 Cited by Cioni, 1996, p. 69.
5 Ibid.
6 Ibid., p. 56.
7 See Taburet-Delahaye, 1994, p. 336.
8 See Cioni, 1996, p. 69.
9 See Haskins, 1905, pp. 421–50.
10 See Vidal, 1910, p. 390, no. 9126; Majic, 1955, p. 170, n. 28; Eubel, 1902, p. 84, no. 136; Wadding, 1733, p. 246, IV. I wish to thank Father Filippo Tamburini, Father John Fanning, Katherine Christensen, and Sophie and Pierre Jugie for their assistance in researching the career of Peter of Sassoferrato. Most of the Papal Penitentiaries were resident in Avignon; two Dominicans and two Franciscans, one of whom was Peter of Sassoferrato, were appointed to Rome; see Schmitt, 1959, p. 311. There were other penitentiaries named Peter during the papacies of John XXII, Benedict XII, Clement VI, and Innocent VI, but none of the others was a Franciscan with a known association with Sassoferrato.
11 See Schmitt, 1959, pp. 78, 311, 349.
12 See Wadding, 1733, p. 242, III.
13 See Civalli, 1594–97, fol. 164. I am grateful to Padre Gustavo Parisciani, historian of the Frati Minori Conventuali delle Marche, and to R. P. Stefano of the Istituto Internazionale di Studi Piceni in Sassoferrato for providing this information.
14 In 1913, the ruined church was put under the direction of the Sisters of Perpetual Help, who undertook its restoration. See Pagnani, 1959, p. 211.

EX COLLECTIONS: M. Gontard, Frankfurt-am-Main, by 1875; R. von Passavant-Gontard, Frankfurt-am-Main, in 1929; [S. J. Phillips Ltd., London, reportedly before 1939].

EXHIBITION: "Ausstellung alter Goldschmiede-Arbeiten," Frankfurt-am-Main, Kunstgewerbemuseum, June–September 1914, no. 111.

REFERENCES: Civalli, 1594–97, fol. 165; *Historische Ausstellung kunstgewerblicher Erzeugnisse*, 1877, pl. 13; *Ausstellung alter Goldschmiede-Arbeiten*, 1914, no. 111; *Sammlung R. von Passavant-Gontard*, 1929, no. 122, pp. 28–29, pl. 45; Schilling, 1929, p. 186; Boehm and Wixom, 1988, pp. 17–18, color ills.; Taburet-Delahaye, 1994, p. 336, fig. 18, p. 337; Cioni, 1996, p. 57, figs. 12, 29, 31–32.

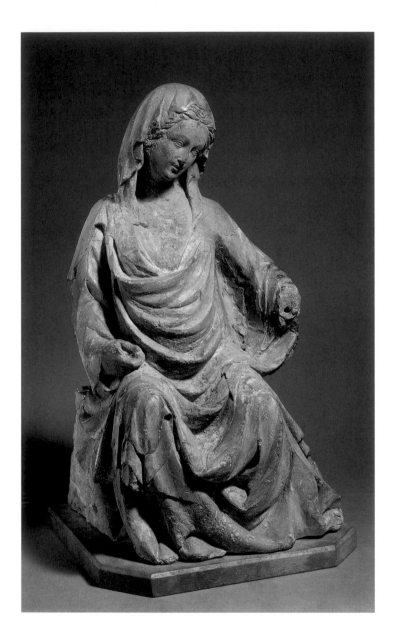

174

ENTHRONED MADONNA

Tuscan, second third of the 14th century
Terracotta: Height, 15¾ in. (40 cm)
Purchase, The Cloisters Collection and Rogers Fund, 1998 (1998.214)

This beautiful terracotta sculpture represents the seated Madonna, in the round. The figure is contiguous with its benchlike support. The Madonna's head and the lower part of the drapery are composed and modeled with especially great care. Her exquisite, smoothly rounded oval face, with its delicate features and peaceful expression, is tipped slightly to the side. A veil falls loosely in parallel folds over the wavy incised strands of hair. A generous mantle covers the Madonna's body almost completely; it is drawn over the upper torso, which, in profile, is somewhat convex. The lower half of the sculpture is richly articulated: The legs, bent at the knees, are arranged as diagonals, partially obscured by the lively drapery folds; the shallow, parallel, and elliptical folds that stretch across the chest are V-shaped at the lap, becoming heavier, deeper, and considerably more plastic below. Yet, the brilliant attention to sculptural form in these areas is not followed consistently in all details: The Madonna's left arm is extended as if to encompass the Christ Child, to which her gaze was directed. Although neither her hand nor the Child is depicted, the hollow between the torso and this raised arm suggests the place for the missing Child. The abbreviated rendering of the Madonna's right hand, and the barest indication of her feet emerging from beneath the drapery are further examples of a summary treatment. To these incomplete or sketchy details should be added the irregular, almost haphazardly configured block, which serves as the Madonna's throne.

Such observations, among others, seem to indicate that this sculpture should not be viewed as a finished work but rather as a goldsmith's model for a Madonna and Child group intended for a tabernacle setting or as a centerpiece for a large altar frontal or altarpiece. It is unclear whether this work initially was used as a model in its clay form and was later fired for preservation, or whether it was fired first and served as a terracotta model. However, the hair-thin as well as the larger cracks in the surface, and the apparent filling in of a portion of the bodice, in addition to the crumbly surfaces, suggest that the model originally was employed only in an unfired state.[1]

In any case, the lost, finished commission undoubtedly was completed with sections of formed metal (probably silver) that were fitted together, as in the case of the Metropolitan Museum's silver-gilt statuette of Saint Christopher—a Toulouse work of the mid-fifteenth century[2]—or the silver baptistery altar preserved in the Museo dell'Opera del Duomo in Florence that was created over several decades, having been commissioned in 1367 and completed in the 1470s.[3] The model for the Christ Child probably was a separate work, designed to be incorporated into the final composition, in the same way that the silver *Enthroned Virgin and Child* in the Church of Sainte-Materne, in Walcourt, Belgium, a work attributed to the Sambre-Maas region and dating to shortly after 1260, was constructed.[4] Similarly, the throne and the hands of the figure in the finished metalwork version of the Museum's terracotta may have been based on models of its separate components.

Thermoluminescence analysis has established that the last firing date of the clay was between 500 and 900 years ago—at the latest, at the end of the fifteenth century[5]—which leads to a search for stylistic parallels in the relevant periods. The most telling comparisons suggest that this graceful sculpture is a highly significant example of Tuscan artistry that probably dates from the second, or middle, third of the trecento (fourteenth century), a period in which the influence of the International, or French Gothic, style[6] was felt—as is apparent in various major Tuscan sculptures, such as several of the seated figures in relief on the medallions on the *Arca di San Cerbone* (Cathedral of Massa Marittima), carved in marble by the Sienese sculptor Goro di Gregorio and signed and dated 1324;[7] the seated figures of the Virtues on the first set of bronze doors (1330–36) by Andrea Pisano for the Baptistery in Florence;[8] and the marble figure of Christ the Redeemer, also by Andrea Pisano and dating from the 1330s, now in the Museo dell'Opera del Duomo, in Florence.[9] Although the lilting drapery style is somewhat similar to that seen in examples of Goro's work, this feature also appears in a more elegant form in the above-mentioned works by Andrea Pisano, in which the fullness and convexity of the torso of the Metropolitan's terracotta also find a parallel.[10] Especially relevant is the fact that the extreme refinement of the Madonna's features, together with their proportions, echoes the facial treatment of a number of Andrea Pisano's works, particularly those just cited.[11] Alternative comparisons may be made with Sienese sculptures of the early quattrocento (fifteenth century), such as the figures by Jacopo della Quercia on the *Fonte Gaia* of 1409–19 (Palazzo Pubblico, Siena),[12] but such connections are less compelling because of the Early Renaissance character of Jacopo's style, in which elements of the International, or French Gothic, style are greatly diminished if not completely abandoned.

No other trecento clay models (or terracottas) apparently exist today, nor do any large-scale metalwork Madonna and Child sculpture groups remain in Italy, although the large silver altars begun in the late thirteenth century in Pistoia[13] and initiated in 1367 in Florence,[14] as well as important reliquaries made by Sienese goldsmiths, demonstrate that such work was, in fact, executed. Although trecento goldsmiths are recorded, current research suggests that they were merely "assemblers," and that the metalwork sculptures—and, of course, their preliminary models—were made by sculptors.[15] It is significant to note both that Andrea Pisano began his career as a metalworker, and that the magnificent corpus (1320–30) of the reliquary cross from the Cathedral of Massa Marittima has been attributed to him.[16]

The Museum's Enthroned Madonna—from the collection of Erich Lederer, originally in Vienna—was brought to Switzerland before World War II and lent to the Musée d'Art et d'Histoire in Geneva, where it remained until its sale by August Lederer in London in 1997.[17] The illustration of the work in the sale catalogue indicated that it had been heavily "restored," perhaps in the nineteenth century, with the addition of plaster hands and feet and of a plaster Christ Child, and covered with an all-encompassing heavy layer of polychromy. The catalogue attributed the statuette to Northern Italy, in the early quattrocento. After the sale and prior to the Museum's purchase of the Enthroned Madonna, when all of the plaster and paint were removed by Joachim Böhm, a Munich restorer, the beauty and importance of this rare, if not unique, clay (or terracotta) trecento sculpture immediately were revealed.

Observations as to the sketchiness of the modeling in several passages, the omission of the Christ Child, and the disruption of some of the surfaces, among other details, noted when the sculpture was transferred to the Metropolitan Museum on approval, suggested that these features were related to the work's original purpose, which was to serve as a model for goldsmiths' work. The confident hand of the sculptor in rendering the Madonna's facial features and the boldness of the modeling of the drapery argue for the attribution of this work to an important master, who was active during the Gothic period in Tuscany.

L C - T/W D W

1 The proposal that the work was a model for a goldsmith was advanced initially by Richard E. Stone and Jack Soultanian of the Department of Objects Conservation at the Metropolitan Museum.

2 Acc. no. 17.190.351. Formerly dated to about 1400, the *Saint Christopher* is now regarded as *retardataire*—a provincial work that reflects an earlier style and, hence, is more probably datable several generations later. See Wixom, 1967, no. VI-7, pp. 228, 373 (with bibliography), ill. p. 229 (called "Languedoc, Toulouse, ca. 1400"); Thuile, 1969, pl. II, figs. 2–3, n.p. (attributed to Pons de Rosso, Toulouse, 1485, on the basis of the author's reading of the marks).

3 See the recent discussion in Butterfield, 1997, pp. 105–25. Of special interest is Verrocchio's clay model for the execution in the scene of the Beheading of Saint John the Baptist, one of the reliefs on the proper left side of the silver altar; see Butterfield, 1997, no. 17, pp. 124–25, 220, pl. 156. This model, which was brought to our attention by Richard Stone, was fired perhaps for presentation purposes. Along with the Museum's new acquisition, it is probably the only model for a metalwork commission that is preserved from the Gothic or Renaissance periods in Italy.

4 See Lüdke, 1983, vol. 1, pp. 2, 5, 84, 126, 138, figs. 30–31, 33, vol. 2, no. 135, pp. 478–83.

5 See the Report on Thermoluminescence Analysis by the Research Laboratory for Archaeology and the History of Art, Oxford, of May 12, 1997.

6 Compare with the Metropolitan's *Virgin of the Annunciation* (French, Île-de-France, about 1320–25, limestone, with traces of polychromy, Gift of J. Pierpont Morgan, 1917, 17.190.739), published in Baron, 1998, no. 71, pp. 125–27, color ill. p. 126. The deep drapery folds falling from the knees and between the legs of this limestone sculpture exemplify the French Gothic style, which seems to have had a profound impact on Early Gothic Tuscan sculpture.

7 See Carli, 1946, plates 27, 30.

8 See Kreytenberg, 1984, plates 23, 27.

9 Ibid., plates 52, 54.

10 This feature is also characteristic of the monumental figures in Giotto's frescoes in the Bardi Chapel in Santa Croce, Florence.

11 See also the marble *Madonna and Child* in Berlin: Kreytenberg, 1984, pl. 49.

12 Illustrated in Carli, 1946, plates 168–169. Jacopo's monumental sculpture of the *Enthroned Madonna and Child*, signed and dated 1408, in the Museo del Duomo, Ferrara, is too massive and the draperies too fluid for a valid comparison with the Metropolitan's terracotta: See Carli, 1946, pl. 161.

13 See Gauthier, 1972, pp. 208–10, 385–86 (with bibliography), ills. pp. 208–10.

14 See note 3, above.

15 See Previtali, 1995, pp. 2–17.

16 See Kreytenberg, 1984, fig. 46.

17 This information was supplied by Gabrielle Mentout of the Musée d'Art et d'Histoire, Geneva.

EX COLLECTIONS: Erich Lederer (1896–1985), Vienna and Geneva; August Lederer, Geneva; [sale, Sotheby's, London, July 2, 1997, lot 93, fig. 14 (color ill.)]; [S. Mehringer, Munich].

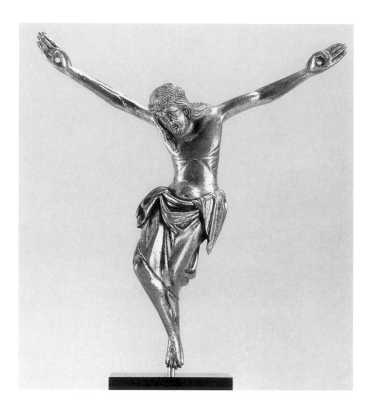

175

CORPUS FROM A CROSS

North Italian (Venice), second half of the 14th century
Bronze, partially gilded: 8¹/₁₆ x 7⅝ in. (20.5 x 19.4 cm)
The Jack and Belle Linsky Collection, 1982 (1982.60.397)

Considering the large scale of this figure of the crucified Christ, it must have come from a processional rather than an altar cross. Moreover, the length of the arms and the size of the upper part of the body are too large, proportionally, in relation to the legs, which would indicate that the figure was meant to be seen from below. Iconographically and stylistically, this corpus corresponds to others from the second half of the fourteenth century and is derived from a type introduced into Tuscany by Giovanni Pisano at the turn of the century that was inspired by French prototypes. The crown of thorns, rarely shown in Italian representations of Christ in this period, is found in Venetian art more frequently than in that of other regions of the country. In this instance, the crown is formed by entwined reeds and is without any visible thorns. The serenity of the face, with its elongated eyes; the shape of the loincloth, which is shorter in the front than are its northern European counterparts; and the absence of exceedingly dramatic overtones are typically Italian. The gilding has to a great extent been rubbed off, but what is left seems to be original.

A very similar corpus, perhaps from the same mold, is in the collection of the Victoria and Albert Museum, London.

C G - M

EX COLLECTION: Jack and Belle Linsky, New York.

EXHIBITION: "Medieval Art from Private Collections," New York, The Cloisters/The Metropolitan Museum of Art, October, 30, 1968–January 5, 1969, no. 106.

REFERENCES: Gómez-Moreno, 1968, no. 106, ill.; *idem*, 1984 a, no. 51, p. 134, ill. p. 135; *idem*, 1984 b, p. 15, ill.

176

TABERNACLE, WITH A CRUCIFIXION GROUP

North Italian (probably the Veneto), about 1350–about 1375
Poplar and oak, with polychromy and gilding: 38½ x 23¼ x 5¾ in. (97.8 x 59.1 x 14.6 cm)
Gift of Ruth Blumka, in honor of Ashton Hawkins, 1985 (1985.229.2)

Painting and sculpture are effectively combined in this tabernacle of painted wood that depicts the Crucifixion. Three-dimensional wooden statuettes of the Virgin Mary, Saint John the Evangelist, and the crucified Christ are set within a case (of later construction).[1] A carved-and-gilded arch, with pierced foliate ornament in the spandrels and supported on each side by twisted columns, forms the front of the aedicula's frame. Intended for private devotion, the self-contained unit was easily portable.

The crucified Christ, nude except for a gilded loincloth tied at his left side, occupies the center of the composition. A crown of thorns encircles his head, which is surmounted by a three-dimensional halo. The stark cross is set into a rocky mound representing Golgotha, the burial place of Adam, whose skull is prominently displayed. The Virgin stands to Christ's right, wringing her hands in lamentation, and Saint John, at Christ's left, rests his head on his right hand in a traditional gesture of mourning. In the painted background, four winged, lamenting angels are outlined against a dark blue sky.

Although the tabernacle was once considered to have been made in fifteenth-century Siena,[2] more recently it has been

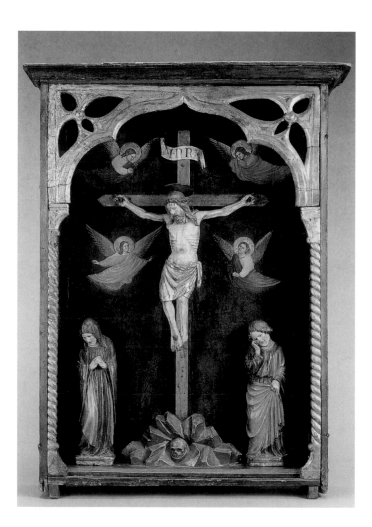

attributed to fourteenth-century Veronese masters.[3] The ascription of the painted portion to the Veronese artist Turone (Turone di Maxio da Camagno, active in the second half of the fourteenth century), whose masterpiece, a polyptych of the *Trinity*, is signed and dated 1360,[4] informs any attribution of the sculpture in the present work. Similarities of style between Turone's rather somber painting and the tabernacle sculptures are particularly apparent in the figure of Christ, where details like the loincloth echo that of the master's Christ figure in the polyptych. A domestic tabernacle such as this one might have been produced by the same group—workers within Turone's shop or an associated enterprise—that provided the elaborate, almost architectural, gilded wooden structures that frame his polyptych of the *Trinity* and many of his other works. The tabernacle also could have been made in another part of northern Italy. Turone was from Lombardy, which, stylistically, like Verona, was a border area significantly affected by artistic influences from north of the Alps. Although the angels surrounding Christ ultimately derive from those in Giotto's *Crucifixion* in the Arena Chapel in Padua, dated between 1304 and 1311, there are strong echoes of German art, as well, in the tabernacle's sculpted figures.[5]

LC-T

1 The three sculptures, presently under study in the studios of the Department of Objects Conservation at the Metropolitan Museum, have been determined to be contemporary in date, if not all by the same workshop.
2 See Breck, 1913, p. 15.
3 Callmann, 1980, p. 38, cites Everett Fahy's attribution of the background painting to the Veronese artist Turone, and the sculpted figures to "an anonymous Veronese master whose small *oeuvre* is brought together by Pope-Hennessy." See also Pope-Hennessy, 1964, vol. 1, pp. 48–49.
4 Museo di Castelvecchio, Verona, Inv. no. 355; illustrated in Marinelli, 1983, pp. 38–39.
5 Compare, for example, the gestures of Mary and John in the thirteenth-century German *Crucifixion* groups from Halberstadt or Wechselburg illustrated in Budde, 1979, figs. 272, 287.

EX COLLECTIONS: Georges Hoentschel, Paris, until 1906; J. Pierpont Morgan (d. 1913), New York; The Metropolitan Museum of Art, New York, 1916 (16.32.110); deaccessioned, March 8, 1971; [Blumka Gallery, New York, by exchange, March 1971].

EXHIBITION: "Beyond Nobility, Art for the Private Citizen in the Early Renaissance," Allentown, Pennsylvania, Allentown Art Museum, September 28, 1980–January 4, 1981, no. 32.

REFERENCES: Breck, 1913, no. 13, pp. 15–16; Callmann, 1980, no. 32, pp. 37–38, ill.

177

THE MAN OF SORROWS (*IMAGO PIETATIS*)

Italian (Florence?), last quarter of the 14th century
Copper gilt, with champlevé enamel: 4¹⁄₁₆ x 3¹⁄₁₆ in. (10.3 x 7.8 cm)
Gift of Georges E. Seligmann, in memory of his wife, Edna, his father, Simon Seligmann, and his brother, René, 1982 (1982.480)

The half-length, gilded image of the dead Christ appears, as if in a vision, above his enameled tomb. He is flanked by Instruments of his Passion: the sponge soaked with vinegar that was offered to him after he was nailed to the cross, and the lance that pierced his side.

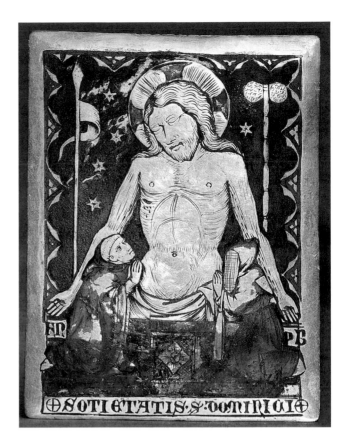

Before him two figures kneel: a monk with a tonsured head, who wears a robe with a hooded cowl, and a flagellant, his face shrouded and his robe open at the back, so that he can beat himself with the scourge that hangs from his wrist. The imagery, the inscription at the bottom (SOTIETATIS·S·DOMINICI), and the abbreviations at either side of the figures (FR, PB[?]) suggest that this plaque was made to be used by a member of a Dominican confraternity.

The focus on the crucified Christ and his suffering was widespread in religious art after the mid-fourteenth century: Pope John XXII (r. 1316–34) declared that the *imago pietatis* should be evoked during the elevation of the bread and wine in the celebration of the Mass, while Pope Innocent VI (r. 1352–62) established indulgences for devotion to the Instruments of the Passion. The theological emphasis on the personal contemplation of Christ's sacrifice and the size of the plaque and that of comparable contemporary images in *verre églomisé* suggest that this plaque originally was set into a small frame and was intended for private use.

Compositional aspects of representations of the half-length figure of Christ posed upright in his tomb, in Florentine painting of the late fourteenth century, have served as a basis for dating related gold-glass images, and likewise can provide an approximate date for the present work.[1]

Losses to the original enameling are evident in the robes of the two kneeling figures, which, rather illogically, appear partly enameled and partly gilded. The lack of definition in the facial features of the Dominican brother indicates further alteration to the surface by smoothing down and regilding. The body of Christ is now largely gilded but enameled in only limited areas to underscore the anatomy of his torso and his bleeding limbs. While this gilding seems to have been redone, and the enameling reduced, it is likely that the image was always gilded, in the manner of contemporary gold glass.

BDB

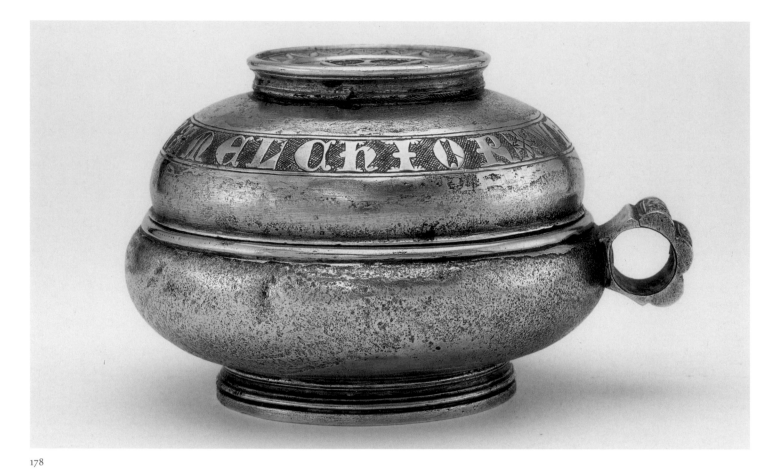

178

1　See, for example, *Painting and Illumination in Early Renaissance Florence*, 1994, p. 130, fig. 44, p. 265, fig. 106, colorpl. p. 297, for images of Christ of this type.

EX COLLECTIONS: Albert Germeau, France; [sale, Hôtel Drouot, Paris, May 4–7, 1868, lot 65]; Victor Gay, Paris; [sale, Hôtel Drouot, Paris, March 23–26, 1909, lot 52]; [Simon Seligmann, Paris]; Georges and Edna Seligmann, New York.

REFERENCE: Gómez-Moreno, 1983, p. 22, color ill.

178

DOUBLE CUP

German or Bohemian (Prague?), 1330–60

Silver and silver gilt, with applied opaque enamel: Height, 6¼ in. (15.9 cm)

Inscribed (around the body of the upper vessel): + CASPAR + MELCHIOR + WALTAZAR •

The Cloisters Collection, 1983 (1983.125a,b)

The only known double cup of its type and date, this example comprises two sections of similar form and profile; it stands on a low ring foot, and is fitted with a handle decorated with cast and chased human-headed grotesques. An enameled roundel with a helm crested with three upended conical Jewish hats is applied to the interior of the lower section, and an escutcheon with a similar device consisting of three Jewish hats is attached to the underside of the base of the upper vessel (see details). The seemingly anomalous coupling of Jewish heraldic devices on an object inscribed with the names of the Three Kings may be explained by the fact that, in the Middle Ages, Epiphany was celebrated outside a Christian context.[1]

The eve of Epiphany, believed to mark the New Year, was considered magical: Natural springs became curative, celestial conjunctions in threes made wishes come true, and animals could talk. Special breads were baked and distributed, and prognostications were made when the forms that resulted from dropping molten lead into water were interpreted. The Three Kings were invoked for protection against a litany of complaints, diseases, and evils. In light of this, the inscription can be understood as purely amuletic or talismanic.

Double cups were used to drink all manner of toasts on special occasions such as betrothals, pledges of loyalty, and farewells, as well as on important days of the liturgical calendar, including saints' days, Pentecost Monday, New Year's Day, the eighth day after Easter, and Three Kings' Day. The present double cup may have been intended specifically for Epiphany, when, it was thought, special toasts would make women fertile and men virile. To emulate the gesture of the Three Kings themselves, elaborately decorated cups often were given as presents. In 1351, for example, King Charles IV, on whose lands and during whose lifetime this double cup assuredly was made, hosted a celebration in Prague of the marriage of Lazar, the leading financier of that imperial city.

While the coat of arms has not been identified, it recurs in identical form engraved on a shield attached to the bottom of one of a set of nested beakers found buried in a wall of a Gothic house in Kutná Hora, in central Bohemia, where the context is unequivocally imperial:[2] Appearing in descending order, one at the bottom of each beaker, are the *Bindenschild* of Austria, the white eagle of Poland, the double-tailed lion of the kingdom of Bohemia, the identical three concentric Jews' hats, and an unidentified coat of arms with a rampant wolf and an inscription including the Hebrew word for the animal (fig. 11). The hierarchical ordering of the coats of arms could indicate that a member of a family named Wolf belonged to a Jewish

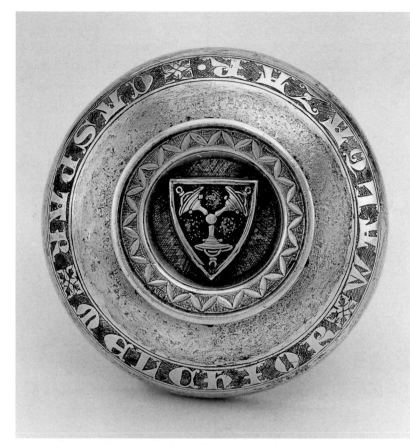

178: Detail of the underside of the base of the upper vessel

178: Detail of the interior of the lower section

178: Detail of the handle

fraternity or community under imperial protection or patronage, and whose device was the three concentric hats.

Even though Jews were somewhat protected, periodically they were subjected to virulent pogroms, notably that of 1349. Several hoards of silver plate and coinage datable to or before that year have been unearthed. The fact that both the Nuremberg beakers and the Cloisters' double cup also were buried suggests that they, too, may have been secreted in the hope that they would be recovered at a later and safer time.

TBH

1 For a detailed discussion of this double cup see Husband, 1982 83, pp. 292–97.
2 See Schiedlausky, 1975, pp. 300–314.

EX COLLECTION: [sale, Sotheby Parke Bernet, London, March 7, 1983, lot 167].

REFERENCES: Husband, 1982–83, pp. 292–97; *idem*, 1983, pp. 19–21, ills. p. 20, colorpl.

179

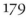

ALTAR CRUET

German or Bohemian, about 1350
Silver and silver gilt: Height, 8 in. (20.3 cm)
The Cloisters Collection, 1986 (1986.284)

Intended to contain either water or wine for use in the celebration of the Mass, this cruet is one of the few fourteenth-century liturgical vessels in the Metropolitan Museum's collections. The horizontal moldings are similar to those found on several excavated silver

Figure 11. Detail of an enameled boss with an unidentified coat of arms, including the Hebrew word for wolf and an image of the animal, which appears on one of a set of nested beakers found in Bohemia. Germanisches Nationalmuseum, Nuremberg

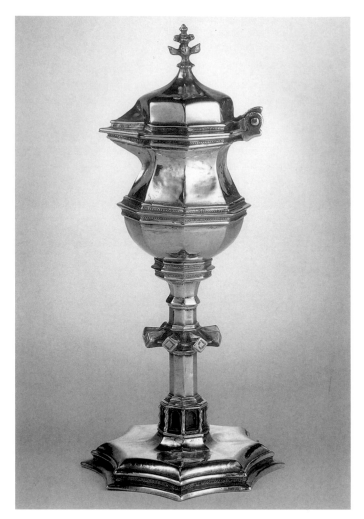

179

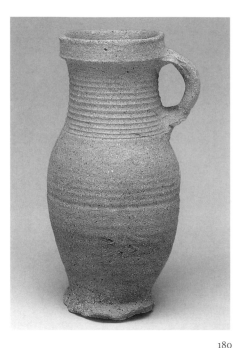

180

vessels that can be associated with the palace of Emperor Charles IV at Kutná Hora, east of Prague, in central Bohemia. Three other cruets of the same design are known, but they appear to come from disparate workshops.[1] The bold clarity of its profile, the balanced proportions, and the simplicity of the decoration contribute to this vessel's restrained elegance, in contrast to the more florid ornamentation characteristic of fifteenth-century goldsmiths' work.

TBH

1 Victoria and Albert Museum, London (Inv. nos. 587, 587a-1910); and see Braun, 1932, pl. 81, no. 308.

EX COLLECTION: Nicholas Gorevic, Sarasota, Florida.

REFERENCE: Husband, 1987 b, p. 16, ill.

180

JUG

German (Lower Rhineland: Siegburg), first half of the 14th century
Unglazed protostoneware: Height, 8½ in. (21.6 cm)
Gift of Anthony and Lois Blumka, 1991 (1991.471.3)

The banded lip distinguishes the form of this vessel, already in production in the late thirteenth century, from later Siegburg jugs.

TBH

EX COLLECTION: [Bastiaan Blok, Noordwijk, The Netherlands].

181

THE BISHOP OF ASSISI HANDING A PALM TO SAINT CLARE

German (Nuremberg), about 1360
Tempera and gold on oak panel, 13¼ x 8⅝ in. (33.7 x 21.9 cm)
The Cloisters Collection, 1984 (1984.343)

Among the earliest German medieval panel paintings preserved is a series of altarpiece fragments probably made for the Clara Cloister in Nuremberg from about 1360 to 1370.[1] Possibly painted in a workshop within the cloister itself, these panels illustrate episodes in the life of Saint Clare. They may be the remains of two altarpieces since each has slightly different decorative details and one subject appears twice. In addition to the Cloisters' panel, the known surviving panels represent *The Death and Coronation of Saint Clare, Pope Innocent IV Confirming the Rule of the Order of the Poor Clares, Christ Appearing in a Ciborium to Saint Clare,* and *Christ Appearing in a Ciborium to Saint Clare and Saint Francis,* all in the Germanisches Nationalmuseum, Nuremberg; *Hortolana Kneeling before a Crucifix* and *Saint Clare Awakening the Dead,* both in the Historisches Museum der Stadt, Bamberg; and a kneeling Annunciation figure, in a private collection in Regensburg.

In our painting three standing nimbed figures are set against a gold ground punched with foliated branches and *rinceaux* and bordered with rosettes in a manner especially close to that of the panels in Bamberg. A bishop, wearing a chasuble of gold and deep red, offers a palm to the young crowned woman before him, who wears a red-and-gold vest bordered in ermine over a green gown decorated with a pattern of red lozenges. Behind the bishop, the tonsured Saint Francis, identifiable by the stigmata on his hands and by his brown cordoned habit, points to a pair of shears in his left hand. Both the bishop and Saint Francis are partially obscured by a stone altar with rosette decoration on which a gilt chalice and an open book inscribed *eto/m[n]es/fid/eles* (and all faithful) are displayed. A white cloth with red and green fringes covers the top and part of the sides of the altar.

The subject illustrates an early event in the saintly life of Clare.[2] On Palm Sunday 1212, the bishop of Assisi handed the eighteen-year-

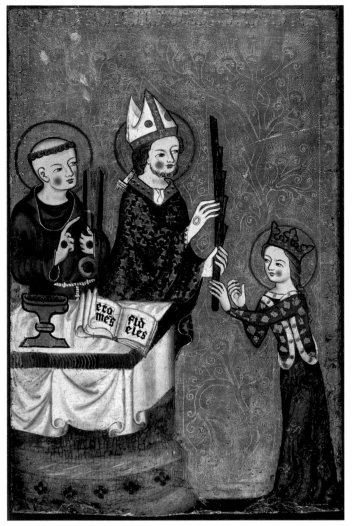

181

EXHIBITIONS: "Caritas Pirckheimer, 1467–1532," Nuremberg, Kaiserburg, June 26–August 8, 1982, no. 61 b; "Gothic and Renaissance Art in Nuremberg: 1300–1550," New York, The Metropolitan Museum of Art, April 8–June 22, 1986, and Nuremberg, Germanisches Nationalmuseum, July 24–September 28, 1986, no. 8 a.

REFERENCES: Lutze and Zimmermann, 1932, pp. 10, 24, 25, 50, pl. 35; Stange, 1934, pp. 201–3, pl. 32; Strieder, 1982, no. 61 b, pp. 83–84, fig. 13; Wixom, 1985, p. 13, colorpl.; Löcher, 1986, no. 8 a, pp. 122–23, colorpl.

182

RELIQUARY CIBORIUM

German (Lower Saxony), late 14th–early 15th century
Copper gilt: Height, 13 11/16 in. (34.7 cm)
Provenance: Cathedral, Braunschweig, Germany (listed in the inventory of 1482).
Gift of Mrs. Raymond Holland, 1983 (1983.410)

The Guelph Treasure, one of the richest ducal collections in medieval Europe, included many reliquaries. This tall, ciborium-shaped vessel is hinged, allowing it to be opened, like others of similar shape in the treasure. It also could be used as a container for the Eucharistic wafer. Its simple yet elegant form can be related to metalwork produced in Lower Saxony about 1400.

CTL

EX COLLECTION: Mrs. Raymond Holland, Old Lyme, Connecticut.

REFERENCES: Neumann, 1891, no. 71, p. 305; von Falke, Schmidt, and Swarzenski, 1930, no. 73, p. 208, pl. 104; Braun, 1940, pp. 226–27, fig. 180; *MMA Annual Report*, 1984, p. 40, ill.

old Clare a palm, a symbolic gesture arranged by Saint Francis. Shortly afterward, the young woman gave up her luxurious life as the daughter of a wealthy nobleman. Her hair was shorn, as alluded to by the scissors held by Saint Francis. Her rich garments, shown here, were abandoned when she was received into the Franciscan Order. Eventually, Saint Francis permitted her to establish her own order—the Order of the Poor Clares—a community committed to vows of poverty.

The crown Clare wears in the Cloisters' panel relates to her coronation in heaven after her death. Thus, this painting refers to the three central episodes in her history. All the panels that depict the story of Saint Clare combine the same simple figure style, dramatic gestures, elegant line, limited range of colors, and skilled use of varied textures and patterns. This style, which is partially shared by contemporary Nuremberg manuscript and glass painting, is especially effective in the present work, with its ineffable charm, naïve elegance, and engaging narrative.

WDW

1 See Kurth, 1929, pp. 41–43.
2 See Braun, 1943, cols. 423–425; *Oxford Dictionary of the Christian Church*, 1957, pp. 294, 1090; *New Catholic Encyclopedia*, 1967, p. 1913.

EX COLLECTIONS: Baron Robert von Hirsch, Basel, before 1931–1978; [sale, Sotheby Parke Bernet, London, June 21, 1978, vol. 1, lot 117, colorpl.]; [Thomas Agnew & Sons Ltd., London].

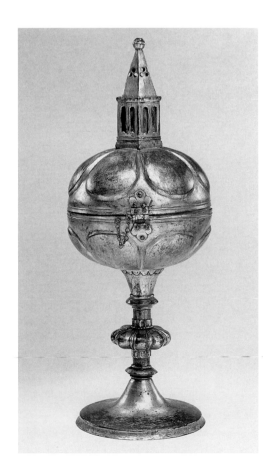

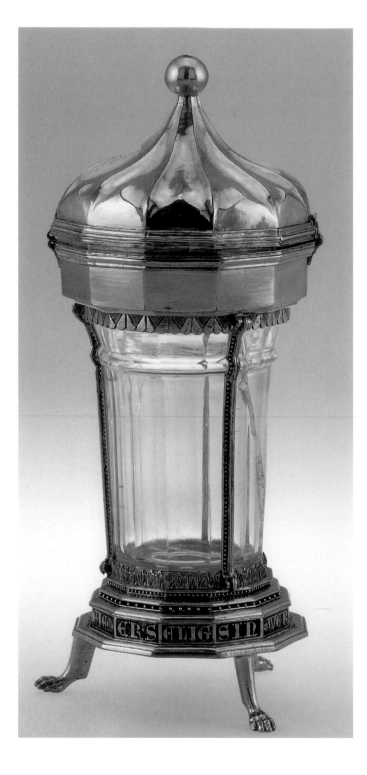

183

COVERED BEAKER

Austrian (Vienna?), about 1350–60

Silver gilt, rock crystal, and translucent enamels: Height, 8¼ in. (21 cm)

Inscribed (around the base): ••WER/HIE•V/S•DR/INCE/ET•W/
INDE/R•MV/EZZ/E•IEM/ER•S/ELIG/SIN

The Cloisters Collection, 1989 (1989.293)

This highly unusual twelve-sided rock-crystal beaker is fitted with a silver-gilt base and cover. Three other nearly identical rock-crystal vessels are known: one mounted in the mid-fourteenth century, probably in Paris; another mounted in the later fifteenth century in southern Germany; and the third mounted in Nuremberg in the late sixteenth century.[1] The location of the workshop that made these

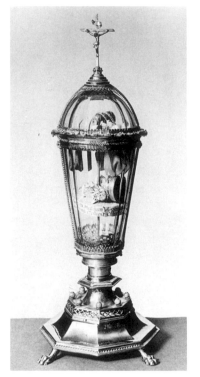

Figure 12. Covered beaker. Central European, probably Vienna or Wiener Neustadt, about 1367. Silver gilt and rock crystal. Cathedral Treasury, Aachen

rock-crystal vessels is uncertain, but it is known that Venice was an important center for the cutting and polishing of rock crystal for the export market.

The closest comparison in terms of the treatment of the mounts is found in a rock-crystal and silver-gilt reliquary beaker that is documented as having been given by King Louis I of Hungary (r. 1342–82) to the Treasury of Aachen Cathedral in 1367 (see fig. 12). The foot of the latter beaker, in particular, as well as that of ours, can, in turn, be linked stylistically with the Liebenau cross, which probably was made in Vienna shortly after 1342 and is now in the Augustinermuseum, Freiburg.[2]

Around the base of the Metropolitan's vessel, in alternating panels of green and blue enamel, is a distich in a Saxon dialect that may be translated: "He who drinks wine from me, ever shall happy be." These engraved panels, which clearly establish the beaker's secular use, are structurally interlocked with the rest of the base, and cannot be removed without severely damaging the object. For this reason, no doubt, the beaker was never converted into a reliquary—as were the other examples cited above. The whimsical deviation of the beaker's three zoomorphic legs, which terminate in paws, from an otherwise strictly geometrical arrangement, dispels any sense of compositional rigidity. In spite of the underlying complexity, the effect is one of elegant simplicity.

TBH

1 Amiens Cathedral (Inv. no. 350); Würzburg, Mainfränkisches Museum (Inv. no. 48673); and Vienna, Kunsthistorisches Museum (Inv. no. 2270). See Hahnloser and Brugger-Koch, 1985, nos. 351, 352, 359, pp. 184–85, 187, plates 298–300.
2 See Fritz, 1982, no. 275, pp. 225–26, no. 249, pp. 182–83, respectively.

EX COLLECTIONS: Hollingworth Magniac, Colworth, West Sussex, England, until 1892; [sale, Christie, Manson & Woods, London, July 2–4, 1892, lot 642,

p. 152]; Sir Thomas Gibson Carmichael, Bart., Castle Craig, until 1902; [sale, Christie, Manson & Woods, London, May 12, 1902, lot 87, p. 31]; [Harding, London]; Montagu, first Lord Swaythling, London, until 1924; [sale, Christie, Manson & Woods, London, May 6, 1924, lot 69, p. 20]; [Crichton, London]; William Randolph Hearst, New York, until 1940; [Joseph Brummer, New York, until 1949]; Ruth and Leopold Blumka, New York.

REFERENCES: Lamm, 1929–30, vol. 1, pp. 233–34, vol. 2, pl. 84, no. 15; Husband, 1990 b, p. 19, colorpl.

184

AMATORY BROOCH IN THE FORM OF A LOMBARDIC *E*

German (possibly Saxon), about 1340–60
Gold and freshwater pearls: Height, 1¼ in. (3.2 cm)
Inscribed (on the inside): •V/REWELININ•VRME DEI+ HERZE•LEVE•/NSTE•MOIS IC IN•/•SIN
The Cloisters Collection, 1986 (1986.386)

This small gold brooch, designed as a locket, was decorated around the periphery with six freshwater pearls, only one of which remains. Riveted to the crossbar of the letter is a small, cast figure of a man holding an arrow in each hand aimed at his heart; he may represent the groom of Frau Minne, whose heart is pierced by arrows of love. The interior of the brooch contains an inscription, perhaps in a Saxon dialect, which may be translated: "Fair lady, may I always remain close to your heart." This brooch, a fine example of fourteenth-century intimate jewelry, reflects the courtly ideals of love in the age of chivalry.

TBH

EX COLLECTIONS: Baron Robert von Hirsch, Basel; [sale, Sotheby Parke Bernet, London, June 20–27, 1978, vol. 2, lot 251, p. 69]; [sale, Sotheby's, London, December 11, 1986, lot 200, p. 104].

REFERENCES: Steingräber, 1957, p. 44, figs. 48, 49; Cherry, 1978, p. 7, pl. 3 A, B; Fritz, 1982, p. 231, fig. 322, n.p.; Husband, 1987 b, p. 16, color ills.; Lightbown, 1992, p. 434, pl. 56.

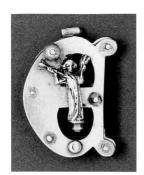

184

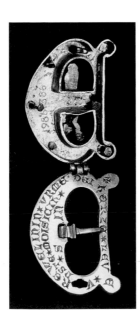

184: Interior

185

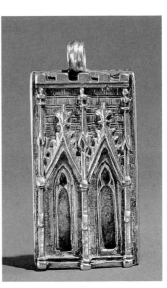

186

185

FINGER RING

English or Italian, 14th century
Gold, with a sapphire: Diameter, ⅝ in. (1.59 cm)
Inscribed: AVE/MARIA/CIVITAS CANTOR/RVTILANS EBORACI ("Hail Mary. Rufus[?] Musician [or crier] of the episcopal city of York")
The Cloisters Collection, 1994 (1994.40)

While the provenance of this ring is unknown, it clearly has a connection to the city of York, as indicated by the inscription. Although the place name suggests English manufacture, the form of the hoop, which is triangular in section; the shape of the bezel; and the projecting rosettes generally are associated with Italian rings. This rare example is enhanced by its bold decoration engraved in reserve and by its crisp profile. Sapphires were accorded amuletic value, and were thought to detect fraud and witchcraft, expel envy, and cure snakebites.

TBH

EX COLLECTION: [Michael Ward, Inc., New York].

REFERENCE: Husband, 1994 b, p. 19, color ill.

186

RELIQUARY PENDANT

German, late 14th century
Silver, silver gilt, and niello: 2¼ x 1 in. (5.7 x 2.5 cm)
Inscribed (on the edge): de Sca Barbara/de Sco Georgio
Gift of Rainer M. Zietz, 1985 (1985.137)

The relics once housed in this pendant were visible through the gabled and crocketed lancet windows on the front, while the reverse is decorated with a relief representing hounds coursing hares.

TBH

EX COLLECTIONS: Margarete Oppenheimer, Munich; [sale, Julius Böhler Kunsthandlung, Munich, May 1936, lot 465, p. 52, pl. 38]; private collection; [sale, Sotheby & Co., London, July 10, 1975, lot 5, p. 6]; Thomas F. Flannery Jr., Chicago; [sale, Sotheby & Co., London, December 1–3, 1983, lot 18, p. 31]; [Rainer Zietz Limited, London].

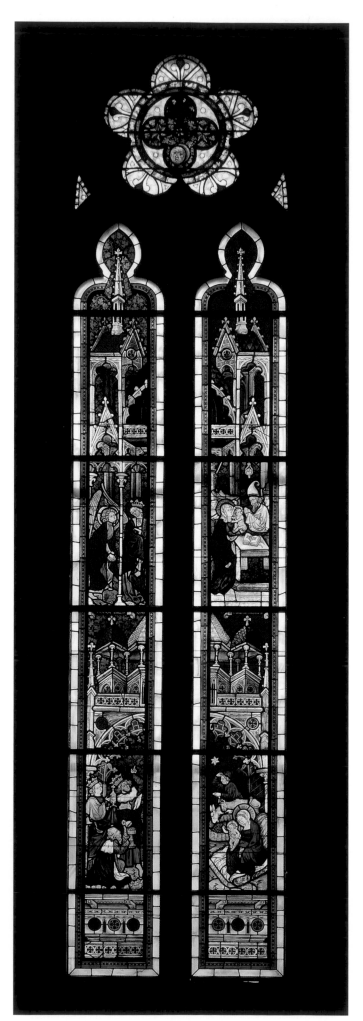

187: *The Annunciation, The Presentation in the Temple,* and *The Adoration of the Magi*

187

SEVEN SCENES FROM THE LIFE OF CHRIST, AND ARCHITECTURAL CANOPIES

Austrian (Ebreichsdorf), about 1390

Pot-metal and colorless glass, with silver stain and vitreous paint: Four lancets (each), 11 ft. 8¾ in. x 12⅛ in. (357.5 x 30.8 cm)

Provenance: Schlosskapelle, Ebreichsdorf.

The Cloisters Collection, 1986 (1986.285.1-13)
The Cloisters Collection, 1987 (1987.40.1,2)

These panels were commissioned for the private chapel in the castle at Ebreichsdorf, south of Vienna. Originally, there were eighteen scenes, some extending across two lights of the windows, but these eight figural panels—one of which entered the Metropolitan Museum's collection in 1936—and another in Vienna are all that survive. The royal atelier responsible for the glass was established in Vienna, where its early work can be seen in the Church of Maria am Gestade, of about 1365, and in the ducal chapel at the Cathedral of Saint Stephen, of about 1395.

The elegant figures, richly damascened backgrounds, and elaborate architectural canopies, as well as the wealth of detail and the brilliant palette that enrich the settings, are all characteristic of this court workshop.

The subsequent acquisition by the Metropolitan Museum of the additional canopy allowed the glazing of the final lancet at the Museum to be completed. Now, the glass from Ebreichsdorf can be

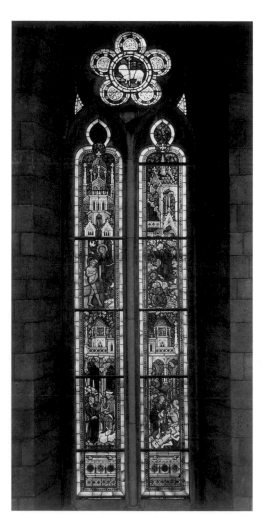

187: *The Baptism of Christ, The Agony in the Garden, Christ Before Pilate,* and *The Harrowing of Hell*

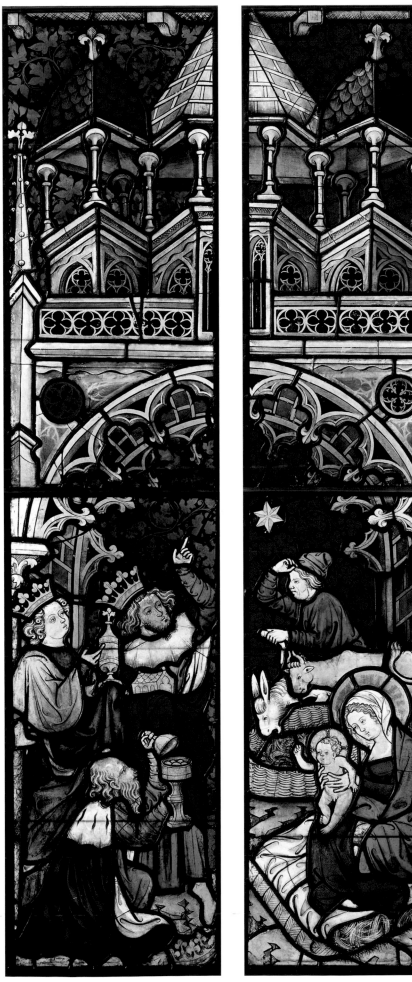

187: *The Adoration of the Magi* (detail)

compared with the earlier panels from Saint Leonhard in Lavanthal, produced by a provincial workshop in about 1350, as both glazing programs are installed in the Gothic Chapel at The Cloisters (see fig. 13), and, together, comprise the largest single holding of fourteenth-century Austrian glass outside of Austria.

тви

EX COLLECTIONS: (1986.285.1-13) Lolowrat-Liebsteinsky, Ebreichsdorf, 1843–73; Arco-Zinneberg, Ebreichsdorf, 1873–1922; [Duveen Brothers, New York]; Mrs. Alexander Hamilton Rice, New York, 1923–57; National Museum of American Art, Smithsonian Institution, Washington, D.C., 1957–86; (1987.40.1,2) [Roy Grosvenor Thomas, New York, by 1923]; George A. Douglass Sr., Greenwich, Connecticut; George A. Douglass Jr., Greenwich, Connecticut.

REFERENCES: Kieslinger, 1922, pp. 147–54; Frodl-Kraft, 1972, pp. 225–28, plates 681–688; Hayward, 1985, pp. 25, 113, ill. p. 25; *idem*, 1987, pp. 36–38, ills.; Hayward, 1988, pp. 19–20, colorpl. p. 19; Frodl-Kraft, 1992, pp. 385–407, figs. 6, 8, 15, 19.

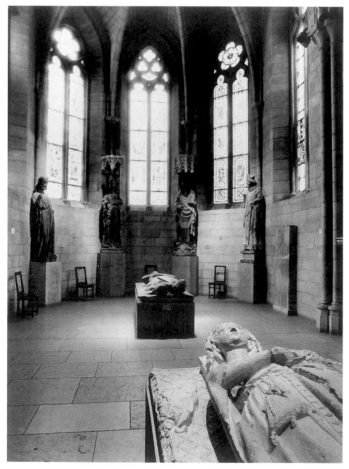

Figure 13. The Gothic Chapel at The Cloisters

188

JUG

German (Lower Rhineland: Siegburg), late 14th or early 15th century
Partially salt-glazed stoneware: Height, 9⅛ in. (23.2 cm)
Gift of Anthony and Lois Blumka, 1991 (1991.471.4)

In contrast to the protostoneware jug (1991.471.3; cat. no. 180), this example is of true stoneware, made of a finer clay that fires at a higher temperature than ordinary earthenware. Stoneware remained the mainstay of production in Siegburg well into the seventeenth century.

тви

EX COLLECTION: [Bastiaan Blok, Noordwijk, The Netherlands].

189

CHALICE

Spanish (Catalonia: Barcelona), about 1380
Silver, silver gilt, and translucent enamel: Height, 7½ in. (19.1 cm)
The Cloisters Collection, 1988 (1988.66)

A rare example of a fourteenth-century silver altar furnishing, this chalice bears the punch mark of Barcelona on the underside of the base. Pierced rectilinear apertures with enamel plaques mounted

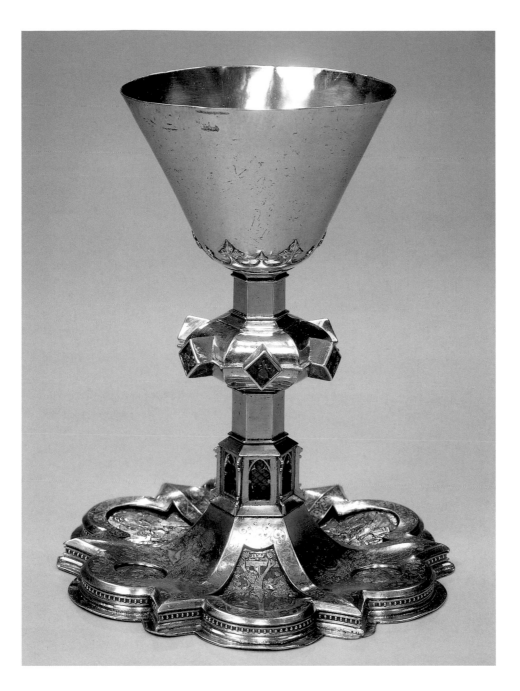

underneath are characteristic of Catalonian goldsmiths' work. A very unusual feature of this chalice, however, is the three male heads between the enameled plaques, which are delicately stippled with a fine, hard stylus. These heads are related to models found in several sketchbooks executed in the International Style. The technique of stippling on metal appears to have been concentrated in the South Lowlands and in the Luxembourg-Prague-Cologne artistic axis, and is rarely found in Spain. The style of the drawing, however, does appear to rely on local models.

TBH

EX COLLECTIONS: R. von Passavant-Gontard, Frankfurt; [S. J. Phillips Ltd., London].

EXHIBITION: "Ausstellung alter Goldschmiede-Arbeiten," Frankfurt-am-Main, Kunstgewerbemuseum, June–September 1914, no. 110.

REFERENCES: *Ausstellung alter Goldschmiede-Arbeiten*, 1914, no. 110; *Sammlung R. von Passavant-Gontard*, 1929, no. 124, p. 29, pl. 46; Husband, 1988, p. 18, ill.

189: Detail of the base

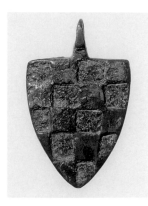

190

191

192

190

HORSE TRAPPING

Spanish (Catalonia), 14th century
Copper alloy, with traces of enamel: Height, 1¾ in. (4.5 cm)
Gift of Ruth Blumka, 1980 (1980.32.1)

The coat of arms, now lacking its tinctures, may belong to the counts of Urgel, who ruled over extensive areas of Catalonia. Three sepulchral monuments belonging to members of this family are now in the Early Gothic Chapel at The Cloisters.

твн

EX COLLECTION: [Blumka Gallery, New York].

191

HORSE TRAPPING

Spanish (Catalonia), 14th century
Gilded copper alloy, with enamel: Diameter, 2¾ in. (7 cm)
Gift of Ruth Blumka, 1980 (1980.32.3)

The coat of arms on this unusually large and well-preserved ornament is that of the counts of Foix, whose domains extended into Catalonia.

твн

EX COLLECTION: [Blumka Gallery, New York].

192

STANDARD ORNAMENT

Spanish (Catalonia), 14th–15th century
Copper alloy: 1⅛ x 1⅞ in. (2.9 x 4.8 cm)
Gift of Ruth Blumka, 1980 (1980.32.2)

This object, with an unidentified coat of arms, is thought to have surmounted the pole or staff of a standard.

твн

EX COLLECTION: [Blumka Gallery, New York].

193

GROTESQUE

English (York?), about 1320–40
Pot-metal and colorless glass, silver stain, and vitreous paint: Diameter (with border), 7¹⁵⁄₁₆ in. (20.1 cm)
The Cloisters Collection, 1991 (1991.144.1)

Bosses with grotesques and drolleries were commonly incorporated into the central zones of fourteenth-century grisaille windows. While the origin of this example is unknown, it exhibits similarities to York glass painting, which gives some credence to its hearsay provenance of York Minster.

твн

EX COLLECTION: [Bastiaan Blok, Noordwijk, The Netherlands].

194

TWO-COLORED TILE

English (Midlands), mid-14th century
Fired earthenware, with slip decoration and lead glaze: 4¾ x 4½ in. (12.1 x 11.4 cm)
The Cloisters Collection, 1991 (1991.112.2)

The pattern of this tile corresponds to that found on a group of tiles said to come from tileries at Penn in Buckinghamshire.

твн

EX COLLECTION: [Blumka Gallery, New York].

195

FOUR TWO-COLORED TILES

English (Oxfordshire), late 14th century
Fired earthenware, with slip decoration and lead glaze: 4½ x 4½ in. (11.4 x 11.4 cm)
The Cloisters Collection, 1991 (1991.112.5a-d)

This quadrant of tiles came either from Hertford College, Oxford, or from the Benedictine abbey of Godstow, north of Oxford.

твн

EX COLLECTION: [Blumka Gallery, New York].

193

194

195

196

TWO-COLORED TILE

English (Midlands), late 14th–early 15th century
Fired earthenware, with slip decoration and lead glaze: 5⅜ x 5⅜ in.
(13.7 x 13.7 cm)
The Cloisters Collection, 1991 (1991.112.3)

Tiles with a similar pattern have been found in Cheshire. Whether the roselike center fill is charged with heraldic significance is unknown.

TBH

EX COLLECTION: [Blumka Gallery, New York].

197

TWO-COLORED HERALDIC TILE

English (Midlands: Nottingham or Derbyshire), late 14th century
Fired earthenware, with slip decoration and lead glaze: 5½ x 5½ in.
(14 x 14 cm)
The Cloisters Collection, 1983 (1983.236.2)

This tile, as well as catalogue numbers 198, 199, and 273 (1983.236.6,1,3), was produced by pressing a design into the unfired clay, firing it, filling in the design with a cream-colored slip, and then firing it a second time. English two-colored tiles were manufactured on a protoindustrial scale in the fourteenth and fifteenth centuries, mostly in the Midlands, and were used for floor paving and wainscoting in both ecclesiastical and secular buildings. The coat of arms is that of England, reversed, after it was quartered in 1340, but before the alterations of 1405. Similar tiles have been found at Smith's Bank, Nottingham, and Dale Abbey, Derbyshire.

The technique of producing medieval two-colored tiles was revived in the nineteenth century, and exemplified the good design and honest craftsmanship much praised and promulgated by the Gothic Revival and Reformed Gothic movements.

TBH

EX COLLECTIONS: Reginald W. Cooper, Nottingham; [Neales, Nottingham, 1983]; [Ronald A. Lee, London].

198

TWO-COLORED HERALDIC TILE

English (Midlands: Nottingham or Warwickshire), 14th–15th century
Fired earthenware, with slip decoration and lead glaze: 5⅜ x 5¼ in.
(13.7 x 13.3 cm)
The Cloisters Collection, 1983 (1983.236.6)

The coat of arms, which is that of England, prior to 1340, but in reverse, is probably anachronistic, and may have been employed for its decorative value only. The tile is said to have come from Keynsham Abbey, Somerset (Avon).

TBH

EX COLLECTIONS: Reginald W. Cooper, Nottingham; [Neales, Nottingham, 1983]; [Ronald A. Lee, London].

200

199

TWO-COLORED HERALDIC TILE

English (Midlands: Warwickshire or Nottingham), late 14th–early 15th century

Fired earthenware, with slip decoration and lead glaze: 5⅜ x 5⅜ in. (13.7 x 13.7 cm)

The Cloisters Collection, 1983 (1983.236.1)

Said to have come from Derbyshire, this tile bears the coat of arms of the Beauchamp family and is related to examples from Chilvers Coton, Coventry, and Ulverscroft.

TBH

EX COLLECTIONS: Reginald W. Cooper, Nottingham; [Neales, Nottingham, 1983]; [Ronald A. Lee, London].

200

MUNICIPAL SEAL OF MIDDELBURG (ONE OF A GROUP OF 545 SEALS AND SEAL IMPRESSIONS)

Netherlandish, about 1374

Brown wax: Diameter, 2¾ in. (7 cm)

Gift of H. P. Kraus, 1981 (1981.534.2)

BDB

EX COLLECTIONS: Pieter Bondam (d. 1800), Utrecht; Petrus van Musschenbroek (1764–1823), Leyden; Sir Thomas Phillipps, London, 1826; [sale, Sotheby Parke Bernet & Co., London, December 10, 1980, lot 21]; [H. P. Kraus, Inc., New York].

REFERENCE: *MMA Annual Report*, 1982, p. 37, ill.

201

SECRET SEAL OF THE CHAPTER OF SAINT MARTIN OF UTRECHT (ONE OF A GROUP OF 545 SEALS AND SEAL IMPRESSIONS)

Netherlandish, 15th century; matrix, 14th century

Green wax: Diameter, 1³¹⁄₆₄ in. (3.77 cm)

Gift of H. P. Kraus, 1981 (Inst. 1981.13.435)

BDB

EX COLLECTIONS: Pieter Bondam (d. 1800), Utrecht; Petrus van Musschenbroek (1764–1823), Leyden; Sir Thomas Phillipps, London, 1826; [sale, Sotheby Parke Bernet & Co., London, December 10, 1980, lot 21]; [H. P. Kraus, Inc., New York].

201

Figure 14. André Beauneveu. *Prophet*, 1392–1405. Limestone. Musée de la Ville, Bourges

202

PROPHET

French (Bourges or Burgundy) or South Lowlands, about 1390–1410

Colorless glass, silver stain, and vitreous paint: 6 x 4¼ in. (15.2 x 10.8 cm)

The Cloisters Collection, 1995 (1995.301)

Uncommonly refined and gemlike in its painterly finesse, this stained-glass fragment with a prophet is related stylistically to the work of André Beauneveu (1335–1401/3), a gifted sculptor, painter, and illuminator from the South Lowlands, who was employed by King Charles V of France; Louis de Mâle, Comte de Flandres; Philippe le Hardi, Duc de Bourgogne; and Jean, Duc de Berry, among others. A close parallel to the figure style—particularly to the treatment of the hair and facial features—may be seen in the prophets depicted in the Psalter of Jean, Duc de Berry (Bibliothèque Nationale de France, ms. Français 13091), illuminated by Beauneveu about 1386 in either Paris or Bourges. A more striking comparison can be made to the limestone standing prophet wearing an apronlike mantle (fig. 14), probably executed by Beauneveu himself shortly after 1392 for the Sainte-Chapelle in the palace at Bourges.[1] Although Beauneveu also designed stained glass for the Sainte-Chapelle at Bourges, which was completed by 1408, it appears to have no direct connection to the present glass fragment, notwithstanding certain formal and stylistic analogies.[2] The itinerant career of Beauneveu and his collaboration with other artists working for the same patrons make it difficult to localize the origins of the Cloisters' *Prophet*.

The original context of the present figure is uncertain, but prophets in architectural settings were standard in several iconographic arrangements, such as that of the Throne of Solomon, as described in 3 Kings 10: 18–20.

T B H

1 See *Les Fastes du Gothique*, 1981, no. 104 A, p. 153.
2 See Scher, 1974, pp. 23–44.

EX COLLECTION: [Galerie für Glasmalerei, Zurich].

REFERENCE: Husband, 1996, p. 20, color ill.

203

THE ENTOMBMENT OF CHRIST

French (Paris), about 1390–1405
Opaque and translucent enamel on gold: 3½ x 3 in. (8.9 x 7.6 cm)
The Jack and Belle Linsky Collection, 1982 (1982.60.398)

The entombment of Jesus Christ after his Crucifixion is variously described in the Four Gospels.[1] Each of the accounts notes the presence of a wealthy man at the scene, Joseph of Arimathaea; with him, according to Matthew and Mark, were Mary Magdalene and Mary, the mother of Joseph. However, Saint John alone refers to Nicodemus, "a man of the Pharisees," as being in attendance. None of the Gospels describes the crowd of mourners gathered at the bier, as seen here, but the depiction of such a group is typical in French art of the Gothic period[2]—and, specifically, of two enameled reliquaries. One (fig. 15) is preserved in Montalto (Ascoli Piceno),[3] and the other is described in an inventory of 1380 of the property of Charles V of France: " . . . another reliquary where below is Our Lord lying on the sepulcher on a white cloth. Nicodemus, Joseph and three Maries nearby, and around the sepulcher the four knights, and above the reliquary is Our Lord showing his wounds and two angels holding the cross, the lance, the crown and the nails; which reliquary is decorated with pearls, rubies and sapphires; weighing 4 marcs 3 ounces of gold. And one angel is missing."[4]

The Metropolitan's plaque shows Joseph of Arimathaea, who asked Pilate for Christ's body, cradling Jesus in his arms while Nicodemus grasps his legs. Mary, Jesus' mother, is the mourning woman in blue. The figure with clasped hands, beardless but with long hair, is sometimes identified as John the Evangelist, but probably represents the third mourning woman, as in the Montalto reliquary. The present work very likely was once also set into the frame of a larger composition.

About 1400, the technique of enameling *en ronde bosse*, which was used for our plaque, became a hallmark of goldsmiths' work for the French royal court.[5] Jewel-like in its effect, it combines luminous color—as well as, here, the mottled gray of the sarcophagus and the floral patterning of the gown of the Virgin[6]—with finely detailed goldwork, as seen in the precisely detailed physiognomies and the scroll pattern stippled on the gold ground. The Montalto reliquary, presented by Pope Sixtus V to the cathedral in 1586, was first described in the inventory of the collection of Cardinal Pietro Barbo in 1457.[7] Other documented works, including Charles V's lost reliquary, mentioned in the 1380 inventory described above; a statue of Saint Michael, commissioned by Charles VI in 1397, for the New Year;[8] and "*Das Goldene Rössel*," made as a New Year's present for Charles VI's wife in 1404, suggest the chronological boundaries for the Metropolitan's relief.

BDB

1 Matthew 27: 57–60, Mark 15: 43–46, Luke 23: 50–53, and John 19: 38–42.
2 For its appearance in art of the fifteenth century see Forsyth, 1970.
3 See Trevisani, 1987, pp. 109–31.
4 "Item, ung autre reliquiaire, ou dessoubz est Nostre Seigneur couché ou sépulcre sur ung drap blanc, Nicodémus, Joseph et les troys Maries environ, et entour ledit sépulcre les quatre chevaliers, et au dessus dudit reliquiaire est Nostre Seigneur montrant ses playes et deux angeloz tenans la croix, la lance, la couronne et les clox; lequel reliquiaire est garny de perles, ballaiz et saphirs; pesant quatre marcs troys onces d'or. Et y fault ung angelot. . . ."; see Labarte, 1879, no. 2291, p. 249.

5 See Müller and Steingräber, 1955, pp. 29–79; Baumstark, 1995.
6 Technical analysis by M. Wypyski, Sherman Fairchild Center, Department of Objects Conservation, The Metropolitan Museum of Art, indicates that the composition of this unusual-colored enamel, as well as of the others, is consistent with Late Medieval and Renaissance enamels.
7 See Müller and Steingräber, 1955, p. 38.
8 See Baumstark, 1995, pp. 213–15.

EX COLLECTIONS: [David Black, London, 1947]; [Rosenberg & Stiebel, New York]; Jack and Belle Linsky, New York, 1947–82.

EXHIBITION: "Medieval Art from Private Collections," New York, The Cloisters/The Metropolitan Museum of Art, October 30, 1968–January 5, 1969, no. 172.

REFERENCES: Gómez-Moreno, 1968, no. 172; Eikelmann, 1984, no. 7, pp. 260–61; Gómez-Moreno, 1984 a, no. 52, p. 135, color ill.; *idem*, 1984 b, p. 16, color ill.

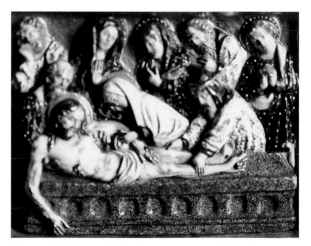

Figure 15. Reliquary. Paris, about 1400–1420. Gold, silver, *ronde-bosse* enamel, and gems. Cathedral of Montalto, Ascoli Piceno

204: Obverse

204: Reverse

204

MEDAL, WITH (OBVERSE) AN EQUESTRIAN
PORTRAIT OF EMPEROR CONSTANTINE
(R. 307–37) AND (REVERSE) AN ALLEGORY
OF SALVATION

French (Paris), 1402–13 (model); 16th century (cast)

Bronze: Diameter, 3¾ in. (9.5 cm)

Inscribed, in raised capitals: (obverse) +CONSTANTINVS·INXPO
DEO FIDELIS·IMPERAT OR ET MODERATOR ROMANORVM·
ET·SEMPER·AVGVSTVS /234 (beneath equestrian group);
(reverse) ·:+MIHI:ABSIT:GLORIARI:· ·:NISI:IN:CRVCE:·
·:DOMINI:NOSTRI:IHV:XPI:· (Galatians 6: 14)

Gift of Mr. and Mrs. Alain Moatti, 1988 (1988.133)

Jean, Duc de Berry, was an avid collector of precious objects that
often referred, however distantly, to antiquity. This fine cast repro-
duces a lost gold medal—itself a copy of another gold medal origi-
nally set with pearls, rubies, and sapphires—that the duc de Berry
acquired in November 1402 in Bourges.[1] The duke also acquired
medals that depicted the Roman emperors Heraclius, Augustus, and
Tiberius; only the one with Heraclius, like the Metropolitan's ex-
ample with Constantine, survives in later casts. The inscriptions on
the present work translate as: "Constantine, faithful in Christ our
God, emperor and ruler of the Romans and forever exalted"
(obverse) and "God forbid that I should glory in anything save in the
Cross of our Lord Jesus Christ" (reverse).

The inscription on the obverse, which reflects the formulary
of the imperial Byzantine court in Constantinople, may have been
provided by Byzantine officials, who accompanied the emperor
Manuel II Palaeologus in Paris from 1400 to 1402;[2] that ruler's entry
into the city probably inspired the equestrian figure of Constantine.[3]
The central image supporting a cross, on the reverse, is possibly a
representation of the Tree and the Fountain of Life. The two flank-
ing figures have been variously interpreted; the late Millard Meiss
suggested that they refer to Grace and Nature.[4]

The sophisticated compositions, elegant figural designs, exotic
physiognomic types, and unusual costume details evident on both
the Constantine and the Heraclius medals suggest a close relation-
ship to the Franco-Netherlandish style of the Limbourg brothers,
Paul, Herman, and John, who illuminated several of the duke's
manuscripts, including the *Belles Heures* (The Cloisters Collection,
54.1.1).[5] As a result, the models for the two medals have been attrib-
uted to the Limbourg brothers themselves.[6] An alternative and more
accepted attribution is to Michelet Saulmon, painter to the Duc de
Berry.[7] Both medals were copied at the end of the fifteenth century
by Giovanni Antonio Amadeo (1447–1522) for two of the large
marble medallions on the façade of the Certosa of Pavia.[8]

WDW

1 See Guiffrey, 1894–96, vol. 1 (1413 inventory), item 199.
2 See Weiss, 1963, pp. 138–40.
3 Ibid., p. 141.
4 See Meiss, 1967, text vol., pp. 55–56.
5 See Weiss, 1963, p. 136; Meiss, 1974, text vol., pp. 130–31, 156.
6 See Weiss, 1963, pp. 130–31, for a history of the attributions; Scher, 1994,
 p. 32.
7 See Weiss, 1963, p. 142; Meiss, 1967, text vol., p. 54; Scher, 1994, p. 32.
8 See Weiss, 1963, p. 137.

EX COLLECTION: [Alain Moatti, Paris].

EXHIBITION: "The Currency of Fame: Portrait Medals of the Renaissance,"
Washington, D.C., National Gallery of Art, January 23–May 1, 1994, and New
York, The Frick Collection, May 24–August 22, 1994, no. 1 a.

REFERENCES: Wixom, 1988, pp. 20–21, ill. p. 20; Scher, 1994, no. 1 a,
pp. 33–35, ill.

205

THE TRINITY AND THE DORMITION OF THE VIRGIN

North French (probably Paris), about 1410–20
Ivory, with traces of polychromy: 2¾ x 2¼ in. (7 x 5.7 cm)
Gift of Mr. and Mrs. Maxime L. Hermanos, 1979 (1979.521.3)

Small, intricately carved ivories were perfect expressions of the courtly tastes at the waning of the Middle Ages. The present precious microcarving, which appears to retain much of its original color, depicts two subjects: In the central compartment, Christ receives the soul of the Virgin in the presence of the Twelve Apostles and attending angels, and in the rounded triangular top half of the plaque, God the Father, enthroned and surrounded by adoring angels, is linked by the dove of the Holy Spirit to the tiny crucifix that he supports.

The mannered style of the figures, with their ample curvilinear drapery and their large heads, is shared by a group of ivories probably carved in Paris in the early fifteenth century, which recently was studied by Di Fabio.[1] Many extant examples are attributed to Paris,[2] and comparisons with Parisian illuminated manuscripts and paintings also reinforce the provenance of this small masterpiece.

Numerous similarly carved miniature ivories survive in jeweled frames, protected by a crystal and with a chain for suspension. Inventory references to "locket reliquaries" indicate that they also may have contained a tiny relic. Alternatively, these diminutive ivories could have embellished larger ensembles, such as reliquaries or monstrances.

A nearly identical representation of the Dormition of the Virgin is in the Germanisches Nationalmuseum, Nuremberg.[3]

CTL

1 See Di Fabio, 1997, pp. 137–48.
2 See Gaborit-Chopin, 1990, pp. 111–19, especially n. 17, and Williamson, 1997, no. 67, pp. 254–55. However, see also Randall, 1994, pp. 127–39, who attributes many of these carvings to Utrecht, about the middle of the fifteenth century.
3 See Koechlin, 1924, vol. 2, no. 970.

EX COLLECTION: Mr. and Mrs. Maxime Levy Hermanos (1899–1985 and 1908–1992), Paris and New York.

REFERENCE: Little, 1980, p. 25, ill.

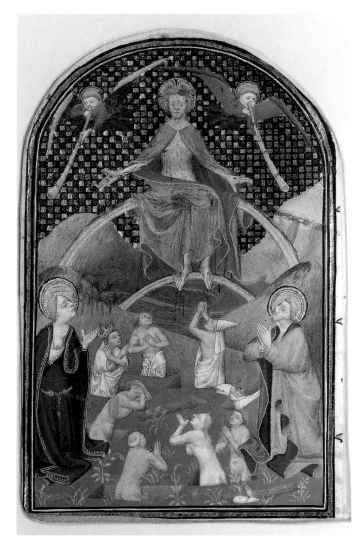

206

THE LAST JUDGMENT, FROM A BOOK OF HOURS

French (Paris), about 1400
Tempera and gold on vellum: 3¾ x 2½ in. (9.5 x 6.4 cm)
Gift of Max Falk, in honor of William D. Wixom, 1998 (1998.179)

Flying above the hills in a sky with a tessellated ground of red, blue, and gold, two angels herald the Last Judgment. Christ, seated on a double rainbow, extends his hands toward the souls of the dead, who emerge from their earthly tombs and raise their hands to him in supplication. They represent people from all walks of life—men, women, a crowned king, and a pope. Imploring Christ on their behalf are the Virgin, at the left, one breast bared, and Saint John the Baptist(?), at the right.

This miniature from a Book of Hours, which illustrated a section of special prayers in French known as the "sept requêtes à nostre Seigneur" (seven requests to our Lord), typifies Parisian manuscript painting about 1400. Attributed by Christopher de Hamel to the Luçon Master, it bears comparison not only with miniatures by that artist and his workshop but also with other contemporary miniatures, as well as with works in other mediums. The pierced and polychromed ivory image of the same subject (fig. 16) in the Museum's collection, for example, shares not only a common

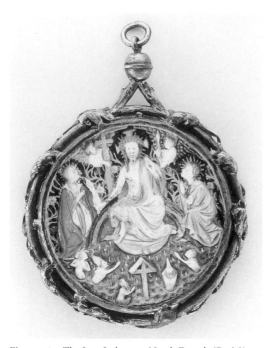

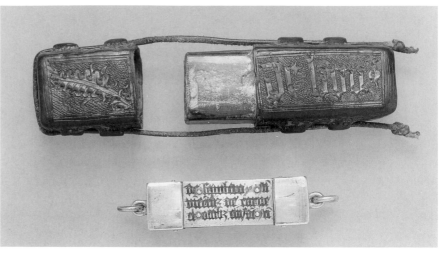

207

Figure 16. *The Last Judgment.* North French (Paris?), about 1400–1420. Ivory, with polychromy, and later silver-gilt frame. The Metropolitan Museum of Art. Gift of J. Pierpont Morgan, 1917 (17.190.894)

iconography but a fragile preciousness of execution characteristic of aristocratic taste at this time.

BDB

EX COLLECTIONS: Daniel Burckhardt-Wildt (1759–1819), Basel; Burckhardt-Wildt family, by descent; [sale, Sotheby Parke Bernet & Co., London, April 25, 1983, lot 104 b]; [Edward Lubin, New York, 1983]; Max Falk, New York.

207

PORTABLE RELIQUARY OF SAINT VINCENT

French, about 1400 (with later terminals)

Translucent enamel on silver (reliquary); cuir-bouilli (boiled and tooled leather) (case): Length, 5½ in. (14 cm)

Inscribed: (in the enamel) *De Sepulcro S[an]c[t]i Vi[n]ce[n]cii & De Carne et Ossib[us] Eiusde[m] S[an]c[t]i* ("Of the Tomb of Saint Vincent & Of the Flesh and Bones of the Same Saint"); (on the case) *De Lign[o]* ("Of the Wood")

Gift of Dr. Louis R. Slattery, 1984 (1984.24.1-2)

BDB

EX COLLECTIONS: [sale, Sotheby Parke Bernet & Co., London, June 24, 1982, lot 34]; [Blumka Gallery, New York].

REFERENCE: *MMA Annual Report*, 1984, p. 40, ill.

208

DIPTYCH

Italian (Padua), about 1400–1420

Gold glass, wood, gesso, and tempera: Height, 3⅝ in. (9.2 cm)

The Cloisters Collection, 1989 (1989.325)

Represented on the left wing of this small devotional diptych is the standing Virgin and Child, and, on the right wing, the Crucifixion. In the gables above, in half-length, are the Angel Annunciate and the Virgin. The figures are executed in etched gold-leaf foil, the flesh areas are toned in pink, and decorative details are picked out in red and green lacquers. While Bologna and Padua both were principal centers of Italian gold-glass manufacture in the later fourteenth and early fifteenth centuries, the use of colors and the favoring of a more painterly approach rather than the linear style of the purely etched-foil examples argue here for a Paduan origin for the diptych.[1] The

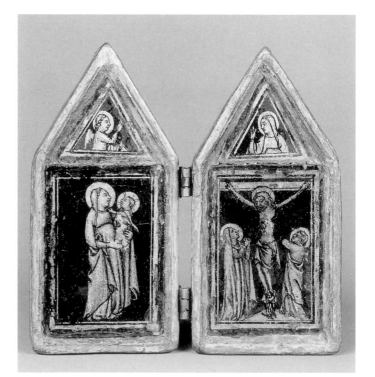

choice of imagery underscores the devotional nature of this small object, which is all the more exceptional as it retains its original wood and gesso frame impressed with a tessellated pattern on the exteriors of the wings.

T B H

1 See Wixom, 1979 a, especially pp. 141–43.

EX COLLECTION: [Blumka Gallery, New York].

209

Master Marcus
Italian (Venetian; active 1396–1411)

CHURCH BELL

North Italian (Venice), 1411

Bronze: Height, 22⅞ in. (58.1 cm); diameter, 14½ in. (36.8 cm); weight, 130 lbs. (59 kg)

Inscribed (on the shoulder): $\overset{\Omega}{M}$[AGISTER] · MARCVS · FILIVS · $\overset{\Omega}{9}$[quondam] · $\overset{\Omega}{M}$[AGISTRI] · VENDRAMI · ME · FECIT · · + · M · C · C · C · C · XI · ("Master Marcus, son of the late Master Vendramus, made me in 1411.")

Provenance: Church of Lisignano, Istria.

Gift of Nathaniel Spear Jr., 1980 (1980.542)

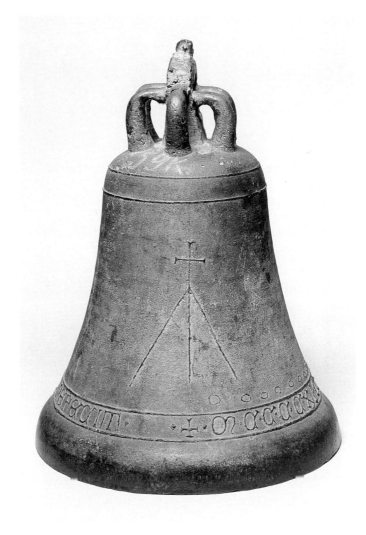

The bell is surmounted by a circular loop, above a crown consisting of two confronted pairs of angular loops, through which wooden crossbars were inserted, from which to suspend it, and two canons, or ears, through which iron bands were passed, in order to secure it. The two side ears show a great deal of wear; one of them, in fact, is so worn that it would have broken off completely if the bell had continued to be used. This ear must have been the one that held the most weight when the bell was swung sideways and rung. The original clapper, now missing, would have been attached to a ring on the inside. Apart from the expected wear sustained by the crown, the bell is in excellent condition, with little sign of corrosion, and the patina is a very pleasant color. In general, the bell is appealing and elegant in shape, and the Gothic lettering of the inscription is accurate and harmoniously designed.

There is an undecorated band between two raised lines on the neck, and a similar one on the shoulder that bears the inscription, above which is the master's personal mark, consisting of three lines that form a kind of tripod surmounted by a cross. Master Marcus is recorded as a native of Venice and the son of Master Vendramus, as noted in the inscriptions on his earlier, documented bells, the first of which dates from 1396. From the inscription on the present example, it would seem that Master Vendramus was already dead in 1411.

The composition of the metal, probably in keeping with the standard used for bells—a higher percentage of tin than regular bronze, with some additional lead—was an important factor in determining the bell's tone, as was the thickness of its wall.

The Metropolitan Museum's medieval bell is a rare example of one with a known provenance that also is signed and dated. It was originally in the parish church of Lisignano, a small town near Pula in the southern part of the peninsula of Istria, which belonged to Austria at the time that the bell was made. At some point in history, probably during World War I, all the bells in the region were earmarked to be melted down and used to manufacture war materials.

By sheer luck, the bell's antiquity was recognized, and for a time it was preserved by the Samassa bell foundry in Leibach, Austria, but it was later sold.

The Department of Medieval Art has a rich collection of bronze and brass objects dating from the twelfth to the sixteenth century, but this acquisition represented only the second bell to enter the collection. The other example is at The Cloisters (52.26).[1]

C G - M

1 See Young, 1953, pp. 293–96, ill. p. 294.

EX COLLECTIONS: Samassa Bell Foundry, Leibach, Austria; Nathaniel Spear Jr., New York.

REFERENCES: Paoletti, 1893–97, pt. 2, p. 133; Gnirs, 1917, pp. 17–18, 60, 94, 218; Gómez-Moreno, 1981, pp. 28–29, ill. p. 28; Blažeković, 1992, pp. 173–75, ill. p. 174.

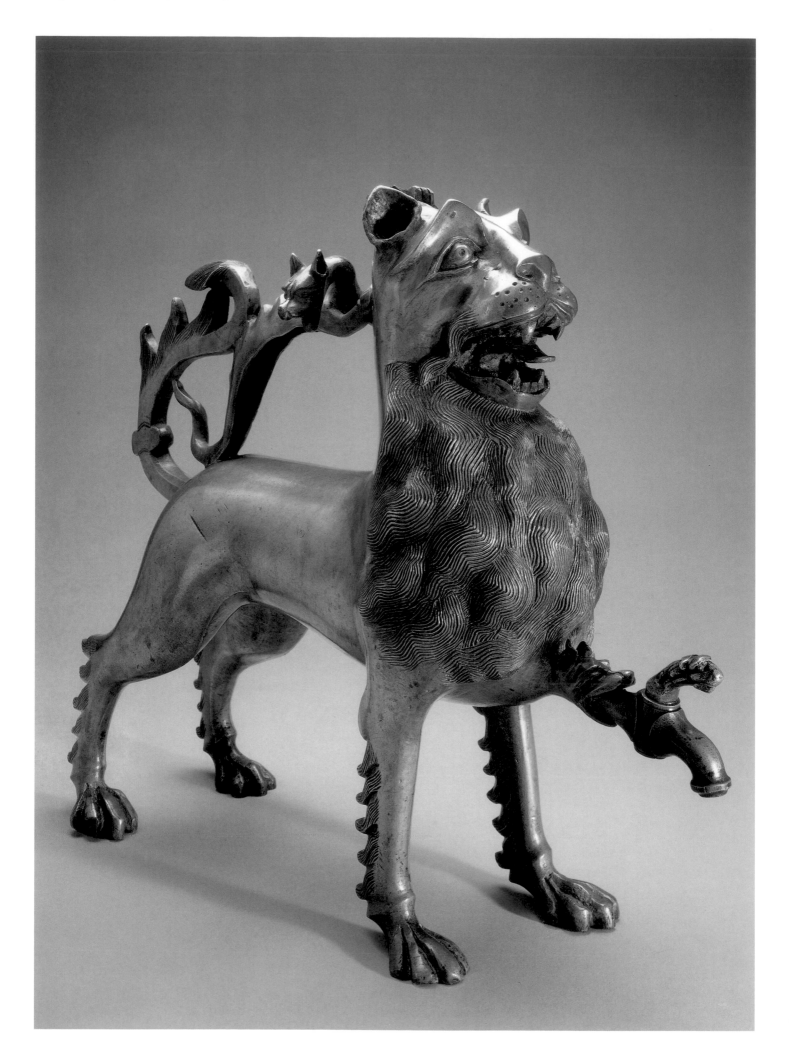

210

AQUAMANILE IN THE FORM OF A LION

German (Nuremberg), about 1400
Latten alloy: Height, 13⅛ in. (33.3 cm)
The Cloisters Collection, 1994 (1994.244)

Cast in the lost-wax process, this aquamanile was filled through an aperture at the top of the animal's head, while a spout and spigot extending from its chest allowed for water to be poured over the user's hands.[1] Aquamaniles take the form of a variety of creatures; the present example represents a proud lion. Produced in the imperial city of Nuremberg,[2] this work is particularly outstanding for its imposing style, masterful modeling, superb casting, golden luster, and beautifully textured surfaces. Although the form and details refer to natural features, each element is simplified and dramatized. The sturdy fringed legs; the upwardly curved and tufted tail; the expanded, mane-covered chest; the retracted head; and the arched eyebrows, flared nostrils, swollen and whiskered upper lip, and menacing maw, with its bared fangs and extended tongue, are all aspects of the unified conception of a very energetic creature caught in the suspended action of a heraldic stance and possibly even an interrupted roar. The diminutive dragon that serves as a handle seems to shriek in supportive yet ineffective defiance.

WDW

1 See the discussion for the Aquamanile in the Form of a Cock (1989.292; cat. no. 136).
2 See Mende, 1974, pp. 8–25, in which related examples in Munich, Amsterdam, Toledo (Ohio), Prague, Lille, and Venice appear as figures 1–7. See also von Falke and Meyer, 1935, nos. 464–469, ill., and Wixom, 1986, p. 79, figs. 88, 89, nos. 18–22, pp. 138–41, ills.

EX COLLECTIONS: Gross, London; [sale, Sotheby's, London, July 7, 1994, lot 16, ill.].

REFERENCE: Wixom, 1995 b, p. 26, colorpl.

211

A FABULOUS BEAST (FRAGMENT OF A TAPESTRY)

German (Upper Rhineland: Basel), about 1420–30
Linen warp with wool weft: 28¾ x 33½ in. (73 x 85.1 cm)
The Cloisters Collection, 1990 (1990.211)

This fragment of a weaving, or *Rücklaken*—a tapestry hung in a domestic interior at frieze level—represents a fabulous composite beast, part horse and part lion, wearing a collar ornamented with small bells that is attached to a leash held by a hand, visible at the left, which is now all that remains of a missing figure. The fragment

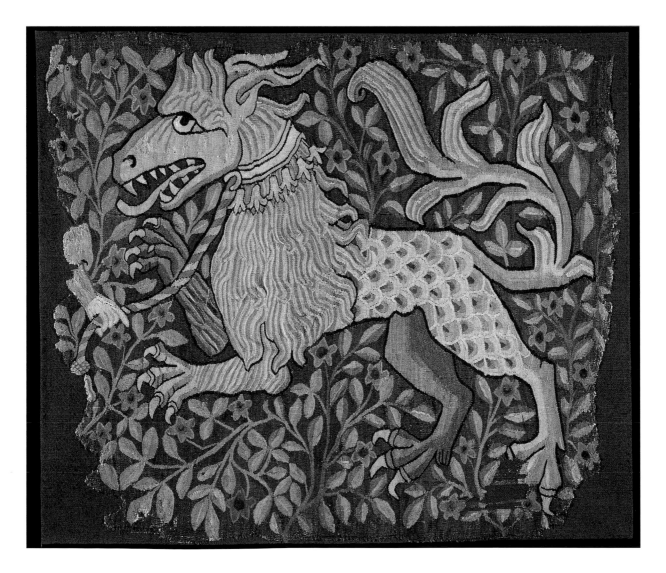

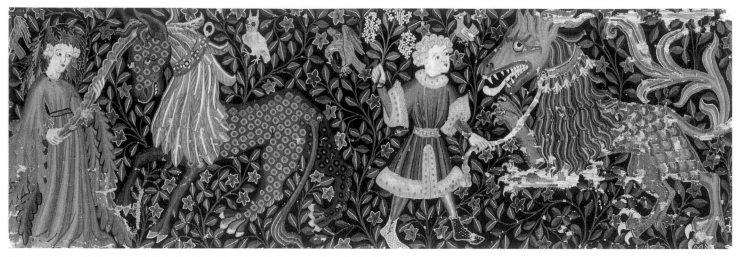

Figure 17. *Courtly Couples with Fabulous Beasts* (section of a tapestry hanging). About 1420–30.
Wool on linen warp. Abbey of Muri-Gries, near Bolzano

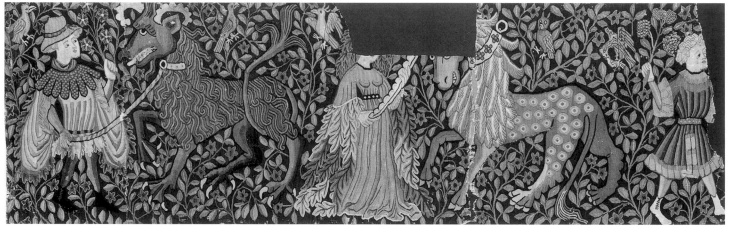

Figure 18. *Courtly Couples with Fabulous Beasts* (section from the right side of a tapestry hanging). About
1420–30. Wool on linen warp. Historisches Museum, Basel

was cut from the right end of a larger piece of a *Rücklaken*, woven
by the earliest known Basel workshop, which is now in the Bene-
dictine monastery at Muri-Gries, near Bolzano (fig. 17). A more
complete series of fragments based on the same cartoon is in the
Historisches Museum, Basel (see fig. 18).[1] Such fantastical animals
are derived from those illustrated in many versions of the *Physiolo-
gus* and in bestiaries. The inscriptions that accompany these crea-
tures on many hangings indicate that they are valued as better
company than corrupt townsfolk, are representative of the un-
sullied forces of nature, and are symbolic of concupiscence. That they
are tethered or otherwise subdued—perhaps by the odor of the
posies many of the accompanying figures hold in their hands—sug-
gests that the couples shown with them likewise have tamed their
libidinous cravings. However, the childlike aspect of these couples
and of the whimsically patterned beasts intimates a certain insou-
ciance and an unaffectedness that make the apparent innocents
seem very much at home with their natural desires in the sur-
rounding idealized and untrammeled world suggested by the ver-
dant background.[2]

TBH

1 See Rapp Buri and Stucky-Schürer, 1990, no. 2, pp. 116–19 (for the
 reconstruction of the Muri-Gries hanging), and no. 1, pp. 112–15 (for
 the slightly earlier Basel hanging).
2 For a full discussion and alternative readings of the iconography see
 Cavallo, 1993, no. 55, especially pp. 626–29.

EX COLLECTIONS: Benedictine Abbey at Muri, Canton Aargau, until about
1800; Peter Vischer-Sarasin, Schloss Wildenstein, near Bubendorf, Canton
Basel, Switzerland, by 1841 or 1843; Peter Vischer-Passavant, Schloss Wilden-
stein; by descent to Peter Vischer-Milner-Gibson, Schloss Wildenstein, until
1989; [sale, Christie, Manson & Woods, London, July 3, 1990, lot 110 b,
pp. 62–64].

EXHIBITION: "Zahm und Wild: Basler und Strassburger Bildteppiche des 15.
Jahrhunderts," Basel, Historisches Museum, 1990, no. 2.

REFERENCES: Burckhardt, 1923, pp. 8–9, fig. 9; Kurth, 1926, vol. 1, pp. 85–86,
212–13, vol. 2, pl. 29 C; Rapp Buri and Stucky-Schürer, 1990, no. 2, pp. 116–19,
fig. 2 C (color); Husband, 1991 b, p. 18, color ill.; Cavallo, 1993, no. 55,
pp. 625–32, colorpl. p. 626, fig. 181, p. 629.

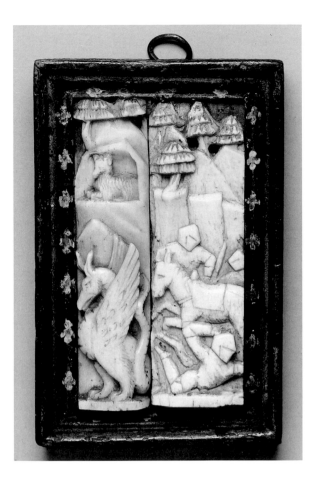

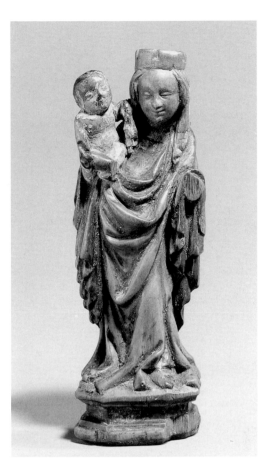

212

PLAQUES, WITH A BASILISK AND A BATTLE SCENE

North Italian (Embriachi Workshop), first half of the 15th century

Bone (in modern frame): 3⅝ x 2 in. (9.2 x 5 cm)

Gift of Robert L. Hermanos and Miriam H. Knapp, in memory of their parents, Mr. and Mrs. Maxime Levy Hermanos (1993.516.2a,b)

CTL

EX COLLECTIONS: Mr. and Mrs. Maxime Levy Hermanos (1899–1985 and 1908–1992), Paris and New York; Robert L. Hermanos and Miriam H. Knapp, 1991–93.

213

VIRGIN AND CHILD

Austrian (Salzburg?), about 1420

Fruitwood, with traces of polychromy: Height, 3⅜ in. (8.6 cm)

The Cloisters Collection, 1985 (1985.213)

The Virgin stands on a low contiguous base that has several moldings. Her body forms an S curve, as she supports the Christ Child on her veiled right arm and hand. She is enveloped in a heavy mantle, whose deep, V-shaped or bucket folds hang loosely in front, vertical folds with curvilinear edges fall beneath each arm, at the sides, and additional folds drape over her feet. While the back of the figure is modeled, the summary character of the carving suggests that the statuette originally was enclosed and perhaps was the central figure of a small tabernacle.

The statuette exemplifies the so-called International Style—frequently known as the "Soft Style" or the "Beautiful Style," when designating central European sculpture (see cat. no. 214; 1986.340). While the localization of many works in this style without provenances is difficult to establish, this particular statuette can be closely associated with several large sculptures produced within the diocese of Salzburg.[1] A characteristic, full-scale polychromed wood example of this kind, dating to about 1420, is in The Cloisters Collection,[2] and an earlier work in this style—a limestone Annunciation group probably also made in Austria, but farther to the east, about 1390—is in the collection of the Medieval Art department.[3] The diminutive carving presented here, acquired as a curatorial purchase and as an adjunct to these two larger works, is representative of a special category of small-scale sculptures intended for private devotional use in an intimate setting, such as a bedroom or a small domestic chapel. Such statuettes of polychromed wood or precious metals could have been the focal point of small house shrines, sometimes referred to as *Hausaltärchen*. For a Late Gothic version see catalogue number 232 (1991.10).

The best examples of small, standing Virgins in the "Soft Style," ranging in height from about fifteen to eighteen centimeters, include one in pearwood made in Salzburg about 1400–1410 and now in a private collection;[4] another Salzburg work in silver gilt, from about 1420, in the Museo Nazionale del Bargello, Florence;[5] a painted-wood Silesian sculpture, from about 1420, in the Württembergisches Landesmuseum, Stuttgart;[6] and a painted-wood Bavarian or Swabian statuette, from about 1420, in the Bayerisches Nationalmuseum, Munich.[7] A silver-gilt and painted figure that possibly represents Saint Dorothy, dating from the beginning of the fifteenth century

as well, resides in the Louvre.[8] All of these comparative works help to pinpoint the style and date of this even smaller statuette, acquired for The Cloisters.

The initial microscopy and radiographic examination revealed a hairline crack at the base of the Virgin's neck. During cleaning, it was discovered that the face and the front half of the crown are replacements, and of different wood, and the paint covering the repair was removed. However, the remaining losses, including the Virgin's left hand, and minor chips, are unrestored.

W D W

1 See *Schöne Madonnen*, 1965, especially nos. 7, 27, 31, and figs. 6, 23, 25, respectively.
2 No. 65.215.2, pinewood, with polychromy: Height, 37 in. (94 cm); see Grimme, 1966, no. 20, p. 108, ill.; Husband, 1970, pp. 278–90, ill. p. 279.
3 Nos. 22.60.1, 22.60.2, limestone: Height, 40⅜ in. (102.6 cm) and 30¾ in. (78.1 cm); see *Meister von Grosslobming*, 1994, nos. 25, 26, pp. 138–41 (with bibliography), ill.
4 See *Spätgotik in Salzburg*, 1976, no. 40, p. 60, colorpl. III, fig. 45.
5 Ibid., pp. 93–94, fig. 91; Lüdke, 1983, vol. 1, fig. 83, vol. 2, K 30, pp. 72, 75, 77, 133, 137, 140; *Arti del Medio Evo*, 1989, no. 139, p. 345 (with bibliography), ill.
6 No. 1930-25.
7 No. MA 4236.
8 See *Die Parler und der schöne Stil*, 1978–80, vol. 2, p. 713, ill., vol. 3, color ill. T-214; Lüdke, 1983, vol. 1, fig. 86, vol. 2, K 82, pp. 72, 82, 137, 140.

EX COLLECTION: [Dr. Julius Böhler, Munich].

214

VIRGIN AND CHILD

German (Nuremberg), about 1425–30

Sandstone: 57½ x 21¼ x 15 in. (146.1 x 54 x 38.1 cm)

Provenance: House at Josefplatz 7, Nuremberg (until 1942).

Gift of Ilse C. Hesslein, in memory of Hans G. Hesslein and the Hesslein family, 1986 (1986.340)

This monumental stone sculpture is a rare and superb late exponent of the International Style, or "Beautiful Style," which, although pervasive in central Europe about 1400, appeared only briefly among the evolving sculptural styles in the imperial free city of Nuremberg. The work comes from the exterior of a private house in Nuremberg. Sculptures of this kind often were found on the corners, at the second-floor level of the building, partially protected from the elements by a projecting canopy. By their very placement, these sculptures appeared "to command an entire square or the length of a street, as though providing protection for the surrounding neighborhood and any passerby,"[1] as well as offering blessings for the inhabitants of the house.

The powerful style of this Virgin and Child is characterized by the special richness of the deep, cascading drapery folds; the boldness of the S curve of the Virgin's stance; and the firmness of the rounded planes of the Virgin's face and the Child's head and body. This style, with its emphasis on massive monumentality, may be seen in two other Nuremberg sculptures of a few years earlier, a large terracotta figure of Saint Andrew in the Church of Saint Andrew at Ochsenfurt and the polychrome Virgin in Glory in the Sebalduskirche in Nuremberg.[2]

This work is the first of its type to be acquired by a public institution outside Nuremberg and beyond eastern Franconia and is also

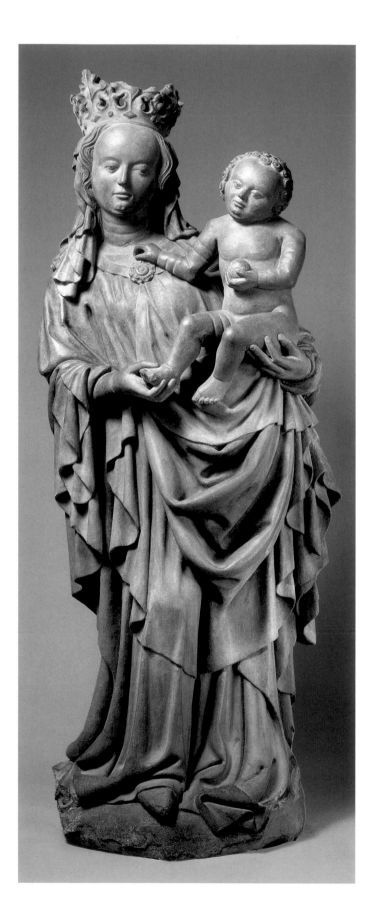

only the second example of a large-scale statue from Nuremberg to enter an American museum; the other is the large Virgin and Child on a Crescent Moon, of about 1470 (1984.198; see cat. no. 227).

W D W

1 See Kahsnitz, 1986, p. 163.
2 Ibid., p. 67, figs. 76, 77.

EX COLLECTIONS: Hesslein family, Nuremberg; Hans G. Hesslein and Ilse C. Hesslein.

REFERENCES: Höhn, 1922, p. ix, ill. p. 53; Schulz, 1927, p. 58, ill.; Wixom, 1987 c, p. 17, ill.; *idem*, 1989 a, pp. 5–6, fig. 5.

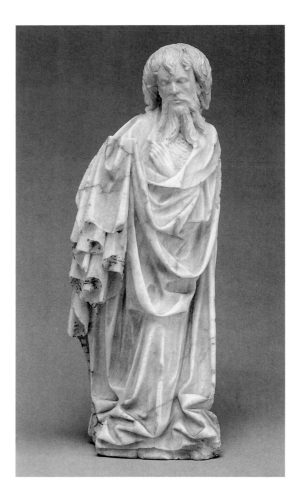

215

SAINT JOHN THE BAPTIST

South Lowlands or German, about 1420–30
Alabaster: Height, 9½ in. (24.1 cm)
The Cloisters Collection, 1995 (1995.412)

A refined and spirited sculpture, this figure of John the Baptist is a particularly accomplished example of alabaster carving of the first half of the fifteenth century, which relates stylistically to the work of the Master of Rimini, a sculptor active about 1430 in the Burgundian Lowlands or perhaps in the Middle Rhineland. He is so called because of an alabaster altar once in the church of Santa Maria della Grazie, near Rimini, and now in the Liebieghaus, Frankfurt-am-Main (see also cat. nos. 216, 217, and 219). While it emanated from the same artistic milieu, the present statuette—with its softer, more limpid drapery patterns, the gentle sway of its stance, and the more lyrical play of its volumes—is distinctly earlier in date than the Frankfurt altar group and appears to reflect, albeit indirectly, the influence of manuscript painting. This sculpture is thus something of a stylistic bridge between regional variants of the International Style and the greater naturalism of alabaster sculptures of the following decade.

The original context of the figure is uncertain, but the rather flattened appearance of its proper left side suggests that it was placed against another component of a larger ensemble. The saint's attribute—a book or a lamb, or both—once held in his right hand, is now missing.

T B H

EX COLLECTION: [Julius Böhler Kunsthandlung, Munich].

REFERENCE: Husband, 1996, p. 19, colorpl.

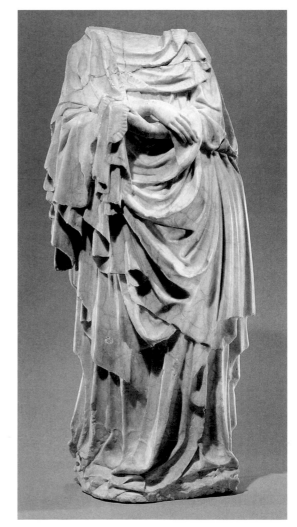

216

Attributed to the Master of the Rimini Altar

HOLY WOMAN

North French or South Netherlandish, about 1430
Alabaster: Height, 19¼₆ in. (48.5 cm)
Gift of The Robert Mapplethorpe Foundation Inc., 1991 (1991.84)

The rhythmic and expressive drapery of this Holy Woman, who may be from a group of the Three Maries at the Holy Sepulcher or perhaps from a Crucifixion, is extremely elegant in its effect. The

exceptional quality of the carving closely corresponds to that of the figures in the large alabaster *Crucifixion* altarpiece formerly in the church of Santa Maria delle Grazie, although executed by a sculptor active about 1430 in the Arras and Tournai area of northern France and in the Burgundian Lowlands. The patterns in the drapery of the apostle figures from this key work by the Master of the Rimini Altar are nearly identical, their large folds lyrically interspersed with smaller forms. It is even possible that the Metropolitan Museum's sculpture comes from this dismantled ensemble.

CTL

EX COLLECTION: Samuel J. Wagstaff Jr., New York.

217

VIRGIN AND CHILD

South Lowlands, 1430–40
Alabaster, with polychromy: Height, 12⅞ in. (32.7 cm)
The Erich Lederer Collection, Gift of Mrs. Erich Lederer, 1986
(1986.319.74)

BDB

EX COLLECTION: The Erich Lederer Collection, Geneva.

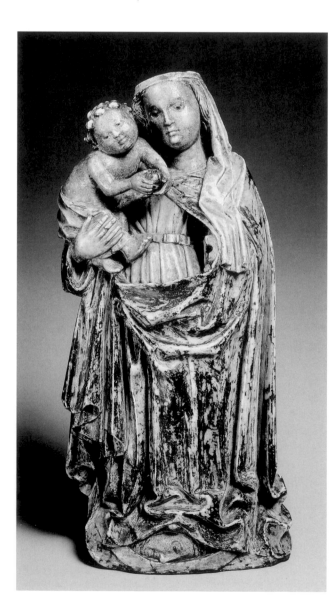

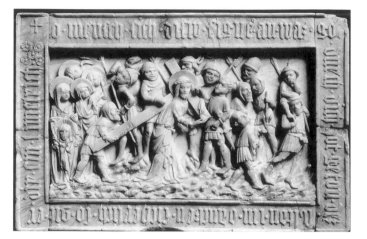

218

Follower of the Master of the Lorsch Calvary
CHRIST ON THE ROAD TO CALVARY

German (Middle Rhineland), about 1440
Alabaster: 7⁷⁄₁₆ x 11⁷⁄₁₆ in. (18.8 x 29 cm)
Inscribed: + o · mensch · sich · disiv(?) · figur · an · was · got · durch · dich · hot · geton · des · soltan · im · dancken · sicherlich · so · git · er · dir · sin · himelrich. ("O mankind, behold this figure; what God has done for you should be kept in your thoughts, for thus he gives you his heavenly kingdom.")
The Cloisters Collection, 1996 (1996.581)

The composition of this devotional relief relies on a larger-scale example in terracotta of about 1425, now fragmentary, but known through an 1837 engraving (fig. 19), which originally was found in the Martinskirche, Lorsch, on the Middle Rhine, between Koblenz and Mainz.[1] Notwithstanding the compositional indebtedness, the focus here shifts from the historical narrative to the emotional intensity that charges this dramatic scene, primarily as a result of the dense composition and the exaggeratedly grotesque portrayal of Christ's tormentors. Thus, the work serves its devotional function, aided by the inscription, which exhorts the viewer to contemplate the sufferings of Christ and to recognize that through them man can achieve the kingdom of Heaven.

There are two other nearly identical reliefs, one in Berlin and the other in the Heiliger Geistkirche, Passau. The dialectical variations in the inscriptions may suggest that the works originated in different localities with, certainly, a geographical range, therefore bringing into question the dissemination of designs and styles, as well as workshop practices.

TBH

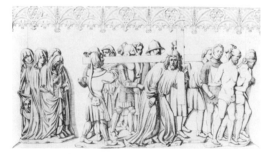

Figure 19. *Christ on the Road to Calvary*. 1837. Engraving. From F. H. Müller, *Beiträge zur teutschen Kunstz und Geschichtskunde durch Kunstdenkmale mit vorzüglicher Berücksichtigung des Mittelalters* (Darmstadt, 1837)

1 The surviving fragments are in the Staatliche Museen zu Berlin, Preussischer Kulturbesitz, Skulpturensammlung. See *Kunst um 1400 am Mittelrhein*, 1975, pp. 92–94, no. 85, pp. 159–60, figs. 76, 77, 133.

EX COLLECTION: [sale, Sotheby's, London, December 12, 1996, lot 35, pp. 27–28]

REFERENCE: Husband, 1997, p. 20, ill.

219

FOUR APOSTLES: SAINTS PETER, ANDREW, JAMES THE GREATER, AND JAMES THE LESSER

South Lowlands, or northeast France, about 1450–60

Alabaster: Each, 13¼ in. (33.7 cm)

(Saints Peter, Andrew, and James the Greater): Gift of Mrs. Ernst Payer, 1991 (1991.416.1-3)
(Saint James the Lesser): Anonymous Gift, in memory of Elke von Lera-Schloss, 1994 (1994.217)

These sculptures, with their heavy draperies, have now joined five others in the Robert Lehman Collection at the Metropolitan Museum (fig. 20);[1] slight discrepancies in style notwithstanding, all appear to belong to the same series, which comprised figures of Christ and the Twelve Apostles. They must have come originally from an altar ensemble similar to that by the Master of the Rimini Altar.[2] Stylistically, this figure group is distinguished by disproportionately small heads and abundant drapery that breaks in large folds.

Except for Saint Peter, who has lost the keys by which he is usually recognized but whose identity is apparent from his conventionally portrayed squarish head, curly hair, and cropped, curly beard, each apostle still retains at least part of his attribute: Saint James the Lesser suffered martyrdom by being beaten to death with a fuller, and a fragment of the projecting panel attached to the pole, which had holes drilled into it, remains in place near the base of the figure. Saint Andrew holds the cross upon which he was crucified upside down, while James the Greater, the pilgrim saint, displays his attribute, the cockleshell.

TBH/CTL

Figure 20. *Four Apostles* (cat. no. 219) shown with the five in the Robert Lehman Collection at The Metropolitan Museum of Art (1975.1484–1488)

1 Acc. nos. 1975.1.1484-88. See Gómez-Moreno, 1968, nos. 49–51, ills.
2 See Legner, 1969, pp. 101–68; Schenkluhn, 1987, nos. 13, 14, ill.

EX COLLECTIONS: (1991.416.1-3) Walter S. Morgan, New York; [sale, Plaza Art Galleries, New York, January 26, 1935]; [Joseph Brummer, New York]; Charles E. Roseman Jr., New York (?), November 22, 1947; Mr. and Mrs. Ernst Payer, Asheville, North Carolina; (1994.217) Walter S. Morgan, New York; [sale, Plaza Art Galleries, New York, January 26, 1935]; [Joseph Brummer, New York]; [sale, Parke Bernet Galleries, New York, February 1977, lot 74]; Private collection.

EXHIBITION: (1991.416.1-3) "Medieval Art from Private Collections," New York, The Cloisters/The Metropolitan Museum of Art, October 30, 1968–January 5, 1969, nos. 49–51.

REFERENCES: (1991.416.1-3) Gómez-Moreno, 1968, nos. 49–51, ills.; Wixom, 1992 b, p. 22, ill.; (1994.217) *MMA Annual Report*, 1994, p. 39, ill.

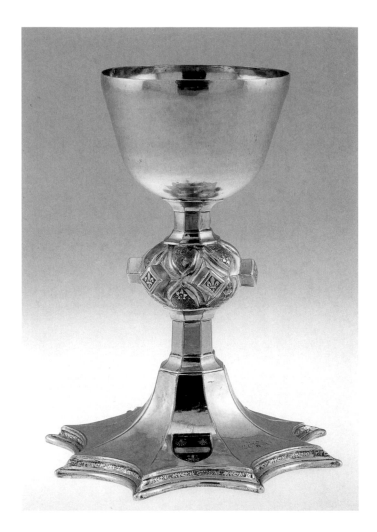

220

CHALICE

French (Rouen), 1450–70
Silver gilt, with translucent enamel: Height, 7⅜ in. (18.7 cm)
Stamped (on the underside of the base): with the hallmark of Rouen and an unidentified goldsmith's mark
The Cloisters Collection, 1990 (1990.120)

Composed of an octagonal stellate base, an octagonal shaft, an engraved hexagonal knop, and a cup (a modern replacement), this chalice combines a number of techniques that exemplify the refined decorative aesthetic of French Gothic metalwork. The petal shapes of the knop are richly engraved with vegetal ornament, including strawberries and pomegranates. Two shield-shaped translucent enamels on silver are set into opposite sides of the base: One represents the Crucifixion and the other bears the coat of arms of the deClercq family. The *Crucifixion* is particularly noteworthy for its use of enameling: a pearly tone for the faces, a golden hue for the hair of John, green for the plants, red for the blood of Christ, black for the cross, and blue in differing opacities for the robe of the Virgin. The octagonal division of the hammered base enhances the refraction of light across the well-preserved silver-gilt surfaces, while a scrolling foliate pattern is stamped along its lower edge.

French Gothic plate of the fifteenth century is rarely preserved, and is poorly represented in the Metropolitan's collection. A chalice still in the church at Béhuard (Maine-et-Loire) and another in the Musée d'Art Sacré, Dijon, are particularly similar to the present example.[1] The previously unidentified city mark on the underside of the base (partially overstruck) is the Agnus Dei of Rouen. The city of Rouen in Normandy was a key center for goldsmiths' work in the Gothic period. Second only to Paris, Rouen had one of the earliest and most active guilds. Apart from two silver spoons in the Victoria and Albert Museum, London, this chalice is the only recognized example of medieval goldsmiths' work of Rouen manufacture.

The deClercq family, whose coat of arms is represented on the chalice, is documented in both Bruges and northern France from the fourteenth to the sixteenth century.[2] Like the Netherlandish chalice of the Housteyn family (1989.358; cat. no. 221), the present one probably was made for use in a family chapel, as the evidence in contemporary inventories suggests.

BDB

1 I wish to thank Élisabeth Taburet-Delahaye, of the Musée du Louvre, and Marie-Madeleine Blondel of the Musée d'Art Sacré, Dijon, for bringing these chalices to my attention.
2 I am grateful to Marie-Hélène Lavallée of the Musée des Beaux-Arts, Lille, for this information.

EX COLLECTIONS: [sale, Hôtel Drouot, Paris, March 24, 1986, lot 48]; [L. P. Bresset et fils, Paris, 1990].

221

CHALICE

Rhenish (possibly Nijmegen), second quarter of the 15th century
Parcel-gilt silver, with traces of enameling: Height, 6³⁄₁₆ in. (15.7 cm)
Inscribed (on the underside of the base): *henryck housteyn / henryck housteyn iōr / johan housteyn iōr / gryta housteyn / alit housteyns / mechtelt housteyns*
Gift of Ruth Blumka, in honor of Timothy B. Husband, 1989 (1989.358)

A masterful blend of Gothic decoration and utilitarian function, this chalice is representative of a type that first appeared in the Rhineland in the mid-fourteenth century, and was popular there and in the Low Countries for about a hundred years. The cup and the base of the chalice are each soldered to a cylinder that slips into the hexagonal knop, where the inserted elements originally were secured by a pin. The stellate base, which is wide and stable without appearing massive, allows the chalice to be laid on its side without rolling.

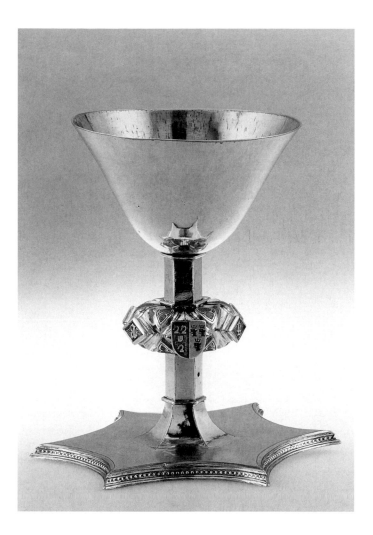

The engraving and faceting of the knop provide both ornament and a means of grasping the vessel. A chalice whose form is very similar is preserved in Fologne in the province of Limbourg.[1] Like this example, it bears the coat of arms of a particular family.

The underside of the base is engraved with the names of members of the Housteyn family. "Gryta," opposite "Henryck," is the first of three female names; the same name is spelled out on the lozenges of the knop. The substitution of "Gryta" for "Jesus" or "Maria," which are more commonly found on the lozenges of a chalice—as on the Fologne example—and the superposition of a coat of arms, presumably the family's, over the sixth lozenge, are accommodations of a standard type of chalice to private use.

Archival records show that members of the Housteyn family were vassals of a fief at Frasselt, near Kranenburg, along the Rhine River in the Duchy of Cleves, in present-day Germany. Hendrich Housteen was granted the manor there in 1419 and served as magistrate from 1419 to 1423. After marrying a woman named Greta in that year, he became master of the kitchen of the duke of Cleves in 1428, a position he still held in 1451. A son, Heinrich, registered at the University of Cologne in 1440, while his elder son, Johann, assumed his father's position as magistrate in 1444.[2] The names "alit" and "mechtelt," presumably those of Hendrich's daughters, are not recorded.

The wide diffusion of this form of chalice makes a precise attribution difficult, but it should be noted that Nijmegen, located near the family's fief at Frasselt, was an important metalworking center in the fifteenth century, with fifty goldsmiths recorded there between 1350 and 1450.[3]

BDB

1 See *Nijmeegs zilver*, 1983, p. 28.
2 I wish to thank W. J. Meeuwissen, keeper of records, and H. de Heiden, at the Gemeentearchief, Nijmegen; Dr. Preuss of the Nordrhein-Westfälisches Hauptstaatsarchiv, Düsseldorf; and G. J. C. Boutmy de Katzmann, curator, Centraal Bureau voor Genealogie, The Hague, for information concerning the Housteyn [Housteen, Hawsteyn, Honsteyn] family.
3 See van Doorslaer, 1935, pp. 208–9, pl. II.

EX COLLECTIONS: Albert R. Nesle, New York, until 1941; [Joseph Brummer, New York, until 1949]; [sale, Parke-Bernet Galleries, New York, April 20–23, 1949, lot 432, p. 105, ill.]; Ruth and Leopold Blumka, New York.

REFERENCE: Boehm, 1990 b, p. 20, ill.

222

THE ANNUNCIATION AND THE CRUCIFIXION

Lowlands, about 1440–60
Silver, with translucent and opaque enamel: 1¾ x 1⅜ in. (4.5 x 3.5 cm)
Inscribed (on the banderole): *ave maria*; (on the *titulus*): *inri*
The Cloisters Collection, 1993 (1993.273.1,2)

On the basis of their close stylistic relationship to contemporary manuscript painting, these rare examples of fifteenth-century *basse-taille* enameling are attributed to the Lowlands. The soft drapery reflects the influence of the International Style of about 1400–1420, but the lucid outlines of the sturdy figures, who are arranged in tightly focused groupings in undefined spaces, as well as the sculptural quality of the tubular folds, presage the more forthright aspect of later devotional imagery in the Lowlands. Although barely visible, there are traces of stippling in the background of the Crucifixion scene. In a later reshaping of the plaques, the designs were slightly trimmed.

TBH

EX COLLECTION: [Blumka Gallery, New York].

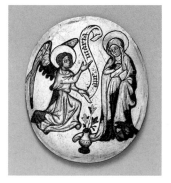 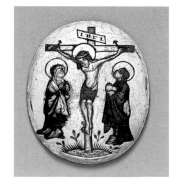

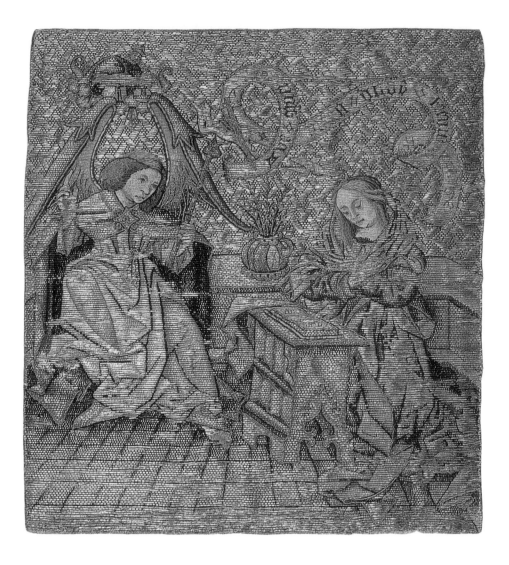

223

THE ANNUNCIATION

Netherlandish, mid-15th century

Silk and metallic threads on linen, with *or nué*, couching, stem, and overcast stitches: 8¼ x 7⅝ in. (21 x 19.4 cm)

Gift of Lois and Anthony Blumka, in memory of Victoria Blumka, 1990 (1990.330)

EX COLLECTIONS: Ullmann, Hamburg; [sale, Sotheby Parke Bernet, London, December 7, 1989, lot 266]; [Blumka II Gallery, New York].

EXHIBITION: "Medieval Masterworks, 1200–1520," New York, Blumka II Gallery, 1990.

REFERENCES: Merrill, 1990, n.p.; Boehm, 1991, p. 19, colorpl.; *idem*, 1995 b, p. 40, colorplates.

In a domestic interior, the Virgin Mary kneels before a prie-dieu on which her prayer book rests. The Archangel Gabriel, at the left, greets her with the Gospel announcement of the forthcoming birth of Jesus: "Ave Maria gratia plena dominus tecum" ("Hail Mary, full of grace, the Lord is with thee," Luke 1: 28).

This embroidery, originally part of an orphrey (a decorative band on a priestly vestment) or an altar frontal, is virtually intact. The selvages at left and right are preserved, and the top and bottom have been trimmed only slightly. In its present form, with the scene almost complete and its shimmering silks still remarkably vibrant, it can be appreciated much like a Netherlandish panel painting—a medium with which it has many compositional and iconographic aspects in common. The embroidery typifies the celebrated Netherlandish *or nué* technique, in which gold is used not only to provide glitter but also to add to the rich three-dimensional quality of the pictorial surface—an effect to which the textile medium naturally lends itself.

BDB

224

STANDING VIRGIN AND CHILD

French (Île-de-France or Champagne), mid-15th century

Limestone, with polychromy: Height, 58¼ in. (148 cm)

Gift of Max and Elinor Toberoff, 1997 (1997.125)

The cult of the Virgin in fifteenth-century France led artists to develop innovative variants in portraying the Virgin as the Queen of Heaven. Here, the playful Christ Child holds a bird in one hand and, with the other, grasps the strap on the Virgin's mantle. The energetic bird, caught in flight, pecks at the Child's hand. Whether dove or goldfinch, the bird not only symbolizes the soul and its resurrection but is also a Eucharistic reference, as it nourishes itself with the blood of Christ. The Virgin wears a brocaded chemise under her voluminous mantle, whose textured lining simulates fur and whose elaborate border contains a raised inscription that repeats the words

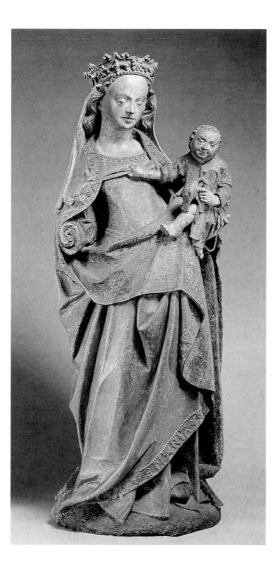

"Ave Maria." The expansive presentation of the figure of the Virgin engages the viewer.

The large breaking drapery folds and the Virgin's high forehead link this sculpture to others from Champagne, especially those associated with Troyes and the Île-de-France. However, the pervasive influence of Burgundy and especially of the work of Jean de la Huerta, active about mid-century in the service of Duc Philippe le Bon in Dijon, can be detected in the noble proportions of the Virgin and of the plump Child.

CTL

EX COLLECTIONS: [Gabrielle Laroche, Paris]; Max and Elinor Toberoff, Paris.

225

PROCESSIONAL CROSS

Spanish (Aragon), mid-15th century

Silver gilt, with traces of enameling, on a walnut core: Height, 36½ in. (92.7 cm)

Gift of Ella Brummer, in memory of her husband, Ernest Brummer, 1982 (1982.363.1)

Crosses of this size, elaborately decorated on both sides, are meant to be carried in a procession, not placed on an altar. The present example is characteristic of crosses produced in ateliers that specialized in works in silver and translucent enamels in northeastern Spain, in what was the kingdom of Catalonia and Aragon before the unification of the country at the end of the fifteenth century. The markings scattered over the cross and its knop are those of the town of Daroca in Aragon. It is possible, however, that the quatrefoils of ungilded silver on the front and back of all four arms of the cross, which once held insets of translucent enamel—tiny specks of which can be detected under the microscope—were made in Catalonia, where considerable quantities of enamels in the *basse-taille* technique originated, during the fourteenth and fifteenth centuries.

The general style of this cross is known as *gótico florido* (flowering Gothic) in Spain. The arms have fleur-de-lis terminals, and repoussé floral motifs inhabited by small animals cover the surface of the cross proper, which is mercury gilded. Around the edges is a series of delicate floral attachments, some of which are missing. At the intersection of the arms is a rectangular plaque, also in repoussé;

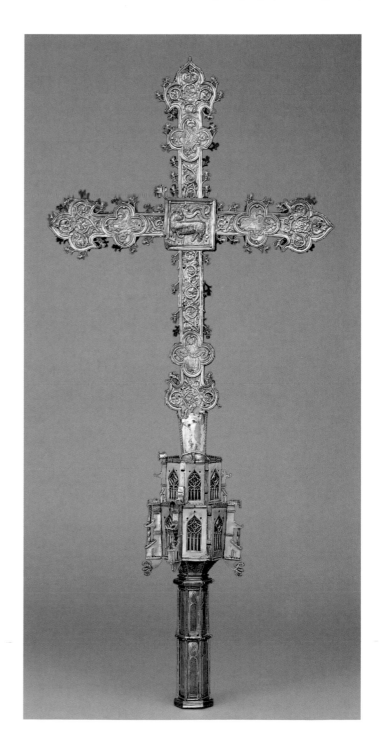

the plaque on the front represents Christ in Majesty and the one on the back the Agnus Dei.

In spite of the loss of some of the original ornamentation, the design is so strong and beautiful that the color, which would have somewhat obscured the virtuoso craftsmanship, is hardly missed. The pattern incised in the background of each quatrefoil is different, which lends greater variety to the already exciting design. Around the *Christ in Majesty*, on the front, are representations of the Mourning Virgin on the left arm, the Pelican in Her Piety on the top, and Adam Rising from His Tomb on the bottom. An image of Saint John the Evangelist would have decorated the right arm, but the outside frame is all that remains of that quatrefoil. The corpus, which would have been cast separately, is also missing. On the back, the quatrefoils around the *Agnus Dei* contain the symbols of the Four Evangelists: the eagle of John on the top, the lion of Mark on the left, the ox of Luke on the right, and the winged man of Matthew on the bottom. The knop is much more sober in style; it consists of a hexagonal fenestrated tower, with buttresses. The shaft bears a simple lancet motif.

The cross suffered considerably through the centuries and probably was restored more than once. In addition to the loss of the translucent enamels and some of the floral attachments, three of the buttresses of the knop and the tips of the bottom fleur-de-lis terminal are missing. The strip that holds the front and the back together originally was silver but is now a base-metal band that has badly oxidized. Many of the silver nails also were replaced with metal ones.

After the Metropolitan Museum acquired the cross, it was cleaned to recapture its initial splendor, and the quatrefoils, which had been reattached at random in an earlier restoration, were rearranged correctly. New silver-coated nails of the same size and shape as the originals now replace several of the oxidized ones, and an effort was made to return the few buttresses preserved from the knop to their proper positions. In its present condition, the cross is,

once again, a beautiful example of Spanish silverwork of the fifteenth century.

There are very few related crosses outside Spain (one is in the Victoria and Albert Museum, London); most are still in their original locations. This unusual addition to the Metropolitan's medieval church objects is of value as it provides a contrast with a Romanesque silver processional cross from northern Spain also in our collection (17.190.1406), underscoring the great difference in style and iconography between the two objects made for the same purpose, but three centuries apart.

C G - M

EX COLLECTIONS: Ruiz, Madrid; Ernest Brummer, New York; [sale, Galerie Koller AG, Zurich, in collaboration with Spink & Son, London, October 16–19, 1979, vol. 1, lot 177, ill.]; Ella Brummer, New York.

EXHIBITIONS: "Medieval Art from Private Collections," New York, The Cloisters/The Metropolitan Museum of Art, October 30, 1968–January 5, 1969, no. 140; "Decorative and Applied Art from Late Antiquity to Late Gothic," Moscow, State Pushkin Museum, May 10–July 10, 1990, and Leningrad, State Hermitage Museum, August 14–October 14, 1990, no. 82.

REFERENCES: Gómez-Moreno, 1968, no. 140, ill.; *idem*, 1983, pp. 23–24, ills. p. 23; Boehm, 1990 a, no. 82, p. 170, colorpl. p. 171.

226

ALTAR FRONTAL, WITH THE MAN OF
SORROWS, THE VIRGIN, AND SAINTS JOHN
THE BAPTIST, JOHN THE EVANGELIST, AND
JEROME

South German (Nuremberg), about 1465
Linen warp, with wool and silk wefts: 34½ x 64½ in. (87.6 x 161.8 cm)
Provenance: Probably Lorenzkirche, Nuremberg.
The Cloisters Collection, 1991 (1991.156)

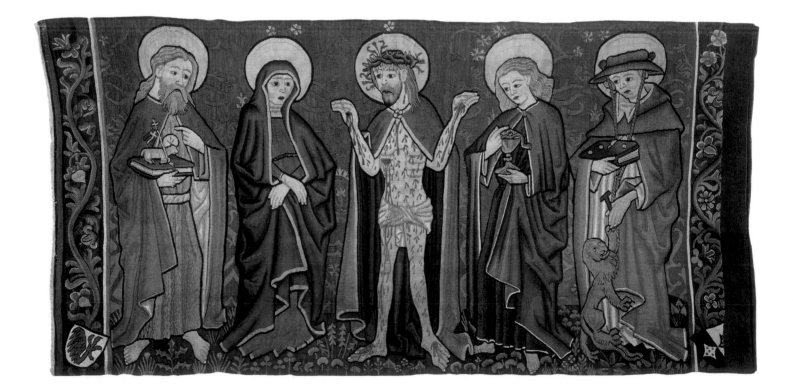

The bloodied body of Christ, flanked by iconic figures, all set against a pomegranate-patterned background, creates a striking devotional image. The bold, linear outlines and weighty figures reflect the stylistic influence of single-leaf wood blocks and block-book illustrations (see fig. 21). The coats of arms at the bottom are those of Martin Pessler (d. 1463), dexter, and of Margarete Toppler (d. 1469), sinister, who were married in 1449. After the death of her husband, Margarete commissioned tapestry frontals for seven of the nine altars in the Lorenzkirche; it is thought that the present frontal may be one of them. Undoubtedly of Nuremberg fabrication,[1] the tapestry frontal is very well preserved, with both selvages intact.

TBH

1 Only one tapestry workshop in mid-fifteenth-century Nuremberg is documented, and the only tapestry that can be associated with this workshop is very different in style. The profusion of tapestries mentioned in inventories and other records during this period, however, would indicate that a number of workshops must have been active to meet the documented demand. See von Wilckens, 1986, no. 58, pp. 200–201, colorpl. p. 200.

EX COLLECTION: Ruth and Leopold Blumka, New York.

EXHIBITIONS: "Medieval Art from Private Collections," New York, The Cloisters/The Metropolitan Museum of Art, October 30, 1968–January 5, 1969, no. 209; "Gothic and Renaissance Art in Nuremberg: 1300–1550," New York, The Metropolitan Museum of Art, April 8–June 22, 1986, and Nuremberg, Germanisches Nationalmuseum, July 24–September 28, 1986, no. 58.

REFERENCES: Gómez-Moreno, 1968, no. 209, ill.; von Wilckens, 1986, no. 58, pp. 200–201, colorpl. p. 200; Husband, 1992 b, p. 23, colorpl. pp. 22–23.

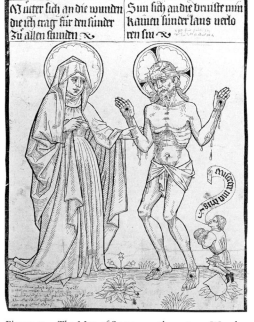

Figure 21. *The Man of Sorrows.* 15th century. Woodcut. Kupferstichkabinett, Staatliche Museen zu Berlin (6315-1878)

227

VIRGIN AND CHILD ON A CRESCENT MOON

German (Nuremberg), about 1470

Linden wood, with polychromy and gilding: 75½ x 27¼ x 17 in. (191.8 x 69.2 x 43.2 cm)

The Cloisters Collection, 1984 (1984.198)

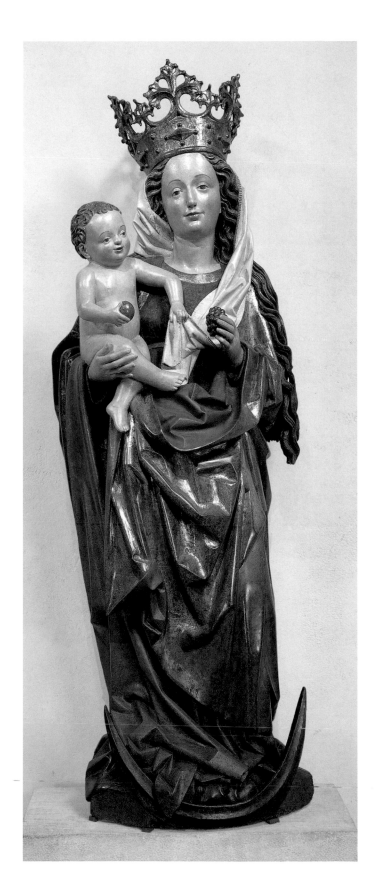

While this large sculpture gives the impression of an independent and massive work, in frontal and three-quarter view, the profile reveals that it is actually carved in very high relief and hollowed out in the back. The Virgin and Child, undoubtedly the focal group of a larger ensemble—as, for example, a devotional altar shrine of a type common in regions of South Germany and Austria in the Late Gothic period—was probably partially enclosed in a shallow box-like setting with flanking saints. Such a shrine may have been protected by folding shutters with painted panels or low-relief carvings depicting either additional saints or Marian scenes.

The iconography of this statue, prevalent from the mid-fifteenth century on in German-speaking areas of Europe, reflects the vision of Saint John in Revelation 12: 1: "A woman clothed with the sun, and the moon under her feet." The background of the lost shrine may have been decorated with golden rays to suggest the sun, against a dark blue ground. The Virgin is also meant to represent Ecclesia triumphing over Synagoga, shown as the moon, and in addition there may be a reference to the Song of Solomon (Canticle of Canticles 6:9): "Who is she that cometh forth as the morning rising, fair as the moon, bright as the sun, terrible as an army set in array?" The orb held by the Christ Child signifies his role as spiritual ruler of the world, and the grapes symbolize his Passion. The subject was one of several favored by the Brotherhood of the Rosary during the late fifteenth century. Prayers before this image, together with confession and penitence, carried the promise of an indulgence.

The general style of the work is central European Late Gothic, but it may be understood more specifically as an example of the widespread influence of Nicolaus Gerhaert von Leiden in South Germany before 1469, when that artist moved to Vienna (see cat. no. 228; 1996.14). The figure of the Virgin, as in other fine examples, is made dramatic by the angular, deeply cut drapery folds of the mantle that envelops her, the sense of monumentality enhanced by her high crown. Flesh areas are smoothly rounded, and the faces are made piquant by the full lips and heavy eyelids. The repeating and opposing lines of the Child's arms, combined with his perky expression, are characteristic of many South German and Austrian works of the fifteenth century, as are the staccato drapery, carving technique, and occasional use of fitted wood inserts. (The left arm, while correctly positioned, is a replacement.) Although partially restored in the lower parts of the statue, the polychromy employs the colors traditionally used for images of the Virgin.

The carving of this work, formerly attributed to the South Tirol, now may be assigned to a gifted and as-yet-unidentified sculptor working in Nuremberg, as recently proposed by Alfred Schädler,[1] who suggested two comparisons to support this argument: the first, with the large *Standing Virgin and Child*, of about 1470, probably originally from Nuremberg and now in the Evgl. Luth. Pfarrkirche, Velden;[2] and the second, with the large figures in *The Mystic Marriage of Saint Catherine*, from the *Behaim Altarpiece*, a Nuremberg work also of about 1470.[3] The Cloisters' statue additionally may be regarded as part of a stylistic evolution in Nuremberg, away from an earlier period represented by such monumental sculpture as that seen here in the large, sandstone *Virgin and Child*, of about 1425–30 (1986.340; cat. no. 214).

The special appeal of this relief statue resides most of all in its stylistic integrity. The Virgin's elegant, high foliated crown, which is original, adds to the overall sculptural impact.

W D W

1 Letter from Alfred Schädler, June 5, 1998, in the Department of Medieval Art files.
2 See Schwemmer, 1959, p. 277, fig. 269.
3 See Kahsnitz, 1986, no. 33, p. 158, colorpl. p. 159.

EX COLLECTIONS: Dr. Karl Krüger, until 1943; Tiroler Landesmuseum Ferdinandeum, Innsbruck; Dr. Peter Hierzenberger, Vienna; [sale, Sotheby Parke Bernet, London, April 3, 1984, lot 14, colorpl.].

REFERENCES: Wixom, 1985, p. 14, ill.; *idem*, 1989 a, p. 22, colorpl.

228

Attributed to Nicolaus Gerhaert von Leiden
North Netherlandish (active in Strasbourg, 1460–died in Vienna, 1473?)

STANDING VIRGIN AND CHILD

Vienna, about 1470

Boxwood: Height (without base), 13¼ in. (33.7 cm); width, 5½ in. (14 cm); depth, 3 in. (7.6 cm)

Purchase, The Cloisters Collection and Lila Acheson Wallace Gift, 1996 (1996.14)

Nicolaus Gerhaert was the finest and most influential sculptor working in the third quarter of the fifteenth century—a pivotal period in the development of Late Gothic sculpture in Northern Europe.[1] A seminal artist of the generation preceding that of Albrecht Dürer, Gerhaert was either born or trained in Leiden, as suggested by his signature and his initials, which appear on three of his extant stoneworks: "nicola[us]. gerardi. de.leyd[en]," "n.v.l.," and "nic[o]laus.von.ley[d]en." He was active in Strasbourg (1460–67), in Trier (1462), probably in Nördlingen (about 1462), in Constance (1465–67) and Baden-Baden (1467), and in Vienna and Wiener Neustadt (1469, until his death).

Although they are undocumented, four or five works in wood have been seriously considered to be by his hand.[2] Of these, the present statuette—probably completed shortly before his death—is especially notable for its sense of drama, its monumentality, and its lyrical homogeneity, which are conveyed through the extraordinarily accomplished carving of the fine-grained wood. The authority of the formal conception and the eloquence of the execution are evidence of the gifts of a great artist. The slim, high-waisted body of the Virgin serves as a pliant cylinder at the core of a lively envelope of drapery. While partially enclosing and obscuring the central volume, this drapery loops away spatially in places and takes on something of its own life in the curving, angular, fluted, and pocketlike folds. The squirming, cross-legged Christ Child is another example of this breaking away in space from the middle. The rhythm and balance of the forms are counterpoised by the linear details and by such textural contrasts as those between the rich abundance of the waves of hair and the smooth, concave valleys of the drapery at the back, or between the overall hatching of the crenate veil juxtaposed against the smooth, polished planes of the Virgin's face and neck. Among the naturalistic details is the delicate manner in which the Virgin's fingertips press into the chubby flesh of the Child, a detail carried over from central European sculptures of the late "Beautiful Style," dating from the first quarter of the fifteenth century.

The condition of the present work generally is excellent, except for the loss and subsequent replacement of the Child's arms and the portion of drapery extending from his left hand. This restoration

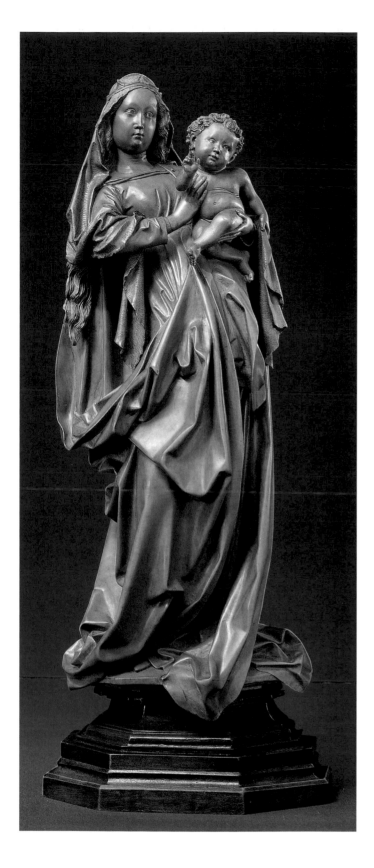

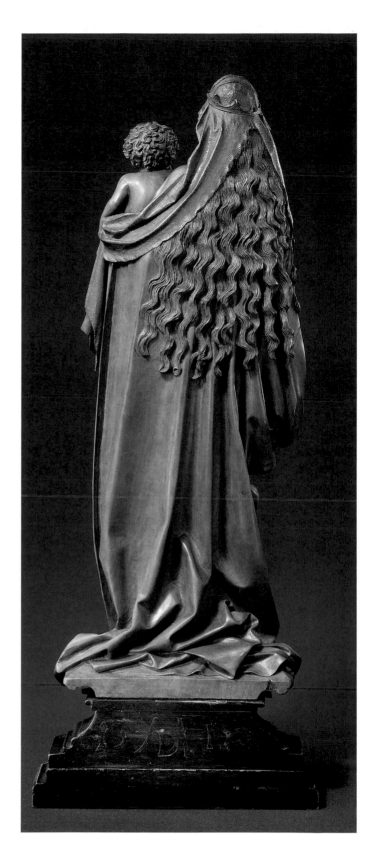

dates from before 1866, while the statuette was in the collection of Baron Anselm Salomon von Rothschild (1803–1874) in Vienna. The partially replaced tips of the Virgin's crown at the back and center front, as well as the dark-wood molded base with its fictive Dürer monogram, also date from this period.[3] The surfaces, in their original unpolychromed state, are intact, but the faces bear the remains of color on the lips and eyes, which were partially strengthened at a later date. A small sequence of parallel notches (*die Tremolierung*) below the Virgin's drapery at the back, which were created by the

rocking motion of the sculptor's chisel, are probably the trial cuts made before he attempted the fine texture of the veil.

The pros and cons of the attribution of this masterpiece to Nicolaus Gerhaert von Leiden (first proposed by Eva Zimmermann in 1970) were carefully addressed by Alfred Schädler, who concluded that this is a late work by the master, made during the last period of his career, or about 1470, when he was working on the imperial tombs in Vienna and Wiener Neustadt. In support of the attribution, it suffices here to cite a few of the characteristics of the present

Virgin and Child, as well as the overall form of that work, in the context of two of the signed and dated sculptures,[4] the finest of the attributed works,[5] and two of the workshop statues.[6] Among these details are the full, oval face and rounded brow of the Virgin; her small mouth, long pointed nose, and long and thick locks of wavy hair; her crenate veil and the thin ridges, and narrow as well as wide valleys, of the drapery folds, including the breaking and concave pocket folds; and the formal concept of a narrow, elongated core partially enclosed by this surrounding and expansive envelope of drapery. The Christ Child—naturalistic, animated, and full bellied, with his enlarged head framed by tight, curly locks of hair—is also typical of the sculptures attributed to Gerhaert.

Kaliopi Chamonikolasová recently has provided a stunning confirmation of Schädler's attribution by firmly citing the Metropolitan Museum's remarkable statuette as the most important link between the Viennese sculptures by Gerhaert or his workshop and those produced north of Vienna in Moravia. Primary among these Moravian monuments is the altarpiece for the high altar of the Church of Saint Elizabeth in Košice, dated by Chamonikolasová to shortly after Gerhaert's presumed death, or between 1474 and 1477.[7] While each of the three main statues displays a considerable correspondence in the proportions and the concept of folds of enveloping drapery, the Moravian style represents a further evolution toward a Late Gothic Mannerism, in which the intricate configurations of the draperies begin to assume an even more independent status.

The Metropolitan Museum's statuette may be seen as continuing a long Netherlandish and Rhenish tradition of devotional works in boxwood.[8] Furthermore, it may have been commissioned by a member of the Viennese imperial court.[9] The exquisite carving throughout, including the back, highlights the probability that the figure was not intended to be enclosed within a tabernacle or shrine—the somewhat compressed profile notwithstanding. Partial evidence for this assumption is provided by the independent metalwork statuettes of the Virgin and Child shown in the watercolor drawings in the *Hallesche Heiltum*.[10] Another suggestive example is a contemporary painting of about 1470 by Colantonio (1430/40–about 1470), which depicts three separate statuettes independent of a tabernacle setting: two angels and the Virgin standing on an altar in a vaulted niche at the back of a private chapel of Queen Isabella I of Castile (1451–1504), who kneels before them with her children.[11]

WDW

1 See Müller, 1966, pp. 79–82, 102, 106–8, 112–14, 122–23, 126–28, 134, 148, 168, 170, 176–77, 179, plates 90–93, 95 a; Baxandall, 1980, pp. 13, 15, 16, 19–21, 159–60, 248–51, plates 6–10, 12.

2 See Schmoll gen. Eisenwerth, 1958, pp. 52–102; Schädler, 1974, pp. 46–82; *idem*, 1983; Recht, 1987, nos. I.01–.12, pp. 115–85, plates 1, 3, 4, 6, 7, 9, 10, 12–17, 22, 25–36; *Dangolsheimer Muttergottes*, 1989; Zimmermann et al., 1992, pp. 223–67.

3 See Schestag, 1866, no. 31, ill.

4 The signed and dated (1464) sandstone epitaph in the Cathedral of Strasbourg (see Wertheimer, 1929, pl. 14), and the signed and dated (1467) sandstone crucifix in Baden-Baden (see Baxandall, 1980, pl. 10).

5 The Dangolsheim painted walnut *Virgin and Child*, of about 1460, in Berlin-Dahlem (see Schädler, 1974, figs. 27–28), and the painted walnut figures of the Mourning Virgin, the Magdalene, and the Crucified Christ from the altarpiece, dated 1462, in Nördlingen (see Schädler, 1974, figs. 9–11, 20–22; *idem*, 1983, fig. 12).

6 The wood *Enthroned Virgin and Child*, which dates to after 1467, in

Vienna (see Schädler, 1983, figs. 18–19), and the sandstone *Standing Virgin and Child*, of about 1467, in Hamburg (see Schmoll gen. Eisenwerth, 1958, figs. 16–20).

7 See Chamonikolasová, 1995, fig. 6. I am indebted to Charles T. Little for this reference.

8 See Middeldorf Kosegarten, 1964, pp. 302–21; Schädler, 1983, p. 43, n. 6, p. 54.

9 See Schädler, 1983, p. 41: "Die Frage, ob sich die Provinienz der Statuette, deren Charakter auf eine fürstliche Kunst- oder Schatzkammer zu weisen scheint, in die Zeit vor 1866 zurückverfolgen läßt, muß hier offenbleiben" (The question of whether the provenance of the statuette, whose quality seems to point to a princely art collection or treasury, can be traced before 1866 must remain open).

10 See Halm and Berliner, 1931, nos. 125, 127, 128, 134, pp. 39–40, plates 42 b, 69 b, 70 b, and 64 c, respectively.

11 See Lüdke, 1983, vol. 1, no. 302 (1), p. 171, fig. 263.

EX COLLECTIONS: Baron Anselm Salomon von Rothschild, Vienna, before 1866–1874; Baron Nathaniel von Rothschild, Vienna; Alphonse and Clarice de Rothschild, until 1947; [Rosenberg & Stiebel Inc., New York, 1948]; Julius Wilhelm Böhler (d. 1967), Munich; Julius Harry Böhler (d. 1979), Munich; Marion Böhler-Eitle (d. 1991), Munich; Florian Eitle, Starnberg, Germany.

EXHIBITION: Munich, Bayerisches Nationalmuseum, 1981–95.

REFERENCES: Schestag, 1866, no. 31, ill.; Zimmermann, 1970, pp. 97–98, figs. 26–27; Homolka, 1972, p. 46 (quoted by Chamonikolasová, 1995, no. 101, p. 80); Schädler, 1983, pp. 41–54, figs. 1–4, 7, 8, 11, 13, 14 (with complete bibliography); Chamonikolasová, 1995, pp. 79–81, 83, fig. 8; Wixom, 1996 b, p. 21, colorplates p. 21, outer and inner front covers.

229

Circle of the Master of the Amsterdam Cabinet (active 1470–90)

THE VIRGIN OF THE APOCALYPSE

German (Middle Rhineland), about 1480–90
Colorless glass, silver stain, and vitreous paint: 13⅞ x 9½ in. (35.2 x 24.1 cm)
The Cloisters Collection, 1982 (1982.47.1)

The Virgin standing on a crescent moon, surrounded by rays of light, is a specific iconographic type, of German origin, which gained currency about the middle of the fifteenth century. Encircled by the rays of perfect light, the Virgin, as Queen of Heaven, outshines the transitory and evanescent nature of all other realms, just as the sun dissipates the light of the moon. The image also may refer to the *Immaculata*, the Virgin as the Church and as the Spouse of Christ. For the biblical sources of the Ecclesia/Synagoga symbolism of this Marian image see catalogue number 227.

The Master of the Amsterdam Cabinet, although little known outside a small circle of scholars, was arguably the greatest graphic artist in the North prior to Albrecht Dürer. His principal works comprise eighty-nine drypoints, known in 124 impressions, eighty of which have long been housed in the print room of the Rijksmuseum in Amsterdam.[1] Additionally, panel paintings, drawings, and manuscript illuminations have been attributed to or associated with this artist, whose identity has never been established. The matter has been complicated by the fact that the Master's hand is evident in a fragmentary manuscript long known as the *Medieval Housebook*

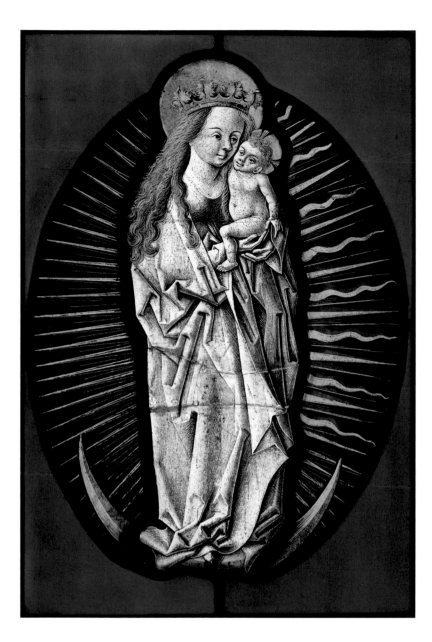

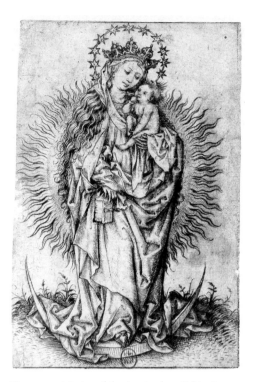

Figure 22. Master of the Amsterdam Cabinet. *The Virgin of the Apocalypse.* About 1490. Drypoint. Rijksprentenkabinet, Rijksmuseum, Amsterdam

(*"mittelalterliche Hausbuch"*). This manuscript, owned by the counts of Waldburg-Wolfegg since the seventeenth century, is famed for its full-page pen-and-ink illustrations of secular imagery, some of which are enhanced with a sparse use of color. Not a medieval housebook in the sense of a fifteenth-century household almanac, it is, rather, a manual largely concerned with warfare, comprising technical treatises addressing medical matters, mining, waterworks, and metallurgy, the mechanics of siege equipment, and the like—all, of interest to the master of munitions in a large and powerful household. Of a less practical nature and certainly more appealing are seven full-page illustrations of the personifications of the planets and of those born under their signs, six double-page illustrations of courtly life and patrician tournaments, and a double-page Garden of Love, as well as illustrations of mine works, minting, and smelting, and a series of technical drawings of equipment and machinery for warfare. The entirety of the manuscript has long been attributed to the "Master of the Housebook" when, in fact, the Master of the Amsterdam Cabinet was responsible for the Mars, Sol, and Luna pages, and the rest of the illustrations were executed by two or more different hands.[2]

While several stained-glass panels have been attributed to these other hands—notably, to the Master of the Genre and Tournament Pages[3]—the present panel, perhaps more than any other surviving example, bears the many characteristics of the Master of the Amsterdam Cabinet's figural style.[4]

Unmannered and freely drawn, the Virgin and Child reflect an immediacy and a naturalness that derive from the Master's abiding interest in worldly imagery. The broad, rounded faces and cheeks, thin-lined brows over widely spaced eyes, small pointed noses, and nubby chins are stylistic hallmarks found repeatedly in his drypoints (fig. 22) and in his drawings, as well as in the *Medieval Housebook* itself. The figures are full and substantial in contrast to the lean, attenuated bodies more frequently encountered in the art of the time. The softness and delicacy of the figures are enhanced by the consummate technical abilities of the glass painter. The crisp enameled lines, parallel-line shading of the drapery, stippled and crosshatched matte to indicate modeling, and the use of *sgraffito* to texture the hair are all technical refinements abundantly evident in the Master of the Amsterdam Cabinet's drypoints. Because of the

great skill required in executing this panel, it seems certain, however, that the master responsible was trained as a glass painter and not as a graphic artist—his intimate knowledge of the drypoint etchings of the Master of the Amsterdam Cabinet notwithstanding. The balanced tension of the composition, subtle working of the facial features, and harmonic integrity of the figures represent the highest qualitative level of glass painting in this period.

T B II

1 For a complete catalogue of the drypoints see Filedt Kok et al., 1985, pp. 91–187.
2 For an overview of the division of hands in this manuscript see Husband, 1985, pp. 141–45.
3 For the relationship of the Master of the Genre and Tournament Pages to stained-glass design see Husband, 1998.
4 See Husband, 1985, pp. 145–47; Filedt Kok, 1988, p. 124.

EX COLLECTION: Sibyll Kummer-Rothenhäusler, Zurich.

EXHIBITIONS: "Das Bild in Glas," Darmstadt, Hessisches Landesmuseum, October 4–November 11, 1979, no. 12; "'s Levens Felheid: de Meester van het Amsterdamse Kabinet of de Hausbuch-meester, ca. 1470–1500," Amsterdam, Rijksmuseum, Rijksprentenkabinet, March 14–June 9, 1985, no. 134; "Decorative and Applied Art from Late Antiquity to Late Gothic," Moscow, State Pushkin Museum, May 10–July 10, 1990, and Leningrad, State Hermitage Museum, August 14–October 14, 1990, no. 70.

REFERENCES: Wentzel, 1966, pp. 360–71, fig. 4; Becksmann, 1968, pp. 352–67, fig. 8; Beeh-Lustenberger, 1979, no. 12, p. 54; Husband, 1982, pp. 21–22, colorpl. p. 21; Filedt Kok et al., 1985, no. 134, p. 272, pl. XIII; Hayward, 1985, pp. 9, 127, ills.; Husband, 1985, pp. 139–57, fig. 1; *idem*, 1990 c, no. 70, p. 146, colorpl. p. 147; Hess, 1994, pp. 52–57, fig. 52.

230

Strassburger Werkstattgemeinschaft (Lautenbach Master)

THE MAN OF SORROWS AND THE *MATER DOLOROSA*

German (Swabia), about 1480

Pot-metal glass and vitreous paint: (1998.215a) 19½ x 16⅜ in. (49.5 x 41.6 cm); (1998.215b) 19⅝ x 16⅜ in. (49.8 x 41.6 cm)

Provenance: Library (subsequently the chapter house), Cathedral of Constance.

The Cloisters Collection, 1998 (1998.215a,b)

About 1480, Peter Hemmel and his Strassburger Werkstattgemeinschaft[1]—a loose association of glass-painting workshops that had been founded three years earlier and that all worked in the Master's style—were commissioned by the dean and chapter of the Cathedral of Constance to glaze the chapter house (formerly the library). Of the original eighty-one panels, only nineteen, including the present two, have survived. The Cloisters' panels came from the upper-center apertures in the second window of the eastern elevation. On a stylistic basis, they can be attributed to one of Hemmel's closest associates; known only as the Lautenbach Master, after the parish church that houses his most extensive glazing program, this exceptionally gifted painter can be identified, by document, as either Peter Hemmel's son or son-in-law.

The inimitable Hemmel style is typified in the *Mater dolorosa* by the delicately modeled features of the figure's round, fleshy face and by the dramatic exuberance of the drapery, its broad planes juxtaposed with tubular folds and deep crevasses. Characteristic of the

Hemmel technique is the preference for defining volume and form with mattes, subtly worked with the brush (stumping) and the stylus, rather than with trace lines and hatchings. The lush *Astwerk*, essentially a translation of canopies and tracery from an architectural to a vegetal vocabulary, set against a rich, damascened background, is an innovative hallmark of the Hemmel manner.

The iconographic program of the window is uncertain. The panels may have surmounted a Crucifixion scene as well as others depicting events from the Passion, and donor panels may have filled the lower apertures. The Man of Sorrows paired with the *Mater dolorosa* also could have been positioned above a representation of the Tree of Jesse, as in the Volkamerfenster (1486–87) in the choir of the Lorenzkirche, Nuremberg, but this arrangement is difficult to reconcile with the three-by-three panel format of the Constance chapter-house windows.

T B H

1 For a concise overview of the Strassburger Werkstattgemeinschaft, see Scholz, [1995], pp. 13–26.

EX COLLECTIONS: [sale, Auktionen H. Helbig, Munich, November 21, 1912, lot 55 a,b, ill.]; Bodmer family, Zurich, 1912–97; [Dr. Barbara Giesicke, Schliengen].

REFERENCES: Wentzel, 1951, p. 39; Frankl, 1956, no. 22, p. 123, no. 44, p. 126, figs. 228, 229; Becksmann, 1979, pp. XLIV, LII–LIII, 86, 115–22, 163, 169, 173, 218, 293 (Regesten), plates VII c (chapter house), XVIII a–c, 45, figs. 142–145, plates 118–120, figs. 374–385, 386–387 (the present panels).

231

SAINT AGNES

German (Swabia), about 1490
Colorless glass, silver stain, and vitreous paint: Diameter, 6¼ in. (15.9 cm)
The Cloisters Collection, 1983 (1983.237)

This representation of Saint Agnes is a fine example—its condition notwithstanding—of a small group of surviving roundels, all of which depict iconic or devotional images, that are distinguished by black backgrounds with *sgraffito* decoration and by their smaller than usual diameters. Both style and circumstantial evidence suggest that these roundels were produced in southern Germany, probably in Swabia.

T B H

EX COLLECTIONS: Walter von Pannwitz, Munich; [Julius Böhler Kunsthandlung, Munich]; [Blumka Gallery, New York].

REFERENCES: von Falke, 1925, no. 97, p. 10; Husband, 1991 a, p. 133, ill.

232

PRIVATE DEVOTIONAL SHRINE (HAUSALTÄRCHEN)

German (Swabia), about 1490
Wood, with polychromy, translucent glazes, and metal hardware: Height, 13¼ in. (33.7 cm)
The Cloisters Collection, 1991 (1991.10)

Of great rarity and appeal, this small and exceptionally well-preserved devotional shrine replicates in miniature the form of a Late Gothic carved altarpiece. Saint Anne is in the center, holding the diminutive Virgin and the Christ Child (*Anna Selbdritt*) and is flanked by the donatrix and the donor. Painted on the outside wings are Saints Ursula and Dorothea; on the inside, Saints Catherine and Barbara; and on the predella, the sudarium.

The predominance of female subjects suggests that a woman commissioned the shrine, and, contrary to convention, she had herself positioned in the place of honor to the proper right of the holy group. The iconography, likewise, is somewhat unorthodox. Saint Catherine, for example, is depicted with a book rather than a wheel, while Saint Barbara is shown with a chalice and the Eucharist instead of the more conventional tower. The uncommon hair shirt worn by the donor may indicate that he was a member of a lay penitent order.

The style of the painted figures generally can be localized in the Algäu-Bodensee region of Swabia, which extended roughly from Augsburg to Constance. Characteristic of this regional style are elongated figures with small heads, weak chins, and thick necks; faces with high foreheads and intense eyes; and drapery that falls in long, tubular folds interrupted by occasional unrealistically crumpled passages. The attenuated bodies, the facial types, and the long, parted tresses of the present figures can be associated, more specifically, with the workshop of Hans II and Ira Strigel (1430–1516), although

232: Outside wings

232: Inside wings and predella

the simplified, plausible drapery patterns and the restrained figural style reflect the influence of Hans Holbein the Elder. While the figure of Saint Anne is stylistically similar, the proportions are more balanced and the drapery more conventionally arranged.

The interior surfaces of the shrine essentially are untouched, and the preservation of the fragile translucent glazes is most remarkable.

TBH

EX COLLECTIONS: Rudolf Braun, until 1836; Peter Vischer-Sarasin, Schloss Wildenstein, near Bubendorf, Canton Basel, Switzerland; Peter Vischer-Passavant, Schloss Wildenstein; by descent to Peter Vischer-Milner-Gibson, Schloss Wildenstein, until 1989; [sale, Christie, Manson & Woods, London, July 6, 1990, lot 14, p. 30]; [Albrecht Neuhaus, Würzburg].

REFERENCE: Husband, 1991 b, p. 20, colorplates p. 21.

233

STANDING VIRGIN AND CHILD

North Lowlands (Utrecht), late 15th or early 16th century

Clay, caster's sand, and animal glue, with polychromy and gilding, over gesso: Height, 8⅜ in. (21.3 cm)

Purchase, The Cloisters Collection, and Gift of John D. Rockefeller Jr., by exchange, 1982 (1982.54)

The model for this cult image dates to the mid-fifteenth century, but the enduring popularity of this devotional figure ensured its continuing replication; this casting probably dates to the end of the fifteenth century or later. Utrecht enjoyed a thriving industry, producing cult and devotional images in pipe clay, terracotta, and composite clay.

TBH

EX COLLECTIONS: [Rainer Zietz Limited, London]; [Michael Ward, Inc., New York].

REFERENCE: Wixom, 1989 a, p. 6, ill.

234

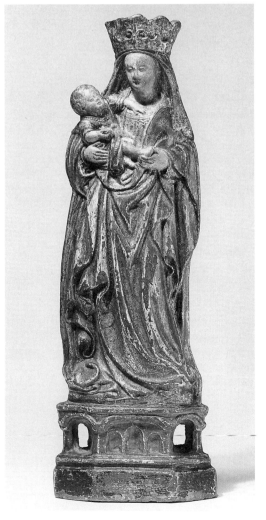

233

234

DEVOTIONAL DIPTYCH

Austrian, late 15th century
Painted wood, with ink on paper and parchment: each wing 28¾ x 25⅜ in. (73 x 64.5 cm)
Gift of Victoria Blumka-Nasatir, 1984 (1984.276)

The texts, in both Latin and German, are prayers for indulgences. A typical example may be read as, "I bow before my Lord and God and his holy five wounds. . . . Whoever says these words with devotion all day will receive one thousand days of indulgences of mortal sins."

TBH

EX COLLECTION: [Blumka Gallery, New York].

235

SAINT GEORGE

South German or Austrian (possibly Vienna), about 1475
Wood, with polychromy and gilding: Height, 17⅜ in. (44.1 cm)
Bequest of Kurt John Winter, 1979 (1979.379)

Saint George stands in a relaxed pose, holding a lance upside down in his right hand to indicate that the fight is over. A bloody wound on the back of the dragon at his feet is the only sign of violence. The position of the young warrior's left hand suggests that a shield once completed the composition and that its bottom edge may have been supported in the dragon's open mouth.

Although youthful and almost angelic, with his hair falling in loose curls and crowned by a green wreath, Saint George has a

pensive and withdrawn countenance, as if he were mindful of his achievements.

The saint's armor is stylistically reminiscent of a set of armor in the Kunsthistorisches Museum, Vienna, that belonged to Archduke Sigmund of Tirol, and to the armor of Maximilian I in Nuremberg. Since the style of armor changed considerably toward the last quarter of the fifteenth century, these similarities suggest a date for the statuette of about 1475. Except for the loss of the shield, the condition of the sculpture is quite good, and the polychromy of the face is beautifully preserved in every detail, which enhances the subtly rendered features. The armor, which now appears brown, originally was covered with a thin coat of silver leaf, only faint traces of which presently can be detected, although the gilding on the hair and on the armor at the shoulders, elbows, and knees has survived intact.

No close parallels for this exquisite sculpture are known. A large statue of Saint George on the high altar of the church in Nördlingen, attributed to an Upper Rhine master and dating to about 1465, is similar in pose. The Nördlingen example, however, is much more elaborate and even frivolous, and has the exceedingly curly hair typical of German sculpture, which reached its most exaggerated form in the latter part of the fifteenth century. The facial features, expression, and hairstyle of the Metropolitan Museum's Saint George have much in common with works by the Swabian sculptor Gregor Erhart (1465–1540)—above all, with the figure of a young man in the *Vanitas* group in the Kunsthistorisches Museum, Vienna, or the *Saint John the Evangelist* from the altarpiece on the high altar of the Benedictine monastery of Blaubeuren, near Ulm. Erhart's sculptures are, however, more attenuated and at least twenty years later in date. Because artists traveled back and forth from Austria to southern Germany, it is virtually impossible to distinguish between the sculpture produced in the two regions without substantial documentation. Among those works still *in situ*, the sculptures in the Hofburgkapelle, Vienna—which were cleaned and restored in 1977–78—have the most in common with the Metropolitan's *Saint George*, not only in the facial features and the handling of the hair, but also in the figures' overall proportions.

CG-M

EX COLLECTIONS: August Carl, Lugano; Kurt John Winter, Scarsdale, New York.

REFERENCE: Gómez-Moreno, 1980, pp. 25–26, ill. p. 26.

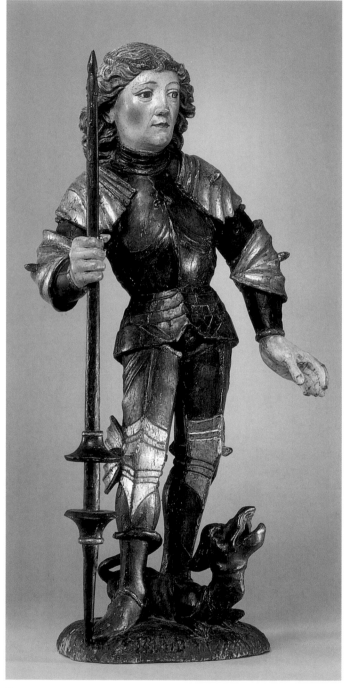

235

236

TWO PILGRIM'S BADGES REPRESENTING SAINT ADRIAN

A. South Lowlands, 1460–80
 Lead alloy: Height, 3⁷⁄₁₆ in. (8.7 cm)
 Inscribed: *S. Adrianus.*

B. South Lowlands, 1480–1500
 Lead alloy: Height, 3⅛ in. (7.9 cm)
 Inscribed: *Sa[n]ct adrian.*
 Provenance: Probably, the Abbey of Saint Adrian, Geraardsbergen, East Flanders.

The Cloisters Collection, 1996 (1996.260.1,2)

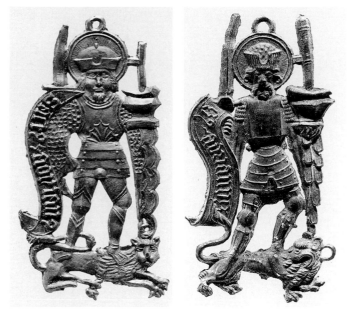

236: A 236: B

Saint Adrian of Nicomedia was a former Roman soldier martyred for his Christian beliefs by having his limbs pulled apart while his body was stretched over an anvil. His relics were translated to the Abbey at Geraardsbergen, south of Ghent, in 1175, thus establishing the foundation as an important pilgrimage site. Adrian, the patron saint of soldiers, jailers, blacksmiths, and messengers, by the fourteenth century also was a considered protector against the plague.

In both of the badges seen here, Saint Adrian is represented in full armor, holding a sword in one hand and an anvil in the other; he stands on a recumbent lion, most probably symbolic of Flanders, of which the lion was the heraldic emblem. The apparent chronological separation in the fabrication of the respective molds reveals the developments made in the style of depicting figures, as well as specific costumes and armor.

Badges corresponding to these two designs are associated with the Sint-Adrianusabdij at Geraardsbergen,[1] and many examples have been excavated in the Province of Zeeland, particularly in Nieuwlande, as a consequence of the inundation of 1530 that destroyed the town, while lesser numbers have been found farther afield in Rotterdam, Dordrecht, and Zwolle.

T B H

1 For a full discussion of the badges from Geraardsbergen of Saint Adrian see van Beuningen and Koldeweij, 1993, pp. 117–21.

EX COLLECTION: [Hill-Stone, Inc., Fine Prints and Drawings, New York].

237

SAINT MARGARET

French (Toulouse), about 1475

Alabaster, with traces of gilding: 15⅜ x 9⅝ x 6⁹⁄₁₆ in. (39.1 x 24.4 x 16.7 cm)

Promised Gift of Anthony and Lois Blumka, in memory of Ruth and Victoria Blumka

Margaret, the Early Christian saint also known as Marina, experienced many painful ordeals before her decapitation at Antioch in Pisidia in central Asia Minor during the reign of Emperor Diocletian

(284–305). This alabaster sculpture conveys a sense of the meekness of the legendary martyr, who is shown here bursting out of the back of a dragon, the creature that became her symbol. From this particular representation we may believe that the saint was chosen for her innocence and faith, as does Anna Jameson, who quotes several metrical phrases from old legends, in her book: "Mild Margarete, that was God's maid; Maid Margarete, that was so meek and mild."[1]

The saint's face and slightly swelling bodice are smooth and delicately rounded. Her eyes are crescent shaped, her small mouth has a dimpled innocence, and her tightly and regularly curled hair falls in heavy strands down her front and back and over her mantle. Loosely draped and patterned in relief like an Italian cut velvet or brocade, this mantle is pulled about the figure just above the body of the dragon, from which the saint emerges, seemingly like an opening flower developing from its earlier form as a bud. Not only is the saint's delicate form revealed but also the circular clasps of her belt, with its feline heads and suspended chain symbolic of her chastity. Her hair is held in place by a narrow diadem set with red stones (or glass), which may be replacements for pearls.

This work is an outstanding example of the late-fifteenth-century Languedoc style, centered in medieval Toulouse, where sculptures in alabaster were rare. Stylistically relevant are a larger, limestone enthroned *Virgin and Child*, called the "Notre Dame de Grasse,"[2] and a standing *Saint Mary Magdalene*[3] (both now in the Musée des Augustins, Toulouse), notable for the similarity of their delicate facial features, long wavy locks of hair, configuration of the draperies, and overall proportions. The physiognomic details recur in other works from the region as well, such as the painted stone *Annunciation* group, of about 1465, from the Vigouroux Chapel in the Cathedral of Notre-Dame, Rodez (now in the church at Inières);[4] the early-sixteenth-century painted stone standing *Virgin and Child* at Bellegarde;[5] and the early-sixteenth-century painted stone *Pietà* in the Church of Saint-Salvi, Albi.[6] Late echoes of this style may be seen in the sculpture of the Bourbonnais region and in Burgundy.[7]

Despite the charm of this work, several significant elements are missing: the saint's right arm and both hands; the dragon's head, claws, and the end of its tail; and the corners of the leafy base. There are repaired breaks below the saint's neck and at the corner of the base under the dragon's left front leg. All of these losses and repairs, already recorded in an early sales catalogue, are old. Nonetheless, the sculpture remains a masterpiece in spite of the damages it has sustained, and is remarkable for the contrast between the freshness and delicacy of the figure and the scaly and coarse textures of the lizard-turned-dragon at the bottom of the composition.

W D W

1 See Jameson, 1895, vol. 2, p. 507; see also Réau, 1955–59, vol. 3, pt. 2, pp. 877–82; Keller, 1984, pp. 395–96; *Oxford Dictionary of Byzantium*, 1991, vol. 2, p. 1299; Murray and Murray, 1996, pp. 304–5. Saint Margaret's feast day is celebrated on July 20. Reading the story of her life was supposed to aid a woman in childbirth. See Wilson, 1985, p. 16.
2 See Aubert, 1946, p. 405, ill.
3 See Bousquet, 1961, pl. 6.
4 See *Trésors d'art gothique*, 1961, no. 101, p. 49, pl. XVI; Bou, 1971, pp. 93–95, plates 18, 46.
5 See Bousquet, 1961, pl. 4.
6 See Forsyth, 1995, pp. 125, 128, 140, figs. 173–174, 195.
7 See Wixom, 1967, no. VII–12, p. 316, ill. p. 317, p. 384.

(illustration on following page)

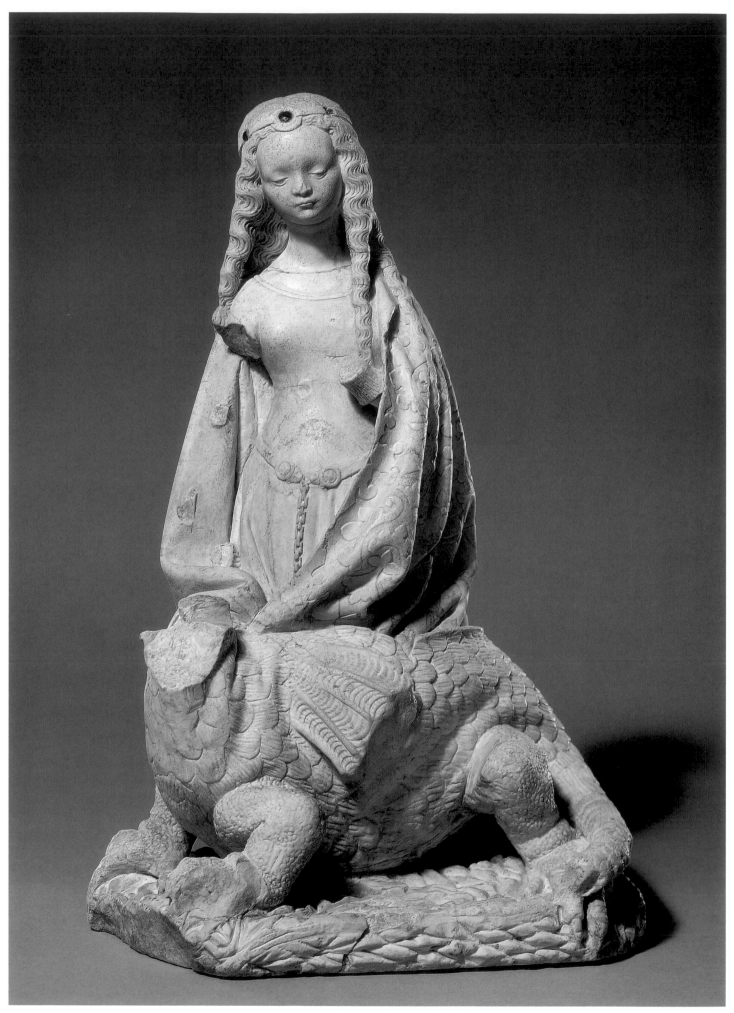

EX COLLECTIONS: Émile Molinier, Paris; [sale, Galeries Durand-Ruel, Paris, June 21–23, and 25–28, 1906, lot 378 (called Sainte Marthe, French, 14th century), ill.]; Leopold and Ruth Blumka, New York.

EXHIBITIONS: "Treasures from Medieval France," The Cleveland Museum of Art, 1966–67, no. VII-12; "Medieval Art from Private Collections," New York, The Cloisters/The Metropolitan Museum of Art, October 30, 1968–January 5, 1969, no. 52.

REFERENCES: Dayot, 1906, no. 378, pp. 8–9; Wixom, 1967, no. VII-12, p. 316, ill. p. 317, p. 384; Gómez-Moreno, 1968, no. 52, ill.; Wixom, 1997 b, p. 23, colorpl.

238

TWO SCENES FROM "DER BUSANT"

Upper Rhenish (Strasbourg), 1480–90

Linen warp, with wool, silk, linen, cotton, and metallic wefts: 2 ft. 7⅞ in. x 4 ft. 4 in. (81 x 132.1 cm)

Gift of Murtogh D. Guinness, 1985 (1985.358)

Rich in scenery and anecdote, this tapestry illustrates, with cartoon-like immediacy, part of the story of "Der Busant" ("The Buzzard"), an Alsatian tale of romance and adventure from the fourteenth century. The poem tells of an English prince, who goes to study in Paris. There, he falls in love with the princess of France, who, alas, is already promised to the king of Morocco. On her wedding day, following a prearranged plan, the English prince, disguised as a minstrel, escapes with the princess into the woods, where she falls asleep with her head in his lap. While she naps, the prince removes a ring from her finger, whereupon a buzzard swoops down and snatches it from his hand. Giving chase, the prince becomes hopelessly lost in the dense forest. Soon, he is living in the forest like a wild animal; hirsute and moving about on all fours, he is virtually indistinguishable, but for his head and crown, from the beasts.

At the left, the prince is shown crouching in the thick vegetation and looking back over his shoulder to gaze at the buzzard, who clasps the ring in his beak. Meanwhile, the princess has awakened and must fend for herself. As she rides forth from the woods on her horse, she seeks the help of a kindly miller, whom she addresses: Her words, which appear in Alsatian dialect on the scrolling band that surrounds her, may be translated: "I, an unhappy lady, beseech you to give me shelter for God's sake." The startled miller, his hat in his hand, replies: "Gladly [though] I, as a poor man, cannot receive you with the honors [you deserve]."[1] Ultimately, the characters "live happily ever after"; the prince is found by hunters and brought back to civilization, and is reunited with his princess through the good offices of the local duke.

Five additional surviving fragments depict other moments in the story of "The Buzzard." The prince, in the company of the sleeping princess and the thieving bird, may be seen in the Clemens Collection at the Museum für Angewandte Kunst, Cologne, in a tapestry fragment, which, surely, is part of the same original hanging as the Metropolitan's weaving. Originally, all of the key moments in the

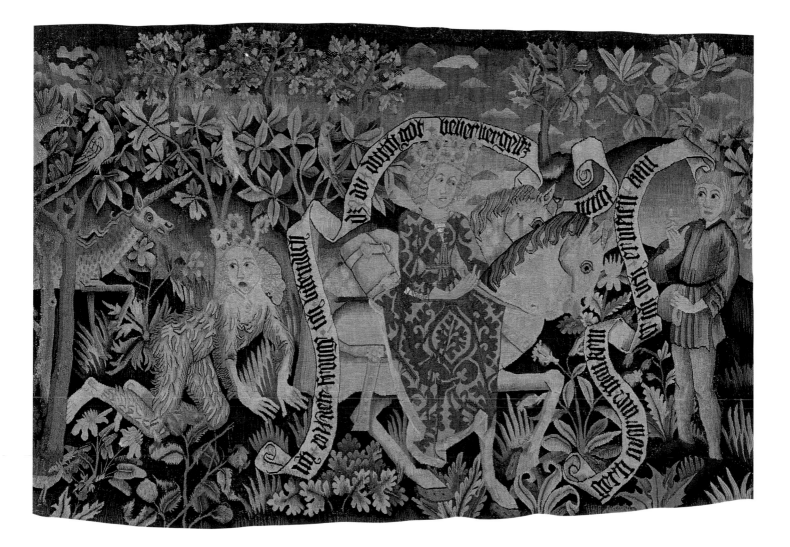

complete narrative would have been depicted sequentially in a long tapestry (or *Rücklaken*), most likely suspended above a bench in a domestic interior.

BDB

1 The text and the translation proposed by Dr. Helmut Nickel appear in Cavallo, 1993, no. 58, p. 644.

EX COLLECTIONS: Roman Abt, Lucerne; [Bossard, Lucerne (?)]; Dr. Albert Figdor, Vienna; [sale, Vienna, June 11–13, 1930, no. 29, ill.]; Walter Edward Guinness, first Baron Moyne (d. 1944); the Honorable Murtogh D. Guinness, New York.

REFERENCE: Cavallo, 1993, no. 58, pp. 642–47 (with earlier literature), colorpl. p. 643.

239

MEDALLION, WITH SAINT GEORGE SLAYING THE DRAGON

German, late 15th century
Mother-of-pearl: Maximum diameter, 2⅛ in. (5.4 cm)
Purchase, Alastair B. Martin Gift, 1986 (1986.10)

The legend of Saint George, which tells of a princess rescued and a town saved by the heroic efforts of a saintly knight, was one of the most popular in the Late Middle Ages. Recorded in Jacobus de Voragine's *Golden Legend*, the story provided a rich source for visual imagery. In this roundel, the slaughter of the dragon is rendered in mother-of-pearl (the shell of a mollusk, *Meleagrina margariti fera*), which allows for carefully detailed carving. The princess stands off to one side, and the towers of the city rise on the hill behind Saint George. Clad in armor and mounted on his caparisoned horse, he thrusts his sword into the mouth of the winged dragon, which is poised at the edge of the lake in which it once dwelt.

As a number of surviving mother-of-pearl medallions represent this subject, their imagery may well depend on contemporary prints. While some mother-of-pearl carvings are, like this example, divorced from their original context, others are preserved in paxes and were ceremonially kissed during the liturgy.[1]

BDB

1 See Kohlhaussen, 1968, no. 330, pp. 241, 243, fig. 375, p. 238, no. 330 a, p. 243, fig. 376, p. 239; Wixom, 1969, pp. 321–23.

EX COLLECTIONS: Mr. and Mrs. John Hunt, Drumlech Bailey, County Dublin, Ireland; Thomas F. Flannery, Jr., Chicago; [sale, Sotheby Parke Bernet, London, December 1, 1983, lot 31, pp. 42–43, color ill.]; [Edward R. Lubin, New York].

240

SAMSON COMBATING THE LION

South German or Austrian, about 1490
Unglazed earthenware: Height, 9⅞ in. (25.1 cm)
Gift of Ruth Blumka, in honor of Michel David-Weill, 1992 (1992.176)

Unusually sculptural in effect, the design of this oven tile is adapted from an engraving by the Master E.S. (L. 4; see fig. 23). The tile maker, however, has placed the scene in an interior with sharply delineated ribbed vaulting and masonry. The animated group is modeled with the linear clarity of the engraved print that inspired it. This type of tile was part of a large, freestanding hot-air oven, fashioned to decorate as well as heat a public room.

Tileries that employed prints as design sources are known to have existed in Nuremberg, the Tirol, and Vienna. Unglazed oven tiles such as this one are far rarer than the polychrome glazed variety, and the unblemished surface of the high relief further enhances this exceptional Late Gothic example.

TBH

EX COLLECTION: Ruth and Leopold Blumka, New York.

REFERENCE: Husband, 1993, p. 26, ill.

Figure 23. Master E.S. *Samson and the Lion.* About 1460–65. Engraving. Graphische Sammlung Albertina, Vienna

241

PACK OF FIFTY-TWO PLAYING CARDS

South Lowlands (Burgundian Territories), about 1470–80

Pasteboard, with pen and ink, tempera, and applied gold and silver:
Each (approx.), 4¾ x 2¾ in. (12.1 x 7 cm)

The Cloisters Collection, 1983 (1983.515.1–52)

The Cloisters' playing cards constitute the only complete fifteenth-century illuminated set known.[1] There are four suits, each with a king, queen, and knave, as well as number or pip cards from one through ten. The unique suit designations all pertain to hunting equipment: gaming nooses, dog collars, tethers, and horns. The collars and horns are red and the tethers and nooses blue, but the relative values are undetermined; the values of the number cards, however, are indicated by the appropriate repetition of the suit sign. The suit of the court cards is, likewise, indicated by the apt symbol, which each figure carries, wears, or has emblazoned on his or her costume. The rounded-end format of the cards also appears to be unique, although other unconventional shapes are found among early cards.

Very few fifteenth-century playing cards have survived, and most of these are printed; rarely do they comprise complete packs.[2] In addition to the Cloisters' set—which is both stenciled and painted—there are only two other illuminated packs, both of them incomplete (see fig. 24).[3] While the names of some games have come down to us, little is known of how the games were played, but most—assuredly—involved gambling. Remarkably, the Cloisters' cards are in nearly perfect condition, which suggests that they were

241: Detail, suit of tethers

Figure 24. Nine of Herons, from the Ambraser Hofjagdspiel. German, Upper Rhineland, about 1440–45. Watercolor, opaque pigments, and gold on pasteboard. Kunsthistorisches Museum, Vienna

either never used or else were not intended to be used in the conventional sense.

The figures on the court cards are arrayed in splendid costumes fashionable at the Burgundian court, which was famed for its sartorial excesses. On closer inspection, however, some of the elements of dress are anachronistic, and several details appear to lampoon the figures: The King of Nooses, for example, wears a yellow bootlet on one foot and a black pointed shoe on the other. Thus, the pack of cards may have been meant to parody the extravagant but outmoded behavior at the Burgundian court, for the amusement of a well-to-do and self-assured denizen of a prospering mercantile town in the South Lowlands.

T B H

1 For an extensive discussion, accompanied by a facsimile set, see Husband, 1994 a.
2 A notable exception is the Hofämterspiel, a complete pack comprising fifty-two printed cards with contemporary color, now in the Kunsthistorisches Museum, Vienna.
3 These are the Stuttgarter Kartenspiel, Upper Rhineland or Swabia, about 1427–31, now in the Württembergisches Landesmuseum, Stuttgart, and the Ambraser Hofjagdspiel, Upper Rhineland or Swabia, about 1440–45, now in the Kunsthistorisches Museum, Vienna.

EX COLLECTIONS: [sale, Hôtel Drouot, Paris, December 12, 1978, lot 50]; [sale, Sotheby Parke Bernet, London, December 6, 1983, lot 70].

EXHIBITION: (1983.515.3,7,9,13,14,19,25,28,31,37,43,47,49) "Playing Cards," New York, Cooper-Hewitt Museum, Smithsonian Institution, March 8–May 26, 1986.

REFERENCES: Husband, 1984, pp. 17–19, ill. p. 17, colorpl. p. 18; Hoffmann, 1985, pp. 40–43, fig. 13; Husband, 1994 a.

242

UPPER LEAF OF A DIPTYCH SUNDIAL

German (Nuremberg), 1480–1500
Ivory, with original polychromy and gilding: 3⁹⁄₁₆ x 2⅞ in. (9.1 x 7.3 cm)
Rogers Fund, 1987 (1987.340)

By the end of the fifteenth century, the imperial city of Nuremberg, situated at the crossroads of the major trade routes through Europe, had become a center for the most sophisticated mapmakers and astronomers, such as Johann Müller (Regiomontanus), who resided there from 1471 to 1476. At this time, Nuremberg emerged as the exclusive producer of diptych sundials. Small enough to hold in the hand, these sundials consisted of two leaves hinged at one end and connected by a string gnomon, which would cast a shadow across the engraved circle of the inside face.

The Metropolitan's leaf is unusual because of the animated carving of its upper exterior face, on which four youths are shown playing a game similar to blindman's buff. A boy at the center, blindfolded by his cap, sits on a stool and holds a shoe suspended by a rope from a stick. Three others encircle him, gesturing with their arms, perhaps trying to capture the shoe. This scene is appropriate for a sundial, since children's games were associated in Late Medieval metaphor with the passage of time, the seasons, and the weather. Such episodes often appear as marginalia in the calendars of illuminated or printed Books of Hours and in illustrations of the Ages of Man. The game represented on this dial may be seen as well on a millefleur tapestry of about the same date in the Museum's collection (65.181.17) that bears the inscription *Selon le temps.*[1]

An ivory plaque by the same workshop is in the Musée des Beaux-Arts, in Niort, France (see fig. 25).[2] Also the upper half of a diptych, it, too, represents a children's game, similarly depicted as being played outside in the bright sunshine. With their hatched grounds and polychromy and the exaggerated gestures of the figures, both leaves are closely related in style to a group of bone game boxes, including one in the Metropolitan's collection (54.135), which recently have been attributed to an Upper Rhenish workshop, about 1450–70.[3]

Given the angular style of carving, it is possible that the composition of this leaf is based on a German print, as was the case for later Nuremberg dials. The supposition is bolstered by Nuremberg's prominence as a center for printing and by the shared imagery of this ivory, ivory game boxes, and contemporary millefleur tapestries. While a source has not been found, the simplified costumes and the dramatic actions occur in early Nuremberg prints, such as Johann Sensenschmidt's illustrations for *The Golden Legend* (1475).

The earliest dated diptych sundial is a boxwood example, from 1511, in the Germanisches Nationalmuseum, Nuremberg.[4] However, the simple Roman numerals on the reverse of the present leaf and its single hole for the string gnomon suggest a date at the end of the fifteenth century. Although compass makers like the one shown at work in figure 26 were not part of an established guild until the mid-sixteenth century, the proposed date of the ivory is consistent with the first record of a compass maker in Nuremberg, who is documented in 1484.[5]

BDB

Figure 25.　Upper leaf of a diptych sundial. German, Nuremberg, 1480–1500. Ivory. Musée des Beaux-Arts, Niort (14.1.148)

Figure 26.　*A Compass Maker at Work* (detail). 1549. From the *Hausbuch der Mendelschen Zwölf . . . bruder stiftung*, II.Fol. 1v. Stadtbibliothek, Nuremberg

1　See Cavallo, 1993, no. 31, pp. 453–57, ill. p. 452.
2　Acc. no. 914 1 148. See Koechlin, 1924, vol. 2, no. 1328. I am grateful to Charles Gendron for information concerning this object.
3　See Randall, 1985, p. 238, no. 358.
4　See Willers, 1986, no. 244, ill. p. 434.
5　See Gouk, 1988, p. 64, table 6.

EX COLLECTIONS: [Blumka Gallery, New York]; Laila Gross, New York; [Blumka Gallery, New York].

REFERENCES: Boehm, 1988, p. 21, ills.; Gouk, 1988, p. 29, fig. 28.

243

PLAYING AT QUINTAIN

French (Paris?), about 1500

Colorless glass, silver stain, and vitreous paint: Diameter, 8 in. (20.3 cm)

The Cloisters Collection, 1980 (1980.223.6)

Quintain originally was a tilting exercise in which a dummy or other target was employed by knights in training for the joust. Balance quintain was a variation to amuse those of a lower station: A seated man held up one leg, placing his foot against the foot of a standing man; one person then tried to upend the other. By the fifteenth century, balance quintain was often played as a courting game, as is depicted here.

T B H

EX COLLECTION: [Bresset Frères, Paris].

REFERENCES: Hayward, 1981, p. 29, ill.; Husband, 1991 a, p. 129, ill.

Figure 27. Master E.S. *The Letter* A. Probably 1466–67. Engraving. Staatliche Graphische Sammlung, Munich

244

THREE APES BUILDING A TRESTLE TABLE

German, about 1480–1500

Colorless glass, silver stain, and vitreous paint: 10¼ x 8⅞ in. (26 x 22.5 cm)

The Cloisters Collection, 1990 (1990.119.3)

Whether this scene was intended to convey anything beyond its obvious whimsy is uncertain. Fables and moralities abounded throughout the Middle Ages, satirizing those who attempted functions for which they were totally unsuited, as, for example, an illiterate working as a librarian. Here, the composition brings to mind alphabets by such artists as the Master E.S., in which the letters are formed by contorted figures or by the arrangement of everyday objects (see fig. 27). With its seriflike corners, the tabletop resembles the letter *I*. Are the apes in the process of deconstructing an alphabet?

T B H

EX COLLECTIONS: [Galerie de Chartres, Chartres]; [Galerie für Glasmalerei, Zurich].

REFERENCE: Husband, 1991 a, p. 132, ill., and color back cover.

245

OPUS ANGLICANUM: CHASUBLE

English, late 15th century
Silk and metallic embroidery on linen (appliqué, on a silk-velvet foundation, with silk embroidery and silver-gilt shot)· 28¾ x 14⅛ in. (73 x 35.9 cm)
The Cloisters Collection, 1982 (1982.432)

This fragment of *opus anglicanum* is remarkable for the richness of its design and its superb state of preservation. The decoration consists of two cherubim, each atop a wheel from which rays of light emanate; four fleurs-de-lis; and four thistles in three different designs, each motif distributed along a vertical axis. These elements, all embroidered in vibrantly colored silk and silver-gilt threads, are appliquéd onto the red velvet foundation on which the scrolls and other designs—accented with attached minute silver-gilt rings or shot—are embroidered directly. The lay of the velvet, the vertical warp and design, and the outline of the fragment indicate that it formed the lower-right quadrant of a chasuble.

TBH

EX COLLECTION: D. Constable-Maxwell, London.

REFERENCE: Husband, 1983, p. 24, ill.

246

HEAD OF CHRIST, FROM A *PIETÀ* GROUP

Netherlandish (North Lowlands: Diocese of Utrecht), late 15th century
Limestone, with traces of wood thorns: 9⁹⁄₁₆ x 10½ x 9⅛ in. (24.3 x 26.7 x 23.2 cm)
Purchase, Rogers Fund; Gifts of J. Pierpont Morgan, George Blumenthal and Messrs. Duveen Bros., by exchange; Bequests of George Blumenthal, Michael Dreicer, Theodore M. Davis and Anne D. Thompson, by exchange; and Mr. and Mrs. Maxime L. Hermanos Gift, 1983 (1983.406)

The Metropolitan Museum has an extensive collection of French and Netherlandish Late Gothic sculpture. Certain of the early-sixteenth-century works, such as the monumental *Entombment* and *Pietà* groups (16.21.1.2), dating from about 1515, from the chapel of the château at Biron, in the Dordogne,[1] represent the eloquent culmination of a naturalistic tendency begun more than a century earlier by the Netherlandish sculptor Claus Sluter (b. Haarlem, about 1350–d. Dijon, about 1406) and continued by subsequent generations of sculptors in Burgundy and in the Rhineland, among other areas. This style may be seen in several of the Museum's sculptures from the second quarter of the fifteenth century, from Poligny. Before 1983, the Metropolitan Museum owned only one sculpture (47.42)—a fragment—from the second half of the fifteenth century: a tonsured funerary effigy head from northeastern France, dated by the late Theodor Müller[2] to about 1460–70. As indicated by Müller, the naturalistic aspect of this object may be understood as a partial parallel to the work of the great Netherlandish/German sculptor Nicolaus Gerhaert von Leiden (see cat. no. 228; 1996.14). The *Head of Christ, from a* Pietà *Group* provides the second example of this phase of sculpture, without any direct connection to Nicolaus Gerhaert and also without the mannerisms of the tonsured effigy

Figure 28. *Christ Seated on the Cold Stone* (detail). East Netherlandish, about 1500. Limestone, with traces of polychromy. Aartsbisschoppelijk Museum, Utrecht (ABM bs 692)

portrait, but with an emphasis on the ideal more appropriate to the subject of the dead Christ. The furrowed brow, taut cheeks, stiffly parted lips, and expression of spirituality anticipate the greater naturalism of the period of the Biron sculptures, at the beginning of the next century. The closest comparison to the *Head of Christ* is the head of a limestone *Ecce Homo* (fig. 28), attributed to the eastern Netherlands and dated about 1500.[3] Like this work, the Metropolitan Museum's sculpture is without signs of weathering.

According to A. M. Koldeweij, our work was exhibited during World War II in 's Hertogenbosch with information stating that it came from the Cathedral of Saint John in that city—a claim that was verified by relatives of the former private owner.[4] However, examination of a recent discussion of the cathedral's inventory has revealed no confirming evidence.[5] In any case, the Metropolitan's *Head of Christ* may have come from an interior sculpture group that probably was associated with an altar.

WDW

1 See Forsyth, 1970, pp. 108, 115–23, 182, figs. 160–162, 176; *idem*, 1995, pp. 140, 178, 205, n. 4, figs. 189–190.
2 See Müller, 1966, pp. 85–86, pl. 97 B.
3 Inv. no. ABM bs 692. I am grateful to Dr. Marieke van Vlierden for this suggestion, in a letter of September 23, 1997. See Bouvy, 1962, no. 186, pp. 110–11, fig. 64.
4 A. M. Koldeweij, in a letter of November 8, 1988, and of February 2, 1992.
5 See Peeters, 1985, p. 366, where there is reference only to sculptures still extant in the cathedral.

EX COLLECTIONS: Private collection, Brabant, Belgium; [Julius Böhler Kunsthandlung, Munich].

EXHIBITION: "The Word Becomes Flesh," Iris and B. Gerald Cantor Art Gallery, College of the Holy Cross, Worcester, Massachusetts, November 4–December 8, 1985, no. 1.

REFERENCES: Böhler, 1982, no. 59, pl. 45; Wixom, 1984 b, p. 16, ill.; Ziegler, 1985, no. 1, pp. 39–40, ill.

247

SAINT JOHN THE BAPTIST

South Lowlands, about 1500
Colorless glass, silver stain, and vitreous paint: Diameter, 8½ in. (21.6 cm)
The Cloisters Collection, 1984 (1984.205)

The glass painter who produced this roundel was certainly aware of the engraved versions of this subject by both the Master FVB (Ill. B. 8: no. 31-I, p. 188) and Martin Schongauer (fig. 29), borrowing elements from each but copying neither. The recessed landscape with the two groups of buildings in the background is purely the invention of the glass painter.

TBH

EX COLLECTIONS: [Pieter de Boer, Amsterdam]; [Kunstzalen A. Vecht, Amsterdam].

REFERENCE: Husband, 1991 a, p. 140, ill.

Figure 29. Martin Schongauer. *Saint John the Baptist.* About 1475–80. Engraving. The Metropolitan Museum of Art, New York. Harris Brisbane Dick Fund, 1927 (27.20.4)

248

Attributed to Niclaus of Haguenau (born about 1445–died before 1538)

SAINT ANTHONY ABBOT

Upper Rhine Valley, Strasbourg, about 1500
Walnut: Height, 44¾ in. (113.7 cm)
The Cloisters Collection, 1988 (1988.159)

This figure of Saint Anthony Abbot combines elements of traditional representations of the saint in an innovative way. These include the hermit's full beard, habit and loose cap, crutch or tau cross (only part of which remains), and the satanic demon under his feet. The antagonist's interaction is unusual; the demon tears at the front and back of the abbot's robes but, despite his ordeal, the saint is shown in sober triumph as he rests a foot on the demon's neck and thrusts his crutch into its jaws.

This sculpture is carved fully in the round; only the vertical core is hollowed out, and the long, full folds of the draperies are dramatic and convincing on all sides, including the back. The massiveness of the cowl is not apparent unless it is seen from the sides or the rear. This three dimensionality suggests that the statue was a movable cult figure, which, when not carried in a procession, might have been placed in an altar shrine or on a bracket behind an altar. The subject—a third-century Egyptian saint whose order, the Antonites, was founded in Europe in the eleventh century—provides a clue to its original setting. The Antonites were dedicated to the care of the sick, largely through the establishment of hospitals.[1] The order had two foundations in Alsace—at Isenheim and Strasbourg—so that it is possible that this figure belonged to one of them.

The central components of the large altarpiece in the Antonite church at Isenheim are the linden-wood carvings of about 1500–1516 attributed to Niclaus of Haguenau, one of the most gifted Upper Rhenish sculptors working about 1500.[2] At the center is a large, enthroned patriarchal figure of the saint (height, 165 cm), whose head derives stylistically from the smaller head of Christ in the *Lamentation* on the predella of the documented Corpus Christi altar carved by Niclaus about 1501 for Strasbourg Cathedral. The Cloisters' sculpture, which fits logically within this stylistic milieu, also may be by or attributed to the master.

The present portrayal incorporates several psychological states, among them introspection, anguish, and triumph, expressed by means of the intense gaze, the folds of flesh, and the richly carved strands of hair and beard. This work, accomplished near the end of the Late Gothic period, represents a major breakthrough in depicting human individuality and spirituality, integral to which is the hint of past struggle and arrested movement. In its entirety, the sculpture conveys a remarkable power and dignity.

WDW

1 See Husband, 1992 a, pp. 19–35, and catalogue number 249 (1990.283), for further discussions.
2 Recht, 1987, pp. 269–83, plates 273, 274, 292.

EX COLLECTION: [Julius Böhler Kunsthandlung, Munich].

REFERENCES: Wixom, 1989 a, p. 31, colorplates p. 31, inside back cover; *idem*, 1989 b, p. 19, colorpl.

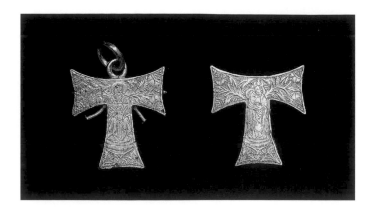

The tau cross was associated with the Order of Saint Anthony Abbot. This capsule is probably best understood within the context of an Antonine hospital, many of which were founded to treat Saint Anthony's fire or *ignis sacer*, a type of ergotism. This disease, widespread in the late fifteenth century, was caused by the consumption of spoiled rye. Symptoms included inflamed nerves, swollen joints, burning stomachaches, boils, and gangrene. The capsule may have contained an amulet or other apotropaic material to ward off the illness, but, more likely, it held an allopathic herbal compound. Plants classified by humor as cold and dry—such as the poppy, verbena, sage, and plantain—were considered efficacious treatments for the burning heat symptomatic of the disease.[1]

TBH

1 For a full discussion of this tau cross, Antonine confraternities, and Saint Anthony's fire see Husband, 1992 a, pp. 19–35.

EX COLLECTION: [sale, Sotheby's, London, July 5, 1990, lot 9, pp. 10–11].

REFERENCES: Husband, 1991 b, p. 20, ill.; *idem*, 1992 a, pp. 19–35, figs. 3, 4, p. 20; Cherry, 1995, p. 153, plates xxixci, ii.

249

THE WINTERINGHAM TAU CROSS

English, about 1485

Partially cast and engraved gold: Height, 1⅛ in. (2.9 cm)

Provenance: Found at Winteringham, South Humberside, North Lincolnshire.

The Cloisters Collection, 1990 (1990.283)

This pendant capsule comprises a cast, walled receptacle about two centimeters deep and a facing plate fitted with a flange and a barrel closure. Under the angle of each arm of the cross is a rivet stem that once held a pearl, and at the bottom edge is a hole for suspending a small bell. The pendant originally was hung from a torque, or perhaps a cord, by a loop (see fig. 30).

Engraved on the obverse is the Trinity and, on the reverse, a standing Virgin and Child. The engraving employs a variety of angled cuts and cross-hatchings that reflect light in contrasting patterns, creating an illusion of exceptional depth and sculptural volume.

250

THE CORONATION OF THE VIRGIN

Lowlands, 1450–1500

Ivory, with silver-gilt mount: Diameter, 1¾ in. (4.5 cm)

Inscribed (on the reverse): IHS

The Cloisters Collection, 1991 (1991.97)

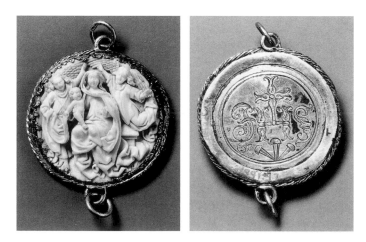

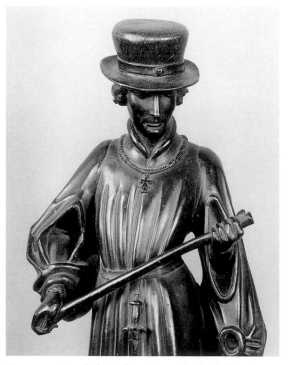

Figure 30. Courtly figure from the tomb of Isabella of Bourbon (d. 1465). From the Abbey Church of Saint Michael, Antwerp, about 1476. Cast copper alloy. Rijksmuseum, Amsterdam

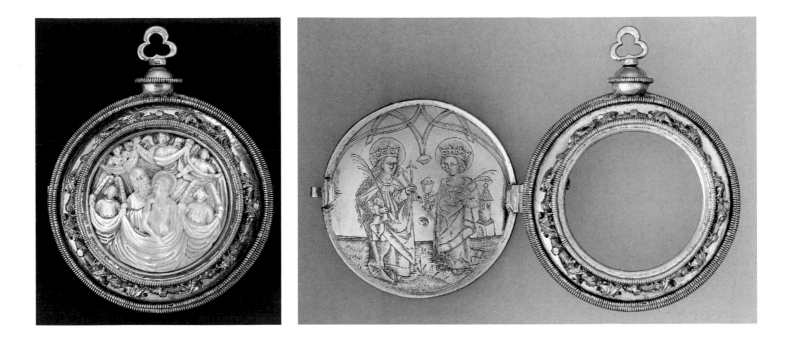

The iconography of this roundel pendant of the Virgin Mary holding the Christ Child while being crowned by two angels refers both to the Virgin's role as the Queen of Heaven and to the Immaculate Conception. While the style is analogous to that of several examples of larger-scale sculpture variously attributed to Hainaut, Brabant, or Gelderland, the composition suggests an awareness of contemporary engravings of the subject—notably, that by Wenzel von Olmütz (L. 23), which is a copy in reverse of an engraving by the Master LCZ (L. 5).

TBH

EX COLLECTION: [Blumka II Gallery, New York].

EXHIBITION: "Medieval Masterworks, 1200–1520," New York, Blumka II Gallery, 1990.

REFERENCE: Merrill, 1990, n.p.

251

OSCULATORY

Austrian (Salzburg), about 1490
Silver gilt and mother-of-pearl: Diameter, 3⅛ in. (7.9 cm)
Provenance: Treasury, Benedictine Abbey of Saint Peter, Salzburg.
The Cloisters Collection, 1989 (1989.80)

An osculatory (from the Latin *osculari,* "to kiss"), worn as a pendant around the neck, was used in the now defunct part of the Church liturgy known as the celebration of the kiss of peace. During the consecration of the Eucharist in the Roman rite, the celebrant would kiss the osculatory to signify the unity of the Church through the bond of charity, and then proclaim to the congregation, "Pax tecum," or "Peace be with you."

The mother-of-pearl plaque on the obverse of the Cloisters' osculatory is carved with an image of the Trinity of the type called the *compassio patris,* which stylistically predates the metalwork capsule.[1] The engraved figures of Ursula and Barbara on the reverse are based on an engraving of Saints Catherine and Barbara by the

Master HS: The engraver of the osculatory merely substituted Ursula's arrows for Catherine's sword (fig. 31). On the backplate is the punch mark of the city of Salzburg in use prior to 1494.

This osculatory joins three other remarkable objects in the Cloisters' Treasury that share the same provenance; thus, this acquisition represents an exceptional instance in which objects from a medieval treasury, long separated, have been reunited.

TBH

1 After a change in the liturgy rendered osculatories obsolete, these objects often were transformed into reliquaries. Thus, in the illustration in Tietze's *Denkmale* volume, the mother-of-pearl roundel is missing and the opening is glazed with a piece of glass. Whether the mother-of-pearl roundel—which does not fit with complete comfort into the aperture—is original to the present osculatory, or was a later, fortuitous, addition is uncertain.

EX COLLECTIONS: Oskar Bondy, Vienna, by February 23, 1933; Leopold Blumka, New York; [Blumka Gallery, New York].

REFERENCES: Tietze, 1913, p. 62, fig. 98, p. 64; Lehrs, 1930, no. 7, pp. 372–73, pl. 214, no. 515; Fritz, 1966, p. 232, fig. 197, p. 414, no. 641, p. 535; Husband, 1989, p. 17, colorplates.

Figure 31. Master HS. *Saints Catherine and Barbara.* About 1490. Engraving. Kupferstich-kabinett, Dresden

252

CHRISMATORY

Probably German, late 15th–early 16th century
Lead: 5⅝ x 5¹¹⁄₁₆ x 3¹⁄₁₆ in. (14.3 x 14.4 x 7.8 cm)
Gift of Ruth Blumka, in honor of Ashton Hawkins, 1985 (1985.229.1)

BDB

EX COLLECTIONS: [Joseph Brummer, New York]; [Blumka Gallery, New York].

253

THE ANNUNCIATION

South German (Swabia?), 1480–1500
Colorless glass, silver stain, and vitreous paint: Diameter (with border), 9⅛ in. (23.2 cm)
The Cloisters Collection, 1985 (1985.244)

Several other close versions of this roundel exist, which suggests that there was a common design, now lost. The retention of the border is a rarity, as these were commonly broken when a roundel was removed from its original glazing.

TBH

EX COLLECTION: Mel Greenland, New York.

REFERENCE: Husband, 1991 a, p. 132, ill.

254

THE MARTYRDOM OF SAINT LEGER

German (Upper Rhineland), about 1490
Colorless glass, silver stain, and vitreous paint: Diameter, 8½ in. (21.6 cm)
The Cloisters Collection, 1980 (1980.223.4)

This gruesome scene represents the bound bishop saint at the hands of his tormentors, who are engaged in piercing his eye with an auger and cutting off his tongue. The linear style suggests a wood block or an engraving as the source.

TBH

EX COLLECTION: [Bresset Frères, Paris].

REFERENCE: Husband, 1991 a, p. 133, ill.

Figure 32. Hans Memling. *Saint Ursula* (detail of the Reliquary Shrine of Saint Ursula). Before 1489. Tempera and oil on panel. Hospital of Saint John, Bruges

255

SAINT CATHERINE OF ALEXANDRIA

South Lowlands (Bruges?), about 1500

Colorless glass, silver stain, and vitreous paint: Diameter, 8¹/₁₆ in. (20.5 cm)

The Cloisters Collection, 1984 (1984.338)

The work of Hans Memling appears to be the stylistic source of this roundel—specifically, the figure of Saint Ursula on the Ursula Shrine in the Hospital of Saint John in Bruges, completed by 1489 (fig. 32). The cusped partial border is unusual on roundels from the Lowlands but is relatively common on examples in England, which suggests that this one may have been produced for the export market.

TBH

EX COLLECTIONS: [Pieter de Boer, Amsterdam]; [J. Polak, Amsterdam].

REFERENCE: Husband, 1991 a, p. 140, ill.

256

THE ADORATION OF THE MAGI

Probably South Lowlands (Brabant), about 1500

Colorless glass, silver stain, and vitreous paint: Diameter, 8⅝ in. (21.9 cm)

The Cloisters Collection, 1983 (1983.235)

The composition of this roundel is freely derived from the central panel of Hans Memling's 1479 *Adoration* triptych in the Hospital of Saint John, Bruges. The preparatory drawing for the roundel, which dates from about 1500 and is now preserved in the Département des Arts Graphiques at the Musée du Louvre (fig. 33),¹ generally follows the painting, but there are sufficient variations to suggest one or more intermediate versions. Copying directly from a painting rather than adapting workshop models was uncommon in roundel production at the end of the fifteenth century. While the source of the

Figure 33. After Hans Memling. *The Adoration of the Magi*. South Lowlands, about 1500. Pen and brown ink, with white highlights and grayish white wash, on brown prepared paper. Département des Arts Graphiques, Musée du Louvre, Paris

composition and the rendering of many of the details in the roundel clearly are of South Lowlands origin, other aspects—such as the rays of the Christ Child's halo, the Child's active focus on the gift presented by one Magus, and the inclusion of a bearded Magus in the foreground—seem to indicate contact with Cologne or the Lower Rhineland. The melding of influences is symptomatic of economic and cultural intercourse between the Lowlands and the Lower Rhineland, and underscores the difficulty in localizing many roundels and/or their designs.

TBH

1 See Lugt, 1968, no. 126, p. 39, pl. 60.

EX COLLECTION: [Galerie für Glasmalerei, Zurich].

EXHIBITIONS: "Northern Renaissance Stained Glass: Continuity and Transformations," Worcester, Massachusetts, Iris and B. Gerald Cantor Art Gallery, College of the Holy Cross, February 2–March 8, 1987, no. 25; "The Luminous Image: Painted Glass Roundels in the Lowlands, 1480–1560," New York, The Metropolitan Museum of Art, May 23–August 20, 1995, no. 17.

REFERENCES: Husband, 1984, p. 19, ill.; *idem*, 1987 a, no. 25, pp. 62–63, ill.; *idem*, 1991 a, p. 148, ill.; *idem*, 1995 a, no. 17, pp. 70–72, ill.

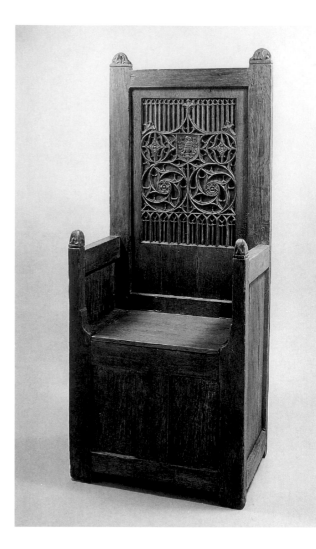

257

CHAIR

Northwest European (possibly Normandy or England), about 1450–1500
Oak: Height, 68⅛ in. (174 cm)
Gift of Dr. and Mrs. Paul G. Ecker, in memory of Victoria Blumka, 1992 (1992.237)

This boxed-in chair displays sturdy frame-and-panel construction. Its two lateral armrests and high, upright back are crowned by handsomely carved finials of foliate design. The Flamboyant Gothic tracery panel, with an as-yet-unidentified coat of arms—very likely a late addition—decorating the back, compares stylistically to the carving on a French chest of about 1480 in Romsey Abbey, England. The unadorned, slightly convex panels on the front add a rustic quality to the chair.

Gothic furniture that has survived unaltered is extremely rare. Secular furniture was closely related to contemporary church fixtures, and woodworkers on both sides of the Channel copied native architectural styles in creating objects such as the Museum's chair. These factors make it difficult to determine where such works were manufactured, although the plain construction of the chair suggests a provincial place of origin.

Although the seat has been replaced, evidence of the original snipe hinges remains. The removal of a dark brown glossy finish applied during an earlier restoration facilitated the detailed observation of the construction and materials, while also contributing to the chair's pristine appearance. X-radiography has indicated that the back stiles originally were longer and that the finials were lowered, implying that the back initially was crowned with carved open tracery.

DK

EX COLLECTION: Dr. and Mrs. Paul G. Ecker, Philadelphia.

REFERENCE: Kletke, 1993, p. 27, ill.

258

FOLDING COMB

Tirolean, about 1500
Boxwood: 4¼ x 3⅜ in. (10.8 x 8.6 cm)
Gift of Ruth Blumka, in honor of Ashton Hawkins, 1985 (1985.200)

CTL

EX COLLECTION: [Blumka Gallery, New York].

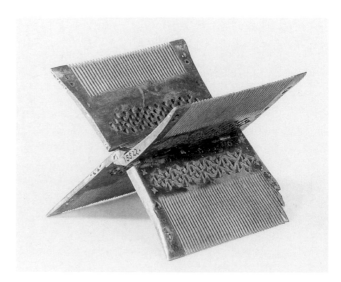

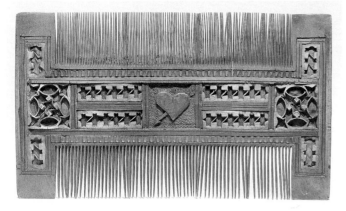

259

COMB

Probably French, 15th–16th century

Boxwood, with bone inlays, and with red and green silk: 3⅞ x 6⁵⁄₁₆ in. (9.8 x 16 cm)

The Cloisters Collection, 1982 (1982.357)

The intricately carved openwork and the fine teeth of this comb, which, remarkably, are preserved, are common to those examples made from boxwood, whose dense, vertical grain allowed for precise, detailed carving.[1] The tradition of using boxwood for combs is apparently ancient—the Latin word for boxwood (*buxum*) was also used to signify "comb."

The decoration, with a heart at the center, is typical of the ornamentation found on combs in the Late Middle Ages. Indeed, the localization of boxwood combs of this type in France is based on the widespread use of amatory inscriptions in French on many examples.[2] Textual sources from the Late Middle Ages indicate that a comb was an expected gift from a husband to his wife at the time of their marriage.[3]

The approximate date of the comb can be inferred from the presence of the coat of arms of Marguerite of Flanders (d. 1405) on

a related boxwood comb in the Musée National du Moyen Âge, Thermes de Cluny, in Paris.[4] The latter example, which is more elaborate, combines openwork carving with silver, but, like the Cloisters' comb, the one in Paris also contains inlaid bone or ivory, the other material from which combs often were made in the Middle Ages. Ivory combs frequently were paired with mirrors and even boxed together in leathern cases;[5] similar sets in boxwood are not known.

The Cloisters' comb is exceptional for the colored silks in contrasting colors of red and green that were set under the openwork areas; the color choice recalls the polychrome enhancement of ivory carvings in Italy about 1400.

BDB

1 Because the wood was stable under climatic fluctuations, boxwood was widely used for scientific and mathematical instruments. See Romanelli, 1992, p. 14. For several fifteenth- and sixteenth-century citations concerning the qualities of boxwood see Gay, 1887, p. 235.
2 See Vadászi, 1973, pp. 61–71.
3 Ibid., p. 62.
4 Inv. no. Cl. 22797. See Vadászi, 1973, p. 65, fig. 5 a–b. See also Erlande-Brandenburg, Le Pogam, and Sandron, 1993, no. 51, p. 54.
5 See Randall, 1985, p. 179, fig. 35.

EX COLLECTIONS: [Joseph Brummer, New York]; [Blumka Gallery, New York].

260

COFFER

North French or South Lowlands(?), late 15th century

Tooled leather over a wooden core, with iron mounts and lock: Height (overall), 5¼ in. (13.3 cm); maximum length, 9¼ in. (23.5 cm); maximum width, 5½ in. (14 cm)

Gift of Frederic G. Fleming, 1990 (1990.248)

BDB

EX COLLECTIONS: Michael Goffart, Liège; Frederic G. Fleming, Port Washington, New York.

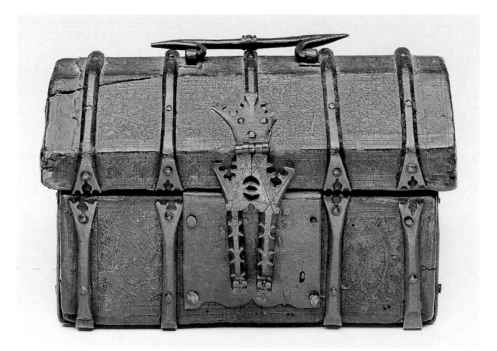

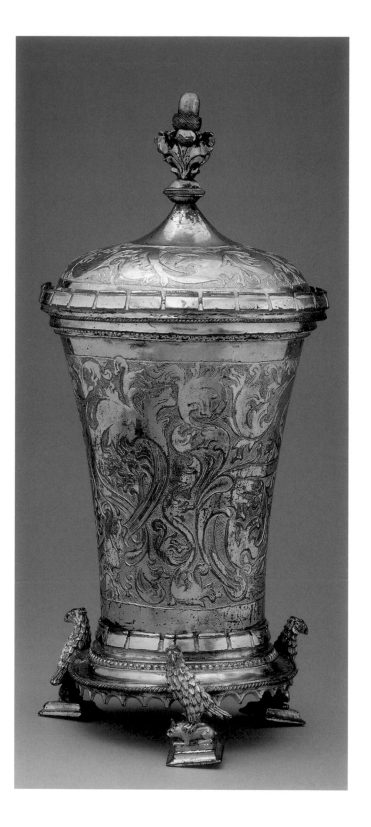

261

Probably Workshop of Sebastian Lindenast the Elder (1460–1526)

COVERED BEAKER

German (Nuremberg), 1490–1500
Copper gilt: Height, 9 in. (22.9 cm)
The Cloisters Collection, 1994 (1994.270a,b)

The distinctive profile of this beaker, which flares gently at the lip, conforms to that of similar vessels bearing the punch mark of the city of Nuremberg. The fashioning of the feet, in the form of animals, and the lush foliate patterns, engraved in reserve on a hatched background, are also characteristic of Nuremberg production. There, as in many medieval cities, goldsmiths were forbidden to work in copper gilt by strict ordinances designed to protect the markets for gold and silver plate. In Nuremberg, however, the Lindenast family had the right, by imperial privilege, to produce this class of wares. Consequently, the very few surviving copper-gilt vessels of this type generally are attributed to the Lindenast workshop.[1]

The vessel and its lid have an engraved overall pattern of undulating, spiky-leafed foliage that overlaps itself as it moves seamlessly across the hatched surfaces, with no beginning or end. Along the bottom edge, a single creature, abashed by its extravagant verdant world, cowers with its tail between its legs, as it encounters a large snarling beast hidden in the background foliage. The gilded surface, rich and mellow in tone, is exceptionally well preserved.

TBH

1 See Kohlhaussen, 1968, pp. 286–87.

EX COLLECTIONS: Albert Figdor, Vienna; Oskar Bondy, Vienna; Ruth and Leopold Blumka, New York.

EXHIBITION: "Medieval Art from Private Collections," New York, The Cloisters/The Metropolitan Museum of Art, October 30, 1968–January 5, 1969, no. 120.

REFERENCES: Gómez-Moreno, 1968, no. 120, ill.; Kohlhaussen, 1968, no. 350, pp. 294–95, fig. 449, p. 293; Husband, 1995 b, p. 27, color ill.

262

SITULA

French or Netherlandish, 2nd half of the 15th century

Brass, with an iron handle: Height, 6¹³⁄₁₆ in. (17.3 cm);
Maximum diameter, 8⅞ in. (22.5 cm)

Inscribed: *Te deum laudamus*

The Cloisters Collection, 1989 (1989.223)

BDB

EX COLLECTION: [Blumka Gallery, New York].

263

LAVER

Netherlandish, probably 15th century

Brass, with iron swivel and suspension loops: Height (with swivel),
12¼ in. (31.1 cm), (without handle), 4⅜ in. (11.1 cm); maximum
diameter, 6½ in. (16.5 cm)

Gift of Joseph G. Reinis, 1991 (1991.473.2)

BDB

EX COLLECTION: Joseph G. Reinis, Brooklyn, New York.

264

STOUP (HOLY-WATER BASIN)

Netherlandish, 15th–16th century

Brass, with (later) iron handle: Height, 6 in. (15.2 cm); maximum
width, 3⁵⁄₁₆ in. (8.4 cm)

Gift of Joseph G. Reinis, 1991 (1991.473.1)

BDB

EX COLLECTION: Joseph G. Reinis, Brooklyn, New York.

266

MAZER (DRINKING BOWL)

English, late 15th–early 16th century
Mazer (maple?), with silver and engraved silver mounts: Height,
4⅜ in. (11.1 cm)
Gift of Ruth Blumka, 1991 (1991.411)

Mazer bowls steadily decreased in size as they evolved from ritual
drinking cups, in the fourteenth century, to individual drinking ves-
sels, toward the end of the fifteenth century.

TBH

EX COLLECTION: Ruth Blumka, New York.

265

TRAMMEL HOOK (*CRÉMAILLÈRE*)

French or Spanish, late 15th or early 16th century
Wrought iron: Length (overall), 66 in. (167.6 cm)
Gift of Dr. Andrew J. Werner, 1978 (1978.398)

Trammel hooks, common kitchen fixtures attached to the interiors
of fireplaces, were employed as a means of suspending cooking ves-
sels at variable heights over or near a flame. This example, which is
ornamented with stylized animal heads, was acquired to embellish
the fireplace from Alençon, now installed in the Unicorn Tapestries
Room at The Cloisters.

TBH

EX COLLECTIONS: [Blumka Gallery, New York]; Dr. Andrew J. Werner, New
York.

267

FORK

German (probably Upper Rhineland), about 1500
Partially engraved silver, with silver gilt and rock crystal: Length,
7⅞ in. (20 cm)
Gift of Dr. Louis R. Slattery, 1980 (1980.33)

Graceful design, fine workmanship, and costly materials transform
this essentially utilitarian object into one of striking elegance.
Because, customarily, fingers, supplemented by knives and spoons,
were employed in eating throughout the Middle Ages, forks are rel-
atively rare. Only in the fourteenth century are they mentioned with
any frequency, and then, apparently, they were used solely for eating
fruits.[1] Forks were not accepted as standard table implements until
the sixteenth century. This fork, with its tines elaborated by tracery,
a rock-crystal handle, and a richly worked foliate knop, was obvi-
ously a luxury item. Its extremely sharp tines suggest that it was used
for serving, rather than to eat with.

The band at the lower end of the handle appears to be a later
addition to repair a break in the crystal.

TBH

1 See Viollet-le-Duc, 1871, pp. 108–12.

EX COLLECTIONS: J. Jantzen, Bremen; [Blumka Gallery, New York].

267

268: Front

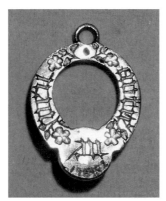

268: Back

269

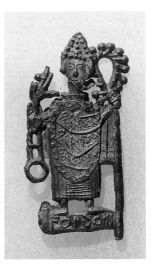

270

269

PILGRIM'S BADGE

English, 15th century
Tin-lead alloy: Diameter, 1 in. (2.5 cm)
Inscribed: CAPVT THOME + ("head of Thomas")
The Cloisters Collection, 1986 (1986.77.4)

This badge, a souvenir of the shrine of Saint Thomas Becket at Canterbury—no doubt the most famous pilgrimage site in England—was unearthed near the London Bridge works in 1831.

TBH

EX COLLECTIONS: Mrs. Allen Williams, London; Rev. Thomas Welton, Upper Clapton, London; [Lawrence Feinberg, Brooklyn, New York].

REFERENCE: Smith, 1848, p. 83, pl. 32, fig. 10.

270

PILGRIM'S BADGE

English, 15th century
Tin-lead alloy: Height, 2¼ in. (5.7 cm)
The Cloisters Collection, 1986 (1986.77.1)

Excavated near the London Bridge works in 1831, this badge represents Saint Leonard, patron saint of prisoners—hence, the manacles suspended from his right arm. The Church of Saint Leonard in Norwich and the Hospital of Saint Leonard in York were both important pilgrimage sites in the Middle Ages. The inscription on the base remains undeciphered.

TBH

EX COLLECTIONS: Mrs. Allen Williams, London; [Lawrence Feinberg, Brooklyn, New York].

REFERENCE: Lamy-Lassalle, 1990, pp. 157–66.

EXHIBITIONS: "Deutsche Bronzen des Mittelalters und der Renaissance, Medaillen und Goldschmiedearbeiten," Düsseldorf, Kunstmuseum der Stadt, December 15, 1960–February 15, 1961, no. 115; "Sechs Sammler stellen aus," Hamburg, Museum für Kunst und Gewerbe, April 7–June 11, 1961, no. 288.

REFERENCES: *Deutsche Bronzen des Mittelalters*, 1960, no. 115; *Sechs Sammler*, 1961, no. 288; Husband, 1980 b, p. 26, ill.

268

HAT OR DRESS ORNAMENT

English, about 1475
Gold, with a garnet: Height, ¹³⁄₁₆ in. (2.1 cm)
Purchase, Gifts in memory of Margaret B. Freeman, 1989 (1989.92)

This small ornament, with a suspension loop at the top, was intended to be sewn onto a hat or other article of dress. Apparently a love token, it is inscribed on the back: "autre ne veut" ("I want no other"). It is said to have been found at Hanley Castle, Worcestershire.

TBH

EX COLLECTIONS: [sale, Christie's, London, December 8, 1987, lot 52, p. 26]; [Blumka Gallery, New York].

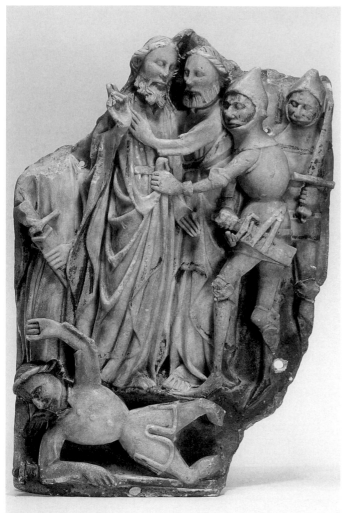

271

273

TWO-COLORED HERALDIC TILE

English (Midlands), late 15th century
Fired earthenware, with slip decoration and lead glaze: 5⅜ x 5⅜ in.
(13.7 x 13.7 cm)
The Cloisters Collection, 1983 (1983.236.3)

Within a square of nine compartments are the coats of arms of the
de Warren and Beauchamp families, an unidentified heraldic or dec-
orative device, a grotesque figure, a hare, a hawk, and a floret. The
tile is said to have come from Derbyshire.

T B H

EX COLLECTIONS: Reginald W. Cooper, Nottingham; [Neales, Nottingham,
1983]; [Ronald A. Lee, London].

274

GLASS FRAGMENT

French (Rouen), 15th century
Pot-metal glass and vitreous paint: 2⅛ x 2½ in. (5.4 x 6.4 cm)
Gift of Shirley Prager Branner, 1985 (1985.91.7)

This fragment is thought to have come from a window in the ambu-
latory chapel of Saint Nicholas in the Rouen Cathedral.

T B H

EX COLLECTIONS: Jean Lafond, Paris; Robert and Shirley Branner, New
York.

271

THE BETRAYAL OF CHRIST

English (Nottingham?), second half of the 15th century
Alabaster, with traces of polychromy: 16 x 11 in. (40.6 x 27.9 cm)
Gift of Louise Crane, in memory of her mother, Mrs. W. Murray
Crane, 1980 (1980.476)

C T L

EX COLLECTION: Louise Crane, New York.

272

TWO-COLORED TILE

English (Midlands, probably Warwickshire), 15th century
Fired earthenware, with slip decoration and lead glaze: 4¼ x 4¼ in.
(10.8 x 10.8 cm)
The Cloisters Collection, 1984 (1984.27)

The decoration of this tile corresponds to examples thought to have
come from Maxstoke Priory in Warwickshire, where major tileries
were located at Stoke, Coventry, and Chilvers Coton, near Nuneaton.

T B H

EX COLLECTIONS: Reginald W. Cooper, Nottingham; [Neales, Nottingham,
1983]; [Ross Levett, Tenants Harbor, Maine].

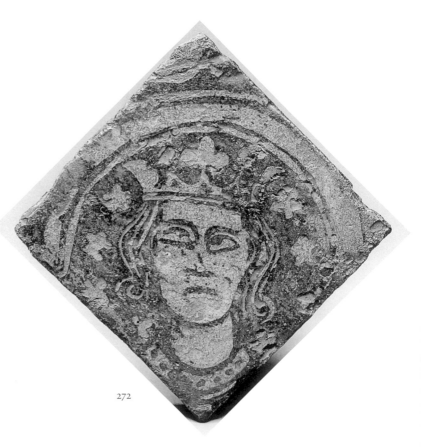

272

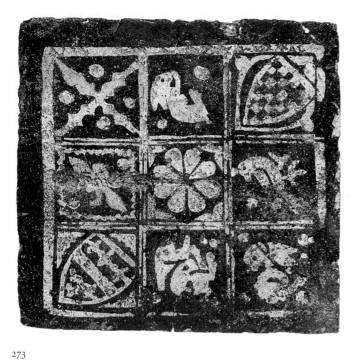

273

274

275

GLASS FRAGMENT

French, 15th century

Colorless glass, with vitreous paint and silver stain: 3¾ x 3½ in. (9.5 x 8.9 cm)

Gift of Mrs. Charles C. Huber, 1984 (1984.239.1)

This fragment, a late use of grisaille, may have formed part of an ornamental tracery light.

TBH

EX COLLECTION: Mrs. Charles C. Huber, Bronxville, New York.

275

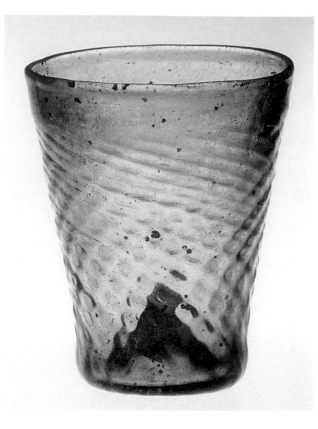

276

CONICAL BEAKER (*MAIGELBECHER*)

German (Middle Rhineland), 1450–1500
Mold-blown potash-lime glass: Height, 4⅜ in. (11.1 cm)
The Cloisters Collection, 1991 (1991.99)

The vessel, typical of Rhenish production, is said to have been excavated at Trier.

TBH

EX COLLECTION: [Bastiaan Blok, Noordwijk, The Netherlands].

277

TWO BEAKERS (*MAIGELEIN*)

German, late 15th century
Mold-blown potash-lime glass: Height, 2⅛ in. (5.4 cm) and 2¼ in. (5.7 cm)
The Cloisters Collection, 1985 (1985.133.1,2)

Ordinary drinking vessels of the later Middle Ages are rare, and those that survive in perfect condition, as these have, are exceptional. Small, shallow drinking vessels of this type are known as *Maigelein*; although the origin of the term is unclear, it is certainly postmedieval.

Long thought to be an archetypal Germanic glass vessel, the *Maigelein* evidently enjoyed a more universal currency; similar examples have been excavated throughout the Lowlands and in northern France. While many of these may have been imports from German glasshouses, fragments have also been found in glasshouse wasters in the South Lowlands.[1] Few examples have turned up in finds that date from after about 1525, an indication that by this time they had gone out of fashion.

TBH

1 See Husband and Hess, 1997, p. 30.

EX COLLECTIONS: (1985.133.1) Leopold Seligmann, Cologne; [sale, Sotheby & Co., London, June 30, 1932, lots 31–35, 37, or 38]; A. von Frey, Paris; Ruth and Leopold Blumka, New York; (1985.133.2) A. Vecht, Amsterdam; [sale, Sotheby & Co., London, November 10, 1938, no. 83]; A. von Frey, Paris; Ruth and Leopold Blumka, New York.

EXHIBITIONS: (1985.133.1) "The Secular Spirit: Life and Art at the End of the Middle Ages," New York, The Cloisters/The Metropolitan Museum of Art, March 26–June 3, 1975, no. 33; (1985.133.2) "Tentoonstelling van oude kunst uit het bezit van den internationalen handel," Amsterdam, Rijksmuseum, July–September 1936, no. 684.

REFERENCES: (1985.133.1) Rademacher, 1931, pp. 290–94, fig. 3, ill. (upper center); Husband, 1975, no. 33, p. 42, ill.; (1985.13.2) *Tentoonstelling van oude kunst*, 1936, no. 684, p. 143.

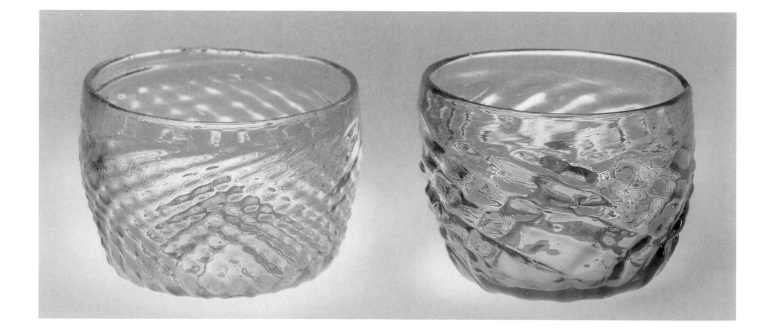

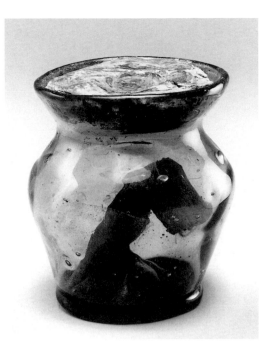

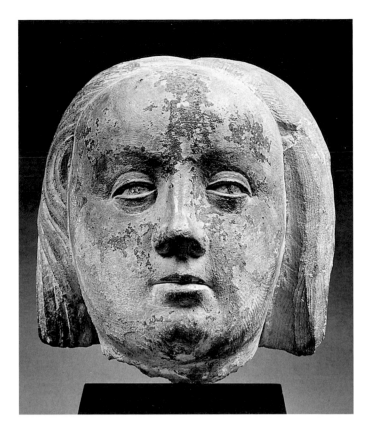

278

RELIQUARY BEAKER

German (Lower Rhineland) or Lowlands, late 15th or early 16th century

Free-blown glass, with applied decoration, boiled leather, silk, and wax: Height, 2¾ in. (7 cm)

The Cloisters Collection, 1997 (1997.513)

The adaptation of ordinary drinking vessels as reliquaries was not uncommon, but few examples have survived, and most of those have been recovered from masonry altars in which they were imbedded at the time the altar was consecrated. In the present example, exceptional for its small size and for the bluish color of the glass, the relic is contained in a tiny silk pouch. The stopper of the vessel, which is made of boiled leather and sealing wax, bears the coat of arms of an unidentified bishop.

TBH

EX COLLECTION: [Bastiaan Blok, Noordwijk, The Netherlands].

279

HEAD OF A WOMAN

French (Champagne: Troyes), about 1500

Limestone: Height, 4¹³⁄₁₆ in. (12.22 cm)

Gift of Mrs. Hayford Peirce, 1987 (1987.442.3)

CTL

EX COLLECTION: Hayford Peirce collection, until 1987.

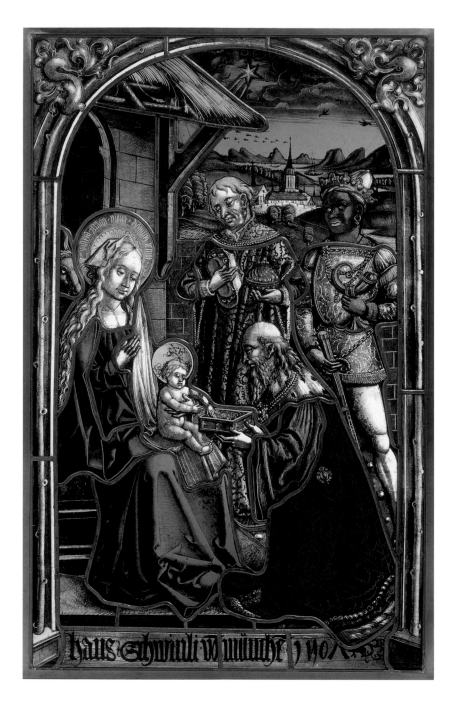

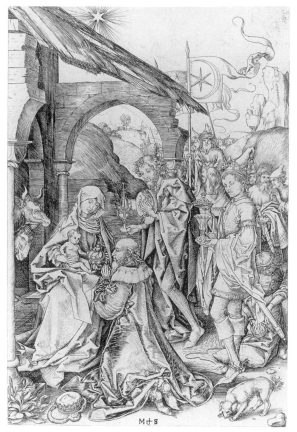

Figure 34. Martin Schongauer. *The Adoration of the Magi.* About 1475. Engraving. National Gallery of Art, Washington, D.C.

280

Circle of the Strassburger Werkstattgemeinschaft

THE ADORATION OF THE MAGI

German (Munich), 1507

Pot-metal and colorless glass, silver stain, and vitreous paint: 27½ x 17¼ in. (69.9 x 43.8 cm)

Inscribed (at the bottom): *hans schwinli·v̄münchēn* 1507

The Cloisters Collection, 1996 (1996.262)

The style of this panel—characterized by weighty figures, individualized facial types, a vivid palette, and an interest in rich textures—is typical of South German glass painting, in general, while the slightly coarse, earthy aspect of the visages, the elongation of the figures, and the broad planes of their drapery, separated by tight tubular folds, are more specific to Oberbayern, and can be seen in the works of contemporary panel painters such as Jan Pollack and Mair von Landshut. The arrangement of the present composition, in which the principal scene is separated from a deeply recessed landscape by a wall, curtain, or other barrier, and the use of a single piece of glass for each compositional element, follow formal devices already established by Nuremberg glass painters in the late 1480s. Other features, however—particularly the Virgin's face, with the arched eyebrows, lower eyelids lined with stickwork, single line of the lips, and nubby chin—are typical of the style of the Strassburger Werkstattgemeinschaft, a loose association of glass painters directed by the highly gifted Peter Hemmel von Andlau that operated in numerous sites across southern and central Europe, from Strasbourg to Vienna, between 1477 and 1499. Although no windows by the Strassburger Werkstattgemeinschaft are documented after 1499, the Metropolitan's panel stylistically and technically reflects the influence of the association's production—notably, in the extensive use of the stylus and of stickwork to model the highly textured mattes, and in the liberal application of silver stain. The present composition relies on Martin Schongauer's engraved version of the subject (of about 1475) and even quotes certain details, such as the

hats of Melchior and Caspar (fig. 34)—an indication of the generally conservative nature of the panel.

The panel's provenance is uncertain, but known Munich commissions for cycles of glass in 1507 include those for the Frauenkirche and the Salvatorkirche, as well as for the Schlosskapelle in Blutenburg. Nothing is known of the donor or commissioner, Hans Schwinli of Munich.

TBH

EX COLLECTION: [Sibyll Kummer-Rothenhäusler, Zurich].

REFERENCE: Husband, 1997, p. 22, colorpl.

281

Hans von Reutlingen or His Workshop

A STANDING BISHOP AND A FEMALE SAINT

German (Cologne), about 1508–12

Silver and silver gilt: Height (1987.217) 4 in. (10.2 cm); (1991.9) 3½ in. (8.9 cm)

Purchase, Desmond Gerald Fitzgerald Charitable Fund Gift, 1987 (1987.217)

The Cloisters Collection, 1990 (1991.9)

Both figures, undoubtedly from the same workshop, were executed in repoussé, raised from two or more sheets of silver to which cast elements were then attached. In scale and style, the bishop and the saint are nearly identical to six figures on buttresses, mounted under canopies, that separate the principal scenes depicted on the hexagonal base of the reliquary bust of Saint Lambert (fig. 35); the bust, commissioned by the prince-bishop Erard de la Marck for the Cathedral of Saint-Lambert (later destroyed) in Liège, is now in the Treasury of the Cathedral of Saint-Paul in that city.

This enormous reliquary was begun by the Aachen goldsmith Hans von Reutlingen and his workshop in 1508, and was delivered in time for the translation of the relics of Saint Lambert on April 28, 1512.[1] The reliquary, the largest and most elaborate surviving example of Late Gothic goldsmiths' work, has been damaged, dismantled, and restored many times since the late sixteenth century.[2] Because the corresponding extant bishop saints are cast—two, after the same model—and all the other principal figures on the shrine are executed in repoussé, it has been proposed that the bishop, even though he cannot be identified, since he is lacking an attribute, is an original that was removed on one of these occasions. The female saint, on the other hand, who, likewise, cannot be identified, has no apparent connection to the narrative of Saint Lambert. Thus, if one or both of the present figures are not from the Liège reliquary, they must have come from a shrine, or shrines—now lost—of like scale, complexity, and authorship.

TBH

1 For documentation of the work of Hans von Reutlingen see Grimme, 1980, pp. 15–50.
2 The reliquary bust was last dismantled and restored in 1971–72; see Colman, 1973–74, pp. 39–84, and Sneyers, 1973–74, pp. 85–86.

EX COLLECTIONS: (1987.217) Thomas F. Flannery Jr., Chicago; [sale, Sotheby Parke Bernet, London, December 1, 1983, lot 22, p. 33]; [Blumka II Gallery, New York]; (1991.9) [Blumka II Gallery, New York].

EXHIBITION: "Medieval Masterworks, 1200–1520," New York, Blumka II Gallery, 1990.

REFERENCES: (1987.217) Husband, 1988, p. 22, ill.; Merrill, 1990, illus.

Figure 35. Hans von Reutlingen. *Reliquary Bust of Saint Lambert* (detail of base showing a standing bishop). 1508–12. Silver and silver gilt. Treasury, Cathedral of Saint-Paul, Liège

282

CHRIST OF THE MYSTIC WINEPRESS

South Netherlandish, about 1500

Wool warp, with silk and metallic wefts: 28¹⁵⁄₁₆ x 30½ in. (73.5 x 77.5 cm)

Gift of Mena Rokhsar, 1994 (1994.484)

The half-length figure of Christ, his right hand raised in blessing
and his left hand touching an orb, is shown at a prie-dieu. His head
is framed by a cloth of honor stretched between the screws of a
winepress. On the ledge behind him are a book—surely, a Bible—
with a single sheet of paper draped over it, and a glass beaker on top
of which is an apple. A column rises behind the curtain, and a rose
and a cup of wine may be seen in a frame at the top of the hanging.
This assemblage of objects, seemingly an odd assortment, alludes to
Christ's sacrifice at the Crucifixion, evoked in the sacrament of the
Eucharist. Two other tapestries in the Metropolitan Museum's col-
lection—especially the one that shows the infant Christ pressing
grapes (14.40.709), which is almost certainly by the same work-
shop—incorporate many identical symbolic allusions (fig. 36).[1]

 The level of accomplishment of the weaver is evidenced by such
details as the translucent appearance of the glass on which the apple
rests, the subtleties of shading in Christ's hair and beard, and the
shimmering quality of the leaves of the trees in the background.
Because of the extraordinarily refined weaving of the silk and wool,

Figure 36. *The Infant Christ Pressing the Wine of the Eucharist.* South
Netherlandish, about 1500. Linen warp, with wool, silk, and gilt wefts. The
Metropolitan Museum of Art, New York. Bequest of Benjamin Altman,
1913 (14.40.709)

this hanging rivals contemporary paintings in the detail it achieves, while the extensive use of metallic threads provides a surface richness that is a distinctive characteristic of the textile medium. Tapestries of this type appear in the inventory of 1555 of the collection of Joan I, la Loca, Queen of Castile and Aragon—an indication of the Spanish royal taste for fine works of art from its Netherlandish territories.

B D B

1 Other tapestry hangings related in style and in metaphor are discussed in Wardwell, 1975, pp. 17–23.

EX COLLECTIONS: [French & Co., New York, by 1944]; Mena Rokhsar, Forest Hills Gardens, New York, after 1969.

EXHIBITION: "From Van Eyck to Bruegel: Early Netherlandish Painting in The Metropolitan Museum of Art," New York, The Metropolitan Museum of Art, September 22, 1998-January 3, 1999.

REFERENCES: Cavallo, 1993, pp. 336, 337, fig. 122; Boehm, 1995 a, p. 27, color ill.

283

MEMENTO MORI

South Lowlands (Brabant?), about 1500
Boxwood: Height, 2⁷⁄₁₆ in. (6.2 cm); depth, ¹¹⁄₁₆ in. (1.7 cm); width, ½–¹⁵⁄₁₆ in. (1.3–2.4 cm)
Gift of Ruth Blumka, in honor of Ashton Hawkins, 1985 (1985.136)

Among the more remarkable achievements of Late Gothic wood carving are miniature boxwood sculptures in the form of altarpieces and tabernacles, or of rosaries, prayer beads, and other objects of personal devotion, all executed with flawless precision in near-microscopic detail. This example takes the form of a casket, and is adorned with scenes and accompanying biblical inscriptions that tell the story of the rich man Dives, who refused succor to the poor Lazarus. His lack of charity on earth condemns Dives literally to roast in hell, for eternity—a fate graphically depicted on the object's interior.

T B H

EX COLLECTION: Ruth and Leopold Blumka, New York.

REFERENCE: Husband, 1986 b, p. 18, ill.

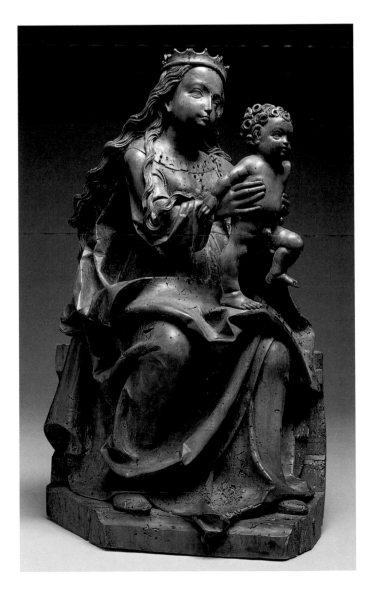

284

Attributed to the Master of Rabenden
VIRGIN AND CHILD, FROM A HOLY KINSHIP
GROUP

German (Upper Bavaria: the Chiemgau), about 1510–15
Linden wood, with traces of polychromy, 23⅜ x 13¾ x 9⁷⁄₁₆ in. (60 x 34.9 x 24 cm)
The Cloisters Collection, 1987 (1987.15)

The alluring charm, the sense of anticipation, and the arrested movement are key elements in the appeal of this delightful work, a fine example of the last phase of German Late Gothic sculpture. In keeping with this style is the contrast of an engagingly expressive naturalism in the fleshy portions of the composition with the drama

and agitation of deeply cut, massive drapery folds that take on a life of their own. Only in the bodice, shoulders, and knees is the natural form of the body of the Virgin revealed through the drapery.

Although the statue has lost most of its original polychromy and the identification of the larger altar shrine for which it was made is uncertain, it may be admired for its vivid animation and its sculptural authority. Not surprisingly, therefore, it is cited in the literature as the work of a major yet anonymous Upper Bavarian sculptor known as the Master of Rabenden, after an altarpiece on the high altar of Rabenden's parish church. Comparison with the details of certain early and mature sculptures by this master tends to confirm the attribution:[1] the slant of the eyes, and the pair of curved lines below; the smooth, full cheeks; the double chins; the downward curve of the fleshy lips; the two modes in the carving of the hair, in tight ringlets or in long, curvilinear strands; and the clear textural contrasts of the hair, flesh, and drapery. Also characteristic is the way the Virgin's fingers press subtly into the flesh of the nude body of the Christ Child, a feature known in South German sculpture since the late "Beautiful Style" of the first and second quarters of the fifteenth century, and which continued in the work of Nicolaus Gerhaert von Leiden, as already noted (see cat. no. 228). Just as important in this attribution is the overall dramatic effect and heightened expression that result from the balance of all the contrasting internal elements.

Details of attachment as well as the fact that both the Virgin and the Christ Child face a missing point of interest at the right lead to an assumption that a separately carved figure confronted the romping Child and his mother. That this was probably Saint Anne is proven by a replica of the entire group—larger, and lacking in quality, to be sure—preserved in the Church of Saint John at Erding.[2] In South Germany the Holy Kinship—in German, *Anna Selbdritt*, which refers to the three generations of the Holy Family—was a favored subject whose basis lay in the widespread devotion to Saint Anne encouraged by brotherhoods dedicated to her.

The Cloisters' group may have been part of a large altarpiece; because of its relatively small size, it probably belonged to the predella, or lower support section. Although the altar shrine at Rabenden has an empty cavity in its predella that would have accommodated such a work, only exact measurements of the cavity eventually may allow or preclude consideration of the group as originally having come from this context.

WDW

1 See Milliken, 1939, pp. 44–45, ill. p. 45, a *Pietà* of about 1515; Benker, 1977, p. 125, a *Saint Andreas* of 1513; Miller, 1983, figs. 9, 10.
2 See Rohmeder, 1971, no. B-8, p. 65, fig. 55; Wixom, 1989 a, p. 24, ill.

EX COLLECTIONS: Bayerisches Nationalmuseum, Munich, 1896–1965; [Galerie St. Raphael, Vienna].

REFERENCES: Graf, Hager, and Mayer, 1896, pp. 40–41; Halm, 1911, pp. 71, 72, 74, fig. 11; *idem*, 1927, pp. 54, 59, fig. 60; Rohmeder, 1971, no. A-19, p. 53, fig. 15; Wixom, 1987 c, p. 18, ill.; *idem*, 1989 a, p. 24, colorpl.

285

THE ADORATION OF THE MAGI, WITH SAINTS JOHN THE EVANGELIST AND CATHERINE OF ALEXANDRIA

German (Cologne), about 1510–15

Colorless glass, silver stain, and vitreous paint: Each, 14¾ x 12⅝ in. (37.5 x 32.1 cm)

Purchase, Bequest of Kate Read Blacque, in memory of her husband, Valentine Alexander Blacque, Bequest of Thomas W. Lamont and Gift of J. Pierpont Morgan, by exchange, and Rogers Fund, 1982 (1982.47.2,3a,b)

These panels, executed in Cologne but under the strong influence of the Lowlands, are thought to have been intended for a private chapel. The original ensemble would have comprised either four panels set horizontally across two double lancet windows, or one single four-light window: The panel with Saints John the Evangelist and Catherine (missing the upper-right quadrant); next, a panel with the Virgin and Melchior, along with one of the other two Magi; and a panel with two additional flanking saints. The housemark on the shield has not been identified.

Stylistically, these panels can be compared with a series of roundels (formerly in the Kunstgewerbemuseum, Berlin) representing scenes from the life of Saint Alexius, as well as with the early work of the Cologne painter Bartholomäus Bruyn and the early glazing of the cloister at Altenberg, where Bruyn may have worked. While colorless glass was standard in roundel production, its use in larger-scale panels appears to be exceptional among Cologne glass painters.

TBH

EX COLLECTION: [Galerie für Glasmalerei, Zurich].

EXHIBITION: "Herbst des Mittelalters, Spätgotik in Köln und am Niederrhein," Cologne, Kunsthalle, June 20–September 27, 1970, no. 88.

REFERENCES: von Euw and Rode, 1970, no. 88, p. 73, fig. 39 (central panel only); Hayward, 1982, pp. 22–24, ills. p. 23; *idem*, 1985, p. 140, ill.; Husband, 1995 a, p. 72, fig. 3.

286

PAX (*KUSSTAFEL*)

South German (Nuremberg?), about 1515–20

Silver, silver gilt, rock crystal, and rubies (or spinels): 6¼ x 4⅞ in. (15.9 x 12.4 cm)

Inscribed (on the crystal): *ihs*; (on the inside of the backplate): ANO•DOM•1•5•2•5•PER•IACO/BV̄•OSTROFZKI/ECLESYE: BLONENSI: COMPARAIVM:

Purchase, The Michel David-Weill Foundation Gift, 1992 (1992.57)

Unusually large and ornate, this pax is one of a surviving handful that are hexalobe in form. Engraved on the crystal is the monogram of Christ; engraved on the back is an image of the Virgin and Child flanked by Saint James the Greater and a female saint, perhaps Dorothea of Caesarea. Although intaglio engraving on rock crystal was known in the Middle Ages, extant examples are exceedingly rare.

The pax most likely originally contained an Agnus Dei wafer, but it is also possible that it subsequently was used to display a relic, which perhaps explains the rather crude holes at center left and right. The inscription on the inside of the backplate indicates that

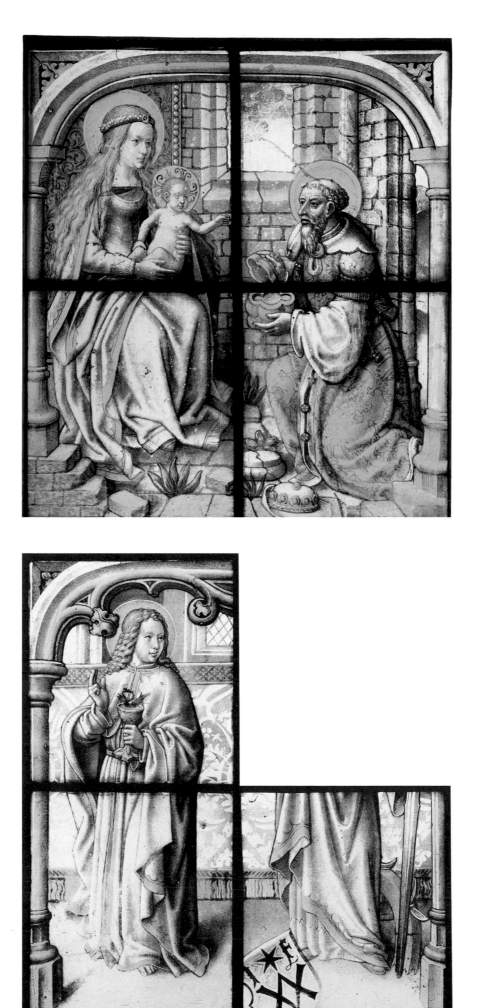

285

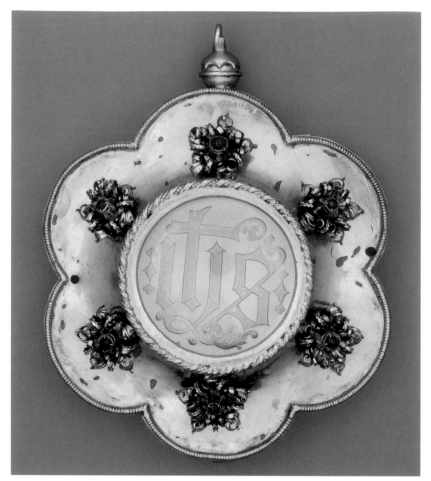

286

the pax was given to a church—probably the Church of the Holy Trinity—in Błonie, a town near Warsaw, by a certain Jacob Ostrofski in 1525, but as there is no reference to Błonie on the engraved heraldic device, it may well be that of Jacob Ostrofski himself.

The trade links between Nuremberg—where the pax may have been made—and Warsaw during the sixteenth century are well documented.

TBH

EX COLLECTIONS: [Martin Kübli Antiquitäten, Basel]; [Albrecht Neuhaus, Würzburg]; [Blumka Gallery, New York].

REFERENCES: *Orangerie '91*, 1991, p. 35; Husband, 1992 b, p. 23, colorpl.

287

Hans Leinberger (active 1510–30)

SAINT STEPHEN

South German (Lower Bavaria), about 1525–30

Linden wood, with traces of polychromy, 33 x 21½ x 8½ in. (83.8 x 54.6 x 21.6 cm)

Bequest of Gula V. Hirschland, 1980 (1981.57.2)

Saint Stephen is shown seated upon a low, partially draped, backless bench. He wears a deacon's dalmatic over a long tunic, and in his right hand he holds an open book supporting three rocks, the instruments of his martyrdom. Curvilinear locks of hair hang down almost to his shoulders, framing his high forehead and smoothly modeled, youthful face.

The work is carved from three pieces of wood: One was used

for the saint and the other two for the lateral extensions of the seat. The modeling is so convincing that, when viewed from the front, the figure—in fact, a sculpture in relief—appears to be rendered fully in the round. The statue is well preserved except for the loss of much of the original polychromy.

Attributed to one of the foremost Late Gothic sculptors of Lower Bavaria, Hans Leinberger of Landshut, this portrayal of Saint Stephen represented an especially welcome addition to the Museum's collection of German sculpture of the period. It is our only example of Leinberger's work and is particularly notable for the animated execution of drapery, which seems to have an internal life of its own as a result of the entrancing combination of deeply scalloped recesses, doughlike thickening of the outer ridges, broken connecting folds, and inexplicably swirling edges. This visual drama contrasts with the benign facial expression of the young saint.

The relief probably was once part of a series of seated figures of saints that may have included Saint Lawrence, another deacon saint often depicted together with Saint Stephen in Late Gothic art. Dr. Alfred Schädler has described the Museum's sculpture as a mature work by Leinberger, after comparing it with the sculptures from an altarpiece of about 1526–28 preserved in Polling.[1]

WDW

1 Letter from Dr. Alfred Schädler, dated June 5, 1998, in the Department of Medieval Art files.

EX COLLECTIONS: Private collection (Baron Kornfeld?), Budapest; [Georg Schuster, Munich]; Gula V. Hirschland, Weston, Connecticut.

REFERENCES: Bramm, 1928, pp. 169, 187; Müller, 1932, p. 286; Wixom, 1981, p. 30, ill.

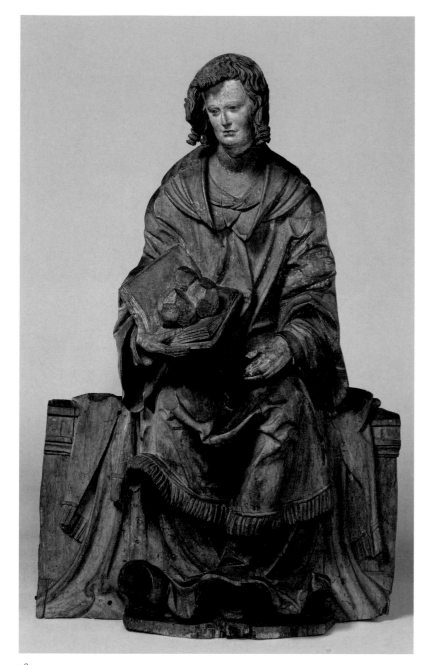

287

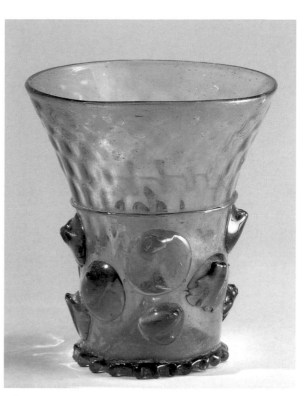

288

288

BEAKER

German (Lower Rhineland), early 16th century

Pattern-molded potash-lime glass, with applied decoration: Height, 3⁹⁄₁₆ in. (9 cm)

The Cloisters Collection, 1983 (1983.16)

The form of this beaker, which has a prunted cylindrical body and a conical bowl, ultimately derives from late-thirteenth-century Islamic drinking glasses. Such prototypes, whether they came directly from the Near East or from Italian sources strongly influenced by such Near Eastern types, must have been introduced into Germany by the early fourteenth century, where they rapidly were absorbed into local glass production. Examples of this early German vessel type are represented in fourteenth-century illuminated manuscripts, and continued with little change well into the fifteenth century; by the turn of the sixteenth century, however, accomplished glasshouses had developed more refined forms with contracted bodies that, in effect, served as stems, and with flared lips that evolved into conical bowls.

The sensitive proportions, graceful balance, and accomplished workmanship of this beaker make it a truly exceptional example of Late Gothic glass produced for domestic use, all the more unusual for its perfect state of preservation.

TBH

EX COLLECTIONS: William Cornwallis Cartwright (1830–1917), Aynhoe Park, Northampton, England; Elizabeth Cartwright, London, until 1975; [sale, Sotheby & Co., London, July 14, 1975, lot 265]; [Rainer Zietz Limited, London].

REFERENCE: Husband, 1983, pp. 24–25, color ill. p. 25.

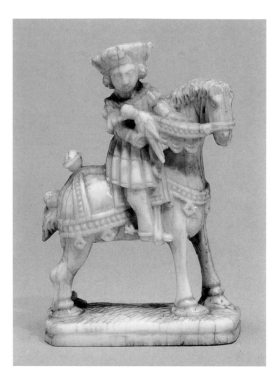

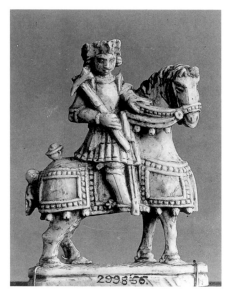

Figure 37. Chess piece. Netherlandish, 1st quarter of the 16th century. Elephant ivory. Victoria and Albert Museum, London

289

CHESS PIECE: A KNIGHT REPRESENTED AS A FALCONER

Netherlandish, first quarter of the 16th century
Elephant ivory, with traces of polychromy: Height, 2⅞ in. (7.3 cm); length, 1¹⁵⁄₁₆ in. (5 cm)
Pfeiffer Fund, 1984 (1984.214)

The diminutive knight is represented as an equestrian falconer, spurred and standing in his saddle, his falcon on his right hand. His horse, whose rear left leg is now almost completely broken away, is elaborately caparisoned, with a bell at the middle of his back.

The ivory undoubtedly is from the same workshop—and, arguably, from the same chess set—as three other knights: One, holding an ax, is in the Victoria and Albert Museum, London (fig. 37); another is in the British Museum, London;[1] and a third belongs to the Bayerisches Nationalmuseum, Munich. Comparisons of costume details seen in tapestries and manuscript illuminations support a date in the first quarter of the sixteenth century and a Netherlandish origin for all four ivories. Particularly striking is the similarity in the type of hat, skirt, and horse trappings depicted in a series of four tapestries that originated in Tournai about 1515.[2]

Traces of red polychromy remain in the incised areas of the chess piece. In the Middle Ages, as today, color was used to distinguish between opposing chessmen on a board, but the knights in a set sometimes were further differentiated by being shown in either a warlike or hunting guise.[3]

BDB

1 See Wichmann and Wichmann, 1964, no. 84, ill.; Dalton, 1909, no. 494, pl. CXVI; Berliner, 1926, no. 65, p. 23. I am indebted to Paul Williamson, keeper of sculpture, Victoria and Albert Museum, London, for the reference to the Munich ivory. The chess pieces in London were acquired in the mid-nineteenth century.
2 See Boccara, 1971, nos. 30–32, ill., no. 33, colorpl.
3 I am grateful to Dr. Helmut Nickel, curator emeritus, Department of Arms and Armor, at The Metropolitan Museum of Art for this suggestion.

EX COLLECTIONS: [sale, Sotheby Parke Bernet, London, March 18, 1976, lot 16]; [Ellin Mitchell, New York].

290

FIVE HERALDIC ROUNDELS

German (Middle Rhineland), about 1500
Pot-metal and colorless glass, with vitreous paint: Diameter, each (approx.), 9½ in. (24.1 cm)
The Cloisters Collection, 1980 (1980.214.1-5)

These five roundels, together with a sixth that is now in the Rheinisches Landesmuseum, Bonn,[1] were installed, in the nineteenth century, in the transom over the main door of the Niederburg, a castle in Gondorf, north of Trier; their earlier provenance, however, is unknown. Only the Bonn roundel retains part of its inscribed border, which identifies the heraldic device as that of a certain Hans Achtermann.

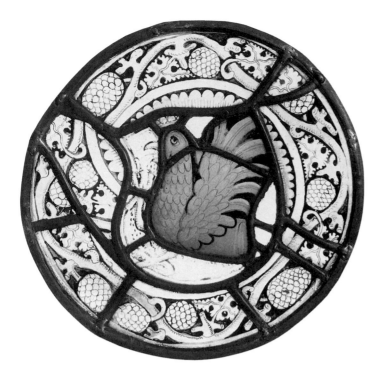

Figure 38. Robert Campin. *The Annunciation* triptych *(Merode Triptych)* (detail of the central panel). About 1425–30. Oil on wood. The Metropolitan Museum of Art, New York. The Cloisters Collection, 1956 (56.70)

The other five roundels are now set into the transoms of the windows in the Campin Room at The Cloisters. Comparable heraldic glass correspondingly appears in the central panel of Robert Campin's *Annunciation* triptych *(Merode Triptych;* see fig. 38), the centerpiece of this gallery.

T B H

1 See Bremen, 1964, no. 20, pp. 34–35.

EX COLLECTIONS: Baroness Angelica von Liebieg, Gondorf, Germany; [Galerie für Glasmalerei, Zurich].

REFERENCES: Hayward, 1981 b, p. 29, ill. (1980.214.1); *idem*, 1985, p. 135, ills.

291

After Hans Leonhard Schäufelein (1480/85–1538/39)

CHRIST TAKING LEAVE OF HIS MOTHER

South German, 1507–about 1515

Colorless glass, silver stain, and vitreous paint: Diameter, 6½ in. (16.5 cm)

Gift of Dr. Louis R. Slattery, in honor of Ashton Hawkins, 1985 (1985.146)

The composition is based on one wood block from a series of thirty designed by Hans Leonhard Schäufelein, illustrating the Passion of Christ (fig. 39); it was published by Ulrich Pinder in the 1507 Nuremberg edition of the *Speculum Passionis Domini nostri Jhesus Christi.* Schäufelein returned to this subject a number of times, producing at least three pen-and-ink versions. Another, more simplified variation formed part of a series of woodcut illustrations for a devotional book of about 1512.

While a lost design is not out of the question, it is more probable that the roundel is based on the 1507 woodcut and that the

composition was altered by the glass painter at the bench; this supposition is corroborated by the fact that an inscribed circle on the woodcut, 14 centimeters in diameter, edits the scene to the form that appears on the roundel. The verve and linear clarity of the painting further suggest that the roundel was executed at an early date by a workshop associated with Schäufelein.

TBH

EX COLLECTIONS: Sibyll Kummer-Rothenhäusler, Zurich; Ruth Blumka, New York.

EXHIBITIONS: "Songs of Glory, Medieval Art from 900–1500," Oklahoma City, Oklahoma Museum of Art, January 22–April 29, 1985, no. 116; "Northern Renaissance Stained Glass: Continuity and Transformations," Worcester, Massachusetts, Iris and B. Gerald Cantor Art Gallery, College of the Holy Cross, February 2–March 8, 1987, no. 24.

REFERENCES: *Songs of Glory*, 1985, no. 116, p. 297, ill.; Husband, 1987 a, no. 24, p. 61, ill.; *idem*, 1990 a, pp. 84–87, fig. 54 (color); *idem*, 1991 a, p. 137, ill.

292

THE CORONATION OF THE VIRGIN

South Lowlands, about 1500

Pen and ink, with wash, on paper: Diameter of the image (approx.), 8 in. (20.3 cm)

Gift of Sibyll Kummer-Rothenhäusler, 1982 (1982.191)

Designs for silver-stained roundels frequently were copied in glass-painting workshops for use at the bench, thus preserving the original drawing. Such working designs, of which this is an example, were reduced to their linear essentials, and rarely reveal any traces of modeling, alteration, or reworking.

TBH

EX COLLECTION: Sibyll Kummer-Rothenhäusler, Zurich.

Figure 39. Hans Leonhard Schäufelein. *Christ Taking Leave of His Mother.* 1507. Woodcut. From the *Speculum Passionis Domini nostri Jhesus Christi* (Nuremberg, 1507)

294

293

SAINT MARK

North Lowlands, about 1500

Colorless glass, silver stain, and vitreous paint. Diameter, 9¼ in. (23.5 cm)

The Cloisters Collection, 1980 (1980.223.1)

The Evangelist, shown writing on a scroll, is identified by his attribute, a lion, seen reposing at his feet. The fact that Saint Mark, conventionally represented barefoot, is depicted wearing sandals may indicate that this roundel was intended for a guildhall of shoemakers, of whom he was the patron saint.

TBH

EX COLLECTION: [Bresset Frères, Paris].

REFERENCES: Hayward, 1981 b, p. 30; Kleinbauer, 1982, p. 78, fig. 16; Husband, 1991 a, p. 138, ill.

294

After a Composition by the Workshop of Dieric Bouts

THE DESCENT OF THE DAMNED

South Lowlands (Leuven?), about 1500/1510

Colorless glass, silver stain, and vitreous paint: Diameter, 8½ in. (21.6 cm)

The Cloisters Collection, 1990 (1990.119.2)

Although the roundel does not rely on a specific design, elements of the composition were freely adapted from several works by Dieric Bouts or his workshop (see fig. 40). This cobbling together of a composition from available models strongly suggests that the design for this roundel was, in fact, generated in Bouts's workshop or a closely related one. Bouts's painted-panel version of this subject is paired with another representing *The Terrestrial Paradise*; a later copy has

Figure 40. Dieric Bouts. *The Descent into Hell.* About 1470. Tempera and oil on panel. Musée des Beaux-Arts, Lille

these two panels flanking a central *Last Judgment.* This arrangement reflects the widely held belief that immediately after death each individual had to submit to a personal reckoning and was then dispatched, depending on his merits or lack thereof, to a place of torment or bliss where the Last Judgment was awaited. The theme also found expression in deathbed scenes—exemplified by woodblock versions of the *Ars moriendi,* a popular and widely circulated text in the latter half of the fifteenth century—which show a dying man in bed confronting alternate visions of the imminent destiny of his soul.

This roundel may have been part of an analogous triad, along with images of Paradise and a deathbed scene, of which models abound.[1] Such a "triptych" glazed into the windows of a private chamber would serve as a daily reminder of the transience of worldly existence, which was viewed as mere preparation for eternal life after death, either in Heaven or hell. Whatever the original context, the composition was apparently very popular, as a number of close versions are known.[2]

TBH

1 For example, the illumination for the Office of the Dead in the *Sforza* or *Black Hours* (Österreichisches Nationalbibliothek, Vienna). For a full discussion see Husband, 1995 a, p. 83.
2 See, for instance, 32.24.43, in The Cloisters Collection. See Husband, 1991 a, p. 142; for further examples see Husband, 1995 a, p. 83.

EX COLLECTION: [Galerie für Glasmalerei, Zurich].

EXHIBITION: "The Luminous Image: Painted Glass Roundels in the Lowlands, 1480–1560," New York, The Metropolitan Museum of Art, May 23–August 20, 1995, no. 26.

REFERENCES: Husband, 1991 a, p. 142, ill.; *idem,* 1995 a, no. 26, pp. 81–84, ill. p. 81.

295

JUSTICE

North Lowlands, about 1510

Colorless glass, silver stain, and vitreous paint: Diameter, 8⅞ in. (22.5 cm)

The Cloisters Collection, 1983 (1983.418)

A satisfactory interpretation of the subject of this roundel has yet to be offered, although there appears to be a correlation between the double-bladed sword of Justice and the two conditions—rich and poor—of the prisoners being ushered away. The discovery of other roundels from the same series might eventually lead to a proper identification of the narrative.

TBH

EX COLLECTION: [Galerie für Glasmalerei, Zurich].

REFERENCES: Husband, 1984, p. 19, ill.; *idem,* 1991 a, p. 139, ill.

295

296

296

ALLEGORICAL FIGURE

South Lowlands, about 1510–15

Colorless glass, silver stain, and vitreous paint: Diameter, 8¾ in. (22.2 cm)

The Cloisters Collection, 1988 (1988.304.2)

The imposing woman depicted here, dressed in an elaborate costume and holding a distaff, cannot be taken to be an ordinary housewife, much less a goatherd. Indeed, the crook lying on the ground provides a distinct visual separation between the figure and the goats in the middle ground. While, during the Middle Ages, the distaff was variously understood to symbolize domesticity, vile temper, witchcraft, and sexual concupiscence, the specific allegorical meaning of this scene, as a whole, remains enigmatic.

The figure's weighty form and bold modeling, along with her fleshy face and long, curling tresses, recall the style of the South Lowlands painter Jan Gossaert (about 1478–1532).

TBH

EX COLLECTIONS: James Rawlings Herbert Boone, Baltimore; Oak Hill House, Johns Hopkins University, Baltimore; [sale, Sotheby's, New York, November 22 23, 1988, lot 66].

REFERENCES: Husband, 1989, p. 18, ill.; *idem*, 1991 a, p. 147, ill.

297

297

THE AGONY IN THE GARDEN

North Lowlands, about 1515

Colorless glass, silver stain, and vitreous paint: Diameter, 8¾ in. (22.2 cm)

The Cloisters Collection, 1988 (1988.304.1)

The composition of this roundel is close to that of *Christ on the Mount of Olives* from the circular Passion series of 1512 by Jacob Cornelisz. van Oostsanen (fig. 41), although in reverse. The figures are disposed in a slightly different manner, but their relationship to the capacious landscape is generally the same. The compositional formula was conventionalized, and can, in fact, be traced back to Martin Schongauer and, ultimately, Jan van Eyck; it was followed by Albrecht Dürer in all three of his graphic versions of the scene. The designer of the present roundel was certainly aware of these earlier versions, as quotes from them are evident.

TBH

EX COLLECTIONS: James Rawlings Herbert Boone, Baltimore; Oak Hill House, Johns Hopkins University, Baltimore; [sale, Sotheby's, New York, November 22–23, 1988, lot 60].

EXHIBITION: "The Luminous Image: Painted Glass Roundels in the Lowlands, 1480–1560," New York, The Metropolitan Museum of Art, May 23–August 20, 1995, no. 18.

REFERENCES: Husband, 1991 a, p. 136, ill.; *idem*, 1995 a, no. 18, pp. 72–73, ill. p. 72.

Figure 41. Jacob Cornelisz. van Oostsanen. *Christ on the Mount of Olives.* 1512. Woodcut. The Metropolitan Museum of Art, New York. The Elisha Whittelsey Collection, The Elisha Whittelsey Fund, 1949 (49.95.19)

298

JOAB MURDERING ABNER

North Lowlands (Amsterdam?), 1510–20

Colorless glass, silver stain, and vitreous paint: Diameter, 8½ in.
(21.6 cm)

The Cloisters Collection, 1984 (1984.206)

This dramatic scene may represent Joab murdering Abner, as relat-
ed in 2 Kings 3: 27: "And when Abner was returned to Hebron, Joab
took him aside to the middle of the gate, to speak to him treacher-
ously: and he stabbed him there in the groin, and he died." This
event was understood as an antitype to the Betrayal of Christ, and
it appears, for instance, in the *Biblia pauperum* block book, first pub-
lished in the Lowlands about 1460. The deliberate gaze of Joab and
the uplifted head and desperate hand gestures of Abner, all rendered
in brooding tones, give the scene a psychological intensity that
underscores the moral repugnance of the treacherous murder.

TBH

EX COLLECTIONS: F. E. Sidney, Holly House, Hampstead, England; [sale,
Christie, Manson & Woods, London, December 9, 1937, lot 52, 53, or 75, p. 10
or 12]; Maurice Drake, London; [Pieter de Boer, Amsterdam]; [Kunstzalen
A. Vecht, Amsterdam].

EXHIBITIONS: "Northern Renaissance Stained Glass: Continuity and Trans-
formations," Worcester, Massachusetts, Iris and B. Gerald Cantor Art Gallery,
College of the Holy Cross, February 2–March 8, 1987, no. 26; "The Lumi-
nous Image: Painted Glass Roundels in the Lowlands, 1480–1560," New York,
The Metropolitan Museum of Art, May 23–August 20, 1995, no. 101.

REFERENCES: Rackham, 1929, p. 14, fig. 2; *Journal of Glass Studies*, 1985, ills.,
cover and frontispiece; Husband, 1987 a, no. 26, pp. 64–65, ill.; *idem*, 1991 a,
p. 144, ill.; *idem*, 1995 a, no. 101, pp. 178–79, ill. p. 178.

299

THE BLINDING OF ZALEUCUS OF LOCRIA

South Lowlands (Leuven), about 1510–20

Colorless glass, silver stain, and vitreous paint: Diameter, 8¾ in.
(22.2 cm)

The Cloisters Collection, 1991 (1991.291.1)

In an effort to curb the licentious behavior of his subjects, Zaleucus,
governor of the province of Locria in western Anatolia, issued an
edict that threatened adulterers with punishment by blinding in
both eyes. Soon after, his own son—seen in the background with

299

300

the object of his lust—was brought up on charges. In order to save one of his son's eyes, Zaleucus offered to have his own eye put out, thus sparing the young man total blindness.

The broad heads, with their large, dark eyes, and the slender figures' draperies, which fall in expansive soft folds, as well as the softly modeled paint, are characteristic of the Leuven style of glass painting.

TBH

EX COLLECTIONS: Dr. Johann Heinrich Angst, Zurich; Engel-Gros, Paris; [sale, Hôtel Drouot, Paris, December 7, 1922, lot 22]; [Galerie für Glasmalerei, Zurich].

300

SUSANNA IN JUDGMENT

South Lowlands, 1510–20
Colorless glass, silver stain, and vitreous paint: Diameter, 8⅝ in. (21.9 cm)
The Cloisters Collection, 1984 (1984.339)

The composition of this roundel, a close version of that of another example long in the Museum's collection,[1] reveals the variety of techniques employed by glass painters following the same design. Various components of the scene, such as the seated dog and the two men at the right, appear in contemporary roundels, sometimes incorporated into compositions of completely different subjects— an indication of the degree to which designs often were cobbled together from the supply available in model books (see fig. 42).[2]

TBH

1 Acc. no. 32.24.56. See Husband, 1991 a, p. 147, ill.
2 See Husband, 1995 a, p. 63, fig. 9, p. 70, figs. 4, 5.

EX COLLECTION: [Galerie für Glasmalerei, Zurich].

REFERENCES: Husband, 1991 a, p. 148, ill.; *idem*, 1995 a, p. 63, fig. 10.

Figure 42. *Susanna in Judgment.* About 1510–20. Colorless glass with silver stain and vitreous paint. The Metropolitan Museum of Art, New York. The Cloisters Collection, 1932 (32.24.56)

301

THE CARRYING OF THE CROSS, WITH SAINT VERONICA

South Lowlands (Antwerp), about 1520
Colorless glass, silver stain, and vitreous paint: Diameter, 8⅝ in.
(21.9 cm)
Inscribed (on Simon's sleeve): IOCHET
The Cloisters Collection, 1980 (1980.223.2)

This densely populated scene, which includes the Virgin Mary; John the Evangelist; Saint Veronica holding the vernicle, or cloth, with the *vera icon*; Simon of Cyrene supporting the base of the cross; as well as a complement of Roman soldiers, descends from Middle Rhenish compositions of about a century earlier. The soldier at the right, in an extreme contrapposto, reflects the strong influence of Antwerp Mannerism, a style much in vogue during the first quarter of the sixteenth century.

 TBH

EX COLLECTION: [Bresset Frères, Paris].

REFERENCE: Husband, 1991 a, p. 157, ill.

302

THE SACRIFICE IN THE TEMPLE

South Lowlands, 1515–25
Colorless glass, silver stain, and vitreous paint: Diameter, 9 in.
(22.9 cm)
The Cloisters Collection, 1980 (1980.223.5)

The subject of this roundel has never been identified satisfactorily. The figure of God the Father who appears in the flames of the sacrificial fire on the altar has no literal source in the Bible.

 TBH

EX COLLECTION: [Bresset Frères, Paris].

REFERENCE: Husband, 1991 a, p. 155, ill.

303

After a Design by the Pseudo-Ortkens Workshop

SUSANNA AND THE ELDERS

South Lowlands (Antwerp or Brussels), about 1520–25

Colorless glass, silver stain, and vitreous paint: Diameter (with border), 13 in. (33 cm)

Inscribed (around the border): *Susanna et · / Exarserūt senes / in cōcupiscentiā / declinaverūt ocu / los suos ut nō vidē / rēt celū daniel 13* ("Susanna went in, and walked in her husband's orchard . . . and they [the Elders] were inflamed with lust towards her . . . and turned away their eyes that they might not look unto heaven. . . ." Daniel 13: 7–9)

The Cloisters Collection, 1990 (1990.119.1)

The composition is a variant of one originated by the Pseudo-Ortkens Workshop in Brussels that was widely reproduced. This large workshop, which probably was under the direction of members of the van Orley family, produced designs for glass and tapestries.

The roundel is exceptional in that it retains its original border with the appropriate, if much excised, text from the Book of Daniel. While there is little question that roundels initially were set within borders—whether inscribed, ornamented, or of undecorated

colored glass—very few of these borders have survived, as they were inevitably destroyed when the roundels were removed from their original glazings.

The story of Susanna, perhaps the most ancient one to contrast the corrupt and false application of the law with its wise and just administration, clearly held great resonance for a people whose social and economic well-being depended on just governance. The theme assumed greater importance for Humanist thinkers with the increasing inability of religious authority to maintain social tranquillity.

TBH

EX COLLECTION: [Galerie für Glasmalerei, Zurich].

EXHIBITION: "The Luminous Image: Painted Glass Roundels in the Lowlands, 1480–1560," New York, The Metropolitan Museum of Art, May 23–August 20, 1995, no. 65.

REFERENCES: Husband, 1991 a, pp. 156–57, ill.; *idem*, 1995 a, no. 65, pp. 140–41, ill. p. 141, colorpl. cover.

304

THE MARTYRDOM OF SAINT JAMES INTERCISUS

North Lowlands (Leiden), about 1520

Colorless glass, silver stain, and vitreous paint: Diameter, 8¾ in. (22.2 cm)

The Cloisters Collection, 1991 (1991.291.2)

Saint James Intercisus ("chopped to pieces") enjoyed the favor of the Persian king Yazdigerd I during the early fifth century. Because of his friendship with the king and the honors and wealth bestowed upon him, James abandoned his Christian belief during the persecutions in about 420. When Yazdigerd died, James's mother and wife wrote to him, rebuking him for his faithlessness. Taking their admonitions to heart, James renounced all his honors and ceased to appear at court. The new king, Bahrām, decided that for such ungratefulness James deserved a painful and lingering death. Unless James renounced Christ, he would be slowly dismembered, joint by joint, starting with his fingers. As James refused to recant, the executioners proceeded with their work until James was a limbless trunk. He was still praising God when his head was finally severed.

The roundel is painted in unusually dark and dense tones, providing a suitably somber atmosphere for this gruesome scene.

т в н

EX COLLECTION: [Galerie für Glasmalerei, Zurich].

EXHIBITION: "The Luminous Image: Painted Glass Roundels in the Lowlands, 1480–1560," New York, The Metropolitan Museum of Art, May 23–August 20, 1995, no. 23.

REFERENCE: Husband, 1995 a, no. 23, p. 78, ill.

305

JUDGMENT OR ALLEGORICAL SCENE

South Lowlands (Brussels?), about 1520

Colorless glass, silver stain, and vitreous paint: Diameter, 9¼ in. (23.5 cm)

The Cloisters Collection, 1992 (1992.412)

The scene depicted in this roundel has so far defied identification. The elegantly dressed young man in the right foreground appears to be tipping a balance with the coins he is drawing from his purse, while a similar coin purse is being held by the bearded man behind the parapet in the background. The seated figure holds the scale as well as the sword of judgment. One of the several witnesses gestures toward the spectacle unfolding before him. Whatever the subject, it appears to have been a popular one, as a number of roundels based on the same composition have survived. The workshop that produced these roundels apparently employed model books in developing its designs, as evidenced by the figure in the left foreground (seen from the back in a three-quarter view), who is shown almost identically in several completely different scenes.

т в н

EX COLLECTION: [Galerie für Glasmalerei, Zurich].

REFERENCES: Husband, 1993, p. 25, ill.; "Principales Acquisitions," 1994, p. 48, fig. 212.

306

SAINT JEROME IN HIS STUDY

South Lowlands, about 1520

Colorless glass, silver stain, and vitreous paint: Diameter, 9 in. (22.9 cm)

The Cloisters Collection, 1988 (1988.304.3)

As is often the case, three incidents are compressed into the composition of this roundel: The principal scene shows Jerome as the learned Church Father, in his study, accompanied by the devoted lion out of whose paw he extracted a thorn. The episode taking place through the window at the left is unaccounted for in *The Golden Legend*, but perhaps it occurred during Jerome's trip from Rome to Jerusalem; through the window at the right Jerome can be seen doing penance in the wilderness. Stylistically, this roundel can be associated with the so-called Pseudo-Ortkens Master, who probably was not an individual at all, but a large Brussels workshop—possibly under the direction of Valentijn van Orley and his son Everaert—that produced designs principally for tapestries, as well as for roundels and other stained glass (see cat. no. 303).

TBH

EX COLLECTIONS: James Rawlings Herbert Boone, Baltimore; Oak Hill House, Johns Hopkins University, Baltimore; [sale, Sotheby's, New York, November 22–23, 1988, lot 69].

REFERENCE: Husband, 1991 a, p. 158, ill.

307

DELILAH CUTTING THE HAIR OF SAMSON

North Lowlands, about 1520–25

Colorless glass, silver stain, and vitreous paint: Diameter, 9⅜ in. (23.8 cm)

The Cloisters Collection, 1980 (1980.223.3)

In addition to the principal scene, this roundel also represents, at the left, Samson at the Gates of Gaza, and, at the right, Samson Slaying the Nemean Lion. The trellis behind the central group compositionally isolates the three scenes.

TBH

EX COLLECTION: [Bresset Frères, Paris].

REFERENCES: Hayward, 1981 b, p. 30; Husband, 1991 a, p. 153, ill.

308

ALLEGORICAL SCENE: BOOK BURNING

North Lowlands, about 1520–30

Colorless glass, silver stain, and vitreous paint: Diameter, 8⅜ in. (21.3 cm)

Inscribed: OLIM GRATVS ERAM ("Once I was revered")

The Cloisters Collection, 1992 (1992.415)

Whether this roundel was inspired by a particular incident of book burning or another form of censorship is uncertain, but it does speak to the turmoil and controversy fomented during the period of Humanism and reform in the Lowlands. The figure's exotic, hooded costume may be a reference to false wisdom or charlatanism.

TBH

EX COLLECTION: [Blumka Gallery, New York].

309

After a Design by Jörg Breu the Elder (1475/76–1537)
THE PLANET VENUS AND HER CHILDREN

German (Augsburg), about 1520–30

Colorless glass, silver stain, and vitreous paint: Diameter, 8 in. (20.3 cm)

Inscribed: VENVS

The Cloisters Collection, 1995 (1995.397)

A group of fifteenth-century illustrated poetic texts, loosely based on Late Antique astrological manuals, detailed the characteristics of the "children" of the seven planets (Saturn, Jupiter, Mars, Venus, Mercury, Sol, and Luna, as they were thought to be), which reflected the influence of the planet in whose house they were born. The imagery of our roundel gives Northern Renaissance expression to this popular medieval theme, and, compositionally, is related to some earlier

fifteenth-century forerunners in the form of wood-block books and manuscript illuminations (see fig. 43). Here, with Eros poised at the front of her eagle-drawn barouche, Venus rides across the sky over those on whose "humors" or temperaments—and even professions—she exerts an effect. Moralists regarded Venus as the personification of both physical and spiritual love, and, thus, of the resulting metaphysical conflict between body and soul. In the present representation, however, to judge from the bathhouse scene, her powers appear to lie largely in the sensual realm. While no preparatory design for this roundel is known, similarities to Breu's distinctive style are unmistakable.

TBH

EX COLLECTION: [Galerie für Glasmalerei, Zurich].

REFERENCE: Husband, 1996, p. 20, color ill.

Figure 43. *The Planet Venus and Her Children.* South Lowlands, about 1460–70. Wood-block illustration. Det Kongelige Bibliotek, Kobberstiksamlingen, Copenhagen

310

THE TEMPTATION OF SAINT ANTHONY

German (Swabia), dated 1532

Colorless glass, silver stain, and vitreous paint: Diameter, 8 in. (20.3 cm)

Inscribed (around the border): *Martinus Widman Pfarrer Cappel ·* 1532 · ("Martin Widman parish vicar at Cappel. 1532."); dated (bottom right): 1532

The Cloisters Collection, 1982 (1982.433.5)

Saint Anthony's test of faith at the hands of a clutch of demons is represented here in a charming, if somewhat naïve, Late Gothic style. The saint, dressed as an abbot, holds a crosier terminating in a tau cross and a mendicant's bell, and is surrounded by fantastical beasts. The inscription suggests that the roundel was a donation by a local priest, who is seen kneeling, next to his coat of arms, before the saint.

This roundel is stylistically consistent with other works known to have originated in the Allgäu district of southern Germany—

specifically, in the village of Kappel, which belongs to the parish of Pfronten and is situated southeast of Kempten (Swabia).

TBH

EX COLLECTION: [Galerie für Glasmalerei, Zurich].

REFERENCES: Husband, 1983, p. 25, ill.; *idem*, 1991 a, p. 167, ill.

311

After a Design by Augustin Hirschvogel (1503–1553)

NETTING QUAIL

German, 16th century

Colorless glass, silver stain, vitreous paint, and cold enamel: Diameter, 9½ in. (24.1 cm)

The Cloisters Collection, 1979 (1979.185)

(illustration on following page)

311

312

Concealed behind a blind painted with an image of a cow, the bird catcher depicted here attempts to trap a covey of unsuspecting quail. Hunter and birds alike appear unaware of an additional threat in the form of a fox stealthily emerging from his lair. This anecdotal scene is one of an extensive series by Augustin Hirschvogel, executed in both circular and rectangular format, representing the various methods of hunting a large variety of birds and animals. While few roundels from the series have survived, many of their compositions are known from twenty-five drawings—including the one upon which this roundel is based—which are now in the Szépmüvészeti Múzeum, Budapest.[1] Although none of the surviving roundels has a known provenance, the subjects of this series would have been appropriate for the glazing of the windows of a hunting lodge or of the manor of a landed estate.

TBH

1 See Schwarz, 1917, pp. 67–79, 171–72. See also Peters, 1979, pp. 367–75, figs. 12–29 (fig. 16 illustrates the drawing upon which this roundel is based); and *idem*, 1980, pp. 79–92.

EX COLLECTION: [Edward R. Lubin, New York].

REFERENCES: Hayward, 1981 b, p. 29; Kleinbauer, 1982, p. 79, fig. 19; Husband, 1991 a, p. 167, ill.

After the Monogrammist SZ, Based on a Composition by Jörg Breu the Elder (1475/76–1537)

ARCHITECTURA, FROM A SERIES OF THE *SEPTEM ARTES MECHANICAE*

German (Augsburg), after 1563

Colorless glass, silver stain, and vitreous paint: Diameter, 8¾ in. (22.2 cm)

Inscribed (on the plaque): ARCHIE/CTVRA

The Cloisters Collection, 1979 (1979.186)

When it was acquired, this roundel was dated about 1520 and, on stylistic grounds, was thought to preserve a lost composition by Jörg Breu the Elder from a series of the Seven Mechanical Arts. That the artist addressed the theme is evidenced by a presumed autograph drawing of "Coquinaria" (Culinary Arts), now in the Staatliche Graphische Sammlung, Munich.[1] Since then, four pot-metal roundels, representing "Milicia" (Military Arts), "Vestiaria" (Art of Weaving), "Mercatura" (Mercantile Arts), and "Venacio" (Art of Hunting), clearly based on the same series of designs as the present roundel, have surfaced in Dresden;[2] "Mercatura" has an unidentified housemark and is dated 1562. Four designs from the same series are in the Graphische Sammlung Albertina, Vienna;[3] two correspond precisely to the Dresden roundels, while another is unmistakably the design for the Cloisters' roundel (fig. 44) and even repeats the

misspelling of "Archiectura" (Architectural Arts). "Mercatura" in the Vienna series bears the same housemark as the corresponding Dresden roundel but, additionally, is monogrammed SZ and is dated 1563, which raises the question of how one relates to the other. The Vienna drawing, nonetheless, establishes a post quem date for our roundel. The later date notwithstanding, the Cloisters' roundel remains of value to the Museum's collections as an example of the influence of Jörg Breu the Elder, in particular, and of the dissemination of popular designs, in general. The unusual use of green opaque enamel on the roundel is of technical interest as well.

TBH

1 Inv. no. 19441. See Biedermann, 1980, vol. 2, no. 606, p. 227, ill. A roundel based on this drawing is in the Victoria and Albert Museum, London (Inv. no. 604-72).
2 Staatliche Kunstsammlungen, Historisches Museum (Inv. nos. A 156, A 153, A 168, and A 165); see Morrall, 1994, pp. 143–44, fig. 11; Dormeier, 1994, p. 155, fig. 5.
3 These are "Vestiaria," "Metalaria," "Archiectura," and "Mercatura" (Inv. no. 13.255-258).

EX COLLECTIONS: Lewis V. Randall, Toronto; [Blumka Gallery, New York].

REFERENCES: Hayward, 1981 b, p. 30; Husband, 1991 a, p. 171, ill.; Morrall, 1994, pp. 142–44, fig. 9.

312

Figure 44. Monogrammist SZ. *Architectura*, from a series of the *Septem Artes Mechanicae*. 1563. Pen and ink, with gray wash, on paper. Graphische Sammlung Albertina, Vienna

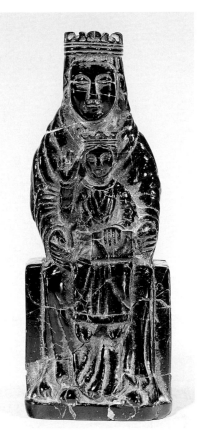

313

ENTHRONED VIRGIN AND CHILD

Spanish (Santiago de Compostela), 16th century(?)
Jet, with traces of gold: Height, 6¾ in. (17.1 cm)
The Jack and Belle Linsky Collection, 1982 (1982.60.400)

Jet is a deep-black lignite substance of organic origin found abundantly in northwestern Spain. It was used to make all kinds of objects related to Saint James the Greater, including statuettes and even amulets, which were purchased by the pilgrims who visited the tomb of the apostle. By the fifteenth century, the fraternity of jet carvers was extremely well organized, and their products were widely distributed as a result of the pilgrimages. The jet industry became rather standardized from the fifteenth century on, and the carvers used models from earlier periods instead of creating new ones, which caused a decline in quality. Iconographically, this statuette of the Virgin and Child corresponds to a Romanesque type, but the style and, above all, the coat of arms and the angels carved on the throne indicate a date no earlier than the sixteenth century.

Because of the extreme brittleness of jet, comparatively little has survived in that medium from Compostela, and what has is widely dispersed. The most comprehensive collection of jet is in the Museo Municipal, Pontevedra, also in the Galician region and not far from Compostela.

CG-M

EX COLLECTION: Jack and Belle Linsky, New York.

EXHIBITION: "Medieval Art from Private Collections," New York, The Cloisters/The Metropolitan Museum of Art, October 30, 1968–January 5, 1969, no. 220.

REFERENCES: Gómez-Moreno, 1968, no. 220, ill.; *idem*, 1984 a, no. 53, p. 136, ill.

Selected Bibliography

Albertoni, 1993
Margherita Albertoni, "Lastrine di rivestimento dall'antica via di Porta San Lorenzo," *Bullettino della Commissione archeologica comunale di Roma* 94 (1991–92; published 1993), pp. 341–92.

Alföldi-Rosenbaum and Ward-Perkins, 1980
Elisabeth Alföldi-Rosenbaum and John Ward-Perkins, *Justinianic Mosaic Pavements in Cyrenaican Churches* (Monografie di archeologia libica, 14), Rome, 1980.

Aliénor d'Aquitaine, 1976
Aliénor d'Aquitaine et son temps (exhib. cat.), Poitiers, Musée Municipal, 1976.

Almagro Basch, 1947
Martín Almagro Basch, "Materiales visigodos del Museo Arqueológico de Barcelona," *Memorias de los museos arqueológicos provinciales* 8 (1947), pp. 56–76.

Andreescu-Treadgold, 1992
Irina Andreescu-Treadgold, "The Early Byzantine Reliquary Discovered at Torcello," *Venezia arti* 6 (1992), pp. 5–13.

Armstrong, 1997
Pamela Armstrong, "Byzantine Glazed Ceramic Tableware in the Collection of The Detroit Institute of Arts," *Bulletin of The Detroit Institute of Arts* 71, nos. 1 and 2 (1997), pp. 4–15.

Arrhenius, 1965
Birgit Arrhenius, "Casting," in *Golden Age and Viking Art in Sweden*, Stockholm, 1965, pp. 13–15.

Arrhenius, 1985
Birgit Arrhenius, *Merovingian Garnet Jewellery: Emergence and Social Implications*, Stockholm, 1985.

Arrhenius, 1990
Birgit Arrhenius, "Die Schraube als Statussymbol: Zum Technologietransfer zwischen Römern und Germanen," in Birgit Arrhenius et al., *Frankfurter Beiträge zur Mittelalter-Archäologie II* (Schriften des Frankfurter Museums für Vor- und Frühgeschichte, Archäologisches Museum, 12), Bonn, 1990, pp. 9–26.

Arslan, 1943
Edoardo Arslan, *La pittura e la scultura veronese dal secolo VIII al secolo XIII, con un'appendice sull'architettura romanica veronese* (Pubblicazioni della Facoltà di Lettere e Filosofia della R. Università di Pavia, 2), Milan, 1943.

Art of the Goldsmith, 1968
The Art of the Goldsmith & the Jeweler: A Loan Exhibition for the Benefit of the Young Women's Christian Association of the City of New York (exhib. cat.), New York, À La Vieille Russie, 1968.

Arti del Medio Evo, 1989
Arti del Medio Evo e del Rinascimento: Omaggio ai Carrand, 1889–1989 (exhib. cat.), ed. by Paola Barocchi et al., Florence, Museo Nazionale del Bargello, 1989.

Aubert, 1946
Marcel Aubert, *La Sculpture française au Moyen-Âge*, Paris, 1946.

Aubert et al., 1958
Marcel Aubert et al., *Le Vitrail français*, Paris, 1958.

Ausgewählte Werke aus den Erwerbungen, 1972
Ausgewählte Werke aus den Erwerbungen, 1962–1971: Festgabe für Lise Lotte Möller zu ihrem 60. Geburtstag am 18. November 1972 (exhib. cat.) (Bildführer, 3), Hamburg, Museum für Kunst und Gewerbe, 1972.

Ausstellung alter Goldschmiede-Arbeiten, 1914
Ausstellung alter Goldschmiede-Arbeiten aus Frankfurter Privatbesitz u. Kirchen-Schätzen (exhib. cat.), Frankfurt-am-Main, Kunstgewerbemuseum, 1914.

Avar Treasure, 1981
Catalogue of the Avar Treasure (sale cat.), London, Sotheby Parke Bernet, December 14, 1981.

Avent, 1975
Richard Avent, *Anglo-Saxon Garnet Inlaid Disc and Composite Brooches* (British Archaeological Reports, no. 11), 2 vols., Oxford, 1975.

Avery, 1985
Charles Avery, *Plaquettes, Medals and Reliefs from the Collection "L"* [Mrs. Erich Lederer], London, 1985.

Avisseau, 1992
Mathilde Avisseau, in *Byzance: L'Art byzantin dans les collections publiques françaises* (exhib. cat.), Paris, Musée du Louvre, 1992.

Avori dell'alto Medio Evo, 1956
Catalogo della mostra degli avori dell'alto Medio Evo (exhib. cat.), Ravenna, Chiostri Francescani, 1956.

Bank, 1985
Alisa Vladimirovna Bank, *Byzantine Art in the Collections of Soviet Museums*, Leningrad, 1985.

von Bargen, 1996
Friederike von Bargen, in *Ägypten Schätze aus dem Wüstensand: Kunst und Kultur der Christen am Nil* (exhib. cat.), Hamm, Gustav-Lübcke-Museum, and Berlin, Museum für Spätantike und Byzantinische Kunst, Staatliche Museen, Preussischer Kulturbesitz, Wiesbaden, 1996.

Barnes, 1967
Carl F. Barnes, Jr., "The Architecture of Soissons Cathedral: Sources and Influences in the Twelfth and Thirteenth Centuries," Ph.D. dissertation, Columbia University, 1967.

Baron, 1969
Françoise Baron, "Enlumineurs, peintres et sculpteurs parisiens des XIIIe et XIVe siècles d'après les rôles de la taille," *Bulletin archéologique du Comité des travaux historiques et scientifiques*, n.s., 4 (1968; published 1969), pp. 37–121.

Baron, 1996
Françoise Baron, *Sculpture française*, vol. 1, *Moyen Âge*, Paris, Musée du Louvre, 1996.

Baron, 1998
Françoise Baron, in *L'Art du temps des rois maudits: Philippe le Bel et ses fils, 1285–1328* (exhib. cat.), Paris, Galeries Nationales du Grand Palais, 1998.

Basilica of S. Apollinare in Classe, n.d.
Basilica of S. Apollinare in Classe: Illustrated Artistic Guide, Ravenna, n.d.

Baumstark, 1995
Reinhold Baumstark, ed., *Das goldene Rössl: Ein Meisterwerk der Pariser Hofkunst um 1400* (exhib. cat.), Munich, Bayerisches Nationalmuseum, 1995.

Baxandall, 1980
Michael Baxandall, *The Limewood Sculptors of Renaissance Germany*, New Haven and London, 1980.

Los beatos, 1986
Los beatos (exhib. cat.), Madrid, Biblioteca Nacional, 1986.

Becker, 1909
Erich Becker, *Das Quellwunder des Moses in der altchristlichen Kunst* (Zur Kunst-Geschichte des Auslandes, vol. 72), Strasbourg, 1909.

Becksmann, 1968
Rüdiger Becksmann, "Das 'Hausbuchmeisterproblem' in der mittelrheinischen Glasmalerei," *Pantheon* 26 (September–October 1968), pp. 352–67.

Becksmann, 1979
Rüdiger Becksmann, *Die mittelalterlichen Glasmalereien in Baden und der Pfalz: Ohne Freiburg i. Br.* (Corpus Vitrearum Medii Aevi, Deutschland, vol. 2, pt. 1), Berlin, 1979.

Beeh-Lustenberger, 1965
Suzanne Beeh-Lustenberger, *Glasgemälde aus Frankfurter Sammlungen* (exhib. cat.), Frankfurt-am-Main, Historisches Museum, 1965.

Beeh-Lustenberger, 1979
Suzanne Beeh-Lustenberger, *Das Bild in Glas: Von der europäischen Kabinettscheibe zum New Glass* (exhib. cat.), Darmstadt, Hessisches Landesmuseum, 1979.

Benker, 1977
Sigmund Benker, "Mittelalterliche Bildwerke der Münchener Frauenkirche im Freisinger Diözesanmuseum," *Das Münster* 30 (1977), pp. 122–26.

Bennett, 1996
Adelaide Bennett, "A Thirteenth-Century French Book of Hours for Marie," *The Journal of The Walters Art Gallery* 54 (1996), pp. 21–50.

Benton, 1994
Janetta Rebold Benton, *Medieval Monsters: Dragons and Fantastic Creatures* (exhib. cat.), Katonah, New York, Katonah Museum of Art, 1994.

Berliner, 1926
Rudolf Berliner, *Die Bildwerke in Elfenbein, Knochen, Hirsch- und Steinbockhorn mit einem Anhange: Elfenbeinarbeiten der Staatlichen Schlossmuseen in Bayern* (Die Bildwerke des Bayerischen Nationalmuseums, vol. 4), Augsburg, 1926.

Bertaux, 1904
Émile Bertaux, *L'Art dans l'Italie méridionale*, vol. 1, *De la fin de l'empire romain à la conquête de Charles d'Anjou*, Paris, 1904.

van Beuningen and Koldeweij, 1993
H. J. E. van Beuningen and A. M. Koldeweij, *Heilig en profaan: 1000 laatmiddeleeuwse insignes uit de collectie H. J. E. van Beuningen* (Rotterdam Papers, 8), Cothen, The Netherlands, 1993.

Biedermann, 1980
Rolf Biedermann, *Welt im Umbruch: Augsburg zwischen Renaissance und Barock* (exhib. cat.), 2 vols., Augsburg, Rathaus and Zeughaus, 1980.

Bierbrauer, 1975
Volker Bierbrauer, *Die ostgotischen Grab- und Schatztunde in Italien* (Biblioteca degli studi medievali, 7), Spoleto, 1975.

Biers, 1977
William Biers, "The Horseman and the Angel," *Archaeology* 30 (September 1977), pp. 333–37.

Binski, 1995
Paul Binski, *Westminster Abbey and the Plantagenets: Kingship and the Representation of Power, 1200–1400*, New Haven and London, 1995.

Bjørn and Shetelig, 1940
Anathon Bjørn and Haakon Shetelig, *Viking Antiquities in England, with a Supplement of Viking Antiquities on the Continent of Western Europe*, pt. 4 of *Viking Antiquities in Great Britain and Ireland*, ed. by Haakon Shetelig, Oslo, 1940.

Blanchet, 1924
Adrien Blanchet, "Une Bague d'un comte de l'Opsikion (Xe s.?)," *Byzantion* 1 (1924), pp. 173–76.

Blažeković, 1992
Zdravko Blažeković, "Zvono majstora Marka u Metropolitan Museum of Art u New York," *Arti musices* 23 (1992), pp. 173–75.

Bloch, 1972–73
Peter Bloch, in *Rhein und Maas: Kunst und Kultur, 800–1400* (exhib. cat.), 2 vols., Cologne, Kunsthalle, 1972–73.

Boccara, 1971
Dario Boccara, *Les Belles Heures de la tapisserie*, Milan, 1971.

Bøe, 1940
Johannes Bøe, *Norse Antiquities in Ireland*, pt. 3 of *Viking Antiquities in Great Britain and Ireland*, ed. by Haakon Shetelig, Oslo, 1940.

Boehm, 1985
Barbara Drake Boehm, in *Notable Acquisitions, 1984–1985: Selected by Philippe de Montebello, Director*, New York, The Metropolitan Museum of Art, 1985.

Boehm, 1988
Barbara Drake Boehm, in *Recent Acquisitions: A Selection, 1987–1988*, New York, The Metropolitan Museum of Art, 1988.

Boehm, 1990 a
Barbara Drake Boehm, in *Decorative and Applied Art from Late Antiquity to Late Gothic* (exhib. cat.), Leningrad, State Hermitage Museum, and Moscow, State Pushkin Museum, Leningrad, 1990 (in Russian).

Boehm, 1990 b
Barbara Drake Boehm, in "Recent Acquisitions: A Selection, 1989–1990," *The Metropolitan Museum of Art Bulletin* 48, no. 2 (Fall 1990).

Boehm, 1991
Barbara Drake Boehm, in "Recent Acquisitions: A Selection, 1990–1991," *The Metropolitan Museum of Art Bulletin* 49, no. 2 (Fall 1991).

Boehm, 1993
Barbara Drake Boehm, in "Recent Acquisitions: A Selection, 1992–1993," *The Metropolitan Museum of Art Bulletin* 51, no. 2 (Fall 1993).

Boehm, 1995 a
Barbara Drake Boehm, in "Recent Acquisitions, a Selection: 1994–1995," *The Metropolitan Museum of Art Bulletin* 53, no. 2 (Fall 1995).

Boehm, 1995 b
Barbara Drake Boehm, in "Textiles in The Metropolitan Museum of Art," *The Metropolitan Museum of Art Bulletin* 53, no. 3 (Winter 1995–96).

Boehm, 1997
Barbara Drake Boehm, in "Recent Acquisitions, a Selection: 1996–1997," *The Metropolitan Museum of Art Bulletin* 55, no. 2 (Fall 1997).

Boehm and Wixom, 1988
Barbara Drake Boehm and William D. Wixom, in *Recent Acquisitions: A Selection, 1987–1988*, New York, The Metropolitan Museum of Art, 1988.

Böhler, 1982
Gemälde, Handzeichnungen, Plastiken (Julius Böhler, dealer's cat.), Munich, 1982.

Boileau, 1879
Étienne Boileau, *Les Métiers et corporations de la ville de Paris: XIII^e Siècle, le livre des métiers d'Étienne Boileau* (Histoire générale de Paris), Paris, 1879.

Bonnet et al., 1989
Jacqueline Bonnet et al., *Les Bronzes antiques de Paris* (Catalogues d'art et d'histoire du Musée Carnavalet), Paris, 1989.

Born, 1989
Hermann Born, in *Kirchenkunst des Mittelalters: Erhalten und Erforschen* (exhib. cat.), ed. by Michael Brandt, Hildesheim, Diözesanmuseum, 1989.

Bou, 1971
Gilbert Bou, *La Sculpture en Rouergue à la fin Gothique, XV^e siècle et début du XVI^e siècle*, [France], 1971.

Bouffard and Theurillat, 1974
Pierre Bouffard and J.-M. Theurillat, *Saint-Maurice d'Agaune: Trésor de l'abbaye* (Orfèvrerie médiévale, 1), Geneva, 1974.

Bousquet, 1961
Jacques Bousquet, "La Sculpture Rouergate et la fin du style gothique: Positions et propositions," *Bulletin du Musée Ingres*, no. 9 (July 1961), pp. 9–15.

Bouvy, 1962
Désiré-Paul-Raymond-Arthur Bouvy, *Beeldhouwkunst: Aartsbisschoppelijk Museum, Utrecht*, Utrecht, 1962.

Boyd, 1997
Susan A. Boyd, in *The Glory of Byzantium: Art and Culture of the Middle Byzantine Era, A.D. 843–1261* (exhib. cat.), ed. by Helen C. Evans and William D. Wixom, New York, The Metropolitan Museum of Art, 1997.

Bramm, 1928
Otto Bramm, "Hans Leinberger, seine Werkstatt und Schule: Ein Scheidungs- und Klärungsversuch," *Münchner Jahrbuch der bildenden Kunst*, n.s., 5 (1928), pp. 116–89.

Branner, 1977
Robert Branner, *Manuscript Painting in Paris during the Reign of Saint Louis: A Study of Styles* (California Studies in the History of Art, 18), Berkeley, 1977.

Braun, 1932
Joseph Braun, *Das christliche Altargerät in seinem Sein und in seiner Entwicklung*, Munich, 1932.

Braun, 1940
Joseph Braun, *Die Reliquiare des christlichen Kultes und ihre Entwicklung*, Freiburg im Breisgau, 1940.

Braun, 1943
Joseph Braun, *Tracht und Attribute der Heiligen in der deutschen Kunst*, Stuttgart, 1943.

Breck, 1913
Joseph Breck, *Catalogue of Romanesque, Gothic, and Renaissance Sculpture*, New York, The Metropolitan Museum of Art, 1913.

Bremen, 1964
Walther Bremen, *Die alten Glasgemälde und Hohlgläser der Sammlung Bremen in Krefeld: Katalog* (Beihefte der Bonner Jahrbücher, vol. 13), Cologne, 1964.

Brenk, 1977
Beat Brenk, *Spätantike und frühes Christentum* (Propyläen Kunstgeschichte, supplement, vol. 1), Frankfurt-am-Main, Berlin, and Vienna, 1977.

Brenk, 1992
Beat Brenk, "Four Langobardic Marble Reliefs Recently Acquired by The Cloisters," in *The Cloisters: Studies in Honor of the Fiftieth Anniversary*, ed. by Elizabeth C. Parker, with Mary B. Shepard, New York, 1992, pp. 63–85.

Bronzen von der Antike bis zur Gegenwart, 1983
Bronzen von der Antike bis zur Gegenwart (exhib. cat.), ed. by Peter Bloch, Berlin, Staatliche Museen, Preussischer Kulturbesitz, 1983.

Brown, 1979 a
Katharine Reynolds Brown, "The Mosaics of San Vitale: Evidence for the Attribution of Some Early Byzantine Jewelry to Court Workshops," *Gesta* 18, no. 1 (1979), pp. 57–62.

Brown, 1979 b
Katharine Reynolds Brown, in *Age of Spirituality: Late Antique and Early Christian Art, Third to Seventh Century* (exhib. cat.), ed. by Kurt Weitzmann, New York, The Metropolitan Museum of Art, 1979.

Brown, 1980
Katharine Reynolds Brown, in *Notable Acquisitions, 1979–1980: Selected by Philippe de Montebello, Director*, New York, The Metropolitan Museum of Art, 1980.

Brown, 1981
Katharine Reynolds Brown, in *Notable Acquisitions, 1980–1981: Selected by Philippe de Montebello, Director*, New York, The Metropolitan Museum of Art, 1981.

Brown, 1983
Katharine Reynolds Brown, in *Notable Acquisitions, 1982–1983: Selected by Philippe de Montebello, Director*, New York, The Metropolitan Museum of Art, 1983.

Brown, 1986
Katharine Reynolds Brown, in *Recent Acquisitions: A Selection, 1985–1986*, New York, The Metropolitan Museum of Art, 1986.

Brown, 1987
Katharine Reynolds Brown, in *Recent Acquisitions: A Selection, 1986–1987*, New York, The Metropolitan Museum of Art, 1987.

Brown, 1988
Katharine Reynolds Brown, in *Recent Acquisitions: A Selection, 1987–1988*, New York, The Metropolitan Museum of Art, 1988.

Brown, 1989
Katharine Reynolds Brown, in "Recent Acquisitions: A Selection, 1988–1989," *The Metropolitan Museum of Art Bulletin* 47, no. 2 (Fall 1989).

Brown, 1990 a
Katharine Reynolds Brown, in *Decorative and Applied Art from Late Antiquity to Late Gothic* (exhib. cat.), Leningrad, State Hermitage Museum, and Moscow, State Pushkin Museum, Leningrad, 1990 (in Russian).

Brown, 1990 b
Katharine Reynolds Brown, in "Recent Acquisitions: A Selection, 1989–1990," *The Metropolitan Museum of Art Bulletin* 48, no. 2 (Fall 1990).

Brown, 1991
Katharine Reynolds Brown, in "Recent Acquisitions: A Selection, 1990–1991," *The Metropolitan Museum of Art Bulletin* 49, no. 2 (Fall 1991).

Brown, 1992
Katharine Reynolds Brown, in "Recent Acquisitions: A Selection, 1991–1992," *The Metropolitan Museum of Art Bulletin* 50, no. 2 (Fall 1992).

Brown, 1993
Katharine Reynolds Brown, in *The Art of Medieval Spain, A.D. 500–1200*, New York, The Metropolitan Museum of Art, 1993.

Brown, 1995 a
Katharine Reynolds Brown, *Migration Art, A.D. 300–800*, New York, The Metropolitan Museum of Art, 1995.

Brown, 1995 b
Katharine Reynolds Brown, in "Recent Acquisitions, a Selection: 1994–1995," *The Metropolitan Museum of Art Bulletin* 53, no. 2 (Fall 1995).

Brown, 1996
Katharine Reynolds Brown, "If Only the Dead Could Talk: An Update on the East German and Hunnish Jewelry Collections at The Metropolitan Museum of Art," in *Ancient Jewelry and Archaeology*, ed. by Adriana Calinescu, Bloomington and Indianapolis, 1996, pp. 224–34.

Bruce-Mitford, 1979
Rupert Bruce-Mitford, *The Sutton Hoo Ship Burial: A Handbook*, 3rd ed., London, 1979.

Bruckner, 1995
Matilda Tomaryn Bruckner, "Reconstructing Arthurian History: Lancelot and the Vulgate Cycle," in *Memory and the Middle Ages* (exhib. cat.), ed. by Nancy Netzer and Virginia Reinburg, Chestnut Hill, Massachusetts, Boston College Museum of Art, 1995, pp. 57–75.

Bruzelius, 1991
Caroline Bruzelius, in Caroline Bruzelius and Jill Meredith et al., *The Brummer Collection of Medieval Art, The Duke University Museum of Art*, Durham, North Carolina, and London, 1991.

Budde, 1979
Rainer Budde, *Deutsche romanische Skulptur, 1050–1250*, Munich, 1979.

Bunker, 1988
Emma C. Bunker, "Lost Wax and Lost Textile: An Unusual Ancient Technique for Casting Gold Belt Plaques," in *The Beginning of the Use of Metals and Alloys: Papers from the Second International Conference on the Beginning of the Use of Metals and Alloys, Zhengzhou, China, 21–26 October 1986*, ed. by Robert Maddin, Cambridge, Massachusetts, 1988, pp. 222–27.

Burckhardt, 1923
Rudolf Friedrich Burckhardt, *Gewirkte Bildteppiche des XV. und XVI. Jahrhunderts im Historischen Museum zu Basel*, Leipzig, 1923.

Buschhausen, 1979
Helmut Buschhausen, in *Age of Spirituality: Late Antique and Early Christian Art, Third to Seventh Century* (exhib. cat.), ed. by Kurt Weitzmann, New York, The Metropolitan Museum of Art, 1979.

Butler, 1920
Howard Crosby Butler, *Syria: Publications of the Princeton University Archaeological Expeditions to Syria in 1904–5 and 1909* (division II, Architecture, section B, Northern Syria), Leyden, The Netherlands, 1920.

Butterfield, 1997
Andrew Butterfield, *The Sculptures of Andrea del Verrocchio*, New Haven and London, 1997.

Byzantine Art in the Soviet Union, 1977
Byzantine Art in the Collections of the Soviet Union (exhib. cat.), Moscow, State Pushkin Museum, 3 vols., 1977 (in Russian).

Cabré, 1928
Juan Cabré, "Decoraciones hispánicas," *Archivo español de arte y arqueología* 4 (1928), pp. 97–110.

Cabré y Aguiló, 1937
Juan Cabré y Aguiló, "Broches de cinturón de bronce damasquinados con oro y plata," *Archivo español de arte y arqueología* 13 (1937), pp. 93–125.

Cabrol and Leclercq, 1914
Fernand Cabrol and Henri Leclercq, *Dictionnaire d'archéologie chrétienne et de liturgie*, vol. 3, Paris, 1914.

Cahn, 1977
Walter Cahn, "Romanesque Sculpture in American Collections. XVI. The Academy of the New Church, Bryn Athyn, Pa.," *Gesta* 16, no. 2 (1977), pp. 69–79.

Cahn and Seidel, 1979
Walter Cahn and Linda Seidel, *Romanesque Sculpture in American Collections*, vol. 1, *New England Museums* (Publications of the International Center of Medieval Art, 1), New York, 1979.

Callmann, 1980
Ellen Callmann, *Beyond Nobility: Art for the Private Citizen in the Early Renaissance* (exhib. cat.), Allentown, Pennsylvania, Allentown Art Museum, 1980.

Cardona, 1993
Esther Alonso Cardona, "Aproximación al Beato del Museo Arqueológico Nacional de Madrid," *Boletín del Museo Arqueológico Nacional* 11 (1993), pp. 63–78.

Cardona, 1995
Esther Alonso Cardona, "Estructuración del Beato del Museo Arqueológico Nacional," *Boletín del Museo Arqueológico Nacional* 13 (1995), pp. 85–102.

Carli, 1946
Enzo Carli, *Goro di Gregorio*, Florence, 1946.

Carlsson, 1977
Anders W. Carlsson, "Senvendeltida och vikingatida djurhuvudformiga spännen från Gotland, en kvantitativ bearbetning," *Fornvännen* 72 (1977), pp. 135–48.

Carr, 1997
Annemarie Weyl Carr, in *The Glory of Byzantium: Art and Culture of the Middle Byzantine Era, A.D. 843–1261* (exhib. cat.), ed. by Helen C. Evans and William D. Wixom, New York, The Metropolitan Museum of Art, 1997.

Cavallo, 1993
Adolfo Salvatore Cavallo, *Medieval Tapestries in The Metropolitan Museum of Art*, New York, 1993.

Caviness, 1973
Madeline Harrison Caviness, "'De convenientia et cohaerentia antiqui et novi operis': Medieval Conservation, Restoration, Pastiche and Forgery," in *Intuition und Kunstwissenschaft: Festschrift für Hanns Swarzenski zum 70. Geburtstag am 30. August 1973*, ed. by Peter Bloch et al., Berlin, 1973, pp. 205–21.

Caviness, 1978
Madeline Harrison Caviness, in *Medieval and Renaissance Stained Glass from New England Collections* (exhib. cat.), ed. by Madeline Harrison Caviness, Cambridge, Massachusetts, Busch-Reisinger Museum, Harvard University, Medford, Massachusetts, 1978.

Caviness, 1979
Madeline Harrison Caviness, "Conflicts between *Regnum* and *Sacerdotium* as Reflected in a Canterbury Psalter of ca. 1215," *The Art Bulletin* 61 (March 1979), pp. 38–58.

Caviness, 1981
Madeline Harrison Caviness, *The Windows of Christ Church Cathedral, Canterbury* (Corpus Vitrearum Medii Aevi, Great Britain, vol. 2), London, 1981.

Caviness, 1985
Madeline Harrison Caviness, in *Stained Glass before 1700 in American Collections: New England and New York (Corpus Vitrearum Checklist I)* (National Gallery of Art, Studies in the History of Art, vol. 15) (Monograph Series 1), Washington, D.C., 1985.

Caviness, 1990
Madeline Harrison Caviness, *Sumptuous Arts at the Royal Abbeys in Reims and Braine: Ornatus Elegantiae, Varietate Stupendes*, Princeton, 1990.

Caviness, Pastan, and Beaven, 1984
Madeline Harrison Caviness, Elizabeth C. Pastan, and Marilyn M. Beaven, "The Gothic Window from Soissons: A Reconsideration," *Fenway Court* (1983; published 1984), pp. 7–25.

Chamonikolasová, 1995
Kaliopi Chamonikolasová, "Nicolaus Gerhaert of Leyden in the Moravian Context," *Wiener Jahrbuch für Kunstgeschichte* 48 (1995), pp. 61–84.

Cherry, 1978
John Cherry, "A Medieval Love Brooch," *Society of Jewellery Historians*, newsletter 5 (October 1978), p. 7.

Cherry, 1995
John Cherry, "The Rings of John Stanbury and Richard Mayo, Bishops of Hereford," in *Medieval Art, Architecture and Archaeology at Hereford* (The British Archaeological Association Conference Transactions, 15), ed. by David Whitehead, [Great Britain], 1995, pp. 150–56.

Childs, 1985
Suse Childs, "Two Scenes from the Life of St. Nicholas and Their Relationship to the Glazing Program of the Chevet Chapels at Soissons Cathedral," in *Corpus Vitrearum: Selected Papers from the XIth International Colloquium of the Corpus Vitrearum, New York, 1–6 June 1982*, ed. by Madeline Harrison Caviness and Timothy B. Husband, New York, 1985, pp. 25–33.

Christie's Review, 1981
Christie's Review of the Season, 1981, ed. by John Herbert, London, 1981.

Cimok, 1995
Fatih Cimok, ed., *Antioch Mosaics*, Istanbul, 1995.

Cioni, 1996
Elisabetta Cioni, "Per Giacomo di Guerrino: Orafo e smaltista senese," *Prospettiva*, nos. 83–84 (July–October 1996), pp. 56–79.

Civalli, 1594–97
Orazio Civalli, "Visita triennale" (manuscript), 1594–97.

Clemen, von Falke, and Swarzenski, 1930
Paul Clemen, Otto von Falke, and Georg Swarzenski, *Die Sammlung Dr. Leopold Seligmann, Köln*, Berlin, 1930.

Collection Spitzer, 1890
La Collection Spitzer: Antiquité, Moyen-Âge, Renaissance, vol. 1, Paris, 1890.

Colman, 1973–74
Pierre Colman, "Le Buste-Reliquaire de Saint Lambert de la cathédrale de Liège et sa restauration: Étude historique et archéologique," *Institut Royal du Patrimoine Artistique/Koninklijk Instituut voor het Kunstpatrimonium Bulletin* 14 (1973–74), pp. 39–83.

Cothren, 1986
Michael W. Cothren, "The Seven Sleepers and the Seven Kneelers: Prolegomena to a Study of the 'Belles Verrières' of the Cathedral of Rouen," *Gesta* 25 (1986), pp. 203–26.

Cotsonis, 1994
John A. Cotsonis, *Byzantine Figural Processional Crosses* (exhib. cat.) (Dumbarton Oaks Byzantine Collection Publications, no. 10), Washington, D.C., Dumbarton Oaks Research Library and Collections, 1994.

Curle, 1923
Alexander Ormiston Curle, *The Treasure of Traprain: A Scottish Hoard of Roman Silver Plate*, Glasgow, 1923.

Dalton, 1909
Ormonde Maddock Dalton, *Catalogue of the Ivory Carvings of the Christian Era with Examples of Mohammedan Art and Carvings in Bone in the Department of British and Mediaeval Antiquities and Ethnography of the British Museum*, London, 1909.

Dandridge, 1992
Edmund P. Dandridge, "The Development of the Canterbury Chest," in *The Cloisters: Studies in Honor of the Fiftieth Anniversary*, ed. by Elizabeth C. Parker, with Mary B. Shepard, New York, 1992, pp. 229–33.

Dandridge, forthcoming
Edmund P. Dandridge, "A Study of the Gilding of Silver in Byzantium," in *Gilded Metals*, ed. by Terry Drayman-Weisser, forthcoming.

Dangolsheimer Muttergottes, 1989
Die Dangolsheimer Muttergottes nach ihrer Restaurierung (exhib. cat.), Berlin, Staatliche Museen, Preussischer Kulturbesitz, 1989.

Dayot, 1906
Armand Dayot, "Émile Molinier," in *Catalogue des objets d'art et de haut curiosité du Moyen-Âge, de la Renaissance et autres... composant la collection de feu M. Émile Molinier* (sale cat.), Paris, Galeries MM. Durand-Ruel, June 21–23 and 25–28, 1906, pp. 7–17.

Deichmann, 1967
Friedrich Wilhelm Deichmann, *Repertorium der christlich-antiken Sarkophage*, vol. 1, *Rom und Ostia*, Wiesbaden, 1967.

Delbrueck, 1929
Richard Delbrueck, *Die Consulardiptychen und verwandte Denkmäler* (Studien zur spätantiken Kunstgeschichte, vol. 2), Berlin and Leipzig, 1929.

Deppert-Lippitz, 1990
Barbara Deppert-Lippitz, in *Early Christian & Byzantine Art: Textiles, Metalwork, Frescoes, Manuscripts, Jewellery, Steatites, Stone Sculptures, Tiles, Pottery, Bronzes, Amulets, Coins and Other Items from the Fourth to the Fourteenth Centuries* (exhib. cat.), ed. by Richard Temple, London, The Temple Gallery, and New York, Robert Haber Ancient Art, London and Shaftesbury, Dorset, England, 1990.

Deppert-Lippitz, 1996
Barbara Deppert-Lippitz, "A Late Antique Gold Fibula in the Burton Y. Berry Collection," in *Ancient Jewelry and Archaeology*, ed. by Adriana Calinescu, Bloomington and Indianapolis, 1996, pp. 235–43.

Deshman, 1986
Robert Deshman, "The Imagery of the Living Ecclesia and the English Monastic Reform," in *Sources of Anglo-Saxon Culture* (Studies in Medieval Culture, 20), ed. by Paul E. Szarmach, with Virginia Darrow Oggins, Kalamazoo, Michigan, 1986, pp. 261–82.

Desjardins, 1879
Gustave Desjardins, ed., *Cartulaire de l'abbaye de Conques en Rouergue* (Société de l'École des chartes, Documents historiques), Paris, 1879.

Deutsche Bronzen des Mittelalters, 1960
Deutsche Bronzen des Mittelalters und der Renaissance: Medaillen und Goldschmiedearbeiten (exhib. cat.), Düsseldorf, Kunstmuseum, 1960.

Dieffenbach, 1879
L. Ferdinand Dieffenbach, *Graf Franz zu Erbach-Erbach: Ein Lebens- und Culturbild aus dem Ende des XVIII. und dem Anfange des XIX. Jahrhunderts* (Deutsche Adels-Gallerie, 1), Darmstadt, 1879.

Di Fabio, 1997
Clario Di Fabio, "La 'Pace' di San Lorenzo di Portovenere, il Maresciallo di Boucicaut e Pedro de Luna: Un promemoria per la storia della cultura figurativa a Genova nell'*Autunno del Medioevo*," *Bollettino d'arte*, supplement to no. 95 ("Studi di oreficeria"), 1997, pp. 137–48.

Domínguez Bordona, 1933
Jesús Domínguez Bordona, *Manuscritos con pinturas: Notas para un inventario de los conservados en colecciones públicas y particulares de España* (Fichero de arte antiguo), 2 vols., Madrid, 1933.

van Doorslaer, 1935
Georges van Doorslaer, *La Corporation et les ouvrages des orfèvres malinois*, Antwerp, 1935.

Dormeier, 1994
Heinrich Dormeier, "Kurzweil und Selbstdarstellung: Die 'Wirklichkeit' der Augsburger Monatsbilder," in Harmut Boockmann et al., "*Kurzweil viel ohn' Mass und Ziel*": *Alltag und Festtag auf den Augsburger Monatsbildern der Renaissance*, Munich, 1994, pp. 148–221.

Drayman-Weisser, 1992
Terry Drayman-Weisser, "Altered States: Changes in Silver Due to Burial and Post-excavation Treatment," in *Ecclesiastical Silver Plate in Sixth-Century Byzantium: Papers of the Symposium Held May 16–18, 1986, at The Walters Art Gallery, Baltimore, and Dumbarton Oaks, Washington, D.C.*, ed. by Susan A. Boyd and Marlia Mundell Mango, Washington, D.C., 1992, pp. 191–95.

Durand, 1992
Jannic Durand, in *Byzance: L'Art byzantin dans les collections publiques françaises* (exhib. cat.), Paris, Musée du Louvre, 1992.

Duval, 1977
Paul-Marie Duval, *Les Celtes* (Univers des formes, 25), Paris, 1977.

Early Christian and Byzantine Art, 1947
Early Christian and Byzantine Art (exhib. cat.), ed. by Dorothy Miner, The Baltimore Museum of Art (organized by The Walters Art Gallery, Baltimore), 1947.

Effenberger, 1992
Arne Effenberger, in Arne Effenberger and Hans-Georg Severin, *Das Museum für Spätantike und Byzantinische Kunst, Staatliche Museen zu Berlin*, Mainz, 1992.

Egbert, 1974
 Virginia Wylie Egbert, *On the Bridges of Mediaeval Paris: A Record of Early Fourteenth-Century Life*, Princeton, 1974.

Eikelmann, 1984
 Renate Eikelmann, "Franko-Flämische Emailplastik des Spätmittelalters," Ph.D. dissertation, Ludwig-Maximilians-Universität, Munich, 1984.

Enamels of Limoges, 1996
 Enamels of Limoges, 1100–1350 (exhib. cat.), New York, The Metropolitan Museum of Art, 1996.

Engemann, 1984
 Josef Engemann, "Eine spätantike Messingkanne mit zwei Darstellungen aus der Magiererzählung im F. J. Dölger-Institut in Bonn," *Jahrbuch für Antike und Christentum* 11 (1984), pp. 115–31.

Entwistle, 1994
 Christopher Entwistle, in *Byzantium: Treasures of Byzantine Art and Culture from British Collections* (exhib. cat.), ed. by David Buckton, London, British Museum, 1994.

Erlande-Brandenburg, 1982
 Alain Erlande-Brandenburg, *Les Sculptures de Notre-Dame de Paris au Musée de Cluny*, Paris, 1982.

Erlande-Brandenburg, Le Pogam, and Sandron, 1993
 Alain Erlande-Brandenburg, Pierre-Yves Le Pogam, and Dany Sandron, *Musée National du Moyen Âge, Thermes de Cluny: Guide to the Collections*, Paris, 1993.

Ernest Brummer Collection, 1979
 The Ernest Brummer Collection: Medieval, Renaissance and Baroque Art (sale cat.), 2 vols., Zurich, Galerie Koller AG, in collaboration with London, Spink & Son, October 16–19, 1979.

Estate of Walter Jennings, 1949
 Paintings & Art Property from the Estate of the Late Walter Jennings: Early American Portraits, Silver, Objects of Art & Furniture (sale cat.), New York, Parke-Bernet Galleries, October 25–26, 1949.

Eubel, 1902
 Conrad Eubel, ed., *Bullarium franciscanum sive Romanorum pontificum Constitutiones*, vol. 6, *Benedicti XII, Clementis VI, Innocentii VI, Urbani V, Gregorii XI, documenta*, Rome, 1902.

European Enamels, 1897
 Catalogue of a Collection of European Enamels from the Earliest Date to the End of the XVII. Century (exhib. cat.), London, Burlington Fine Arts Club, 1897.

von Euw, 1972–73
 Anton von Euw, in *Rhein und Maas: Kunst und Kultur, 800–1400* (exhib. cat.), 2 vols., Cologne, Kunsthalle, 1972–73.

von Euw and Rode, 1970
 Anton von Euw and Herbert Rode, in *Herbst des Mittelalters: Spätgotik in Köln und am Niederrhein* (exhib. cat.), Cologne, Kunsthalle, 1970.

Evans, 1992
 Helen C. Evans, in "Recent Acquisitions: a Selection, 1991–1992," *The Metropolitan Museum of Art Bulletin* 50, no. 2 (Fall 1992).

Evans, 1993
 Helen C. Evans, "An Early Christian Sarcophagus from Rome Lost and Found," *Metropolitan Museum Journal* 28 (1993), pp. 77–84.

Evans, 1995
 Helen C. Evans, in "Recent Acquisitions, a Selection: 1994–1995," in *The Metropolitan Museum of Art Bulletin* 53, no. 2 (Fall 1995).

Evans, 1997
 Helen C. Evans, in *The Glory of Byzantium: Art and Culture of the Middle Byzantine Era, A.D. 843–1261* (exhib. cat.), ed. by Helen C. Evans and William D. Wixom, New York, The Metropolitan Museum of Art, 1997.

Evison, 1969
 Vera I. Evison, "A Viking Grave at Sonning, Berks.," *The Antiquaries Journal* 49 (1969), pp. 330–45.

von Falke, 1925
 Otto von Falke, ed., *Skulpturen und Kunstgewerbe*, vol. 2 of *Die Kunstsammlung von Pannwitz*, ed. by Max J. Friedländer and Otto von Falke, Munich, 1925.

von Falke and Meyer, 1935
 Otto von Falke and Erich Meyer, *Romanische Leuchter und Gefässe: Giessgefässe der Gotik* (Denkmäler deutscher Kunst, Bronzegeräte des Mittelalters, vol. 1), Berlin, 1935.

von Falke, Schmidt, and Swarzenski, 1930
 Otto von Falke, Robert Schmidt, and Georg Swarzenski, eds., *The Guelph Treasure: The Sacred Relics of Brunswick Cathedral Formerly in the Possession of the Ducal House of Brunswick-Lüneburg*, Frankfurt-am-Main, 1930.

Les Fastes du Gothique, 1981
 Les Fastes du Gothique: Le Siècle de Charles V (exhib. cat.), Paris, Galeries Nationales du Grand Palais, 1981.

Faye and Bond, 1962
 C. U. Faye and W. H. Bond, *Supplement to the Census of Medieval and Renaissance Manuscripts in the United States and Canada*, New York, 1962.

Filedt Kok, 1988
 Jan Piet Filedt Kok, "Über den Meister des Amsterdamer Kabinetts oder den Hausbuchmeister: Forschungsergebnisse der Ausstellungen in Amsterdam und Frankfurt," *Städel-Jahrbuch*, n.s., 11 (1987; published 1988), pp. 117–26.

Filedt Kok et al., 1985
 Jan Piet Filedt Kok et al., *'s Levens felheid: De Meester van het Amsterdamse Kabinet of de Hausbuch-Meester, ca. 1470–1500* (exhib. cat.), Amsterdam, Rijksmuseum, Rijksprentenkabinet, 1985.

Firatli, 1990
 Nezih Firatli, *La Sculpture byzantine figurée au Musée Archéologique d'Istanbul* (Bibliothèque de l'Institut Français d'Études Anatoliennes d'Istanbul, 30), Paris, 1990.

"Fogg Art Museum," 1940–41
 "William Hayes Fogg Art Museum, Appendix II: Loans," *Report of the President of Harvard College and Reports of the Departments* (1940–41).

Foltiny, 1973
 Stephan Foltiny, "Ein slowakischer Bronzediademtyp im Metropolitan Museum of Art in New York," *Musaica* [Univerzity Komenského, Zborník Filozofickej Fakulty] 24 (1973), pp. 89–97.

Forsyth, 1970
 William H. Forsyth, *The Entombment of Christ: French Sculptures of the Fifteenth and Sixteenth Centuries*, Cambridge, Massachusetts, 1970.

Forsyth, 1978
 Ilene H. Forsyth, "The Theme of Cockfighting in Burgundian Romanesque Sculpture," *Speculum* 53 (April 1978), pp. 252–82.

Forsyth, 1995
 William H. Forsyth, *The Pietà in French Late Gothic Sculpture: Regional Variations*, New York, 1995.

Fox, 1958
 Cyril Fox, *Pattern and Purpose: A Survey of Early Celtic Art in Britain*, Cardiff, 1958.

Frankl, 1956
 Paul Frankl, *Peter Hemmel: Glasmaler von Andlau* (Denkmäler deutscher Kunst), Berlin, 1956.

Frazer, 1980
 Margaret E. Frazer, in *Notable Acquisitions, 1979–1980: Selected by Philippe de Montebello, Director*, New York, The Metropolitan Museum of Art, 1980.

Frazer, 1981
 Margaret E. Frazer, in *Notable Acquisitions, 1980–1981: Selected by Philippe de Montebello, Director*, New York, The Metropolitan Museum of Art, 1981.

Frazer, 1984
 Margaret E. Frazer, in *Notable Acquisitions, 1983–1984: Selected by Philippe de Montebello, Director*, New York, The Metropolitan Museum of Art, 1984.

Frazer, 1986 a
Margaret E. Frazer, "Medieval Church Treasuries," *The Metropolitan Museum of Art Bulletin* 43, no. 3 (Winter 1985–86), pp. 3–56.

Frazer, 1986 b
Margaret E. Frazer, in *Recent Acquisitions: A Selection, 1985–1986*, New York, The Metropolitan Museum of Art, 1986.

Frazer, 1988 a
Margaret E. Frazer, "Silver Liturgical Objects from Attarouthi in Syria," in *Abstracts of Papers* (Fourteenth Annual Byzantine Studies Conference, The Menil Collection and the University of Saint Thomas, Houston, Texas, November 10–13, 1988), 1988, pp. 13–14.

Frazer, 1988 b
Margaret E. Frazer, in *Recent Acquisitions: A Selection, 1987–1988*, New York, The Metropolitan Museum of Art, 1988.

Frazer, 1990 a
Margaret E. Frazer, in *Decorative and Applied Art from Late Antiquity to Late Gothic* (exhib. cat.), Leningrad, State Hermitage Museum, and Moscow, State Pushkin Museum, Leningrad, 1990 (in Russian).

Frazer, 1990 b
Margaret E. Frazer, in "Recent Acquisitions: A Selection, 1989–1990," *The Metropolitan Museum of Art Bulletin* 48, no. 2 (Fall 1990).

French Gothic Art, 1928
The Seventh Loan Exhibition: French Gothic Art of the Thirteenth to Fifteenth Century (exhib. cat.), The Detroit Institute of Arts, 1928.

Friedman, 1989
Florence D. Friedman, *Beyond the Pharaohs: Egypt and the Copts in the 2nd to 7th Centuries A.D.* (exhib. cat.), Providence, Museum of Art, Rhode Island School of Design, and Baltimore, The Walters Art Gallery, Providence, 1989.

Fritz, 1966
Johann Michael Fritz, *Gestochene Bilder: Gravierungen auf deutschen Goldschmiedearbeiten der Spätgotik* (Beihefte der Bonner Jahrbücher, vol. 20), Cologne, 1966.

Fritz, 1982
Johann Michael Fritz, *Goldschmiedekunst der Gotik in Mitteleuropa*, Munich, 1982.

Frodl-Kraft, 1972
Eva Frodl-Kraft, *Die mittelalterlichen Glasgemälde in Niederösterreich* (Corpus Vitrearum Medii Aevi, Österreich, vol. 2, Niederösterreich), Vienna, Cologne, and Graz, 1972.

Frodl-Kraft, 1992
Eva Frodl-Kraft, "The Stained Glass from Ebreichsdorf and the Austrian 'Ducal Workshop,'" in *The Cloisters: Studies in Honor of the Fiftieth Anniversary*, ed. by Elizabeth C. Parker, with Mary B. Shepard, New York, 1992, pp. 385–407.

Gaborit-Chopin, 1978
Danielle Gaborit-Chopin, *Ivoires du Moyen Âge*, Fribourg, 1978.

Gaborit-Chopin, 1990
Danielle Gaborit-Chopin, "Une 'Pitié Nostre Seigneur' d'ivoire," in *Festschrift für Peter Bloch zum 11. Juli 1990*, ed. by Hartmut Krohm and Christian Theuerkauff, Mainz, 1990, pp. 111–19.

Gaborit-Chopin, 1998
Danielle Gaborit-Chopin, in *L'Art du temps des rois maudits: Philippe le Bel et ses fils, 1285–1328* (exhib. cat.), Paris, Galeries Nationales du Grand Palais, 1998.

Galliner, 1932
Arthur Galliner, *Glasgemälde des Mittelalters aus Wimpfen* (Denkmäler deutscher Kunst), Freiburg im Breisgau, 1932.

"Galway Brooch," 1854
"The Galway Brooch," *The Gentleman's Magazine and Historical Review* (February 1854), pp. 146–47.

Garrucci, 1879
Raffaele Garrucci, *Storia della arte cristiana nei primi otto secoli della chiesa*, vol. 5, *Sarcofagi ossia sculture cimiteriali*, Prato, 1879.

Garrucci, 1880
Raffaele Garrucci, *Storia della arte cristiana nei primi otto secoli della chiesa*, vol. 6, *Sculture non cimiteriali*, Prato, 1880.

Gauthier, 1972
Marie-Madeleine Gauthier, *Émaux du Moyen Âge occidental*, 2nd ed., Fribourg, 1972.

Gauthier, 1983
Marie-Madeleine Gauthier, *Les Routes de la foi: Reliques et reliquaires de Jérusalem à Compostelle*, Fribourg, 1983.

Gauthier, 1987
Marie-Madeleine Gauthier, *Émaux méridionaux: Catalogue international de l'oeuvre de Limoges*, vol. 1, *L'Époque romane*, Paris, 1987.

Gay, 1887
Victor Gay, *Glossaire archéologique du Moyen Âge et de la Renaissance*, vol. 1, Paris, 1887.

Germanen, Hunnen und Awaren, 1987
Germanen, Hunnen und Awaren: Schätze der Völkerwanderungszeit (exhib. cat.), ed. by Wilfried Menghin, Tobias Springer, and Egon Wamers, Nuremberg, Germanisches Nationalmuseum, and Frankfurt-am-Main, Archäologisches Museum, Museum für Vor- und Frühgeschichte, Nuremberg, 1987.

Giesen, 1956–57
Josef Giesen, "Kölner Brettsteine," *Jahrbuch des Kölnischen Geschichtsverein*, 1956–57, pp. 74–77.

Glory of Byzantium, 1997
The Glory of Byzantium: Art and Culture of the Middle Byzantine Era, A.D. 843–1261 (exhib. cat.), ed. by Helen C. Evans and William D. Wixom, New York, The Metropolitan Museum of Art, 1997.

Gnirs, 1917
Anton Gnirs, *Alte und neue Kirchenglocken: Als ein Katalog der Kirchenglocken im österreichischen Künstenlande und in angrenzenden Gebieten, mit Beiträgen zur Geschichte der Gussmeister*, Vienna, 1917.

Goffen, 1988
Rona Goffen, *Spirituality in Conflict: Saint Francis and Giotto's Bardi Chapel*, University Park, Pennsylvania, and London, 1988.

The Golden Legend, 1969
The Golden Legend of Jacobus de Voragine, trans. by Granger Ryan and Helmut Ripperger, New York, 1969.

Goldhelm, Schwert und Silberschätze, 1994
Goldhelm, Schwert und Silberschätze: Reichtümer aus 6000 Jahren rumänischer Vergangenheit (exhib. cat.), Frankfurt-am-Main, Archäologisches Museum, Museum für Vor- und Frühgeschichte, 1994.

Goldschmidt, 1914
Adolph Goldschmidt, *Die Elfenbeinskulpturen*, vol. 1, *Aus der Zeit der karolingischen und sächsischen Kaiser, VIII.–XI. Jahrhundert*, Berlin, 1914.

Goldschmidt, 1918
Adolph Goldschmidt, *Die Elfenbeinskulpturen*, vol. 2, *Aus der Zeit der karolingischen und sächsischen Kaiser, VIII.–XI. Jahrhundert*, Berlin, 1918.

Goldschmidt, 1923
Adolph Goldschmidt, *Die Elfenbeinskulpturen*, vol. 3, *Aus der romanischen Zeit, XI.–XIII. Jahrhundert*, Berlin, 1923.

Goldschmidt, 1926
Adolph Goldschmidt, *Die Elfenbeinskulpturen*, vol. 4, *Aus der romanischen Zeit, XI.–XIII. Jahrhundert*, Berlin, 1926.

Goldschmidt and Weitzmann, 1934
Adolph Goldschmidt and Kurt Weitzmann, *Die byzantinischen Elfenbeinskulpturen des X.–XIII. Jahrhunderts*, vol. 2, *Reliefs*, Berlin, 1934.

Gómez-Moreno, 1968
Carmen Gómez-Moreno, *Medieval Art from Private Collections* (exhib. cat.), New York, The Cloisters/The Metropolitan Museum of Art, 1968.

Gómez-Moreno, 1980
Carmen Gómez-Moreno, in *Notable Acquisitions, 1979–1980: Selected by Philippe de Montebello, Director,* New York, The Metropolitan Museum of Art, 1980.

Gómez-Moreno, 1981
Carmen Gómez-Moreno, in *Notable Acquisitions, 1980–1981: Selected by Philippe de Montebello, Director,* New York, The Metropolitan Museum of Art, 1981.

Gómez-Moreno, 1983
Carmen Gómez-Moreno, in *Notable Acquisitions, 1982–1983: Selected by Philippe de Montebello, Director,* New York, The Metropolitan Museum of Art, 1983.

Gómez-Moreno, 1984 a
Carmen Gómez-Moreno, in *The Jack and Belle Linsky Collection in The Metropolitan Museum of Art,* New York, 1984.

Gómez-Moreno, 1984 b
Carmen Gómez-Moreno, in *Notable Acquisitions, 1983–1984: Selected by Philippe de Montebello, Director,* New York, The Metropolitan Museum of Art, 1984.

Gonosová, 1994
Anna Gonosová, in Anna Gonosová and Christine Kondoleon, *Art of Late Rome and Byzantium in the Virginia Museum of Fine Arts,* Richmond, Virginia, 1994.

Gothic Art in Europe, 1936
Catalogue of an Exhibition of Gothic Art in Europe (c. 1200–c. 1500) (exhib. cat.), London, Burlington Fine Arts Club, 1936.

Gouk, 1988
Penelope Gouk, *The Ivory Sundials of Nuremberg, 1500–1700,* Oxford, 1988.

Gouron, 1950
Marcel Gouron, "Découverte du tympan de l'église Saint-Martin à Saint-Gilles (Gard)," *Annales du Midi* 62 (April 1950), pp. 115–20.

Gousset, 1982
Marie-Thérèse Gousset, "Un Aspect du symbolisme des encensoirs romains: La Jérusalem Céleste," *Cahiers archéologiques* 30 (1982), pp. 81–106.

Grabar, 1957
André Grabar, "Le Reliquaire byzantin de la cathédrale d'Aix-la-Chapelle," in *Karolingische und ottonische Kunst: Werden, Wesen, Wirkung* (Forschungen zur Kunstgeschichte und christlichen Archäologie, vol. 3), Wiesbaden, 1957, pp. 282–97.

Graf, Hager, and Mayer, 1896
Hugo Graf, Georg Hager, and Joseph A. Mayer, *Allgemeine kulturgeschichtliche Sammlungen: Das Mittelalter,* vol. 2, *Gothische Alterthümer der Baukunst und Bildnerei* (Kataloge des Bayerischen Nationalmuseums, vol. 6), Munich, 1896.

Graham-Campbell, 1972
James Graham-Campbell, "Two Groups of Ninth-Century Irish Brooches," *Journal of the Royal Society of Antiquaries of Ireland* 102 (1972), pp. 113–28.

Grau Lobo, 1996
Luis A. Grau Lobo, *Pintura románica en Castilla y León,* Valladolid, 1996.

Grierson, 1955
Philip Grierson, "The Kyrenia Girdle of Byzantine Medallions and Solidi," *The Numismatic Chronicle and Journal of the Royal Numismatic Society,* 6th ser., 15 (1955), pp. 55–70.

Grimm, 1996
Alfred Grimm, in *Ägypten Schätze aus dem Wüstensand: Kunst und Kultur der Christen am Nil* (exhib. cat.), Hamm, Gustav-Lübcke-Museum, and Berlin, Museum für Spätantike und Byzantinische Kunst, Staatliche Museen, Preussischer Kulturbesitz, Wiesbaden, 1996.

Grimme, 1966
Ernst Günther Grimme, *Deutsche Madonnen,* Cologne, 1966.

Grimme, 1980
Ernst Günther Grimme, "Der Aachener Goldschmied Hans von Reutlingen (um 1465 bis um 1547): Versuch einer Dokumentation seines Werkes," *Aachener Kunstblätter* 49 (1980–81; published 1980), pp. 15–50.

Grodecki, 1947
Louis Grodecki, *Ivoires français* (Arts, styles et techniques), Paris, 1947.

Grodecki, 1953
Louis Grodecki, "Un Vitrail démembré de la cathédrale de Soissons," *Gazette des beaux-arts,* 6th ser., 42 (October 1953), pp. 169–76.

Grodecki, 1956
Louis Grodecki, "La Cathédrale de Rouen, sauvetage—restauration, 1939–1955: Les Vitraux," *Les Monuments historiques de la France,* n.s., 2 (April–June 1956), pp. 101–10.

Grodecki, 1957
Louis Grodecki, "Les Vitraux de Saint-Urbain de Troyes," in *Congrès archéologique de France, CXIII^e session, 1955, Troyes,* Orléans, 1957, pp. 123–38.

Grodecki, 1960
Louis Grodecki, "Les Vitraux soissonnais du Louvre, du Musée Marmottan et des collections américaines," *La Revue des arts* 10 (1960), pp. 163–78.

Grodecki, 1965
Louis Grodecki, "Le Maître de Saint Eustache de la cathédrale de Chartres," in *Gedenkschrift Ernst Gall,* ed. by Margarete Kühn and Louis Grodecki, Berlin, 1965, pp. 171–94.

Grodecki, 1973
Louis Grodecki, "Nouvelles Découvertes sur les vitraux de la cathédrale de Troyes," in *Intuition und Kunstwissenschaft: Festschrift für Hanns Swarzenski zum 70. Geburtstag am 30. August 1973,* ed. by Peter Bloch et al., Berlin, 1973, pp. 191–203.

Grodecki, 1976
Louis Grodecki, *Les Vitraux de Saint-Denis: Étude sur le vitrail au XII^e siècle* (Corpus Vitrearum Medii Aevi, France, Études, vol. 1), Paris, 1976.

Grodecki, 1977
Louis Grodecki, *Le Vitrail roman,* Fribourg, 1977.

Grodecki and Brisac, 1984
Louis Grodecki and Catherine Brisac, *Le Vitrail gothique au XIII^e siècle,* Fribourg, 1984.

Grousset, 1885
René Grousset, *Étude sur l'histoire des sarcophages chrétiens: Catalogue des sarcophages chrétiens de Rome qui ne se trouvent point au Musée du Latran* (Bibliothèque des Écoles Françaises d'Athènes et de Rome, no. 42), Paris, 1885.

Guide to Anglo-Saxon Antiquities, 1923
A Guide to the Anglo-Saxon and Foreign Teutonic Antiquities in the Department of British and Mediaeval Antiquities, London, British Museum, 1923.

Guiffrey, 1894–96
Jules Guiffrey, *Inventaires de Jean, duc de Berry (1401–1416),* 2 vols., Paris, 1894–96.

de Guilhermy, 1840–72
Ferdinand-François de Guilhermy, "Détails historiques, Saint-Denis, 1840–1872" (manuscript), 2 vols., Paris, Bibliothèque Nationale de France, nouv. acq., MSS fr. 6121 and 6122.

Hahnloser and Brugger-Koch, 1985
Hans Robert Hahnloser and Susanne Brugger-Koch, *Corpus der Hartsteinschliffe des 12.–15. Jahrhunderts,* Berlin, 1985.

Halbach, 1984
Anke Halbach, *Wohnbauten des 12. bis 14. Jahrhunderts in Burgund* (Veröffentlichung der Abteilung Architektur des Kunsthistorischen Instituts der Universität zu Köln, 27), Cologne, 1984.

Hallman, 1997
Rob Hallman, "A Lapis Lazuli Pendant (1984.32) in the Early Christian Collections, The Metropolitan Museum of Art," unpublished paper, New York University, 1997.

Halm, 1911
Philipp Maria Halm, "Der Meister von Rabenden und die Holzplastik des Chiemgaues," *Jahrbuch der königlich preussischen Kunstsammlungen* 32 (1911), pp. 59–84.

Halm, 1927
Philipp Maria Halm, *Studien zur süddeutschen Plastik: Altbayern und Schwaben, Tirol und Salzburg*, vol. 2, Augsburg, Cologne, and Vienna, 1927.

Halm and Berliner, 1931
Philipp Maria Halm and Rudolf Berliner, eds., *Das Hallesche Heiltum: Man. Aschaffenb. 14* (Jahresgabe des Deutschen Vereins für Kunstwissenschaft, 1931), Berlin, 1931.

Hamann, 1955
Richard Hamann, *Die Abteikirche von St. Gilles und ihre künstlerische Nachfolge*, Berlin, 1955.

de Hamel, 1987
Christopher de Hamel, "Medieval and Renaissance Manuscripts from the Library of Sir Sydney Cockerell (1867–1962)," *The British Library Journal* 13 (Autumn 1987), pp. 186–210.

de Hamel, 1996
Christopher de Hamel, *Cutting Up Manuscripts for Pleasure and Profit* (Sol. M. Malkin Lecture in Bibliography, 11), Charlottesville, Virginia, 1996.

Harbison, 1984
Peter Harbison, "Earlier Carolingian Narrative Iconography: Ivories, Manuscripts, Frescoes and Irish High Crosses," *Jahrbuch des Römisch-Germanischen Zentralmuseums Mainz* 31 (1984), pp. 455–71.

Harhoiu, 1977
Radu Harhoiu, *The Fifth-Century A.D. Treasure from Pietroasa, Romania, in the Light of Recent Research* (British Archaeological Reports, supplementary series, 24), trans. by Nubar Hampartumian, Oxford, 1977.

Harris, 1989
Julie Ann Harris, "The Arca of San Millán de la Cogolla and Its Ivories, "Ph.D. dissertation, University of Pittsburgh, 1989 (microfilm, Ann Arbor, Michigan).

Harris, 1991
Julie Ann Harris, "Culto y narrativa en los marfiles de San Millán de la Cogolla," *Boletín del Museo Arqueológico Nacional* 9 (1991), pp. 69–85.

Harris, 1993
Julie Ann Harris, in *The Art of Medieval Spain, A.D. 500–1200*, New York, The Metropolitan Museum of Art, 1993.

Harrsen, 1949
Meta Harrsen, *The Nekcsei-Lipócz Bible: A Fourteenth-Century Manuscript from Hungary in the Library of Congress, MS. Pre-accession 1, a Study*, Washington, D.C., 1949.

Harrsen, 1958
Meta Harrsen, comp., *Central European Manuscripts in The Pierpont Morgan Library* (Mediaeval and Renaissance Manuscripts in The Pierpont Morgan Library), New York, 1958.

Haskins, 1905
Charles H. Haskins, "The Sources for the History of the Papal Penitentiary," *The American Journal of Theology* 9 (July 1905), pp. 421–50.

Hattatt, 1985
Richard Hattatt, *Iron Age and Roman Brooches: A Second Selection of Brooches from the Author's Collection*, Oxford, 1985.

Hattatt, 1987
Richard Hattatt, *Brooches of Antiquity: A Third Selection of Brooches from the Author's Collection*, Oxford, 1987.

Hattatt, 1989
Richard Hattatt, *Ancient Brooches and Other Artefacts: A Fourth Selection of Brooches Together with Some Other Antiquities from the Author's Collection*, Oxford, 1989.

Hayward, 1970
Jane Hayward, "'The Seven Sleepers' from Rouen," *Worcester Art Museum News Bulletin and Calendar* (March 1970), pp. 2–3.

Hayward, 1981 a
Jane Hayward, in Sumner McKnight Crosby et al., *The Royal Abbey of Saint-Denis in the Time of Abbot Suger (1122–1151)* (exhib. cat.), New York, The Metropolitan Museum of Art, 1981.

Hayward, 1981 b
Jane Hayward, in *Notable Acquisitions, 1980–1981: Selected by Philippe de Montebello, Director*, New York, The Metropolitan Museum of Art, 1981.

Hayward, 1982
Jane Hayward, in *Notable Acquisitions, 1981–1982: Selected by Philippe de Montebello, Director*, New York, The Metropolitan Museum of Art, 1982.

Hayward, 1985
Jane Hayward, in *Stained Glass before 1700 in American Collections: New England and New York (Corpus Vitrearum Checklist I)* (National Gallery of Art, Studies in the History of Art, vol. 15) (Monograph Series 1), Washington, D.C., 1985.

Hayward, 1986
Jane Hayward, in *Recent Acquisitions: A Selection, 1985–1986*, New York, The Metropolitan Museum of Art, 1986.

Hayward, 1987
Jane Hayward, in *Stained Glass before 1700 in American Collections: Mid-Atlantic and Southeastern Seaboard States (Corpus Vitrearum Checklist II)* (National Gallery of Art, Studies in the History of Art, vol. 23) (Monograph Series 1), Washington, D.C., 1987.

Hayward, 1988
Jane Hayward, in *Recent Acquisitions: A Selection, 1987–1988*, New York, The Metropolitan Museum of Art, 1988.

Hayward, 1992
Jane Hayward, "Two Grisaille Glass Panels from Saint-Denis at The Cloisters," in *The Cloisters: Studies in Honor of the Fiftieth Anniversary*, ed. by Elizabeth C. Parker, with Mary B. Shepard, New York, 1992, pp. 303–25.

Hayward, 1994
Jane Hayward, in "Recent Acquisitions, a Selection: 1993–1994," *The Metropolitan Museum of Art Bulletin* 52, no. 2 (Fall 1994).

Hayward, forthcoming
Jane Hayward, *European Stained Glass in The Metropolitan Museum and The Cloisters* (Corpus Vitrearum Medii Aevi, United States, vol. 1), forthcoming.

Hayward et al., 1982
Jane Hayward et al., *Radiance and Reflection: Medieval Art from the Raymond Pitcairn Collection* (exhib. cat.), New York, The Cloisters/The Metropolitan Museum of Art, 1982.

Heaton, 1904
Harriet A. Heaton, *The Brooches of Many Nations*, ed. by John Potter Briscoe, Nottingham and London, 1904.

von Hefner-Alteneck, 1866
Jakob Heinrich von Hefner-Alteneck, *Kunst-Kammer seiner königlichen Hoheit des Fürsten Karl Anton von Hohenzollern-Sigmaringen*, Munich, 1866.

Heinrich der Löwe, 1995
Heinrich der Löwe und seine Zeit: Herrschaft und Repräsentation der Welfen, 1125–1235 (exhib. cat.), ed. by Jochen Luckhardt and Franz Niehoff, 3 vols., Braunschweig, Herzog Anton Ulrich-Museum, Munich, 1995.

Hess, 1994
Daniel Hess, *Meister um das "Mittelalterliche Hausbuch": Studien zur Hausbuchmeisterfrage*, Mainz, 1994.

Hess, forthcoming
Daniel Hess, *Die mittelalterlichen Glasmalereien in Hessen und Rheinhesse, vol. 2, Frankfurt und mittleres Hessen* (Corpus Vitrearum Medii Aevi, Deutschland), forthcoming.

Heurgon, 1958
Jacques Heurgon, *Le Trésor de Ténès*, Paris, 1958.

Hildebrand, 1883
Hans Hildebrand, *The Industrial Arts of Scandinavia in the Pagan Time* (South Kensington Museum Art Handbooks), London, 1883.

Hildebrand, 1892
 Hans Hildebrand, *The Industrial Arts of Scandinavia in the Pagan Time*, new ed., London, 1892.

Hill, 1953
 Dorothy Kent Hill, "Animals from Ancient Spain," *The Bulletin of The Walters Art Gallery* 5, no. 7 (April 1953), n.p.

Hindman, 1987
 Sandra Hindman, in *Important Western Medieval Illuminated Manuscripts and Illuminated Leaves* (Bruce P. Ferrini, dealer's cat.), Akron, Ohio, 1987.

Hines, 1997
 John Hines, *A New Corpus of Anglo-Saxon Great Square-headed Brooches*, London, 1997.

Historische Ausstellung kunstgewerblicher Erzeugnisse, 1877
 Historische Ausstellung kunstgewerblicher Erzeugnisse zu Frankfurt am Main, 1875 (exhib. cat.), Frankfurt-am-Main, Thurn und Taxissche Palais, 1877.

Hoffmann, 1970
 Konrad Hoffmann, *The Year 1200: A Centennial Exhibition at The Metropolitan Museum of Art* (exhib. cat.) (The Cloisters Studies in Medieval Art, 1), New York, The Metropolitan Museum of Art, 1970.

Hoffmann, 1985
 Detlef Hoffmann, *Gemalte Spielkarten: Eine kleine Geschichte der Spielkarten anhand gemalter Unikate* (Insel Taschenbuch, 912), Frankfurt-am-Main, 1985.

Höhn, 1922
 Heinrich Höhn, *Nürnberger gotische Plastik*, Nuremberg, 1922.

Holmes, Little, and Sayre, 1986
 Lore Holmes, Charles T. Little, and Edward V. Sayre, "Elemental Characterization of Medieval Limestone Sculpture from Parisian and Burgundian Sources," *Journal of Field Archaeology* 13 (Winter 1986), pp. 419–38.

Homolka, 1972
 Jaromír Homolka, *Gotická plastika na Slovensku*, Bratislava, 1972.

Huch, 1943
 Ricarda Huch, *Altchristliche Mosaiken des IV. bis VII. Jahrhunderts: Rom/ Neapel/Mailand/Ravenna* (Iris Bucher der Natur und Kunst), Bern, 1943.

Hürkey, 1983
 Edgar J. Hürkey, *Das Bild des Gekreuzigten im Mittelalter: Untersuchungen zu Gruppierung, Entwicklung und Verbreitung anhand der Gewandmotive*, Worms, Germany, 1983.

Husband, 1970
 Timothy B. Husband, "A Beautiful Madonna in The Cloisters Collection," *The Metropolitan Museum of Art Bulletin* 28 (February 1970), pp. 278–90.

Husband, 1975
 Timothy B. Husband, in *The Secular Spirit: Life and Art at the End of the Middle Ages* (exhib. cat.), New York, The Cloisters/The Metropolitan Museum of Art, 1975.

Husband, 1980 a
 Timothy B. Husband, *The Wild Man: Medieval Myth and Symbolism* (exhib. cat.), New York, The Cloisters/The Metropolitan Museum of Art, 1980.

Husband, 1980 b
 Timothy B. Husband, in *Notable Acquisitions, 1979–1980: Selected by Philippe de Montebello, Director*, New York, The Metropolitan Museum of Art, 1980.

Husband, 1981
 Timothy B. Husband, in *Notable Acquisitions, 1980–1981: Selected by Philippe de Montebello, Director*, New York, The Metropolitan Museum of Art, 1981.

Husband, 1982
 Timothy B. Husband, in *Notable Acquisitions, 1981–1982: Selected by Philippe de Montebello, Director*, New York, The Metropolitan Museum of Art, 1982.

Husband, 1982–83
 Timothy B. Husband, "A Fourteenth-Century Double Cup," in *Art at Auction: The Year at Sotheby's, 1982–83*, London, 1983, pp. 292–97.

Husband, 1983
 Timothy B. Husband, in *Notable Acquisitions, 1982–1983: Selected by Philippe de Montebello, Director*, New York, The Metropolitan Museum of Art, 1983.

Husband, 1984
 Timothy B. Husband, in *Notable Acquisitions, 1983–1984: Selected by Philippe de Montebello, Director*, New York, The Metropolitan Museum of Art, 1984.

Husband, 1985
 Timothy B. Husband, "The Master of the Amsterdam Cabinet, The Master of the Housebook Genre and Tournament Pages, and a Stained-Glass Panel at The Cloisters," in *Corpus Vitrearum: Selected Papers from the XIth International Colloquium of the Corpus Vitrearum, New York, 1–6 June 1982*, ed. by Madeline Harrison Caviness and Timothy B. Husband, New York, 1985, pp. 139–57.

Husband, 1986 a
 Timothy B. Husband, in *Gothic and Renaissance Art in Nuremberg, 1300–1550* (exhib. cat.), New York, The Metropolitan Museum of Art, and Nuremberg, Germanisches Nationalmuseum, Munich and New York, 1986.

Husband, 1986 b
 Timothy B. Husband, in *Recent Acquisitions: A Selection, 1985–1986*, New York, The Metropolitan Museum of Art, 1986.

Husband, 1987 a
 Timothy B. Husband, in Virginia Chieffo Raguin et al., *Northern Renaissance Stained Glass: Continuity and Transformations* (exhib. cat.), Worcester, Massachusetts, Iris and B. Gerald Cantor Art Gallery, College of the Holy Cross, 1987.

Husband, 1987 b
 Timothy B. Husband, in *Recent Acquisitions: A Selection, 1986–1987*, New York, The Metropolitan Museum of Art, 1987.

Husband, 1988
 Timothy B. Husband, in *Recent Acquisitions: A Selection, 1987–1988*, New York, The Metropolitan Museum of Art, 1988.

Husband, 1989
 Timothy B. Husband, in "Recent Acquisitions: A Selection, 1988–1989," *The Metropolitan Museum of Art Bulletin* 47, no. 2 (Fall 1989).

Husband, 1990 a
 Timothy B. Husband, "Hans Leonhard Schäufelein and Small-scale Stained Glass: A Design for a Quatrelobe and Two Silver-stained Roundels in New York," in *Hans Schäufelein: Vorträge, gehalten anlässlich des Nördlinger Symposiums im Rahmen der 7. Rieser Kulturtage in der Zeit vom 14. Mai bis 15. Mai 1988*, Nördlingen, 1990, pp. 81–96.

Husband, 1990 b
 Timothy B. Husband, in "Recent Acquisitions: A Selection, 1989–1990," *The Metropolitan Museum of Art Bulletin* 48, no. 2 (Fall 1990).

Husband, 1990 c
 Timothy B. Husband, in *Decorative and Applied Art from Late Antiquity to Late Gothic* (exhib. cat.), Leningrad, State Hermitage Museum, and Moscow, State Pushkin Museum, Leningrad, 1990 (in Russian).

Husband, 1991 a
 Timothy B. Husband, *Stained Glass before 1700 in American Collections: Silver-stained Roundels and Unipartite Panels (Corpus Vitrearum Checklist IV)* (National Gallery of Art, Studies in the History of Art, vol. 39) (Monograph Series 1), Washington, D.C., 1991.

Husband, 1991 b
 Timothy B. Husband, in "Recent Acquisitions: A Selection, 1990–1991," *The Metropolitan Museum of Art Bulletin* 49, no. 2 (Fall 1991).

Husband, 1992 a
 Timothy B. Husband, "The Winteringham Tau Cross and *Ignis Sacer*," *Metropolitan Museum Journal* 27 (1992), pp. 19–35.

Husband, 1992 b
Timothy B. Husband, in "Recent Acquisitions: A Selection, 1991–1992," *The Metropolitan Museum of Art Bulletin* 50, no. 2 (Fall 1992).

Husband, 1993
Timothy B. Husband, in "Recent Acquisitions: A Selection, 1992–1993," *The Metropolitan Museum of Art Bulletin* 51, no. 2 (Fall 1993).

Husband, 1994 a
Timothy B. Husband, *The Cloisters' Playing Cards and Other Hand-painted Packs of the Fifteenth Century/Die Cloisters-Spielkarten und andere handgemalte Kartenspiele des 15. Jahrhunderts*, Vienna, 1994.

Husband, 1994 b
Timothy B. Husband, in "Recent Acquisitions, a Selection: 1993–1994," *The Metropolitan Museum of Art Bulletin* 52, no. 2 (Fall 1994).

Husband, 1995 a
Timothy B. Husband, *The Luminous Image: Painted Glass Roundels in the Lowlands, 1480 1560* (exhib. cat.), New York, The Metropolitan Museum of Art, 1995.

Husband, 1995 b
Timothy B. Husband, in "Recent Acquisitions, a Selection: 1994–1995," *The Metropolitan Museum of Art Bulletin* 53, no. 2 (Fall 1995).

Husband, 1996
Timothy B. Husband, in "Recent Acquisitions, a Selection: 1995–1996," *The Metropolitan Museum of Art Bulletin* 54, no. 2 (Fall 1996).

Husband, 1997
Timothy B. Husband, in "Recent Acquisitions, a Selection: 1996–1997," *The Metropolitan Museum of Art Bulletin* 55, no. 2 (Fall 1997).

Husband, 1998
Timothy B. Husband, "The Dissemination of Design of Small-scale Glass Production: The Use of the Medieval Housebook," *Gesta* 37 (1998).

Husband and Hess, 1997
Timothy B. Husband and Catherine Hess, *European Glass in the J. Paul Getty Museum*, Santa Monica, California, 1997.

Ill. B.
The Illustrated Bartsch, ed. by Jane C. Hutchison, vol. 8, New York, 1980.

Illuminated Books, 1949
Illuminated Books of the Middle Ages and Renaissance (exhib. cat.), The Baltimore Museum of Art (organized by The Walters Art Gallery, Baltimore), 1949.

Irmscher et al., 1991
Johannes Irmscher, Alexander P. Kazhdan, Robert F. Taft, and Annemarie Weyl Carr, in *The Oxford Dictionary of Byzantium*, 3 vols., New York, 1991.

Irtenkauf, Halbach, and Kroos, 1969
Wolfgang Irtenkauf, K. H. Halbach, and R. Kroos, *Die Weingarter Liederhandschrift*, Stuttgart, 1969.

Jackson, 1990
Peter Jackson, trans., *The Mission of Friar William of Rubruck: His Journey to the Court of the Great Kahn Möngke, 1253–1255* (Works Issued by the Hakluyt Society, 2nd ser., no. 173), London, 1990.

Jacobsthal, 1944
Paul Jacobsthal, *Early Celtic Art*, 2 vols., Oxford, 1944.

James, 1977
Edward James, *The Merovingian Archaeology of South-west Gaul* (British Archaeological Reports, supplementary series, 25), 2 vols., Oxford, 1977.

Jameson, 1895
Anna Jameson, *Sacred and Legendary Art* (Writings on Art of Anna Jameson, vols. 1 and 2), ed. by Estelle M. Hurll, 2 vols., Boston, 1895.

Jansen, 1936
Franz Jansen, "Der Paderborner domdechant Graf Christoph von Kesselstatt und seine Handschriftensammlung," in *Sankt Liborius: Sein Dom und sein Bistum, zum 1100 Jährigen Jubiläum der Reliquienübertragung im Auftrage des Metropolitankapitels*, ed. by Paul Simon, Paderborn, 1936, pp. 355–68.

Jessup, 1950
Ronald Frederick Jessup, *Anglo-Saxon Jewellery*, London, 1950.

Jewellery through 7000 Years, 1976
Jewellery through 7000 Years, London, British Museum, 1976.

Jewelry: Ancient to Modern, 1979
Jewelry: Ancient to Modern, Baltimore, The Walters Art Gallery, New York, 1979.

Journal of Glass Studies, 1985
Journal of Glass Studies 27 (1985), cover and frontispiece.

Kaftal, 1950
George Kaftal, *St. Francis in Italian Painting* (Ethical and Religious Classics of the East and West, no. 4), London, 1950.

Kahsnitz, 1986
Rainer Kahsnitz, in *Gothic and Renaissance Art in Nuremberg, 1300–1550* (exhib. cat.), New York, The Metropolitan Museum of Art, and Nuremberg, Germanisches Nationalmuseum, Munich and New York, 1986.

Kalavrezou-Maxeiner, 1985
Ioli Kalavrezou-Maxeiner, *Byzantine Icons in Steatite* (Byzantina Vindobonensia, vol. 15), Vienna, 1985.

Karl, 1925
Louis Karl, "Notice sur un légendier historique conservé à Rome," *Revue archéologique*, 5th ser., 21 (1925), pp. 293–322.

Katsarelias, 1997
Dimitrios G. Katsarelias, in *The Glory of Byzantium: Art and Culture of the Middle Byzantine Era, A.D. 843–1261* (exhib. cat.), ed. by Helen C. Evans and William D. Wixom, New York, The Metropolitan Museum of Art, 1997.

Kauffmann, 1975
Claus Michael Kauffmann, *Romanesque Manuscripts, 1066–1190* (A Survey of Manuscripts Illuminated in the British Isles, vol. 3), London, 1975.

Kauffmann, 1984
Claus Michael Kauffmann, in *English Romanesque Art, 1066–1200* (exhib. cat.), London, Hayward Gallery (in association with The Arts Council of Great Britain), 1984.

Keller, 1984
Hiltgart Leu Keller, *Reclams Lexikon der Heiligen und der biblischen Gestalten: Legende und Darstellung in der bildenden Kunst*, Stuttgart, 1984.

Kidd, 1988
Dafydd Kidd, "Some New Observations on the Domagnano Treasure," *Anzeiger des Germanischen Nationalmuseums*, 1987 (published 1988), pp. 129–40.

Kidd, 1990
Dafydd Kidd, "Gilt-silver and Garnet-inlaid Sheath Fittings from Hungary: Early Medieval Recent Acquisitions in the British Museum (I)," *Archäologisches Korrespondenzblatt* 20 (1990), pp. 125–27.

Kieslinger, 1922
Franz Kieslinger, "Die Glasmalereien des Österreichischen Herzoghofes aus dem Ende des 14. Jahrhunderts," *Belvedere* 1 (1922), pp. 147–54.

Kimpel, 1991
Dieter Kimpel, "A Parisian Virtue," in Caroline Bruzelius and Jill Meredith et al., *The Brummer Collection of Medieval Art, The Duke University Museum of Art*, Durham, North Carolina, and London, 1991, pp. 124–39.

Kiss, 1984
Attila Kiss, "Über eine silbervergoldete gepidische Schnalle aus dem 5. Jahrhundert von Ungarn," *Folia archaeologica* 35 (1984), pp. 57–76.

Klein, 1976
Peter K. Klein, *Der ältere Beatus-Kodex Vitr. 14-1 der Biblioteca Nacional zu Madrid: Studien zur Beatus-Illustration und der spanischen Buchmalerei des 10. Jahrhunderts* (Studien zur Kunstgeschichte, vol. 8), Hildesheim and New York, 1976.

Kleinbauer, 1982
W. Eugene Kleinbauer, ed., "Recent Major Acquisitions of Medieval Art by American Museums: Number Four," *Gesta* 21, no. 1 (1982), pp. 75–80.

Kletke, 1993
Daniel Kletke, in "Recent Acquisitions: A Selection, 1992–1993," *The Metropolitan Museum of Art Bulletin* 51, no. 2 (Fall 1993).

Klindt-Jensen, 1957
Ole Klindt-Jensen, *Denmark before the Vikings* (Ancient Peoples and Places, vol. 4), New York, 1957.

Klindt-Jensen and Wilson, 1966
Ole Klindt-Jensen and David M. Wilson, *Viking Art*, Ithaca, New York, 1966.

Kluge-Pinsker, 1991
Antje Kluge-Pinsker, *Schach und Trictrac: Zeugnisse mittelalterlicher Spielfreude in salischer Zeit* (Mainz, Römisch-Germanisches Zentralmuseum, Forschungsinstitut für Vor- und Frühgeschichte, Monographien, vol. 30), Sigmaringen, Germany, 1991.

Knoepfli, 1989
Albert Knoepfli, *Die Kunstdenkmäler des Kantons Thurgau*, vol. 4, *Das Kloster St. Katharinenthal*, Basel, 1989.

Koechlin, 1906
Raymond Koechlin, *Catalogue raisonné de la collection Martin Le Roy*, vol. 2, *Ivoires et sculptures*, Paris, 1906.

Koechlin, 1924
Raymond Koechlin, *Les Ivoires gothiques français*, 2 vols., Paris, 1924.

Kohlhaussen, 1968
Heinrich Kohlhaussen, *Nürnberger Goldschmiedekunst des Mittelalters und der Dürerzeit, 1240 bis 1540* (Jahresgabe des Deutschen Verein für Kunstwissenschaft), Berlin, 1968.

Kondoleon, 1994
Christine Kondoleon, in Anna Gonosová and Christine Kondoleon, *Art of Late Rome and Byzantium in the Virginia Museum of Fine Arts*, Richmond, Virginia, 1994.

Kortekaas, 1984
G. A. A. Kortekaas, *Historia Apollonii Regis Tyri* (Mediaevalia Groningana, 3), Groningen, The Netherlands, 1984.

Kosmer, 1975
Ellen Kosmer, "Master Honoré: A Reconsideration of the Documents," *Gesta* 14, no. 1 (1975), pp. 63–68.

Kötzsche, 1972–73
Dietrich Kötzsche, in *Rhein und Maas: Kunst und Kultur, 800–1400* (exhib. cat.), 2 vols., Cologne, Kunsthalle, 1972–73.

Kötzsche, 1979
Lieselotte Kötzsche, in *Age of Spirituality: Late Antique and Early Christian Art, Third to Seventh Century* (exhib. cat.), ed. by Kurt Weitzmann, New York, The Metropolitan Museum of Art, 1979.

Kratz, 1972
Artur Kratz, "Goldschmiedetechnische Untersuchung von Goldarbeiten im Besitz der Skulpturenabteilung der Staatlichen Museen Preussischer Kulturbesitz Berlin (Frühchristlich-Byzantinische Sammlung)," *Aachener Kunstblätter* 43 (1972), pp. 156–89.

Kraus, 1966
Henry Kraus, "Notre-Dame's Vanished Medieval Glass. I.—The Iconography," *Gazette des beaux-arts*, 6th ser., 68 (September 1966), pp. 131–48.

Kraus, 1967
Henry Kraus, "Notre-Dame's Vanished Medieval Glass. II.—The Donors," *Gazette des beaux-arts*, 6th ser., 69 (February 1967), pp. 65–78.

Kraus, 1981
Illuminated Manuscripts from the Eleventh to the Eighteenth Centuries (H. P. Kraus dealer's cat. no. 159), New York, 1981.

Kreytenberg, 1984
Gert Kreytenberg, *Andrea Pisano und die toskanische Skulptur des 14. Jahrhunderts* (Italienische Forschungen, 3rd ser., vol. 14), Munich, 1984.

Kunst um 1400 am Mittelrhein, 1975
Kunst um 1400 am Mittelrhein, ein Teil der Wirklichkeit (exhib. cat.), Frankfurt-am-Main, Liebieghaus, Museum Alter Plastik, 1975.

Kurth, 1926
Betty Kurth, *Die deutschen Bildteppiche des Mittelalters*, 3 vols., Vienna, 1926.

Kurth, 1929
Betty Kurth, "Die Wiener Tafelmalerei in der ersten Hälfte des 14. Jahrhunderts und ihre Ausstrahlungen nach Franken und Bayern," *Jahrbuch der kunsthistorischen Sammlungen in Wien*, n.s., 3 (1929), pp. 25–55.

Labarte, 1879
Jules Labarte, *Inventaire du mobilier de Charles V, roi de France* (Comité des travaux historiques et scientifiques, Collection de documents inédits sur l'histoire de France, 3rd ser., Archéologie), Paris, 1879.

Lafond, 1913
Jean Lafond, "Vitraux," in A. Loisel, *La Cathédrale de Rouen* (Petites Monographies des grands édifices de la France), Paris, 1913, pp. 110–23.

Lafond, 1927
Jean Lafond, "Vitraux," in André Masson, *L'Église abbatiale Saint-Ouen de Rouen* (Petites Monographies des grands édifices de la France), Paris, 1927, pp. 74–94.

Lafond, 1954
Jean Lafond, "Le Vitrail du XIVe siècle en France: Étude historique et descriptive," in Louise Lefrançois-Pillion, *L'Art du XIVe siècle en France*, Paris, 1954, pp. 185–238.

Lafond, 1959
Jean Lafond, "Notre-Dame de Paris," in Marcel Aubert et al., *Les Vitraux de Notre-Dame et de la Sainte-Chapelle de Paris* (Corpus Vitrearum Medii Aevi, France, vol. 1, Département de la Seine, 1), Paris, 1959, pp. 11–67.

Lafond, 1970
Jean Lafond, *Les Vitraux de l'église Saint-Ouen de Rouen* (Corpus Vitrearum Medii Aevi, France, vol. 4, pt. 2, vol. 1, Département de la Seine-Maritime, 2), Paris, 1970.

Lafond, 1975
Jean Lafond, "La Verrière des Sept Dormants d'Éphèse et l'ancienne vitrerie de la cathédrale de Rouen," in *The Year 1200: A Symposium*, New York, The Metropolitan Museum of Art, 1975, pp. 399–416.

Lafond, 1978
Jean Lafond, *Le Vitrail: Origines, technique, destinées*, Paris, 1978.

Lamm, 1929–30
Carl Johan Lamm, *Mittelalterliche Gläser und Steinschnittarbeiten aus dem Nahen Osten* (Forschungen zur islamischen Kunst, 5), 2 vols., Berlin, 1929–30.

Lamy-Lassalle, 1990
Colette Lamy-Lassalle, "Enseignes de pèlerinage de Saint Léonard," *Bulletin de la Société nationale des antiquaires de France*, 1990, pp. 157–66.

Landais, 1992
Hubert Landais, "The Cloisters or the Passion for the Middle Ages," in *The Cloisters: Studies in Honor of the Fiftieth Anniversary*, ed. by Elizabeth C. Parker, with Mary B. Shepard, New York, 1992, pp. 41–48.

Lasko, 1994
Peter Lasko, *Ars Sacra, 800–1200*, 2nd ed., New Haven and London, 1994.

Leeds, 1933
Edward Thurlow Leeds, *Celtic Ornament in the British Isles Down to A.D. 700*, Oxford, 1933.

Leeds, 1936
Edward Thurlow Leeds, *Early Anglo-Saxon Art and Archaeology; Being the Rhind Lectures, Delivered in Edinburgh, 1935*, Oxford, 1936.

Leeds, 1949
Edward Thurlow Leeds, *A Corpus of Early Anglo-Saxon Great Square-headed Brooches*, Oxford, 1949.

Legner, 1969
Anton Legner, "Der Alabasteraltar aus Rimini," *Städel-Jahrbuch*, n.s., 2 (1969), pp. 101–68.

Lehmann-Brockhaus, 1942–44
Otto Lehmann-Brockhaus, "Die Kanzeln der Abruzzen im 12. und 13. Jahrhundert," *Römisches Jahrbuch für Kunstgeschichte* 6 (1942–44), pp. 257–428.

Lehner, 1871
F. A. Lehner, *Verzeichniss der Schnitzwerke*, Sigmaringen, Germany, Fürstlich Hohenzollernsches Museum, 1871.

Lehrs, 1930
Max Lehrs, *Geschichte und kritischer Katalog des deutschen, niederländischen und französischen Kupferstichs im XV. Jahrhundert*, vol. 7, Vienna, 1930.

Lemoisne, 1909
P. André Lemoisne, "Miniatures et dessins," in Paul Leprieur, André Pératé, and P. André Lemoisne, *Catalogue raisonné de la collection Martin Le Roy*, vol. 5, Paris, 1909, pp. 129–81.

Leone de Castris, 1980
Pierluigi Leone de Castris, "Tondino di Guerrino e Andrea Riguardi: Orafi e smaltisti a Siena (1308–1338)," *Prospettiva*, no. 21 (April 1980), pp. 24–44.

Leone de Castris, 1988
Pierluigi Leone de Castris, "Sullo smalto fiorentino di primo Trecento," *Bollettino d'arte*, supplement to no. 43 ("Oreficerie e smalti traslucidi nei secoli XIV e XV"), 1988, pp. 41–56.

Levárdy, 1963
Ferenc Levárdy, "Il Leggendario Ungherese degli Angiò conservato nella Biblioteca Vaticana, nel Morgan Library e nell'Ermitage," *Acta Historiae Artium* 9 (1963), pp. 75–138.

Levárdy, 1973
Ferenc Levárdy, *Magyar Anjou Legendárium: Hasonmás kiadás, a bevezetö tanulmányt írta, a legendaszövegeket összeállította és a kiadást sajtó alá rendezte*, Budapest, 1973.

Levi, 1947
Doro Levi, *Antioch Mosaic Pavements* (Publications of the Committee for the Excavation of Antioch and Its Vicinity, 4), 2 vols., Princeton and London, 1947.

Liber quotidianus contrarotulatoris garderobae, 1787
Liber quotidianus contrarotulatoris garderobae: Anno regni regis Edwardi primi vicesimo octavo A.D. MCCXCIX & MCCC, London, 1787.

Lightbown, 1978
Ronald W. Lightbown, *Secular Goldsmiths' Work in Medieval France: A History* (Reports of the Research Committee of the Society of Antiquaries of London, no. 36), London, 1978.

Lightbown, 1992
Ronald W. Lightbown, *Mediaeval European Jewellery, with a Catalogue of the Collection in the Victoria & Albert Museum*, London, 1992.

Lillich, 1990
Meredith Parsons Lillich, "Les Vitraux de la cathédrale de Sées à Los Angeles et dans d'autres musées américains," *Annales de Normandie* 40 (July–October 1990), pp. 151–75.

Lindley, 1987
Phillip Lindley, in *Age of Chivalry: Art in Plantagenet England, 1200–1400* (exhib. cat.), ed. by Jonathan Alexander and Paul Binski, London, Royal Academy of Arts, 1987.

Little, 1979 a
Charles T. Little, "Ivoires et art gothique," *Revue de l'art*, no. 46 (1979), pp. 58–67.

Little, 1979 b
Charles T. Little, in *Notable Acquisitions, 1975–1979: Selected by Philippe de Montebello, Director*, New York, The Metropolitan Museum of Art, 1979.

Little, 1980
Charles T. Little, in *Notable Acquisitions, 1979–1980: Selected by Philippe de Montebello, Director*, New York, The Metropolitan Museum of Art, 1980.

Little, 1981 a
Charles T. Little, "Membra Disjecta: More Early Stained Glass from Troyes Cathedral," *Gesta* 10, no. 1 (1981), pp. 119–39.

Little, 1981 b
Charles T. Little, in *Notable Acquisitions, 1980–1981: Selected by Philippe de Montebello, Director*, New York, The Metropolitan Museum of Art, 1981.

Little 1981 c
Charles T. Little, in Sumner McKnight Crosby et al., *The Royal Abbey of Saint-Denis in the Time of Abbot Suger (1122–1151)* (exhib. cat.), New York, The Metropolitan Museum of Art, 1981.

Little, 1982
Charles T. Little, in *Notable Acquisitions, 1981–1982: Selected by Philippe de Montebello, Director*, New York, The Metropolitan Museum of Art, 1982.

Little, 1984 a
Charles T. Little, in *The Jack and Belle Linsky Collection in The Metropolitan Museum of Art*, New York, 1984.

Little, 1984 b
Charles T. Little, in *Notable Acquisitions, 1983–1984: Selected by Philippe de Montebello, Director*, New York, The Metropolitan Museum of Art, 1984.

Little, 1985 a
Charles T. Little, "A New Ivory of the Court School of Charlemagne," in *Studien zur mittelalterlichen Kunst, 800–1250: Festschrift für Florentine Mütherich zum 70. Geburtstag*, ed. by Katharina Bierbrauer, Peter K. Klein, and Willibald Sauerländer, Munich, 1985, pp. 11–28.

Little, 1985 b
Charles T. Little, in Lisbeth Castelnuovo-Tedesco, "Romanesque Sculpture in North American Collections. XXIII. The Metropolitan Museum of Art. Part III: Italy (2)," *Gesta* 24 (1985), pp. 157–58.

Little, 1985 c
Charles T. Little, in *Notable Acquisitions, 1984–1985: Selected by Philippe de Montebello, Director*, New York, The Metropolitan Museum of Art, 1985.

Little, 1987 a
Charles T. Little, "Romanesque Sculpture in North American Collections. XXVI. The Metropolitan Museum of Art. Part VI. Auvergne, Burgundy, Central France, Meuse Valley, Germany," *Gesta* 26 (1987), pp. 153–68.

Little, 1987 b
Charles T. Little, in *Recent Acquisitions: A Selection, 1986–1987*, New York, The Metropolitan Museum of Art, 1987.

Little, 1988
Charles T. Little, in *Recent Acquisitions: A Selection, 1987–1988*, New York, The Metropolitan Museum of Art, 1988.

Little, 1989 a
Charles T. Little, in *Treasures from The Metropolitan Museum of Art: French Art from the Middle Ages to the Twentieth Century* (exhib. cat.), Yokohoma Museum of Art, 1989.

Little, 1989 b
Charles T. Little, in "Recent Acquisitions: A Selection, 1988–1989," *The Metropolitan Museum of Art Bulletin* 47, no. 2 (Fall 1989).

Little, 1990
Charles T. Little, in *Decorative and Applied Art from Late Antiquity to Late Gothic* (exhib. cat.), Leningrad, State Hermitage Museum, and Moscow, State Pushkin Museum, Leningrad, 1990 (in Russian).

Little, 1991
Charles T. Little, in "Recent Acquisitions: A Selection, 1990–1991," *The Metropolitan Museum of Art Bulletin* 49, no. 2 (Fall 1991).

Little, 1992
Charles T. Little, in "Recent Acquisitions: A Selection, 1991–1992," *The Metropolitan Museum of Art Bulletin* 50, no. 2 (Fall 1992).

Little, 1993 a
Charles T. Little, in *The Art of Medieval Spain, A.D. 500–1200*, New York, The Metropolitan Museum of Art, 1993.

Little, 1993 b
Charles T. Little, in "Recent Acquisitions, A Selection: 1992–1993," *The Metropolitan Museum of Art Bulletin* 51, no. 2 (Fall 1993).

Little, 1994 a
Charles T. Little, with Lore Holmes, "Searching for the Provenances of Medieval Stone Sculpture: Possibilities and Limitations," *Gesta* 33 (1994), pp. 29–37.

Little, 1994 b
Charles T. Little, in "Recent Acquisitions, a Selection: 1993–1994," *The Metropolitan Museum of Art Bulletin* 52, no. 2 (Fall 1994).

Little, 1997 a
Charles T. Little, in *The Glory of Byzantium: Art and Culture of the Middle Byzantine Era, A.D. 843–1261* (exhib. cat.), ed. by Helen C. Evans and William D. Wixom, New York, The Metropolitan Museum of Art, 1997.

Little, 1997 b
Charles T. Little, in *Images in Ivory: Precious Objects of the Gothic Age* (exhib. cat.), ed. by Peter Barnet, The Detroit Institute of Arts, 1997.

Little, 1997 c
Charles T. Little, in "Recent Acquisitions, a Selection: 1996–1997," *The Metropolitan Museum of Art Bulletin* 55, no. 2 (Fall 1997).

Little, forthcoming
Charles T. Little, "The Road to Glory: New Early Images of Thomas Becket's Life," in *Reading Medieval Images: Essays in Honor of Ilene H. Forsyth*, ed. by Elizabeth Sears and Thelma R. Thomas, forthcoming.

Little and Husband, 1987
Charles T. Little and Timothy B. Husband, *Europe in the Middle Ages*, New York, The Metropolitan Museum of Art, 1987.

Löcher, 1986
Kurt Löcher, in *Gothic and Renaissance Art in Nuremberg, 1300–1550* (exhib. cat.), New York, The Metropolitan Museum of Art, and Nuremberg, Germanisches Nationalmuseum, Munich and New York, 1986.

Longhurst, 1929
Margaret H. Longhurst, *Catalogue of Carvings in Ivory*, pt. 2, London, Victoria and Albert Museum, 1929.

Lüdke, 1983
Dietmar Lüdke, *Die Statuetten der gotischen Goldschmiede: Studien zu den "autonomen" und vollrunden Bildwerken der Goldschmiedeplastik und den Statuettenreliquiaren in Europa zwischen 1230 und 1530* (Tuduv-Studien, Reihe Kunstgeschichte, vol. 4), 2 vols., Munich, 1983.

Lugt, 1968
Frits Lugt, *Inventaire général des dessins des écoles du nord: Maîtres des anciens Pays-Bas nés avant 1550*, Paris, Cabinet des Dessins, Musée du Louvre, 1968.

Lüthgen, 1920
Eugen Lüthgen, *Die abendländische Kunst des 15. Jahrhunderts* (Forschungen zur Formgeschichte der Kunst aller Zeiten und Völker, vol. 1), Bonn and Leipzig, 1920.

Lüthgen, 1921
Eugen Lüthgen, *Rheinische Kunst des Mittelalters aus Kölner Privatbesitz* (Forschungen zur Kunstgeschichte Westeuropas, vol. 1), Bonn and Leipzig, 1921.

Lutze and Zimmermann, 1932
Eberhard Lutze and E. Heinrich Zimmermann, "Nürnberger Malerei, 1350–1450," *Anzeiger des Germanischen Nationalmuseums*, 1930–31 (published 1932).

E. D. Maguire, 1997
Eunice Dauterman Maguire, in *The Glory of Byzantium: Art and Culture of the Middle Byzantine Era, A.D. 843–1261* (exhib. cat.), ed. by Helen C. Evans and William D. Wixom, New York, The Metropolitan Museum of Art, 1997.

H. Maguire, 1996
Henry Maguire, *The Icons of Their Bodies: Saints and Their Images in Byzantium*, Princeton, 1996.

H. Maguire, 1997
Henry Maguire, in *The Glory of Byzantium: Art and Culture of the Middle Byzantine Era, A.D. 843–1261* (exhib. cat.), ed. by Helen C. Evans and William D. Wixom, New York, The Metropolitan Museum of Art, 1997.

Majic, 1995
P. Timotheus Majic, "Die Apostolische Pönitentiarie im 14. Jahrhundert," *Römische quartalschrift* 50 (1955), pp. 129–77.

Mango, 1972
Cyril Mango, comp., *The Art of the Byzantine Empire, 312–1453: Sources and Documents* (Sources and Documents in the History of Art Series), Englewood Cliffs, New Jersey, 1972.

Mango, 1986
Marlia Mundell Mango, *Silver from Early Byzantium: The Kaper Koraon and Related Treasures* (exhib. cat.) (A Walters Art Gallery Publication in the History of Art), Baltimore, The Walters Art Gallery, 1986.

Mann, 1977
Vivian B. Mann, "Romanesque Ivory Tablemen," Ph.D. dissertation, New York University, 1977 (microfilm, Ann Arbor, Michigan).

Marinelli, 1983
Sergio Marinelli, *Museum of Castelvecchio, Verona*, Venice, 1983.

Martin, 1994
M. Martin, in *Reallexikon der germanischen Altertumskunde*, ed. by Johannes Hoops, vol. 8, Berlin, 1994.

Martin and Cahier, 1841–44
Arthur Martin and Charles Cahier, *Monographie de la cathédrale de Bourges*, 3 vols., Paris, 1841–44.

Martini, 1985
Laura Martini, in *Oreficeria sacra nel Chianti Senese (XII–XV secolo)* (exhib. cat.), ed. by Cecilia Alessi and Laura Martini, Siena, San Gusmè, 1985.

Martiniani-Reber, 1986
Marielle Martiniani-Reber, *Lyon, Musée Historique des Tissus: Soieries sassanides, coptes et byzantines, Ve–XIe siècles* (Inventaire des collections publiques françaises, 30), Paris, 1986.

Martiniani-Reber, 1992
Marielle Martiniani-Reber, in *Byzance: L'Art byzantin dans les collections publiques françaises* (exhib. cat.), Paris, Musée du Louvre, 1992.

Mathews, 1982
Thomas F. Mathews, "The Early Armenian Iconographic Program of the Ējmiacin Gospel (Erevan, Matendaran MS 2374, *olim* 229)," in *East of Byzantium: Syria and Armenia in the Formative Period*, ed. by Nina G. Garsoïan, Thomas F. Mathews, and Robert W. Thomson, Washington, D.C., 1982, pp. 199–215.

Mathews, 1997
Thomas F. Mathews, in *The Glory of Byzantium: Art and Culture of the Middle Byzantine Era, A.D. 843–1261* (exhib. cat.), ed. by Helen C. Evans and William D. Wixom, New York, The Metropolitan Museum of Art, 1997.

May, 1957
Florence Lewis May, *Silk Textiles of Spain, Eighth to Fifteenth Century* (Hispanic Notes & Monographs, Essays, Studies, and Brief Biographies, Peninsular Series), New York, 1957.

Medieval and Renaissance Miniatures, 1975
Medieval and Renaissance Miniatures from the National Gallery of Art, comp. by Carra Ferguson, David S. Stevens Schaff, and Gary Vikan, Washington, D.C., 1975.

Megaw, 1970
J. V. S. Megaw, *Art of the European Iron Age: A Study of the Elusive Image*, New York and Evanston, Illinois, 1970.

Megaw and Megaw, 1989
Ruth Megaw and Vincent Megaw, *Celtic Art: From Its Beginnings to the Book of Kells*, New York, 1989.

Meiss, 1967
Millard Meiss, *French Painting in the Time of Jean de Berry: The Late Four-teenth Century and the Patronage of the Duke* (National Gallery of Art Kress Foundation Studies in the History of European Art, no. 2), 2 vols., London, 1967.

Meiss, 1974
Millard Meiss, *French Painting in the Time of Jean de Berry: The Limbourgs and Their Contemporaries* (Franklin Jasper Walls Lectures), 2 vols., New York, 1974.

Meister von Grosslobming, 1994
Der Meister von Grosslobming (exhib. cat.), ed. by Arthur Saliger, Vienna, Österreichische Galerie, 1994.

Melnikas, 1975
Anthony Melnikas, *The Corpus of the Miniatures in the Manuscripts of Decretum Gratiani* (Studia Gratiana, vols. 16–18), 3 vols., 1975.

Mende, 1974
Ursula Mende, "Nürnberger Aquamanilien und verwandte Gussarbeiten um 1400," *Anzeiger des Germanischen Nationalmuseums*, 1974, pp. 8–25.

Mende, 1983
Ursula Mende, *Die Bronzetüren des Mittelalters, 800–1200*, Munich, 1983.

Mende, 1992
Ursula Mende, "Schreiber-Mönch und reitende Superbia: Bronzeleuchter der Magdeburger Gusswerkstatt des 12. Jahrhunderts," in *Erzbischof Wichmann (1152–1192) und Magdeburg im hohen Mittelalter: Stadt—Erzbistum—Reich* (exhib. cat.), Magdeburg, Kulturhistorisches Museum, 1992, pp. 98–115.

Menghin, 1983
Wilfried Menghin, *Gotische und langobardische Funde aus Italien im Germanischen Nationalmuseum, Nürnberg* (Die vor- und frügeschichtlichen Altertümer in Germanischen Nationalmuseum, vol. 2), Nuremberg, 1983.

Meriçboyu and Atasoy, 1983
Yildiz Meriçboyu and Sümer Atasoy, *Büst seklinde kantar ağirliklari/Steelyard Weights in the Form of Busts in the Archaeological Museum of Istanbul* (İstanbul Arkeoloji Müzesindeki), Istanbul, 1983.

Merrill, 1990
Allison A. Merrill, *Medieval Masterworks, 1200–1520* (exhib. cat.), New York, Blumka II Gallery, 1990.

Metropolitan Museum of Art Guide, 1994
The Metropolitan Museum of Art Guide: Works of Art Selected by Philippe de Montebello, Director, 2nd ed., New York, The Metropolitan Museum of Art, 1994.

Meyrick, 1836
Samuel R. Meyrick, "Account of the Doucean Museum, Now at Goodrich Court," *The Gentleman's Magazine* (April 1836), pp. 378–84.

Michaelides, 1987
Dimitri Michaelides, *Cypriot Mosaics*, Nicosia, 1987.

Middeldorf Kosegarten, 1964
Antje Middeldorf Kosegarten, "Inkunabeln der gotischen Kleinplastik in Hartholz," *Pantheon* 22 (September–October 1964), pp. 302–21.

Millar, 1930
Eric George Millar, *The Library of A. Chester Beatty: A Descriptive Catalogue of the Western Manuscripts*, 2 vols., Oxford, 1930.

Millar, 1953
Eric George Millar, *An Illuminated Manuscript of La Somme le Roy, Attributed to the Parisian Miniaturist Honoré*, Oxford, 1953.

Millar, 1959
Eric George Millar, ed., *The Parisian Miniaturist Honoré* (The Faber Library of Illuminated Manuscripts), London, 1959.

Miller, 1983
Albrecht Miller, "Die Figur des hl. Rasso in der Münchner Frauenkirche," *Weltkunst* 53 (July 1, 1983), pp. 1777–80.

Milliken, 1939
William M. Milliken, "Late German Gothic Sculpture," *The Bulletin of The Cleveland Museum of Art* 26 (April 1939), pp. 43–46.

Milliken, 1958
William M. Milliken, "Early Byzantine Silver," *The Bulletin of The Cleveland Museum of Art* 45 (March 1958), pp. 35–41.

Miner and Edelstein, 1945
Dorothy Miner and Emma J. Edelstein, "A Carving in Lapis Lazuli," *The Journal of The Walters Art Gallery* 7–8 (1944–45; published 1945), pp. 83–103.

MMA Annual Report, 1979
The Metropolitan Museum of Art: One Hundred Ninth Annual Report of the Trustees for the Fiscal Year July 1, 1978, through June 30, 1979, New York, 1979.

MMA Annual Report, 1980
The Metropolitan Museum of Art: One Hundred Tenth Annual Report of the Trustees for the Fiscal Year July 1, 1979, through June 30, 1980, New York, 1980.

MMA Annual Report, 1981
The Metropolitan Museum of Art: One Hundred Eleventh Annual Report of the Trustees for the Fiscal Year July 1, 1980, through June 30, 1981, New York, 1981.

MMA Annual Report, 1982
The Metropolitan Museum of Art: One Hundred Twelfth Annual Report of the Trustees for the Fiscal Year July 1, 1981, through June 30, 1982, New York, 1982.

MMA Annual Report, 1983
The Metropolitan Museum of Art: One Hundred Thirteenth Annual Report of the Trustees for the Fiscal Year July 1, 1982, through June 30, 1983, New York, 1983.

MMA Annual Report, 1984
The Metropolitan Museum of Art: One Hundred Fourteenth Annual Report of the Trustees for the Fiscal Year July 1, 1983, through June 30, 1984, New York, 1984.

MMA Annual Report, 1985
The Metropolitan Museum of Art: One Hundred Fifteenth Annual Report of the Trustees for the Fiscal Year July 1, 1984, through June 30, 1985, New York, 1985.

MMA Annual Report, 1987
The Metropolitan Museum of Art: One Hundred Seventeenth Annual Report of the Trustees for the Fiscal Year July 1, 1986, through June 30, 1987, New York, 1987.

MMA Annual Report, 1990
The Metropolitan Museum of Art: One Hundred Twentieth Annual Report of the Trustees for the Fiscal Year July 1, 1989, through June 30, 1990, New York, 1990.

MMA Annual Report, 1991
The Metropolitan Museum of Art: One Hundred Twenty-first Annual Report of the Trustees for the Fiscal Year July 1, 1990, through June 30, 1991, New York, 1991.

MMA Annual Report, 1992
The Metropolitan Museum of Art: One Hundred Twenty-second Annual Report of the Trustees for the Fiscal Year July 1, 1991, through June 30, 1992, New York, 1992.

MMA Annual Report, 1993
The Metropolitan Museum of Art: One Hundred Twenty-third Annual Report of the Trustees for the Fiscal Year July 1, 1992, through June 30, 1993, New York, 1993.

MMA Annual Report, 1994
The Metropolitan Museum of Art: One Hundred Twenty-fourth Annual Report of the Trustees for the Fiscal Year July 1, 1993, through June 30, 1994, New York, 1994.

Montelius, 1873
Oscar Montelius, *Antiquités suédoises*, Stockholm, 1873.

Montelius, 1912
Oscar Montelius, *A Guide to the National Historical Museum, Stockholm*, Stockholm, 1912.

Moretti, 1971
Mario Moretti, *Architettura medioevale in Abruzzo (dal VI al XVI secolo)*, Rome, 1971.

Moretti, 1972
Mario Moretti, ed., *Decorazione scultore-architettonica altomedioevale in Abruzzo*, Rome, 1972.

Morey, 1936
Charles Rufus Morey, *Gli oggetti di avorio e di osso del Museo Sacro Vaticano* (Catalogo del Museo Sacro della Biblioteca Apostolica Vaticana, vol. 1), Vatican City, 1936.

Morrall, 1994
Andrew Morrall, "Die Zeichnungen für den Monatszyklus von Jörg Breu d. Ä.: Maler und Glashandwerker im Augsburg des 16. Jahrhunderts," in Hartmut Boockmann et al., *"Kurzweil viel ohn' Mass und Ziel": Alltag und Festtag auf den Augsburger Monatsbildern der Renaissance*, Munich, 1994, pp. 128–47.

Morris, 1927
Frances Morris, "A Group of Early Silks," *Bulletin of The Metropolitan Museum of Art* 22 (April 1927), pp. 118–20.

Müller, 1932
Theodor Müller, "Hans Leinberger (zur Ausstellung in Landshut im Juli 1932)," *Zeitschrift für Kunstgeschichte* 1 (1932), pp. 273–88.

Müller, 1966
Theodor Müller, *Sculpture in the Netherlands, Germany, France, and Spain, 1400 to 1500* (Pelican History of Art), Baltimore, 1966.

Müller and Steingräber, 1955
Theodor Müller and Erich Steingräber, "Die französische Goldemailplastik um 1400," *Münchner Jahrbuch der bildenden Kunst*, 3rd ser., 5 (1954; published 1955), pp. 29–79.

Munby, 1972
Alan Noel Latimer Munby, *Connoisseurs and Medieval Miniatures, 1750–1850*, Oxford, 1972.

Murray and Murray, 1996
Peter Murray and Linda Murray, *The Oxford Companion to Christian Art and Architecture*, New York, 1996.

Nesbitt, 1997
John Nesbitt, in *The Glory of Byzantium: Art and Culture of the Middle Byzantine Era, A.D. 843–1261* (exhib. cat.), ed. by Helen C. Evans and William D. Wixom, New York, The Metropolitan Museum of Art, 1997.

Neumann, 1891
Wilhelm Anton Neumann, *Der Reliquienschatz des Hauses Braunschweig-Lüneburg*, Vienna, 1891.

New Catholic Encyclopedia, 1967
New Catholic Encyclopedia, vol. 3, New York, 1967.

Newman, 1978
Suzanne M. Newman, in *Medieval and Renaissance Stained Glass from New England Collections* (exhib. cat.), ed. by Madeline Harrison Caviness, Cambridge, Massachusetts, Busch-Reisinger Museum, Harvard University, Medford, Massachusetts, 1978.

Newton, 1975
Peter A. Newton, "Some New Material for the Study of the Iconography of St Thomas Becket," in *Thomas Becket: Actes du colloque international de Sédières, 19–24 août 1973*, Paris, 1975, pp. 255–63.

Niehr, 1989
Klaus Niehr, in *Kirchenkunst des Mittelalters: Erhalten und Erforschen* (exhib. cat.), ed. by Michael Brandt, Hildesheim, Diözesanmuseum, 1989.

Nijmeegs zilver, 1983
Nijmeegs zilver, 1400–1900 (exhib. cat.) (Catalogi van het kunstbezit van de Gemeente Nijmegen, no. 5), Nijmegen, The Netherlands, Nijmeegs Museum, "Commanderie van Sint-Jan," 1983.

Nockert and Lundvall, 1986
Margareta Nockert and Eva Lundvall, *Ärkebiskoparna från Bremen: En textilarkeologisk undersökning Bremen—Sverige* (exhib. cat.), Stockholm, Statens Historiska Museum, 1986.

Oman, 1957
Charles Chichele Oman, *English Church Plate, 597–1830*, New York and London, 1957.

Orangerie '91, 1991
Orangerie '91: Internationaler Kunsthandel im Martin-Gropius-Bau, Munich, 1991.

Ornamenta Ecclesiae, 1985
Ornamenta Ecclesiae: Kunst und Künstler der Romanik (exhib. cat.), ed. by Anton Legner, 3 vols., Cologne, Schnütgen-Museum, 1985.

Ottin, 1896
Léon Ottin, *Le Vitrail: Son Histoire, ses manifestations à travers les âges et les peuples*, Paris, 1896.

Ousterhout, 1997
Robert G. Ousterhout, in *The Glory of Byzantium: Art and Culture of the Middle Byzantine Era, A.D. 843–1261* (exhib. cat.), ed. by Helen C. Evans and William D. Wixom, New York, The Metropolitan Museum of Art, 1997.

Oxford Dictionary of Byzantium, 1991
The Oxford Dictionary of Byzantium, ed. by Alexander P. Kazhdan et al., 3 vols., New York, 1991.

Oxford Dictionary of the Christian Church, 1957
The Oxford Dictionary of the Christian Church, ed. by Frank Leslie Cross, London and New York, 1957.

Pagnani, 1959
Alberico Pagnani, *Storio di Sassoferrato dalle origini al 1900*, vol. 2, Sassoferrato, 1959.

Painting and Illumination in Early Renaissance Florence, 1994
Painting and Illumination in Early Renaissance Florence, 1300–1450 (exhib. cat.), by Laurence B. Kanter et al., New York, The Metropolitan Museum of Art, 1994.

Palol Salellas, 1952
Pedro de Palol Salellas, "Algunas piezas de adorno de arnés de época tardorromana e hispanovisigoda," *Archivo español de arqueología* 25 (1952), pp. 297–319.

Palol Salellas, 1953–54
Pedro de Palol Salellas, "Bronces de arnés con representaciones zoomórficas," *Ampurias* 15–16 (1953–54), pp. 279–92.

Paoletti, 1893–97
Pietro Paoletti, *L'architettura e la scultura del Rinascimento in Venezia: Ricerche storico-artistiche*, 2 pts., Venice, 1893–97.

Parker and Little, 1994
Elizabeth C. Parker and Charles T. Little, *The Cloisters Cross: Its Art and Meaning*, New York, 1994.

Die Parler und der schöne Stil, 1978–80
Die Parler und der schöne Stil, 1350–1400: Europäische Kunst unter den Luxemburgern (exhib. cat.), ed. by Anton Legner, 5 vols., Cologne, Schnütgen-Museum, 1978–80.

Pastan, 1989
Elizabeth C. Pastan, "Fit for a Count: The Twelfth-Century Stained Glass Panels from Troyes," *Speculum* 64 (April 1989), pp. 338–72.

Paulsen, 1933
Peter Paulsen, *Studien zur Wikinger-Kultur* (Forschungen zur Vor- und Frühgeschichte aus dem Museum Vorgeschichtlicher Altertümer in Kiel, vol. 1), Neumünster, Germany, 1933.

Pawelec, 1990
Katharina Pawelec, *Aachener Bronzegitter: Studien zur karolingischen Ornamentik um 800* (Bonner Beiträge zur Kunstwissenschaft, vol. 12), Cologne, 1990.

Payne, 1895
George Payne, "Some Anglo-Saxon Ornaments Found near Teynham, Kent," *Proceedings of the Society of Antiquaries of London*, 2nd ser., 15 (1893–95), p. 184.

Pazaras, 1997
Theocharis N. Pazaras, in *The Glory of Byzantium: Art and Culture of the Middle Byzantine Era, A.D. 843–1261* (exhib. cat.), ed. by Helen C. Evans and William D. Wixom, New York, The Metropolitan Museum of Art, 1997.

Pearson and MacCoull, 1989
Birger A. Pearson and Leslie S. B. MacCoull, "Everyday Life in Roman-Byzantine Egypt," in Florence D. Friedman, *Beyond the Pharaohs: Egypt and the Copts in the 2nd to 7th Centuries A.D.* (exhib. cat.), Providence, Museum of Art, Rhode Island School of Design, and Baltimore, The Walters Art Gallery, Providence, 1989, pp. 28–36.

Peeters, 1985
C. J. A. C. Peeters, *De Sint Janskathedraal te 's-Hertogenbosch* (De Nederlandse monumenten van geschiedenis en kunst), The Hague, 1985.

Perrot, 1970
Françoise Perrot, in "Séance du 14 octobre," *Bulletin de la Société nationale des antiquaires de France*, 1970, pp. 262–64.

Perrot, 1972
Françoise Perrot, *Le Vitrail à Rouen* (Connaître Rouen), Rouen, 1972.

Peters, 1979
Jane S. Peters, "Early Drawings by Augustin Hirschvogel," *Master Drawings* 17 (Winter 1979), pp. 359–92.

Peters, 1980
Jane S. Peters, "Frühe Glasgemälde von Augustin Hirschvogel," *Anzeiger des Germanischen Nationalmuseums*, 1980, pp. 79–92.

Pirling, 1974
Renate Pirling, *Das römisch-fränkische Gräberfeld von Krefeld-Gellep, 1960–1963* (Germanische Denkmäler der Völkerwanderungszeit, series B, Die fränkischen Altertümer des Rheinlandes, vol. 8), Berlin, 1974.

Pope-Hennessy, 1964
John Pope-Hennessy, *Catalogue of Italian Sculpture in the Victoria and Albert Museum*, 3 vols., London, 1964.

Porter, 1974
Dean A. Porter, "Ivory Carving in Later Medieval England, 1200–1400," 2 vols., Ph.D. dissertation, State University of New York at Binghamton, 1974 (microfilm, Ann Arbor, Michigan).

Powell, 1966
Thomas George Eyre Powell, *Prehistoric Art* (Praeger World of Art Series), New York, 1966.

Previtali, 1995
Giovanni Previtali, "Scultura e smalto traslucido dell'oreficeria toscana del primo Trecento: Una questione preliminare," *Prospettiva*, no. 79 (July 1995), pp. 2–17.

"Principales Acquisitions," 1994
"Principales Acquisitions des musées en 1993," *La Chronique des arts* (supplement to the *Gazette des beaux-arts*) (March 1994), pp. 3–80.

Rackham, 1929
Bernard Rackham, "Stained Glass in the Collection of Mr. F. E. Sidney. II. Netherlandish and German Medallions," *Old Furniture: A Magazine of Domestic Ornament* 8 (September 1929), pp. 13–18.

Rada y Delgado and Malibrán, 1871
Juan de Dios de la Rada y Delgado and Juan de Malibrán, *Memoria que presentan al Excmo. Sr. Ministro de Fomento, dando cuenta de los trabajos practicados y adquisiciones hechas para el Museo Arqueológico Nacional*, Madrid, 1871.

Rademacher, 1931
Franz Rademacher, "Die gotischen Gläser der Sammlung Seligmann-Köln," *Pantheon* 8 (July 1931), pp. 290–94.

Randall, 1985
Richard H. Randall, Jr., with Diana Buitron et al., *Masterpieces of Ivory from The Walters Art Gallery*, Baltimore and New York, 1985.

Randall, 1994
Richard H. Randall, Jr., "Dutch Ivories of the Fifteenth Century," *Nederlands kunsthistorisch jaarboek* 45 (1994), pp. 127–39.

Rapp Buri and Stucky-Schürer, 1990
Anna Rapp Buri and Monica Stucky-Schürer, *Zahm und Wild: Basler und Strassburger Bildteppiche des 15. Jahrhunderts* (exhib. cat.), Basel, Historisches Museum, Mainz, 1990.

Réau, 1955–59
Louis Réau, *Iconographie de l'art chrétien*, 3 vols., Paris, 1955–59.

Recht, 1983
Roland Recht, "Sculptures découvertes à Saint-Lazare d'Avallon," *Bulletin monumental* 141 (1983), pp. 149–63.

Recht, 1987
Roland Recht, *Nicolas de Leyde et la sculpture à Strasbourg (1460–1525)*, Strasbourg, 1987.

Reich der Salier, 1992
Das Reich der Salier, 1024–1125 (exhib. cat.), Pfalz, Historisches Museum (organized by Mainz, Römisch-Germanisches Zentralmuseum, Forschungsinstitut für Vor- und Frühgeschichte, and Bischöfliches Dom- und Diözesanmuseum), Sigmaringen, Germany, 1992.

Reinburg, 1995
Virginia Reinburg, "Remembering the Saints," in *Memory and the Middle Ages* (exhib. cat.), ed. by Nancy Netzer and Virginia Reinburg, Chestnut Hill, Massachusetts, Boston College Museum of Art, 1995, pp. 17–32.

Renner, 1970
Dorothee Renner, *Die durchbrochenen Zierscheiben der Merowingerzeit* (Kataloge vor- und frühgeschichtlicher Altertümer, vol. 18), Mainz and Bonn, 1970.

de Ricci, 1913
Seymour de Ricci, *Catalogue d'une collection de miniatures gothiques et persanes appartenant à Léonce Rosenberg*, Paris, 1913.

de Ricci, 1937
Seymour de Ricci, with W. J. Wilson, *Census of Medieval and Renaissance Manuscripts in the United States and Canada*, vol. 2, New York, 1937.

Ripoll López and Darder Lissón, 1994
Gisela Ripoll López and Marta Darder Lissón, "*Frena equorum*: Guarniciones de frenos de caballos en la antigüedad tardía hispánica," *Espacio, tiempo y forma* (1st ser., Prehistoria y arqueología) 7 (1994), pp. 277–356.

Ritter, 1926
Georges Ritter, ed., *Les Vitraux de la cathédrale de Rouen, XIIIe, XIVe, XVe, et XVIe siècles*, Cognac, 1926.

Rohmeder, 1971
Jürgen Rohmeder, *Der Meister des Hochaltars in Rabenden* (Münchner kunsthistorische Abhandlungen, vol. 3), Munich and Zurich, 1971.

Romanelli, 1992
Susan Jean Romanelli, "South Netherlandish Boxwood Devotional Sculpture, 1475–1530," Ph.D. dissertation, Columbia University, 1992 (microfilm, Ann Arbor, Michigan).

Romanesque Art, 1959
Romanesque Art, ca. 1050–1200, from Collections in Great Britain and Eire (exhib. cat.), Manchester, England, City of Manchester Art Gallery, 1959.

Rosasco and Ward, 1987
Joan Rosasco and Michael Ward, *Origins of Design: Bronze Age and Celtic Masterworks* (exhib. cat.), New York, Michael Ward, Inc., 1987.

Ross, 1954
Marvin C. Ross, "Two Byzantine Nielloed Rings," in *Studies in Art and Literature for Belle da Costa Greene*, ed. by Dorothy Miner, Princeton, 1954, pp. 169–71.

Ross, 1962

Marvin C. Ross, *Catalogue of the Byzantine and Early Mediaeval Antiquities in the Dumbarton Oaks Collection* (Dumbarton Oaks Catalogues), vol. 1, *Metalwork, Ceramics, Glass, Glyptics, Painting*, Washington, D.C., 1962.

Ross, 1965

Marvin C. Ross, *Catalogue of the Byzantine and Early Mediaeval Antiquities in the Dumbarton Oaks Collection* (Dumbarton Oaks Catalogues), vol. 2, *Jewelry, Enamels, and Art of the Migration Period*, Washington, D.C., 1965.

de Rossi, 1880

Giovanni Battista de Rossi, in *Bullettino di archeologia christiana* 7 (1880).

Rouse and Rouse, 1990

R. H. Rouse and M. A. Rouse, "The Commercial Production of Manuscript Books in Late-Thirteenth-Century and Early-Fourteenth-Century Paris," in *Medieval Book Production, Assessing the Evidence: Proceedings of the Second Conference of the Seminar in the History of the Book to 1500, Oxford, July 1988*, ed. by Linda L. Brownrigg, Los Altos Hills, California, 1990, pp. 103–15.

Salles and Lion-Goldschmidt, 1956

Georges A. Salles and Daisy Lion-Goldschmidt, *Adolphe Stoclet Collection*, pt. 1, *Selection of the Works Belonging to Madame Feron-Stoclet*, Brussels, 1956.

Sammlung E. und M. Kofler-Truniger, 1964

Sammlung E. und M. Kofler-Truniger, Luzern (exhib. cat.), Zurich, Kunsthaus, 1964.

Sammlung R. von Passavant-Gontard, 1929

Sammlung R. von Passavant-Gontard (Veröffentlichung des Staedelschen Kunstinsitituts, 3), Frankfurt-am-Main, 1929.

Sandars, 1968

Nancy K. Sandars, *Prehistoric Art in Europe* (Pelican History of Art), Harmondsworth, Middlesex, England, 1968.

Sande, 1996

Siri Sande, in *Byzantium: Late Antique and Byzantine Art in Scandinavian Collections* (exhib. cat.), ed. by Jens Fleischer, Øystein Hjort, and Mikael Bøgh Rasmussen, Copenhagen, Ny Carlsberg Glyptotek, 1996.

Sandoval, 1601

Prudencio de Sandoval, *Primera parte de las fundaciones de los monesterios del glorioso padre San Benito*, Madrid, 1601.

Sauerländer, 1972

Willibald Sauerländer, *Gothic Sculpture in France, 1140–1270*, trans. by Janet Sondheimer, London, 1972.

Saunders, 1983

W. B. R. Saunders, "The Aachen Reliquary of Eustathius Maleinus, 969–970," *Dumbarton Oaks Papers*, no. 36 (1982; published 1983), pp. 211–19.

Schädler, 1974

Alfred Schädler, "Studien zu Nicolaus Gerhaert von Leiden: Die Nördlinger Hochaltarfiguren und die Dangolsheimer Muttergottes in Berlin," *Jahrbuch der Berliner Museen* 16 (1974), pp. 46–82.

Schädler, 1983

Alfred Schädler, "Die 'Dürer'-Madonna der ehemaligen Sammlung Rothschild in Wien und Nicolaus Gerhaert," *Städel-Jahrbuch*, n.s., 9 (1983), pp. 41–54.

Schäfer, 1891

Georg Schäfer, *Provinz Starkenburg: Kreis Erbach* (Kunstdenkmäler im Grossherzogthum Hessen, Inventarisirung und beschreibende Darstellung der Werke der Architektur, Plastik, Malerei und des Kunstgewerbes bis zum Schluss des XVIII. Jahrhunderts), Darmstadt, 1891.

Schatz aus den Trümmern, 1995

Schatz aus den Trümmern: Der Silberschrein von Nivelles und die europäische Hochgotik (exhib. cat.), Cologne, Schnütgen-Museum, 1995.

Scheler, 1867

Auguste Scheler, ed., *Lexicographie latine du XII^e et du XIII^e siècle: Trois Traités de Jean de Garlande, Alexandre Neckam et Adam du Petit-Pont*, Leipzig, 1867.

Schenkluhn, 1987

Wolfgang Schenkluhn, *Nachantike kleinplastische Bildwerke*, vol. 1, *Mittelalter, 11. Jahrhundert bis 1530/40* (Wissenschaftliche Kataloge), Frankfurt-am-Main, Liebieghau, Museum Alter Plastik, Melsungen, Germany 1987.

Scher, 1974

Stephen K. Scher, "Note sur les vitraux de la Sainte-Chapelle de Bourges," *Cahiers d'archéologie et d'histoire du Berry*, no. 35 (December 1973; published 1974), pp. 23–44.

Scher, 1994

Stephen K. Scher, in *The Currency of Fame: Portrait Medals of the Renaissance* (exhib. cat.), ed. by Stephen K. Scher, New York, The Frick Collection, and Washington, D.C., National Gallery of Art, New York, 1994.

Schestag, 1866

Franz Schestag, *Katalog der Kunstsammlung des Freiherrn Anselm von Rothschild in Wien*, 2 vols., Vienna, 1866.

Schiedlausky, 1975

Günther Schiedlausky, "Ein gotischer Bechersatz," *Pantheon* 33 (October–December 1975), pp. 300–314.

Schilling, 1929

R. Schilling, "Ausstellung der Sammlung R. v. Passavant-Gontard im Städelschen Kunstinstitut," *Pantheon* 3 (April 1929), pp. 183–87.

Schlunk, 1947

Helmut Schlunk, "Arte visigodo, arte asturiano," in *Ars Hispaniae: Historia universal del arte hispánico*, vol. 2, Madrid, 1947, pp. 225–416.

Schmidt, 1975

Gerhard Schmidt, "Materialien zur französischen Buchmalerei der Hochgotik I (Kanonistische Handschriften)," *Wiener Jahrbuch für Kunstgeschichte* 28 (1975), pp. 159–70.

Schmitt, 1959

Clément Schmitt, *Un Pape réformateur et un défenseur de l'unité de l'Église: Benoît XII et l'Ordre des Frères Mineurs, 1334–1342*, Quaracchi, Italy, 1959.

Schmoll gen. Eisenwerth, 1958

J. A. Schmoll gen. Eisenwerth, "Madonnen Niklaus Gerhaerts von Leyden: Seines Kreises und seiner Nachfolge," *Jahrbuch der Hamburger Kunstsammlungen* 3 (1958), pp. 52–102.

Schnitzler, 1932

Hermann Schnitzler, "A Romanesque Ivory Carving in the Arthur Sachs Collection," *Bulletin of the Fogg Art Museum* 2, no. 1 (November 1932), pp. 13–18.

Schnitzler, Volbach, and Bloch, 1964

Hermann Schnitzler, Wolfgang Friedrich Volbach, and Peter Bloch, *Sammlung E. und M. Kofler-Truniger, Luzern*, vol. 1, *Skulpturen: Elfenbein, Perlmutter, Stein, Holz—europäisches Mittelalter*, Lucerne and Stuttgart, 1964.

Schnitzler et al., 1965

Hermann Schnitzler, Peter Bloch, Charles Ratton, and Wolfgang Friedrich Volbach, "Mittelalterliche Kunst der Sammlung Kofler-Truniger, Luzern" (exhib. cat.), Aachen, Suermondt-Museum der Stadt, *Aachener Kunstblätter* 31 (1965).

Schnütgen-Museum, 1968

Das Schnütgen-Museum: Ein Auswahl, Cologne, 1968.

Scholz, 1995

Hartmut Scholz, "Die Strassburger Werkstattgemeinschaft: Ein historischer und kunsthistorischer Überblick," in *Bilder aus Licht und Farbe: Meisterwerke spätgotischer Glasmalerei, "Strassburger Fenster" in Ulm und ihr künstlerisches Umfeld* (exhib. cat.), Ulm, Ulmer Museum, 1995, pp. 13–26.

Schöne Madonnen, 1965

Schöne Madonnen, 1350–1450 (exhib. cat.), Salzburg, Salzburger Domkapitel, 1965.

Schrader, 1979

J. L. Schrader, in *Notable Acquisitions, 1975–1979*, New York, The Metropolitan Museum of Art, 1979.

Schulz, 1927
Friedrich Traugott Schulz, "Der plastische und reliefplastische Schmuck an Nürnbergs Profanbauten," in *Nürnberg*, vol. 23 of *Monographien deutscher Städte*, Berlin and Friedenau, 1927, pp. 57–61.

Schulze-Dörrlamm, 1991
Mechthild Schulze-Dörrlamm, *Die Kaiserkrone Konrads II. (1024–1039): Eine archäologische Untersuchung zu Alter und Herkunft der Reichskrone* (Mainz, Römisch-Germanisches Zentralmuseum, Forschungsinstitut für Vor- und Frühgeschichte, Monographien, vol. 23), Sigmaringen, Germany, 1991.

Schwartz and Thomas, 1994
Ellen C. Schwartz and Thelma K. Thomas, "Beyond Empire: Artistic Expressions of Byzantium" (exhib. brochure), Ann Arbor, The University of Michigan Museum of Art, 1994.

Schwarz, 1917
Karl Schwarz, *Augustin Hirschvogel: Ein deutscher Meister der Renaissance*, Berlin, 1917.

Schwemmer, 1959
Wilhelm Schwemmer, *Die Kunstdenkmäler von Mittelfranken* (Die Kunstdenkmäler von Bayern, Mittelfranken), vol. 10, *Landkreis Hersbruck*, Munich, 1959.

Sechs Sammler, 1961
Sechs Sammler stellen aus (exhib. cat.), Hamburg, Museum für Kunst und Gewerbe, 1961.

Semff, 1980
Michael Semff, "Ein Kruzifixus-Torso des 12. Jahrhunderts aus Südtirol," *Pantheon* 38 (October–December 1980), pp. 339–46.

Ševčenko, 1991
Nancy P. Ševčenko, in *The Oxford Dictionary of Byzantium*, 3 vols., New York, 1991.

Shaver-Crandell and Gerson, 1995
Annie Shaver-Crandell and Paula Gerson, with Alison Stones, *The Pilgrim's Guide to Santiago de Compostela: A Gazetteer*, London, 1995.

Shelton, 1981
Kathleen J. Shelton, *The Esquiline Treasure*, London, 1981.

Shepard, 1990
Mary B. Shepard, "The Thirteenth Century Stained Glass from the Parisian Abbey of Saint-Germain-des-Prés," Ph.D. dissertation, Columbia University, 1990.

Simon, 1993
David L. Simon, "Late Romanesque Art in Spain," in *The Art of Medieval Spain, A.D. 500–1200*, New York, The Metropolitan Museum of Art, 1993, pp. 199–204.

Small, Thomas, and Wilson, 1973
Alan Small, Charles Thomas, and David M. Wilson, *St. Ninian's Isle and Its Treasure* (Aberdeen University Studies Series, no. 152), 2 vols., London, 1973.

Smith, 1848
Charles Roach Smith, "Religious Signs or Tokens of the Middle Ages," in *Collectanea antiqua: Etchings and Notices of Ancient Remains, Illustrative of the Habits, Customs, and History of Past Ages*, vol. 1, London, 1848, pp. 81–91.

Smith, 1908
Reginald A. Smith, "Anglo-Saxon Remains," in *The Victoria History of the County of Kent*, ed. by William Page, vol. 1, London, 1908, pp. 339–87.

Smith, 1914
Reginald A. Smith, "Irish Brooches of Five Centuries," *Archaeologia* 65 (1914), pp. 223–50.

Sneyers, 1973–74
René Sneyers, "Le Buste-Reliquaire de Saint Lambert de la cathédrale de Liège et sa restauration: Traitement," *Institut Royal du Patrimoine Artistique/Koninklijk Instituut voor het Kunstpatrimonium Bulletin* 14 (1973–74), pp. 84–86.

Songs of Glory, 1985
Songs of Glory: Medieval Art from 900–1500 (exhib. cat.), Oklahoma City, Oklahoma Museum of Art, 1985.

Sotomayor, 1962
Manuel Sotomayor, *S. Pedro en la iconografía paleocristiana: Testimonios de la tradición cristiana sobre San Pedro en los monumentos iconográficos anteriores al siglo sexto* (Biblioteca teológica granadina, 5), Granada, 1962.

Spahr, 1968
Gebhard Spahr, *Weingartner Liederhandschrift: Ihre Geschichte und ihre Miniaturen*, Weissenhorn, Germany, 1968.

Spätgotik in Salzburg, 1976
Spätgotik in Salzburg: Skulptur und Kunstgewerbe, 1400–1530 (exhib. cat.) (Jahresschrift, Salzburg, Salzburger Museum Carolino Augusteum, vol. 21), Salzburger Museum Carolino Augusteum, 1976.

Springer, 1981
Peter Springer, *Kreuzfüsse: Ikonographie und Typologie eines hochmittelalterlichen Gerätes* (Denkmäler deutscher Kunst, Bronzegeräte des Mittelalters, vol. 3), Berlin, 1981.

Sprinz, 1925
Heiner Sprinz, *Die Bildwerke der Fürstlich Hohenzollernschen Sammlung, Sigmaringen*, Stuttgart, 1925.

Stange, 1934
Alfred Stange, *Deutsche Malerei der Gotik*, vol. 1, *Die Zeit von 1250 bis 1350*, Berlin, 1934.

Steingräber, 1957
Erich Steingräber, *Antique Jewelry*, New York, 1957.

Stickler, Boyle, and De Nicolò, 1985
Alfons M. Stickler, P. Leonard E. Boyle, and Paolo De Nicolò, *Biblioteca Apostolica Vaticana*, Florence, 1985.

Stoddard, 1973
Whitney S. Stoddard, *The Façade of Saint-Gilles-du-Gard: Its Influence on French Sculpture*, Middletown, Connecticut, 1973.

Stratford, 1983
Neil Stratford, "Glastonbury and Two Gothic Ivories in the United States," in *Studies in Medieval Sculpture* (The Society of Antiquaries of London, Occasional Paper, n.s., 3), ed. by F. H. Thompson, London, 1983, pp. 208–16.

Stratford, 1984
Neil Stratford, in *English Romanesque Art, 1066–1200* (exhib. cat.), London, Hayward Gallery (in association with The Arts Council of Great Britain), 1984.

Stratford, 1987
Neil Stratford, in *Age of Chivalry: Art in Plantagenet England, 1200–1400* (exhib. cat.), ed. by Jonathan Alexander and Paul Binski, London, Royal Academy of Arts, 1987.

Strieder, 1982
Peter Strieder, in *Caritas Pirckheimer 1467–1532* (exhib. cat.), Nuremberg, Kaiserburg, Munich, 1982.

Stuhlfauth, 1896
Georg Stuhlfauth, *Die altchristliche Elfenbeinplastik* (Archäologische Studien zum christlichen Altertum und Mittelalter, vol. 2), Freiburg im Breisgau, 1896.

Stuhlfauth, 1925
Georg Stuhlfauth, *Die apokryphen Petrusgeschichten in der altchristlichen Kunst*, Berlin, 1925.

Taburet, 1983
Elisabeth Taburet, in *L'Art gothique siennois: Enluminure, peinture, orfèvrerie, sculpture* (exhib. cat.), Avignon, Musée du Petit-Palais, Florence, 1983.

Taburet-Delahaye, 1994
Elisabeth Taburet-Delahaye, "Lo smalto traslucido a Siena e Parigi nella prima metà del Trecento," in *Il Gotico europeo in Italia*, ed. by Valentino Pace and Martina Bagnoli, Naples, 1994, pp. 325–41.

Taburet-Delahaye, 1996
Elisabeth Taburet-Delahaye, in *Enamels of Limoges, 1100–1350* (exhib. cat.), New York, The Metropolitan Museum of Art, 1996.

Tentoonstelling van oude kunst, 1936
Catalogus van de tentoonstelling van oude kunst uit het bezit van den internationalen handel/Catalogue: Exhibition of Ancient Art Belonging to the International Trade/Exposition d'art ancien appartenant au commerce international (exhib. cat.), Amsterdam, Rijksmuseum, 1936.

Theophilus, 1963
Theophilus, *On Divers Arts: The Treatise of Theophilus*, trans. by John G. Hawthorne and Cyril Stanley Smith, Chicago, 1963.

Thuile, 1969
Jean Thuile, *Histoire de l'orfèvrerie du Languedoc, généralités de Montpellier et de Toulouse: Répertoire des orfèvres depuis de Moyen-Âge jusqu'au début du XIXe siècle*, vol. 3, Paris, 1969.

Tietze, 1913
Hans Tietze, *Die Denkmale des Benediktinerstiftes St. Peter in Salzburg* (Österreichische Kunsttopographie, vol. 12), Vienna, 1913.

Tonnochy, 1933
A. B. Tonnochy, "A Romanesque Censer-Cover in the British Museum," *The Archaeological Journal* 89 (1932; published 1933), pp. 1–16.

Török, 1992
Gyöngyi Török, "Neue Folii aus dem 'Ungarischen Anjou-Legendarium,'" *Zeitschrift für Kunstgeschichte* 55 (1992), pp. 565–77.

Tóth, 1992
Endre Tóth, "A History of the Peoples Living in the Carpathian Basin from the Palaeolithic Times to the Hungarian Conquest II," in István Fodor et al., *The Hungarian National Museum*, Budapest and Milan, 1992, pp. 55–82.

Treasures of Early Sweden, 1984
Treasures of Early Sweden/Klenoder ur äldre svensk historia, Stockholm, Statens Historiska Museum, 1984.

Trésors d'art gothique, 1961
Trésors d'art gothique en Languedoc (exhib. cat.), Montauban, Musée Ingres, 1961.

Trésors des églises, 1965
Les Trésors des églises de France (exhib. cat.), Paris, Musée des Arts Décoratifs, 1965.

Trevisani, 1987
Filippo Trevisani, "Il reliquiario di Montalto, Montalto Marche, Palazzo Arcivescovile," in *Studio Sixtina, nel IV centenario del pontificato di Sisto V (1585–1590)*, Rome, 1987, pp. 109–31.

Vadászi, 1973
Erzsébet Vadászi, "Peignes du gothique tardif dans notre collection," *Ars Decorativa* 1 (1973), pp. 61–71.

Vayer and Levárdy, 1972
L. Vayer and Ferenc Levárdy, "Nuovi contributi agli studi circa il Leggendario Angiovino Ungherese," *Acta Historiae Artium* 18 (1972), pp. 71–83.

Verdier, 1958
Philippe Verdier, "A Stained Glass from the Cathedral of Soissons," *The Corcoran Gallery of Art Bulletin* 10, no. 1 (November 1958), pp. 4–22.

Verdier, 1980
Philippe Verdier, *Le Couronnement de la Vierge: Les Origines et les premiers développements d'un thème iconographique* (Université de Montréal, Institut d'Études Médiévales, Conférences, 1972), Montreal and Paris, 1980.

Verron, 1971
Guy Verron, ed., *Antiquités préhistoriques et protohistoriques, Musée Départemental des Antiquités de la Seine-Maritime*, Rouen, 1971.

Vidal, 1910
J.-M. Vidal, ed., *Benoît XII (1334–1342): Lettres communes, analysées d'après les registres dits d'Avignon et du Vatican* (Bibliothèque des Écoles Françaises d'Athènes et de Rome, 3rd ser., II *bis*), vol. 2, Paris, 1910.

Viollet-le-Duc, 1871
Eugène Viollet-le-Duc, *Dictionnaire raisonné du mobilier français de l'époque carlovingienne à la Renaissance*, vol. 2, Paris, 1871.

Viollet-le-Duc, 1875
Eugène Viollet-le-Duc, *Dictionnaire raisonné de l'architecture française du XIe au XVIe siècle*, 10 vols., Paris, 1875.

Voelkle and Wieck, 1992
William M. Voelkle and Roger S. Wieck, with Maria Francesca P. Saffiotti, *The Bernard H. Breslauer Collection of Manuscript Illuminations*, New York, 1992.

Vöge, 1900
Wilhelm Vöge, *Die Elfenbeinbildwerke* (Berlin, Königliche Museen, Beschreibung der Bildwerke der christlichen Epochen, vol. 1), 2nd ed., Berlin, 1900.

Volbach, 1922
Wolfgang Friedrich Volbach, *Mittelalterliche Elfenbeinarbeiten* (Orbis Pictus, Weltkunst-Bücherei, vol. 11), Berlin, 1922.

Volbach, 1923
Wolfgang Friedrich Volbach, *Die Elfenbeinbildwerke*, vol. 1 of *Die Bildwerke des deutschen Museums*, ed. by Theodor Demmler, Berlin and Leipzig, 1923.

Volbach, 1930
Wolfgang Friedrich Volbach, *Mittelalterliche Bildwerke aus Italien und Byzanz* (Berlin, Staatliche Museen, Bildewerke des Kaiser Friedrich-Museums), 2nd ed., Berlin and Leipzig, 1930.

Volbach, 1968
Wolfgang Friedrich Volbach, in Wolfgang Friedrich Volbach and Jacqueline Lafontaine-Dosogne, *Byzanz und der christliche Osten* (Propyläen Kunstgeschichte, vol. 3), Berlin, 1968.

Volbach, 1976
Wolfgang Friedrich Volbach, *Elfenbeinarbeiten der Spätantike und des frühen Mittelalters* (Mainz, Römisch-Germanisches Zentralmuseum, Kataloge vor- und frühgeschichtlicher Altertümer, vol. 7), 3rd ed., Mainz, 1976.

de Waal, 1908
Anton de Waal, "Ein Sarkophag im Museum des deutschen Campo Santo," *Römische Quartalschrift* 22 (1908), pp. 52–54.

Wadding, 1733
Luke Wadding, ed., *Annales Minorum, seu Trium Ordinum a S. Francisco institutorum*, vol. 7, Rome, 1733.

Waldman, 1994
Louis Waldman, "The Cloisters-L'Aquila Pulpit: An Unknown Signature," *Gesta* 33 (1994), pp. 60–64.

Ward, 1985
Michael Ward, *Jewels of the Barbarians* (exhib. cat.), New York, Michael Ward, Inc., 1985.

Wardwell, 1975
Anne E. Wardwell, "The Mystical Grapes: A Devotional Tapestry," *The Bulletin of The Cleveland Museum of Art* 62 (January 1975), pp. 17–23.

Wardwell, 1989
Anne E. Wardwell, "Recently Discovered Textiles Woven in the Western Part of Central Asia before A.D. 1220," *Textile History* 20 (Autumn 1989), pp. 175–84.

Warner, 1912
George Warner, *Queen Mary's Psalter: Miniatures and Drawings by an English Artist of the 14th Century, Reproduced from Royal MS. 2 B. VII in the British Museum*, London, 1912.

Watt and Wardwell, 1997
James C. Y. Watt and Anne E. Wardwell, *When Silk Was Gold: Central Asian and Chinese Textiles* (exhib. cat.), New York, The Metropolitan Museum of Art, and The Cleveland Museum of Art, 1997.

Weerth, 1868
Ernst aus'm Weerth, *Kunstdenkmäler des christlichen Mittelalters in den Rheinlanden*, vol. 3, Bonn, 1868.

Weigelt, 1924
Curt H. Weigelt, "Rheinische Miniaturen," *Wallraf-Richartz-Jahrbuch* 1 (1924), pp. 5–28.

Weiss, 1963
Roberto Weiss, "The Medieval Medallions of Constantine and Heraclius," *The Numismatic Chronicle and Journal of the Royal Numismatic Society*, 7th ser., 3 (1963), pp. 129–44.

Weitzmann, 1977
Kurt Weitzmann, *Late Antique and Early Christian Book Illumination*, New York, 1977.

Weitzmann, 1978
Kurt Weitzmann, *The Icon: Holy Images, Sixth to Fourteenth Century*, New York, 1978.

Wentzel, 1951
Hans Wentzel, "Das Ratsfenster von 1480 im Chor des Ulmer Münsters und sein Meister Peter Hemmel von Andlau," *Ulm und Oberschwaben* 32 (1951), pp. 9–46.

Wentzel, 1954
Hans Wentzel, *Meisterwerke der Glasmalerei*, 2nd ed., Berlin, 1954.

Wentzel, 1966
Hans Wentzel, "Schwäbische Glasmalereien aus dem Umkreis des 'Hausbuchmeisters,'" *Pantheon* 24 (November–December 1966), pp. 360–71.

Wertheimer, 1929
Otto Wertheimer, *Nicolaus Gerhaert: Seine Kunst und seine Wirkung* (Jahresgabe des Deutschen Vereins für Kunstwissenschaft, 1929), Berlin, 1929.

Wessell, 1968
Klaus Wessell, *Byzantine Enamels from the 5th to the 13th Century*, trans. by Irene R. Gibbons, Greenwich, Connecticut, 1968.

Westermann-Angerhausen, 1974
Hiltrud Westermann-Angerhausen, "Ein Kaiserliches Schmuckstück im Schnütgen-Museum," *Museen in Köln, Bulletin* 13 (April 1974), pp. 1230–31.

Westermann-Angerhausen, 1975
Hiltrud Westermann-Angerhausen, "Eine unbekannte Fibel aus dem ottonischen Kaiserinnenschmuck?" *Mainzer Zeitschrift* 70 (1975), pp. 67–71.

Westermann-Angerhausen, 1983–84
Hiltrud Westermann-Angerhausen, "Ottonischer Fibelschmuck: Neue Funde und Überlegungen," *Jewellery Studies* 1 (1983–84), pp. 20–36.

Westermann-Angerhausen, 1991 a
Hiltrud Westermann-Angerhausen, "Spuren der Theophanu in der ottonischen Schatzkunst?" in *Kaiserin Theophanu, Begegnung des Ostens und Westens um die Wende des ersten Jahrtausends: Gedenkschrift des Kölner Schnütgen-Museums zum 1000. Todesjahr der Kaiserin*, ed. by Anton von Euw and Peter Schreiner, vol. 2, Cologne, 1991, pp. 193–218.

Westermann-Angerhausen, 1991 b
Hiltrud Westermann-Angerhausen, "Typ, Stil und Datierung der fünf mittelalterlichen Weihrauchfässer im Trierer Domschatz," in *Schatzkunst Trier: Forschungen und Ergebnisse* (Treveris Sacra, vol. 4), ed. by Franz J. Ronig, Trier, Germany, 1991, pp. 195–208.

Westwood, 1876
John Obadiah Westwood, *A Descriptive Catalogue of the Fictile Ivories in the South Kensington Museum, with an Account of the Continental Collections of Classical and Mediaeval Ivories*, London, 1876.

Wichmann and Wichmann, 1964
Hans Wichmann and Siegfried Wichmann, *Chess: The Story of Chesspieces from Antiquity to Modern Times*, trans. by Cornelia Brookfield and Claudia Rosoux, New York, 1964.

Wieck, 1996
Roger S. Wieck, "*Folia Fugitiva*: The Pursuit of the Illuminated Manuscript Leaf," *The Journal of The Walters Art Gallery* 54 (1996), pp. 233–53.

von Wilckens, 1986
Leonie von Wilckens, in *Gothic and Renaissance Art in Nuremberg, 1300–1550* (exhib. cat.), New York, The Metropolitan Museum of Art, and Nuremberg, Germanisches Nationalmuseum, Munich and New York, 1986.

von Wilckens, 1991
Leonie von Wilckens, "Seidengewebe des 12.–13. Jahrhunderts aus Nordmesopotamien und Bagdad," *Jahrbuch des Museums für Kunst und Gewerbe Hamburg*, n.s., 8 (1989; published 1991), pp. 27–44.

Wille, 1952
Christa Wille, "Die figürlichen Glasmalereien des 14. Jahrhunderts aus dem hessischen Raum," Ph.D. dissertation, University of Mainz, 1952.

Willers, 1986
Johannes Willers, in *Gothic and Renaissance Art in Nuremberg, 1300–1550* (exhib. cat.), New York, The Metropolitan Museum of Art, and Nuremberg, Germanisches Nationalmuseum, Munich and New York, 1986.

Williams, 1977
John Williams, *Early Spanish Manuscript Illumination*, New York, 1977.

Williams, 1991
John Williams, "Imaginería apocalíptica en el románico tardío español," in *"O Pórtico da Gloria e a arte do seu tempo": Actas simposio internacional sobre Santiago de Compostela, 3–8 de outubro de 1988* (Colección de difusión cultural, 6), La Coruña, Spain, 1991, pp. 371–82.

Williams, 1992
John Williams, "Purpose and Imagery in the Apocalypse Commentary of Beatus of Liébana," in *The Apocalypse in the Middle Ages*, ed. by Richard K. Emmerson and Bernard McGinn, Ithaca, New York, and London, 1992, pp. 217–33.

Williams, 1993
John Williams, in *The Art of Medieval Spain, A.D. 500–1200*, New York, The Metropolitan Museum of Art, 1993.

Williams, forthcoming
John Williams, *The Illustrated Beatus: A Corpus of the Illustrations of the Commentary on the Apocalypse*, vol. 5, *The 12th and 13th Centuries*, London, forthcoming.

Williamson, 1982
Paul Williamson, "The Raymond Pitcairn Collection at the Cloisters," *The Burlington Magazine* 124 (July 1982), p. 472.

Williamson, 1997
Paul Williamson, in *Images in Ivory: Precious Objects of the Gothic Age* (exhib. cat.), ed. by Peter Barnet, The Detroit Institute of Arts, 1997.

Wilpert, 1929
Giuseppe Wilpert, *I sarcofagi cristiani antichi*, vol. 2, Rome, 1929.

Wilson, 1985
Stephen Wilson, ed., *Saints and Their Cults: Studies in Religious Sociology, Folklore, and History*, Cambridge, England, and New York, 1985.

Wixom, 1967
William D. Wixom, *Treasures from Medieval France* (exhib. cat.), The Cleveland Museum of Art, 1967.

Wixom, 1969
William D. Wixom, "Four Late Gothic Additions to the Medieval Treasury," *The Bulletin of The Cleveland Museum of Art* 56 (November 1969), pp. 320–31.

Wixom, 1972
William D. Wixom, "Twelve Additions to the Medieval Treasury," *The Bulletin of The Cleveland Museum of Art* 59 (April 1972), pp. 86–111.

Wixom, 1974 a
William D. Wixom, "A Lion Aquamanile," *The Bulletin of The Cleveland Museum of Art* 61 (October 1974), pp. 260–70.

Wixom, 1974 b
William D. Wixom, "Two Thirteenth-Century Walnut Angels," *The Bulletin of The Cleveland Museum of Art* 61 (March 1974), pp. 82–96.

Wixom, 1979 a
William D. Wixom, "Eleven Additions to the Medieval Collection," *The Bulletin of The Cleveland Museum of Art* 66 (March–April 1979), pp. 86–151.

Wixom, 1979 b
William D. Wixom, in *Age of Spirituality: Late Antique and Early Christian Art, Third to Seventh Century* (exhib. cat.), ed. by Kurt Weitzmann, New York, The Metropolitan Museum of Art, 1979.

Wixom, 1980
William D. Wixom, in *Notable Acquisitions, 1979–1980: Selected by Philippe de Montebello, Director*, New York, The Metropolitan Museum of Art, 1980.

Wixom, 1981
William D. Wixom, in *Notable Acquisitions, 1980–1981: Selected by Philippe de Montebello, Director*, New York, The Metropolitan Museum of Art, 1981.

Wixom, 1982
William D. Wixom, in *Notable Acquisitions, 1981–1982: Selected by Philippe de Montebello, Director*, New York, The Metropolitan Museum of Art, 1982.

Wixom, 1983
William D. Wixom, in *Notable Acquisitions, 1982–1983: Selected by Philippe de Montebello, Director*, New York, The Metropolitan Museum of Art, 1983.

Wixom, 1984 a
William D. Wixom, in *The Jack and Belle Linsky Collection in The Metropolitan Museum of Art*, New York, 1984.

Wixom, 1984 b
William D. Wixom, in *Notable Acquisitions, 1983–1984: Selected by Philippe de Montebello, Director*, New York, The Metropolitan Museum of Art, 1984.

Wixom, 1985
William D. Wixom, in *Notable Acquisitions, 1984–1985: Selected by Philippe de Montebello, Director*, New York, The Metropolitan Museum of Art, 1985.

Wixom, 1986
William D. Wixom, in *Gothic and Renaissance Art in Nuremberg, 1300–1550* (exhib. cat.), New York, The Metropolitan Museum of Art, and Nuremberg, Germanisches Nationalmuseum, Munich and New York, 1986.

Wixom, 1987 a
William D. Wixom, "A Late Thirteenth-Century English Ivory Virgin," *Zeitschrift für Kunstgeschichte* 50 (1987), pp. 337–58.

Wixom, 1987 b
William D. Wixom, "A Saltcellar of Crystal and Gold of the Thirteenth Century in The Metropolitan Museum of Art," in *Hommage à Hubert Landais: Art, objets d'art, collections, études sur l'art du Moyen Âge et de la Renaissance sur l'histoire du goût et des collections*, Paris, 1987, pp. 30–35.

Wixom, 1987 c
William D. Wixom, in *Recent Acquisitions: A Selection, 1986–1987*, New York, The Metropolitan Museum of Art, 1987.

Wixom, 1988
William D. Wixom, in *Recent Acquisitions: A Selection, 1987–1988*, New York, The Metropolitan Museum of Art, 1988.

Wixom, 1989 a
William D. Wixom, "Medieval Sculpture at The Cloisters," *The Metropolitan Museum of Art Bulletin* 46, no. 3 (Winter 1988–89).

Wixom, 1989 b
William D. Wixom, in "Recent Acquisitions: A Selection, 1988–1989," *The Metropolitan Museum of Art Bulletin* 47, no. 2 (Fall 1989).

Wixom, 1990
William D. Wixom, in "Recent Acquisitions: A Selection, 1989–1990," *The Metropolitan Museum of Art Bulletin* 48, no. 2 (Fall 1990).

Wixom, 1991
William D. Wixom, in "Recent Acquisitions: A Selection, 1990–1991," *The Metropolitan Museum of Art Bulletin* 49, no. 2 (Fall 1991).

Wixom, 1992 a
William D. Wixom, "*In quinto scrinio de Cupro*, a Copper Reliquary Chest Attributed to Canterbury: Style, Iconography, and Patronage," in *The Cloisters: Studies in Honor of the Fiftieth Anniversary*, ed. by Elizabeth C. Parker, with Mary B. Shepard, New York, 1992, pp. 195–227.

Wixom, 1992 b
William D. Wixom, in "Recent Acquisitions: A Selection, 1991–1992," *The Metropolitan Museum of Art Bulletin* 50, no. 2 (Fall 1992).

Wixom, 1994
William D. Wixom, "A Thirteenth Century Support Figure of a Seated Friar," *Wiener Jahrbuch für Kunstgeschichte* 46–47 (1993–94; published 1994), pp. 797–802.

Wixom, 1995 a
William D. Wixom, "Two Cloisonné Enamel Pendants: The New York Temple Pendant and the Cleveland Enkolpion," in *Byzantine East, Latin West: Art-Historical Studies in Honor of Kurt Weitzmann*, ed. by Christopher Moss and Katherine Kiefer, Princeton, 1995, pp. 659–65.

Wixom, 1995 b
William D. Wixom, in "Recent Acquisitions, a Selection: 1994–1995," *The Metropolitan Museum of Art Bulletin* 53, no. 2 (Fall 1995).

Wixom, 1996 a
William D. Wixom, "Traditions et innovations au musée des Cloîtres," in *Sculptures hors contexte: Actes du colloque international organisé au Musée du Louvre par le Service culturel le 29 avril 1994*, pp. 93–119, Paris, 1996.

Wixom, 1996 b
William D. Wixom, in "Recent Acquisitions, a Selection: 1995–1996," *The Metropolitan Museum of Art Bulletin* 54, no. 2 (Fall 1996).

Wixom, 1997 a
William D. Wixom, in *The Glory of Byzantium: Art and Culture of the Middle Byzantine Era, A.D. 843–1261* (exhib. cat.), ed. by Helen C. Evans and William D. Wixom, New York, The Metropolitan Museum of Art, 1997.

Wixom, 1997 b
William D. Wixom, in "Recent Acquisitions, a Selection: 1996–1997," *The Metropolitan Museum of Art Bulletin* 55, no. 2 (Fall 1997).

Wulff, 1909
Oskar Wulff, *Altchristliche und mittelalterliche byzantinische und italienische Bildwerke* (Berlin, Königliche Museen, Beschreibung der Bildwerke der christlichen Epochen, 2nd ed., vol. 3), vol. 1, *Altchristliche Bildwerke*, Berlin, 1909.

Wulff, 1911
Oskar Wulff, *Altchristliche und mittelalterliche byzantinische und italienische Bildwerke* (Berlin, Königliche Museen, Beschreibung der Bildwerke der christlichen Epochen, 2nd ed., vol. 3), vol. 2, *Mittelalterliche Bildwerke*, Berlin, 1911.

Young, 1953
Bonnie Young, "A Medieval Bell," *The Metropolitan Museum of Art Bulletin* 11 (June 1953), pp. 293–96.

Zakin, 1985
Helen Jackson Zakin, "Grisailles in the Pitcairn Collection," in *Corpus Vitrearum: Selected Papers from the XIth International Colloquium of the Corpus Vitrearum, New York, 1–6 June 1982*, ed. by Madeline Harrison Caviness and Timothy B. Husband, New York, 1985, pp. 83–92.

Ziegler, 1985
Joanna E. Ziegler, *The Word Becomes Flesh* (exhib. cat.), Worcester, Massachusetts, Iris and B. Gerald Cantor Art Gallery, College of the Holy Cross, 1985.

Zimmermann, 1970
Eva Zimmermann, in *Spätgotik am Oberrhein: Meisterwerke der Plastik und des Kunsthandwerks, 1450–1530* (exhib. cat.), Karlsruhe, Badisches Landesmuseum, 1970.

Zimmermann et al., 1992
Eva Zimmermann et al., "Zuschreibungsprobleme: Beiträge des Berliner Colloquiums zur Dangolsheimer Muttergottes," *Jahrbuch Preussischer Kulturbesitz* 28 (1991; published 1992), pp. 223–67.

Index